AMERICAN ART OF THE 20TH CENTURY

PAINTING · SCULPTURE · ARCHITECTURE

AMERICAN ART

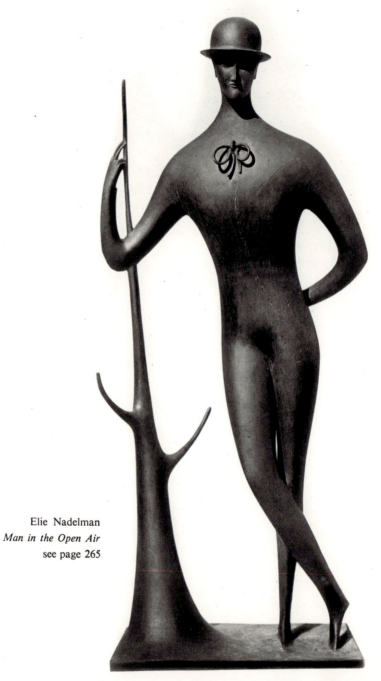

Elie Nadelman
Man in the Open Air
see page 265

PRENTICE-HALL, INC., ENGLEWOOD CLIFFS, N.J.

OF THE 20TH CENTURY

SAM HUNTER

Professor, Department of Art and Archaeology, Princeton University

with sections on architecture by

JOHN JACOBUS

Professor of Art and Urban Studies, Dartmouth College

HARRY N. ABRAMS, INC., NEW YORK

FOR ALEXA, EMMY, AND JACKIE

Book design by Robin Fox

Library of Congress Cataloging in Publication Data

Hunter, Sam, 1923–
 American art of the 20th century: painting, sculpture,
architecture

 Bibliography: p.
 1. Art, Modern—20th century—United States.
2. Art, American. I. Jacobus, John M. II. Title.
[N6512.H78 1973b] 709′.73 73–10210
ISBN 0-13-024075-3

ISBN 0-13-024075-3
Library of Congress Catalogue Card Number: 73–10210

Printed and bound in Japan

Contents

AMERICAN ART OF THE 20TH CENTURY

1 · The Usable Past

IT IS A MEASURE OF THE POWERFUL pressures of American provincialism that the story of the modern spirit in art in the nineteenth century is a chronicle of lonely and defeated ventures against academic orthodoxy, Puritan prohibitions, and the timid proprieties of the "genteel tradition" by a few unusual and courageous artists. Our great triad of native painters near the close of the century, Thomas Eakins, Albert Ryder, and Winslow Homer, stand out distinctly from the art scene by reason of their proud, stern independence. In their separate and distinguished styles these men found viable native idioms. Homer created an epic of the American out-of-doors; Eakins pursued an unpopular naturalism; Ryder, a contemplative, visionary art. They created no movements or schools, and more often than not, public hostility or indifference rewarded their efforts to delineate truthfully the American experience as they felt it. Homer and Eakins stood apart, too, in that they had followed the course of European art, and arrived independently at a form of *plein air* painting. But America was not ready for even such elementary affirmations, which it regarded with the suspicion usually reserved in that period for political radicalism. Only in the twentieth century did these struggles produce a sustained, collective artistic effort which could meet the challenge of modern life and bring American culture into the international mainstream.

In the interval, the sequence of our art was highly individualistic and erratic. Strange hiatuses appeared within the body of progressive painting; Impressionism and Post-Impressionism were only superficially explored, long after the mood that helped produce them in Europe had passed. Eakins's personal campaign for naturalism enlisted virtually no critical or artistic support at home, although by European standards the style was no longer revolutionary, and Continental painters were preoccupied with more complex pictorial problems. How could one expect Eakins, who had spent four years in Paris during the great formative years of early Impressionism, to welcome and investigate the most advanced styles of his time when his attempts to establish first principles of candor and seriousness even under the banner of naturalism met with violent opposition?

Realism did not arrive officially until early in the twentieth century, on the wings of political Progressivism and with the awakening on a national scale of the reform spirit. The new dispensation was short-lived, however, and the realists were soon briskly dispatched to the American attic of obsolescence by a more radical modernism. The realist discoverers of the American scene themselves scarcely had the opportunity to enjoy their victory before abstract painting styles made their innovations seem as outmoded as last year's Ford. The reasons for the skittish evolution of our art, which moved from a state of uncritical provincialism to a self-conscious, contemporary sophistication in a few brief years, must be sought in the changing character of American life. The modern spirit advanced and retreated with the mood of the times. It was precipitated finally in significant artistic productions by our rapid industrial expansion, and by the same economic and social forces which so profoundly transformed American life, thought, and manners after the Civil War.

In 1900, America could look back on an amazing half-century of progress during which the nation had been capitalized on an unprecedented scale, vast fortunes had been amassed, and a whole new urban, industrial population had been created. In a very short time, the conflicts and inequities brought by our heady industrial growth

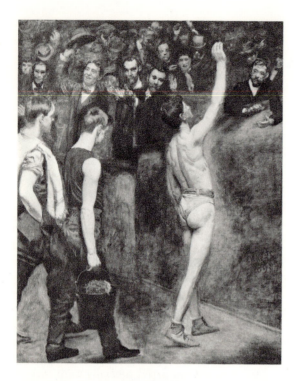

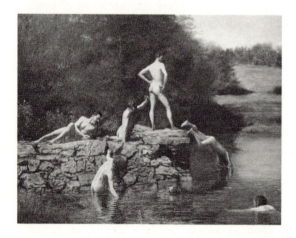

were to be expressed in an art and literature of protest, under the aegis of naturalism. But as the country stood poised uncertainly between the old order and a new emerging metropolitan culture, and as the contradictions in American life deepened, the whole motive for the new era—a growing sentiment for radical reform—was momentarily lost in a wave of renewed business confidence. The boundless and infectious self-assurance of a prospering business community seemed to have closed the gate firmly on social change and on the stirrings of agrarian protest that had been set off by the depression of the mid-nineties. Populism and agrarian grievance, which had inspired the first primitive realism of Hamlin Garland and other Western writers, were overshadowed by the Alaskan gold rush and the disappearance of the free silver issue. Bryan's defeat in 1896, and then the fulfillment of American imperialist ambitions in Cuba, cut away the underpinnings of Populist dissent and converted an emerging literature of protest from a utopianism which questioned the fundamental economic relationships of American society to a more pragmatic social criticism which was at the same time more effective and less basic. Since a consciousness of vital social issues had never deeply penetrated art anyway, painting merely prolonged its provincial idyl, while a relaxed America contemplated the green and lovely prospects of endless prosperity and unlimited opportunity. The irrepressible Age of Confidence, the Gilded Age, had reached full tide.

"I find America so cheerful, and so full of swagger and self-satisfaction, that I hardly know it," Henry Adams marveled and complained in a letter of 1900. "The change since 1893 is star-

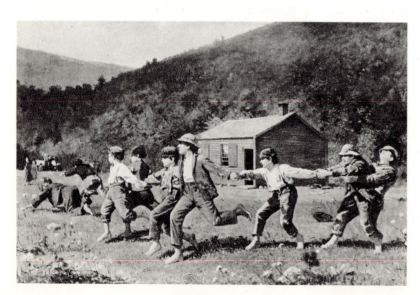

1. (*top left*) THOMAS EAKINS. *Salutat*. 1898. Oil on canvas, 49½ × 39½". Addison Gallery of American Art, Phillips Academy, Andover, Mass.

2. (*middle left*) THOMAS EAKINS. *The Swimming Hole*. 1883. Oil on canvas, 27 × 36". Fort Worth Art Center Museum, Fort Worth, Tex.

3. (*left*) WINSLOW HOMER. *Snap the Whip*. 1872. Oil on canvas, 22 × 36". The Butler Institute of American Art, Youngstown, Ohio

tling. . . ." In its leading editorial on the first day of the new century, the *New York Times* reflected the national mood of complacent optimism, describing the year past as an *annus mirabilis* in business and production, and anticipating even more remarkable performances in the one ahead. That same year some sort of apogee was reached when J. P. Morgan and Andrew Carnegie (the multimillionaire who began life as a $1.20-a-week bobbin boy) began negotiations for the formation of the world's biggest corporation, United States Steel.

In a country where the worship of bigness was deep in the temper of the time, art objects were being accumulated on the same colossal scale as the new fortunes. The business plutocrats continued that wholesale appropriation of European art which was eventually to flood the country with truckloads of horrible bric-a-brac and ornament, and, almost incidentally, to enrich our na-tional museums with old masters. For their homes, in keeping with their public eminence, the nouveau riche chose expensive vulgar imitations of grand European residences: the schloss, château, and palazzo. It was the time of the craze for the emblems of European magnificence and power. According to one critic, the most fashionable architect of the Gilded Age, Richard Morris Hunt, was kept busy building Fifth Avenue French châteaus on the order of the resplendent Vanderbilt home at the corner of Fifty-Second Street, "while less eminent rivals were designing Rhine castles for brewers, or weird combinations of architectural souvenirs—an eclecticism that reached its climax in a brilliant design, unfortunately not executed, for a building exhibiting a different historical style on every story."

One of the few who dared question the prevailing tastes which so transparently reflected the yearning for showy, nouveau-riche trappings was

4. WINSLOW HOMER. *Eight Bells*. 1886. Oil on canvas, 25 × 30″. Addison Gallery of American Art, Phillips Academy, Andover, Mass.

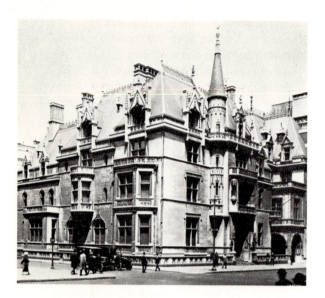

5. RICHARD MORRIS HUNT. Vanderbilt House, New York City. 1879–80 (demolished)

the architect Louis Sullivan: "Must I show you," he wrote mockingly, "this French château, this little *Château de Blois*, on this street corner here in New York, and still you do not laugh? Must you wait until you see a *gentleman* in a silk hat come out of it before you laugh? Have you no sense of humor, no sense of pathos? Must I tell you that while the man may live in the house physically (for a man may live in any kind of house, physically), that he cannot possibly live in it morally, mentally, or spiritually, that he and his home are a paradox, a contradiction, an absurdity, a characteristically New York absurdity; that he is no part of the house, and his house is no part of him?"

The more fanciful forms of private bad taste had their counterpart in the general stylistic anarchy and indifferent standards of public decoration. In words that were to remain unhappily apropos for the next half-century, a sensitive critic, James Jackson Jarves, wrote in 1864: "In America, the present is an epoch of monstrous plaster figures, daubed with crazy paint; of mammoth cast-iron washbasins called fountains; of cast-iron architecture and clumsy gateways to public parks; of shoddy portrait statues and inane ideal ones; of ornaments, pictures and sculptures made to gull and sell."

The decades after the Civil War were indeed the dark ages of American taste, a period during which resistance to the gathering forces of modernism was expressed both by its ostentatious vulgarizations and by its shy withdrawals into a negative aestheticism and refinement. The Gilded Age's uninhibited extravagance at least caught something of the energy of the times, but the other side of the coin was a spirit of aesthetic discouragement. It was reflected in the stubborn adherence to dead traditional forms in architecture when a robust, native style of building had emerged and its much maligned champions were crying to be heard, and hired. Characteristic, too, was the vogue for painters like Sargent and Whistler, whose styles, whatever their other merits, were unvital, aristocratic, European in the fashionable sense—another symptom of the flight from the vulgar American present. Collectors and patrons also joined the conspiracy of fashion against a distressing, problematic present by concentrating their purchases in the old masters, whose values were certified and sure.

Many of the most discerning and cultivated critics were ultimately impotent before their prejudice against their own times. They were "apostles" of old world culture in the New World. Charles Eliot Norton, the last of the Boston Brahmins; art critic and collector James Jackson Jarves, who formed the famous group of Italian primitives now at Yale University; and the painters William Morris Hunt and John La Farge had dedicated themselves in their varied ways to the task of broadening American civilization by making intelligible and accessible great areas of the European and Oriental artistic past. In the living American present, however, they could discern only the negative aspects of democratic vulgarity and anarchy. They expressed their fear of modern life, of a present and future in which Norton, for one, could only envision "outbreak after outbreak of passion and violence," by taking refuge in a refined aestheticism and cultivating a new traditionalism. Their writings and art reestablished contact with the Renaissance, the late medieval and Oriental past, as if they hoped to exorcise the noisy age of progress and the irrevocably changed conditions of modern life. Such nostalgia put our spokesmen for sensibility and aesthetic values as much out of touch with the vital elements in American life as did the pretentious taste of the nouveau-riche vulgarians.

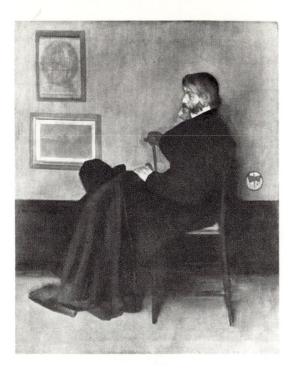

6. JAMES A. MCNEILL WHISTLER. *Thomas Carlyle:
Arrangement in Grey and Black, No. 2.* 1872.
Oil on canvas, 67 × 56″. Glasgow Art Gallery
and Museum, Glasgow, Scotland

7. JOHN SINGER SARGENT.
Mr. Charles D. Ayer. 1880.
Oil on canvas, 25⅝ × 17¼″. The Art Institute of Chicago

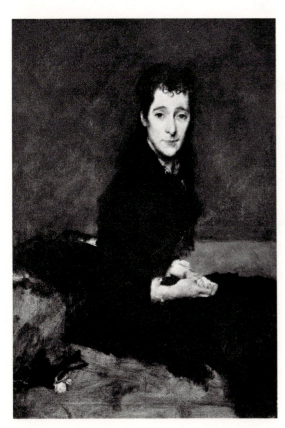

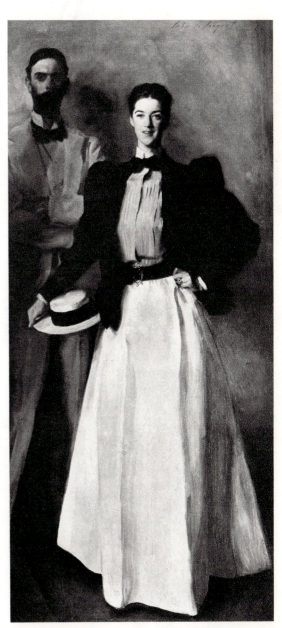

8. JOHN SINGER SARGENT.
Mr. and Mrs. Isaac Newton Phelps Stokes. 1897.
Oil on canvas, 84¼ × 39¾″.
The Metropolitan Museum of Art, New York City.
Bequest of Edith Mintum Stokes, 1938

9. WILLIAM MORRIS HUNT.
Marguerite. 1870.
Oil on canvas, 50⅛×31″.
Museum of Fine Arts, Boston.
Abraham Schuman Fund

10. MARY CASSATT.
Caresse Enfantine. 1902.
Oil on canvas, 32×26¼″.
National Collection of Fine Arts,
Smithsonian Institution,
Washington, D.C.
Gift of William T. Evans

11. JOHN LA FARGE. *Hill Top*.
c. 1868. Oil on canvas, 24×13″.
Museum of Fine Arts, Boston.
Bigelow Collection

12. WILLIAM MORRIS HUNT. *The Ball Players*. Oil on canvas, 16×24″.
The Detroit Institute of Arts. Gift of Mrs. John L. Gardner

Lewis Mumford has described the postbellum years as "the Brown Decades," delineating an era that began in mourning at Lincoln's funeral and took its general coloration from "the smut of industrialism." To extend his figure, "brown" was also the deepening hue of discouragement and defeatism in the genteel tradition, was reflected in the décor of both fashionable and popular life, and was repeated, too, in the palette of American art. After the fifties brownstone caught the public fancy in New York building; and brown, or dark, lugubrious interiors were characteristic—interiors that denied light with their window hangings of double thickness, maroon wallpapers, and massive walnut suites upholstered in red plush. How remote from the fresh and intense colors of French Impressionism, which accorded with a modern spirit of hopefulness and freedom, was the sober palette of the period's significant American art! A Rembrandtesque gloom, half pensiveness, half resignation, darkens the atmosphere of Thomas Eakins's forthright realism. The golden dreams of Ryder, Inness, and Blakelock are fogged by rich brown varnishes, and a crepuscular and elegaic mood steals over romantic painting of the period. The morning freshness of Winslow Homer's first significant style of outdoor painting, around 1866, emerged from a duskier academicism. But in later years he returned to a more sober, autumnal palette. In its first flush of youth, modern American painting managed to look prematurely mellow and time-worn.

The prevailing murkiness and obscurities of American art after the Civil War, and its romantic introspections, were in part the result of a creative tradition dominated by transcendental and subjective elements, mistrustful of any hedonism. But the romantic resignation of our art, so out of tune with the blatant energies of a growing, prosperous land, also registered an aesthetic uncertainty. The critic Frank Jewett Mather held the times responsible for the mood of doubt he saw mirrored in Eakins's art. It was a moment, he wrote, "of hesitation. Darwin, Huxley, Herbert, Spencer, and Matthew Arnold were novelties, presenting urgent problems, which thinking people had to cope with. Everything in belief, and much in practice, had to be radically reconstructed, with a dire offchance that only destruction was possible. There had been no time to think it through, nor yet to adopt the defeatist policy of letting it alone. . . .

13. ALBERT PINKHAM RYDER. *Forest of Arden.* 1888–97. Oil on canvas, 19 × 15″. The Metropolitan Museum of Art, New York City. Bequest of Stephen C. Clark, 1961

[Eakins's] gift was to understand a generation, seeking grimly to find itself, and saddened by an uncertain quest." That same "uncertain quest," however, produced quite positive liberations in Continental painting, which somehow were stifled or distorted into egocentric dreams and romantic fancies during the same period in America. The heightened sensations of French Impressionist painting dramatize by contrast the sobriety of contemporary artistic modes in America. The best American art did not offend so flagrantly as those earlier landscape schools on the Continent which Ruskin had censured for seeming "to look at nature through a black looking glass." But the dark cast of romantic sentiment and yearnings was not to be dislodged readily from American painting in the last decades of the century.

It was perhaps only fitting that the modern spirit should most vigorously proclaim itself first in Chicago, and not in painting or sculpture, but in architecture. Advances in technology brought the possibility of the steel-frame skyscraper, and with it, new constructional problems and solutions. Indeed, brutal industrial necessity was the mother of radical engineering techniques and aes-

14. RALPH A. BLAKELOCK. *Moonlight.* c. 1855–59.
Oil on canvas, 27¼ × 32¼″.
The Brooklyn Museum, New York City.
Dick S. Ramsay Fund

15. GEORGE INNESS. *The Coming Storm.* c. 1880.
Oil on canvas, 27½ × 42″.
Addison Gallery of American Art, Phillips Academy,
Andover, Mass.

16. WINSLOW HOMER.
Long Branch, New Jersey. 1869.
Oil on canvas, 16 × 21¾″.
Museum of Fine Arts, Boston.
Charles Henry Hayden Fund

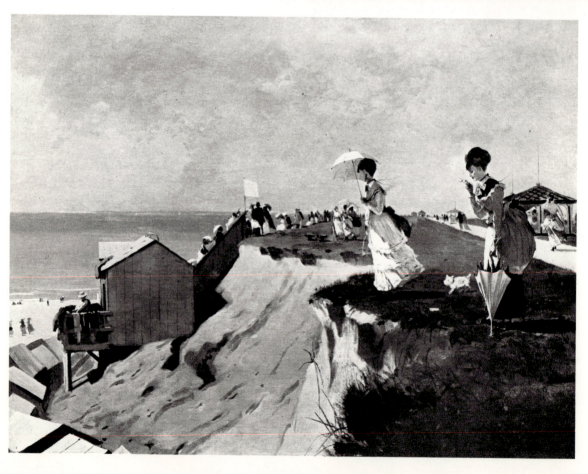

17. THOMAS EAKINS.
The Thinker: Louis N. Kenton. 1900.
Oil on canvas, 82 × 42″.
The Metropolitan Museum of Art, New York City.
Kennedy Fund, 1917

captious and fleeting; it can pull itself down and rebuild itself in a generation, if it will. It has done and can do great things when the mood is on. There can be no new New York, but there may be a new Chicago."

Around Chicago formed the "modern movement" in architecture. The ground had been prepared by Henry Hobson Richardson in the East, where after 1880 and until his death six years later he achieved a plain severity of style that was the parallel in architecture of the stern realism of Thomas Eakins. Richardson's expression, its sobriety notwithstanding, had distinct romantic overtones evoked by his heavy courses of rough-finished stone, and a certain medievalism in idiom. He died as the transition from masonry to steel-and-glass was being made. Despite its refreshing simplicity, his style still preserved the load-bearing wall, which disguises rather than clarifies the functional aspects of the building and its frame. The plainness of his neo-Romanesque forms and the coherence of his style, however, paved the way for a new mood of independence in American building. Like Eakins's efforts at an objective realism, Richardson's structures were the first indication of a new spirit of objectivity in the arts.

In the late eighties and nineties, the office buildings and department stores of LeBaron Jenney, Holabird and Roche, Burnham and Root, and of the Richardson disciple, Louis Sullivan, gave the Middle West a "functionalist" renaissance in building. Chicago became the birthplace of the steel-skeleton skyscraper and of the wholly original modern idiom developed first by Sullivan and then by his pupil, Frank Lloyd Wright. The pioneers of the modern movement unfortunately also received their first severe setback on native ground at the Chicago World's Fair of 1893. That fair was dominated by the suave Beaux-Arts classicism of McKim, Mead, and White, and the revivalist idioms of other fashionable, shallow eclectics of the period. "[The exposition of 1893] condemned American architecture to the imitative and the derivative for another generation," Henry Steele Commager later wrote in *The American Mind*. Only Sullivan's Transportation Building, with its daring Golden Portal, gave any indication of vital new directions in American architecture at the celebrated and influential exposition.

With the more enterprising pioneers like Richardson and Root dead, Sullivan and his pupil

thetic invention. These in turn bore directly on the great revolution in taste which America was soon to experience. That these solutions, and the new sense of building for human needs and comforts they embodied, emerged in Chicago, the symbolic industrial and metropolitan center of the nineties, was also appropriate. The dynamic growth of that city and the social evils attendant on its rapid industrialization called forth new critical and creative energies. "Chicago," wrote Louis Sullivan in *Kindergarten Chats* in 1901, "is young, clumsy, foolish; its architectural sins are unstable,

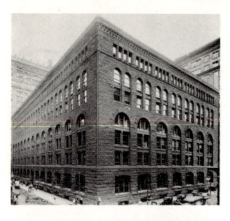

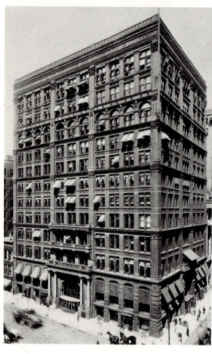

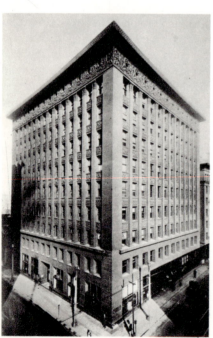

18. (*top left*) H. H. RICHARDSON.
Marshall Field Wholesale Store, Chicago.
1885–87 (demolished 1931)

19. (*middle left*) WILLIAM LE BARON JENNEY.
Home Insurance Building,
La Salle and Adams Streets, Chicago.
1883–85 (demolished 1929)

20. (*bottom left*) LOUIS SULLIVAN. Wainwright Building,
St. Louis, Mo. 1890–91

21. (*below*) BURNHAM AND ROOT. Reliance Building,
Chicago. 1890–94

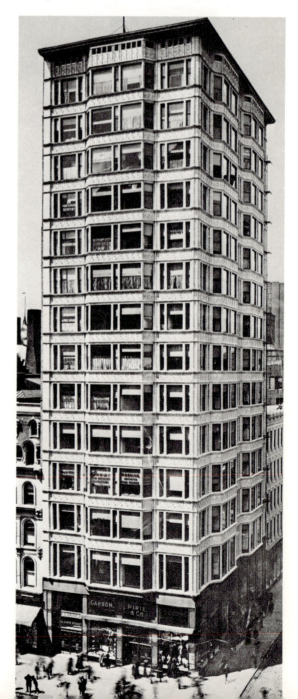

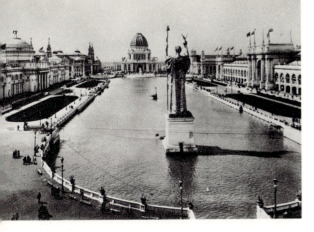

22. McKim, Mead, and White.
Chicago World's Fair Building, Columbian Exposition.
1893 (demolished)

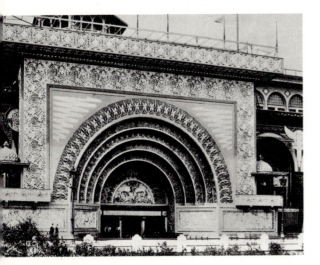

Wright almost singlehandedly carried the burden of the new spirit in the decade after the Chicago Exposition. Sullivan had a Whitmanesque devotion to democracy, and identified its ideals of freedom with modernism; he was an eloquent, if solitary, spokesman for the new principles of building, which he formulated around the hard core of functionalism. His forceful and eloquent writings place him as America's first apostle of a revolutionary modernism. Where other sensitive men had shrunk from the materialism and technological realities of the age of progress, Sullivan embraced them in the belief that the new social conditions thus produced deserved a new and challenging artistic style, a creative expression that would fulfill the needs of a period of drastic change. Sullivan's theorizing, poetizing, and best of all his actual building, represented the same search for some new aesthetic fundamentalism that animated the art of the French Post-Impressionist painters in the same epoch; it was opposed to the retrospective, romantic mood of the more popular turn-of-the-century styles in art and architecture. American painting or sculpture of the period offers no aesthetic radicalism comparable to Louis Sullivan's.

In the "tall office building" Sullivan found an exalted symbol of the modern spirit. "It must be,"

23. Louis Sullivan.
Transportation Building (detail of Golden Portal),
Columbian Exposition, Chicago. 1893 (demolished)

24. Frank Lloyd Wright. Exterior view, Robie House, Chicago. 1909

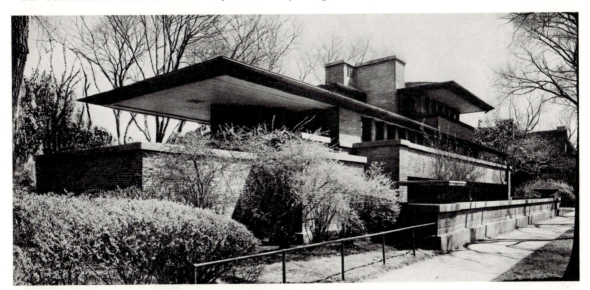

he wrote, "every inch a proud and soaring thing, rising in [such] sheer exultation that from bottom to top it is a unit without a single dissenting line—that is the new, the unexpected, the eloquent peroration of the most bald, most sinister, most forbidding conditions." And by the character of its buildings, he warned, posterity would judge society's creative health and its happiness: "What people are within, the buildings express without; and inversely, what the buildings are objectively is a sure index of what the people are subjectively. In the light of this dictum, the unhappy, irrational, heedless, pessimistic, unlovely, distracted and decadent structures which make up the great bulk of our contemporaneous architecture point with infallible accuracy to qualities in the heart and mind and soul of the American people that are unhappy." Five years later, in 1901, Sullivan's estimate of the situation in architecture perfectly summed up the crisis in the fine arts. "We are at that dramatic moment in our national life," he wrote, "wherein we tremble between decay and evolution, and our architecture, with strange fidelity, reflects this equipoise. That the forces of decadence predominate in quantity there can be no doubt. . . . That there is in our national life, in the genius of our people, a fruitful germ, and that there are a handful who perceive this, is likewise beyond question."

The forms of literature and art responded less readily to the pressures of technology than those of architecture; and changes in artistic methods faced perhaps even stronger resistance than Sullivan encountered after the Chicago Fair. During the interregnum of conservatism which lasted from Bryan's defeat in 1896 to the emergence of muckraking agitation under Theodore Roosevelt, the nation was in a complacent and self-congratulatory mood. It was the era of the Gibson Girl, of Richard Harding Davis, and of adventure fiction and historical confectionery in the novel. As the human distress produced by an unrestrained industrial colossus became more acute and began to press on the American consciousness, art and literature became more frivolous and vacant of serious content. The crudest fantasies of immaturity were given credence in writing that glorified success, romantic exploits in far-off places, and a state of eternal innocence and youth. The very real and present terrors of the economic struggle—those conditions that Louis Sullivan described as "most bald, most sin-

ister, most forbidding"—would soon be uncovered in the realist novels of Frank Norris, Stephen Crane, and Theodore Dreiser. But they were brushed aside for the moment, as the century of hope breathed its last and the Gilded Age enjoyed a final flourish.

Dreiser's *Sister Carrie* was published in 1900, and immediately suppressed as too sordid and "pornographic" because it honestly described the compromising relationships into which a member of the new urban proletariat was compelled by economic circumstances beyond her control. Dreiser's treatment was straightforward and objective without any touch of sensationalism or bad taste, but his revelation of some bitter truths of the battle for survival was unacceptable to Americans who preferred the lie of the Age of Innocence. When Dreiser was being spurned and attacked, popular reading consisted of Horatio Alger's success stories and such romantic delectations as Charles Major's *When Knighthood Was in Flower*. The more literate turned to *The Century* and similar strongholds of gentility whose editors took care never to sully their pages with the more unpleasant facts of contemporary existence. In the hands of *The Century's* long-time editor, Richard Watson Gilder, the genteel tradition was safe. Gilder had the dubious distinction of rejecting Stephen Crane's early venture in realism, *Maggie;* he once confessed, too, that he had edited the indelicacies out of *Huckleberry Finn;* and at another time he refused to receive

25. Louis Sullivan.
Carson, Pirie & Scott Building, Chicago. 1899

Robert Louis Stevenson in the magazine's offices on the strength of rumors questioning the author's respectability.

In painting such exaggerated prudishness was equally insidious. It was Eakins's candor and scientific objectivity that led to his dismissal from a teaching post at the powerful Pennsylvania Academy in 1886, after he defied local taboos by posing nude male and female models together in an anatomy demonstration. Walt Whitman, a close friend of the painter, once said of Eakins: "I never knew of but one artist, and that's Tom Eakins, who could resist the temptation to see what they think they ought to rather than what is." Eakins's naturalism had posed a threat to decorum, as it was understood in polite Philadelphia art circles, ever since 1875, when he had dared paint objectively a surgical operation, accurate even to the surgeon's bloody hands. *The Gross Clinic,* masterpiece of Eakins's youth, was howled down in the press as a "degradation of art." One critic savagely attacked the artist because he succeeded in his intention of creating a convincing impression of actuality: ". . . as for people with nerves and stomachs, the scene is so real that they might as well go to a dissecting room and have done with it."

The fear that truth to life threatened the traditional dignity of painting was in the background of much nineteenth-century criticism. Such views stemmed from the position of privilege given by official art to the ideal stereotypes of an outworn classicism. A cosier expression of the same prejudice was the Victorian concept that art consisted of "beautiful things seen beautifully." As a consequence, art in America revolved around a sterile vogue for sugary anecdote; picturesque landscape, grandiose in dimension and elevated in sentiment; or a spurious classicism based on French Academy prototypes. Paintings in these categories could be counted on to receive the most flattering wall positions, and took all the prizes at the various Academy annuals. When Eakins proposed to paint what he actually knew and what could be verified by the senses, he violated the most sacrosanct canons of contemporary art. "The business of art," a critic of the period had rather pompously intoned, in defense of the genteel taste, "is to afford joyance. . . . What a shame it is the great gifts of expression should ever be wasted on heinous and joyless subjects."

That such a feeble idealism did not altogether

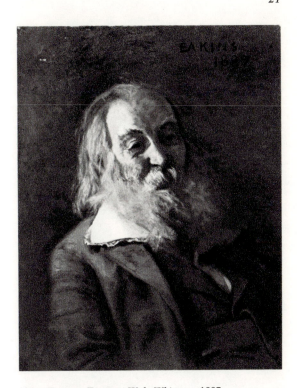

26. THOMAS EAKINS. *Walt Whitman.* 1887.
Oil on canvas, 30 × 24″.
Pennsylvania Academy of the Fine Arts, Philadelphia

dominate our culture was due to the persistence of a more vigorous and hardheaded tradition of empirical thought whose forms were being extended and infused with new content appropriate to the times by such pioneering spirits as Louis Sullivan, and indeed, Thomas Eakins. The need to relate art to actual American life had already been recognized and eloquently expressed as early as mid-century by Emerson when he wrote: "We do not with sufficient plainness or sufficient profoundness address ourselves to life, nor dare we chant our times and social circumstances. . . . Banks and tariffs, the newspaper and the caucus, Methodism and Unitarianism, are flat and dull to dull people, but rest on the same foundations of wonder, as the town of Troy, and the temple of Delphos, and are as swiftly passing away." By 1880 the critic W. Mackay Laffan could rather more irreverently express the growing sense of the validity of the commonplace American reality: "There be more joy over one honest and sincere American horse pond, over one truthful and dirty tenement, over one unaffected sugar refinery, over one vulgar but unostentatious coal wharf than there shall be over ninety and nine mosques of St. Sophia, Golden Horns, Norman-

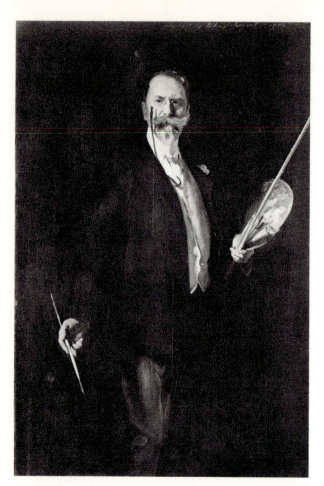

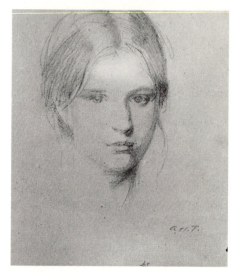

27. JOHN SINGER SARGENT.
William Merritt Chase. 1902.
Oil on canvas, 62½ × 41⅜″.
The Metropolitan Museum of Art, New York City.
Gift of pupils of William M. Chase, 1905

28. ABBOTT H. THAYER.
*Portrait of the Artist's Daughter,
Mary*. c. 1887. Drawing, 8½ × 7½″.
National Collection of Fine Arts,
Smithsonian Institution, Washington,
D.C. Gift of John Gellatly

dy cathedrals, and all the rest of the holy conventionalities and orthodox bosh." Its downright, colloquial language and preference for the humble, unvarnished American thing over the grandest European artifact give this statement an authentic Whitman ring. Behind it were new but as yet unfocused artistic attitudes: an affirmation of the American experience, accepted in all its rawness, and the rejection of European authority. It was not until the next century, however, that there appeared an entire school of artists dedicated to the ideal that the artist had to paint the life he knew best if a genuine American art were to develop.

In the intervening years the impact of American thought and American life on art was less important than the awakening among artists of a new interest in European painting. Quickened by contacts with Rome, Düsseldorf, Munich, and Paris during the last three decades of the century, a number of American painters besides Homer and Eakins had begun to seek more sophisticated viewpoints and techniques. In the seventies William Chase, Frank Duveneck, and Abbott Thayer

were linked with Eakins in a loose association known as "the New Movement." For a time Düsseldorf, and then Munich, with its more sentimental adaptions of French naturalist styles, became the fashionable foreign center for American art pilgrims. Frank Duveneck established a school in Munich in 1878 and many young Americans, later known as "the Duveneck boys," came to study. Duveneck based his style on the bravura brushwork and dark palette of the Bavarian painter Wilhelm Liebl, who in turn had been influenced by Hals and the early Manet. Despite the obvious appeal of the Munich style to shallow technicians, the new manner nonetheless embodied a more liberal spirit than much of the art current in America. One of the Duveneck boys was John Twachtman, who later turned to Impressionism after the Munich style had been discredited for its "brown sauce" and emphasis on "technique for technique's sake." Twachtman joined Childe Hassam, J. Alden Weir, and other artists in 1898 to form an Impressionist group called "the Ten"; and Ernest Lawson, a Twachtman pupil, later became a charter member of the

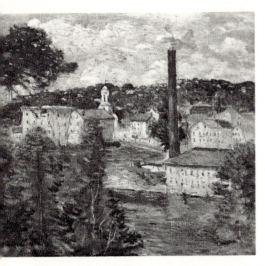

29. JOHN ALDEN WEIR. *Willimantic, Connecticut.*
1923. Oil on canvas, 20 × 24". University Art
Collections, Arizona State University, Tempe

30. CHILDE HASSAM. *The Church at Gloucester.*
1918. Oil on canvas, 30 × 25".
The Metropolitan Museum of Art, New York City.
Arthur H. Hearn Fund, 1925

31. LOUIS C. TIFFANY. *Duane Street, New York.*
1878. Oil on canvas, 27 × 30".
The Brooklyn Museum, New York City.
Dick S. Ramsay Fund

twentieth century's first band of rebel realists,
"the Eight."

The protests against current academic practices
by the Munich-trained painters and then by "the
Ten" had been rare instances of organized Ameri-
can protest in the latter half of the nineteenth
century, a period that in France had been rich in

examples of artistic truancy. In this country, the
problem of re-creating those successive phases
of revolution which punctuated modern Euro-
pean art was a difficult one. During the Brown
Decades, provincial tastes and prevailing academ-
ic styles presented serious obstacles to the artist
who wished to experiment with new and progres-
sive ideas. The absence of continuous and pro-
found visual traditions was equally discouraging.
Hypothetically, the artist in America had greater
freedom of choice than the European, but actually
he found it more difficult to forge new idioms,
there being so few examples of high creativeness
in his own past to support original ventures.
While the academic caste in America was relative-
ly new and far less powerful than its French
counterpart, our visual traditions as a whole were
impoverished; provincial eccentricity in an art
of little consequence, or a shallow imitation of
the more conventional European modes, were
the usual results of our illusory condition of
freedom.

Everything conspired, it seems, to give Ameri-
ca a minor role in the fine arts during the late
nineteenth century. Even the independent posi-
tion of Eakins, Ryder, and Homer was somewhat
compromised at the end of their careers when
they accepted membership in the most august
official art body, the National Academy of De-

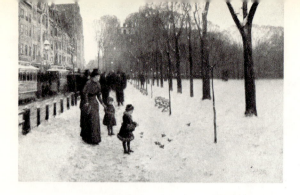

32. CHILDE HASSAM. *Boston Common at Twilight.*
1885–86. Oil on canvas, 42×59⅞″.
Museum of Fine Arts, Boston.
Lent by Miss Maud Appleton

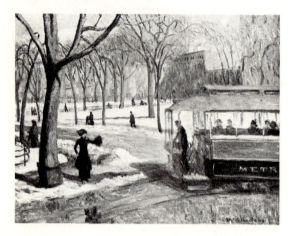

33. WILLIAM J. GLACKENS. *The Green Car.* 1910.
Oil on canvas, 24×32″.
The Metropolitan Museum of Art, New York City.
Arthur H. Hearn Fund, 1937

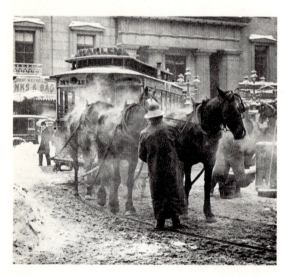

34. ALFRED STIEGLITZ. *The Terminal, New York.* 1893.
Photograph printed from a lantern slide
by Alfred Stieglitz.
George Eastman House Collection, Restricted

35. WILLIAM MERRITT CHASE.
The Tenth Street Studio. 1890. Oil on canvas, 47×66″.
Museum of Art, Carnegie Institute, Pittsburgh

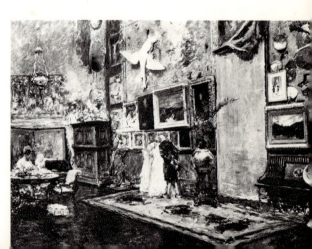

sign. Revolutions in art were absorbed or deflected before they had the opportunity to gather momentum, in part because the division between "official" art and advanced art was never altogether clear. Advanced art, as the Duveneck boys practiced it in the eighties, was woefully backward in relation to contemporary France, and aroused mainly an academic interest in America by the following decade. At that, the new generation of American realists relied heavily on the Duveneck pictorial formula, a style which originated with the French avant-garde back in the 1860s.

Our history of organized artistic protest had not been an inspiring one. Sometimes it seemed indeed that revolts were made only to provide new opportunities for defections. An excellent example was William Merritt Chase. He had been associated with Eakins in "the New Movement" of the seventies, and was a leading spirit in the formation of the Society of American Artists in 1877, which set out to free painters from the stuffy attitudes and restrictive exhibition policies of the powerful National Academy. But by 1892 the Society had also become parochial, when it forced Eakins's resignation by refusing to exhibit his *Agnew Clinic* on the grounds of "his neglect of the beauties and graces of painting." Chase himself later became the prime apostle of *le morçeau bien fait*, or the well-turned detail, and, from an exalted teaching post at the Art Students League, one of the main custodians of a conservative traditionalism. In time he would be the very symbol of artistic reaction against which the new generation of realists made their revolt. The Society of American Artists, in which Chase played the dominating role, closed the final chapter of progressive nineteenth-century art by disbanding and merging with the National Academy in 1906. It was left to a group of young insurgents to revive the moribund spirit of rebellion and give new substance to a neglected ideal of "independents'" exhibitions.

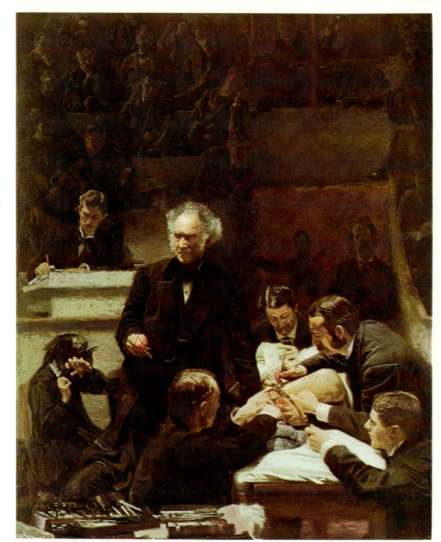

36. THOMAS EAKINS.
The Gross Clinic. 1875.
Oil on canvas, 96 × 78″.
Jefferson Medical College
of Philadelphia

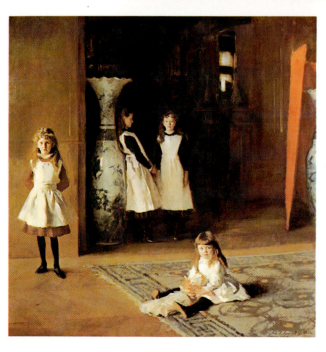

37. JOHN SINGER SARGENT.
Four Daughters of Edward Darley Boit.
1882. Oil on canvas,
87⅝ × 87⅝″.
Museum of Fine Arts, Boston.
Gift of the daughters of Edward D. Boit

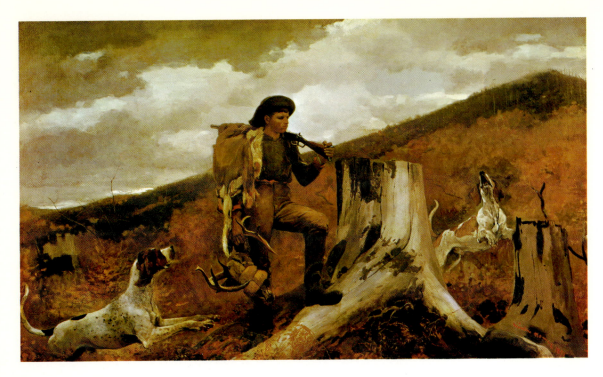

38. WINSLOW HOMER. *Huntsman and Dogs*. 1891. Oil on canvas, 28 × 48″. Philadelphia Museum of Art.
William L. Elkins Collection

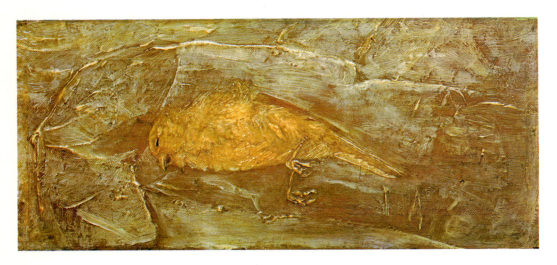

39. ALBERT PINKHAM RYDER. *The Dead Bird*. 1890–1900. Oil on panel, 4¼ × 9⅞″.
The Phillips Collection, Washington, D.C.

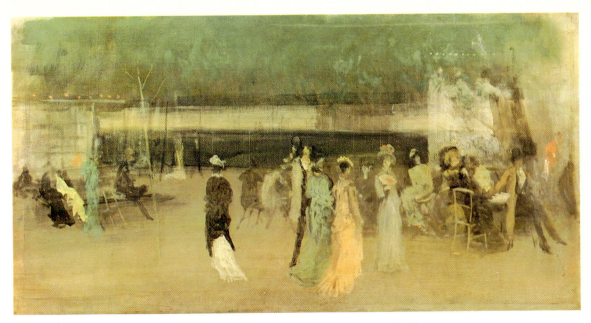

40. JAMES A. McNEILL WHISTLER. *Cremorne Gardens No. 2*. Oil on canvas, $27 \times 53\frac{5}{8}$".
The Metropolitan Museum of Art, New York City

41. MARY CASSATT.
Young Woman Sewing.
c. 1886. Oil on canvas,
$36\frac{1}{4} \times 25\frac{1}{2}$".
The Louvre, Paris

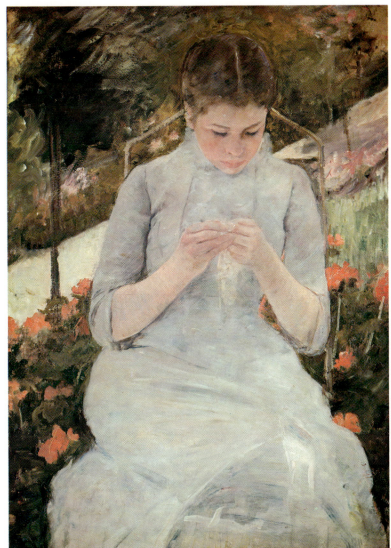

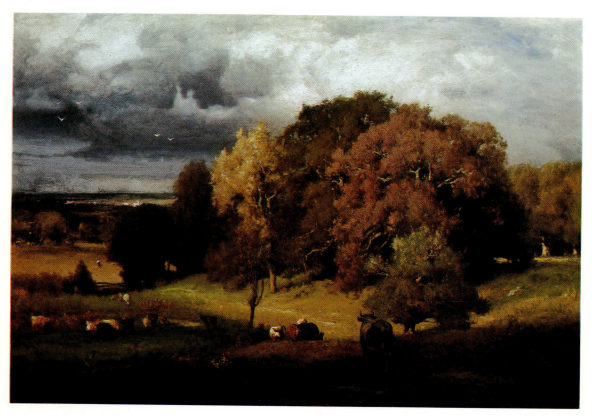

42. GEORGE INNESS. *Autumn Oaks*. Oil on canvas, 21⅛ × 30¼″. The Metropolitan Museum of Art, New York City. Gift of George I. Seney, 1887

2 · Pioneers in Architecture, East and West, 1890-1920

AMERICAN ARCHITECTURAL PRACTICE on the eve of the twentieth century was characterized by a rather unstructured professional community, a certain lack of standardization in education and apprenticeship, considerable regional autonomy, and a general receptiveness to new ideas and procedures. Not yet rigidly institutionalized, American architects and their engineering associates were called upon to meet a variety of challenges in the construction of buildings, often with little or no helpful precedent. Less inhibited than Europe by the weight of a long historical tradition and an established professional body, the United States responded with greater alacrity to the development of new, specialized building archetypes. Many of these solutions were conceived in response to particular economic or social needs, such as the rapid construction and reconstruction of cities to meet the demand of a booming population, steeply escalating land values, and the rapid settlement of the ever diminishing wilderness frontier. These factors help explain the emergence in the last years of the nineteenth century of a uniquely American building type, the tall office building—namely the skyscraper—as a distinct genre. Its unique soaring image and construction features excited the wonder and admiration of European visitors, whose homelands possessed nothing quite like it.

A generation earlier, American architects, taking their cues from English romantic designers and landscapers, had adapted the small rural villa or "country seat" into the all-pervasive concept of the private middle-class dwelling: frequently custom designed, constructed on small rectangular plots in a normally grid-plan suburban subdivision, connected to the urban metropolis of skyscrapers by local railroad or trolley line, and nominally within the reach of anyone with a regular income. These two achievements of American architecture, the skyscraper and the individual dwelling, have given a particularly varied density and texture to the modern American city, in contrast to the European metropolis, which tends to be built over at a much more even rate, irrespective of whether the land is used for commercial, industrial, or residential purposes.

Thanks to this early differentiation of building types, the beginnings of modern architecture are especially rich in the United States, and the split between this new architecture and the academic monumentality and varied historical styles of the immediate past is particularly sharp. Modernist innovations in design in the early twentieth century are largely confined to commercial, industrial, and residential projects, while traditional solutions tend, until after World War II, to be the norm in civic and monumental schemes. Historically, a sharp distinction is usually maintained between solitary individualists like Louis Sullivan and Frank Lloyd Wright and the traditional architectural establishment, represented by the partners of the firm of McKim, Mead and White, Daniel H. Burnham, or Cass Gilbert. Yet the works of these two divergent groups spring from many of the same sources in the recent past, and their buildings frequently offer interesting parallels in composition while differing in design and ornament.

The patriarchal figure for American architects commencing their careers in the last two decades of the nineteenth century was Henry Hobson Richardson, who had died prematurely, in mid-career, in 1886. His had been a varied practice, including houses, churches, public buildings, and commercial edifices; significantly, it was not limited to Boston and New England but at the end comprised major works in Pittsburgh, Cincinnati, and Chicago. Charles F. McKim

and Stanford White had worked with him in the 1870s; his Chicago commercial masterpiece, the Marshall Field Wholesale Store (completed posthumously in 1887), had a profound influence on the formation of an independent architecture in that city in the hands of Louis Sullivan, John W. Root, and others during the late eighties and nineties. Richardson's position in the evolution of an architecture at once American and modern is equivalent to and contemporary with the efforts of those solitary realists Thomas Eakins and Winslow Homer. Like their paintings, his buildings are bluff and forthright, not disrespectful of the lessons of history yet eschewing academic precocity and fluency.

Out of Richardson's prosaic ordering of masonry masses and round-arched windows and entrances, two lines may be traced. His sparse forms and relative freedom from historical prototypes, especially in his later works, and his reliance upon the straightforward expressive effect of a material such as rough, quarry-faced ashlar pointed the way toward the work of Sullivan and Wright in Chicago. Similarly, his timbered, shingled houses established a tradition that would be developed in personal, idiosyncratic ways by Bernard Maybeck and Charles and Henry Greene on the West Coast after 1900. Simultaneously, the simplifications and breadth of form characterizing Richardson's work had moderated the strident cacophony of mid-nineteenth-century eclecticism, notably of the Victorian Gothic persuasion, so that his blunt, round-arched forms could lead to the cool academic-classic revival of the late nineteenth century, culminating but not ending in the monumental designs for Chicago's Columbian Exposition of 1893. Richardson's double legacy to twentieth-century American architecture created a dichotomy that would last for nearly fifty years.

No organized group such as the "ash-can" Eight dominated avant-garde architecture during the first decade of the century, though it is reasonable to link the followers and disciples of Louis Sullivan and of Frank Lloyd Wright into a Prairie School. Nor did the new architecture ever achieve a group manifestation on the order of the Armory Show; the numerous World's Fairs of the period in such "remote" metropolises as St. Louis, San Francisco, and San Diego were dominated by the establishment and given over to vast, seductive panoramas of

academic design, of considerable pictorial effect in their own terms, but of limited functional integration.

Chicago with its suburbs was the restless hub of architectural activity just before and after 1900. The skyscraper as a key new genre in urban architecture is widely and popularly believed to be a Chicago invention, though the investigations of Winston Weisman and others have indicated that, slightly earlier, New York played a pioneering role in the evolution of "tall" buildings—structures of more than the customary four or five stories, made commercially attractive through the installation of safe, mechanically operated elevators. The Chicago contribution of architects like Sullivan and Root was the development of an original manner of treating the form, the pattern of its fenestra-

43. Louis Sullivan.
Guaranty (now Prudential) Building,
Buffalo, N.Y. 1894–95

tion, and the development of an autonomous decorative system, to effectively express the form and structure of the building. Chicago proved to be fertile soil for the elaboration of the isolated-pier foundation and the fireproofed steel frame (as opposed to the somewhat unintegrated use of cast-iron members in earlier buildings), and Sullivan took many of his design cues from this technological achievement, though he was by no means its slave.

Sullivan's work as the most distinctive of the Chicago skyscraper architects had a wide geographical distribution despite the relatively small number of buildings that constituted his active career. But, the fact that outstanding works of his were to be seen before 1900 in St. Louis, Buffalo, and New York as well as Chicago did not ensure anything like the wide influence on subsequent commercial design realized by Richardson in the previous generation. His Wainwright Building, St. Louis (1890–91), and its successor, the Guaranty (now Prudential) Building, Buffalo (1894–95), are among his finest essays in the enrichment of the steel-framed rectangular cube. In terms of a selective emphasis of motifs in the expression of the steel grid and its related bay system, these designs are infinitely more sophisticated than the rather awkward horizontal and vertical divisions of more conventional Chicago skyscrapers such as Jenney's Home Insurance Building (1883–85), which is reputed to be the first of the steel-framed towers. Sullivan's designs, particularly in the Guaranty Building, where the vertical

44. McKim, Mead and White.
New York Life Insurance Building,
Kansas City, Mo. 1890

45. Burnham and Root.
Monadnock Building, Chicago.
1889–92

ribbonlike assemblage of the windows culmi-
nates in a round arch just below the elaborate
cornice, would seem to be an attenuation of the
vertical configuration of Richardson's Marshall
Field Wholesale Store, the exaggeration justified
by the steel frame of the newer work. Another,
more cautious yet equally thoughtful way of
modifying and transforming the round-arched
Richardsonian theme for use in a tall building
is to be seen in McKim, Mead and White's New
York Life Insurance Building, Kansas City,
Missouri (1890), where a rather literal Renais-
sance vocabulary replaces Sullivan's decorative
originality, and more conventional propor-
tions conceal the vertical sweep characteristic of
his towerlike designs.

Sullivan's decorative art is best seen in the
lamentably temporary (and hence destroyed)
Golden Portal of the Transportation Building
at the Chicago Columbian Exposition of 1893.
Color (gilt, silver, and green) was here combined
with an unusual interlace in the spandrels and
archivolts of the round-arched entry, whose
overall form and scale again were derived from
Richardson. Sullivan's lyrical accomplishment,
which suggests that his personal, ornamented
style could have been easily adapted to monu-
mental public structures, forms an interesting
parallel to the frequent use of Roman triumphal
arches in the academic architecture of the day.

The work of the firm of Daniel H. Burnham
and John W. Root (and of D. H. Burnham and
Company after Root's death in 1892) indicates
alternatives to Sullivan's ornamental precocity.
The Monadnock Building (1889–92) and the
Reliance Building (1890–94) offer contrasting
approaches, determined in part by material and
structure. The former, one of the last load-
bearing masonry structures, is ponderous and
devoid of relief; the latter, a light, steel-framed
design clad in white tile with somewhat incon-
sequential (and almost invisible) Gothic decora-
tions, is one of the most ethereal of early sky-
scrapers, a fortuitous yet not insignificant
herald of designs that would appear in quantity
only much later.

In contrast to the relatively free designs char-
acteristic of this phase of the Chicago School,
numerous academic and historicizing sky-
scrapers were built at this time, and, to the regret
of many, this conservative mode of dressing up
a commercial design tended to dominate the
work of the generation after 1900. A remarkable

success in the employment of historical forms in
a colossus of modern construction is the soaring
Gothic-clad Woolworth Building, New York
(1913), the work of Cass Gilbert, and for many
years the world's tallest office building. Some-
what apart from the main line of independent or
traditional skyscraper design is Ernest Flagg's
second Singer Building, New York (1906–8),
demolished, as were so many fine landmarks of
the period, in the 1960s. Another impressive, but
more durable, effort to adapt historical motifs
to the tallest building of *its* day is the Flatiron
(formerly Fuller) Building, New York (1902), by
D. H. Burnham and Company. In these three
New York skyscrapers a solution to vertical
unity was sought through the use of a tall,
attenuated shaft of relative simplicity, regularity,
and continuity, placed on an elaborate base
designed to relate to the street and capped with
a distinctive spire, dome, or cornice.

Domestic architecture of the early twentieth
century has been, for the historian, almost com-
pletely dominated by the overpowering figure of
Frank Lloyd Wright. His independent prac-
tice began in 1893, after five years in the employ
of Louis Sullivan and his partner, Dankmar
Adler. Wright's houses and occasional public
buildings of the pre–World War I period had a
momentary if passing influence upon the group
of architects in the Middle West known as the
Prairie School, many of whom had worked in his
Oak Park Studio. His greatest impact was
destined to be upon the emerging European
avant-garde, many of whom would ultimately be
recognized as the masters of the International
Style. Probably no artist before or since has had
so seminal an influence on his peers abroad,
producing not emulation but the jolt necessary
to stimulate others to personal achievement.

Although Wright was the most important of
Sullivan's disciples, his work is mainly domestic,
a field that interested Sullivan only slightly.
The growing specialization of building genres—
a phenomenon that certainly abetted Sullivan
in the rapid perfection of his style of office
building—was even more important to Wright.
One can argue that Wright's ambitions as an
architect of monuments were hardly well served by
actual opportunity, yet he was uniquely devoted
to the problem of the individual residence
throughout his life—unlike successful architects
of the later twentieth century, who normally
graduate beyond, for them, the apparently un-

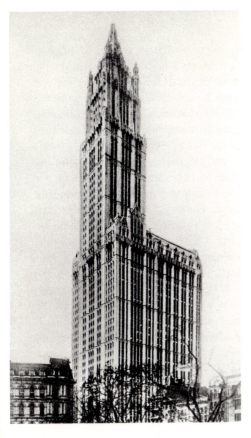

46. CASS GILBERT.
Woolworth Building, New York City. 1913

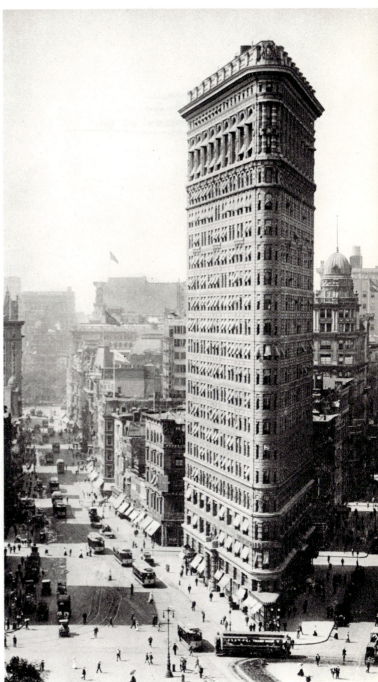

48. D. H. BURNHAM AND CO.
Flatiron (formerly Fuller) Building,
New York City. 1902

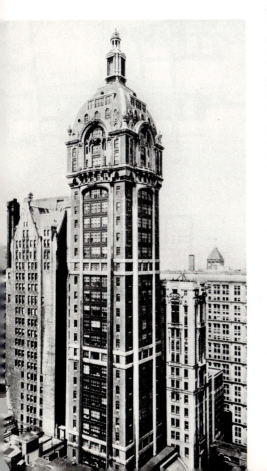

47. ERNEST FLAGG.
Second Singer Building, New York City.
1906–8 (demolished)

49. FRANK LLOYD WRIGHT.
Robie House, Chicago.
Simplified perspective. 1909

challenging and unprofitable design of houses. The essence of his style is its domesticity; thus it seems improbable that he could have thrived initially except as an architect working in the suburbs of a large American city about 1900, with its regular demand for innumerable private dwellings.

Wright's early practice ranged from the modest cottage and the familiar suburban family dwelling to an occasional mansion with requisite carriage house, conservatory, and garden. All seem to have been designed to moderate *scale*; even the largest and most elaborate do not impose themselves as ostentatious or monumental. Ideally the "Prairie House" (a name adopted by Wright for his work of this period) should sit flat upon the ground, shunning the familiar dank subterranean cellar. Its formal characteristics should emphasize the predominant horizontals of the site (often a tight, narrow

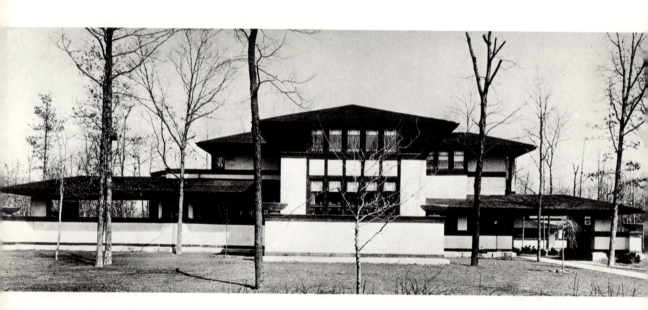

50, 51. FRANK LLOYD WRIGHT.
Ward Willitts House, Highland Park, Ill.
Exterior and plan of main floor.
1900–1902

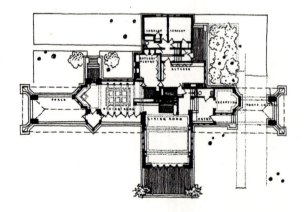

plot in the subdivisions of Chicago or Oak Park), and the low-pitched, wide-flaring roof should further stress the ground-hugging effect. It is ironic how many of these features have been bowdlerized in the ubiquitous ranch house, sibling of the "split-level" in mid-century subdivisions.

The subsidiary exterior forms of the Prairie House tend to emphasize a layered effect, and in many cases the interlocking of horizontal and vertical elements results in a breakup of the boxlike nature of the basic mass, notably in the Robie House (1909). On the interior, spaces are not separated by doors but flow together; the major division is usually accomplished with a large fireplace—the symbolic, functional, and structural core of the home—with distinct spaces radiating from this center. Conventional, individual windows are frequently replaced by continuous strips of glass rectangles or squares separated only by a simple wood mullion. Working within this original formula, and taking heed of each client's need, Wright was able to conceive of a seemingly infinite number of variations. Moreover, the very quantity of Wright's houses in this period testifies to his local popularity

and, perhaps, to the independence of mind of professional and business people living in the Chicago suburbs at this time who were looking for a distinctive rather than a conventional habitation.

Parallel to Wright's efforts are the houses of Charles and Henry Greene, whose practice was centered about the Los Angeles suburb of Pasadena. Independent yet related to the tradition of nineteenth-century domestic architecture in wood (as was Wright), their works, like the Blacker and Gamble houses (1907 and 1908, respectively), are elaborate, elegant treatises in timber construction, but their manner lacked the creative cutting edge that would lift Wright's work beyond its local milieu. The brothers enjoyed a considerable success in the first decade of the century, then slipped from favor.

Much the same pattern is to be found in the career of another, but very different, architect practicing in southern California at this time: Irving Gill. A native of central New York State, Gill worked from 1890 to 1892 with Adler and Sullivan in Chicago (where he would have met Wright), and then moved to the West Coast. Characteristic of his style is the Walter Dodge

52. FRANK LLOYD WRIGHT. Unity Church, Oak Park, Ill. Interior. 1906

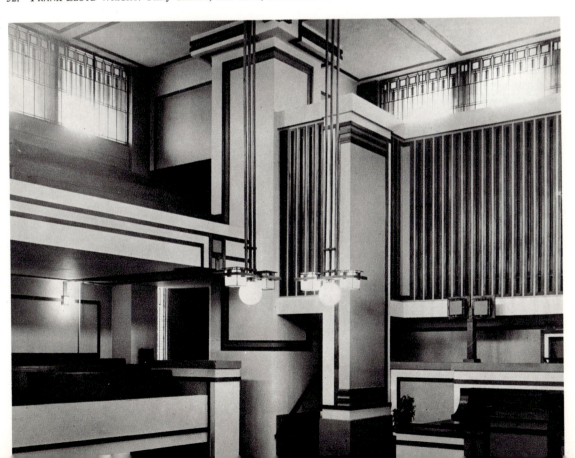

53. IRVING GILL. Gilman Hall, Bishop's School, La Jolla, Calif. 1916

54. Begun by ARTHUR B. BENTON. Glenwood Mission Inn, Riverside, Calif. Patio. 1902–11

House, Los Angeles (1915–16), another casualty of the 1960s. Gill, interested in concrete from an early date, offers in his work parallels to both the reductive, pale-surfaced buildings of Adolf Loos in Austria and the Hispano-American colonial revival that pervaded the Southwest during the early twentieth century. His crisp geometries, with their flat roofs, rectangular windows, round-arched openings, and stuccoed surfaces, are basically a simplification of an indigenous revival movement, typified by various romantic Mission Style works on the periphery of the Los Angeles basin such as the Glenwood Mission Inn, Riverside (1902–11), the earlier parts by Arthur B. Benton. Gill's work forms a base upon which two Viennese émigrés to southern California, Rudolph Schindler and Richard Neutra, would subsequently establish an outpost of the continental International Style in the 1920s.

The buildings of Bernard Maybeck represent a corollary to the work of the Greenes and Gill. Perhaps the most bohemian of all American architects of the period, Maybeck had been trained in Paris at the Ecole des Beaux-Arts, as had Richardson and Sullivan before him, but his response to that traditional education was capricious. His First Church of Christ, Scientist, Berkeley (1909–11), was a very richly orna-mented fantasia on several Romanesque and Gothic themes. Here columns in cast concrete are juxtaposed to wooden posts and beams, and the rich timbered finish of the interior can be contrasted on the exterior to the overlapping eaves sheltering walls of asbestos siding and windows of rectangular industrial-metal sash. A curious mixture, altogether characteristic of Maybeck's puckish temperament. The lush, autumnal classicism of his Palace of Fine Arts, a plaster-and-wood creation for the 1915 Panama-Pacific Exposition in San Francisco (the building survived, dilapidated, until its replacement by a stiff, cold copy in permanent materials in the 1960s), more closely reflects his Beaux-Arts training, yet at the same time demonstrates the picturesque nature of his talent. Much of this gift would rub off on his sometime associate, Julia Morgan, in her design for San Simeon, William Randolph Hearst's aspiringly Hadrianic retreat overlooking the Pacific Ocean.

A contrasting simplicity of surface, if not of volume, can be seen in Wright's earliest monu-

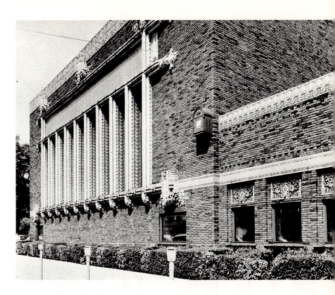

55. LOUIS SULLIVAN.
People's Savings and Loan Association Bank, Sidney, Ohio. 1917–18

mental effort in poured concrete, Unity Church, Oak Park (1906), which compares interestingly with Maybeck's slightly later church in Berkeley. In part, the fractured cubic forms are an offshoot of Wright's domestic style of that decade, but mass is more assertive in his church, the height of the building barely balanced by the horizontal slabs of the roof cornice. The layout is obviously traditional, almost academic, with its repeated use of major and minor axes intersecting each other at right angles. Consequently, the main meeting room, almost biaxially symmetrical and nearly entirely illuminated by clerestory win-dows, produces a space and volume radical in its geometric abstraction yet rigidly classic in its use of time-hallowed compositional devices, notably the ideal central plan. In this respect Wright's architecture invites comparison with the studied monumentality of McKim, Mead and White works, such as Low Library, Columbia University, New York (1893–97). In this building the classical image is fleshed out by the familiar repertory of classical forms—a colossal colon-nade and a Pantheon-type saucer dome—so that the iconographic references are unmistak-able, even banal.

Public monuments in the early twentieth century can be exemplified by the last great generation of railroad terminals, some of which are already gone or are in danger of demolition as these lines are being written—so quickly does our era render obsolete monuments to com-

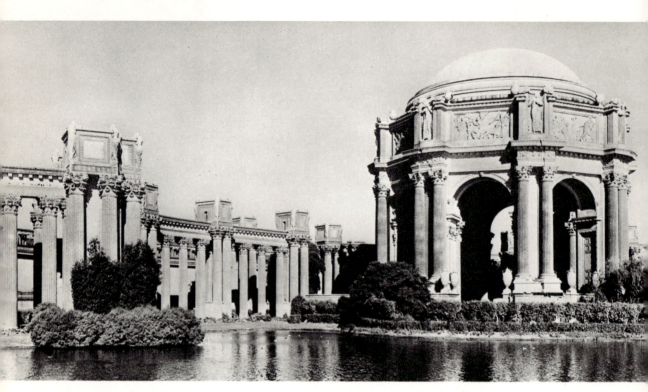

56. BERNARD MAYBECK. Palace of Fine Arts, Panama-Pacific Exposition, San Francisco. 1915
(since demolished and replaced with replica)

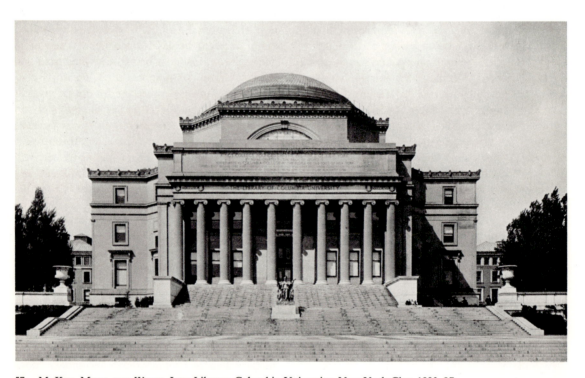

57. MCKIM, MEAD AND WHITE. Low Library, Columbia University, New York City. 1893–97

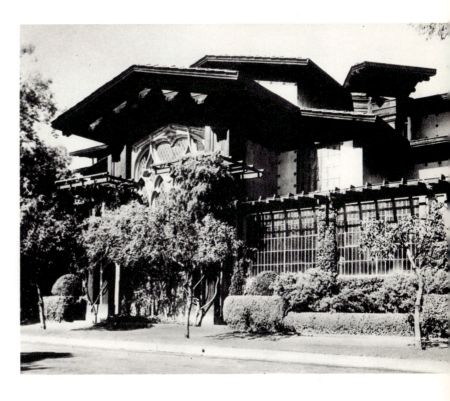

58. BERNARD MAYBECK.
First Church of Christ,
Scientist, Berkeley, Calif.
1909–11

merce, industry, and communications barely two generations old. New York's Pennsylvania Station (1906–10), by the ubiquitous McKim, Mead and White, was appreciated fully only after its destruction in the 1960s. Frequently ridiculed in its lifetime as a somewhat implausible adaptation of the design of a Roman bath to a modern train depot (and entry to a metropolis), it is admired now for almost the very same reason: that this particular antique building type was indeed adaptable to a program requiring the smooth movement of large numbers of people from street to railroad car under often unfavorable weather conditions. From major entrances on each of the four streets bounding the site stairs led down to two enormous, high-vaulted rooms, one a literal reproduction of a coffered Roman groin vault, the other a glass-and-steel hall evoking the modern tradition of nineteenth-century train sheds. From this glass-covered concourse stairs descended further to the platforms serving the individual tracks of the Pennsylvania Railroad, whose lines had just been extended, in tubes, under the Hudson River, into Manhattan—a technical achievement that prompted the building in the first place. Penn Station was New York's gateway to Philadelphia, Washington,

Chicago, and distant points; as a low, ground-hugging mass, dominated by long colonnades on its main façade, it formed a superb contrast to the verticality of the commercial architecture around it. At the center of the mass, the vaulted hall and glass shed rose above the silhouette, producing the graduated pyramidal effect of superimposed elements. This, together with the plan of major and minor axes of circulation linking the large, static, symmetrical spaces with street and platform, auto and train, was a paragon of academic theory and planning. It emphasized that circulation and movement in a highly organized, rational fashion was one of the key functions of public architecture.

Academic classicism, often inappropriate or awkward when applied to contemporary situations as in tall office buildings, provided, as it turned out, a workable matrix for programs requiring movement of crowds or the interconnection of a variety of functional elements. Significantly, this type of axial planning with graduated masses was employed by Wright in the design of the Imperial Hotel, Tokyo (1915–22), even though the proportions and style of the building grew out of his distinctively low-slung, horizontally disposed Prairie Style, aesthetically a world removed from the sedate

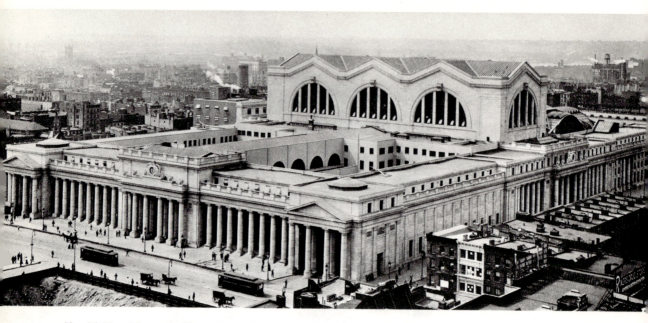

59. McKim, Mead and White. Pennsylvania Station, New York City. 1906–10 (demolished)

60. Pennsylvania Station. Grand Concourse

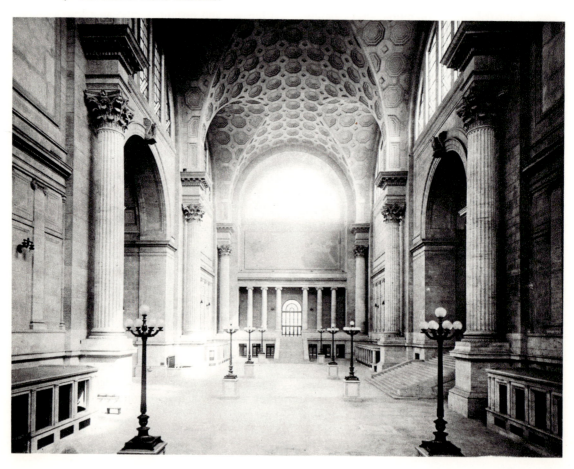

61. FRANK LLOYD WRIGHT. Imperial Hotel, Tokyo.
Exterior perspective. 1915–22 (demolished)

62. Pennsylvania Station. Original disposition, showing platform and tracks

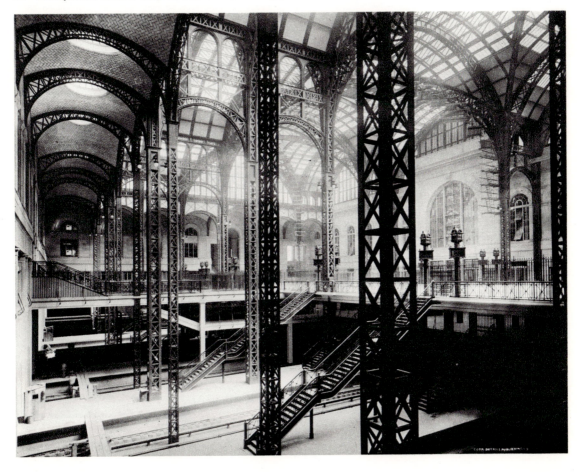

mixture of columns, arches, and vaults of Penn Station. Wright's creative achievement in the Imperial Hotel indicated that a radical, modern solution could be based upon familiar historical principles of planning.

Penn Station's East Side neighbor, Grand Central (1903–13), by Reed and Stem and Warren and Wetmore, though not so original an invention as Wright's overseas masterpiece, suggested that progress and development were possible even within the confines of massive, Roman-inspired elevations. Here, instead of stairs, ramps link the street to upper and lower level concourses, facilitating movement especially for arriving passengers going up to the street. The covering of the track level north of the station made possible the development of Park Avenue, and led the designers to carry the avenue around and through the upper parts of the building and across Forty-second Street, on the south side, by a bridge. The separation and interconnection of rail, vehicular, and pedestrian traffic were treated here in a way that predicts the Futurist projects of Sant'Elia in Italy and, ultimately, certain aspects of Le Corbusier's Ville Radieuse projects of the 1920s.

Nor were the elevations on the interior of Grand Central carried out in a textbook fashion: while its academic ancestry is obvious, the use of flattened segmental arches and vaults and simplified wall and pier surfaces suggests a kind of modernism in design that would be popularized in the 1920s as Art Deco.

Each in its own way, Grand Central and the Imperial Hotel provide a much too optimistic indication of the further possibilities of traditional architecture at the beginning of the century. The popularity of Wright, Greene and Greene, Maybeck, and Gill waned drastically in the years around 1910; of the entire group, only Wright had the strength, genius, and good fortune to persevere through the twenties, until

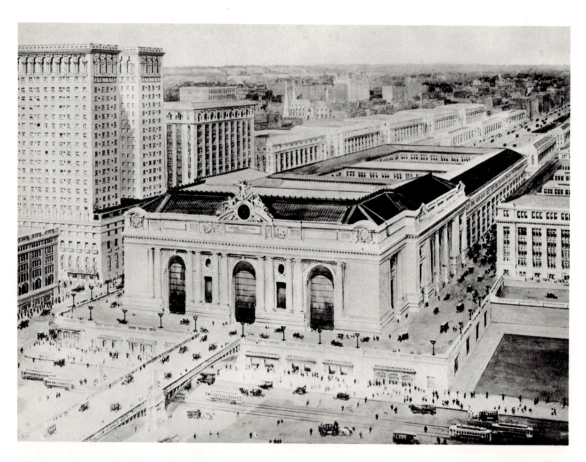

63. REED AND STEM; WARREN AND WETMORE. Project for Grand Central Terminal, New York City, showing original concept for development of Park Avenue, before construction of Commodore Hotel

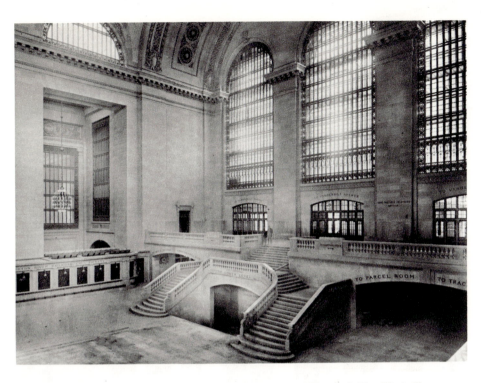

64. REED AND STEM; WARREN AND WETMORE. Grand Central Terminal, New York City. Main Concourse. 1903–13

another rotation in the cycle of taste brought him and his work back into favor in the thirties. It is not insignificant that his most important work of the teens, the Imperial Hotel, was constructed abroad. Such a project was virtually unthinkable in this country—the only work of comparable scale, Midway Gardens, Chicago (1914), was torn down in the twenties without a thought, rendered obsolete by Prohibition.

Even Sullivan, who lived and continued his practice in fairly straitened circumstances until 1924, had little work to do save for a handful of small banks in midwestern towns of modest size. Much of his time and energy during the last quarter-century of what would ultimately be a tragic, half-wasted career was devoted to the publication of *Kindergarten Chats* and *The Autobiography of an Idea*. Of his pupils, Purcell and Elmslie were the most successful. In buildings like their Merchants' National Bank, Winona, Minnesota (1911–12), we discover with

pleasure an indigenous American modernism grafted onto the tradition of monumental civic architecture, a tradition that for its resourcefulness and originality reaches back to the Jeffersonian classicism of the republic's early years. This partnership was responsible as well for one of the few truly great Prairie Houses not by Wright: the sentinel-like Bradley House, Woods Hole, Massachusetts (1912), its main body raised upon a contracted basement to command the view of the ocean. The relative failure and invisibility of Sullivan's unique legacy become even more ironic when measured against the scholarly expertise of a contemporary monumental shrine, Henry Bacon's suave, knowledgeable Lincoln Memorial (1917). For all its outward virtues, the structure is a frigid and hollow accomplishment, scarcely appropriate to its subject and only superficially in accord with the progressive spirit of an earlier neo-classicism in the national capital.

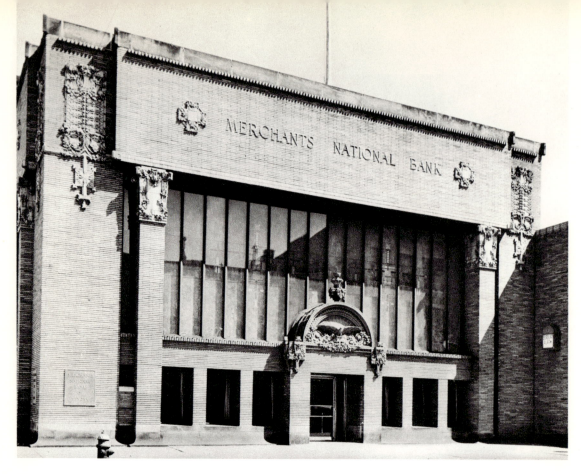

65. PURCELL AND ELMSLIE. Merchants' National Bank, Winona, Minn. 1911–12

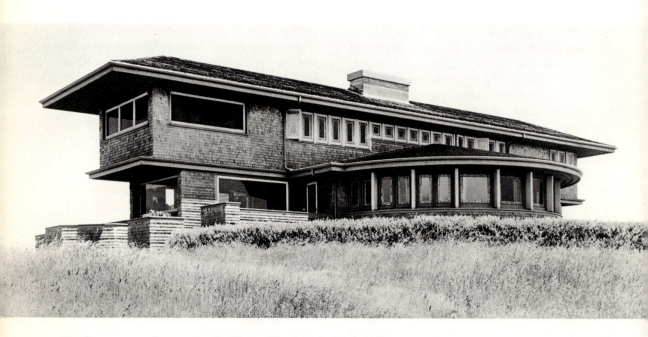

66. PURCELL AND ELMSLIE. Bradley House, Woods Hole, Mass. 1912

67. IRVING GILL. Walter Dodge House, Los Angeles. 1915–16 (demolished)

68. GREENE AND GREENE. Blacker House, Pasadena, Calif. 1907

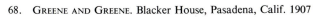

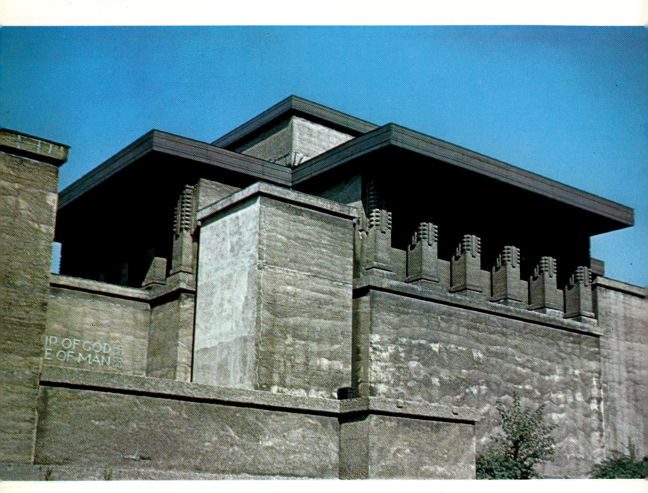

69, 70. FRANK LLOYD WRIGHT. Unity Church, Oak Park, Ill. Exterior and plan. 1906

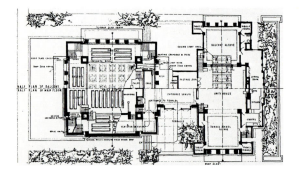

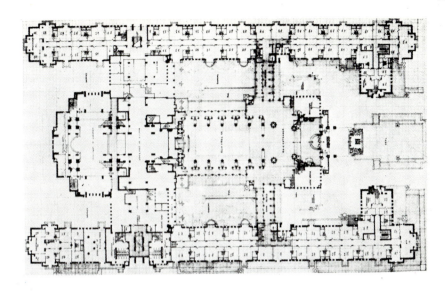

71, 72. FRANK LLOYD WRIGHT. Imperial Hotel, Tokyo. Plan and Banquet Hall. 1915–22 (demolished)

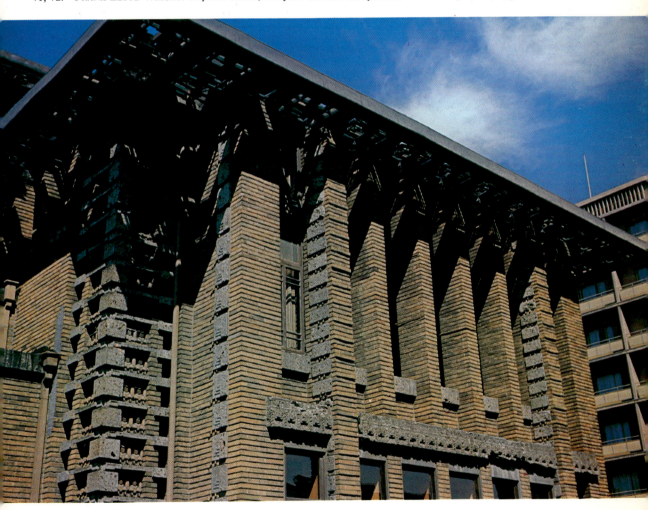

73. FRANK LLOYD WRIGHT. John Snowden House, Los Angeles. 1926

74. RUDOLPH SCHINDLER. Buck House, Los Angeles. 1934

3 · Insurgent Realists

THE ELEMENTS OF progressivism in art, which had been repeatedly driven underground or converted to a genteel academicism by the pressures of provincialism and Victorian prudishness in the decades after the Civil War, erupted after 1904. In Theodore Roosevelt's second term a new spirit of insurgence seized the American imagination, as national interest was focused on reform. Writers and artists suddenly came out into the open to take up the cause of the common man against organized corporate power and abuses of privilege. Painters awoke to the teeming life of the streets and found a new sympathy for the oppressed humanity of our industrial centers. It was characteristic that in the period of "exposé" journalism and the "exposé" fiction of the naturalists, progressive painting should be in the hands of a group of newspaper-trained artist-journalists. There was a certain naive romanticism and boyish opportunism in the manner in which these new painters,

and even such new writers as Jack London, assumed reformist attitudes. The Rooseveltian appetite for life, which helped free them from a stagnant past, was refreshing and salutary. But it was shallow, too; sheer gusto did not promise to be the most durable basis for art.

The new movement in painting was not, however, so directly concerned with radical politics or the class struggle as was literature, and on the whole it substituted a more tolerant spirit for the moral indignation and reforming zeal of the naturalist writers. Mainly, it was an expression of an awakened sense of life and of the need to be more direct and open-hearted. Although later identified with the New York scene, it first centered around Philadelphia, and many of its participants had studied at the Pennsylvania Academy with Thomas Anschutz, the pupil of Thomas Eakins.

Spokesman and champion of the group of reb-

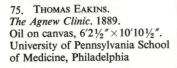

75. THOMAS EAKINS.
The Agnew Clinic. 1889.
Oil on canvas, 6'2½" × 10'10½".
University of Pennsylvania School
of Medicine, Philadelphia

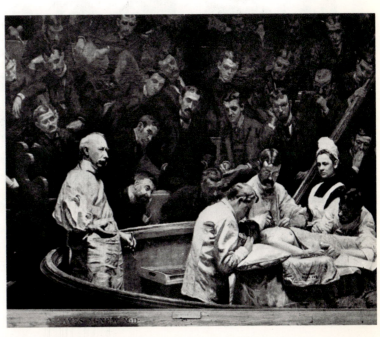

els was Robert Henri, perhaps the most vital and influential artistic personality of his day. In the words of John Sloan, who later acknowledged Henri as his "father in art," his message was "making pictures from life." For Henri, "life" became the operative word in his vocabulary; it referred not so much to the artist's objective recording of something in the external world as the inward sensation of "being alive," achieved through the exercise of the craft of painting. Henri pleaded for the viability of the emotions, and his appeal was in line with a growing sentiment of freedom which was rapidly undercutting the stuffy Victorian outlook. "Because we are saturated with life, because we are human," he wrote later in *The Art Spirit*, "our strongest motive is life, humanity; and the stronger the motive back of a line, the stronger, and therefore more beautiful, the line will be. . . . It isn't the subject that counts but what you feel about it."

Henri studied two years at the Pennsylvania Academy under Anschutz, and then repaired to Paris, where in 1888 he entered a conventional Beaux-Arts studio of the Academy. The academic productions of Paris seemed sterile and unpromising, and he, like most Frenchmen, was at a loss before late Impressionism and was unfamiliar with Post-Impressionist painting. In the late eighties and in the nineties, the Post-Impressionism of Cézanne, Van Gogh, and Gauguin was known by a very small, select circle in Paris. Only with the great private and salon retrospectives of Van Gogh in 1901 and 1905, of Gauguin in 1903 and 1906, and of Cézanne in 1906 and 1907, did the new generation in Paris experience at first hand those major innovations in color and form which were to be the direct inspiration of Fauvism, Cubism, and Expressionist art.

In the early "Spanish" Manet, in Hals, and in Velázquez, Henri found both a simple pictorial

76. THOMAS ANSHUTZ. *Steel Workers—Noon Time*. c. 1882. Oil on canvas, 17 × 24".
Collection Dr. and Mrs. Irving F. Burton, Huntington Woods, Mich.

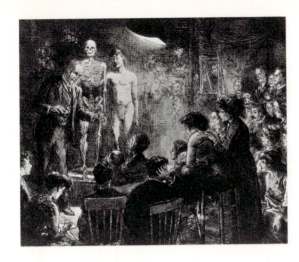

77. (*left*) JOHN SLOAN.
Anshutz on Anatomy. 1912.
Etching, 7½×9″.

78. (*middle*) GEORGE BELLOWS.
Forty-Two Kids. 1907.
Oil on canvas, 42×60″.
The Corcoran Gallery of Art, Washington, D.C.

79. (*bottom left*) ARTHUR B. CARLES.
L'Eglise. c. 1910.
Oil on canvas, 31×39″.
The Metropolitan Museum of Art, New York City.
Arthur H. Hearn Fund, 1962

80. (*bottom right*) ROBERT HENRI. *West 57th Street*.
1902. Oil on canvas, 26×32″.
Yale University Art Gallery, New Haven, Conn.
Mabel Brady Garvan Collection

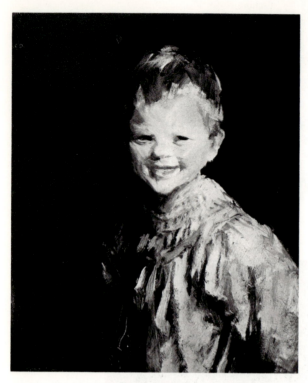

81. ROBERT HENRI. *Laughing Child.* 1907.
Oil on canvas, 24 × 20″.
Whitney Museum of American Art, New York City

formula that he could assimilate and a sympathetic taste for picturesque subject matter. There was often a certain gypsy quality about Henri's preferred subjects. The style Henri finally arrived at was no more or less daring than Duveneck's, although his themes were less conventional. Like so many late-nineteenth-century painters, he worked in the vein of what Frank Jewett Mather has called Manet's "dark Impressionism." Naturalism with vivacity of surface execution would be a more exact description of the manner, for it involved little of the Impressionists' analytical methods or their spirit of objectivity. It was pre-Impressionist painting; the expression of the artist's interest in subject matter loomed larger than any objective technical system. In Henri's art there was little hint of those optical and plastic "sensations" that were at the core of French Impressionism. Nor was he aware of the most dynamic elements in the art of Manet, or in that of the radical painters of the decades of the sixties and seventies. Their focus on artistic method at the expense of representation, their atomization of the world of appearances—the clear beginnings of "the recollection by painting of its own particular means," that generic emphasis on process in "modernist" art—were to result in suppressing naturalistic illusion altogether by

the twentieth century, a tendency Henri could not understand and later bitterly opposed.

Still, it isn't quite just to isolate the backwardness of Henri's methods as a phenomenon peculiar to America. Even in France, between the turn of the century and 1905, there was a relaxation in styles, and painting was ridden by archaisms. Matisse around 1901 repudiated the bright colors of Neo-Impressionism and returned to a dark manner based on Courbet and early Manet. In the first years of the new century Picasso painted in dark tonalities and then in pervasive blues a depressed subject matter of fringe bohemian life. Not until Fauvist painting erupted in 1905, with its brilliant, fresh color, heightened sensations, and expressive freedom of handling was there any painting that corresponded to twentieth-century man's new sense of liberation and optimism. Once the Fauves had emancipated painting, however, contemporary American techniques seemed woefully retarded and obsolete.

The methods of the American realists could not be regarded as innovations, in any case. Their spirit of insurgence and desire to address art to life was the real substance of their radicalism. That in itself was enough to assure them a tortuous, uphill climb to recognition.

On that ascent Henri kept the younger painters'

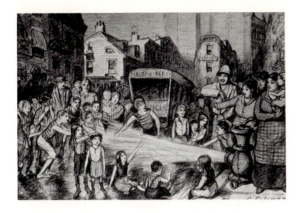

82. GLENN O. COLEMAN. *Street Bathers*. c. 1906.
Crayon, 11 × 15¾″.
Whitney Museum of American Art, New York City

83. JEROME MYERS. *The Tambourine*. 1905.
Oil on canvas, 22 × 32″. The Phillips Collection,
Washington, D.C.

84. WILLIAM J. GLACKENS.
Parade, Washington Square. 1912.
Oil on canvas, 26 × 31″.
Whitney Museum of American Art, New York City

morale up and acted as a living catalyst for their art, encouraging them to paint seriously and keeping them abreast of at least the more conservative European tendencies. In 1891 Henri returned from abroad to teach at the Pennsylvania Academy. It was then that he met the group of young artist-illustrators who had been working for Edward Davis, the father of Stuart Davis and art director on the *Philadelphia Press*. These were William Glackens, George Luks, Everett Shinn, and John Sloan. Henri imparted to his young disciples a new cosmopolitan spirit, urged them to travel abroad and to choose the medium of oil painting over illustration, or at least to combine the two vocations. In 1904 he set up a school of his own in New York City's Lincoln Arcade, in a Latin Quarter district on upper Broadway. There gathered all the rebels against the American genteel tradition, the Philadelphia artists who had followed Henri to New York, and others, like George Bellows and Glenn O. Coleman, who were also to associate themselves with the new realism.

The Philadelphia painters were highly varied in individual temperament and even in their styles. Glackens and Shinn were the worldlings, naturally drawn to society and the life of fashion which they nevertheless rendered in their early work with an abundance of life and zest. Glackens had worked in a muted, Whistlerian landscape idiom after a year in Paris during the mid-nineties. And then, with the examples of Henri and of Parisian painting of the sixties in mind, he had begun to paint in a dark, robust manner that suggests Daumier, the

85. JEROME MYERS.
Two Figures in the Park. 1911. Pencil, 11⅜ × 7¼″.
The Metropolitan Museum of Art, New York City.
Gift of the Estate of Mrs. Edward Robinson, 1952

early Manet, and the romantic Cézanne. *On the Quai,* formerly in the collection of the Kraushaar Gallery, New York, is the promising if rudimentary beginning not so much of realism as of an assimilation of the more vital Continental painting modes of the previous generation. There was, however, too much ground for Glackens to retrace, and in too short a space of time; and there were many distractions and pressures in the American social scene. As a result he made do with an elementary, reportorial realism rather than probe the medium of painting more deeply in the analytical European spirit.

After Glackens had served his apprenticeship with the *Philadelphia Press*, and following his Paris sojourn, he went to Cuba in 1898, along with George Luks, to cover the Spanish-American War. Upon his return to New York, he began drawing its street scenes with more directness,

finding the pushcarts, crowds, and tenements a stimulating new source of subject matter. He became most celebrated for his festive paintings of the city parks in a holiday mood, and for such scenes of fashionable life as *Chez Mouquin.* Around 1910 the tempo of the realists' response to life slackened, and they began to strain after "style" and a more authoritative pictorialism. Glackens succumbed to a saccharine formula derived from Renoir that in time approached commercial magazine illustration.

Something of the same pattern may be discerned in the evolution of Shinn's art. He submitted to sophisticated European models, applying them in a lively if somewhat derivative fashion to the American scene. Degas was his greatest inspiration, and like the French master, Shinn found his most sympathetic subject matter in the theater's world of illusion. He showed performers

86. WILLIAM J. GLACKENS.
Chez Mouquin. 1905.
Oil on canvas, $48\frac{1}{8} \times 36\frac{1}{4}$".
The Art Institute of Chicago

87. EVERETT SHINN.
London Hippodrome. 1902.
Oil on canvas, $26\frac{3}{8} \times 35\frac{1}{4}''$.
The Art Institute of Chicago

caught in a moment of action under the lights, or fashionable theater-goers descending from their carriages beside a bright marquee, often with an ash can or disheveled-looking passers-by in the background. His themes seemed to exhaust their charm with repetition, and in later years he devoted himself doggedly to re-creating his early subjects in pastel. They notably lacked fresh observation and were little better than pedestrian illustration.

Everett Shinn was the dandy of the realists, with many friends in the theater and in society. Perhaps it was his taste for luxury in conjunction with the realism of his art that attracted Theodore Dreiser, for he was said to be the model for the painter Eugene Witla in Dreiser's novel about a realist artist, *The Genius*. In that novel the painter is remarkable, but still credible, realizing both his artistic ambition to create truthful images of the world about him and his vainest dreams of power in the commercial world as a celebrated publishing potentate. Witla is finally corrupted by power and all but destroyed by ruthless commercialism. After a number of bitter experiences, he recovers his first moment of truth by returning successfully to painting, producing works that seem to shout: "I'm dirty, I'm commonplace, I am grim, I am shabby, but I am life." Dreiser's novel interests us now not so much for its inexorable demonstration of the destructiveness of the American success-worship, but because he could conceive of an artist equally comfortable and equally effective in the studio and at the reins of a powerful business establishment. Eugene Witla

embodies a decided romanticism about the possible social role of the artist, which in an oblique way must explain the realist painters' failure to reach more radical pictorial solutions. With so much of their artistic personalities absorbed by life, they were unable to proceed to a serious investigation of the more demanding formal problems of art.

Famous for his tall tales and bombast, George Luks was the most colorful figure among the new realists, and perhaps best projected the boyish romanticism of the Roosevelt era. He was trained in Düsseldorf, where he joined the cult of the slashing brush, studied at the Pennsylvania Academy, served as a war correspondent in Cuba, and did a prodigious amount of newspaper illustration before his paintings began to sell. Technically, Luks, like Henri, found his inspiration in the direct painting tradition of Manet, Hals, and Velázquez. Hals's earthy themes, good humor, and animal spirits especially appealed to Luks, but he applied Hals to the American scene with a curiously anachronistic effect. For despite the Dutch master's sympathies for common people, his art always retains the stamp of aristocratic style. When Hals was circumspect or impressionistic to a degree in his handling, and registered his subjects broadly as merry types, he was expressing the prerogative of his patron class. He felt responsible to the ruling burghers of Holland and reproduced, in a sense, their pleasure in the spectacle of common life. His art implies a hierarchical social order, and his more raffish tavern scenes, like Shakespeare's low-comedy incidents,

88. GEORGE LUKS. *The Wrestlers.* 1905.
Oil on canvas, 66¼ × 81¼".
Museum of Fine Arts, Boston.
Charles Henry Hayden Fund

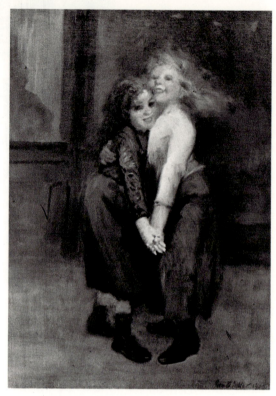

89. GEORGE LUKS. *The Spielers.* 1905.
Oil on canvas, 36 × 26".
Addison Gallery of American Art,
Phillips Academy, Andover, Mass.

are designed as relief to the pageantry of aristocratic life. Life presented itself to Luks, on the other hand, in less schematized fashion, and he necessarily identified himself with his dirty street gamins, athletes in violent action, scenes of the Gansevoort Docks in winter; or drew on his childhood in the Pennsylvania mining country for subject matter. In the circumstances of contemporary painting, this work achieved a fresh impact; yet, like Henri's, his rather dashing style always seemed superimposed on its content and was never free of artificiality.

In the search for vital styles, the realists had little enough in their own past to consult. Even those artists in whom they had come to recognize distinctive American qualities were of no immediate use to them. The tradition of popular illustration and genre painting, given a variety of individual inflections by Caleb Bingham, William Sidney Mount, and Winslow Homer, was hopelessly dated; Eakins's realism, with its passionate scientific concern for form, seemed pedantic; and the crude artisanship and contemplative strain of Ryder's painting scarcely suited the new age of energy. Drawing on the European past instead, Luks, Henri, and other realists apparently fixed on painting idioms of maximum informality to convey in the most direct, elementary way their pleasure in everyday reality. Yet they aspired to the European sense of style in art. Though they insisted that art be democratic, and viable in human terms, they were extremely conscious of their artistic posture, and perhaps unwittingly invested their ideal of the artist with attributes of the superman. Henri spoke of the vocation of art as fit only for "commanding" and "energetic"

personalities; Luks was a supreme egoist. Such behavior was perhaps a backhanded admission of the high seriousness of the life of art, of what Henry James called its "sacred office."

While the emulation of obsolete European styles was a move in the direction of reeducating and internationalizing American painting, the realists were unable to square life and art, and wished for the best of both possible worlds. With the sublime arrogance of the provincial, Luks characteristically begged the question, admitting his roots in European tradition and in the same breath denying its artistic authority or aesthetic values. "The world has but two artists," he would boast, "Frans Hals and little old George Luks." And he would fume when people spoke of painting as an end in itself: "Art—my slats! Guts! Guts! Life! Life! I can paint with a shoestring dipped in pitch and lard."

Of all the artists who felt Henri's influence, John Sloan was on the most intimate personal terms with him, and perhaps owed most to the

older artist. He began to paint seriously in 1897, when he shared a studio with Henri; later he followed Henri to New York and acquired most of his education in modern art through him. Until Henri had introduced him to Forain, Daumier, and Goya, Sloan had been doing intricate illustration inspired by the decorative style of Art Nouveau. From these new and more vital aesthetic hints, and from Henri's own "dark Impressionism," Sloan evolved the pictorial formula of his realism. It mixed elements of illustration and caricature with a feeling for the painterly means. Like the painting of so many of the other newspaper-trained artists, his work betrays a curious mixture of hackwork and sensibility.

Sloan came to New York permanently in 1904, continuing his career as illustrator for magazines and newspapers, but finding more time to paint. He had begun to establish his link with the new American realists as early as 1900 with paintings of Philadelphia city life. These still retained a cer-

tain nineteenth-century flavor of picturesque genre, however, and only after 1904 did he begin systematically to observe the life of the streets in New York from a fresh and less sentimental point of view, seeking a more personal, expressive realism. A tireless stroller and "incorrigible window watcher," in his own words, Sloan came to see the New York slums as a kind of stage set where all sorts of lively, unexpected business was in progress; and he became indefatigable in his search for human drama, recording little vignettes of urban life in a diary as well as in his paintings. The Lower East Side, the West Side below Fourteenth Street, the Bowery, which he described as "a maze of living incident," were some of his favorite haunts. The fact that he found vitality and human interest in the seamier pockets of the big city was quite in tune with the spirit of the new realism, as was his tendency to give human squalor the touch of romance.

It was a period when Theodore Roosevelt was

90. JOHN SLOAN. *Sunday, Women Drying Their Hair.* 1912. Oil on canvas, 25½ × 31½". Addison Gallery of American Art, Phillips Academy, Andover, Mass.

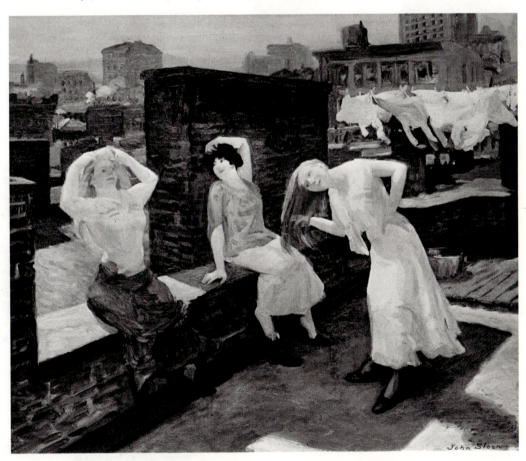

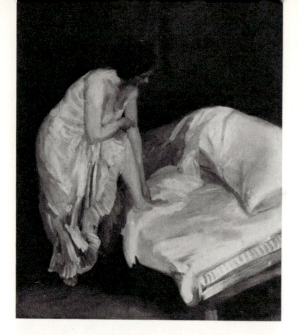

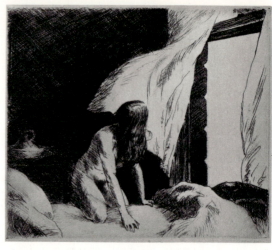

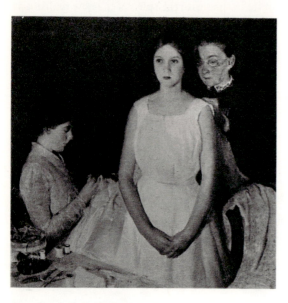

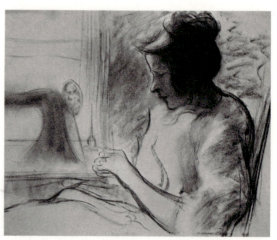

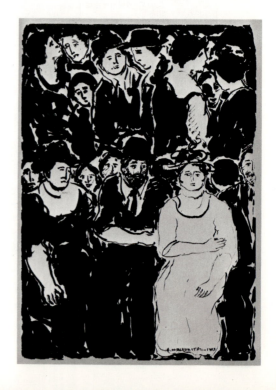

91. (*top left*) JOHN SLOAN.
The Cot. 1907. Oil on canvas,
36¼ × 30″. Bowdoin College Museum of Art,
Brunswick, Me.

92. (*top right*) EDWARD HOPPER.
Evening Wind. 1921.
Etching, 6⅞ × 8¼″.

93. (*above*) CHARLES HAWTHORNE.
The Trousseau. 1910.
Oil on canvas, mounted on wood, 40 × 40″.
The Metropolitan Museum of Art, New York City.
George A. Hearn Fund, 1911

94. (*middle right*) JOSEPH STELLA.
A Slovack Machine Operator. 1919.
Charcoal, 18½ × 23¼″.
Collection Mr. and Mrs. Lester Francis Avnet,
Great Neck, N.Y.

95. (*right*) ABRAHAM WALKOWITZ.
East Side Figures. 1903.
Ink, 10 × 7″.
Collection Mr. and Mrs. H. Lawrence Herring,
New York City

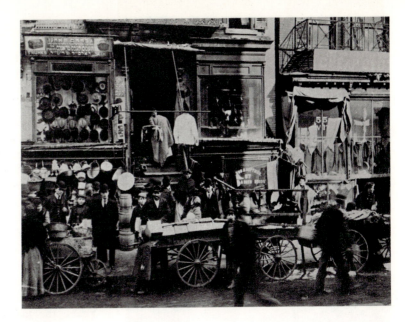

96. Hester Street, 1900.
Photograph

reprimanding American writers for being less interested in the Fulton Market than they were in the picturesque marketplaces of Europe. In his essay "Dante in the Bowery," Roosevelt claimed: "The Bowery is one of the great highways of humanity, a highway of seething life, of varied interest, of fun, of work, of sordid and terrible tragedy; and it is haunted by demons as evil as any that stalk through the pages of *The Inferno*." The literature and art of the Gilded Age had either sentimentalized "the poor" and the derelict as harmless, lovable ruffians or ignored them altogether. Under the new dispensation of social reform, they became real and pressing problems, enlisting the passionate interest not only of social workers but of artists and writers as well. Stephen Crane stood on his feet most of one night in a blizzard down on the Bowery, observing a bread-line for his story "The Men in the Storm," one of the first primitive ventures in naturalism. In his own way, John Sloan was as conscientious about immersing himself in the raw American experience and painting lower-class life.

Sloan's naturalism was not so coarse-grained as Luks's nor so superficial in its investigation of natural appearances as Shinn's or Glackens's. He was more the careful craftsman, and though a less fluent stylist, achieved an art of greater sincerity and depth. His foreground was the un-promising commonplace: the sidewalks of New York, a gloomy downtown barroom, a woman wearily hanging out wash from a tenement fire escape. But his background was often mysterious, and he invested the dreary prose of everyday life with the touch of romantic lavishness. That he

managed to do this even within the atmosphere of his "small" style was something of a triumph. He is remembered as an American Hogarth for his ability to catch common people of gross character, or he is singled out for his profound human sympathies. Actually, despite a certain humor and energy in handling, Sloan's people are neither very deeply felt nor are they remarkable comic inventions. The artist's rather crude caricatures represented a struggle to conquer his ineptness at vital characterization; at best, his figuration goes just beyond the clichés of popular illustration. Sloan did have something urgent to communicate about life, but with pictorial means that were not altogether adequate for the job. He more than compensated, however, by evoking romantic atmosphere and mood, and by conveying his own innocence and sense of wonder before "the lure of the great cities."

Dreiser's novels, Crane's New York sketches, and Sloan's city paintings are of a period, and all have about them the atmosphere of the American dream. They express a wish for some larger individual fulfillment, for a more splendid existence than the crushing real world offers. Like Dreiser in his ponderous, labored technique, and Crane in his patently artificial reproductions of lower-class speech, Sloan's work reveals the strain of forging a romantic idiom around the refractory materials of the new naturalism. He was not sufficiently sophisticated or detached to be able to subdue the brute aspects of existence within a framework of aesthetic hedonism, as the Continental realists Degas and Lautrec had done. His message was that of a poetic, romantic sensi-

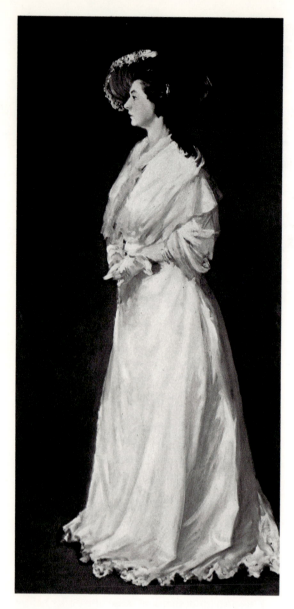

97. ROBERT HENRI. *Young Woman in White.* 1904.
Oil on canvas, 78¼ × 38⅛".
National Gallery of Art, Washington, D.C.
Gift of Violet Organ, 1949

bility: if he was to fail ultimately at fitting life into
a substantial artistic system, he seemed to have
decided, then he would remove his art to a differ-
ent atmosphere altogether. This he did by means
of a certain richness of chiaroscuro and the sug-
gestive play of his lighting.

A nocturnal scene like *The Haymarket* (1907)
achieves a mystery which blurs and enlarges its
literal meaning as a transcription of fact. In one of
the city's disreputable districts, three dressy ladies
emerge from a rich, mahogany darkness into the
luminous doorway of a rooming house, under the
appreciative eye of a sidewalk Lothario; to one

side a child rolls a hoop; a mother, carrying wash,
tries to distract her little daughter from taking an
interest in the scene. One is reminded that Sloan,
on one of his many walks, noted a streetwalker
gaudily arrayed in a great plumed hat that made
her look like "some wild creature of the night";
and one remembers that Daumier's treatment of
lower-class life was also compounded of senti-
mentality, energy, and mystery. Even in daylight
Sloan preferred gray weather as a shield against a
too stark and bald reality. *The Wake of the Ferry*
(1907), painted on such a day, merely frames a
blank expanse of gleaming water against the dark
silhouettes of boat struts, a gate, and a huddled
figure. The rich shadows and the scintillation of
light create an intense, lyric impression. J. B.
Yeats, the father of the poet William Butler
Yeats and an intimate of Sloan, liked to speak of
the artist's "mountain gloom." One could "never
be tired of peering into that gloom," he wrote
in *Harper's Weekly* of Sloan's painting *Mc-
Sorley's Back Room.* Sloan's darkling romanti-
cism brought the Brown Decades full circle;
when, in later years, he pursued a more brilliant,
objective color scheme in the effort to meet the
challenge of the School of Paris and of an ultra-
modernism that bewildered him, his art lost all
its distinctive character.

The realist group's new departures in mood,
subject matter, and social attitude, if not in tech-
nique, very soon aroused the open hostility of the
official art world. The challenge of Henri, Luks,
Sloan, Glackens, and Shinn to contemporary au-
thority met with increasing rejections of their
work by the National Academy and the Society of
American Artists. Suppression by these institu-
tions was tantamount to denial of a public view-
ing, since private art galleries—the alternative
exhibiting opportunities for the artist as we now
know them—were virtually nonexistent. When,
in 1907, the jury for the National Academy an-
nual, on which Henri ironically enough served,
voted to limit the number of entries by Sloan and
reserved judgment on Henri's work, the two art-
ists withdrew from the exhibition in protest. With
Glackens, Sloan and Henri laid plans for a
counter-exhibition in a private gallery, and thus
was born the germ of the first large independents'
show of the new century.

The show took place at the Macbeth Gallery in
New York in 1908. Henri, Sloan, Luks, Glackens,
and Shinn, the original Philadelphia rebels, were

98. ERNEST LAWSON. *Brooklyn Bridge.*
Oil on canvas, 20 × 24″.
Collection Norman E. Newman,
Fort Lee, N.J.

99. GIFFORD BEAL. *Freight Yards.* 1915.
Oil on canvas, 35½ × 47½″.
Everson Museum of Art, Syracuse, N.Y.

100. ALFRED H. MAURER. *The Bridge.*
Oil on canvas, 18 × 21½″.
Collection Dr. Seymour Wadler, New York City

101. MAURICE PRENDERGAST. *The Promenade.*
1913. Oil on canvas, 30 × 34″.
Whitney Museum of American Art, New York City.
Bequest of Alexander M. Bing

102. ROCKWELL KENT. *Toilers of the Sea*.
1907. Oil on canvas, 38 × 44″.
The New Britain Museum of American Art,
New Britain, Conn. Charles F. Smith Fund

103. (*middle*) ARTHUR B. DAVIES.
Unicorns. 1906.
Oil on canvas, 18¼ × 40¼″.
The Metropolitan Museum of Art, New York City.
Bequest of Lillie P. Bliss, 1931

104. (*bottom*) LOUIS MICHEL EILSHEMIUS.
Afternoon Wind. 1899.
Oil on canvas, 20 × 36″.
The Museum of Modern Art, New York City

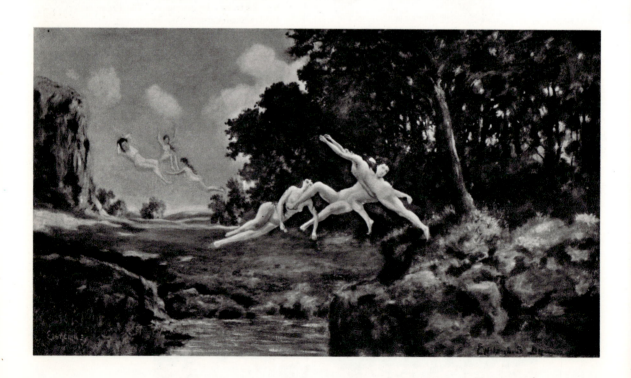

joined by Maurice Prendergast, Ernest Lawson, and Arthur B. Davies; the group became known in the newspapers as the "Eight Independent Painters" or simply "the Eight." Prendergast was an Impressionist who was aware of Cézanne; Lawson also worked in an Impressionist style; and Davies painted allegorical landscape in a dreamy Pre-Raphaelite manner. The realists were central to the group, but the other painters, whose work seemed more conservative, shared with them a spirit of rebellion against the parochial policies of the Academies.

The Eight almost immediately scored a success of notoriety; but to everyone's surprise, the financial results of their demonstration were also extremely gratifying. In the press their efforts were greeted with the same vindictive glee that artistic innovation in Europe had aroused, and such epithets were produced, then and subsequently, as "the apostles of ugliness," "the revolutionary gang," "the black gang," and—the most popular —the "ash-can school." Even so generally perceptive a critic as James Huneker of the *New York*

Sun described their canvases disapprovingly as "darkest Henri." Despite, or possibly because of, the sniping of journalists, the public came in droves. The new insurgent spirit could no longer be either contained or denied and, with so much to support it in the atmosphere of political progressivism, encountered less actual resistance than had been anticipated. "We've made a success," Sloan wrote in elation after the first sales returns were in, "—Davies says an *epoch*. The sales at the exhibition amount to near $4,000. Macbeth is pleased as 'Punch'!" Even the Pennsylvania Academy soon jumped on the bandwagon, asking for the show and circulating it among eight cities after the New York exhibition closed.

The amorphous program and heterogeneous styles of the Eight did not promise long collective life, and the 1908 grouping was never repeated. As James Thrall Soby has observed, it "consisted of artists who, finding themselves more closely allied in friendship than in belief, formed their title by the anti-doctrinal expedient of counting

105. GEORGE BELLOWS. *Stag at Sharkey's*. 1909. Oil on canvas, 36¼ × 48¼". The Cleveland Museum of Art. Hinman B. Hurlbut Collection

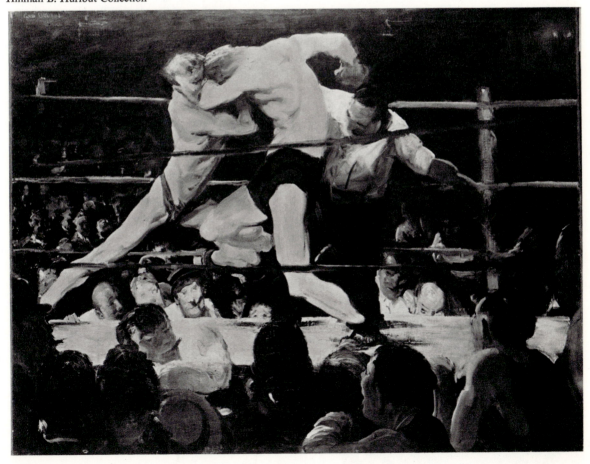

106. ALFRED MAURER. *Evening at the Club.* c. 1905.
Oil on canvas, 29 × 36″.
Addison Gallery of American Art, Phillips Academy,
Andover, Mass.

107. BEN BENN. *Mother and Child.* 1915.
Oil on canvas, 36 × 27″.
Whitney Museum of American Art,
New York City

noses." Perhaps the most salutary result of their loose association was the revival of a languishing tradition of artistic protest. Organized dissent had died with the decay of the Society of American Artists. Now the insurgents laid elaborate plans for bringing new currents of art to the American public. "Eventually the 'men of the rebellion' expect to have a gallery of their own," the *New York Herald* reported in 1907, "where they and those who may be added to them can show two or three hundred works of art. It is likely, too, that they may ask several English artists to send over their paintings from London to be exhibited with the American group. The whole collection may be shown in turn in several large cities in the United States."

This statement proved ominously prophetic and actually spelled the decline of realism. It did anticipate the huge "Exhibition of Independent

108. MAURICE PRENDERGAST. *Girl in Blue.* 1912.
Oil on canvas, 13⅜ × 11¼″.
Joseph H. Hirshhorn Collection

Artists" organized in 1910 by the original members of the Eight and such camp-followers as George Bellows and Glenn Coleman. But more importantly, it foreshadowed New York's great international show of modernism at the Twenty-Sixth Street Armory in 1913, which made the new realism seem conservative and dated.

With the Armory Show, and with the concurrent exhibitions of the more radical European and American moderns that Alfred Stieglitz had begun to stage in 1908, New York was swept by the excitement of the experimental, and experienced a dramatic reversal in fashions and tastes. The relaxed, slightly old-fashioned atmosphere of Pepitas on Twenty-Third Street, where Sloan, Henri, J. B. Yeats, and other progressive artists had foregathered, gave way to a more knowing and perhaps more anxiously *au courant* Greenwich Village bohemia. Mabel Dodge Luhan, who played hostess to the artist evangelists of the New Freedom from her lower Fifth Avenue salon, announced later: ". . . it seems as though everywhere, in that year of 1913, barriers went down and people reached each other who had never been in touch before; there were all sorts of new ways to communicate, as well as new communications. The new spirit was abroad and swept us all together." It also gave short shrift to the Eight and to their realism, and somewhat obscured their accomplishment—for they were the first to revive an insurgent mood, to attack ugliness and provincialism, and to venture, albeit timidly and with outmoded pictorial means, into the modern mainstream.

109. ROBERT HENRI.
The Masquerade Dress:
Portrait of Mrs. Robert Henri.
1911. Oil on canvas,
76½ × 36¼″.
The Metropolitan Museum of Art,
New York City.
Arthur H. Hearn Fund, 1958

110. FRANK DUVENECK.
The Cobbler's Apprentice.
Oil on canvas, 39½ × 27⅞″.
The Taft Museum, Cincinnati, Ohio

111. WILLIAM MERRITT CHASE.
An English Cod. 1904.
Oil on canvas, 36¼ × 40¼″.
The Corcoran Gallery of Art,
Washington, D.C.

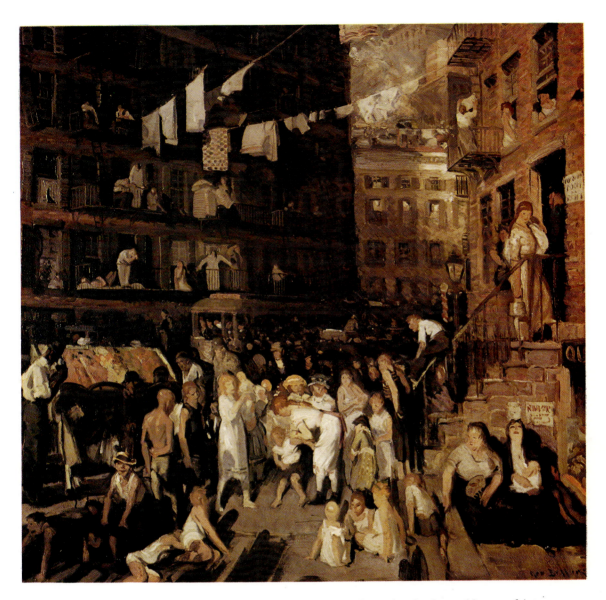

112. George Bellows. *Cliff Dwellers*. 1913. Oil on canvas, 39 ½ × 41 ½". Los Angeles County Museum of Art

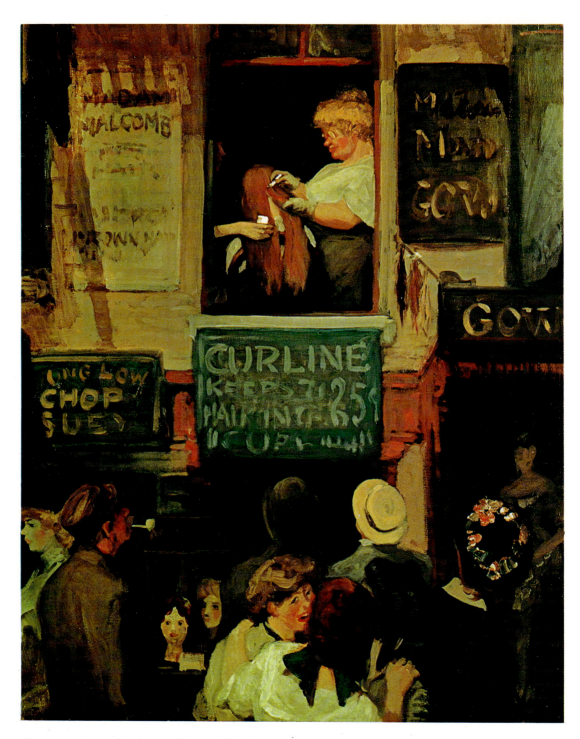

113. JOHN SLOAN. *Hairdresser's Window.* 1907. Oil on canvas, 31⅞ × 26″.
Wadsworth Atheneum, Hartford, Conn. The Ella Gallup Sumner and Mary Catlin Sumner Collection

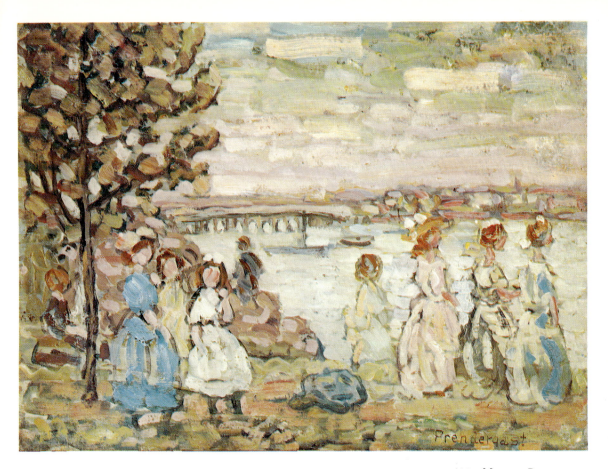

114. MAURICE PRENDERGAST.
Evening Walk. 1917–20.
Oil on panel, 15 × 24".
Private collection, New York

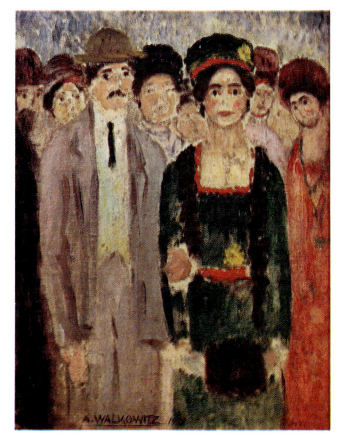

115. ABRAHAM WALKOWITZ.
In the Street. 1909.
Oil on canvas, 13½ × 10½".
Joseph H. Hirshhorn Collection

116. EVERETT SHINN. *Revue*. 1908. Oil on canvas, 18 × 24″. Whitney Museum of American Art, New York City

117. WILLIAM J. GLACKENS. *Hammerstein's Roof Garden.* 1901. Oil on canvas, 30 × 25″.
Whitney Museum of American Art, New York City

118. ARTHUR B. DAVIES. *Dream.* 1908. Oil on canvas, 18 × 30″. The Metropolitan Museum of Art, New York City. Gift of George A. Hearn, 1909

4 · The New Spirit

THE YEAR 1908 SAW THE REALISM of the Eight established, and also inaugurated Alfred Stieglitz's exhibitions of the radical European moderns. It was a year in which the representatives of the official art world were suddenly awakened to the threat to traditional values in the new art. The growing misgivings with which contemporary authority faced the future were candidly expressed, if inadvertently, by Sir Purdon Clarke, director of the august Metropolitan Museum. In an interview which, like so many of the more painful dodo observations delivered by conservative opinion, was reprinted and embalmed for posterity in the pages of Stieglitz's magazine, *Camera Work*, he solemnly warned: "There is a state of unrest all over the world in art as in all other things. It is the same in literature, as in music, in painting, and in sculpture. And I dislike unrest."

Sir Purdon could not have chosen a more apt word to describe that new mood which was to produce so stimulating and fertile an episode in the saga of American creative life. Out of the ferment of the Progressive period, out of its challenge to stagnant conventions in painting, and drawing on the example of the advanced art of Europe, a new generation had come forward to claim its liberation. Between 1908 and the war years a group of young artists emerged who were newly oriented to contemporary European art and felt little or no inhibition about testing modern idioms. While the Henri group was seeking a way through realism, these young artists for the most part had been biding their time, studying or working in Paris, and there they had begun to establish direct contact with the most emancipated expressions of the time. Max Weber and Arthur Burdett Frost, Jr., were among the first foreigners to join Matisse's new painting class, which started in 1907; they were followed in later years by Arthur B. Carles, Morgan Russell, and Patrick

Henry Bruce. At about the same time Alfred Maurer, who had come to Paris in 1900 and whose distinction it was to be the first American expatriate painter of the new generation, felt the influence of Matisse and Fauve painting. By 1908 there were enough young American artists of progressive tendencies in France, including Weber, Maurer, Bruce, Edward Steichen, and others, to form the New Society of American Artists in Paris, supplanting a more conservative parent organization which had been in existence for some years.

Between 1904 and 1912, Charles Demuth, John Marin, Stanton Macdonald-Wright, Arthur Dove, Andrew Dasburg, William and Marguerite Zorach, Abraham Walkowitz, Thomas Benton, Morton Schamberg, Charles Sheeler, Joseph Stella, Marsden Hartley, Oscar Bluemner, and John Covert also lived and studied in Europe, and felt the influence at first hand of such new movements as Fauvism, Cubism, Futurism, Der Blaue Reiter (the Blue Rider), Orphism, and abstract art. As they began to drift back to America in the years preceding the first World War and to exhibit paintings showing distinct Continental derivations, the whole center of gravity of the American art world shifted. The insurgent spirit of the realists survived, but their forms became outmoded by the time war overtook Europe. It seemed, indeed, that New York was about to become an aesthetic outpost of Paris, and that abstract idioms might work some permanent transformation on the American art scene.

Borrowing its militancy from the Progressive era, the modern spirit arrived in America aggressively and confidently, generating among its adherents rapt and messianic feelings. It fitted suddenly, and all too neatly, into the evolving pattern of the American's mobility of feeling and his enthusiasm for novelty and change. If we

Americans had not invented "modernism," for a time we made it our own. How profoundly or superficially its conventions in art were understood only became clear in the following decade. In the meantime, between 1908 and 1920, the spirit of intellectual adventure was abroad in the land and nothing seemed able to stem its advance. Everything seemed possible to the human spirit through art, and such nineteenth-century prophecies of the American promise as Walt Whitman's appeared to be on the verge of fulfillment.

Exciting new beginnings could be seen everywhere, from the fantastic growth of the "little" magazines to the new ventures in experimental theater; from the poetry renaissance in Chicago to the emergence of a promising new crop of writers and their dedicated patrons and literary hostesses who conducted salons on both sides of the Atlantic. The "new," whether in poetry, prose, the theater, painting, or enlightened politics, found widespread support from America's best critical and creative minds. For a number of years members of the intellectual community, reaching out to refresh and sustain each other in such distinguished new publications as *Seven Arts, Dial, The New Republic, The Little Review, Smart Set,* and *Camera Work*, demonstrated the solidarity of a community of related and responsive spirits unique in our modern cultural life. To the eager champions of the new spirit who wrote for these magazines, modernism became all things: an aesthetic proclamation of the spirit, a social gambit, and even a principle of national regeneration.

Many of the sponsors of the "new" art spoke the vitalist language of Robert Henri and shared his humanist aims. They were, however, far more receptive to European standards and more anxious to attain a contemporary sophistication. They extended a welcome to Parisian aesthetic principles which the Henri group had withheld. Unlike the generation of realist painters and naturalist writers, these artistic missionaries focused on the individual rather than on social forces as the key to realizing the American promise. The social equation of the reform movement was reversed: instead of trying to make group life more equable in order to free creative forces in the individual, the new enlightenment was now seen to emanate from the liberated modern individual who was expected to transform the group. James Oppenheim, founder of *Seven Arts*, which like so many of the brightest hopes and expectations of

modernism was to expire with the war, anticipated a time when "the lost soul among nations, America, could be regenerated by art." Writing and painting were envisioned as part of one great advancing cause whose aim was nothing less than the reconstruction of modern man, and therefore of society. Such brilliant, young, social-minded critics as Van Wyck Brooks, Randolph Bourne, Lewis Mumford, Paul Rosenfeld, and Waldo Frank, who wrote for *Seven Arts*, proselytized for the new movement as a way of binding men together in fraternal fellowship, and directed a withering fire against entrenched powers in both the art world and the social scene. They dreamed of an "organic" art that would lead to a potent renewal of modern life. A spirit of enlightenment, verbalized in the impressionistic language of utopian yearning, invaded criticism. Painting suddenly stood for an entirely new kind of aspiration. Writing of Post-Impressionism, Hutchins Hapgood of the *New York Globe* declared significantly: "It shakes the old foundations and leads to a new life, whether the programs and ideas have permanent validity or not."

Out of this atmosphere of high hopes emerged Alfred Stieglitz, an artist in his own right with the camera, a dealer, and first impresario of modernism in America. It is customary to date the arrival of modern art from the dramatic Armory Show of 1913, an event certainly of the utmost significance in the history of American taste. The Armory Show was our first introduction to the potent medicine of European artistic innovation on a wide, popular basis. Stieglitz, however, had been administering small doses over the five years preceding it, and his bold maneuvers prepared the ground for the triumph of modernism. He played a sheltering, patriarchal role for painters at a time when they desperately needed guidance and support, and gave them a sense of belonging to an active, cosmopolitan art life of exacting standards, comparable to the highest in Europe. Thanks largely to the Stieglitz protectorate, the American artist was freed of his provincial diffidence and crushing sense of isolation. Arthur Dove, like many other Stieglitz painters, was later to acknowledge his dealer's critical role. "I do not think," he wrote, "I could have existed as a painter without that super-encouragement and the battle he has fought day by day for twenty-five years. He is without a doubt the one who has done the most for art in America."

119. MAX WEBER.
Tapestry No. 2. 1913.
Oil on canvas, 34½ × 23¼″.
Private collection

120. MARSDEN HARTLEY.
Musical Theme No. 1. 1912–13.
Oil on panel, 21 × 26″.
Estate of Edith Gregor Halpert

121. HENRY FITCH TAYLOR.
Figure with Guitar, II. 1914.
Oil on canvas, 35 × 24″.
Noah Goldowsky Gallery,
New York City

122. JOHN R. COVERT.
Temptation of St. Anthony. 1916.
Oil on canvas, 25⅝ × 23¾″.
Yale University Art Gallery, New Haven, Conn.
Gift of Collection Société Anonyme

123. ARTHUR G. DOVE. *Portrait of Alfred Stieglitz.*
1925. Collage of camera lens, photographic plate,
clock and watch springs, and steel wool
on cardboard, $15\frac{7}{8} \times 12\frac{1}{8}''$.
The Museum of Modern Art, New York City.
Edward M. M. Warburg Fund

Stieglitz himself was a new type of personality in the arts. He was a second-generation American of Jewish-German descent whose parents emigrated at the time of the Civil War. After 1900, the massive waves of immigration began to exert their pressures on the art scene, giving it a more international character and making the port of New York a more cosmopolitan cultural center. In Stieglitz's generation there were a number of other significant artistic personalities of foreign descent who also contributed to the intermingling of racial and national strains: the painters Joseph Stella, Abraham Walkowitz, Max Weber; the sculptors Jacob Epstein, Gaston Lachaise. Like Paris with the advent of Picasso, Miró, Gris, Modigliani, Soutine, Chagall, and others, the mainstream of art in twentieth-century New York was fed by many currents. The mixing of different peoples and backgrounds also gave new fluidity to the social structure, and created a freer and more tolerant intellectual atmosphere in which the new could be eagerly received.

After settling in America and establishing a successful business, in 1881 the elder Stieglitz re-

turned to Germany with his family to give his children a Continental education. Alfred took up the study of engineering at the Berlin Polytechnic, but his imagination was soon captured by the new science of photography, whose mechanics he pursued in the academic laboratories of Berlin. By 1887 he had won a first prize in the London *Amateur Photographer*, and when he returned to New York in 1890, he had acquired a small reputation in his chosen medium. In the next two decades he became celebrated for his photographs of New York life; the impressionistic realism of his photographs corresponded to the painting of the Eight. Later, Stieglitz began to isolate his subject matter, and often to abstract it, and his own art

124. ABRAHAM WALKOWITZ. *Beach Scene.*
1903. Watercolor, $9\frac{1}{2} \times 12\frac{3}{4}''$.
Paintings and Drawings, Ltd., New York City

125. MAURICE STERNE. *Resting at the Bazaar.* 1912.
Oil on canvas, $26\frac{3}{4} \times 31\frac{1}{2}''$.
The Museum of Modern Art, New York City.
Abby Aldrich Rockefeller Fund

126. ABRAHAM WALKOWITZ. *New York*. 1917.
Watercolor, ink, and pencil, 30⅝ × 21¾″.
Whitney Museum of American Art,
New York City. Gift of the artist in
memory of Juliana Force

became more formal and symbolic. He also be-
came active in local photography groups, reor-
ganizing the languishing Society of American
Photographers and editing its official organ, *Cam-
era Notes*. In 1903 he founded his own magazine,
Camera Work, which in its fourteen years of ex-
istence became equally famous for its handsome,
meticulously accurate gravure reproductions and
its many important articles on photography and
art. These were written specially for it by Bernard
Shaw, Maurice Maeterlinck, Gertrude Stein (in
her first appearance in an American publication),
Francis Picabia, Charles Caffin, Willard Hunt-
ington Wright, Marius de Zayas, and Benjamin
de Casseres.

In 1906 Stieglitz and his friend, Edward Stei-
chen, a young painter and photographer, opened
the Little Gallery of the Photo-Secession in the
three-room attic of a brownstone at 291 Fifth
Avenue. The next year Stieglitz began to exhibit
art as well as photographs, commencing with the
drawings of Pamela Colman-Smith. "The Seces-
sion Idea," he explained in *Camera Work*, "is
neither the servant nor the product of a medium.
It is a spirit." And Stieglitz promised that his little
gallery would remain hospitable to artistic effort
in any medium so long as it showed "honesty of
aim, honesty of self-expression, honesty of revolt
against the autocracy of convention."

Soon the Photo-Secession Gallery was func-
tioning only marginally as a showplace for the
new photography, and its exhibitions were domi-
nated by advanced painting and sculpture ema-
nating from Paris. Edward Steichen, who spent
summers in France and was on familiar terms
with many of the new French artists, served as an
enthusiastic liaison. It was apparently Steichen
who proposed the first two exhibitions of Euro-
pean moderns, a show of Rodin's watercolors in
January 1908, followed four months later by
Matisse drawings. Between exhibitions he wrote
to Stieglitz: "I have another cracker-jack exhibi-
tion for you that is going to be as fine in its way as
the Rodins are.

"Drawings by Henri Matisse, the most modern
of the moderns—his drawings are the same to him
and his paintings as Rodin's are to his sculpture.
. . . Some are more finished than Rodin's, more
of a *study* of form than movement—*abstract* to
the limit."

Stieglitz's first two exhibitions of European
moderns encountered in the press a stony indiffer-
ence that should have dampened even the most
ardent spirit. The dean of American newspaper
critics, Royal Cortissoz of the *New York Herald*,
described the Rodin watercolors as "studio drift-
wood." The Matisse exhibition, his first in Ameri-
ca, excited even more of the pointed patronizing
derision which soon became the customary press
response to Stieglitz's shows. J. Edgar Chamber-
lain of the *New York Evening Mail* declared
Matisse's female figures were "of an ugliness that
is most appalling and haunting, and that seems to
condemn this man's brain to the limbo of artistic
degeneration." The same old tired epithets that
had been used to discredit Eakins and progressive
art of the past, revealing again the intellectual and
emotional impoverishment of American art crit-
icism at its popular level, were dusted off and
pressed into service to ridicule the new and unac-
customed in art. In a moment of levity Chamber-
lain mockingly asked forbearance for the
outlandish Matisse show. "This sort of thing,"
he wrote, "should be treated with respect, just as
adventism, Eddyism, spiritualism, Doukhobor
outbreaks, and other forms of religious fanati-
cism are. One never knows when a new revolution
is going to get started." In point of fact, Mr.
Chamberlain was more of a prophet than he could
have imagined. With Stieglitz's introduction of
Rodin and Matisse, and with the quickening tem-

128. MORRIS KANTOR.
Synthetic Arrangement. 1922.
Oil on canvas, $77 \times 55''$.
National Collection of Fine
Arts, Smithsonian Institution,
Washington, D.C.

127. JOSEPH STELLA. *Spring*. 1914.
Oil on canvas, $75 \times 40\frac{1}{8}''$.
Yale University Art Gallery, New Haven,
Conn. Gift of Collection Société Anonyme

129. MAX WEBER. *Tea*. 1911.
Oil on canvas, $12 \times 16''$.
Private collection

po of his subsequent shows, modernism for the first time began to gain a foothold in American taste. Perhaps even more significantly, the returning expatriate painters were encouraged to go on with the bold experiments they had tentatively begun in Paris.

After the Matisse show, the Photo-Secession Gallery found itself in financial difficulties and was forced to abandon its quarters. But Stieglitz found additional outside support, and in the fall of 1908 reopened his gallery in different rooms at the same address, 291 Fifth Avenue. The historic new quarters of "291," as the gallery came to be known, inaugurated a new and more intensive

phase of exhibiting activities. The vital statistics of Stieglitz's shows, which took place at a time when advanced painters and sculptors had virtually no alternative opportunity for exhibiting, comprise a most imposing and complete survey of early modernism. They show, too, the growing participation of Americans in the new movements. In 1909 he gave Alfred Maurer, Marsden Hartley, and John Marin their first one-man shows in this country. The following year, when a large independents' show was organized by the New York realists with none of the Stieglitz artists participating, 291 showed a group, "Younger American Painters," which included Maurer,

Hartley, Marin, Dove, Steichen, Weber, and Arthur Carles. In a sense this exhibition challenged the realists' claim as representatives of progressive tendencies, and made the growing distinction between American scene painting and abstract or semiabstract modes clear for the first time.

From 1910 until 1917, when the war temporarily closed his gallery, Stieglitz scored an impressive number of American firsts: Cézanne's watercolors; Picasso's watercolors and drawings; Henri Rousseau's paintings; Manolo's and Matisse's sculpture. Stieglitz also in this period gave Francis Picabia, Constantin Brancusi, and the Americans Abraham Walkowitz, Oscar Bluemner, Elie Nadelman, Georgia O'Keeffe, and Stanton Macdonald-Wright their first exhibitions in this country, and presented the first serious exhibition of children's drawings and

of Negro sculpture anywhere in the world. In his succeeding galleries, The Intimate Gallery (1925–1929) and An American Place (1929–1946), Stieglitz showed the sculpture of Gaston Lachaise, Charles Demuth's paintings, and staged regular exhibitions of Marin, O'Keeffe, Hartley, and Dove. No dealer in America, and few in Europe, had launched so much significant new painting and sculpture in so short a period.

Indeed, Stieglitz was a good deal more than a dealer as we understand the term today; he was a creative person in his own right, and his relations to his American artists were to say the least unconventional, with commercial considerations refreshingly absent. He saw himself and his artists as workers in the cause of creative freedom, and 291 took on a symbolic character, often encouraging among its admirers a spirit of mystical rever-

130. ARTHUR G. DOVE. *Sails*. 1911. Pastel, 17⅞ × 21½″. Formerly collection Phillip Goodwin

ence. Stieglitz's incorruptibility became a legend, and many casual visitors were put off by his apparent indifference to them, and by his unwillingness either to promote or even to attempt to explain the puzzling new shapes and forms inhabiting the spanking white walls of his gallery. In a foreword to the Forum Exhibition of Modern American Painters in 1916, Stieglitz bluntly expressed his views of the gallery system, and hinted at his own objectives in showing art. "I feel," he wrote, "that the system now in vogue of bringing the public into contact with the painting of today is basically wrong. The usual exhibition is nothing but a noise maker. It does not do what it is professedly to do: To bring about a closer Life between Expression and Individual."

291 was in effect an experimental station for a group of free souls, united by common creative and social aims. The general public was admitted, but only initiates were entirely welcome and made to feel at home. To the naive or bewildered who sought an explanation of the new art, Stieglitz turned a deaf ear, saying, "You will find as you go through life that if you ask what a thing means, a picture, or music, or whatever, you may learn something about the people you ask, but as for learning *about* the thing you seek to *know*, you will have to sense it in the end through your own experience, so that you had better save your energy and not go through the world asking what cannot be communicated in words. If the artist could describe in words what he does, then he would never have created it."

Stieglitz's Olympian manner intimidated more

131. OSCAR BLUEMNER. *Old Canal Port.*
1914. Oil on canvas, 30¼ × 40¼".
Whitney Museum of American Art,
New York City

than one collector who could never be sure that their own aesthetic attitudes might not suddenly offend and alienate the dealer, denying them a purchase. Despite his apparent detachment from the motives of the marketplace and his somewhat offhand methods of dealing with the public, among intimates he affected the role of high priest, educator, and teacher. The degree to which he did so, and the intensity of feeling his presence generated, are reflected in the memorial volume published in 1934, *America and Alfred Stieglitz.* Many of the foremost intellectuals of his day sought stimulation and refreshment in Stieglitz's company, and he was universally known and admired by creative people, a number of whom contributed to his memorial book. In addition to the artists and art critics directly associated with his gallery or magazine, there were many others for whom 291 or the Stieglitz apartment provided a refuge and source of stimulating conversation, among them Sherwood Anderson, Carl Sandburg, the composer Ernest Bloch, Walter Lipmann, Lewis Mumford, and Waldo Frank. Stieglitz, however, was also subject to a kind of adulation best compared in modern times with the group of intense female worshipers of D. H. Lawrence. An English novelist appropriately characterized Lawrence's fanatical disciples in a book title as *The League of Impassioned Pigmies.* Stieglitz posthumously suffered such rapturous appreciations as the remarks of one female admirer who described 291, or "The Room," as "an Immaculate Conception," "the Song of Songs," and who saw Stieglitz's life as one dedicated "to the beauty of all life, derived and springing out of the love-life." There is no reason to assume that Stieglitz enjoyed or encouraged such abject worship; however, one suspects that his sense of mission may have blinded him to his own electrifying impact on his entourage.

In Stieglitz's period the self-realization of the individual was also allied with the strivings of women for place and independence; more generally, it was part of the effort to reinstate feeling and instinct as important human forces. Modern utilitarian society was served warning by the new art expressions that the life of the emotions had been unwisely neglected. Personalities like Stieglitz and Lawrence assumed the roles of faith healers and life givers in a period reacting violently to Victorian repressions. They supplied something that was missing in modern life, just as

132. ELIE NADELMAN. *Untitled*. c. 1906.
Brush and ink, 11½ × 6¼".
Wasserman Family Collection,
Chestnut Hill, Mass.

133. GEORGIA O'KEEFFE. *Drawing No. 13*. 1916.
Charcoal, 24⅜ × 18½".
The Metropolitan Museum of Art, New York City.
The Alfred Stieglitz Collection, 1949

the radical simplifications, the joyous, intense colors, and the new primitivism of modern art had done. The novelist Edna Bryner found in the Stieglitz milieu a profound emotional satisfaction, based on "a remembrance back to a very ancient life when participation was common and completely satisfying." In the face of modern life, with its dominating materialist values, the creative artist sought refuge in some ideal community of like-minded spirits, or simply in his own creative powers. Stieglitz, like D. H. Lawrence, almost compulsively exaggerated the potencies of the individual creative spirit and made the most exacting demands imaginable on himself. He wished that he might have "the physical strength of a scale that can weigh a thousand tons of coal, plus a psychic sensitivity of the scale that can weigh a ray of light."

In such statements and attitudes one feels something of the unstable hopefulness that surrounded European art, not so much in the twentieth century as in the last years of the preceding century, at a time when modernism on the Continent was more directly identified with social aspirations and with a critical, reforming spirit. There was something of William Morris's social idealism in Stieglitz's outlook, mingled with distinctly American romantic attitudes. However, unlike the *fin-de-siècle* movements which were tied to a return

to some nostalgic, neo-traditional community, Stieglitz's brave new world was forward-looking. As Waldo Frank envisioned it, 291 embodied the proclamation of a new order. It stood as a symbol of the birth of a new world where "myriad creative men and women, teachers, workers, artists, scientists toil together . . . in ways as variedly profound as must be the world in which the new-born Man—the true person—with his exquisite sensibilities and enormous powers, may prosper."

Since the new art was so mystically dedicated to the evolution of "the true person," and the ideal hopes for fundamental social-spiritual change were suddenly shattered by the war, it was to be expected that the modern art which identified itself with a discredited idealism would also suffer an enormous decline in prestige. That is precisely what happened after the war. The fact that the decline of modernism took a more drastic form in America, that the movement was riddled with more damaging defections here than in Europe, is in part explained by the fact that so much utopian sentiment which had been supporting it was suddenly cut away by the disillusioned mood of the postwar period. Perhaps even more important, however, was the fact that American artists had after all only made a superficial alliance with the new European styles, and in the absence of strong visual traditions of their own, were not yet

134.　MAX WEBER. *New York at Night*. 1915.
Oil on canvas, 35 × 22″.
The Collection of Fine Arts, University of Texas, Austin

ism, and American scene painting acquired ever more tenacious holds on our art. Modernism became a series of individual directions and lost its broad, collective character, despite its manifold early promise.

From the beginning, modernist art was conceived as an "interpretation" of American life and became a vehicle for the expression of certain shared feelings about experience and the individual's aspiration. The American's view of modern art was at once both more idealized and more pragmatic than the European's. Andrew Dasburg, one of the first American abstract artists of quality, suggested in 1920 why one of the central impulses of modern art, Cubism, hadn't deeply penetrated native consciousness. "One cannot write of 'actual' Cubism in America," he declared, "but only of the effort. We lack the intellectual integrity to work logically within the limitations inherent in an idea. We want instead to gather the best from many sources. . . . This idea of combining a variety of forms of perfection into one complete ideal realization prevents any creative work being done which possesses the contagious force of Cubism." Dasburg suggests the disparity between American eclecticism and the more profound European ability to create something new continually within an established style. Perhaps our early modernism was encumbered by

ready to surrender provincial attitudes. In any case, it is unlikely that modernism as expressed by the artist members of the 291 milieu would have been even as successful as it was without Stieglitz's faith and ardent support.

In the decade of the twenties, American art experienced a relaxation in abstract styles, and there was a limited reaction to the excesses of the early modern movements. European art also went through a period of cautious consolidation and returned to naturalism in some degree, but soon erupted with new assertions of experimental freedom in Surrealism. Despite its sometimes academic practices and diversionary polemics, Surrealism was a genuine effort to resuscitate an important principle of creative liberty. The Surrealist revolution was scarcely felt in America until the forties. Instead, naturalism, Expression-

135.　STUART DAVIS. *The President*. 1917.
Oil on canvas, 26 × 36″.
Munson-Williams-Proctor Institute, Utica, N.Y.

too much ideological baggage, diverting it from essential aesthetic and formalistic considerations necessary to sustain a style. But that, too, was in the American grain and in the spirit of the time, as was Stieglitz's effort to make something high-minded and essentially moral of the artistic effort.

After two world wars and a long hiatus that saw most of the initial hopes of modernism dismantled, it is inevitable that we should look back on the idealistic mood of the decade between 1910 and 1920 as an age of innocence. Today, however, Stieglitz's example may be regarded as a corrective to the contemporary advanced artist's gnawing sense of isolation, for he embodied a general cultural ambition that few of our artists today permit themselves to feel. He once said to a friend, as they stood observing the New York skyline from within 291: "If what is in here cannot stand up against what is out there, then what is in here has no right to exist. But if what is out there can stand up against what is in here, then what is in here does not need to exist." Stieglitz was prepared to give way before the millennium, but in the meantime he would fight for experimental art as a noble and elevated cause. Stieglitz created a fascinating community of like-minded spirits with himself at its center, and for his ultimate goal he desired a better world. But he nurtured few illusions that it could materialize of its own accord. If his enthusiasm for the modern at times seemed undiscriminating and was obscured by a somewhat muzzy idealism, he nevertheless lived according to his own high principles with an altogether admirable singleness of purpose.

Stieglitz was of even more importance as a catalyst of new pictorial and sculptural ideas than as a theorist or evangelist. 291 became the first important American center for the radical new forms of modern art, which achieved national publicity with the celebrated Armory Show of 1913. Part of the legacy of 291 was the formation of the Société Anonyme in 1920 by Katherine Dreier, Marcel Duchamp, and Man Ray. An itinerant museum and collection of modern painting and sculpture, the Society, or the Museum of Modern Art as it was first known, bought and circulated the new art, with the emphasis on nonobjective styles. Its guiding spirit, Katherine Dreier, an amateur painter, also wrote, lectured extensively, and arranged lectures by such artists and critics as Walter Pach, Joseph Stella, Henry McBride, and Christian Brinton in an effort to promote the

136. KATHERINE S. DREIER. *Abstract Portrait of Marcel Duchamp*. 1918. Oil on canvas, 18 × 32". The Museum of Modern Art, New York City. Abby Aldrich Rockefeller Fund

137. MORTON L. SCHAMBERG. *Machine*, 1916. Oil on canvas, 30⅛ × 22¾". Yale University Art Gallery, New Haven, Conn. Gift of Collection Société Anonyme

understanding of modern art in America. Among the many important artists that the Society presented in their first American exhibitions were Schwitters, Campendonk, Klee, Malevich, Miró, Baumeister, and Vantongerloo. The bulk of the Society's fine collection was given to the Yale University Art Gallery in 1941. Here one may still see the paintings by some of the neglected and interesting early American moderns: Patrick Henry Bruce, Morton Schamberg, John Covert, and Joseph Stella. It is also not too farfetched to

consider the opening of the Museum of Modern Art in New York in 1929 as another outgrowth of the pioneering Stieglitz activity. The proselytizing spirit of 291 has been passed on to other public collections of modern art such as the Solomon R. Guggenheim Museum, which uses its artistic resources to educate and elevate public tastes in a more tempered messianic spirit.

One other aspect of Stieglitz's impresarioship deserves attention: his publication *Camera Work*. In this magazine was printed perhaps the first sustained, serious criticism of American artistic life and culture, and the first tentative "modern" art criticism. Many of the articles, especially those written by the brilliant Benjamin de Casseres and the Mexican caricaturist and critic Marius de Zayas, may seem dated, but they represent the apprenticeship of the modern spirit in America. This holds true even though their prose reflects a *passé* literary impressionism, and their aesthetic is conditioned by the romantic decadence. It is curious to note that when Stieglitz was showing the radical simplifications and powerful forms of the Fauve Matisse, and of Picasso during his "Negro" period, Benjamin de Casseres could summon up the waning epicurean

139. MARIUS DE ZAYAS. *Elle*,
from the periodical *291* (New York City:
November, 1915)

glow of the nineties, of a world in dissolution. In his essay "Modernity and the Decadence," he wrote: "I desire a world without a center. I seek the Ultima Thule of each sensation. I love the dispersed and muffled sonorities of weakened forces. I desire as many personalities as I have moods." To Casseres the modern meant the last hot-house refinements of the romantic spirit. "Beyond Verlaine, Debussy, Picasso, Arthur Symons, Maurice Maeterlinck, Lafcadio Hearn, Stéphane Mallarmé, Rémy de Gourmont, Anatole France, there is nothing," he declared. Such writing and attitudes were quite in contrast to those of other early critics of modern art like Roger Fry or Clive Bell in England, whose criticism sternly avoided the purple passage and limited itself to formal analysis.

Yet the romantic writing of Casseres belongs to an important current of modern criticism. He in fact anticipated the Surrealists when, in a more fantastical mood, he wrote: "I desire to be ephemeral, protean, and to chase butterflies of my fancy across abyss and meadowland and even into those fatal caves in the moon where the Goddess of Lunacy spins her cataleptic dreams." And like the poet-seer Rimbaud, he relied upon disorder and unreason to free artistic intuition from the suffocating limitations of logical thought and modern civilized life. In such formulations the modern spirit of revolt and the romantic decadence join forces: they both aim to liberate the life of pure instinct. Casseres's apparently anarchic scheme of values was part of an effort to reinstate the artist's world of imagination, even at the cost of discrediting conventional reality. "Sanity and simplicity," he wrote in 1913, "are the prime curses of civilization. . . . We should mock existence at each moment, mock ourselves, mock others, mock everything by the perpetual creation of fantastic and grotesque attitudes, gestures and direct attributes."

Dated though such statements may now seem, they were important in creating a receptive atmosphere for the emergence of more vital forms of modern art. In flavor they also anticipate the war with American culture waged in the twenties by such elaborate ironists as James Branch Cabell or that more robust debunker, H. L. Mencken. The postwar debunking journalism was, as Alfred Kazin has pointed out in *On Native Grounds*, the American version of Dada. When Marius de Zayas declared in *Camera Work* in 1916, "America waits inertly for its own potentiality to be expressed in art," he expressed a skepticism that became the substance of the indictment of American life in the next decade. (Holding up the American "booboisie" to ridicule, H. L. Mencken was later to suggest that the "Anglo-Saxon of the great herd is . . . the least civilized of men and the least capable of true civilization. . . . He is almost wholly devoid of aesthetic feeling.") The opening salvo in the attack on American provincialism and insensitivity came from the *Camera Work* critics. "In all times," de Zayas wrote darkly, "art has been the synthesis of the beliefs of peoples. In America this synthesis is an impossibility, because all beliefs exist here together. One lives here in a continuous change which makes impossible the perpetuation and the universality of an idea. . . . Each individual remains isolated, struggling for his own physical and intellectual existence. In the United States there is no general sentiment in any sphere of thought."

De Zayas carried his attack on American culture over into an assault on modern art itself, however, thus anticipating the more systematic and all-encompassing negations of the Dadaists. It is a measure of Stieglitz's tolerance that he would sponsor a point of view so at variance with his own more sanguine outlook. In an essay published in *Camera Work* in 1913, "The Sun Has Set," de Zayas found that "unconsciousness" in art was "the sign of creation, while consciousness at best that of manufacture." Proceeding from this definition, which was in a sense the *reductio ad absurdum* of the revolt against reason, he described the modern artist as "an eclectic in spirit and an iconoclast in action," and took exception to his willful distortions and self-conscious primitivism. For him such strategies suggested that modern art was willed and contrived. As the Dadaists were to ask a few years later, he posed the question whether the modern artists were not "an anachronism," "a logical absurdity." He concluded that they were rather the impotent slaves of their own time, reflecting in their derivative styles the last nervous convulsions of a period that was "chaotic, neurotic, inconsequent and out of equilibrium." De Zayas terminated his argument with the statement: "Art is dead." Although he was thereby expressing the nihilism of Dada, he wasn't prepared to push his view further and adopt a counter-aesthetic, nor did he explore the liberating and fruitful possibilities of

"anti-art" attitudes, as the Dadaists later did with such resourcefulness and ingenuity.

For a moment, however, Dada did enjoy a certain fashionable success in America. In 1921 Marcel Duchamp and Man Ray published one issue of *New York Dada*. Picabia had come to America in 1913, and Duchamp in 1915; they soon became closely associated with the Stieglitz circle. With Stieglitz, Picabia helped found a new proto-Dada publication, *291*, in 1915. For this magazine he did characteristic mechanical drawings of machine forms, to which were appended such provocative titles as *Portrait of Alfred Stieglitz* or *A Young American Girl in a State of Nudity*. Visual puns vied with *idéogrammes* by Guillaume Apollinaire, typographical experiments, fantastic prose-poem fragments by Stieglitz himself, and

other inspirational contributions in free verse to make *291* in its brief year of existence the boldest and most original venture in American publishing. Like the criticism of Casseres and de Zayas, however, *291* exercised a certain restraint in stating the case for the disenchanted modern.

American disillusion of the period never matched the extreme positions of the European Dadaists in their rebellion against modern society and the machine. The machine forms which Picabia and Duchamp used to deprecate and to exorcise the mechanistic environment of modern life, and also to challenge the "noble" conventions of the figurative styles of the past, did not achieve a widespread influence among American artists. Perhaps the sentimental attachment of the American to the machine as a creator of material com-

140. (*left*) MARCEL DUCHAMP. *The King and Queen Surrounded by Swift Nudes*. 1912. Oil on canvas, 45¼ × 50½″. Philadelphia Museum of Art. The Louise and Walter Arensberg Collection

143. (*facing page*) FRANCIS PICABIA. *Ici, c'est ici Alfred Stieglitz?* Pen and red and black ink, 29⅞ × 20″. The Metropolitan Museum of Art, New York City. The Alfred Stieglitz Collection, 1949

141. (*bottom left*) MAN RAY. *Aerograph*. 1919. Airbrush and watercolor, 29¼ × 23½″. Cordier & Ekstrom Gallery, New York City

142. (*bottom right*) FRANCIS PICABIA. *Voilà Elle*, from the periodical *291* (New York City: November, 1915)

VOILÀ ELLE

ICI, C'EST ICI STIEGLITZ
FOI ET AMOUR

145. FRANCIS PICABIA.
Amorous Procession. 1917.
Oil on cardboard, 38¼ × 29⅛″.
Collection Mr. and Mrs.
Morton G. Neumann, Chicago

146. MAN RAY. *Clock Wheels*. 1925.
Rayograph, 11 × 9″. Yale University
Art Gallery, New Haven, Conn.
Gift of Collection Société Anonyme

144. MARCEL DUCHAMP.
Chocolate Grinder, No. 1. 1913.
Oil on canvas, 24¾ × 25½″.
Philadelphia Museum of Art.
The Louise and Walter Arensberg Collection

147. MAN RAY. *Gift*. 1921
(replica of lost original).
Flatiron with nails, height 6½″.
Collection Mr. and Mrs.
Morton G. Neumann, Chicago

148. JOHN MARIN.
Woolworth Building and Vicinity. 1914.
Pencil, 9½ × 7½".
Estate of Edith Gregor Halpert

fort, and his basic optimism about the future, did not permit him to view technology critically. There was a social violence in Dada's feigned madness and anarchism that was antipathetic to the milder, reformist American spirit. Nor were Americans capable of the kind of ingenuity and wit which animated the zany spirit of play so integral to the inventions of Dada art.

Morton Schamberg emulated Picabia for a time, but died in 1918 before he had fulfilled his early promise. Charles Sheeler was in the beginning influenced by Schamberg. Demuth credited Duchamp with a significant role in the evolution of his early style. Yet neither Sheeler nor Demuth permitted himself the total defiance of either Duchamp or Picabia, or of the official Dadaists. Rather, their mature pictures were bland, diagrammatic interpretations of the new industrial landscape, objective and, with some notable exceptions, uncritical in their observation. The American artist could not achieve the European's aesthetic detachment, and he felt no deep sense of alienation from his own crude industrial environment: John Marin's exulting cry of identification before the Manhattan skyline was the classic early reaction of the American artist to the new landscape of power: "I see great forces at work, great movements; the large buildings and the small buildings; the warring of the great and the small. . . . While these powers are at work pushing, pulling, sideways, downwards, upwards, I can hear the sound of their strife and there is great music being played." Here was an echo of the affirmations of Whitman and Louis Sullivan, of Henri and Stieglitz, up a few decibels, but still ringing hopefully with the wonder of the American promise.

In a more agitated and romantic mood, the American Futurist Joseph Stella registered the fresh impact on his senses of the new American dynamism. Of his painting *Brooklyn Bridge* (1917–1918), he wrote: "To realize this towering imperative vision, I lived days of anxiety, torture and delight alike, trembling all over with emotion. . . . Upon the swarming darkness of the night, I rung all the bells of alarm with the blaze of electricity scattered in lightnings down the oblique cables, the dynamic pillars of my composition, and to render more pungent the mystery of my metallic apparition, through the green and red glare of the signals I excavated here and there caves as subterranean passages to infernal recesses."

A decade after Stella had celebrated the Brooklyn Bridge in paint, a poet, Hart Crane, made it the imaginative symbol of technology triumphant and as a myth for moderns. Invoking the spirit of Walt Whitman, he described the bridge as the "terrific threshold of the prophet's pledge." His brilliant, packed imagery re-creates the bedazzled excitement and even the locale of Stella's painting and word-picture:

Again the traffic lights that skim thy swift
Unfractioned idiom, immaculate sigh of stars,
Beading thy path—condense eternity:
And we have seen night lifted in thine arms.

For the American artist and poet, Roebling's engineering feat, the suspension bridge, became a symbol of sublimated energy and spiritual aspiration. Another manifestation of the American sensibility that shows respect for the machine may be found in Ernest Hemingway. In *A Farewell to Arms* during the retreat from Caporetto the hero finds comfort and distinct personal satisfaction in the existence of the oiled barrels of guns and of cannon simply as pure physical sensation, in the

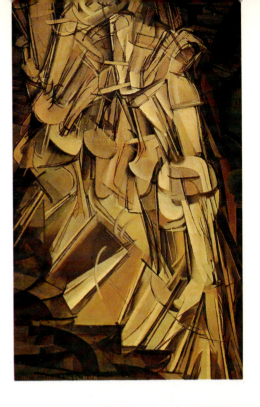

149. MARCEL DUCHAMP.
Nude Descending a Staircase, No. 2. 1912.
Oil on canvas, 58 × 35″.
Philadelphia Museum of Art.
The Louise and Walter Arensberg Collection

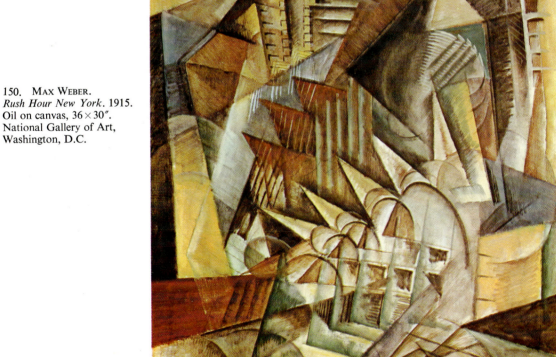

150. MAX WEBER.
Rush Hour New York. 1915.
Oil on canvas, 36 × 30″.
National Gallery of Art,
Washington, D.C.

151. JOHN MARIN. *Lower Manhattan* (*Composing derived from top of Woolworth*). 1922.
Watercolor and collage on paper, 21⅝ × 26⅞″. The Museum of Modern Art, New York City. Lillie P. Bliss Bequest

152. MAX WEBER.
Chinese Restaurant. 1915.
Oil on canvas, 40×48″.
Whitney Museum of American Art,
New York City

153. JOSEPH STELLA. *Battle of Lights, Coney Island*. 1914. Oil on canvas, 75¾×84″. Yale University Art Gallery, New Haven, Conn. Gift of Collection Société Anonyme

154. FRANCIS PICABIA.
Very Rare Picture on the Earth. 1915.
Gilt, silver paint, and collage on wooden forms on
cardboard, 44¾ × 34″.
Peggy Guggenheim Collection, Venice

155. MARCEL DUCHAMP.
The Bride Stripped Bare by Her Bachelors, Even. 1915–23.
Oil and lead wire on glass, 8′ 1¼″ × 5′ 9⅛″.
Philadelphia Museum of Art.
The Louise and Walter Arensberg Collection

way one would find security and warmth in the presence of some reliable old friend. The Dadaists twitted the machine as a threat to civilized values, or enlisted it as an accomplice to discredit traditional values in art. Only the American felt the machine as an intimate, physical presence, and identified his personal destiny with it. Stella contemplated the "mystery" of his "metallic apparition," the Brooklyn Bridge; Hart Crane made it a symbol of grace and sublime freedom. Marin, like many other contemporary artists, found release and artistic satisfaction in the prospect of American scale and constructive dynamism.

America's modernist moods were on the whole romantic and idealistic. Despair was given a halfway and inconclusive formulation, as demonstrated by the writing of Casseres and de Zayas in *Camera Work*. For most American artists, modernism became identified in the decade 1910 to 1920 with the American promise. Just as John Sloan and his friends had used realism to project the quality of the American dream, so our first modern artists approached the formal discipline of modern styles in a mood of optimistic excitement. They would not brook the limits imposed by Cubism, or inflict on themselves the conditions of working "logically within the limitations inherent in an idea." Nor did Dada have any real success in this country. And Futurism, which canonized the machine and exalted modern life in a programmatic art, was given a far more subjective, unsystematized accent in Joseph Stella's painting and verbal utterances, as an example.

It is remarkable that Alfred Stieglitz could have held in balance the conflicting claims of native romanticism and European aesthetic formalism. His great contribution, indeed, was to relate the European sense of art to his own romantic individualism and to that of his artists. He understood the experimental as part of the American's inalienable right to seek new expressions of creative liberty, and he gave this search moral and ideological overtones. He himself, for example, once referred to a sequence of his cloud photographs as an effort "to put down my philosophy of life—to show that my photographs are not due to subject matter—not to special trees, or faces, or interiors, to special privileges, clouds were there for everyone—no tax as yet on them—free."

The painters whom Stieglitz showed worked out from accepted visual facts to attain some subjective or interpretive statement. Even the work

156. MAX WEBER.
Grand Central Terminal. 1915.
Oil on canvas, 60 × 40″. Estate of the artist

157. ALFRED STIEGLITZ.
New York from the Shelton Looking West.
1935. Photograph

158. JOSEPH STELLA. *Brooklyn Bridge*. 1917–18.
Oil on canvas, 84 × 76″.
Yale University Art Gallery, New Haven,
Conn. Gift of Collection Société Anonyme

159. MARCEL DUCHAMP. *L.H.O.O.Q.* 1919.
Color reproduction of the *Mona Lisa* altered with
pencil, 7¾ × 4⅞″. Reproduced from a lithograph
made from the original, 11¾ × 9″ (1971).
Collection Arturo Schwarz, Milan

160. FRANCIS PICABIA. *Portrait of Cézanne*. 1920
(destroyed), from the review *Cannibale*
(Paris: April 25, 1920)

161. ARTHUR G. DOVE. *The Critic*. 1925.
Newspaper clippings, magazine ads,
velvet on cardboard, 19 × 12½″.
Whereabouts unknown

of the most abstract of his artists, Arthur Dove, was nature-saturated and poetic in mood. An uncompromising rejection of naturalist illusion, and its replacement by some visual system of autonomous plastic signs—the core of European modernism—was never realized as a collective effort in America. Despite the "organic" character of Stieglitz's thought and his aim to bring about "a closer Life between Expression and Individual," he could not take the radical step of entirely dissociating art from natural appearances. His artists perhaps *wanted* to conceive of art as a necessary, organic, and independent structure, but in the end they all were forced to make conciliatory gestures toward tradition. The gap between abstraction and painting that clung to naturalist illusion was as great as that in the evolutionary order between the crustaceans and the vertebrates. With few exceptions, the gap in art was not decisively closed by the first "wave" of American modernism.

Yet, if American painting could not establish itself within the more exacting Continental disciplines, Stieglitz was wise enough to teach us to measure it not as a failure in terms of the European standard but as a valid local expression. It was as a projection of indigenous modes of feeling that American art in the modern period attained its first distinction and made its contribution to international art. Stieglitz and his Gallery 291 provided a rich soil for the new ventures; in it the modern spirit struck roots and enjoyed its first extraordinary flowering.

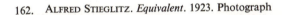

162. ALFRED STIEGLITZ. *Equivalent.* 1923. Photograph

5 · Scandal on Twenty-Sixth Street

THE IMPACT OF Alfred Stieglitz's exhibitions of new European painting and sculpture almost immediately affected the New York art world. The more open-minded artists were enthralled by radical European innovations and were anxious for a comprehensive view of the world art picture, so many tantalizing glimpses of which Stieglitz had supplied. But many of the progressive American artists, and particularly the group of realists surrounding Henri, were thrown on the defensive; they could not take kindly to a foreign art more revolutionary than their own, one whose aims they could not share. A competitive feeling arose between the two groups which later flared into open antagonism. It emerged first at the time of the great exhibition of independents in 1910. "Stieglitz," wrote John Sloan, one of the sponsors, "is hot under the collar about our show. . . . I imagine he thinks we have stolen his thunder in exhibiting 'independent' artists." If the independents had stolen Stieglitz's thunder, however, it was only in the staging of their exhibition, and not in its actual character. They included none of the more adventurous American moderns such as Carles, Dove, Hartley, Marin, Maurer, and Weber, whom Alfred Stieglitz had already exhibited as a group at 291 earlier that year. The divisions among artists of progressive tendency became even more apparent the next year, when Rockwell Kent proposed another independents' show to Sloan, but stipulated that the exhibiting artists agree not to submit paintings to the National Academy exhibition that year. When the show was held, Sloan, Henri, Glackens, Lawson, and Shinn were absent, since they refused to abide by Kent's condition. Among those who did agree and exhibited were, ironically enough, the modernists Maurer, Marin, and Hartley.

In 1911, Jerome Myers, Walt Kuhn, and Elmer MacRae discussed a more ambitious exhibition.

A committee of twenty-five, dominated by the original members of the Eight and calling itself the Association of American Painters and Sculptors, was formed to develop the idea of another comprehensive showing of independent artists. For about a year plans were discussed, and the group tried to arrange the use of an exhibition hall. Neither a location nor the money for the venture was forthcoming, and it seemed that the new independents' show would have to be abandoned. At the moment of greatest discouragement, the committee approached Arthur B. Davies, who had a formidable reputation as a fund raiser, and asked him to accept the presidency. He agreed in effect to shoulder the main responsibility for the exhibition, and immediately set about his new task with great enterprise and energy. It was Davies who almost single-handedly changed the original conception of the independents' show into the great survey of modern European art now known as the Armory Show. The move did not ingratiate him with his more nationalist-minded associates, and in due time aroused their deep hostility. They were helpless to oppose him in the beginning, however, since he alone held out the promise of adequate financial backing. "Thus it was that I," wrote Jerome Myers later, describing his appeal to Davies for assistance, "an American art patriot, who painted ashcans and the little people around them, took part in inducing to become the head of our association the one American artist who had little to do with his contemporaries, who had vast influence with the wealthiest women, who painted unicorns and maidens under moonlight."

As a painter, Davies was more conservative than the realists who looked to Henri for leadership. The refined aestheticism and romantic mood of his painting stemmed from the Pre-Raphaelites; one could scarcely have guessed that the bold

colors of Matisse or the radical simplifications of the Cubists would soon engage Davies's sympathies. He was, however, an urbane man of wide artistic culture and taste, and had actually studied the new art of Europe more than most artists of his generation. Davies had shown an interest in Stieglitz's exhibitions, and from them he bought

163. ARTHUR G. DOVE. *Nature Symbolized —Connecticut River*. 1911. Pastel on linen, 18 × 21″. Estate of Edith Gregor Halpert

164. MARSDEN HARTLEY. *Movement—Sails*. 1916. Oil on canvas, 23½ × 19½″. Collection Mrs. Waldo Frank, New York City

a Cézanne watercolor and a Picasso. "Davies' thorough understanding of all the new manifestations," Walt Kuhn later wrote, "was due to one thing only—his complete knowledge of the past."

There are a number of widely differing versions of the origins of the Armory Show, all of them written many years after the event by men who admitted a violent partisanship either to Davies or to the forces opposing him within the committee. From the point of view of those like Guy Pène du Bois, a fellow member and publicist for the group, who later complained that Davies was a "severe, arrogant, implacable" man, the new president robbed the show of its value as a national demonstration by showing the foreign article. It was, of course, the new European art that immediately became the public sensation of the show. Yet it is hard to believe Davies could have remained in a position of major responsibility if his behavior had been as partisan as it was later said to have been, or if the majority of the committee had been in open conflict with him. It was only after the exhibition was held, and public reactions were in, that the disgruntled members attacked the change in policy. In any case, there seems little doubt that Davies was the guiding spirit of the show, and that his ideas must have intrigued the committee to a degree, since they accommodated him; it is also certain that Walt Kuhn, the secretary of the Society, and Walter Pach, a liaison in Paris, played primary roles in making the actual European selections on the spot.

The idea of a comprehensive show of new art

165. MAX WEBER. *New York*. 1912. Oil on canvas, 21 × 25″. Estate of the artist

166. (*left*) ARTHUR B. DAVIES.
Intermezzo. 1915.
Oil on canvas, 28 × 14″.
Graham Gallery,
New York City

167. (*right*) MAN RAY.
*Portrait of
Marcel Duchamp.* 1923.
23¼ × 19¼″.
Private collection,
New York

tendencies had already occurred to many Europeans outside France. In 1911 the critic Roger Fry staged, amid public hoots and critical protest, the first Grafton Gallery Post-Impressionist Exhibition in London. Then, in 1912, a large group of Van Gogh, Gauguin, Cézanne, and Munch paintings, with others by living moderns, was shown in Cologne in an exhibition called the Sonderbund. That show seems to have precipitated Davies's dream of a large European cross-section in America, for upon receiving the catalogue, he sent it to Walt Kuhn with the note: "I wish we could have a show like this." Davies's suggestion became a reality when Kuhn immediately set off for Cologne and contracted to borrow a large group of paintings from the Sonderbund. He then proceeded to the Hague, where he saw pictures by Redon, and borrowed a roomful for the New York exhibition. In Paris, Kuhn was suddenly overcome by "the magnitude and importance of the whole thing," and he cabled Davies, who joined him there a week later.

The next several weeks Davies and Kuhn "practically lived in taxicabs," tracking down artists and making arrangements with their dealers for loans. The American painter Alfred Maurer introduced them to Vollard, the dealer who had exhibited many of the Impressionists and Post-Impressionists. Another painter, Walter Pach, was an invaluable contact with living French artists, among them Marcel Duchamp, whose *Nude Descending a Staircase* became the runaway sensation of the Armory Show. In London, Davies and Kuhn went to see Roger Fry's second modern exhibition at the Grafton Gallery, and satisfied themselves that they had already selected an equally good or superior group of paintings and sculptures, though they did arrange to borrow from the show. When all arrangements had been completed, Davies and Kuhn returned to America, leaving Pach to look after details of packing and shipping.

Back in New York they set about trying to arouse enthusiasm for the unprecedented new exhibition, which was now planned for the Armory of the New York National Guard's 69th Regiment, at Twenty-Sixth Street and Lexington Avenue. Kuhn persuaded Frederick James Gregg of the *New York Sun* to take charge of publicity, and the services of Guy Pène du Bois, editor of *Arts and Decoration,* were enlisted. At the last minute the great barracks-like hall of the Armory was softened by symbolic swags of evergreen and other decorations financed by the generous Mrs. Gertrude Vanderbilt Whitney. The exhibition opened February 17, 1913, with a band bravely playing and art students distributing catalogues and badges with the pine-tree flag of the American revolutionary period and the fitting inscription "The New Spirit."

The Armory Show contained about sixteen hundred pieces of sculpture, paintings, drawings, and prints; it included a large American selection, made by William Glackens, which comprised three-quarters of the whole. Work by most of the celebrated modernists—Picasso, Matisse,

168. "International Exhibition of Modern Art," poster for the Armory Show, New York City, 1913.
Joseph H. Hirshhorn Foundation

169. "International Exhibition of Modern Art," interior view.
Armory Show, 69th Regiment Armory, New York City, 1913

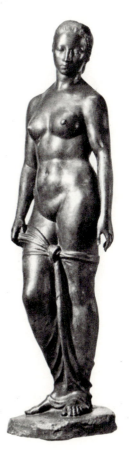

170. FRANCIS PICABIA. *Star Dancer and Her School of Dancing*. 1913.
Watercolor, 21⅞ × 29⅞″.
The Metropolitan Museum of Art, New York City.
The Alfred Stieglitz Collection, 1949

171. WILLEM LEHMBRUCK.
Standing Woman. 1910.
Bronze, height 75⅛″.
The Museum of Modern Art,
New York City

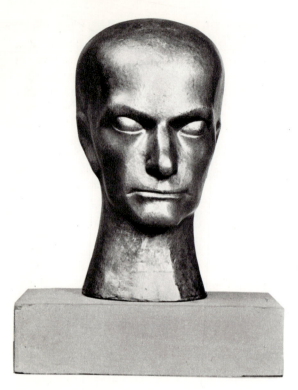

172. RAYMOND DUCHAMP-VILLON. *Baudelaire*. 1911.
Bronze cast, height 15½″.
The Columbus Gallery of Fine Arts, Columbus, Ohio.
Howald Fund

173. *The Rude Descending the Staircase* (*Rush Hour at the Subway*). Cartoon illustrating "Seeing New York with a Cubist" in *New York Evening Sun*, March 20, 1913

Brancusi, Duchamp, Kandinsky, Picabia, Léger, Braque, Rouault, Maillol, Lehmbruck—were represented, as well as a large group of paintings by Cézanne, Redon, Van Gogh, and Gauguin. In fact, Davies's aim was nothing less than to show the evolution of modern art since the romantic period. In order to give a proper historical perspective to the revolutionary works of the present, he set them off with pictures by Delacroix, Ingres, Corot, and Courbet, as well as the Impressionists and the Post-Impressionists. Except for the absent Italian Futurists—Davies tended to misconstrue and overlook them as "feeble realists," and they had anyway refused to show unless allowed to exhibit as a group—and despite the weak German Expressionist section, the exhibition made an impressive representation of the main modern currents. Many of the important modern works in American collections were purchased directly out of the Armory Show by such celebrated collectors as John Quinn, Dr. Albert Barnes, and Arthur Jerome Eddy; Bryson Burroughs bought from the exhibition the Metropolitan Museum's first Cézanne.

With our present advantage of hindsight, we might now quarrel with certain serious omissions, and with the general tendency to group the living artists with the dead. But whatever confusion that arrangement created was more than compensated by Davies's effort to establish a plausible historical framework for modern art. Although the Armory Show was soon to take on a carnival character for the press and general public, it was an admirably serious effort to demonstrate the logical evolution of modern art over a century of artistic effort. As Davies reasonably declared in his "Explanatory Statement":

"The Society has embarked on no propaganda. It proposes to enter on no controversy with an institution. Its sole object is to put the paintings, sculptures and so on, on exhibition so that the intelligent may judge for themselves, by themselves. . . ."

Overnight, however, the Armory Show became front-page news and the center of heated controversy. The press reaction ranged from mock howls of pain to threats of violent retaliation. More than one public official urged the exhibition be closed as a menace to public morality, and that the activities of the Society be legally proscribed. The general public joined the chorus of jeers and outrage, but also enjoyed the spectacle of scandal

in high culture and the discomfort of the entrenched powers, who were called on to defend traditional values against the new insurgents. For sheer newsprint devoted to it, the exhibition was without precedent; for the first time in American history modern art achieved national prestige, albeit a prestige of notoriety. Even such public figures as ex-President Theodore Roosevelt felt impelled to deliver an opinion in print. The result was that the Armory Show became a huge public success. In the three cities where it was shown, New York, Chicago, and Boston, a quarter of a million paid admissions were registered, and it is estimated an equal number were admitted without charge. Such attendance figures for art exhibitions of any style or period were unheard of at the time.

Duchamp's *Nude Descending a Staircase* was undoubtedly the most intriguing puzzle of the show, and something of a *cause célèbre*. Julian Street called it an "explosion in a shingle factory"; newspaper cartoonists had a field day lampooning it under such titles as *The Rude Descending the Staircase* (*Rush Hour at the Subway*), drawing everyday American experiences in pseudo-Cubist style. Amusingly enough, the mock-Cubist styles adopted to poke fun at the new art were a good deal more lively than the intricate Art Nouveau conventions most of the newspaper illustrators normally espoused. Written criticism of the show was altogether less light-hearted; it was fundamentally and deeply frightened, violently hostile, and often unscrupulous. With the exception of the writing of the publicists hired to promote the exhibition, and apart from the enlightened Henry McBride, Harriet Monroe in Chicago, the critics who wrote for *Camera Work,* and James Huneker, the reports and analyses of the exhibition were uncomprehending and unsympathetic.

The *New York Times* described the show as "*pathological!*" and repeatedly accused the Cubists and Futurists (who were, with the notable exception of Joseph Stella, not included in the exhibition) of being "cousins to the anarchists in politics." Royal Cortissoz, pundit of the *New York Herald*, fumed: "This is not a movement and a principle. It is unadulterated cheek." Banner newspaper headlines on the order of "Making Insanity Profitable" were characteristic. In an article entitled "Lawless Art," *Art and Progress,* the official magazine of the American Federation of Arts, compared the new European artists to "anarchists, bombthrowers, lunatics, depravers." And even the dignified Mr. Cortissoz indulged in the same violent jingoism, a species of criticism that has been the least creditable aspect of the puritanical, provincial outlook, from the Armory Show to the period of the Depression when Thomas Craven repudiated modernism as "an imported ideology." "The United States," wrote Cortissoz, "is invaded by aliens, thousands of whom constitute so many perils to the health of the body politic. Modernism is of precisely the same heterogeneous alien origin and is imperiling the republic of art in the same way."

Some years later H. L. Mencken was to discover a vulnerable target for his satirical gifts in the *homo Americanus* who could entertain such ridiculous fears and provincial prejudices. In *Prejudices: Second Series*, published in 1920, Mencken wrote: "The one permanent emotion of the inferior man, as of all the simpler mammals, is fear—fear of the unknown, the complex, the inexplicable. What he wants beyond everything else is safety. His instincts incline him toward a society so organized that it will protect him . . . against the need to grapple with unaccustomed problems, to weigh ideas, to think things out for himself, to scrutinize the platitudes upon which his everyday thinking is based." It was far more convenient, and safe, to dismiss the new artists as madmen and charlatans than seriously to examine their work on its merits.

At the Art Institute of Chicago, where a selection from the Armory Show was presented after the New York closing, the exhibition provoked incensed responses and even public disorders. The opening there coincided with an Illinois morals investigation, and the state vice commission was warned that some of the outlandish new paintings were "immoral and suggestive." The results of the commission's investigation were inconclusive, and no action was taken; but according to legend, the Chicago underworld, enticed by the prospect of salacious art in high places, visited the show in great numbers to see what all the fuss was about. A spokesman for the Law and Order League of that city demanded the exhibition be shut down, declaring: "The idea that people can gaze at this sort of thing without it hurting them is all bosh." And art students at the Institute were advised by their instructors to shun the show like the plague, or, alternately, were conducted through it in the spirit of "crime

174. HENRI MATISSE. *The Blue Nude*. 1907.
Oil on canvas, $36\frac{1}{4} \times 44\frac{1}{8}$".
The Baltimore Museum of Art.
Cone Collection

175. CONSTANTIN BRANCUSI. *Sleeping Muse*. 1909–11.
Marble, height $11\frac{1}{2}$".
Joseph H. Hirshhorn Foundation

admiration but astonishment." But few were able to share Cros's further view that "Whatever happens, these first years of our century announce an efflorescence which will be one of the richest in the history of art. And it is good to live in this time of struggle, when men are rudely fighting to capture the new beauty."

Meyer Schapiro has pointed out in a profound and unfortunately little-known essay on the Armory Show, "Rebellion in Art,"[1] that the real crisis of the exhibition threatened not the modernists, despite the violent attacks on them, but the traditionalists. If the spokesmen for the status quo were correct in their repeated charges that the new art was produced by lunatics, charlatans, and political subversives, then it should have caused them less apprehension; the public was far from being deluded or corrupted by the new art. Yet the conservative critics and artists took it seriously enough to feel the need to justify themselves. The Armory Show was a challenge not to

does not pay." The students responded enthusiastically to the moral misgivings of their seniors by burning Brancusi, Matisse, and Walter Pach in effigy. To no avail were the efforts of Harriet Monroe, one of the distinguished leaders of the Chicago poetry renaissance and founder of *Poetry* magazine. As a working art critic, she patiently and reasonably tried to present the case for modern art in the press. Hers was a lonely voice; everyone could find reassurance in the statement she quoted from the European critic Guy-Charles Cros, "The new seems absurd; it arouses not

[1] Daniel Aaron, ed., *America in Crisis* (New York: Knopf), 1952.

be ignored. The vehement rebuttals of such generally level-headed critics as Frank Jewett Mather or of the dowdier academician Kenyon Cox indicated that they were deeply and genuinely disturbed and thrown on the defensive. Kenyon Cox warned in a series of ponderous meditations in the *New York Times* that the "real meaning" of Cubism, Futurism, and experimental art was "nothing else than the total destruction of the art of painting." Frank Jewett Mather conceded some value to the experimental mood of the new art, but then added: "Yet I feel that all such gains . . . come to very little so long as art is unguided by any sound social tradition and left the prey of boisterous and undisciplined personalities." A schism had dramatically opened between "sound" and "frivolous" art values, between official and progressive painting in America. In subsequent years the enemies of the modern and those who opposed even the sentiment of modernity did not relax their attitudes of vigilance. However, they were soon unable to pose with real conviction or enthusiasm a positive alternative, since even the art they defended was becoming a retarded and diluted academic derivative of some form of modernism.

The Armory Show also represented a crisis from the liberal point of view. It created serious doubts for the realist painters and for progressive critics like Theodore Roosevelt. They were prepared to accept the spirit of change but balked at too extreme a change. Such uneasiness before the more radical appeals to freedom and modernity in art had also been characteristic in Europe, but, as Dr. Schapiro has noted, it was especially "striking to observe in America where individuality and freedom are advertised as national traits." Thus, Theodore Roosevelt, in his ambiguous review of the show in *The Outlook* of March 29, 1913, conceded that at least "the note of the commonplace" was refreshingly absent from the new work. He felt his sympathies engaged, but only up to a point. He admitted, more in sorrow than in anger, that progressive movements were likely to lead to excesses, and that there was "apt to be a lunatic fringe among the votaries of any forward movement." Roosevelt concluded finally on a note of stern disapproval: "In this recent exhibition the lunatic fringe was fully in evidence, especially in the rooms devoted to the Cubists and the Futurists, or near-Impressionists."

The puritanical reaction of the American public

176. HENRI MATISSE. *Back I.* 1909.
Bronze, 74⅜ × 44½ × 6½".
The Museum of Modern Art, New York City
Mrs. Simon Guggenheim Fund

to modern forms was no more intense than had been the inhospitable receptions of the French to advanced movements in art since Manet and the Impressionists. While we were less than prepared, at the popular level, for the impact of the Armory Show, the more sophisticated art public of France showed little more foresight or understanding before twentieth-century art forms, despite the succession of great artist-martyrs in the preceding century. Uninformed American opinion, however, was magnified by the growth of pressure groups which in the spirit of conformity refused to tolerate anti-establishment ideals. The values of the new art were based precisely on new expressions of individualism. They corresponded to the radical empiricism of contemporary science and to the adventurous spirit apparent in other areas of thought during the first two decades of the new century, conveying a new sense of enlightenment, emancipation, and hope in many spheres of human endeavor. But to the public these values

177. PABLO PICASSO. *Woman's Head*. 1909.
Bronze, height 16¼".
The Museum of Modern Art, New York City.

178. ROBERT DELAUNAY.
Window on the City, No. 4. 1910–11.
Oil on canvas, 44¾ × 51½".
The Solomon R. Guggenheim Museum, New York City

179. MORGAN RUSSELL.
Four Part Synchromy No. 7. 1914–15.
Oil on canvas, 15⅜ × 11½".
Whitney Museum of American Art, New York City.
Gift of the artist in memory of Gertrude V. Whitney

became an intellectual corollary of socialism, anarchism, and radical politics. The division between popular values and those of our best minds was more sharply accentuated as we entered upon the modern period of standardized mass culture. And the press played an aggressive role in inflaming the prejudices of the general public. It was a role shaped, as H. L. Mencken put it, by American journalism's "incurable fear of ideas, its constant effort to evade the discussion of fundamentals by translating all issues into a few elemental fears, its incessant reduction of all reflection to mere emotion."

The wider recognition accorded modernism, and its relative success here after the Armory Show, are due in great part to the efforts of a few early patrons, collectors, critics, and dealers in whose activities Americans may take a justifiable pride. The Stein family in Paris had, during the very first years of the century, bought and encouraged Matisse and Picasso with enthusiasm and conviction, and at a time when the French were still reviling the moderns. Under the influence of the Steins, the Cone sisters of Baltimore also bought Matisse in his Fauve period, and then other modern painters. The advent of Stieglitz, and then the Armory Show, stimulated the formation of such impressive modern collections as those of John Quinn, Dr. Albert Barnes, Walter

Arensberg, Arthur Jerome Eddy, and Lillie P. Bliss; today they form the nucleus of our outstanding museum collections in late-nineteenth and twentieth-century art. Yet it was many years before museums, with their inevitable influence on general standards, and the public at large could accept the revolutionary art of their century.

Much of the first impact of the Armory Show

180. STANTON MACDONALD-WRIGHT. *A Synchromy*. 1914.
Watercolor and gouache, 20¾ × 12¾".
Private collection

on taste was felt in the field of decoration, and took the form of a transformation in the design of utilitarian objects of daily life. In the applied arts, a kind of debased currency of modernism penetrated the American environment on a grand scale and seemed to make the new forms of art familiar and welcome. It is still a question, however, whether the basic sentiment of modernity, the unceasing quest for new freedoms of expression, today disturbs the lay public any less than it did in 1913. On the basis of the shocked reactions that unfailingly greet new manifestations in contemporary painting and sculpture, one can only assume that in its more vital and still-developing contemporary formulations modern art will never be entirely acceptable.

Whether or not the American public has yet accepted modern art in the deepest sense, the established values in the art world itself were thoroughly shaken after the Armory Show. As an index to the change in taste, prices of the Impressionists, Post-Impressionists, and twentieth-century European art jumped astoundingly after 1913, and the market for the modern boomed. Three hundred paintings were purchased directly from the show. John Quinn spent between five and six thousand dollars to form the main body of a superb collection which was later sold at auction. After the show, new galleries sympathetic to

181. WASSILY KANDINSKY.
Improvisation No. 27. 1912.
Oil on canvas, 47⅜ × 55¼".
The Metropolitan Museum of Art,
New York City. The Alfred
Stieglitz Collection, 1949

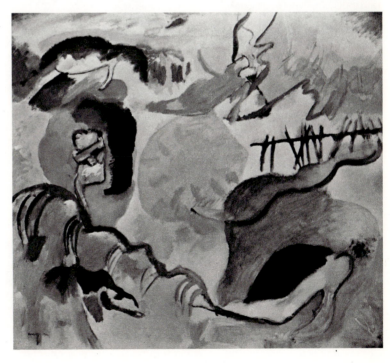

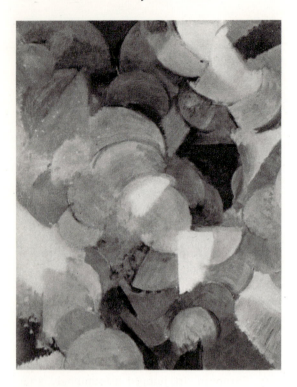

182. STANTON MACDONALD-WRIGHT.
"Conception" Synchromy. 1915.
Oil on canvas, 30×24".
Whitney Museum of American Art,
New York City

modern art such as the Daniel, the Bourgeois, and the Modern, the last organized by Marius de Zayas with Walter Arensberg's financial support, sprang into existence and implemented the effort that Stieglitz had for many years carried on alone.

The "advanced" painting that no gallery other than 291 would have touched prior to the show now found its way into exhibitions. A case in point was that of the Synchromists. Late in 1913, the Carroll Gallery showed the paintings of Morgan Russell and Stanton Macdonald-Wright, cofounders of a movement which was one of the most interesting American ventures of the period. Macdonald-Wright and Russell had been in Paris between 1912 and 1913 when Robert Delaunay, with Frank Kupka, had begun loosening up Cubist structure and directing it toward a free, pure-color abstraction; their brilliant chromatic experiments were allied to but independent of Kandinsky's "Improvisations" of this and the immediately preceding years. A few months after Delaunay and Kupka had made these color innovations, in a style which Guillaume Apollinaire later dubbed Orphism, the two young Americans arrived at an almost indistinguishable idiom. They protested in manifestoes that they,

183. PATRICK HENRY BRUCE. *Forms.* 1925–26. Oil on canvas, 28¾×35¾".
The Corcoran Gallery of Art, Washington, D.C.

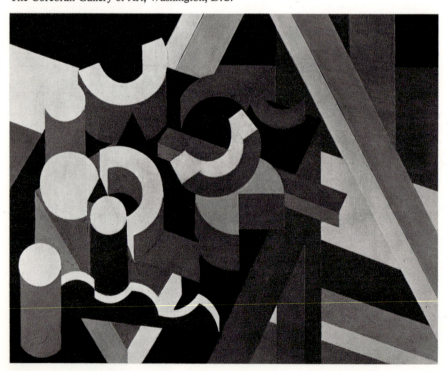

184. THOMAS HART BENTON. *Constructivist Still Life, Synchromist Color*. 1917. Oil on paper, 17½ × 13⅝″. The Columbus Gallery of Fine Arts, Columbus, Ohio. Howald Collection

185. ARTHUR G. DOVE. *Portrait of Ralph Dusenberry*. 1924. Oil on canvas with applied wood and paper, 22 × 18″. The Metropolitan Museum of Art, New York City. The Alfred Stieglitz Collection, 1949

rather than the Europeans, had originated the new style. Whatever the justice of their claim, they worked with enough expressive individuality and verve to make the problem of derivation irrelevant. They painted flowing, rhythmic abstract compositions in parallel bars and concentric arcs of intense primary color. Later they were joined by two other Americans, Patrick Bruce and Arthur Burdett Frost, Jr. Although Synchromism petered out with World War I, during its heyday it affected a number of American painters and found an articulate, influential champion in Willard Huntington Wright, the brother of one of its founders.

Another sign of the more emancipated artistic atmosphere attendant on the Armory Show was Mrs. Gertrude Vanderbilt Whitney's establishment in 1915 of the Friends of the Young Artists, from which grew the Whitney Studio Club three years later. The club gave its artist members individual and group exhibitions; it was the germ of New York City's present Whitney Museum of American Art, which opened in 1931. The Whitney Museum has devoted itself to encouraging contemporary American artists by purchases and interpretive exhibitions.

One of the most adventurous and significant presentations of the new American art following the Armory Show was the Forum Exhibition of

Modern American Painters in 1916, organized by Willard Huntington Wright. Wright had been an accomplished literary journalist and editor of *Smart Set*, thus preceding Mencken and George Jean Nathan as the director of one of the period's most sophisticated literary publications. Wright returned from Europe in 1915 to write a monthly art chronicle for the *Forum* and to contribute art criticism to *Camera Work*, and brought out his book, *Modern Painting*, a year after the publication of Arthur Jerome Eddy's *Cubists and Post-Impressionists*, the pioneering American work on modern art. He became a serious and discerning critic, despite an exclusive partisanship for Synchromism which led him to make reckless comparisons and blinded him to the far more influential contribution of Matisse, the Cubists, the Futurists, and other contemporary movements. Nevertheless, his views on modern art, in principle, were more daring than any that had been expressed, apart from contributions to *Camera Work;* the show which he induced *Forum* magazine to sponsor was one of the vital demonstrations of modern art in the period.

The Forum Exhibition was an effort to make an *authoritative show* of American moderns, the inescapable implication being that the public had been treated to a good deal of spurious art in the guise of modernism. It was also intended, as

186. MAN RAY.
*Admiration of the Orchestrelle
for the Cinematograph.* 1919.
Gouache, wash and ink, and
air brush, $26 \times 21\frac{1}{2}''$.
The Museum of Modern Art,
New York City.
Gift of A. Conger Goodyear

Wright declared in the foreword, "to turn attention for the moment from European art" and redirect it to native efforts, which had been obscured by the sensation made at the Armory Show by Duchamp and others. Wright wisely obtained as a committee of sponsors a catholic and prominent list of men, to certify and help explain the work in the exhibition. They were the critic Christian Brinton, an editor of *Art in America;* Robert Henri; W. H. de B. Nelson, editor of *International Studio;* Alfred Stieglitz; and Dr. John Weichsel, president of the People's Art Guild, an organization that mixed proselytizing for advanced art with social welfare work. Seventeen artists were represented, and each wrote an explanatory note to his work. The participants were Thomas Benton, Oscar Bluemner, Andrew Dasburg, Arthur Dove, George Of, Ben Benn, Marsden Hartley, S. Macdonald-Wright, John Marin, Alfred Maurer, Henry McFee, Man Ray, Morgan Russell, Charles Sheeler, Abraham Walkowitz, and Marguerite and William Zorach. All the artists but

Ben Benn and George Of were working under the influence of either Cubism, Matisse, or Synchromism, and almost without exception their statements stressed the formal aspects of their art. For a number, the work they showed was to remain the most boldly experimental of their careers.

On the defensive after the nightmarish reception of the Armory Show, Wright may have protested too much in his foreword with the statement: "Not one man represented in this exhibition is either a charlatan or a maniac." With some impatience and in a schoolmasterish tone he chided the public into accepting work "vouched for by men whose integrity and knowledge of art are beyond question." He wrote: "To ridicule the pictures here on view can only be a confession of ignorance. All new excursions into the field of knowledge have been met with ridicule; but despite that ridicule, the new has persisted, in time becoming the old and the accepted." Wright's hopeful admonitions were in contrast to the Forum Exhibition statement made by Stieglitz,

187. CHARLES DEMUTH.
My Egypt. 1927.
Oil on composition board,
$35\frac{3}{4} \times 30''$.
Whitney Museum of American Art,
New York City

188. CHARLES SHEELER.
Pertaining to Yachts and Yachting.
1922. Oil on canvas, $20 \times 24''$.
Philadelphia Museum of Art.
Bequest of
Margaretta S. Hinchman

189. GEORGIA O'KEEFFE. *Radiator Building—Night, New York*.
1927. Oil on canvas, 48 × 30″. Fisk University, Nashville, Tenn.
The Alfred Stieglitz Collection

190. GASTON LACHAISE. *Torso*. 1930.
Bronze, height 11½″.
Whitney Museum of American Art,
New York City

191. ELIE NADELMAN. *Hostess*. 1918.
Painted cherry wood, height 32½".
Joseph H. Hirshhorn Collection

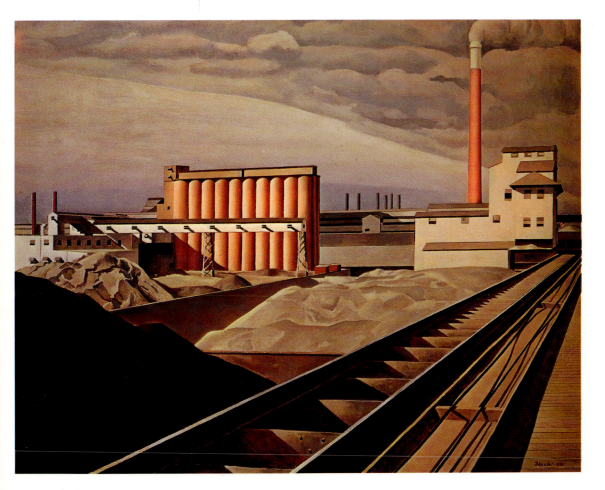

192. CHARLES SHEELER. *Classic Landscape*. 1931. Oil on canvas, 25 × 32¼". Collection Mrs. Edsel B. Ford

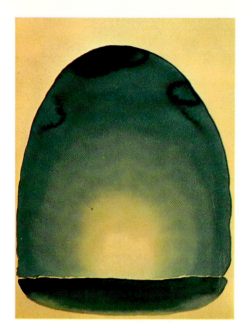

193. GEORGIA O'KEEFFE.
Light Coming on the Plains III. 1917.
Watercolor, 12×9″.
Amon Carter Museum of Western Art,
Fort Worth, Tex.

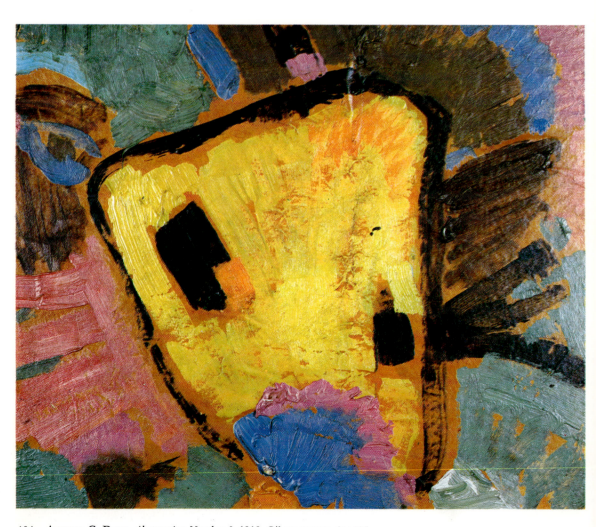

194. ARTHUR G. DOVE. *Abstraction Number 2*. 1910. Oil on canvas, 9×10″.
Collection Mr. and Mrs. George Perutz, Dallas

who answered in a decided negative the question: "Is the American really interested in . . . any form of art?" The conservative critic Frank Jewett Mather remained unimpressed by Wright's carefully reasoned justifications for the exhibition. "I think that the seriousness of these moderns," he wrote, "matters very little."

Yet if there was any challenge in the criticism of the times to the kind of smug historical point of view Mather represented, it was Wright's. Wright was one of the first to reverse customary critical procedures, interpreting the past through the eyes of the present instead of stepping out of his time and measuring the present invidiously against the past. Following the example of Roger Fry and Clive Bell in England, he sought in the art of the past some universal principle of design or formal organization, of "significant form," in Bell's apt phrase, that would provide a common clue to all aesthetic experience. In the Forum catalogue, Wright declared with a good deal of courage that the greatest art of the past, of El Greco, Rubens, and others, moves us for exactly the same reasons that the most experimental art of the present does: "The truth of modern art, despite its often formidable and bizarre appearance, is only a striving to rehabilitate the natura and unalterable principles of rhythmic form to be found in the old masters, and to translate them into relative and more comprehensive terms." And he proposed the unprecedented thesis: "A picture to be a great work of art need not contain any recognizable objects. Provided it gives the sensations of rhythmically balanced form in three dimensions, it will have accomplished all that the greatest masters have ever striven for."

Wright's challenging view was perhaps the most lucid and closely argued rejection of nineteenth-century naturalism in American art criticism of the period. "Were realism the object of art," he wrote, "painting would always be infinitely inferior to life—a mere simulacrum of our daily existence, ever inadequate in its illusion. . . . Our minds call for a more forceful emotion than the simple imitation of life can give. We require problems, inspirations, incentives to thought."

Wright's criticism corresponded in time and temper to a heroic moment in American painting. But not long afterward, arising undoubtedly out of the cruel erosion of hope and confidence that followed World War I, criticism retreated and so

195. WILLIAM ZORACH.
Leo Ornstein at the Piano. 1918.
Oil on canvas, 30 × 24".
Bernard Danenberg Galleries, New York City

196. CHARLES DEMUTH. *Acrobats*. 1918.
Watercolor, 10⅞ × 8⅞". Private collection

197. GEORGIA O'KEEFFE. *Red and Orange Streak*. 1919. Oil on canvas, 27 × 23″. Collection the artist

did art, seeking safer modes of thought and feeling. Wright himself later became obsessed with color theory and put his aesthetic faith in the color organ. Then he gave up art criticism altogether to become a famous detective-story writer under the pseudonym S. S. Van Dine. Perhaps the radical tenor of Wright's thought might have found more to support it in the intellectual climate of England, and certainly his career as a critic could have prospered better in Paris. In provincial America he was isolated, and eccentricity was his fate.

The reassertion of nationalist feeling and provincialism had come soon after the Armory Show. Even as more liberated styles received stimulation from the exhibition, there was a reaction against the domination of the Europeans. A good deal was made of the invidious comparison between the American and European art object. The publicist for the show, Frederick James Gregg, declared that "the vast mass of the American works exhibited represented simply arrested development." William Glackens was even more depressed by the American section and said: "We have no innovators here. Everything worthwhile in our art is due to the influence of French art. We have not arrived at a national art. . . . Our own art is arid and bloodless." This sense of

failure and cultural inferiority, though not universal, led in time to more aggressive attacks on internationalism. Jerome Myers complained bitterly, "Davies had unlocked the door to foreign art and thrown the key away. Our land of opportunity was thrown wide open to foreign art, unrestricted and triumphant; more than ever before, we had become provincials. . . . While foreign names became familiar, un-American propaganda was ladled out wholesale."

The cross-currents and conflicts of a renewed interest in the American scene, and the influence of European modernism divided progressive forces in American painting. In 1917 the independents idea was revived with the founding of the Society of Independent Artists. The new officers were balanced between the moderates and radicals. William Glackens was made president; Maurice Prendergast, vice-president; Walter Pach, treasurer; John Covert, secretary; and Walter Arensberg, managing director. Taking as its motto the slogan of the celebrated French Independents of 1884, "No Jury—No Prizes," the Society held its historic first exhibition, with 2,500 works by 1,300 artists. The show was a cross-section of American art, much of it mediocre, but it also included the best moderns in this country and a number of distinguished Europeans. Among those who sent work were Schamberg, Stella, Pach, Maurer, Demuth, Bruce, Hartley, Frost, Friedman, Man Ray, O'Keeffe, Zorach, Dreier, Weber, Dove, Halpert, Hawthorne, the American realists, and the Europeans Picasso, Gleizes, Signac, Duchamp-Villon, Vlaminck, Brancusi, and Metzinger.

There was strongly divided opinion as to the importance of the show. Marcel Duchamp had withdrawn because he felt the representation was too conservative—a conclusion he reached when the scandalized jury rejected his entry. Called *Fountain,* and signed R. Mutt, it was in fact a commonplace urinal, on which Duchamp's startled fellow-artists refused to confer the art-worthy status of "readymade," the French Dadaist's designation for his found objects. Henri, especially, complained afterward about the large amount of amateurish work and was critical of the more radical moderns. During the war the organization languished, although it continued to hold annual exhibitions. When it renewed activities in the postwar period, it was dominated by the more reactionary elements,

and the few advanced artists who continued to exhibit began to shift their styles toward more realistic interpretations of the American scene.

The Armory Show had put the custodians of orthodoxy on the defensive, but the unforeseen attention focused on European innovation, at the expense of native art, was the signal for the beginning of a retreat from internationalism. The contagious idealism kindled during the early Stieglitz period was mislaid in the war. The high expectations of one generation were exchanged for the caution and skepticism of another. Randolph Bourne wrote bitterly but prophetically in his war diary in 1917: "The war . . . or American promise. One must choose. . . . For the effect of the war will be to impoverish the American promise."

In the twenties a new mood of disenchantment set in, and modernism no longer served as a summons to action. Nor was the American artist concerned any longer with testing himself by European standards, by the aesthetic criteria of a culture which the war had convinced him was in its decline. Interest in the American scene as a reassuring source of common experience revived, but often with an addiction to its grotesque aspects. Experimentation lost its momentum and collective meaning, and for most artists modernism became a matter of imitative clichés, easily mastered and easily discarded. The Armory Show was robbed of its potency. A few of the sterner spirits survived the postwar crisis in painting, however, and, building on the modern legacy, fashioned their own distinctive styles in the decade that followed.

198. MARCEL DUCHAMP.
Fountain (signed R. Mutt). 1917.
Porcelain, height 24⅝".
Galleria Schwarz, Milan

6 · Innocents at Home and Abroad

THE EAGER AMERICAN acceptance of the experimental, which had kindled so many hopes during the first years of 291, bore fruit in the decade after the controversial Armory Show despite the many hostile rumblings that exhibition had set off. Out of their contact with advanced Parisian painting, first *in situ* and then at home under Stieglitz's auspices, a growing number of American artists had already begun to show radical new styles before 1913. Some of the artists who made the most significant contribution to the first flowering of an advanced art were Max Weber, Marsden Hartley, Arthur Dove, John Marin, and Charles Demuth.

Their painting spans a long and often contradictory period, from the lusty birth of innovation through the virtual extinction of modernism as a collective effort in the twenties and thirties, to the emergence of a new generation of abstract artists of conviction in the early forties. As had happened often in the past, the provincial innocence of our first wave of moderns was a source of both strength and weakness. It shielded the artist from the theoretical preoccupations of advanced European movements, from group manifestoes and polemics, in some cases preserving an essential individualism which proved most refreshing. On the other hand a lack of depth in their commitment to modern forms worked against even our best artists, and ultimately betrayed them into a shallow eclecticism. In the prevailing conservative artistic atmosphere of the postbellum period, the modern painter and sculptor were, on the whole, unable to resist the pressures of philistinism and returned to less demanding styles of realism.

No individual American artist can be singled out as the pioneer of advanced styles. The early years of the modern movement are somewhat obscured by public interest in the paintings of the realists, of John Sloan, Henri, and other members of the Eight. The first to react to the more sophisticated European styles may have been Alfred Maurer, who was living in Paris in 1900 and became by 1904 a welcome visitor in the Rue de Fleurus apartment of Gertrude and Leo Stein. In 1908 Maurer's rather fashionable salon painting manner, which took its cue from Sargent and from Maurer's American teacher, William Merritt Chase, began to change under the influence of Matisse's Fauve painting. Maurer was probably introduced to Matisse's new style through the Steins, who had begun to collect the French artist's work after the Autumn Salon of 1905, where the Fauves had first exhibited together. Max Weber and Patrick Henry Bruce also established their claim as pioneers when they joined Matisse's first painting class in 1908. And so, too, did Arthur Dove, who arrived in Paris in 1907, and Arthur B. Carles, both of whom probably became aware of new currents in painting through Maurer.

By 1910 John Marin had been abroad five years and was in the Austrian Tyrol, at Kufstein, doing watercolors of mountain scenery in an extremely free and improvisatory manner. Back in America in 1910, after two years abroad, Arthur Dove painted what was apparently the country's first entirely nonrepresentational painting, *Abstraction Number 2*. It coincided in time with the first of Wassily Kandinsky's abstract paintings, although Dove's precocious discovery of abstraction now seems to have been fragmentary and inconclusive, since he did not develop a consistent non-objective style in the years immediately following. And, in 1909, when Alfred Stieglitz gave Marsden Hartley his first one-man show, the New York art dealer could write in *Camera Work* of the avant-garde look of Hartley's Van Goghish landscape: ". . . his interpretation of sky, mountains and woods in brilliant coloring is of a decorative rather than realistic effect."

The direct exposure to Fauve painting in Paris seems to have been the first inspiration of America's advanced painting; but Stieglitz's exhibition of Cézanne's watercolors and Picasso's Cubist drawings and paintings in 1911 became an even more important influence. The Armory Show, the appearance of Picabia in New York at that time, and the presence of Marcel Duchamp in America after 1915 were also decisive factors in establishing European artistic viewpoints in this country. It was perhaps the painter Max Weber who in the beginning best understood, and conveyed, the new European sense of art, through his paintings and declarations. Indeed he, more than any of his countrymen, showed through the first two decades of his art that professionalism in medium and instinctive grasp of formal principle which had traditionally been associated with art emanating from Paris. If in retrospect his career seems marked by eclecticism and a constant shifting of aesthetic ground, he nevertheless provided an example of seriousness in painting that made more consistent talents seem narrowly provincial in their limitations.

Weber was born in Russia in 1881 and emigrated to America with his family at the age of ten. His formative artistic education began at the Pratt Institute in Brooklyn, when he took Arthur Wesley Dow's popular composition course. Dow was one of the pioneers of the new interest in oriental art, and he had been at Pont-Aven in Brittany with Gauguin and Emile Bernard. His interest in the decorative styles of Japanese art and in a nonnaturalistic use of color, as exemplified by Gauguin and the Nabis, made him an enlightened and vital teacher. He was also one of the few members of the teaching profession who later came vigorously to the defense of the Armory Show, and thus showed a willingness to endure public censure for the sake of principle.

By 1905 Weber had saved enough money from teaching art to go to Paris. His arrival coincided with the public debut of Matisse and the other Fauve painters who had broken through the fetters of naturalism and a doctrinaire Neo-Impressionism to paint with a new freedom and intensity of color. The year 1905 was also the occasion of a large Cézanne exhibition at the same celebrated Autumn Salon where Matisse and his friends made history. Cézanne's paintings were shown again even more extensively in the following two years, and by 1908 he had become the acknowledged inspiration of the early Cubist paintings of Picasso and Braque. That year Weber came directly into contact with the new French painting when he enrolled in Matisse's private *Académie;* he had already become an admirer and intimate of Henri Rousseau. On the eve of Weber's departure from Paris for America at the end of the year, Rousseau held a soirée for him. Later the French painter is reported to have advised Weber not to "forget nature." It was Weber who introduced Stieglitz to Rousseau's painting and persuaded him to give the French Primitive his first American exhibition at 291 early in 1911. As Stieglitz wrote, ". . . Weber . . . first sang the hymn to Rousseau in America. Weber's daily songs were: '*Cézanne, cet homme*' followed by '*Rousseau, cet ange.*'"

The combined influences of Cézanne, Matisse, Rousseau, and Cubism were to shape Weber's early style; such influences were little in evidence, however, when he held his first American one-man show in the cellar of a New York framing shop early in 1909. It was Stieglitz who became the decisive catalyst in Weber's more radical stylistic ventures. The two men met in the fall of 1909, and Weber went to live for a brief period at 291, assisting Stieglitz in hanging his shows. In 1910 he was included along with Dove, Marin, Hartley, and Maurer in 291's first group show of native moderns, "Younger American Painters." The exhibition invited the earliest press attacks on the emerging American modernists, and was described as a hoax and an "insult to the public." This violent reaction marks the dishonorable beginning of a series of bellicose deprecations which greeted Weber's successive exhibitions. At this time the artist's interests were widening in line with the new aesthetic viewpoints he had absorbed abroad. Perhaps it was Picasso's Negro period that now drove him to investigate Mayan and Aztec sculpture, the totems of Pacific Indians, and other examples of primitive art in New York's Museum of Natural History.

He also began to contribute articles to *Camera Work* on the relevance of primitive cultures to modern sensibility. And with considerable eloquence he set forth his views on the dynamic, new spatial concepts that were behind the Cubist movement. In an article rather awkwardly entitled "The Fourth Dimension from a Plastic Point of View," he wrote: "In plastic art there is a fourth dimension which may be described as the last

200. MAX WEBER. *The Geranium*. 1911.
Oil on canvas, 39⅞ × 32¼".
The Museum of Modern Art, New York City.
Acquired through the Lillie P. Bliss Bequest

199. MAX WEBER. *Decoration with Cloud*
(*Motherhood*). 1913. Oil on canvas, 60 × 40".
Estate of the artist

consciousness of a great and overwhelming sense of space-magnitude in all directions at the same time." In Europe, the ecstatic discovery of the space-time continuum in art had been a common feature of many of the early theoretical disquisitions on Cubist painting by Apollinaire, Metzinger, and others.

By 1910 Weber had begun to show his own individual interpretation of the drastic simplifications in form and color and the strong, rhythmic outlines of Matisse's art. Matisse's influence persisted until as late as 1913 in such paintings as *Decoration with Cloud*. Between 1910 and 1912, Weber also experimented with Cubist structure, and composed more aggressively. *The Geranium* of 1911 shows a fine understanding of early Cubism; the two compact female forms resemble Picasso's figuration of 1908 and 1909. Weber, however, achieved a distinctive personal synthesis of the abrupt, angular Cubist style with Matisse's brilliant, sensuous palette. In the masks and resigned attitudes of his figures there are elements of caricature and a touch of poetic melancholy which bear the stamp of an individual artistic

temperament. Weber was at pains to link the painting with the Cubist ideals of geometric structural analysis and mystery, describing it thus: "The conception and the treatment spring from a search for form in the crystal." But his mannered elongations of form are probably more related to the profound impression made upon him by the art of El Greco during a trip to Spain. The rather tender and wistful characterization of the figures, for all their formalism, perhaps grew out of Weber's awareness of himself as a Jew, a consciousness of origins which played a large part in his choice of themes in his later years.

The reactions of critics to Weber's new paintings, hung at 291 in a one-man show in 1911, were invariably vicious or hysterical. One writer found that his forms had "no justification in nature" and compared them to "the emanations of someone not in his right mind." Another was aghast at the artist's "brutal, vulgar and unnecessary display of art license." And still another incensed puritan ungenerously wrote: "Such grotesquerie could only be acquired by long and perverse practice." Weber's wistful, tentative Cubism provided the philistine press with their

first solid target prior to the Armory Show.

Among the vanguard paintings at the Armory Show, Duchamp's *Nude Descending a Staircase*, Picabia's *Procession at Seville*, and Stella's Futurist *Battle of Lights, Coney Island* came to exert the most seminal influence on American painters. The intense activism of surface in these works, as compared to the more contemplative emphasis of orthodox French Cubism, touched a sympathetic artistic nerve in this country. They seemed to crystallize the heightened sensations with which American artists were now trying to express the explosive character of urban experience. The multiplicity and energy of metropolitan life were given form by Weber in a new Cubist-Futurist vocabulary which employed violent, kaleidoscopic effects, suggesting movement and a mood of agitated apprehension. In many of the paintings executed between 1915 and 1917, Weber brilliantly communicated a new sense of release and energetic excitement, even when his formal synthesis contained so many elements that the picture surface seemed to buckle under the load. *Chinese Restaurant* of 1915 is surely one of the more ambitious and interesting American paintings in a period notable for boldly experimental work. While it may be judged an uncertain artistic success, owing to its obvious stylistic inconsistencies, it is nevertheless a remarkable and convincing demonstration of a vital native assimilation of Parisian aesthetics. It conveys an authentic experience.

On the one hand the painting seems to announce itself as a venture in decorative Cubism, and its rich, ornamental surface and varied patterning can be related to the collage. These effects, however, curiously coexist with pockets of fluid, transparent space where we catch glimpses, in shallow depth, of the multiple images and fragmentary geometric structures of Analytical Cubism. There is another plane of mobile visual sequence that suggests the paroxysm of Futurism, and its effort to capture kinetic sensations. Yet the picture has an undeniable impact, perhaps because it quite literally re-creates Weber's own agitated, vertiginous impressions of the bizarre décor of his subject. "On entering a Chinese restaurant from the darkness of the night outside," he wrote, "a maze and blaze of light seemed to split into fragments the interior and its contents, the human and the inanimate. For the time being the static became transient and fugitive—oblique

201. MAX WEBER. *The Two Musicians*. 1917. Oil on canvas, 40⅛ × 30⅛". The Museum of Modern Art, New York City. Acquired through the Richard D. Brixey Bequest

202. MAX WEBER. *Beautification*. 1942. Oil on canvas, 36 × 28". Bernard Danenberg Galleries, New York City

planes and contours took on vertical and horizontal positions, and the horizontal became oblique, the light so piercing and luminous, the color so liquid and the light and movement so enchanting! To express this, kaleidoscopic means had to be chosen."

Through 1917, Weber continued to experiment in a Cubist-Futurist idiom. After that date, in

response to the same revival of interest in naturalism then being experienced abroad, he began to incorporate more and more realistic descriptive detail into his painting, with more damaging disunity to his style. The return to the traditional assurances of naturalistic allusion, which in the case of Matisse and Picasso provided a temporary respite from a heroic period of adventurous experiment, seemed to rob Weber's art of its whole momentum and coherence. Caught in the cross-currents of movements and countermovements, in the early twenties he emulated Picasso's inflated neoclassical style. Then he painted landscapes in a manner that combined the palette of Cézanne with a coarser pigment surface and an Expressionist vehemence in handling. He became a lapidary of jeweled color and thick, shining paint paste, but something of his original fine energy seemed to have been lost, despite the new emphasis on voluptuous surface. Weber's mood became retrospective, his performance repetitive, if more obviously dramatic.

In the forties, Weber painted more schematically in fluid oil wash, taking his figure style perhaps from Picasso's *Guernica*, and lacing his overworked surfaces with a network of line. His subjects generally were Hassidic scholars engaged in argument, or moving in fantastic gyrations whose plastic motivation and symbolism were based on a sense of religious ecstasy. Weber's late work is related only tenuously in character or quality to the achievement of *The Geranium, Chinese Restaurant,* or even to his Expressionist style of the early twenties. The rapid decline of American experimental art left a vacuum which increasingly all but the most resolute innovators filled by relaxing into less demanding styles of realism or eclecticism.

The paintings of Marsden Hartley similarly show the generative powers of the first modern impulses received from Europe and, with modifications, the same pattern of isolation from the modernist mainstream, compromise, and a sharp letdown in the artist's critical standards. Hartley had begun in 1908 to paint his own free version of Segantini's academic Impressionism, with its "stitchings of color." Then in 1909 he exhibited at 291 work which had become more concentrated formally, unified around a style that suggested both the expressive, rhythmic pigmentation of Van Gogh and the more somber tonalities of Ryder. Hartley was abroad in 1912, and there he

203. MARSDEN HARTLEY. *Autumn.* 1908.
Oil on canvas, 30×30″. University
Gallery, University of Minnesota, Minneapolis.
On extended loan from Ione and Hudson Walker

204. MARSDEN HARTLEY. *Movement No. 10.* 1917.
Oil on composition board, 15¼×19½″.
The Art Institute of Chicago

experimented with Cubism; he then loosened his style, in response to the high-keyed colors and the more inspirational abstract art of Kandinsky and the members of the Blue Rider (*Der Blaue Reiter*). That year, at the invitation of Franz Marc, he showed with the Blue Rider in the first German Autumn Salon in Berlin, organized by Herwarth

Walden, editor of *Der Sturm* and one of the important early champions of modern art.

By 1915 Hartley had arrived at a personal synthesis of the emblematic insignia and ornament of decorative Cubism, and the fluid movement and intense spectrum colors of Kandinsky's first abstract style. His new work was bold and aggressive, incorporating references to German militarism in such repeated symbols as the Maltese cross, within a scheme of strident, primary color, often set off by ragged areas of flat black. The next year he moved toward a new austerity and experimented with flat, slab-like arrangements of rectilinear shapes, somewhat Constructivist in spirit. His palette was softened toward pastel and neutral hues, and he employed blander forms, held in subtle tension despite their drastic, geometric simplicity. Very few of his paintings of this brief period now exist; those that are still accessible have a distinction in color, and a most interesting balance of elegance with a stolid,

forceful simplicity. They also indicate a powerful, assured grasp of abstract idioms that for a variety of cultural reasons soon atrophied in the unstable atmosphere of American art.

Like Weber, Hartley seemed able for a brief period to find his integrity and individuality as an artist within the radical structural language of European abstraction. He expressed his emotions forcefully and with a distinction that eluded him in later years when he sought a more obviously personal artistic identity, and worked within a more mannered style. Following the general tendency of the twenties to return to the object and to nature, Hartley rediscovered Cézanne around 1926, a Cézanne, however, whose vibrancy and tenuousness he hardened into emphatic decoration and an enameled, facile coherence of form. Beginning in 1931 with his *Dogtown* landscapes painted in the vicinity of Gloucester, he worked in a simplified, rugged Expressionism, curiously cold, passive, and inert despite its

205. MARSDEN HARTLEY. *Lobster Fishermen*. 1940–41. Oil on composition board, 29¾ × 40⅞″. The Metropolitan Museum of Art, New York City. Arthur H. Hearn Fund, 1942

drastic outlines and vivid color contrasts. Only between 1908 and 1917, that is, before he had resolved his period of experiment and before he had begun to state all too succinctly his own rather circumscribed artistic personality, did Hartley demonstrate an impressive vitality and invention. After that period he made his major reputation in the predictable style that won him his widest public following.

Arthur Dove's was a more consistent performance, if more limited in range, than either Hartley's or Weber's. Once he arrived at the new language of abstraction, he pursued it to its radical conclusions and never recanted. Dove had been in Europe between 1907 and 1909. Through Alfred Maurer and Arthur Carles he was in contact with the work of the contemporary French vanguard. By 1915 he had firmly established himself in a painting genre of flowing, amorphous shape, muted color, and repeated rhythmic accent. As early as 1910 he tentatively approached abstract modes in a loose geometric style, and then, the following year, moved into a freer manner, but one that renewed contact with nature, in such pastels as the *Nature Symbolized* series. His forms were related after 1915 to the soft

color masses of the Synchromists, to Kandinsky, and more ancestrally, to Gauguin's arabesques and the fanciful organic shapes of Art Nouveau. During his earliest phase, Dove painted in a restrained, monochromatic palette reinforced by sober earth colors. Later he used more resonant tonalities, but always retained neutrals, tans, and warm blacks as a foil for his more intense hues. Like the early Kandinsky of 1910–1914, Dove used colors and forms to suggest an attenuation of naturalistic shapes and a diffusion of local colors taken from some actual scene. He painted the disembodied elements of a dream-landscape that had begun to blur, to distend, and to take on mysteriously heightened powers as an abstract composition. Dove transposed but did not entirely eliminate his landscape impressions, and his living, organic forms constantly evoked nature, analogically if not more directly. Of his paintings, he wrote: "I should like to take wind and water and sand as a motif and work with them, but it has to be simplified in most cases to color and force lines and substances just as music has done with sound."

Dove's mood of poetic reverence in the presence of nature, that sense his paintings convey

206. ARTHUR G. DOVE.
Abstraction Number 2. c. 1911.
Charcoal, $20\frac{5}{8} \times 17\frac{1}{2}''$.
Whitney Museum of American Art, New York City

207. ARTHUR G. DOVE.
A Walk, Poplars. 1920.
Pastel, $21\frac{1}{2} \times 18''$.
Estate of Edith Gregor Halpert

of saturation in landscape color and of a strong underlying relation to real experience, was mingled with other psychological manifestations. His expanding circular shapes, graduated in concentric bands of diminishing color intensity, suggested both a symbolic representation of the effects of light and a mood of mysticism, as if the artist were intent upon losing himself in the dark flow and pulse of organic nature. In his statement for the Forum Exhibition Catalogue he had declared his artistic aim was to find visual symbols which espoused both the inner stirrings of the self and external nature: "to give in form and color the reaction that plastic objects and sensations of light from within and without have reflected from my inner consciousness. . . . My wish," he continued, "is to work so unassailably that one could let one's worst instincts go unanalyzed. . . ." One is reminded of the statements of another artist to whose work Dove's bears certain spiritual affinities, Odilon Redon. The Frenchman had written of his dreaming, symbolist art: "I intend an irradiation which seizes the spirit and escapes all analysis." The play of nonaggressive, rhythmic shape and the mood of mystic imminence in Dove's paintings struck a balance between the fantastic-symbolist modes of turn-of-the-century art and the more vital, flowing color bands of his contemporaries, the Synchromists.

An effort has been made in recent years to relate Dove to mid-century directions in abstract art, but the comparison is strained by the diverse aims and the unrelated artistic backgrounds of painters of the first and the contemporary periods of abstraction. Any resemblance, for example, between the paintings of Dove and Clyfford Still, or the Mark Rothko of an early phase, must remain superficial despite obvious similarities in appearance. Dove worked within one of the viable blueprints of early modernism, a form of synthetic, rhythmic abstraction inherited from Kandinsky, and perhaps Delaunay, but minus their brilliant spectrum colors. His repertory of devices was limited, his forms often seemed decoratively stylized rather than plastic or organic, and they projected a consistent symbolic intention, an aesthetic he shared with the more literal-minded Georgia O'Keeffe. Dove's ragged edges and engulfing black shapes, which rise and fall like some impersonal tide, share with the effects of Still and Rothko a parenthood in Kandinsky, Arp, and "biomorphic" abstraction. In his best work

208. ARTHUR G. DOVE.
Fog Horns. 1929. Oil on canvas, 18 × 26″.
Colorado Springs Fine Arts Center.
Gift of Oliver B. James

209. JOSEPH STELLA. *Tree, Cactus, Moon*. c. 1928.
Gouache, 40½ × 27¼″.
Estate of Edith Gregor Halpert

one feels the operation of a strange, luminous subjective consciousness, which is nonetheless firmly planted in external reality.

Another aspect of Dove's art that distinguished it from that of his contemporaries was the collage.

210. GEORGIA O'KEEFFE.
Black Iris. 1926.
Oil on canvas, $36 \times 29\frac{7}{8}''$.
The Metropolitan Museum of Art,
New York City.
The Alfred Stieglitz Collection,
1949

211. (*below*) GEORGIA O'KEEFFE.
Abstraction. 1926.
Oil on canvas, $30 \times 18''$.
Whitney Museum of American Art,
New York City

This he converted into a personal, intimately expressive form. Employing fragments of everyday reality, he evolved a tender poetry of the commonplace, distinguished by its simplicity, good humor, and lyrical grace.

Arthur Dove and Georgia O'Keeffe, who became Stieglitz's wife, are in retrospect perhaps the two most original artists of the Armory Show period and its immediate aftermath. Both worked fruitfully within an idiom of organic abstraction which had not yet defined itself with the completeness of Cubism, and thus afforded more potential freedom to the individual sensibility. Today, with hindsight and conditioned by the art of our own contemporaries, the work of these two Americans impresses us by its assimilation of European biomorphism and by its independence, rather than by a sense of derivativeness. All the Americans emerging under the aegis of Stieglitz in advanced styles, whether Cubist-derived or organic, shared the intellectual excitement of exploring new paths in the radical modes

212. Georgia O'Keeffe.
Portrait W, No. II. 1917.
Watercolor, 12 × 9″.
William Zierler Gallery,
New York City

213. (*below*) Georgia O'Keeffe.
Cross by the Sea, Canada. 1932.
Oil on canvas, 36 × 24″.
The Currier Gallery of Art,
Manchester, N.H.

of vanguard art. Yet each of the major figures left a residue of identifiable emotive characteristics: Weber's sober intellectual penetration; Hartley's affection for heraldic devices and symmetrical orders; the mysticism and romantic poetry of Dove and O'Keeffe; and, as we shall see, Marin's impetuousness and powers of improvisation and Demuth's rarity and fastidious elegance.

The tradition of biomorphic abstraction was given a very individual inflection by Dove and O'Keeffe. O'Keeffe in particular seemed able to invest abstract painting with fresh content and significant new forms. In such paintings as *Light Coming on the Plains III* and *Portrait W. No. 11,* there is a daring reduction of pictorial means to a simple scheme of symmetrically opposed color stains, or a serpentine spiral of graduated rings of smudged pastel. The Imagistic and Symbolist overtones of these simple configurations are all the more surprising since the means are so unpromisingly tenuous and nonaggressive. In these

and related paintings she plays with ideas of distinctness and indistinctness, concentration and diffusion, until they take on the character of statements about the essential ambiguities of experience itself. In terms of the conspicuous patterning even of the art of Kandinsky, from whom her own painting seemed to derive, this looks like a sharp departure; O'Keeffe subverts rational ego in favor of a more informal and "open" kind of painting, as Mark Rothko and, in a different fashion, Kenneth Noland have more recently done. In her sublimation of matter, in her feeling for limitless boundaries and self-renewing images, O'Keeffe treats abstraction not merely as an occasion for formal exposition, but as a mode of lived experience.

That places her in a somewhat equivocal relationship to European abstract tradition, for she accepts European formality and taste but subtracts something of its explicitness in favor of an unbounded and more permissive experience. Her art seems characteristically American in standing aloof from final solutions. What must have once seemed a curious lack of commitment to formal exposition, or at best a weak and muffled echo of it, has today become a prevailing way of art in which we see reflected the ambiguity and indeterminacy of our own experience of reality. Despite their essential modesty of scale and ambition, and without being an actual influence, the paintings of O'Keeffe and Dove prefigure attitudes and an imagery that belong to contemporary abstraction; they are part of an intelligible continuity of taste and change between two otherwise antithetical generations.

John Marin is an artist who will never date, even though he can scarcely be described as an influence on or significant forebear of contemporary art. This may be explained in part by his fierce attachment to values of freedom, to a traditionally American romantic individualism, and in part by his remarkable tactile sense. The lyrical effusions so often associated with his art, or his scintillating mastery of the watercolor medium interest present-day artists less than Marin's expressive surfaces. Late in his life when Marin had begun to work more consistently in oils, he told a biographer that he wished "to give paint a chance to show itself entirely as paint." This insistence on the stubborn, irreducible, material reality of paint later became the very heartbeat of contemporary artistic creation in America, with

214. Georgia O'Keeffe. *White Canadian Barn, No. 2.* 1932. Oil on canvas, 30 × 72″.
The Metropolitan Museum of Art, New York City.
The Alfred Stieglitz Collection, 1949

215. Charles Sheeler. *Bucks County Barn.* 1923.
Tempera and crayon, 19¼ × 25½″.
Whitney Museum of American Art, New York City

the emergence of the postwar "Action" painters. If Marin still engages the interest of vanguard artists today or commands their respect, it is because he managed in his art to further significantly the destruction of traditional illusionist means—to carry forward the vital rehabilitation of those "painting techniques, whose principal sin," the poet Mallarmé had parenthetically observed in 1874, "is to mask the origin of this art which is made of oils and colors."

It is a measure of Marin's remarkable versatility that he can be related to both the first and second phases of American modernism. A statement made by the artist in 1947, when Marin renewed his earlier mood of radical aesthetic experiment, now seems prophetic of the aims of the Abstract Expressionists; he then wrote: "Using paint *as* paint is different from using paint to paint a picture. I'm calling my pictures this year 'Movements in Paint' and not movements of boat, sea, or sky, because in these new paintings, although I use objects, I am representing paint first of all, and not the motif primarily."

The other living link between Marin and the contemporary generation is his intense love of personal liberty. In his passionate pursuit of artistic freedom Marin quite often has consciously played the role of the eccentric individualist, adapting himself to the popular image of the shrewd, laconic Yankee who scorns the highfalutin' and pretentious, mistrusts intellectualism, and affects a picturesque and slightly fantastic style. A friend, Loren Mozely, has described him as "an American original." Mozely has stated that Marin's "letters as well as his speech are full of tasty Yankee expressions such as 'Crackerjack,' 'High Cockalorum,' 'Hum-Dinger.' " The paradox of Marin, as of so many American artists, lies in the combination of an aggressive native pride carried to the point of an almost gleeful provincialism, and an abiding respect for the cosmopolitan spirit. His art reflects and unites these warring impulses. Writing to Alfred Stieglitz in 1927, in a loose, Whitmanesque prose, Marin all too readily admitted the contradictions within himself, but with that characteristically disarming candor and energy which make his self-fascination seem expansive and creative rather than restricting:

Curiously twisted creature.
Prejudiced as Hell.
Unprejudiced as Hell.
Narrow-minded as they make 'em.
Broad-minded next minute.
Hating everything foreign, to a degree, with the opposite coming in, time and time.
A shouting spread-eagled American.
A drooping wet-winged sort of nameless fowl the next.
But, take it easy, whoa there, pull up. . . .

Marin came to modern art relatively late, and after considerable hesitation. He had apprenticed himself to an architect (a fact which has often been used inconclusively to explain his feeling for decisive pictorial structure), and then actually prac-

216. JOHN MARIN. *London Omnibus*. 1908. Watercolor, 11¼ × 15″. The Metropolitan Museum of Art, New York City. The Alfred Stieglitz Collection, 1949

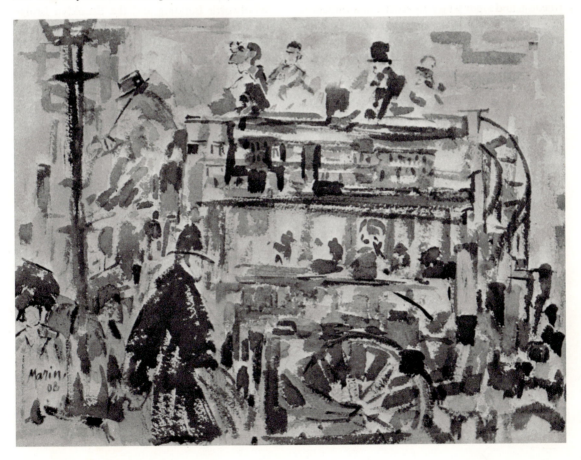

ticed as an architect before settling on painting. At the age of twenty-eight he began to give art his whole attention, entering the Pennsylvania Academy, where he worked under William Merritt Chase and Thomas Anschutz. There he met Arthur Carles, who later shared his interest in advanced European art and became a close companion in Paris. From 1905 to 1911 Marin lived abroad and made a considerable reputation from his etchings of European monuments, executed in a delicate, atmospheric style which suggests Whistler's tonal refinements and aestheticism. But even in his early European *Wanderjahre*, when he seemed to be compiling a careful notebook on the European past with much emphasis on unspectacular, descriptive detail, Marin's more wayward impulses erupted. An etching of the Cathedral at Rouen shows his restless, nervous energy shaking itself loose in a characteristically soaring transcription.

By 1908 he had begun to use fresh color and exercise a new freedom in the watercolor medium, in his own looser but more intense adaptation of Impressionist technique. His *London Omnibus* of that year treated a commonplace scene with a freedom and vigor which forecast a new direction in Marin's art. In 1910, at Kufstein in the Austrian Tyrol, Marin executed a series of scenic watercolors of an even more inventive and improvisatory nature, using merely suggestive color diffusions and an incisive, fragmentary technique to indicate position and form. This transitional style, diffuse and accented at once, oriental in its economy, is reminiscent of the Neo-Impressionist manner employed in watercolors by Matisse and Marquet in 1904, as they stood at the threshold of a more explosive Fauve manner. There is no evidence that Marin was aware of the Fauves, but through his friends Alfred Maurer and Arthur Carles he undoubtedly absorbed something of the growing sentiment of freedom, if not the actual technical viewpoints of the contemporary Paris art world.

In 1909 Marin held his first one-man show at the Stieglitz gallery. This exhibition enjoyed a *succès d'estime*. Writing in *Camera Work*, Paul Haviland declared that Marin's watercolors were "pronounced by authorities" to be "the best examples of the medium which have ever been shown in New York." And the critic Charles Caffin, scenting the abstract bias of his work, wrote: "Consciousness of facts disappears in

217. JOHN MARIN. *Castorland*. 1912. Oil on canvas, 22 × 27″. Collection Dr. and Mrs. Samuel C. Karlan, Whitestone, N.Y.

a spiritualized version of form and color."

Only in 1911 and 1912, however, after he had passed his fortieth birthday, did Marin's modernism decisively announce itself in a dynamic new graphic style, with the first of his etchings of the Woolworth Building and the Brooklyn Bridge. Like Weber, Hartley, and Dove, he was undoubtedly deeply influenced at a critical moment in his development by his association with Alfred Stieglitz. At 291 he had had the opportunity in 1911 to see and examine at his leisure exhibitions of Cézanne's late watercolors and the early Cubist drawings and watercolors of Picasso. The importance of exposure to this work was later pointed out by Charles Caffin in the *New York American*. Describing the transition in Marin's style from his anecdotal, European etchings, he wrote: "Then the exhibition at 291 of Cézanne and Picasso water colors and the talks in the gallery that they stimulated opened up to him the suggestion of abstraction as a motive. He spent a summer in the Tyrol, seeking to discover the principles of abstract expression in the study of mountain scenery. Then he returned to New York and for a while tested his experience and enlarged it by studying the colossal aspects of the city's skyscrapers."

Marin's new manner drew on the spontaneous color effects and the heightened sensations of the Fauves; on the structure of Cubism; and perhaps most deeply of all, on Cézanne's watercolors. These influences were ignited by the artist's in-

218. ARTHUR G. DOVE. *That Red One*. 1944. Oil on canvas, 27×36″.
William H. Lane Foundation, Leominster, Mass.

219. MAN RAY. *The Rope Dancer Accompanies Herself with Her Shadows*. 1916. Oil on canvas, 52×73⅜″.
The Museum of Modern Art, New York City. Gift of G. David Thompson

220. MARSDEN HARTLEY. *Portrait of a German Officer*. 1914. Oil on canvas, 69¼ × 41⅜″.
The Metropolitan Museum of Art, New York City. The Alfred Stieglitz Collection, 1949

221. MORGAN RUSSELL.
Synchromy in Orange: To Form. 1913–14.
Oil on canvas, 11′ 3″ × 10′ 3″.
The Albright-Knox Art Gallery,
Buffalo, N.Y.
Gift of Seymour H. Knox

222. `LYONEL FEININGER. *Markwippach*. 1917. Oil on canvas, 31¾ × 39¾″.
The Cleveland Museum of Art. Gift of Julia Feininger

223. PATRICK HENRY BRUCE. *Composition III*. 1916–17.
Oil on canvas, 63¼ × 38″.
Yale University Art Gallery, New Haven, Conn. Gift of Collection Société Anonyme

tense and individual reaction to the dynamism of New York, a New York in the midst of a building boom. Such landmarks as the Manhattan Bridge, the Woolworth Building, the New York Central Railroad Terminal had either just been completed or were in construction. In these rising structures Marin found a concrete manifestation of the spirit of explosive growth, vitality, and romantic hope of America, and his impressions had a fresh impact after his prolonged absence on the Continent. An ability to compose rhythmically, and to register vision with utmost rapidity and brevity were brilliantly demonstrated in these early etchings of New York's rising skyline. It was part of Marin's special and more obvious gift that he could toss off the evocative, lyrical fragment with little apparent effort or meditation.

The huge industrial travail and growth of America particularly seemed to strike a responsive chord. To Stieglitz he wrote in 1913: "You cannot create a work of art unless the things you behold respond to something within you. Therefore if these buildings move me, they too must have life. Thus the whole city is alive; buildings, people, all are alive; and the more they move me the more I feel them to be alive." Marin found an optimistic song in the "tall office building," just as Louis Sullivan had, and he answered with a passionate "yes" the challenge of machine civili-

zation at a time when it still had the power to exalt young artists.

The sense of new energies in American life and culture undoubtedly had much to do with liberating Marin's art. Yet perhaps the plastic tensions in his work were based even more profoundly on his assimilation of the dynamic principles of European pictorial forms. As early as 1916 Charles Caffin had called attention to the structural integrity and the solid grasp of abstraction in Marin's art, quite apart from the convulsive, Expressionist character and native stridency later critics tended to emphasize. Caffin wrote: "The various planes and surfaces of the transparent edifice are locked together with the logic of the builder who makes provisions for the stresses and strains of his assembled materials. I might illustrate the effect of this organic orderliness by the analogy of a person studying a foreign language, when he no longer consciously translates the words and idioms from one tongue to the other, but thinks freely in the new one. Marin is no longer translating the concrete into abstract, he has learned to think in the latter. And his freedom reacts upon oneself. . . . One accepts what is seen without any need of conjecture. One can enjoy freely the spiritual appeal of the expression." Among the first American moderns, Marin successfully and consistently "learned to think" in a

224. JOHN MARIN.
Region of Brooklyn Bridge Fantasy.
1932. Watercolor, $18\frac{3}{4} \times 22\frac{1}{4}''$.
Whitney Museum of American Art,
New York City

225. JOHN MARIN.
Off Cape Split, Maine. 1938.
Oil on canvas, 22½ × 28⅛".
The Metropolitan Museum of Art,
New York City.
George A. Hearn Fund, 1946

new language of abstract signs and symbols, and to give his structures a concrete pictorial power.

In 1914 Marin began to summer on the Maine coast, which was to become one of his favored painting locales. His first watercolors based on nature showed more reticence than those he had done from urban motifs. Their delicacy of tone and atmospheric effects, despite the use of broken color, related these works more to his experiments in the Tyrol than to the explosive New York views done in his new graphic style. Around 1919, landscape and city views became unified around an abstract, structural core as Marin began to simplify radically, employing what he described as "frames within frames," a free system of rectilinear compartments whose emphatic outlines prevented his "movements" from sliding off the edges of the picture. "When I got what I wanted," he later wrote, "I nailed the stuff down in those frames." From the twenties to his death in 1953 Marin continually drew on nature for his motifs. He was fascinated by the rugged contours of the Maine landscape and the sea, but he transposed his impressions into abstract pictorial design. By way of explanation he wrote: "Seems to me that the true artist must perforce go from time to time to the elemental big forms—Sky, Sea, Mountain, Plain—and those things pertaining thereto, to sort of re-true himself up, to recharge the battery. For these big forms have everything. But to

express these, you have to love these, to be part of these in sympathy."

During the early thirties Marin began for the first time to work consistently in oils, and to make the resistances of the pigment as physical medium do some of the structural work that his more explicit, graphic organization had previously done. His more fluid approach showed a remarkable freedom for a period when abstract and nonfigurative idioms were still dominated by the geometric prejudice of Cubism. By the late thirties and forties, Marin no longer pinpointed expressive effects with graphic descriptive fragments, but depended almost exclusively on a few salient movements, large planes of color, and the expressive potential of the paint itself. His effects were coarser, in obedience to a broader principle, and his strength lay in his intense, vital surfaces, which more than compensated for the elimination of descriptive interest. The references to nature, to a ship's sail, a gull, a horizon line, seemed indeed to have been interpolated as an afterthought, or to function entirely as indicatory signs, establishing direction, movement or some necessary plastic accent. In *Off Cape Split, Maine*, executed in 1938, the effort "to show paint as paint" and the intensification of the painted surface command our attention, rather than the suggestion of a ship dancing on the sea. Marin did not wish to free himself from nature com-

pletely, and he remained, even in this last phase, as visual as he was architectural, conveying a heightened, transposed "impression," but an impression nevertheless. Yet his combination of condensed sensation and abbreviated structure puts him in closer relationship to the spirit of Cézanne than to the other early American moderns who emulated Cézanne's elevated formal language. There is something of Cézanne's later delicacy of color in Marin's watercolors and in his variety of soft pinks, powder blues, and violets, which have the chromatic refinement of eighteenth-century porcelain.

While Marin's oils today excite the greatest interest among contemporary artists and show an admirable freedom, it was in the watercolors that he remained the most decisive. When he used oil pigment, he handled it with a swiftness and lightness, and with those summary, spontaneous indications of movement, that seem more appropriate to the watercolor medium. He showed no very profound desire to explore the material possibilities of the weightier medium, or to seek a more grave and substantial articulation of form, despite his vital tactile sense. Marin's instinctive lyricism compelled him to feel the least burdened by the paint vehicle, to wrest the mind and senses free from its material properties. Taking his cue from Cézanne, however, he learned to use watercolor to create plastic structures, giving the medium a refreshing new vitality and a peculiarly American integrity. At the end of his life, like Cézanne, he surrendered himself to broadly lyrical impulses based merely on rhythmic color phrase and accent, thereby returning to the impetuous romantic mood of the decade between 1910 and 1920.

Another artist superb in his mastery of the watercolor medium was Charles Demuth. Like Marin, he was aware of Cézanne and followed his method of using delicate touches and dilute washes to create a structure of colored planes. For Demuth the lighter medium also allowed of certain reticences much less admissible in oils, and he actually seemed to be stimulated creatively by the limitations of the medium. Its possibilities for fine effects and clarity seemed to gibe with his own temperament, with a certain fastidiousness and an intense, if narrow, sensibility. Demuth once remarked with customary insight and modesty: "John Marin and I drew our inspiration from the same source, French modernism. He

226. JOHN MARIN. *Beach, Flint Island, Maine*. 1952. Oil on canvas, 21¾ × 28¼".
Marlborough Gallery, New York City

227. CHARLES DEMUTH. *Three Pears*. 1933. Watercolor, 9⅜ × 13½".
Williams College Museum of Art, Williamstown, Mass.

brought his up in buckets and spilt much along the way. I dipped mine out with a teaspoon, but I never spilled a drop."

Thirteen years Marin's junior, Demuth was more urbane and reserved in manner, with something of the expatriate dandy about him; his art was as much a matter of intellect, decorum, and fine style as Marin's was of instinct, fancy, and impulse. Demuth was born in 1883 in Lancaster, Pennsylvania, and his painting embodies something of the cleanness of line and the simple, formal elegance of Pennsylvania Dutch folk art. Many of his works were inspired directly by the orderly colonial architecture which filled the landscape of his childhood and youth. This early environment seems finally to have dominated a

contemporary sophistication acquired in the capitals of the world and in the Stieglitz circle. Some self-imposed puritanical restraint, in conjunction with delicate health, prevented him from realizing the fullest sensuous possibilities of his art. His art is fragile and cold rather than robust, but it shows a perfection of taste, an aristocratic grace and, at its best, unexpected strength. Demuth's achievement is the more remarkable since, unlike Marin, Weber, Dove, Hartley, Stella, and others, he did not absorb an expatriate experience and then use it to illuminate the dynamic American present. Rather, he sheltered behind the European sense of art and used Parisian aesthetics as a shield against native experience, which he approached in a spirit of ironic detachment. Demuth's life and art provide a Jamesian parable; where Marin and others tried to match their own heightened responses to the American scene with bold aesthetic experiment, Demuth shrank back from American materialism and, indeed, from any kind of extravagance, looseness, or excess. A fellow student of his, Rita Wellman, has described this spirit of critical detachment, and the corresponding emphasis on artistic values for their own sake: "When we were young, we were very old. We were all bored with life: knew everything there was to know, and only condescended to give our time and talents to painting because it seemed to our jaded spirits the one respectable calling left."

In 1905, at the age of twenty-two, Demuth en-

228. ALFRED H. MAURER. *Still Life with Doily.*
c. 1930–31. Oil on pressed board, 18 × 21½".
Brandeis University Art Collection,
Waltham, Mass. Gift of Mr. and Mrs. Ben Heller

rolled at the Pennsylvania Academy and, following in the footsteps of Marin, Carles, and Maurer, worked under Thomas Anschutz. He spent a year in Paris in 1907, and then in 1912 went to Europe again, for a two-year period. He may have been aware of the Fauves and the Cubists while abroad, but didn't show any direct evidence of the new experimental moods until his return to America. In 1915 he was doing delicate but rather freely handled watercolor landscapes that suggested Marin's influence, and fragile flower pieces whose tinted colors may have been a recapitulation of Rodin's watercolors. Rodin had been shown at Stieglitz's gallery in 1908 and again in 1910. Even in these very early paintings Demuth revealed a delicacy of style and sentiment that were to remain characteristic of his art.

That same year he began a series of watercolor illustrations for Emile Zola's *Nana*, one of the early and most shocking declarations of French naturalism. During the next four years, for his own amusement and with no publishing venture in prospect, Demuth illustrated Henry James's stories *Turn of the Screw* and *The Beast in the Jungle*, Poe's *The Masque of the Red Death*, and other writings. These illustrations revealed not only a lively romantic taste and literary imagination, but the greatest deftness in the watercolor medium. Although the illustrations were informal and free in style, the play of delicate stains and blushes of tone against sinuous curvilinear contours suggested a certain mild perfume of the romantic decadence. Demuth admired both Aubrey Beardsley and Toulouse-Lautrec for their graphic styles, aristocratic attenuations, and taste for a picturesque "wickedness." He was closer perhaps to Lautrec in his more vital color and supple line. Most of all, these watercolors suggest Pascin, both in manner and in the mingling of sensitive mood and sophistication.

Had Demuth done only these illustrations, his claim to our interest would be that of a rather limited illustrator, if a brilliant one. From 1917 to 1919, however, he executed a far more ambitious series of watercolors of vaudeville and nightclub performers; in these he passed beyond illustration. The preciosity of his early style, with its thinness and artificial quality, gave way to more decisive composition, forceful color, and a new expressive power, as he pitted himself against action in the real world rather than the closed world of the literary imagination. Like

Toulouse-Lautrec, Demuth was physically incapacitated to a degree, first by lameness and then, after 1920, more seriously by diabetes. The grace and agility of the acrobat and theatrical performers may have had a particular appeal to this artist who was by temperament and constitution barred from a strenuous physical life. He showed action caught in the spotlight's glare, heightened by the illusion of the theater, as Lautrec had done, and his chosen themes became in a sense a metaphor for the artistic life.

Some time after the Armory Show, and in contact with Alfred Stieglitz, Demuth had begun to engage in more drastic experiment. His Art Nouveau serpentines and free color stains were formalized as he moved toward a more abstract rhythmic structure of line and color mass, suggesting the new influence of Dove, O'Keeffe, and the Synchromists. He did not go far toward abstraction but did show a lively awareness of its contemporary manifestations, using a circular center of light and intense color in graduated, concentric bands of diminishing intensity to frame his action. In *Acrobats* (1919), a spotlight forms a loose figure eight of yellow and orange, dying away into mauve, against which the tense dark-colored silhouettes of his riders' arched bodies bend and strain. James Thrall Soby has suggested, most appropriately, that Demuth's soft, elegant circular frames owe something to Fragonard and the Rococo garland. Undoubtedly, they are also allied to the flowing, vegetal forms and the "symbolic" representation of light of his American contemporaries Dove and O'Keeffe. Demuth's art was unique in that it created a tension between a form of "soft" abstraction, with its possible spiritual implications of passivity and mystery, and lively action.

A complementary style of "hard" abstraction, deriving from Cubism, emerged during a trip to Bermuda in 1916. In architectural studies, and seascapes such as *Bermuda No. 2 (The Schooner)*, Demuth began to use directional lines and analytical planes in a new Cubist-Futurist vocabulary of form. He parted company with his European sources, however, in the effort to create, within the new architectonic discipline, diaphanous effects of light. He interpreted his motifs as flattened prismatic shapes, extending their edges subtly, attenuating and recomposing them in a criss-cross weft of intersecting diagonals and shafts of light, like a night sky raked by search-

229. CHARLES DEMUTH. *Acrobats*. 1919.
Watercolor and pencil, 13 × 7⅞".
The Museum of Modern Art, New York City.
Gift of Abby Aldrich Rockefeller

230. CHARLES DEMUTH.
Trees and Barns, Bermuda. 1917.
Watercolor, 9½ × 13½".
Williams College Museum of Art, Williamstown, Mass.

231. (*top left*) CHARLES DEMUTH.
Stairs, Provincetown. 1920.
Gouache and pencil on cardboard, $23\frac{1}{2} \times 19\frac{1}{2}$″.
The Museum of Modern Art, New York City.
Gift of Abby Aldrich Rockefeller

232. (*top right*) CHARLES SHEELER. *Lhasa.* 1916.
Oil on canvas, $25\frac{1}{2} \times 31\frac{3}{4}$″.
The Columbus Gallery of Fine Arts, Columbus, Ohio.
Gift of Ferdinand Howald

233. (*middle left*) CHARLES DEMUTH.
Rue Du Singe Qui Peche. 1921.
Tempera on cardboard, $21 \times 16\frac{1}{4}$″.
Collection Bernard Heineman, Jr., New York City

234. (*middle right*) NILES SPENCER. *City Walls.* 1921.
Oil on canvas, $39\frac{3}{8} \times 28\frac{3}{4}$″.
The Museum of Modern Art, New York City

235. (*left*) PRESTON DICKINSON. *Industry II.*
Oil on canvas, $24\frac{3}{4} \times 30$″.
Whitney Museum of American Art, New York City.
Gift of Mr. and Mrs. Alan H. Temple

236. NILES SPENCER. *Near Avenue A*. 1933.
Oil on canvas, 30¼ × 40¼″.
The Museum of Modern Art, New York City.
Gift of Nelson A. Rockefeller

lights. This was the method of Lyonel Feininger, the American-born modernist who spent his formative youth and maturity in Germany, and was associated there with the Blue Rider and the Bauhaus. Feininger's art, however, communicates an atmosphere of mystical contemplation, is apparitional in form and inward in mood, suggesting a relationship to north European modes of feeling.

For all its charm, finesse, and structural integrity, Demuth's art of this period has no very profound spiritual resonance, nor was it meant to have. It is conceived in a more bland, objective, and even functional American spirit, retaining a canny hold on concrete visual facts. The selection of observed data, in Bermuda consisting of ships and wooden cottages, and later of the trim

lines of Pennsylvania domestic architecture and the simple logic of industrial forms, is significant in itself. For Demuth was attracted, it would seem, to those aspects and surfaces of life whose structural simplicity and sober plainness he could match in an art that, while it lent itself to subtlety and refinement, allowed a minimum of sensuous elaboration.

In 1919, in his Provincetown motifs, Demuth began to use tempera, and about 1920 worked in oil, reserving it particularly for his industrial landscapes, where more massive and weighty effects seemed in order. But whatever the medium, he still employed it sparingly and dryly, with the least possible indulgence of his own pleasurable sensation in its manipulation. Demuth's own variant on the "new objectivity" was achieved by suppressing any wayward painterly sensuality, and there was a certain crisp American literalism at the core of his most abstract transpositions of motifs from nature or from the contemporary industrial landscape.

Even in such a fine native application of Cubism as *My Egypt* (1927), one feels that Demuth was not so much concerned with spiritualizing matter, in the sense either of the motif—a grain elevator—or the pigment itself, as he was with dematerializing it, reducing everything to its minimal expressive equivalent in art. The same intense and often hollow interest in the cold, disembodied visual fact became even more central to the art of the group later called the Precisionists: Charles Sheeler, Preston Dickinson, and Niles Spencer. They scrupulously regroomed the

237. CHARLES SHEELER.
American Landscape. 1930.
Oil on canvas, 24 × 31″.
The Museum of Modern Art,
New York City.
Gift of Abby Aldrich Rockefeller

238. CHARLES DEMUTH.
I Saw the Figure Five in Gold. 1928.
Oil on composition board, 36 × 29¾".
The Metropolitan Museum of Art,
New York City.
The Alfred Stieglitz Collection, 1949

American industrial environment in styles that
struck an uneasy balance between an ascetic,
decorative Cubism and photography. This dry
and literalistic tradition has continued in our
time in the manner called "magic" or sharp-focus
realism—a style which combines intense realism
with either slick-magazine illustrative conven-
tions or a pastiche of old master draftsmanship.
The fantasy, or literary and symbolic overtones
of this painting manner, however, do not disguise
its kinship with a profound American tradition of
adulating the disembodied visual fact. Such paint-
ing evolves out of a basic puritanism and mistrust
of hedonism which has been the core of so much
American artistic sensibility. The denial of the
sensuous character of the material means of paint-
ing has probably been one of the most identifiable
marks of American provincialism, and its most
damaging weakness, from the journeymen paint-
ers of the eighteenth century to Winslow Homer,
from Charles Demuth and Charles Sheeler to
Ben Shahn and Andrew Wyeth. It may also be
one of the hidden reasons for the American pred-
ilection for watercolor. Demuth, however, bril-
liantly skirted the pitfalls of asceticism and mat-
ter-of-fact literalism, relying upon the natural
delicacy of his perceptions and a certain irony
and wit to sustain and nourish his art. The quali-
ties of wit, impertinence, and ironical intelligence
in his work may have been set free by contact with
the painting and person of Marcel Duchamp.

He became friendly with Duchamp shortly
after the French artist's arrival in New York in
1915. Perhaps it was his influence that led Demuth
to append such mildly satirical titles to his free
adaptations of industrial forms as *Incense of a
New Church* and *The Home of the Brave*. Demuth
also used numbers and letters in an inappropriate
pictorial setting in his paintings to create a sudden
evocation of everyday reality, often with ironic
intent. He did not carry Duchamp's interest in
mechanical forms to the point of pure abstraction
nor did he go so far as to engage in the buffoon-
ery and nonsense-play of the official Dada move-
ment. His protest against the degradation of
values under industrialization was arch and

239. CHARLES SHEELER
Upper Deck. 1929.
Oil on canvas,
29⅛ × 22⅛".
Fogg Art Museum,
Harvard University,
Cambridge, Mass.
Louise E. Battens
Fund Purchase

240. MORTON L. SCHAMBERG (assisted
in the construction by Elsa von
Freytag Loringhoven). *God*.
c. 1918. Miter box and
plumbing trap, height 10½".
Philadelphia Museum of Art.
The Louise and Walter
Arensberg Collection

oblique—some factory chimneys lurking in the background of a landscape, a mocking commentary in a title, but little beyond that.

Nor did Demuth use his art to discredit the "noble means" of traditional art. To do so would have implied an attack on his own position, since American visual traditions had scarcely been established, and the individual artist could not afford to mock something he was in the process of building himself. In a nation where the machine was identified with the American promise, and still seemed part of a complex story of a people's deliverance from the wilderness; in a nation where the assurances of a cultivated existence had not been altogether won, American artists unconsciously checked the too violent expression of their own or their society's disorders. They could not risk those adventurous excursions into the unmarked mental regions where Dada's disquieting puns and iconoclasm came to birth. More youthful in spirit, more sanguine and idealistic, the American artists were not yet prepared to admit the possible boredom of modern life. And they had had no Baudelaire, no Symbolist

movement to teach them the spiritual uses of ennui. It took two world wars and a discernible increase in the violence and tensions of contemporary life to release the American artists' more rebellious impulses in some systematic, creative fashion.

Demuth's approach to Duchamp's innovation was also limited and restrained both by his mandarin sense of style, and by a pervasive good humor. He is closest to Dada perhaps in his handsome homage to the poet William Carlos Williams, *I Saw the Figure Five in Gold*, belonging to the Metropolitan Museum of Art. The title is taken from the first line of a poem by his friend. The painting, remarkable in many ways, reveals a cunning sense of artifice and free association in its symbolism, connecting it both to decorative Cubism and to Duchamp. It mingles the visual, the auditory, and extra-pictorial associations for dramatic purposes, giving the composition an unexpected urgency, and even blatancy. The golden number five is repeated and recessed against a violent red, rectilinear shape which throws it back again, like an echo reverberating

241. CHARLES SHEELER. *Architectural Cadences*. 1954. Oil on canvas, 25 × 35″.
Whitney Museum of American Art, New York City

242. NILES SPENCER. *Erie Underpass*. 1949.
Oil on canvas, 28 × 36″.
The Metropolitan Museum of Art, New York City.
Arthur H. Hearn Fund, 1950

243. STEFAN HIRSCH. *Manhattan*. 1921.
Oil on canvas, 29 × 34″.
The Phillips Collection, Washington, D.C.

244. JOSEPH STELLA. *The Port*, first panel of
New York Interpreted series. 1920–22.
Oil on canvas, 88¼ × 54″.
The Newark Museum, Newark, N.J.
Felix Fuld Bequest Fund Purchase, 1937

245. RALSTON CRAWFORD. *Grain Elevators from
the Bridge*. 1942. Oil on canvas, 50 × 40″.
Whitney Museum of American Art, New York City.
Gift of the Friends of the Whitney Museum

from a wall. Out of the bright visual center of
clashing, intense color stream shafts of cool blue-
grays, muffling the total brilliance and giving it
an added sonority. There are schematic indica-
tions of a city street scene, bent to fit the curves
of the number five. The effect is kaleidoscopic,
a little like watching a revolving pinwheel, alter-
nately brilliant and somber, or it can be related
to the cinematic illusion created by a rapidly
magnified, rotating title, or an aggressive credit
line, that seems to come rushing rapidly out at
the audience from the movie screen. Yet De-
muth's illusion is relatively uncomplex; he does
not appeal to chance and accident or allow his

forms to proliferate in strange, metamorphic births as the Dadaists did. He starts with a small visual idea, maintains it on a highly conscious level, and stills any disruptive psychological overtones.

Demuth's fine sense of color, at once delicate in tone and structural, was again evident in the more realistic watercolors of flowers and still life which preoccupied him in the last decade of his life. These themes provided a welcome lyrical relief from his industrial themes and the more exacting labors of oil painting. But the fanciful quality and freedom of his earlier watercolors gave way to a colder efficiency and precision and often to a more commonplace literalism, as if in recognition that the mood of aesthetic experiment had passed out of the American artistic atmosphere. For the pioneers of modernism, their own art had become a matter of individual direction. Demuth seemed, in the paintings of his last years, to address himself to an ideal of impeccable workmanship, showing a new dryness of execution; and he returned to more emphatic descriptive color. In some of his still lifes, however, he again evoked Cézanne with color at once tensely structural and delicate in its nuance.

His adherence to the formal principles of modernism, even threatened as they were by the cross-currents of a confused and contradictory postbellum atmosphere, distinguishes Demuth from many of the other innovators who emerged after the Armory Show. He was an artist of restricted and confined sensibility who found it necessary to concentrate all his resources at one point, as it were. But for continuous creative impulse, and for his distinction as a stylist, Demuth must stand in the first rank of the pioneers of twentieth-century American art. Some time after Demuth's death, Marcel Duchamp generously acknowledged his artistic contribution with these words: "His work is a living illustration of the disappearance of a 'Monroe Doctrine' applied to art; for today, art is no more the crop of privileged soils, and Demuth is among the first to have planted the good seed in America."

246. CHARLES DEMUTH. *Machinery*. 1920.
Tempera and pencil on cardboard, $24 \times 19\frac{7}{8}''$.
The Metropolitan Museum of Art,
New York City.
The Alfred Stieglitz Collection, 1949

247. CHARLES SHEELER. *Americana*.
1931. Oil on canvas, $48 \times 36''$.
Collection Edith and Milton Lowenthal,
New York City

7 · Architecture, American Style, 1920-1945

BUILDING IN AMERICA between the great wars has yet to receive adequate recognition. Architectural activity in the twenties and thirties follows the pioneer innovations in structure and design (both commercial and residential) at the turn of the century, and precedes the universal acceptance and institutionalization of the modern idiom that finally occurred in the late forties. As a period it is overshadowed in worldwide perspective by the extraordinary achievements of the new architecture in Europe, which came to be known as the International Style. This revolutionary movement was destined to establish, to all intents and purposes, the distinctive vocabulary and syntax of subsequent twentieth-century architecture. Hence this era in American design coincides with, and is largely eclipsed by, the early maturity of the great European innovators—Le Corbusier, Mies van der Rohe, and Gropius, not to mention others of lesser fame but of comparable achievement— several of whom would migrate to the United States toward the end of the period, seeking refuge from political circumstances that made it impossible to continue work in their homelands.

Foreign domestic designs of the early twenties such as Le Corbusier's La Roche-Jeanneret House, Paris (1923), or Gerrit Rietveld's Schroeder House, Utrecht (1924), are bellwethers of this "International" architecture of reductive, cubic geometry (its forms largely inspired by the new abstract painting as well as by the early domestic work of Wright), of glass walls and concealed supports that gave a sense of weightlessness and transparency to the structure. This vocabulary made only a sporadic and inconclusive appearance on these shores prior to the arrival of Gropius and Mies van der

Rohe in the late 1930s—and even then radical modernism remained a minority movement for another decade. In the twenties and thirties American architecture pursued an unsteady course, either employing a variety of historical and traditional modes or, often no more logically, introducing modernistic features without getting to the root of the construction problems and social issues that were the concerns of the new European architecture. A standoffish, somewhat isolationist posture with respect to Europe prevailed, not unlike the situation that developed in painting, and no more than reflecting the nature of America's diplomatic and political relations with the rest of the world at that time.

Frank Lloyd Wright, whose earlier Prairie Houses were a crucial formative influence on the new European architects of the 1920s, was frequently sarcastic, or bluntly hostile, when speaking of the early works of the International

248. LE CORBUSIER.
La Roche-Jeanneret House, Paris.
Façade. 1923

249. GERRIT RIETVELD.
Schroeder House, Utrecht,
The Netherlands. 1924

Style (subsequently he would relent to the point of incorporating some of its effects in later work such as Falling Water of 1936). The only major innovator of 1900 to survive as an active designer, he seems even more isolated than before—cut off from most of his professional colleagues because of his convictions, and hardly in touch with that handful of others who were separately seeking a path toward architectural reform. Wright's work, beginning with the Barnsdall (Hollyhock) House, Los Angeles (c. 1917–20), becomes idiosyncratic to the point of defying comparison with the work of any of his contemporaries. Turning his back on the open plan, continuous horizontal forms, and broad overhanging roofs of the Prairie Style at just the moment when it was enjoying maximum influence in Europe, he opts for a personal reinterpretation of traditional adobe shapes of the Southwest and finds inspiration in the generous, massive forms of the Pre-Columbian architecture of Central America. The resulting ponderous volumes seem reactionary in view of the equally simple but open, largely transparent geometry then being introduced in Europe. But Wright's California mode, further developed in a series of concrete-block houses, was original; it grew out of his concern with the southern California landscape and its indigenous architecture—but not the sort of historical revival, however appropriate and effective, exemplified by Riverside's Mission Inn. The predominantly arid, treeless (pre-irrigation) landscape with its stark, bald hills was far removed from Chicago's flat prairies or the wooded hills of Wright's native Wisconsin, and it surely played a significant role in his shift in style.

Southern California was the locale of other progressive architects at this time. Wright's eldest son, Lloyd Wright, moved there in 1911, worked briefly as a draftsman for Irving Gill, the former Sullivan associate, and set up his own practice in 1915. He was associated, logically, with his father's work in the area, as was the young Viennese architect Rudolph Schindler, who had been trained at the Vienna Academy by Otto Wagner, and who was left in charge during Wright's trips to Japan to supervise the construction of the Imperial Hotel. Schindler's own concerns for the architecture of the Southwest (he had been to Taos in 1915) might even have stimulated his employer's interests in native American prototypes. However, Schindler and Wright grew apart by the early twenties, likely with some ill feeling, and each went his separate way; their failure to make a common cause was typical of the time and place.

Schindler's first important work, the Lovell House, Newport Beach (1925–26), was the earliest masterpiece of the new International Style on American shores, its openness and structural delicacy the antithesis of Wright's surprisingly ponderous works of the period. Perched within an open concrete frame, and featuring a two-story living room with a floor-to-ceiling glass wall at one end, it was an original transcription of many new characteristics of European architecture: hovering, cantilevered volumes, white stucco or concrete surfaces, and a general aura of functional transparency. Schindler remained alone in his efforts, however, save for the arrival of another Viennese, Richard Neutra, in 1925 (after a brief stopover at Taliesin). They maintained an informal partner-

250. RUDOLPH SCHINDLER. Lovell House, Newport Beach, Calif. 1925–26

251. RICHARD NEUTRA. Lovell House, Griffith Park, Los Angeles. 1929

membered as the effective founder of the new tradition in California architecture. Neutra was kept busy during the thirties with the construction of houses and apartments in and around Los Angeles, and some of his finest, most delicately structured houses date from the late 1940s. In the fifties other southern California architects would carry his penchant for reducing structural support to a seemingly illogical extreme.

If southern California then seemed the most fertile area of architectural experiment, espe-

252. JOHN MEAD HOWELLS AND RAYMOND HOOD. Chicago Tribune Tower as built. 1922–25

ship for a brief period and submitted a project for the League of Nations competition in 1926, but their association (apparently also their friendship) was ruptured when Neutra was chosen to build the second Lovell House on the side of a steep ravine in Griffith Park, Los Angeles (1929). Neutra displayed an intimate knowledge of International Style aesthetics in his design of a complex, multilevel steel-framed house with large strips and curtains of glass, reproducing the characteristic fragility of the new European mode.

Schindler's work continued and even prospered in a modest way during the thirties and later, but he probably lacked the executive ability and chic of Neutra, who is now re-

253. ELIEL SAARINEN. Project for Chicago Tribune Tower. Awarded 2d prize. 1922

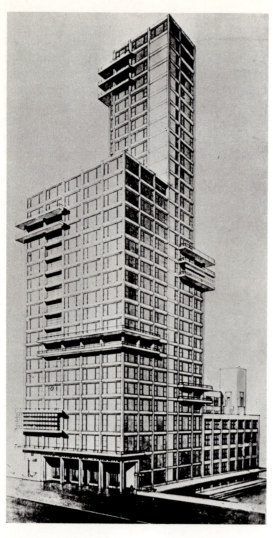

cially on the domestic level, professional action was still concentrated in the Middle West and East, chiefly in Chicago and New York. Here we are concerned with an episode in skyscraper design that is generally treated in a negative fashion, compared unfavorably either to the works of the early pioneers of 1900 or to the institutionalized modernism of the fifties and sixties. The key event at the beginning of the period was the international competition in 1922 for the Chicago Tribune Tower. It is customary to deplore the winning and executed design in the Gothic mode by John Mead Howells and Raymond M. Hood, and to cite as superior either the second-place design—a more delicately applied Gothic upon an unquestionably finer mass—by the Finnish architect Eliel Saarinen, or the uncompromisingly contemporary idiom of the entry submitted by Walter Gropius and Adolf Meyer. Critics have tended to look not too inquisitively at the 263 entries, featuring the usual mixture of competence, mediocrity, and sheer hokum, thereby overlooking the trend of

254–57. Projects for Chicago Tribune Tower, 1922, by: (*left*) WALTER GROPIUS AND ADOLF MEYER, (*below left*) BERTRAM GROSVENOR GOODHUE, (*center*) WILLIAM DRUMMOND, (*right*) WALTER BURLEY GRIFFIN

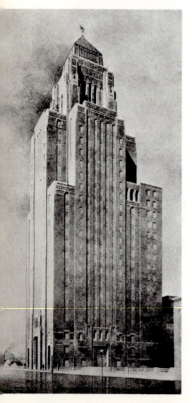

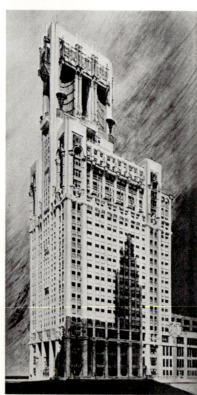

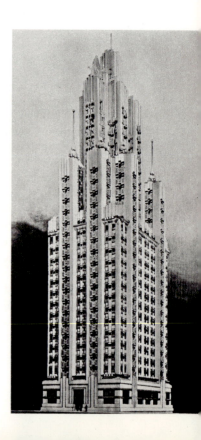

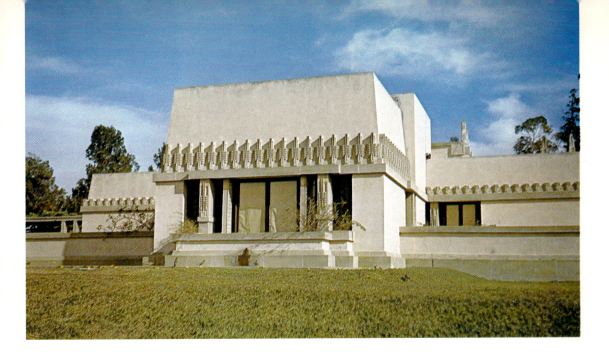

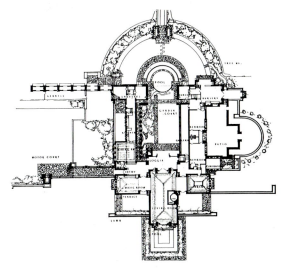

258, 259. FRANK LLOYD WRIGHT.
Barnsdall (Hollyhock) House, Los Angeles.
Exterior and plan. c. 1917–20

260. FRANK LLOYD WRIGHT.
Ennis House, Los Angeles. 1922–24

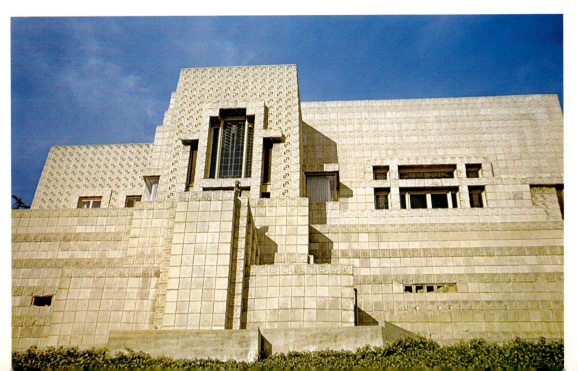

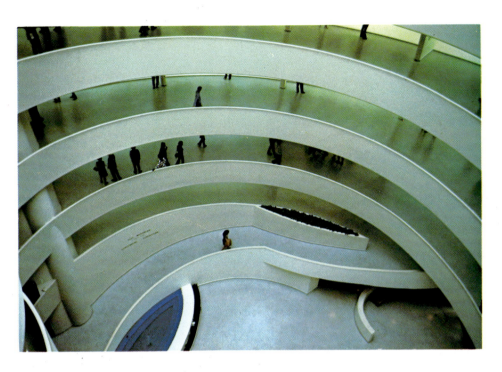

262, 263. FRANK LLOYD WRIGHT. The Solomon R. Guggenheim Museum, New York City. Interior (*above*) and exterior (*below*). Designed 1943; constructed 1957–59

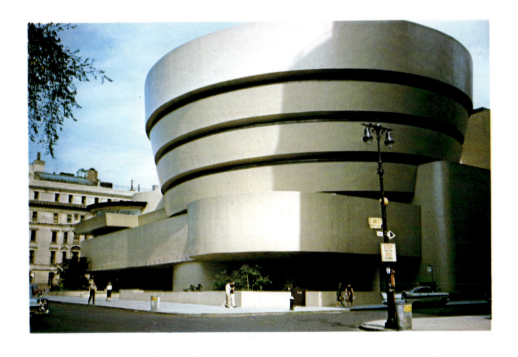

◄

261. REINHARD AND HOFMEISTER; CORBETT, HARRISON AND MACMURRAY; HOOD AND FOUILHOUX. Rockefeller Center, New York City. 1931–40

264. FRANK LLOYD WRIGHT. Johnson Wax Building, 1936–39, and Research Tower, 1946–49, Racine, Wis.

265. LUDWIG MIES VAN DER ROHE. Crown Hall (School of Architecture), Illinois Institute of Technology, Chicago. 1952–56

the jury's preference. The first three designs as well as a number of honorable mentions were slanted toward the Gothic, a testimony of the powerful influence at the time of the Woolworth, then the tallest of American skyscrapers (about 800 feet). The remainder of honorable mentions went to mildly modernistic designs that suggested a kind of "invisible" Gothic ancestry, such as the project by Bertram Grosvenor Goodhue. Classicizing and Renaissance-inspired projects were passed over almost uniformly.

Interestingly, Wright did not enter the competition; neither he nor Sullivan was among the list of ten invited architects. Of the old Prairie School, only two, William Drummond and Walter Burley Griffin, submitted projects (James Gamble Rogers might be considered a courtesy member of this group, for Wright mentions him as one of "the Chicago School" in the 1890s "who never left Gothic"). Griffin provides a convincing buttressed mass with a complex surface pattern of considerable originality; Drummond offers a rather more conventional shaft capped with an overscaled tower that can only be called movie-palace-alhambra. The buildings that would grow out of the Tribune Tower competition would be devoid of contact with the older Chicago School, and a solid case can be made for tracing their genealogy back to the New York skyscrapers of the late nineteenth century. (If the Midwestern tradition were momentarily moribund, its characteristics would reappear a generation later when American architects would take up the manner of a German architect, resident for the second half of his working life in Chicago: Mies van der Rohe.)

Although Howells and Hood's executed project for the Tribune Tower was a fairly explicit Gothic design, it was clear from a variety of competition projects that the more thoughtful designers (e.g., Saarinen, Goodhue) were exploring means of getting beyond the pitfalls of a literally historicizing image. Nonetheless, the obvious appropriateness of Gothic verticality was maintained, and within a decade Hood had designed the New York Daily News Building (for the eastern branch of the McCormick-Patterson newspaper empire) as a planar shaft with continuous vertical window strips, the whole devoid of historical association reference yet in fact a palimpsest with medieval underlay.

266. BERTRAM GROSVENOR GOODHUE. State Capitol, Lincoln, Nebr. 1916–28

267. WILLIAM VAN ALEN. Chrysler Building, New York City. Spire. 1930

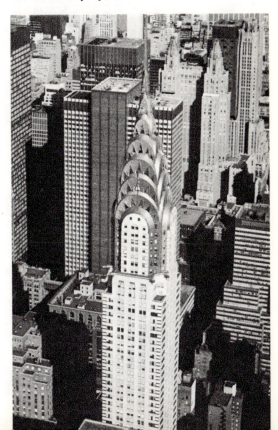

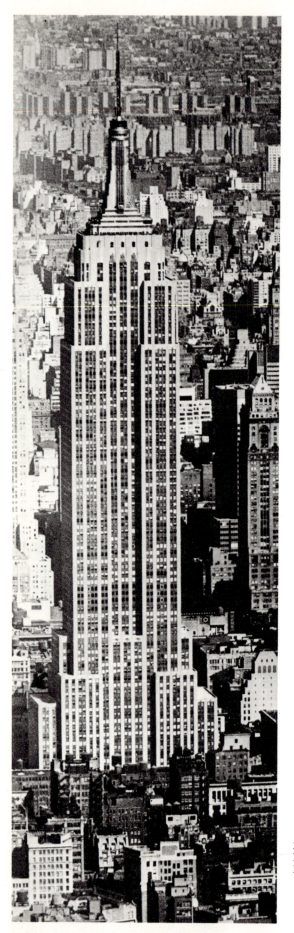

Thus the Gothic skyscraper with its inherent flaws and iconographic illogic was a progenitor of this modernistic style, which provided in rapid succession (and in New York) the two tallest skyscrapers after the Woolworth: the Chrysler (1930, by William van Alen; 1,048 feet to the top of its spire) and the Empire State (1931, by Shreve, Lamb and Harmon; 1,250 feet to the top of the original tower).

The Chrysler and the Empire State were long deprecated by critics and historians who measured stylistic accomplishment largely by European developments, but, in part owing to the chic bestowed upon this bygone era by Pop artists in the 1960s, they have now attained serious status. The highly original spires, functioning as did the Gothic octagon on the Tribune Tower but in a manner more consistent with the main body of the shaft, are seen today as decisive additions to the skyline in a metropolis where

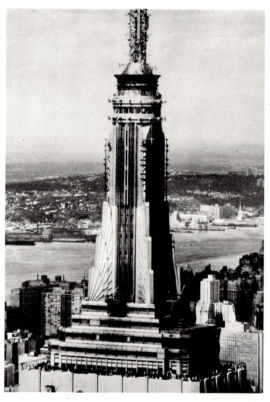

268, 269. SHREVE, LAMB AND HARMON, Empire State Building, New York City. Exterior and detail of spire. 1931

the sheer tower with flat deck (or simulation of same) has become the rule. Once ridiculed, the step-back ziggurat silhouette imposed upon so many Manhattan commercial blocks by zoning regulations, and rendered in sublime chiaroscuro in the imaginary projects of Hugh Ferriss (one of the most sought after architectural delineators of the era), currently seems to be a fortuitous virtue of an earlier day. When stylized in the elevations of the various buildings of Rockefeller Center (1931–40, by Reinhard and Hofmeister; Corbett, Harrison and MacMurray; Hood and Fouilhoux), it can be read as an element of futuristic design, giving the otherwise inert slab a dynamic, forward-moving quality to complement the bland repetitive verticals of the window embrasures. Or, handled in the manner of "industrial design" (the up-to-date packaging of radios, refrigerators, and other appliances), as in Raymond Hood's first McGraw-Hill Building (1931), not just the spire but the whole structure becomes an Art Deco artifact. In its emphasis on horizontal rather than vertical window strips, separated by aquamarine tiles, McGraw-Hill seems to be an atypical reflection of European design formulas in a Manhattan skyscraper of the period.

Even more distinctively representative of International tendencies is the Philadelphia Saving Fund Society (PSFS) Building (1932), by George Howe and William Lescaze. Howe had previously been a partner in a Philadelphia firm specializing in lush, evocative suburban houses in a variety of provincial medieval modes, and his young partner was a recent arrival from Switzerland. Howe performed a dramatic turnabout with this unique structure, which is more cosmopolitan than any other American skyscraper before the late forties, and whose virtues of layout and design, practically alone among buildings of this period, rise above the surface-level stylishness of its contemporaries. The lower portion, containing shops and the banking room, is clearly differentiated from the office tower above; on certain of its faces the window strips and structural columns are constructed in an interwoven fashion that goes deeper than the "industrial design" look of many buildings of the day. In other features, however, such as the curving wall just above street level, we are reminded of the characteristic streamlining of the 1930s.

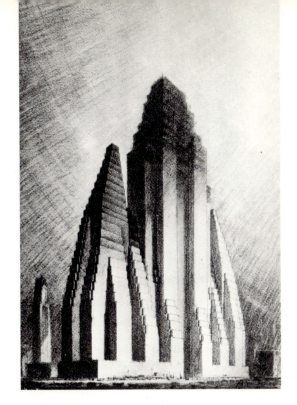

270. HUGH FERRISS.
The effect of zoning on skyscrapers. 1929

271. RAYMOND HOOD. Former McGraw-Hill Building, New York City. 1931

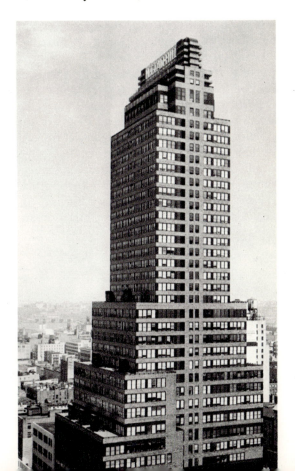

272. GEORGE HOWE AND WILLIAM LESCAZE.
Philadelphia Saving Fund Society (PSFS) Building,
Philadelphia. 1932

Industrial design—the adaptation of stream-line, teardrop, airflow forms to factory products, household artifacts, furnishings, shopfronts, not to mention automobile, train, and aircraft design—is one of the most important visual developments of the 1930s. Few architects (not even Wright) completely escaped its seductive wiles. As a movement it seems to have been generated spontaneously in the work of Norman Bel Geddes, Raymond Loewy, Henry Dreyfuss, and Walter Dorwin Teague. Although partaking somewhat in the chic of Art Deco Paris of the twenties, it leaves behind the superficial Cubism of that movement for an adaptation of the curvilinear surfaces of Central European Expressionism as seen in the architecture of Erich Mendelsohn. Yet the streamlined surfaces of the American movement are much more machine-oriented, efficient-seeming; as thin, taut, and resilient as the aluminum skin of an airplane wing or fuselage. Functional as stream-lined forms may have been in airplane design of the thirties—in the revolutionary development of the low-wing monoplane—these shapes were primarily a decorative insignia when adapted to auto designs such as the Chrysler "Airflow" or Lincoln "Zephyr," or locomotive designs such as the sleek casings (largely unrelated to the inner workings) of the New York Central or Pennsylvania Railroad steam engines of the day. No more functional in the same sense were the wraparound, chrome-trimmed forms of modernistic furniture, but there seemed to be some "expressive" or "emotive" justification for cars and locomotives sporting an airfoil or teardrop profile. It was even employed by Buckminster Fuller in his Dymaxion Car, where the tapered form was at least partly justified by the need for balancing the body on a three-wheel chassis and his hope of ultimately making the car over into a convertible plane with retractable wings.

The impact of this movement in architecture was heaviest at the New York World's Fair of 1939–40, after which its influence was largely spent. In the (temporary) theme monument of the Trylon and Perisphere and in such exhibition buildings as the General Motors Futurama, conceived by Norman Bel Geddes, it found an appropriate vehicle. A permanent monument is the proscenium arch of Radio City Music Hall (1933), a sleek, stylized variant upon the concentric arches of Sullivan's Chicago Auditorium Building, and an extraordinary about-face from the hallowed movie-palace interior represented by Walter Alschlager's Baroque-inspired Roxy Theater (1929). Another is the entrance arch of Union Terminal, Cincinnati (1931), by Fellheimer and Wagner, where the style merges with academic procedures.

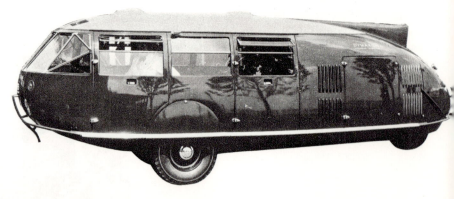

273. BUCKMINSTER FULLER.
Dymaxion Car. 1933

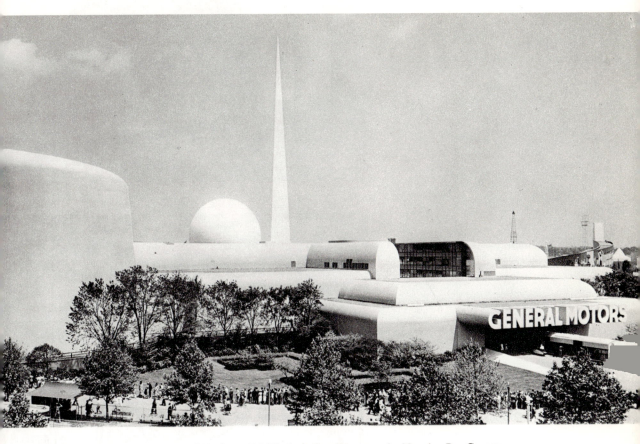

274. General Motors Highway and Horizons Exhibit, including Futurama, by NORMAN BEL GEDDES, and beyond, Trylon and Perisphere, by WALLACE K. HARRISON. New York World's Fair. 1939–40 (demolished)

Wright's major commercial commission of this period, the Johnson Wax Building, Racine, Wisconsin (1936–39), comes within a hairbreadth of inclusion in the streamline movement. The stylistic inspiration for its brick and glass-tube sheath is, however, almost certainly the afore-mentioned Expressionist manner of Erich Mendelsohn. The smooth, angle-avoiding surfaces of the building, both inside and out, are quite different from Wright's earlier compositional features, and interestingly the circle and its segments will become one of the standard design alternatives in his later work. The concept of the Guggenheim Museum, New York, with its continuous ramp spiraling around a circular light well, the space literally reproduced in the shape of the exterior, is a logical outgrowth of the fluent spaces and continuous enclosing surfaces of Johnson Wax. Although the museum was not built until 1957–59—after a considerable struggle with the authorities involved, and some imposed modifications in the design which coars-

ened the final shape without injuring in the slightest the basic concept—it had originally been designed in 1943. Consequently, it is as much an offshoot of 1930s modernism as it is a contemporary (in construction) of that postwar architectural development which featured the extensive use of massive concrete forms to create dense volumes, in reaction to the brittle, glazed transparency of the earlier postwar mode.

Wright christened the medium-cost dwellings of this period Usonian (after Samuel Butler), and from the mid-thirties onward a large number were built. Basically they were Prairie Houses updated, with simplified plans, flat roofs (rather than the low-hipped roofs of most Prairie Houses), and simplified fenestration. His most famous house of the period, Falling Water, Bear Run, Pennsylvania, built for Edgar Kaufmann, Sr. (1936), is too extensive and special a case to be considered within this group. A house of many balconies, it can be interpreted as a further elaboration and exploration of the tray-

275. Radio City Music Hall,
New York City.
Proscenium, showing Rockettes. 1933

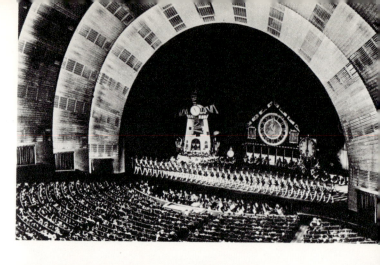

276. WALTER ALSCHLAGER.
Roxy Theater, New York City.
Upper proscenium. 1929

277. FELLHEIMER AND WAGNER.
Union Terminal, Cincinnati. 1931

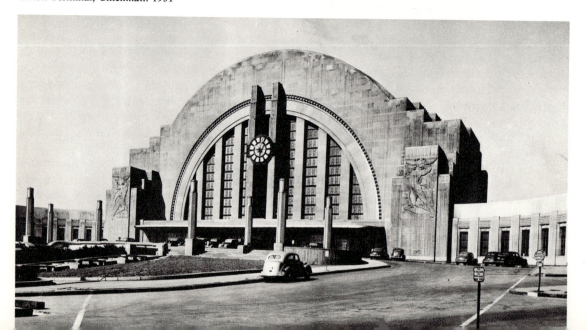

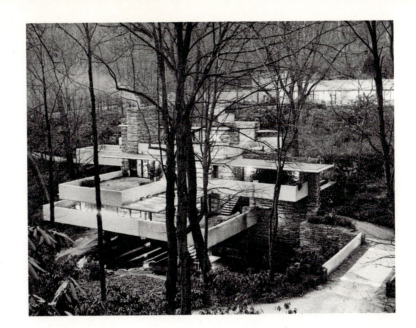

278. FRANK LLOYD WRIGHT.
Falling Water,
Bear Run, Pa. 1936

and shelflike theme of the Schindler and the Neutra Lovell houses. Falling Water is, of course, much more. The clear pale surfaces of the balcony parapets seem to be appropriated from the vocabulary of the International Style, but the dynamic interpenetration of volumes and voids could derive either from that source or from Wright's earlier work. Wright himself correctly pointed out the similarity of mass between Falling Water and a house in Oak Park built a quarter-century earlier. Characteristically, he followed the main line of American naturalism in siting the house on a ravine above a stream so that the flowing water seems completely integrated in the architect's design. Moreover, the balconies on the downstream side are placed so as to echo the rock ledges over which the stream cascades. The main vertical elements are of stone, thus providing a degree of textural interest as well as a material link between the house and the topography.

The most remarkable essay of the period in the manipulation of space and materials was Wright's own winter residence and studio, Taliesin West, Scottsdale, Arizona, begun in 1938 and still in the process of evolution and growth at the time of his death in 1959. There he created an oasis in the desert, the raked slope of the roofs and the battered, rough masonry walls echoing the backdrop of the mountains. In plan, with its varying intersecting angles, Taliesin West is another option that Wright would

introduce into his later domestic work. This desert retreat is the most personal of all Wright's works, a striking contrast to the cosmopolitan mien of Falling Water or Johnson Wax, many of whose features contain a degree of knowledgeable, stylish affectation which he presumably detested. But then, Wright's genius was larger than life, full of the contradictions necessary to sustain a richly inventive career in design.

Given subsequent events, Falling Water, with its integration of several modernist traditions, seems to have been a kind of welcome mat for the arrival of the several distinguished European designers, led by Gropius and Mies van der Rohe, who were to continue and conclude their careers in the New World. Preceding them by a decade was Eliel Saarinen, recipient of second prize in the Tribune Tower competition, who brought a turn-of-the-century romanticism prevalent in his native Finland (he had designed the Helsinki depot in 1904) to his work at Cranbrook School, Bloomfield Hills, Michigan, beginning in 1925. Although never drawn to the austere purism of the International Style, Saarinen (whose son, Eero, would become a prominent architect of the fifties) allowed his designs to take on a simpler, geometric cast toward the end of the thirties. Notable examples are churches at Columbus, Indiana (1940–42), and Minneapolis (1949), of straightforward, rectangular forms which contrast with both the more richly expressive work of Wright and the lean, trim designs

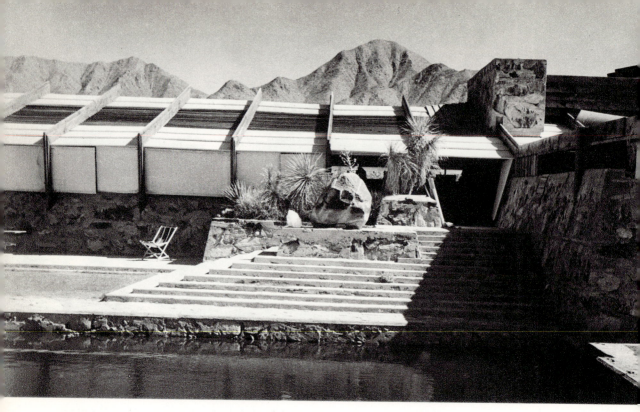

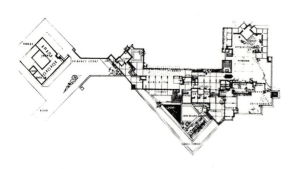

279, 280. FRANK LLOYD WRIGHT. Taliesin West, Scottsdale, Ariz. Exterior and plan.
1938 to date

that Mies and Gropius then were introducing to the United States.

Leading architects as well as mathematicians, physicists, and art historians were fleeing Germany in the 1930s, and many found refuge in America. In 1937 Walter Gropius and Marcel Breuer (who would form a partnership for a few years) were brought to Harvard to reform the curriculum; among their students who were to become leaders of the profession were Philip Johnson and Paul Rudolph. That same year László Moholy-Nagy, the versatile Bauhaus designer and teacher, came to Chicago to teach at the short-lived New Bauhaus. Mies arrived in Chicago in 1938 to take charge of the archi-

tectural department at Illinois Institute of Technology (formerly the Armour Institute). The Expressionist architect Erich Mendelsohn arrived in 1941, after stays in England and Palestine, to settle in San Francisco and teach for a brief period at Berkeley, which would subsequently be headed by one of the prominent architects of the Bay Region school in the forties and fifties, William W. Wurster.

Parenthetically, the emergence of a Bay Region school of architects around 1940 should be noted. Rooted in the romantic wood-framed houses of Maybeck or Greene and Greene, and represented by such architects as Wurster and Gardner Dailey, this trend, referred to as "organic" by some critics, largely ignored the precise geometries of the International Style in favor of refining and modernizing an indigenous vernacular tradition. Hence Wurster's Stern Hall, University of California, Berkeley (1941), has the plane surfaces and strong balcony horizontals of the new mode, but the architect employed homely vertical sash windows rather than glass walls or ribbon windows. The result is soft, plain, and familiar, an alternative kind of modernism that is often contrasted with the so-called rationalism of works by Neutra or

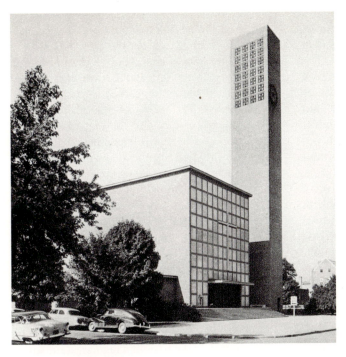

281. ELIEL SAARINEN AND EERO SAARINEN.
Church of Christ,
Columbus, Ind. 1940–42

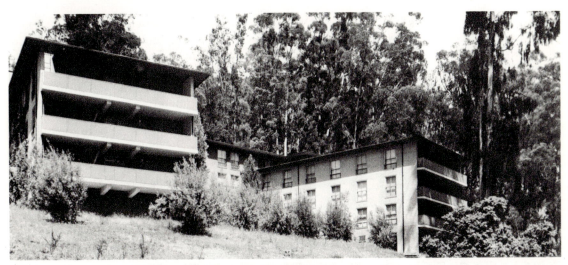

282. WILLIAM W. WURSTER. Stern Hall,
University of California, Berkeley. 1941

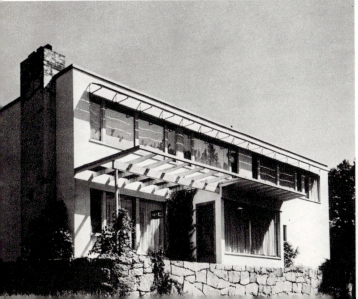

283. WALTER GROPIUS AND MARCEL BREUER.
James Ford House, Lincoln, Mass. 1939

Gropius. As will be seen, some of the best works of the Bay Region architects would be built in the years just after 1945.

For a short time before America's entrance into the war, Gropius and Breuer were active as designers of small houses around Boston and Cambridge. In addition to houses for themselves was one for James Ford at Lincoln, Massachusetts (1939). In these works the crisp contours and clear surfaces of Bauhaus styling, originally worked out in concrete and stucco, were transposed into wood-framed houses with flush vertical siding, the whole painted white. Clarity was sometimes blurred by projecting horizontal sun shades or trellises, brick chimneys, and stone retaining walls. Despite these modifications, the traditional International Style aspect remained largely intact, and these houses preserved the image of machine-age modernism parallel to that shown by the works of Neutra in southern California throughout the thirties (allowances being made for differences in material and climate). Not until after the war would the works of Gropius and, more significantly, of Breuer evolve into a distinctively American idiom.

Ludwig Mies van der Rohe's first works in America were altogether different, even though their roots in Europe were identical to those of Gropius, and in the long run Mies was to have a greater impact as a designer upon the future course of architecture. In 1939 he was asked to produce a master plan for I.I.T., and over the course of the next decade and a half he built a number of buildings on the site, including a power house, a chapel, several classroom and laboratory structures, and Crown Hall, a vast open glazed space that served as the School of Architecture. The timing of this project, its unusual characteristics, and the fact that some of the buildings were actually completed during the war placed Mies conspicuously in the forefront of architectural design, especially in its nondomestic aspect, soon after the end of hostilities. By the early 1950s he was recognized everywhere as the leader of the new American design and the ultimate heir of the Chicago School, moribund for several decades.

Mies's adaptation and regularization of the International Style saw the elimination of its active, dynamic, irregular aspects. In place of unstable geometries, interlocking spaces, and narrow, unaccented contours, he chose to design the campus on the basis of a regular, static square module. Working with predominantly low, horizontal masses, he created a bay system of equally expressive vertical supports with precise emphasis at the corners, contrasting with earlier tendencies to avoid a strong statement at the angles. The various rectangular cubes were arranged in an unobtrusive symmetry to form a series of partly enclosed courts, which, open at their angles, provided for an easy, unostentatious spatial flow. Regularity, repetition, linear precision, and structural clarity replaced the unstable elements of flux and even ambiguity

284. LUDWIG MIES VAN DER ROHE. Second, definitive scheme for the Illinois Institute of Technology, Chicago. Aerial view. 1940 (only partially completed)

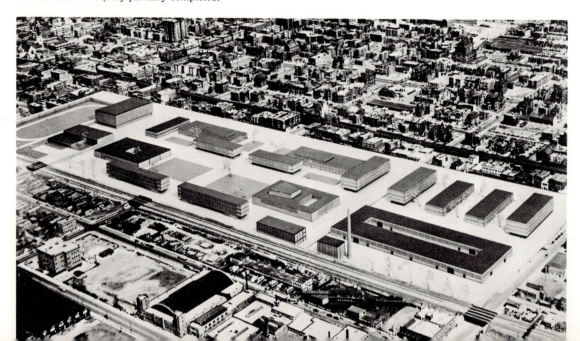

285. ALBERT KAHN ASSOCIATES. Dodge Half-Ton Truck Plant, Warren, Mich. 1937

characteristic of his earlier works such as the Barcelona Pavilion (1929). So neat was Mies's tying up of the International Style's loose ends that it seemed for a time as if he had led modernist architecture into a classicizing solution, in which further development would be based upon certain restricted canons of proportion, or upon the invention of subtle refinements in the balancing of structural and surface tensions.

Although Mies's achievement in Americanizing the International Style to a degree undreamed of by a Neutra or a Gropius was largely the result of his own inner evolution, of his search for the best solution, his industrial style of steel, glass, and brick was anticipated in the numerous factories of the 1930s by the Detroit firm of Albert Kahn Associates. Kahn had one of the most typical, wide-ranging practices of any large, comprehensive architectural firm of the day. In 1917 he began the famed River Rouge plant for the Ford Motor Company; he also specialized in neo-Gothic and neo-Georgian mansions for industry executives in nearby Grosse Pointe and other exclusive suburbs; numerous banks and office buildings, classicizing as well as Gothicizing, in downtown Detroit; and many buildings for the University of Michigan at Ann Arbor. And the firm was not confined to the United States: it was responsible for extensive industrial work in Europe and at many locations in the Soviet Union, including Kharkov, Dne-propetrovsk, and Rostov. Although the majority of Kahn Associates' work is of interest to the social historian rather than to the architectural critic, the various factories of the late 1930s, notably those for General Motors and the Chrysler Corporation, exhibit a refined precision of architectural detail that is remarkable for the period, and is surely a source for the Miesian style that would be adapted to downtown skyscrapers by 1950.

The interwar period thus ends with the massive transfusion of a still evolving European mode into the mainstream of progressive American architecture, which heretofore had seen this work chiefly in southern California. Equal with, certainly not unrelated to, this phenomenon were Wright's reassertion of his genius and his emphasis upon the organic, nature-oriented, antiurban aspects of his buildings and philosophy—in contrast to the industrial, technological, city-oriented architecture of Mies. These two developments emerged when the indigenous modernism of American commercial design of the twenties and thirties was declining in importance, mainly because of the paucity of building commissions during the Depression. Neither this native commercial style nor its corollary, the streamline industrial design celebrated at the New York World's Fair of 1939–40, survived the period of inactivity caused by World War II.

8 · American Scenes and Symbols

EVEN AS AMERICA'S MOOD of experiment in art reached a decisive peak shortly after the Armory Show, a limited reaction was in the making. After World War I, a conservative atmosphere reasserted itself more strongly until finally the center of gravity in art shifted once again, away from Europe and artistic innovation to the native scene and a revival of naturalism. The new realists shared none of the challenging rebelliousness or reforming zeal of the Eight; their art was instead cheerless, harsh, haunted by romantic nostalgia, and addicted to the grotesque. It began by seeking refuge in the familiar and the commonplace, as a rebuke to the aesthetic conundrums of the modernists. But the scene it disclosed was not humanly reassuring, and the reality it set forth was a world of shadows, haunted by strange forces and an atmosphere of emptiness. Like the modernists who had begun to react negatively to the machine and to the new landscape of power, the romantic realists, by quite different pictorial metaphors, told the story of the disenchantment and spiritual vacancy behind the American success story.

The new romantic realists fashioned their paintings gracelessly and unaesthetically, working out of a clumsy artisan tradition and from sudden moments of vision. They lacked any profound sense of style. Pictorially, they were as limited, average, and undistinguished as the humiliated landscape, broken-down architecture, and drab scenes they made the stock-in-trade of their subject matter. It was an underprivileged art that seemed disinclined to draw attention to itself; yet the least attractive aspects of American life were presented without apology. The romantic realists were less interested in painting as such than in "picturing" or describing, and they rejected out of hand any commitment to formal principle or aesthetic ideal. Mounting pressures of American provincialism in the postwar era once again forced devastating alternatives upon the artist, exposing a cruel division in native sensibility. He was forced to fight an increasingly lonely battle for modernism against the American grain, giving all his devotion to the integrity of his principles and consoling himself with pride in his

286. CHARLES E. BURCHFIELD.
November Evening. 1934. Oil on canvas, $32\frac{1}{8} \times 52''$.
The Metropolitan Museum of Art, New York City.
George A. Hearn Fund, 1934

287. EDWARD HOPPER. *House by the Railroad*. 1925.
Oil on canvas, $24 \times 29''$.
The Museum of Modern Art, New York City

independence and self-knowledge. Thus, John Marin, Arthur Dove, and Charles Demuth in their different ways had come to use experimentalism as a metaphor for their separate and distinguished brands of individualism. The alternative course of action was to surrender to the raw American experience. Modified by their own idiosyncratic visions, this latter course became for the emerging realists a general objective. Realism, nostalgic and romantic in the twenties, and progressively more violent in mood and more Expressionistic in form during the thirties, once again asserted itself as the dominant American tendency.

Most striking of the first realists were Charles Burchfield and Edward Hopper. Their art coincided in time and temper with the first stories and novels of Sherwood Anderson and Sinclair Lewis. *Winesburg, Ohio*, Anderson's gallery of grotesque small-town lives, and *Main Street*, Lewis's satire on boosterism and middle-class conformity, appeared in 1919 and 1920. Burchfield and Hopper seemed to work out of the same sources in American life. Lewis's description of the typical American main street, "where dullness is made God," establishes the tone for Hopper's paintings of the national spiritual vacuum and his visual descriptions of sullen, mechanical lives set in stagnant scenes. Burchfield was an acknowledged admirer of Anderson's writing. Perhaps he was drawn to the novelist's sentimental lyricism, his fascination with the commonplace, and his brooding introspection in the face of the moral rot of small-town existence. Anderson's description of himself as a writer "whose sympathy went out to the little frame houses on often mean enough streets in American towns, to defeated people, often with thwarted lives" is also applicable to Burchfield's artistic personality and accomplishment.

James Thrall Soby has very brilliantly characterized Burchfield when he describes him as "a painter of memories in an era of anticipation." In the small-town backwaters of American life and in their decaying architecture, Burchfield found a symbolic projection of a private ennui that could deepen into fantasy and significant emotional experience. He had grown up in Salem, Ohio, and then gone briefly to the Cleveland School of Art, only to return to Salem in 1916. Between that date and his induction into the army in 1918, he independently arrived at a fanciful symbolic mode of expression in watercolor that suggests the paintings of Edvard Munch, and the melancholy, introspective mood of much European art of the turn-of-the-century era. Back in Salem, Burchfield wrote, he experienced a personal crisis: "A curious depression assailed me, and I worked constantly to keep it down." Out of this mood flowed a series of fantasies in watercolor which turned the familiar landscape of his youth into a symbolic representation of childhood fears and ghostly apparitions. "As I progressed," the artist declared in his journal, "I went further back into childhood memories and it became such an obsession that a decadence set in. I tried to re-create such moods as fear of the dark, the feelings of flowers before a storm, and even to visualize the songs of insects and other sounds."

Employing the curving forms and ornamental line of Art Nouveau, Burchfield created a hallucinatory atmosphere in which everything in nature was freely distorted and became vaguely menacing: windows and doorways of houses doubled as eyes or mouths; flowers were faces; all nature joined a ghostly retinue of fearful presences. This vein of depressed fantasy and dream had been explored with signal success by many north European artists around 1900; it was Burchfield's achievement to give validity to the same mood within the more restricted pictorial scheme of the watercolor in the American landscape some thirty years later. His awareness of and attraction to the brooding spirit of the North was made clear in his journal, where he later wrote of the imaginary locale that had always haunted him, of "some fabulous Northland unlike any place on earth—a land of deep water-filled gashes in the earth; old lichen-covered cliffs and mesas, with black spruce forests reflected in the pools, against which white swans gleam miraculously. This romantic land of the imagination, the mysterious North that has haunted me since I was a boy—it does not really exist, but how did it come into being?"

It is the author's opinion, however, that Burchfield's literary imagination more often than not outstripped his power to create convincing illusion, and the pictorial results were not always commensurate with his fine inspiration. In such watercolors of 1916–1918 as *Church Bells Ringing*, *Rainy Winter Night* or *The Night Wind*, the artist's grotesque fancies and expressive means achieve the unity of a style. Many of his other works even in the same period are singularly lacking in atmosphere and bear no stamp of individual vision.

288. CHARLES BURCHFIELD.
Church Bells Ringing, Rainy Winter Night. 1917.
Watercolor, 30 × 19″. The Cleveland Museum of Art.
Gift of Louise M. Dunn in memory of Henry G. Keller

Charles Addams. Burchfield described it as a "house where anything might have happened, or be happening." At the end of the twenties and through the thirties his feeling for the weird became further diluted, almost as if even the grotesque were powerless to deal with the "measureless grossness and slag," in Whitman's phrase, of the American visual reality. Ramshackle house fronts, dilapidated factories, and dismal back streets were set down now with little aesthetic or imaginative elaboration; the artist seemed to succumb to the dull torpor, the enervating tempo, the gritty ugliness of those aspects of American life he had chosen to treat. He dealt too timidly with the harsher visual truths of American life, repeating and ritualizing them with a discouraged objectivity, and American materialism took its revenge finally by smothering his imagination.

Burchfield had set himself the task of exploring in humble visual metaphors the failures behind the American success story, the corruption of the landscape that followed in the wake of industrial progress and which most Americans had managed conveniently to ignore. The dreary tonelessness of his own art, however, too closely matched his subject matter. He began as a romantic fantast,

They show a curious and often meaningless penmanship embroidery, as if the artist were at a loss and fell back disconsolately on a random, half hearted inventiveness of linear detail.

After 1921, when he moved permanently to Buffalo, Burchfield began to document the American scene in a more objective manner. He painted the great vacant façades of the homes of the Awkward Age, and in his treatment of these architectural relics, found a new outlet for his mood of nostalgia. Sometimes fantasy was given humorous relief by satirical caricature, particularly as he introduced figures into his compositions. At other times he used the extravagant, peaked architectural forms of Buffalo to create a more somber atmosphere. *House of Mystery*, a watercolor of 1924, is most probably the direct ancestor of the haunted houses of the *New Yorker* cartoonist

289. CHARLES BURCHFIELD. *House of Mystery*. 1924.
Watercolor, 29½ × 24½″. The Art Institute of Chicago

290. AARON BOHROD. *Landscape near Chicago*. 1934.
Oil on composition board, 24 × 32″.
Whitney Museum of American Art, New York City

291. FRANZ KLINE. *Palmertown, Pa*. 1941.
Oil on canvas, 22 × 27″.
Collection Dr. and Mrs. Theodore J. Edlich, Jr.,
New York City

aggressive even in his apprehension, but ended as a mild elegist of defeat. In the latter phase of his work he seemed unable to make the radical distinction between raw experience and art. To Thomas Benton, John Steuart Curry, Grant Wood, and other Regionalist painters, Burchfield's art may have supplied the first hint of a violent rebuke to modernism in its makeshift, illustrative style and American scene subject matter. But these artists primed Burchfield's despondency with false optimism and interpreted his subject matter as an endorsement of a new jingoism. In some of his Midwestern farm scenes, such as *November Evening*, Burchfield had painted a rural America from which pioneer zest had long since vanished, leaving a vacuum of endless chores,

loneliness, and fears. Benton and Curry dramatized Burchfield's gnarled distortions in form, his ornamental arabesques, but brightened his palette and mood, and tried instead to re-create the heroic myth of the American West. Their mawkish, melodramatic Regionalism was not as convincing as Burchfield's less self-conscious treatment of the local scene, and his unembarrassed admission of ugliness.

What Charles Burchfield was to domestic wooden architecture, and to the rural or small-town scene, Edward Hopper was to the crassly "modernistic" America of the large cities. In the inhuman surfaces of urban life, anonymous brick house fronts, neon signs, ubiquitous diners, gas pumps, cinema interiors, and even in pavement itself, he found metaphors for spiritual vacancy and imprisonment. Like Burchfield, he was an artist of American ennui and loneliness; unlike him, Hopper never expressed an explicit fantasy, or subordinated description to free invention.

Hopper's paintings represent the revival of the anecdote, but the story they tell is always the same one. His favorite subjects were the least prepossessing, least promising visual commonplaces of American life. Their very familiarity robbed them of their relevance to feeling. Somehow Hopper managed miraculously to extract fresh sensation from his stagnant scenes. A motif may be nothing more than a deserted street at night, with a brightly lit lunchroom at one side, through the windows of which figures are seen sitting torpidly, not unlike Surrealist dummies. In another painting the subject is a bizarre Victorian house caught in a striking angle lighting which gives it mysterious new properties. A subject that he repeated is the interior of the modern movie "palace," painted in a manner that vividly summons up the artificial dream world of the cinema. The helpless surrender and preoccupation of the audience is heightened by contrasts in color, value, and degree of definition between the amorphous black mass the spectators make and the brilliant square of white screen. Vacuity is compounded with inanition by setting the scene off with an inattentive usherette who stands to one side, lost in her own thoughts. Despite the figure style of spare and, indeed, famished realism, there is a poetry hinted at in the color and lighting, a certain taste for luxurious sensation that won't be suppressed. With his strange, artificial quality of light, Hopper

292. GRANT WOOD. *Midnight Ride of Paul Revere.* 1931. Oil on Masonite, 30 × 40″. The Metropolitan Museum of Art, New York City. Arthur H. Hearn Fund, 1950

294. JOHN STEUART CURRY. *John Brown.* c. 1939. Oil on canvas, 69 × 45″. The Metropolitan Museum of Art, New York City. Arthur H. Hearn Fund, 1950

293. THOMAS HART BENTON. *Arts of the West.* 1932. Tempera, 7′ 10″ × 13′5″. The New Britain Museum of American Art, New Britain, Conn. Harriet Russell Stanley Fund

managed to create romantic atmosphere as no American realist since John Sloan had done. He was in all probability directly influenced by Sloan and other members of the Eight, whom he knew and for a time imitated in the earlier years of the century.

His atmosphere, however, is stifling and curiously unreal, with a strange anxiety hovering at its edges, as if the sheer inertia and immobility of his figures and scenes might foreshadow some extraordinary event. Hopper's combination of bald literalism and dramatic heightening give a mood of impenetrable monotony the quality of a dream. The last, pale, dying radiance of light which lends his cityscapes their somber glow suggests that romantic feeling has brushed the scene

somewhere. A weakened echo of lavishness and mystery is enough to provide relief from the otherwise drab, routine realism and the unspectacular views.

Hopper came to maturity in a period whose prevailing temper was either realistic or experimental; he set himself against both tendencies, and was a long time developing his own distinctive style. He had studied at the Chase School of Art for five years under Robert Henri and Kenneth Hayes Miller, and then had gone to Paris in 1906. On his return to America Hopper participated in the first exhibition of the Independents in 1910. He witnessed but did not take part in the early demonstrations of a more radical modernism at Stieglitz's gallery, the Forum Gallery and in the

295. EDWARD HOPPER. *Early Sunday Morning*. 1930. Oil on canvas, 35 × 60″.
Whitney Museum of American Art, New York City

296. EDWARD HOPPER. *Eleven A.M.* 1926. Oil on canvas, 28 × 36″.
Joseph H. Hirshhorn Foundation

297. MILTON AVERY. *Swimmers and Sunbathers*. 1945. Oil on canvas, 28 × 48⅛″.
The Metropolitan Museum of Art, New York City

298. BEN SHAHN. *The Red Stairway*. 1944. Tempera on Masonite, 16 × 23⅝″. City Art Museum of St. Louis, Mo.

299. ISAAC SOYER. *Employment Agency*. 1937. Oil on canvas, 34¼×45″.
Whitney Museum of American Art, New York City

300. THOMAS HART BENTON.
Country Dance. 1928.
Oil on gesso panel, 30×25″.
Bernard Danenberg Galleries, New York City

301. EDWARD HOPPER.
New York Movie. 1939.
Oil on canvas, 32¼ × 40⅛″.
The Museum of Modern Art,
New York City

302. JOHN SLOAN. *Before Her Makers and Her Judge*,
illustration for *The Masses*. 1930.
Pencil, 16½ × 25″.
Whitney Museum of American Art, New York City

Armory Show. Discouraged by his own personal
struggle to live by art, and alienated by the more
radical artistic tendencies, he abandoned painting
for etching and commercial illustration from 1915
to 1923. On the basis of his first strong artistic
contacts, Hopper's deepest sympathies lay with
John Sloan's romantic mood, although he was to
depend on enervation rather than energy to con-
vey it. In 1914 he painted *Corner Saloon*, employ-
ing a sensitive and feeling brush to set down the
red brick façades which were to become one of
the ubiquitous stage properties of his art. The
commonplace subject, the suffusion of warm light

and enriched surface effects, place this New York
street scene very close to Sloan's work. Hopper
later acknowledged his debt to the older artist
when he praised Sloan's ability to render "re-
markably the quality of a brooding silent interior
in this vast city of ours." And he continued:
"Sloan's design is the simple and unobtrusive
tool of his visual reaction. It attempts tenaciously
and ever the surprise and unbalance of nature, as
did that of Degas."

The reference to Degas is unexpected but il-
luminating in relation to Hopper's art; it is prob-
ably more significant in psychological terms than
it is compositionally. For Degas was one of the
first modern Europeans to show human boredom
and mental funk candidly, to paint people as they
were *unrelated* rather than related to each other.
Degas was adept at setting up compositional
tensions across empty areas of space, areas which
not only figured as design elements but created a
distracting mood of vacancy and anticipation as
well. He was too fine an artist to underscore the
possible psychological implications of giving
human action a marginal role in his pictorial
schemes. In great part this aspect of his art, and
his habit of catching his human subjects unaware
as they stood self-absorbed outside the action,
reflected a growing process of abstraction in all
late-nineteenth-century art, mirrored differently
in the painting of Manet and the orthodox Im-
pressionists. However, Degas's procedures also
represented a new sense of the disintegration of
the traditional concept of the individual. The

303. EDWARD HOPPER. *Nighthawks*. 1942. Oil on canvas, 30 × 60″. The Art Institute of Chicago

human subject had lost its centrality and was seen, aesthetically, merely as one possible motif among others. More importantly, the individual had begun to lose some of his reality, to be transformed into a symbol or a "case," as interest shifted from man to his defining environment. This process had already taken place in the naturalist and realist novels of Zola and Flaubert, and in the twentieth century it belatedly affected the American naturalist writers. Degas's art was among the first to signal visually the radical change in feeling. It was no accident that Degas should attract Hopper—an artist who gave his humanity significance only in terms of an oppressive urban environment, and made their lusterless lives a function of a stage-set modern world, in which they move dully like automatons.

Hopper was shrewd enough to know that his kind of realism had become dated, but he must have felt confident that the lack of a more contemporary sophistication need not necessarily stand in his way. He found encouragement in Thomas Eakins's example, and described him as an artist who "in the nineteenth century used the methods of the seventeenth, and is one of the few painters of the last generation to be accepted by contemporary thought in this country."

The wooden, apathetic creatures that inhabit

304. WALT KUHN. *The Blue Clown*. 1931.
Oil on canvas, 30 × 25″.
Whitney Museum of American Art, New York City

Hopper's paintings are probably related to the doll-like figures of Guy Pène du Bois, Kenneth Hayes Miller, Walt Kuhn, and other realists of his period. Perhaps they show Hopper's ineptness at significant characterization, but it is to the artist's credit that he could force us to associate them and the scenes in which they participate with the thwarted lives of Sinclair Lewis's or Sherwood Anderson's characters. Although he dealt for the most part with metropolitan life and its settings, Hopper's central theme was also the ugliness and frustrations of provincial life, an existence lacking romantic fulfillment and satisfying spiritual values.

Without the precedent of Hopper, it would be difficult to conceive such varied and distinct poetic documentations of the American scene of the late thirties and early forties as those of Ben Shahn, Walter Stuempfig, and Loren MacIver. In styles of social realism, traditional romanticism, and a magically heightened abstraction of evocative symbol and sign, these artists registered their visions on an exposed poetic nerve, and transmuted a harsh external reality: the drab surfaces, vacant back lots, and visual horrors of the modern urban environment. The exploration of picturesque elements in the local scene by both Hopper and Burchfield led even more logically, and obviously, to the Regionalist styles of the thirties; in mood, these two artists also anticipated the fantasy, if not the violence, of the Expressionists who later in the same decade turned a feverishly disenchanted eye on the American scene.

Social realist painting in the thirties and early forties was itself a product not only of the visual explorations of Burchfield and Hopper, but of the political and economic crisis of the great Depression. The impact of that traumatic and tragic event was to force a new kind of search among American artists for their cultural identity, first through themes of social protest in realism, and then, by virtue of the stimulation supplied by the Federal Art Project, in surprising experiments with a Constructivist abstraction, as we shall see.

In the thirties some of the notable social and romantic realists who began to make their reputation were Reginald Marsh, Raphael, Isaac, and Moses Soyer, Isabel Bishop, Yasuo Kuniyoshi, William Gropper, Philip Evergood, Edwin Dickinson, and Milton Avery. Marsh became

305. GUY PÈNE DU BOIS.
Mr. and Mrs. Chester Dale Dining Out. Mid-1920s.
Oil on canvas, 30 × 40".
The Metropolitan Museum of Art, New York City.
Gift of Chester Dale, 1963

306. KENNETH HAYES MILLER.
The Fitting Room. 1931.
Oil on canvas, 28 × 34".
The Metropolitan Museum of Art, New York City.
Arthur H. Hearn Fund, 1931

celebrated for his robust characters on the Bowery, a derelict population which he endowed with almost monumental energies utilizing the visual rhetoric of High Renaissance style. The Soyer brothers developed their touching genre portraits of exhausted shopgirls and absorbed office workers, which like so much realism in the period dramatize the human cost of the Depression experience. Isabel Bishop, on the other hand, painted common people, and very often two or three carefully posed figures, with the unsentimental professionalism of an old master in thinned oil washes. The simplified formula of Yasuo Kuniyoshi's poetic if somewhat glamorized figure studies provided one of

307. (*top left*) YASUO KUNIYOSHI.
I'm Tired. 1938. Oil on canvas, 40¼ × 31″.
Whitney Museum of American Art, New York City

308. (*top right*) RAPHAEL SOYER. *Office Girls*. 1936.
Oil on canvas, 26 × 24″.
Whitney Museum of American Art, New York City

309. (*middle left*) ISABEL BISHOP. *Waiting*. 1938.
Oil and tempera on gesso panel, 29 × 22½″.
The Newark Museum, Newark, N.J. Arthur F. Egner
Memorial Committee Purchase, 1944

310. (*middle right*) REGINALD MARSH.
The Bowery. 1930. Oil on canvas, 48 × 36″.
The Metropolitan Museum of Art, New York City.
Arthur H. Hearn Fund, 1932

311. (*left*) WILLIAM GROPPER. *The Senate*. 1935.
Oil on canvas, 25⅛ × 33⅛″.
The Museum of Modern Art, New York City.
Gift of A. Conger Goodyear

the models for the faculty and students of the Art Students League in New York, which became the stronghold of the revived American realism.

Actually, in retrospect the varieties of realism are surprising, and they seem to have acquired more visual appeal and personal character with the passage of time. In the case of William Gropper's broadly caricatured "capitalists" and virulent lawmakers, the removal of the social target and animus permits us better to appreciate his abrupt and powerful simplicities of design and figuration. One of the artists who endured the trials and social tribulations of his time within a more personal kind of vision was Philip Evergood, whose grotesquerie and fantasy have lost none of their bite. A different kind of romanticism sustains the theatrical, dreamlike settings of tumbling figures and studio props in Edwin Dickinson's extravagant but elegantly depicted imaginary scenarios. (At a later date, Walter Murch managed to combine qualities of romantic lighting with a more banal subject

312. MILTON AVERY. *Three Friends*. 1944. Oil on canvas, 36 × 42″. Collection Roy R. Neuberger, New York City

313. EDWIN DICKINSON. *Composition with Still Life*. 1933–37. Oil on canvas, 8′ 1″ × 6′ 5¾″. The Museum of Modern Art, New York City. Gift of Mr. and Mrs. Ansley W. Sawyer

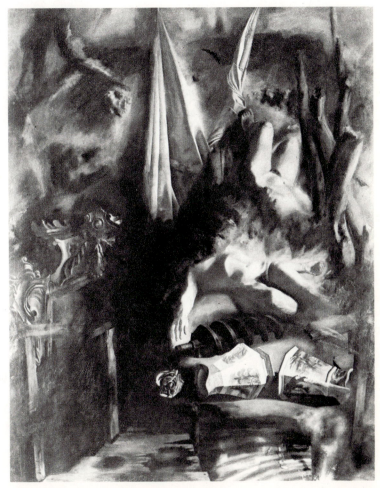

314. IVAN LE LORRAINE ALBRIGHT.
Fleeting Time Thou Has Left Me Old. 1946.
Lithograph, $16\frac{5}{8} \times 12\frac{1}{4}''$

In its effort to combine social realism with an elliptical visual shorthand and to make this synthesis meaningful to Americans, Ben Shahn's art provides one of the more interesting experiments of the late thirties. Shahn and his art must be set against the general mood of a period in revolt against the hedonist aesthetics and formalism of Paris painting. American painting was dominated by Regionalist, realist, and Expressionist styles. The New Deal of Franklin D. Roosevelt, with its enlightened arts program, had encouraged mural decoration, and a new artistic self-consciousness

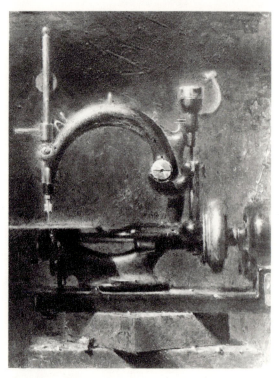

315. WALTER MURCH. *Sewing Machine.* 1953.
Oil on canvas, $25\frac{1}{2} \times 19\frac{1}{2}''$.
Collection Mr. and Mrs. Frank A. Lavaty, New York City

316. ADOLPH GOTTLIEB. *Sun Deck.* 1936.
Oil on canvas, $24 \times 36''$.
University of Maryland Department of Art, College Park

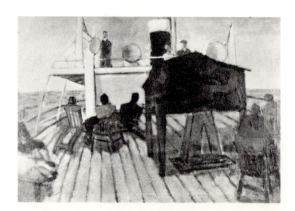

matter in his theatrical household objects.) This mild decadence turned into positive melodrama in the forties with Ivan le Lorraine Albright's art of visible human deterioration.

Whatever its nature, realism dominated the decade of the thirties and the early forties. Even as art began to change with the emergence of the American Abstract Artists group, and after 1943 with the Abstract Expressionists, there remained a residual attachment to recognizable subject matter and figurative styles which often gave the "second wave" of modernists their distinctive character. Many of the nascent abstractionists had worked in different manners, including realism, prior to their conversion to advanced styles. Their realist ventures ranged from the intimism of Adolph Gottlieb to James Brooks's monumental WPA muralist style and the expressionist fury of Jackson Pollock, who was influenced in the late thirties by the Mexicans Orozco and Siqueiros. Of the artists who worked in figurative styles, or out of humanist motives, only a few tried to maintain some continuity with European modernism, as did Milton Avery through Matisse's simplified drawing and flattened color masses, or Ben Shahn, who apparently was aware of the painting of Klee.

317. JACKSON POLLOCK. *Untitled.*
c. 1936. Oil on canvas, 50×36″.
Marlborough Gallery, New York City

318. JOSÉ CLEMENTE OROZCO.
Modern Migration of the Spirit,
panel from *Gods of the Modern
World* series. c. 1933.
Fresco, 10′ 7″×10′ 6″.
Baker Library, Dartmouth College,
Hanover, N.H.

319. DAVID ALFARO SIQUEIROS.
Echo of a Scream. 1937.
Duco on wood, 48×36″.
The Museum of Modern Art,
New York City. Gift of
Edward M. M. Warburg

was emerging. Inspired by this program of public art, obsessed with social problems, and influenced by the vigorous revival in Mexican mural painting under Rivera and Orozco, American artists had set themselves a program of national self-discovery. Curry, Benton, and Grant Wood tried to create a new Regional style of melodramatic realism. The passion for creating an "American" idiom led to a narrow chauvinism, with a violent rejection of European modernism (even though an artist like Benton was directly indebted to Paris painting and had been a member of the American vanguard at the time of the Forum Exhibition). In time, however, there was a further reaction against the provincialism of the Regionalists. Out of this repudiation emerged the modified social-realist art of Ben Shahn. It represented a militant response to both the woolly idealism of the Regionalists and their blind political optimism, as well as a renewal of interest in European painting modes.

Shahn grew up in an atmosphere of left-wing radicalism. Many of his early projects in the thirties took the form of social polemic and caricature. His art took note of such controversial issues as the execution of the anarchists Sacco and Vanzetti, and the imprisonment of the labor leader Tom Mooney. Shahn also worked for a time in Mexico as an assistant to Diego Rivera, whose ideological and technical influence on the younger painter is apparent in work of this period.

320. THOMAS HART BENTON. *City Activities with Subway.* Mural, 1931.
Oil and egg tempera on linen, mounted on reinforced wallboard, 7½′×12′.
The New School for Social Research, New York City

321. (*far left*) GEORGE BIDDLE.
Tenement (study for a fresco
in the Justice Department Building,
Washington, D.C.). c. 1935. Tempera
on Masonite, 40¾ × 31⅝″.
University of Maryland
Department of Art, College Park

322. (*left*) BEN SHAHN.
The Passion of Sacco and Vanzetti,
from the series of 23 paintings.
1931–32. Tempera on canvas,
84½ × 48″. Whitney Museum of
American Art, New York City.
Gift of Edith and Milton Lowenthal
in memory of Juliana Force

323. (*bottom left*) BEN SHAHN.
Handball. 1939. Tempera on
paper, mounted on composition
board, 22¾ × 31¼″.
The Museum of Modern Art,
New York City.

As Shahn developed in the late thirties and early forties, he began to move from a public art of direct social criticism to a more personal art that portrayed the individual in terms of private emotional experience. Elegiac poetic content began to replace satire, and he portrayed figures of the old and homeless marooned on a park bench; children carried away by the excitement of play; lovers in a park, imprisoned by a network of fence railing and their own dream. His figures, often reduced to a significant, expressive silhouette and pressed into the maze of urban building patterns, became eloquent images of loneliness in an art that was hard-boiled and sensitive by turns.

Flat, poster-like, and extremely denuded, his earlier imagery suggested a deceptive callousness and a photographic objectivity; but beneath the surface a sympathetic poetry played. In technique, Shahn most often used tempera, obtaining effects alternately of dry incandescence and of a metallic luster. His surfaces, his colors, his expressive language of image and symbol progressively reflected the increasing influence of Paul Klee; yet the nervous pulse of his work and its commercial-art blatancy are ummistakably native. Drawing on a sophisticated, semiabstract idiom, Shahn portrayed the American scene with interpretive imagination. He was a poignant and effective lyricist, and always a fine reporter. When he tends, as in his late painting, to emphasize wider allegorical themes rather than to consult specific incident, his art loses its tension and suffers from affectation. Its limitations and tendency toward visual stereotype have become even clearer against the background of the vigorous movements in contemporary American abstract painting.

Shahn's magical realism became a formative influence on many of his younger contemporaries, most notably on Andrew Wyeth. Wyeth is, however, an almost clinically direct, realist reporter by comparison. He seems, in fact, to strive frankly for the absolute verisimilitude of the photograph. But the sense of loneliness and of spiritual malaise in the American scene that both Shahn and Hopper underlined have also become his themes. He sometimes approaches Shahn's manner of expressing fantasy by setting a figure starkly against an intricately embroidered expanse of nature, a nature in a state of unnatural inanition and haunted by somber forces.

324. BEN SHAHN. *Liberation*. 1945. Tempera on paper, mounted on composition board, 29¾ × 39¾".
Collection James Thrall Soby, New Canaan, Conn.

325. BEN SHAHN. *Pretty Girl Milking a Cow*. 1940.
Tempera on Masonite, 22 × 30".
Collection Edgar Kaufmann, Jr., New York City

Wyeth's major paintings have been done in the flat and unemphatic technique of tempera. Despite their photographic sharpness of focus and painstaking effort, they are often surprisingly awkward technically, and not altogether convinc-
ing visually. More than one critic has noted that his humanity is curiously lifeless, his anatomies naively misarticulated for all their stupefying and meticulous detail.

Although many journalists have insisted on building an image of Wyeth as a stubborn "loner," he in fact has clear affinities with the Regionalists of the thirties, who turned away from the "corruption" of urban life to celebrate the homespun virtues of the frontier and the rural landscape. His style also owes a considerable debt to his brother-in-law, Peter Hurd, who became known for his arid Southwest landscape paintings; Hurd also first used the meticulous tempera technique. Wyeth carried his manner further, and even glamorized it by creating far more brilliant and stagey theatrical effects, deliberately seeking a poetic intensity ranging from a stereotyped idealism to more threatening moods.

His touches of pessimism and even morbid fancy are perhaps his most authentic feature, and stem from a longtime native tradition of "gothic"

326. ANDREW WYETH. *Young America*. 1950. Tempera on canvas, 32½ × 46″.
Pennsylvania Academy of the Fine Arts, Philadelphia

fantasy and a preoccupation with decay, whether
in nature, run-down farm buildings, or the time-
eroded human countenance. Wyeth's attitude
toward his subject matter is strangely ambivalent,
however, oscillating between hopeful idealiza-
tions of youth and uglified portraiture of old age.
Interestingly, he is usually more honored by the
general public for his optimism and noble senti-
ment than for his harsher, more despairing side.
His introspections, however, do not stand firm
or run deep, for he relies mainly on the stock
responses of his audience, and his art seems cal-
culated and superficial rather than the product of
some inner artistic compulsion. It is the sense of
vacuity in Wyeth's art, with its patinated, "an-
tiqued" surfaces and heavily nostalgic American
way of life, which finally leaves the viewer with a
sense of frustration and discouragement.

The first painting to bring Wyeth fame was
Christina's World. In it a Maine neighbor, crip-
pled by paralysis, reaches tensely and awkwardly
toward farmhouses on the brow of a hill, looming

in the distance almost symbolically like some
unattainable goal. The fine, grassy field is a magi-
cal tracery of abstract writing, reminding one of
Mark Tobey, and also underlining the essential
eclecticism of Wyeth's pictorial manner. The
colors—the arid brown of the landscape and the
chemical pink of the girl's dress—verge on a Sur-
realist intensity, but the parable of entrapment
and frustration finally seems shallow and con-
trived. This theatrical bit of country grotesque,
like so much of Wyeth's art, is ambivalent, falling
between picturesque descriptive detail on the one
hand and a more imaginative identification with
the victim on the other.

What most appeals to the public, one must con-
clude, apart from Wyeth's conspicuous virtuosi-
ty, is the artist's very banality of imagination. He
comfortably fits the common-sense ethos and
nonheroic mood of today's popular culture, de-
spite his occasional lapses into introspection.
The old veteran of World War I, shabby but
proud in his military jacket with his medals; the

young boy dreaming of heroic exploits on the battlefield, and wearing a borrowed airman's jacket too large for him; the gallery of affectionate but patronizing portraits of Negroes around Chadd's Ford, from charming pickaninnies to wizened grandpas; the wine-sodden drifter—these are all apparently actual people who surround Wyeth at his farm. The crowds at his recent museum retrospective delighted in picking them out repeatedly, like familiar characters in a play. It would be tempting to invest these figures with the power of myth, but they refuse to function symbolically. They are quickly grasped and soon forgotten, and all the more so now, because socially they seem so dated and inauthentic.

In the art of a number of American Expressionists, the sense of vulnerability that characterizes the preceding artists achieves a higher pitch of violence and grisly fantasy. Henry Koerner used many of Shahn's technical devices and subjects in the fifties but he turned the American scene into a mockery of billboards, cheap amusement parks, and a bored, brutish, sensation-hungry populace. Alton Pickens, influenced by the symbolism of the German Expressionist Max Beckmann, painted human deformities in the tormented mood of a Grünewald, with an added taste for modern psychological horror. In form these two artists were extremely mannered and unadventurous, for all their technical ingenuities.

Their popularity was not surprising in a country where movies and comic strips cultivate and reflect a taste for violence, and where many of our best writers have found freaks and human degeneration a fruitful subject matter.

The work of Walter Stuempfig in the forties and fifties was also descriptive in character, and depicted the American scene, but he found an old-world beauty in the ugliness of the urban dust heap. Influenced by Eugene Berman and his brother Leonid, and in some of his compositions by Shahn, Stuempfig painted the American landscape with the nostalgia of a European. He gave a gas works or a dilapidated American façade a memorable air of permanence, as if they were a heap of Roman ruins.

Along with realism and traditional romanticism, the dominating tendency of the forties was a vehement Expressionism. It is still practiced by a few distinguished American artists, although it has generally merged with abstraction. Strong subjective feeling, brilliant color, and violent handling became for a time identifying trademarks of American painting. One of the most individual Expressionist painters of the forties was Hyman Bloom. Russian-born, trained in Boston, Bloom was influenced by the blazing color and distortions of Soutine and El Greco. He evolved a personal symbolism of cantors, rabbis, and synagogue interiors of an extraordinary vivid-

327. HENRY KOERNER.
Vanity Fair. 1946.
Oil on canvas, 36 × 42″.
Whitney Museum of American Art,
New York City

328. WALTER STUEMPFIG. *The Wall.* 1946.
Oil on canvas, 31¼ × 48¼".
Pennsylvania Academy of the Fine Arts, Philadelphia

329. HYMAN BLOOM. *The Bride.* 1941.
Oil on canvas, 20⅛ × 49⅞".
The Museum of Modern Art, New York City

ness, aiming for stupendous color effects and rich visual sensations. His debt to Soutine was more than compensated for by the impression he conveyed of deep and sincere emotion. The iridescence of color in the exotic settings and costumes of his church that bewitched Bloom, and his interest in religious ritual, later gave way to a mode of near-abstraction. His themes began to look like interior anatomies, an abstract flesh that glowed with brilliant color as it decomposed and putrefied. Then Bloom's violent romanticism took on a more gloomy cast and he produced a series of bloated corpses and severed limbs, livid and rather frightening.

Jack Levine was Bloom's fellow student at the Boston Museum School, and two years his senior. Like Bloom, he owed a technical debt to Soutine and to other European Expressionists. Unlike Bloom, his art is worldly and satirical, and takes its stand as an indictment of the avarice of the rich, the miscarriage of justice, the squalor of official public life. Though he blurs, distorts, and paints with lavish abandon, Levine is essentially a realist reporter. Even his most violent distortions

cannot dislodge a certain literalism, as if his inventions were superimposed on an armature of photography. His inflamed social conscience and satirical themes invest his art with the flavor of the thirties, and seem remote from present-day artistic preoccupations. Levine's palette has lightened, and his effects have become elaborately illusionist; he paints now in thin washes, creating a fine filament of form and atmosphere in an elaborate effort to give his subjects a quality of mystery.

Both of these gifted technicians, Bloom and Levine, have experienced the same sentimental education, and have drawn parallel conclusions from it. They brought rich and exotic foreign backgrounds to Boston's atmosphere of priggish gentility; both insisted violently on their capacity to feel, to live intensely through the senses in their art. Both were in the social and cultural position of the outsider. And they carried their attitude to the utmost limits with a typical American feeling for extremes: Levine's sense of social outrage turned the society he portrayed into a gallery of grotesques; Bloom's disenchanted mood produced cadavers and a morbid awareness of the corruption of the body, and of death, in the form of ectoplasmic abstractions.

In America the contemporary artist has not always been on the best of terms with life, even though the material comforts of existence are probably more accessible to him here than elsewhere in the world. Indeed, the pressures of materialism and the deeply rooted American psychology of the utility of all products, including the cultural product of art, often undermine the artist's position. On the one hand the artist is made acutely aware of his separation from shallow popular culture, and his creativeness is threatened by this sense of isolation. On the other hand he may also be unconsciously affected by the corrupted visual currency of mass media, of advertising art, and driven into slick and synthetic expression. The "skin" of American realism, fantastic art, and Expressionism often has a distinctly native look, a photographic or commercial-art finish, and an air of deceptive callousness, as if the artist were not only unable to release his basic human sympathies but was even afraid of betraying any obvious affection or regard for the material possibilities of the medium itself. The later careers of Bloom and Levine seem to have been an acting out of violent repentance for their early

330. JACK LEVINE.
The Feast of Pure Reason. 1937.
Oil on canvas, 42×48″.
The Museum of Modern Art,
New York City.
On extended loan from the
United States WPA Art Program

331. MAN RAY. *The Lovers at Observatory Hour.* 1932–34. Oil on canvas, 39⅜×98½″. Private collection, New York City

sensuality in paint. Levine's art has become more and more synthetic and immaterial; Bloom permits himself a taste for luxurious sensation only in a rather contrived atmosphere of the charnel house.

A fantastic realism or Expressionism, rather than Surrealism, have been the usual forms which the more violent reactions to the American experience have taken among our artists. Official Surrealism, with its dreams, romantic disorders, and bizarre inventions, has only touched America

lightly. In Europe Surrealism positively represented a new liberation of sensibility in the continuing revolution of modern art, and an assertion of the artist's prerogative to paint as he wished, to create and dream, even if his dreams reflected personal anxieties or the collective nightmare of the postwar epoch. In America, which ironically prides itself on the freedom of the individual, the artist has been in many subtle ways barred from making such radical appeals to freedom. When he has taken his stand too distinctly outside the

optimistic folkways of American society, the art-
ist is subjected not only to violent criticism, but
also to a destructive process of demoralization.
He suffers from a lingering sense of guilt. In a
utilitarian culture which has still a hard puritani-
cal core, daydreams and chimerical visions are
not easily tolerated. At least they are not usually
set forth in explicitly "high" art, but reserved for
the fantasy-life of the cinema or the lonely-hearts
columns. By mutual consent of artist and public,
Surrealism is frowned upon. It has, however,
forced its way into American art through the back
door, in the more violent forms of realism, in
much of the Symbolist abstract painting of the
early forties, and most recently in the dream ob-
jects of Pop Art.

The notable lack of success of the movement in
this country also stems from the fact that many of
the arcane images of European Surrealism are
alien to the American spirit. It takes a highly con-
scious effort on the part of the American artist to
recover some sense of what Nathaniel Hawthorne
called a "picturesque and gloomy wrong" in his
own past, that awareness of evil which has been
one of the main sources of Surrealist inspiration.
No painter has been able to draw on the formal
culture and puritan repressions of New England
for this sense as have so many of our great writers.
Our artists' indifference to their past has been
most interestingly described by the contemporary
abstract painter Robert Motherwell. Speaking
of Max Ernst, Motherwell has written: "His art
depends on a sense of the vicious past. To the
American mind nothing could be more alien. . . .

332. PETER BLUME. *Parade*. 1930.
Oil on canvas, 49¼ × 56⅜".
The Museum of Modern Art, New York City.
Gift of Abby Aldrich Rockefeller

Such images as a black mass, a bloody nun, an
invader from the east cannot arouse deep feelings
in most of us . . . for better or worse most Ameri-
cans have no sensation of being either elevated or
smothered by the past. . . . Consciously aban-
doning the past is the essentially American crea-
tive act; we painters here remain indifferent to the
objects surrounding us. Our emotional interest is
not in the external world, but in creating a world
of our own. . . . It is from this reasoning that we
can account for the fact that objectless painting,
that is, various modes of abstraction, appeals
more to the most modern American painters than
Surrealism."

The American artist of the recent past closest

333. PETER BLUME.
The Eternal City. 1937.
Oil on composition board,
34 × 47⅞".
The Museum of Modern Art,
New York City.
Mrs. Simon Guggenheim Fund

to Surrealism was Peter Blume. His earliest paintings, such as *Parade* of 1930 and *South of Scranton,* combined free association, fantastic imagery, and the precisionist surfaces of Sheeler and the "Immaculates." In later years he mixed a more illustrational realism with bizarre and ambitious allegory. He paints with the scrupulous care of a fifteenth-century Flemish craftsman, and is clearly an astonishing technician. Blume is also an effective polemicist in such a painting as *The Eternal City,* a violently satirical evocation of Rome under Italian Fascism, with Mussolini burlesqued as a jack-in-the-box. But Blume, it seems, feels compelled to paint for a popular audience, in terms of immediately comprehensible visual facts. Man's struggle with hostile nature and his effort to build a new world were the grandiose themes of one of the artist's more ambitious large paintings *The Rock*. For all its elegance of detail, vivid presentation, and reminiscences of the old masters, the painting is remarkably bleak—a manufactured dream-allegory designed to please an audience accustomed to science-fiction fantasy. Blume is a technically accomplished artist of deep and sincere conviction, who, like another Surrealist crowd pleaser, Salvador Dali, became perhaps too conscious of his own audience.

The pressures on the American painter to produce a facile, smoothly manufactured artistic object, and the general lack of appreciation that awaited those artists who did not submit to popular taste, have resulted in the adoption of extreme aesthetic positions. Personal mysticism, based on an inward poetic vision, has been one of the more fruitful avenues of exploration for a number of American artists. At the other pole, there was apparent in the middle and late forties a growing mood of dynamism and a radical new atmosphere of freedom among abstract artists. In the middle ground between the intensely private romantic and the abstract artist, a number of painters worked as eclectics, keeping alive the contact with international idioms. Stuart Davis, notably, was one of the few artists who remained above the factional battles of the Regionalists and Expressionists in modernism's dark days, during the twenties and early thirties. He maintained a meaningful continuity between America's first phase of experiment and contemporary abstract styles.

Among those artists who have attempted to delineate an intensely personal world, concentrating all the resources of their sensibility at one point, Morris Graves and Loren MacIver are perhaps the most interesting. Their small, passionate utterance and romanticism are in a distinct American artistic tradition, recalling the confined but powerful sensibility of Ryder and the poetess Emily Dickinson. In Morris Graves, too, an entirely new American Regionalism is represented. He has traveled briefly in Europe and

334. MORRIS GRAVES. *Bird in the Spirit*. c. 1940–41. Gouache, 21½ × 42″. Whitney Museum of American Art, New York City. Gift of the Friends of the Whitney Museum

335. MARK TOBEY. *Tundra*. 1944.
Tempera on board, 24 × 16½".
Collection Roy R. Neuberger, New York City

Japan, but otherwise has spent his life in Seattle. Like the art of his neighbor Mark Tobey, Graves's paintings have been associated with the Pacific Northwest. Both Graves and Tobey have been strongly drawn to Oriental philosophy and art. Tobey has made a study of Japanese calligraphy and is known for his "white writing," a delicate, automatic, nonrepresentational script which is probably as indebted to Paul Klee as it is to the art of the East. Graves's art is, by contrast, imagistic and particularized, though it has been somewhat influenced by the witching atmosphere and many of the devices of Tobey's style.

A deeply religious man and a serious student of Vedanta, Graves has made a tender, lyrical poetry from such images as a pine tree tremulously holding a full moon in its branches, or tiny birds and snakes, images which seem to be secreted rather than painted on the canvas or paper. His art is rapt, visionary, hypnotic. Its mystical mood is best caught in the nature poetry which D. H. Lawrence wrote in the New World. In recent years Graves's mysticism has sometimes raised a communication problem for all but the rare, in-

doctrinated religious spirit like himself. For his technique so closely imitates that of the East, even to the use of scrolls and the cultivation of an archaic patina, that his art has often seemed a replica of ancient Chinese or Korean painting. In some of his more recent paintings, however, Graves has returned to a more traditional western expression, employing dryly opulent color that recalls Redon. Such recent ventures as *Fox with Phoenix Wing*, or his more abstract works, have less of an air of preciosity.

Loren MacIver has become one of America's better-known women painters. An imagist poet in paint, she finds unusual pictorial associations in commonplace objects and impressions: in the pattern and rainbow reflections of a gutter oil slick, in a bunch of flowers blooming on a garbage heap, or in the sad phantom-face of one of America's famous clowns. Her paintings attempt to recapture the ecstasy of enchanted moments, a remembered pleasure on the edge of some sad, cold reality. Their soft, smoky pastel shades and gleaming, lapidary lights are given substance by the artist's instinct for abstract design. MacIver's sensibility is intensely feminine, like Virginia Woolf's or Katherine Mansfield's. The city air for her is full of bright images and vivid discoveries that would elude all but the most elfin temperament. During a trip to Italy in 1952 she was dazzled by the visual splendors of Venice, and painted the city as an airy dream-impression, with a delicate necklace of façades dancing in a heat shimmer, punctuating a broad expanse of cool

336. LOREN MacIVER. *Hopscotch*. 1940.
Oil on canvas, 27 × 35⅞".
The Museum of Modern Art, New York City

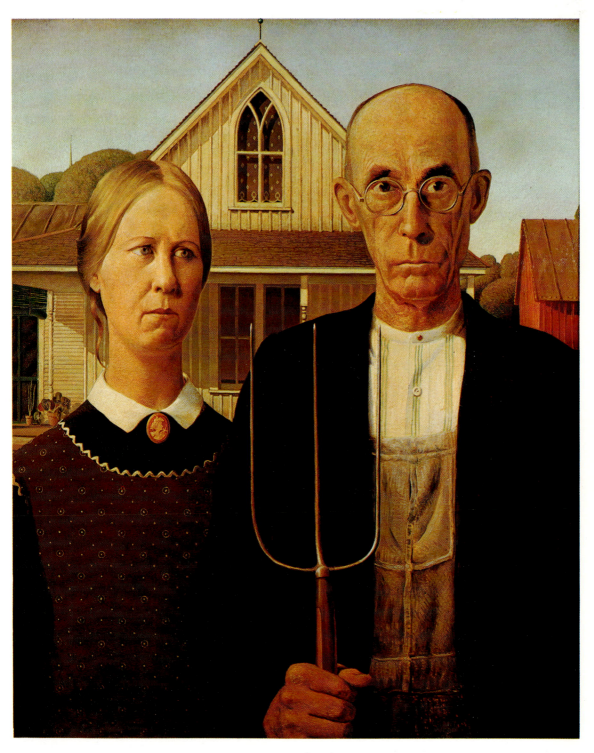

337. GRANT WOOD. *American Gothic*. 1930. Oil on beaverboard, $29\frac{7}{8} \times 24\frac{7}{8}''$.
The Art Institute of Chicago. Friends of American Art Collection

338. JACK LEVINE. *Gangster Funeral*. 1953.
Oil on canvas, 63 × 72".
Whitney Museum of American Art,
New York City

339. REGINALD MARSH. *Pip and Flip*. 1932. Egg tempera on Masonite, 48¼ × 48¼".
Collection Bernard Danenberg, New York City

340. ARSHILE GORKY. *The Artist and His Mother.* 1926–29. Oil on canvas, $60 \times 50''$.
Whitney Museum of American Art, New York City. Gift of Julien Levy for Maro and Natasha Gorky
in memory of their father

341. MORRIS GRAVES. *Blind Bird*. 1940.
Gouache, $30\frac{1}{8} \times 27''$.
The Museum of Modern Art, New York City

343. PHILIP EVERGOOD. *Lily and the Sparrows.* 1939.
Oil on composition board, 30 × 24″.
Whitney Museum of American Art, New York City

342. ANDREW WYETH. *Christina's World.* 1948.
Tempera on gesso panel, 32¼ × 47¾″.
The Museum of Modern Art, New York City

344. ROMARE BEARDEN.
Saturday Morning. 1969.
Collage on board, 44 × 56″.
Cordier & Ekstrom Gallery,
New York City

345. FRITZ GLARNER. *Relational Painting*. 1946. Oil on canvas, 42 × 43″. Collection the artist

346. STUART DAVIS.
Colonial Cubism. 1954.
Oil on canvas, 45 × 60″.
Walker Art Center, Minneapolis

347. STUART DAVIS.
Blips and Ifs. 1963–64.
Oil on canvas, 71 × 53″.
Amon Carter Museum of
Western Art, Fort Worth, Tex.

348. BURGOYNE DILLER. *Color Structure No. 2.* 1963.
Formica on wood, 72¼ × 48 × 17″.
Collection Noah Goldowsky Gallery and R. Bellamy, New York City

349. ILYA BOLOTOWSKY. *Dark Diamond.* 1971.
Acrylic on canvas, 42 × 42″.
Grace Borgenicht Gallery, New York City

blue lagoon and sky. Her art owes much to Paul Klee's innocent wonder before experience; it similarly creates a world in microcosm, an enchanted garden where the commonplace becomes transformed into the marvelous at the wave of a wand.

The common link between all the preceding artists, despite their variety of styles and moods, has been a preoccupation with subject matter, with images either sacred or profane, literal or fantastic. Drawing on the American scene, the artists of the period between the wars for the most part attempted to give visual substance to their feelings within the framework of external reality. Even Morris Graves's visionary art would fit into this general scheme, at least insofar as he, too, uses legible images. While his art is not directly connected with the American scene, its very remoteness from common everyday reality, its intense individuality, and its mood of nostalgia may be taken as a rebuke to his admittedly hostile surroundings. As an artist of narrow romantic sensibility who cultivates exceptional states of mind, he has also taken the route of evasion when confronted with the most radical modern painting, just as those artists have done who more obviously found refuge in external reality.

A cardinal rule of art history is that at any given period certain styles and prescribed pictorial means are more fruitful and productive than others, and that these engage the efforts of the most serious contemporary artists. In our own time the repudiation of illusionism, the rejection of the anecdote, a concern with pure pictorial values, all those tendencies associated with the collective visual revolution known as modernism, have acquired the status of a program for the most convincing artists. Those artists who have turned their back on the form-language of modernism and revived traditional procedures and aesthetic values of the past have been threatened by academicism and second-hand effects. It is, therefore, ironic that the artist who perhaps drew the most vitality from the American scene, and whose art over the last three decades of his life was almost unique for continuous creative impulse, was the confirmed abstractionist Stuart Davis.

Like Hopper, Davis dated from the period of the first realists, the Eight, many of whom he came to know as a boy in Philadelphia. His father was Edward Davis, art director of the *Philadelphia Press*, under whom Shinn, Luks, Henri, and Sloan first worked as artist-journalists. In 1910, at the age of sixteen, Davis began to study painting in New York with Robert Henri, the guiding spirit and spokesman for the new realists. Davis acknowledged Henri's stimulating influence as a teacher and expressed his appreciation of a liberal viewpoint so opposed to the stultifying academic outlook found in most art schools of the period. But he later qualified his enthusiasm when he told an interviewer that "the emphasis on 'anti-artistic' subject matter, which was implicit in the whole Henri idea, tended to give subject matter, as such, a more important place than it deserves in art. . . . Reliance on the vitality of subject matter to carry the interest prevented an objective appraisal of the dynamics of the actual color-space relations on the canvas" and he added: "I became vaguely aware of this on seeing the work at the Armory Show, but it took years to clarify the point."

After working with Henri for three years, Davis was painting in a manner of simplified realism. Soon after leaving school he joined Sloan, Coleman, and other artists of the new realist camp as an illustrator for the old *Masses*, then under the editorial direction of Max Eastman. In 1916 he withdrew from the magazine, with these artists and two others, over policy differences. Art Young, the art director of the *Masses* and victor in the ideological scuffle, issued a statement at the time of the rupture, coining the phrase that led to the most famous of the various epithets used to describe the realists: "The Ash Can School." In the *New York Sun* on April 8 he was quoted as follows: "The five dissenting artists want to run pictures of ash cans and girls hitching up their skirts in Horatio Street—regardless of ideas—and without title."

The break with the *Masses* apparently confirmed Davis's growing doubts about realism and descriptive subject matter already stirred by the Armory Show. In later years he described the impact of America's first wholesale introduction to modernism: "The Armory Show was the greatest shock to me—the greatest single influence I have experienced in my work. All my immediately subsequent efforts went toward incorporating Armory Show ideas into my work." By 1919, Davis was painting landscape in a freer, expressive manner derived from Van Gogh, and had, in his own words, "learned to think of color more or less

351. GERALD MURPHY. *Razor*. 1922.
Oil on canvas, 32 × 36″.
Dallas Museum of Fine Arts. Foundation for the Arts
Collection. Gift of Gerald Murphy

350. STUART DAVIS. *Lucky Strike*. 1921.
Oil on canvas, 33¼ × 18″.
The Museum of Modern Art, New York City.
Gift of The American Tobacco Company, Inc.

objectively so that I could paint a green tree red without batting an eye." In the preceding years Davis had conducted explorations of New Jersey night-life in the company of another young painter who also felt an allegiance to the new naturalist school, and wished to go to actual life for artistic material. Now Davis found in the Post-Impressionists Gauguin and Van Gogh, and in Matisse, "the same excitement" which he had gotten "from the numerical precision of the Negro piano players in the Newark saloons." Thus had Davis begun to make his own relation to the American scene, and to its spirit of dynamism, at the level of popular culture. From that time forward, he always tried to convey in his art something of the vitality he felt so keenly in jazz music.

In 1920 Davis moved toward a more uncompromising nonrepresentational art, using "a conceptual instead of an optical perspective." The following year he was executing such works as *Lucky Strike*, his own vital, painted version of the Cubists' *papier collés*. In 1927, he began the first of a series of abstract variations in the spirit of decorative Cubism, based on the motif of an eggbeater, an electric fan, and a rubber glove. In these paintings Davis drastically simplified his forms, eliminating all but the most schematic descriptive content, and reducing that to a system of flat planes and geometric shapes. "I felt," he was later to say, "that a subject had its emotional reality fundamentally through our awareness of such planes and their spatial relationships." The next year he went to Paris, where he found his radical experimental mood confirmed; he returned to his native land in 1929 and was immediately depressed by the "gigantism" and inhumanity of New York City. He was convinced, nevertheless, that as an American artist he "had need for the impersonal dynamics of New York City." His continuing variations on the eggbeater theme showed an even more simplified graphic style, with larger planes of solid, bright color, relieved by a supple tracery of line.

During the thirties and forties, Davis's style became more abstract, but denser in its linear detail, full of cadenced movement and restless surface activity. Even in his more abstract inventions, however, he depended on locale,

352. STUART DAVIS. *House and Street*. 1931.
Oil on canvas, 26 × 42¼".
Whitney Museum of American Art, New York City

354. STUART DAVIS. *Percolator*. 1927.
Oil on canvas, 36 × 29".
The Metropolitan Museum of Art, New York City.
Arthur H. Hearn Fund, 1956

353. STUART DAVIS. *Rapt at Rappaport's*. 1932.
Oil on canvas, 52 × 40".
Joseph H. Hirshhorn Foundation

introducing a cursive, running script of lettering fragments taken from signboards, and glimpses of some characteristic American shop fronts, houses, or streets.

Although he was indebted to decorative Cubism and perhaps most of all to Léger (whom he once described as "the most American painter

painting today"), Davis gave a distinctly native inflection, a special lightness, and an altogether personal, whimsical humor to his European sources. If his painting sometimes seemed too much in the spirit of the poster and merely a form of graceful decoration, he showed an impressive, structural color sense from the first. "I think of color," he has written, "as an interval of space— not as red or blue. People used to think of color and form as two things. I think of them as the same thing, so far as the language of painting is concerned. Color in a painting represents different positions in space."

Davis added a cleanness of line and sparkling, extrovert color to Parisian idioms. A man who expressed a partiality for jazz and other popular art forms, he sought also to inject brisk new rhythms and an irreverent gaiety into abstract painting. For the stage properties of Cubism, the pipes, mandolins, and harlequins, Davis substituted the surfaces of American life: ensembles of gas pumps, colonial houses, local street scenes, disembodied lettering and signs. Some of his more abstract, irregular silhouettes and his bright color seemed to have anticipated Matisse's humorous, playful *Jazz* cutouts of his last years. The artist revealed an intensity of feeling and a pictorial energy that took his painting beyond the category

355. ARSHILE GORKY. Study for a mural for the Administration Building, Newark Airport, Newark, N.J. 1935–36. Gouache, 13⅝ × 29⅞″. The Museum of Modern Art, New York City. On extended loan from the United States WPA Art Program (mural destroyed)

of decoration. Reflected in his art was also a twenties mood of cheerful but ironic detachment, and a deeply engrained habit of teasing American culture, all of which can be related to the poetry of E. E. Cummings. (Like Cummings, Davis was both a fine lyricist and an effective satirist.)

Davis used scraps of lettering or abstract words and phrases to give an abrasive, contemporary quality to a painting, the shock of a suddenly evoked, everyday reality in the midst of an abstract pictorial scheme. At other times letters were identified with the individual and his emotions in an anonymous urban environment. "I often use words in my pictures," Davis said, "because they are a part of an urban subject matter." He described the content of one of his phrases as being "as real as any shape of a face or a tree. . . ." Thus in a modest way Davis evolved an abstract visual language which was also a sensitive recorder of real impressions—a small language, perhaps, but passionate nonetheless. It was thoroughly contemporary, unmistakably American, and decisively his own.

Davis's art is one of the few links of continuity between America's first phase of advanced art and contemporary experiment. While his expression is no longer related in style or aims to present-day abstraction, in the thirties it provided a useful frame of reference and a point of support for many of the young artists who were beginning to move toward abstraction. David Smith, the

sculptor, indicated that he found stimulation in Davis's liberal viewpoint on the WPA art project, during a period dominated by regionalist styles or a somber Expressionism. Some of the more geometric abstractions by Arshile Gorky in the same era bear a resemblance to Davis's work of the eggbeater phase, as do many of the paintings of the members of the American Abstract Artists group which was formed in 1936, significantly the year in which Alfred H. Barr, Jr., organized the historic exhibition, "Cubism and Abstract Art," at the Museum of Modern Art.

The annual exhibitions of the American Abstract Artists soon became as stimulating a source of advanced ideas for a growing group of younger modernists as 291 had been twenty years earlier. The evolving abstract styles in America tended to be somewhat timid and academic syntheses, at first of Russian and German Constructivism. Mondrian was perhaps the greatest single influence, coming to New York in 1938 and building a following among such artists as Ilya Bolotowsky, Fritz Glarner, and Burgoyne Diller. Indirectly, his purity of style and example of dedication affected artists as diverse as Carl Holty and Ad Reinhardt. A more eclectic abstraction, mixing biomorphism with geometric structure, was apparent in the related paintings of Gorky, John Graham, and the young Willem de Kooning; in these instances, it was Mondrian diffused through Picasso's

356. BURGOYNE DILLER.
First Theme. 1933–34.
Oil on canvas, 30 × 30″.
Collection Mrs. Burgoyne Diller,
New Jersey

358. WILLEM DE KOONING. *Still Life*. 1930–40.
Oil on board, 11¼ × 8¼″.
Allan Stone Gallery, New York City

357. AD REINHARDT. *Untitled*. 1940.
Paper collage, 15¼ × 13″.
Marlborough Gallery, New York City

359. ILYA BOLOTOWSKY.
White Abstraction. 1934–35.
Oil on board, 36¾ × 19″.
Grace Borgenicht Gallery,
New York City

grid-like "studio" paintings of 1930 that carried the weight of admired precedent. Somewhat apart stood Arthur B. Carles, with his more personal and spontaneous paintings, and Hans Hofmann, whose Matisse-like still lifes of the period already anticipated in their Fauvist exuberance the free abstraction which would dominate the next decade in America. For all these different artists Stuart Davis was something of a cultural hero, having persisted in his Cubist-derived art despite considerable public hostility towards international abstract idioms.

To the generation of Hopper, Burchfield, and others who drew on the local scene, Davis's art must have posed a challenge, for it provided more refreshing answers in the quest for a native art than the various styles of romantic realism offered. "In my own case," Davis wrote, "I have enjoyed the dynamics of the American scene for many years, and all my pictures . . . are referential to it. They all have their originating impulse

in the impact of the contemporary American environment." For the generation of emerging younger artists who would soon be moving toward even more radical modes of abstraction, Davis's work confirmed a growing resolve to search for expression outside of representational styles. Just as Alexander Calder served the young sculptors of the period, Davis became for the new painters a living proof that the pressures of provincialism could be successfully set aside. He also provided a high standard of taste, if not a direct incentive for further experiment. Throughout the period of reaction, in the twenties and during the depressed thirties, Davis painted according to aesthetic principles far more strict and exacting than those of his contemporaries. The new generation of abstract artists were to find a badly needed solace and encouragement in his statement: "The act of painting is not a duplication of experience, but the extension of experience on the plane of formal invention."

360. (*top left*) CARL HOLTY. *Of War*. 1942. Tempera on canvas, 45×36″. Collection Robert Graham, New York City

361. (*top right*) HANS HOFMANN. *Pink Table*. 1936. Oil on plywood, 58¼×44½″. Estate of the artist

362. (*left*) ARTHUR B. CARLES. *Abstraction*. 1939–41. Oil on canvas, 41×56″. Joseph H. Hirshhorn Foundation

9 · The Crisis in Painting

IMMEDIATELY AFTER the war years, the most vital developments in American painting centered on a fresh and underivative form of abstraction. Called "Abstract Expressionism" or "Action Painting," and identified with a rather heterogeneous group of painters known as the "New York School," the new painting genre radically transformed our artistic atmosphere. It was generally acknowledged, but more often deplored, as the dominant American current. Perhaps the critical figure in the evolution of the new mode was Jackson Pollock. His name became anathema to the public at large, who received a rather sensational journalistic portrait of him as the Peck's bad boy of technique, as an artist who splashed paint about over immense surfaces in violation of all rules and decorum. To the layman he represented modern anarchy, just as for many younger abstract artists he became the heroic symbol of their new sense of liberation and hope.

Perhaps Pollock's greatest contribution lay in "going the full length," in his willingness to expend himself extravagantly and profligately, often at the cost of the harmony and coherence of individual paintings, in order to take possession of the modern abstract picture with a power and intensity that have become legendary.

Paradoxically, to possess modern tradition on one's own terms became for American artists at a crucial period in our painting history—during the early and middle forties—a way of bringing American art back into the international mainstream. Energy, sometimes reduced to an unrelenting rhythmic monotone or mere motor violence, was one of the hallmarks of Pollock's painting. In the beginning these energies were tumultuous, self-fascinated, and desperate; in the later phases of his work they were more controlled and impersonal. The very superabundance of his pictorial energies, the expression of a power almost grotesque in relation to its situation, links Pollock to a native tradition of romantic exaggeration and hyperbole.

As a distinctly American romantic temperament, Pollock made his own individualism the theme of his art. In an early "dark" style particularly, his paintings functioned as a kind of fever chart of the ecstasies and the torments of his sense of isolation. The very fact that he felt it necessary to express his anguished sensibility in a Herculean dimension was also in the American grain. If Pollock seemed driven to register his own rancors, fancies, and impulses, it was not merely as an act of self-indulgence; his was an honest record of the sensitive man's response to contemporary crisis, an effort to come to terms with a world in which traditional order and traditional values were seriously threatened. The violent emotionalism of his first style marked the rise of a new school of romantic sensibility in American art. It was new because it synthesized indigenous modes of feeling and the vital form-language of European modernism. Pollock's tormented individualism relates him to a whole gallery of American romantics from Melville and Poe through Faulkner. His radical achievement was to make the American romantic sensibility viable in abstract art, to express it unsentimentally, without losing sight of the examples of high creativeness in modern tradition.

That Pollock was able to move into a significant advanced painting style in the late thirties, along with a number of other American artists, was due to a unique set of circumstances. Most important was the international crisis, which made the prevailing Regionalist sentiment and the complacent optimism of American scene painting suddenly appear preposterously provincial. A world in dissolution deserved better of the artist than an uneasy aesthetic isolationism which identified

363. JACKSON POLLOCK. *Totem Lesson II.* c. 1945.
Oil on canvas, 12′ 4¾″ × 11′ 8¾″.
Marlborough Gallery, New York City

powers made them do so in a more critical and independent spirit.

Of all the artistic influences in the air, the belated discovery of Surrealism was perhaps the most important. Surrealism was one of the major lacunae in our artistic culture, and its absence left the modern American artist without a portion of the romantic patrimony. The importance of both Dada and Surrealism arose as much from their mood of romantic protest, their state of mind, as it did from their actual program or artistic methods. Although this spirit had never seized the American imagination, in Europe the Surrealists figured prominently in the continuing art revolution which sought to release the artist from the harsh compulsions of modern life, from what one critic has described as "the regimentation of men and the culture of things." (It is interesting to observe that when American abstract artists did seek in Surrealism new means to express their flight from the crude material values of contemporary life, they were driven not into an art of private dreams, as might be expected, but one of immediate sensations. They revealed themselves as sensitive materialists even as they flew in the face of contemporary materialism.)

virtue in art with the rural western idyl of Thomas Benton, the backwoods folklore of John Steuart Curry, and the somewhat satirical ancestor worship of Grant Wood. The dramatic crisis in European culture drew American artists closer to the spirit of Continental modernism, and the migration of European intellectuals and artists to these shores renewed vital artistic contacts that had lain moribund for many years. There was a sense even by the late thirties, as John Peale Bishop has noted, that the European past had been confided to us, since we alone could "prolong it into the future."

The immediate stimulation for the American vanguard came from the group of Surrealists who gathered around the dealer Peggy Guggenheim in the early years of World War II, and from the influential teaching of the German modernist Hans Hofmann, who had opened an art school in New York. The Federal Art Project of the WPA was another factor in the emergence of an advanced art. As a national experience in self-discovery, it both reinforced and offset the new rapprochement with modern European modes. In their eagerness to find a new way for art, Americans began again to consult Continental examples; but a newly awakened sense of their own

364. HANS HOFMANN. *Bacchanale.* 1946.
Oil on cardboard, 63½ × 47⅞″.
Estate of the artist

365. "Artists in Exile," exhibition at the
Matisse Gallery, New York City, March, 1942. From
left to right, first row: Matta, Ossip
Zadkine, Yves Tanguy, Max Ernst,
Marc Chagall, Fernand Léger; second row:
André Breton, Piet Mondrian, André Masson,
Amédée Ozenfant, Jacques Lipchitz, Pavel
Tchelitchew, Kurt Seligmann, Eugene Berman

366. ARSHILE GORKY. *Untitled*. 1946.
Ink, crayon, and wash, 20 × 26″.
Collection Mr. and Mrs. Stephen D. Paine, Boston

The Surrealists, by their presence in America during World War II, were to offer some very crucial hints for a new synthesis of abstract form and a romantic-feeling content. Their "automatism" and rehabilitation of instinct provided a vital alternative to the geometric design and pattern-making of the academicians of Cubism and abstract art. While the rational constructions of the Cubists had given modern art perhaps its most impressive and elevated style, by the late twenties much of the generative power of the movement had been lost or supplanted by an abstract academicism. In America even a decade

later, a mannered, academic Cubism was considered our most advanced style; it was reflected in the competent, doctrinaire, nonobjective painting of the American Abstract Artists group. To such currents in art, Surrealism posed the alternative of the spontaneous, of unpremeditated impulse, and gave a new primacy to creative freedom. A number of Americans were quick to seize on this alternative, and used it to enlarge the expressive possibilities of their art. Eventually, they subordinated Surrealist intuitions completely to their own artistic needs and purposes.

The impact of the Surrealist liberties on the American avant-garde was sharp, if somewhat oblique. Pollock was undoubtedly affected by the milieu around Peggy Guggenheim, his first dealer, and his own methods were "automatic" to a degree. Later he wrote: "The source of my painting is the Unconscious. I approach painting the same way I approach drawing, that is, directly, with no preliminary studies. . . . When I am painting, I am not much aware of what is taking place; it is only after that I see what I have done."

Arshile Gorky, an elegant, mannered virtuoso in both figurative and abstract modes during the thirties, was in the early years of the next decade deeply influenced by the unstable forms and molten space of Yves Tanguy, Joan Miró, and Matta Echaurren. Later André Breton claimed Gorky for Surrealism when he suggested that Gorky treated nature "as a cryptogram." The earliest paintings of Adolph Gottlieb, Mark Rothko, William Baziotes, and Clyfford Still were all in varying degrees concerned with myth and with the "primitive"; and these artists worked in a

367. Art of This Century Gallery, interior. 1942.
Designed by Frederick Kiesler

368. (*left*) MATTA. *The Earth Is a Man.*
1942. Oil on canvas, 72¼ × 96".
Collection Mr. and Mrs. Joseph R. Shapiro,
Oak Park, Ill.

369. (*middle left*) ARSHILE GORKY.
Garden in Sochi. 1941.
Oil on canvas, 44¼ × 66¼".
The Museum of Modern Art, New York City.
Purchase Fund and Gift of
Mr. and Mrs. Wolfgang S. Schwabacher

370. (*middle right*) ADOLPH GOTTLIEB.
The Rape of Persephone. 1942.
Oil on canvas, 38 × 30".
Collection Annalee G. Newman, New York City

form of symbolic, Surrealist-tinctured abstraction. Along with Motherwell and Pollock, they all relied on "accident," felicitous or disruptive, to give vitality to their creations. The American aesthetic of the accidental descends in a direct line from the Surrealist *trouvaille*, or lucky find.

In New York during the early forties there were two private temples of Surrealism, the Julien Levy Gallery and Peggy Guggenheim's Art of This Century Gallery. Most active and significant was Peggy Guggenheim, who not only became a transmission point for the painting of international Surrealism, but introduced its makers, in the flesh, to the American art scene. She made accessible to the young New York painters whose work she exhibited such artists as Miró, Masson, Ernst, Tanguy, and Matta. For the first time since Duchamp and Picabia had invaded New York in the period of the Armory Show, our art-

371. WILLIAM BAZIOTES.
Dwarf. 1947. Oil on canvas, 42 × 36⅛".
The Museum of Modern Art, New York City.
A. Conger Goodyear Fund

372. ARSHILE GORKY. *Drawing*. 1946. Pencil and wax crayon, 22 × 30″. Estate of the artist

ists knew what it actually felt like to live in the midst of an active international art milieu. They were able to keep abreast of the new currents, not by having recourse to the latest issue of *Cahiers d'Art* as they had in the past, but simply by listening and observing. They must have felt modern art freshly and with a new sense that they were actually living it; contact with many of the impressive reputations of Paris had done something to free them of their provincial diffidence.

More than anything else, it seems now in retrospect, the sudden efflorescence of cosmopolitanism during the war was the inspiration of the new abstract expressions. During the thirties there had been many promising hints of a new synthesis, especially in the painting of Pollock, Gorky, and Hofmann, but they were not entirely decisive. The moment of crystallization had to wait until the first years of the forties, and it was only then that the search for abstract idioms assumed the unity of a sustained collective effort. Hans Hofmann had begun to splash pigment around freely on

373. ARSHILE GORKY. *The Leaf of the Artichoke Is an Owl*. 1944. Oil on canvas, 28 × 36″. Collection Ethel K. Schwabacher, New York City

374. JACKSON POLLOCK. *The Flame*. c. 1937.
Oil on canvas, $20\frac{1}{8} \times 30\frac{1}{8}''$.
Collection Lee Krasner Pollock

375. JACKSON POLLOCK. *War*. 1944
(subsequently inscribed 1947). Brush,
pen and ink, and crayon, $20\frac{1}{2} \times 26''$.
Collection Lee Krasner Pollock

canvas as early as 1938, but his influence was not so immediately decisive as Pollock's. Gorky had in some ways anticipated Pollock, particularly when he began to paraphrase Picasso in the late thirties; but the fascination his sources held for Gorky delayed his highest creative moment until the mid-forties. For all his remarkable instincts and painterly gifts, Gorky lacked the primitive force and energy that seem necessary to bring on the "new" in art. His remained an epicurean sensibility until the last years of his life, when he suddenly seemed to catch fire from the painting atmosphere he himself had been instrumental in creating. Then his art blazed out in passionate fulfillment of his great promise.

The first and most decisive public expression of the new mood came from Pollock. Everything that had been amorphous, contingent on circumstance, and unstable in advanced painting came

into focus in his art with his first New York exhibition in 1943. The unwavering pitch at which he registered his own sensations and even revealed his uncertainties lent a new confidence and security to the American vanguard. His spirit of monumental intransigence and dynamism helped release energies that had been pent up in American art for twenty years. Pollock's first expression was dark and narrow, haunted by obsessive themes and a self-absorbed romanticism; yet he managed miraculously to preserve a plastic painting rationale derived from the most elevated modern styles. He achieved this even as many fellow artists whom we now associate with him seemed prepared to leave the high road of twentieth-century painting tradition for the byways of myth and symbolism. From the beginning there was a touch of revolution in Pollock's painting; many artists who now seem more drastic or advanced are still elaborating on some phase of that revolution.

Pollock had grown up in Arizona and Southern California. Geographical impressions may very well have played a significant role in the development of his painting. He described his delight as a youth at seeing the western landscape, immense and illimitable, unroll before him from freight trains or his old Ford. His early peregrinations filled him even in maturity with some nostalgia, as if the freedom of boyhood and the open road were best. He retained something of the restiveness of his youth and an unformulated, primitive sense of the vastness of things American. A rootless feeling which was as sharp as his instinctive distaste for social restraints, real or imagined, persisted throughout his life. He was killed in a tragic automobile accident in the summer of 1956, at the age of forty-four.

As a personality he recreated D. H. Lawrence's ambiguous picture of the American free spirit in *Studies in Classic American Literature*. Lawrence was acute enough to see in American writing of the golden age a refreshing, new human consciousness, as he put it. At the same time, he suggested that the American writer, who lacked so many of the assurances of a cultivated existence and was *sui generis* a romantic, might shrink from the harsh forms of native reality and seek relief in the expression of extreme states of mind. For Lawrence, the American imagination was in fugue, in eternal revolt against the parenthood of European authority and traditional values. In the

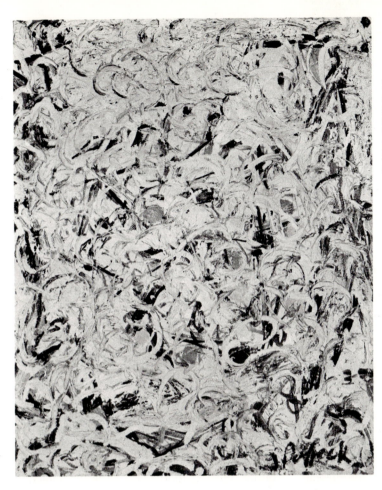

376. JACKSON POLLOCK.
Sounds in the Grass:
Shimmering Substance. 1946.
Oil on canvas, $30\frac{1}{8} \times 24\frac{1}{4}''$.
The Museum of Modern Art,
New York City.
Mr. and Mrs. Albert Lewin
and Mrs. Sam A. Lewisohn Fund

377. JACKSON POLLOCK.
Echo. 1951.
Oil on canvas, $91\frac{7}{8} \times 86''$.
The Museum of Modern Art,
New York City.
Acquired through the
Lillie P. Bliss Bequest
and the Mr. and Mrs.
David Rockefeller Fund

need and passion to create new artistic values where none existed before, American genius fulfilled itself. "Henceforth masterless" was his half-mocking, half-admiring refrain for the New World's mystique of freedom. Impatient of European civilization, and himself eager to find renewal at more primitive sources, Lawrence was able to sympathize with antitraditional modes of feeling and expression. But he was also mindful of their limitations, and warned that the American's romantic egoism might become a prison. The estrangement of the modern writer and painter from contemporary mass culture seems more acute in America because, as Lawrence discerned, it feeds on a native habit of inwardness. Modern art in Europe has also been created under conditions of isolation ever since the Impressionists. But the alienation of the artist has been less destructive in tradition-directed cultures. An urge to abstraction and the suppression of individualized feeling has always been indigenous to the American temper.

The romantic bias of Pollock's individualism and his sense of freedom as expressed in his art stand out in sharper definition when his work is compared with the abstract painting of the same European generation. No painters of the French vanguard, many of whom acknowledged Pollock's influence, permitted themselves the liberties

he took. Barring some notable exceptions, the foreign abstract article generally still kept the look of studio manufacture, and an air of knowing if shallow professionalism. Pollock's raw directness and his lack of finish struck most contemporary European critics as being in appallingly bad taste. Those painters who followed his example in France under the banner of *tachisme,* and briefly adopted his formal devices and scale, were unwilling or unable to pursue the more radical implications of his art. From criticism during the 1950s in Europe of contemporary American painting, it would seem that the French, especially, regarded artists like Pollock as little more than promising; they were convinced that painting only *begins* where American abstract art so suggestively but disappointingly ended. Behind Pollock's art was a conviction, equally strong, that the moment painting indulges in a derivative pictorialism, the moment it becomes a conscious artifact, it loses its creative meaning. The European found audacity, originality, and certain intriguing effects in the new American painting, but missed its inner working process.

The eruption of new creative energies may be attributed to the divided will of our art at the end of the thirties, to the often self-contradictory efforts of American painters to reassimilate modernism and also to discover themselves. A fellow

378. LEE KRASNER. *Bird's Parasol.*
1964. Oil on canvas, 61 × 46⅛".
National Music Publishers' Association, Inc.

379. ALFONSO OSSORIO. *To You the Glory.* 1950.
Watercolor and wax, 30 × 22".
Collection Edward F. Dragon, East Hampton, N.Y.

380. MARK TOBEY. *E Pluribus Unum*. 1942.
Tempera on paper, 19¾ × 27¼″.
Seattle Art Museum.
Gift of Mrs. Thomas D. Stimson

381. LANDES LEWITIN. *Knockout*. 1955–59.
Oil and ground glass on composition board, 23⅞ × 17⅞″.
The Museum of Modern Art, New York City.
Promised gift and extended loan from Royal S. Marks

painter has said perceptively that in the beginning Pollock was influenced by Picasso, and then turned against his inspiration and violently eliminated all evidence of his debt. The very erasures, eliminations, and emendations were converted into a viable expression, as they were during that same period in the more urbane but also more derivative work of Gorky. The American vanguard's search for authority has been a troubled one, moving between a Scylla of fashionable modernism and a Charybdis of provincial Expressionism. The history of that voyage is the story of Pollock's evolution as a painter.

Pollock began his artistic education in 1929, when he came to the Art Students League in New York and studied with Thomas Benton. Benton's homely American scene realism was at the time compelling, and he was a vital personality who exerted a strong influence on his students. Although Pollock studied with him for only two years, he did not begin to shake off Benton's style until the middle thirties. It is significant that the younger artist found his independence not so much in reaction to Benton but *through* him, by re-creating, amplifying, and exaggerating his first teacher's rhythmic distortions under conditions of greater intensity, until his forms achieved a different order of life. In a sense, Pollock arrived at abstraction by pushing Expressionism to a point where subject matter was so improbable

382. RICHARD POUSETTE-DART. *Star Happenings*. 1968. Oil on canvas, 41 × 75″. Collection Joan Simon, New York City

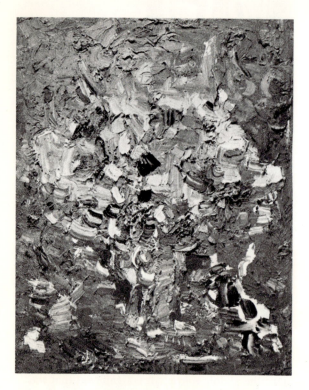

383. HANS HOFMANN. *Fragrance*. 1956.
Oil on canvas, 60 × 48″. Honolulu Academy of Arts

a night sky in the background lit by blood-red flames. The artist always felt a very personal relationship to the painting, which stood as a private symbol of frustration and hope and represented a voyage of the soul from darkness into light. The fact that the light in the painting emanated from a conflagration apparently signified that Pollock's crisis would be resolved by violent catharsis.

In a sense that is exactly what happened immediately afterward, first in his bold distortions based on Mexican painting and then in his rapid and aggressive assimilations of Picasso and European modernism. In the late thirties, Pollock filled notebooks with abstract anatomical themes that were Picassoid, but with a difference. To Picasso's delimited, contained abstract imagery of the period Pollock applied his own expansive energies, with startling and novel results. His nervous, broken line shredded Picasso's fantastic anatomies, reducing them to a system of

that there was no need to retain it. By the middle thirties, Pollock found in the Mexican Orozco a more satisfying drama of violence. His paintings of this period are muddy, crude, and inchoate but already stamped with genuine temperament; they still describe, if very freely, figure groups or landscapes.

In 1936 Pollock began to eliminate recognizable subject matter, and replaced it with angular, nonrepresentational shapes and thick, rhythmic coils of tarry black line which stood out in assertive texture and relief. His color combinations of muddy blue-greens, brick reds, and yellows were loud and violent; the forms, elementary in their simplicity but full of character. These paintings were still close to Orozco in spirit. Curiously enough, the color schemes and rugged, plastered surfaces were similar to some Gorky still life of the same epoch—paintings which, however, Pollock denied he had ever seen.

There is one small crayon and watercolor painting from this period of a rather more representational character that deserves attention for what it reveals of Pollock's inner struggle. It is an alternately muddy and vivid little landscape, with a black hole in the foreground holding a ladder, and

384. HANS HOFMANN. *Olive Grove*. 1960.
Oil on canvas, 84 × 52″.
Private collection, New York

385. JACKSON POLLOCK. *The She-Wolf*. 1943. Oil on canvas, $41\frac{7}{8} \times 67''$. The Museum of Modern Art, New York City

386. ARSHILE GORKY.
The Liver Is the Cock's Comb.
1944. Oil on canvas, 72 × 98″.
The Albright-Knox Art Gallery,
Buffalo, N.Y.
Gift of Seymour H. Knox

387. HANS HOFMANN.
Effervescence. 1944.
Oil, india ink, casein, and
enamel on panel, 54 1/8 × 35 1/2″.
University of California Art Museum,
Berkeley. Gift of the artist

388. WILLEM DE KOONING. *Excavation*. 1950. Oil on canvas, 6′ 8⅛″ × 8′ 4⅛″.
The Art Institute of Chicago. Gift of Mr. Edgar Kaufmann, Jr., and Mr. and Mrs. Noah Goldowsky

389. BRADLEY WALKER TOMLIN. *No. 20*. 1949.
Oil on canvas, 7′ 2″ × 6′ 8¼″.
The Museum of Modern Art, New York City. Gift of Philip C. Johnson

390. ROBERT MOTHERWELL.
Pancho Villa, Dead and Alive. 1943.
Gouache and oil with collage
on cardboard, 28 × 35⅞″.
The Museum of Modern Art,
New York City

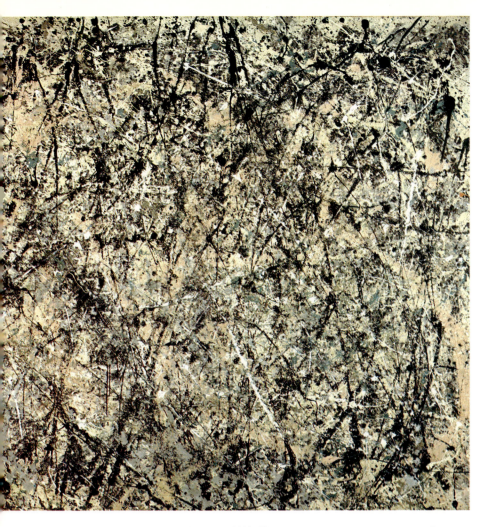

391. JACKSON POLLOCK. *Lavender Mist*. 1949–50.
Oil, enamel, and aluminum paint on canvas,
7′ 4″ × 9′ 11″.
Collection Alfonso Ossorio and Edward F.
Dragon, East Hampton, N.Y.

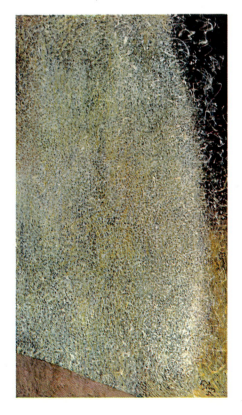

392. MARK TOBEY. *Edge of August*. 1953.
Casein on composition board, 48 × 28″.
The Museum of Modern Art, New York City

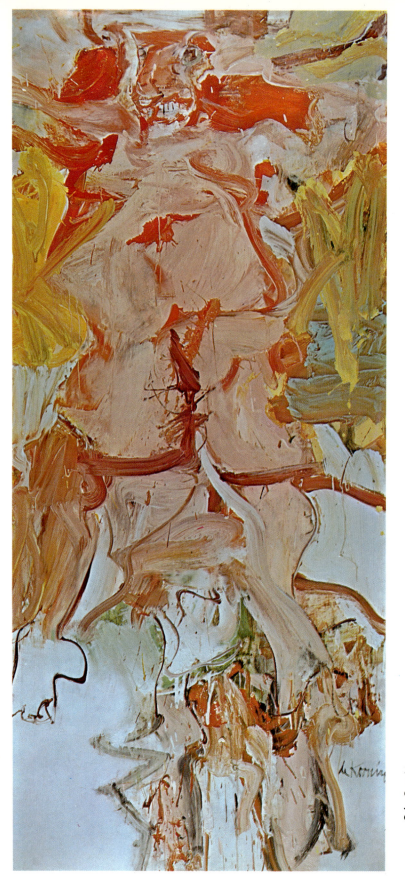

393. WILLEM DE KOONING. *Woman, Sag Harbor.* 1964. Oil on wood, 80 × 36″. Joseph H. Hirshhorn Collection

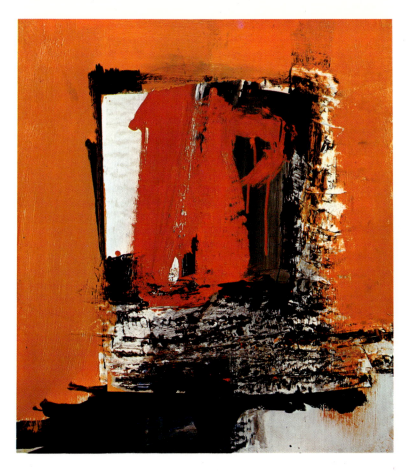

394. FRANZ KLINE. *Reds over Blacks*. 1961. Oil on canvas, $21 \times 18\frac{1}{2}''$.
Collection A. I. Sherr, New York City

395. JAMES BROOKS. *Gordion*. 1957. Oil on canvas, $41\frac{1}{2} \times 89\frac{1}{2}''$.
Collection Dr. and Mrs. Bernard Brodsky, New York City

396. HANS HOFMANN. *Ignotium per Ignotius*. 1963. Oil on canvas, 84½ × 60″.
Collection Mr. and Mrs. Deane F. Johnson, Los Angeles

397. ROBERT MOTHERWELL. *Western Air*. 1946–47.
Oil on canvas, 72 × 54″.
The Museum of Modern Art, New York City

In 1942 Pollock participated in his first New York group show, organized by John Graham at the MacMillan Gallery. Showing with him were Graham, Lee Krasner (now Mrs. Pollock), and Willem de Kooning, another unheralded member of the avant-garde who less than ten years later was to share the leadership of progressive American painting. Pollock showed a blue-green, Ex-

398. WILLEM DE KOONING. *Night Square*. c. 1949.
Enamel on composition board, 30 × 40″.
Martha Jackson Gallery, New York City

399. (*bottom*) WILLEM DE KOONING. *Related to Attic*. 1949.
Oil on paper, 30½ × 40″.
Collection Dr. and Mrs. Israel Rosen, Baltimore

expressive accents or more generalized thematic variations. Carried away perhaps by a random inventiveness in line, Pollock had begun to create more evenly distributed effects. They broke up the unity of Picasso's abstract figuration and were the first step toward a free and cursive calligraphy which totaly dispensed with image suggestion.

These drawings also revealed a tension between ugliness and elegance, clumsiness and finesse, that persisted throughout Pollock's work. He often seemed to wish to destroy his great natural gifts as a draftsman by deliberately breaking the rhythm of his line when it had achieved only the most rudimentary signs or configurations. If Pollock pursued the rude and apparently incomplete statement, however, it was with the purpose of freeing himself from the prejudice of geometric design. Even more, he sought to repudiate *any* commitment as to style or manner; in this early work there was, indeed, almost a fetish of "nonstyle." Such impersonality has disturbed many critics. It was a necessary adjunct to a more elevated painting objective, however: the aim to create a more inclusive, plastic point of view which would translate even the most extravagant emotion into convincing pictorial sensation. His sensitivity to the felt structure of drawing and later of painting in all its palpable immediacy had much in common with early Cubism, and that despite a great show of recklessness and the apparent absence of formal order.

400. FRANZ KLINE. *Nijinsky* (*Petrushka*). 1949.
Oil on canvas, 33½ × 28".
Collection Mr. and Mrs. I. David Orr,
New York City

401. FRANZ KLINE.
Nijinsky (*Petrushka*). c. 1950.
Oil on canvas, 46 × 35¼".
Collection Muriel Newman, Chicago

pressionist-flavored abstract painting. His abstract figuration had a look of phantasmagoria and already resembled those disembodied, astral eyes which later became a key theme in his painting. In these agitated movements and grotesquely suggestive whirlpools of line Pollock found a private totem which persistently refused to be expelled from his painting.

Some time later, de Kooning, too, discovered that his abstract paintings were still inhabited by an obsessive reality, the human figure of an earlier phase, or, more exactly, the Woman. Such fearful presences are not out of character with Abstract Expressionist painting, because the genre permits wide inclusions. They also indicate that this painting was never abstract in the more narrow, limited sense of nonobjective art. It was, on the contrary, always emotive and vital in its handling, and rich in content, a content that betrayed the exaggerated fears, the exalted moods, and the libido of its creators.[1] Frequently this content suggests a search for some hidden or lost mytho-poetic symbolism. A highly charged atmosphere survives in Pollock's freest abstract transpositions from Picasso, and these paintings often end, as if he had been powerless to prevent it, by looking like fantasias of the unconscious.

In the general rhythm of Pollock's work, imagery itself generates an abstract invention which destroys references to natural appearances. But

[1]Edgar Allan Poe provides useful clues to the ambiguous content of Pollock's painting. An unconscious byproduct of paint manipulation, this content is at once more than an expression of pure aesthetic relation and less than imagery. Pollock's forms, or writing, are too emotionally charged and unstable to be contained by the first category; and they are not sufficiently articulated or explicit in reference to fit the second. They belong perhaps to Poe's realm of "fancies," which he described in *Marginalia* as follows: "There is a class of fancies, of exquisite delicacy, which are *not* thoughts, and to which, *as yet*, I have found it absolutely impossible to adapt language. I use the word 'fancies' at random, and merely because I must use some word; but the idea commonly attached to the term is not even remotely applicable to the shadows of shadows in question. They seem to me rather psychical than intellectual. They arise . . . at those mere points of time where the confines of the waking world blend with those of dreams. . . . Now, so entire is my faith in the *power of words,* that, at times, I have believed it possible to embody even the evanescence of fancies such as I have attempted to describe." One should not make the mistake, however, of considering Pollock an inspirational, paint-drunk genius, or as a creator of fantasy primarily. He had always addressed himself to medium in immediate physical and material terms. It is possible to achieve fully formed fantasy only by illusionist pictorial means which no longer prove useful to many serious contemporary artists. Pollock steadfastly repudiated illusionist devices as a violation of modern art's tradition of concreteness and its central aesthetic purposes.

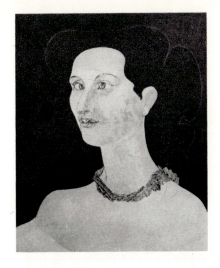

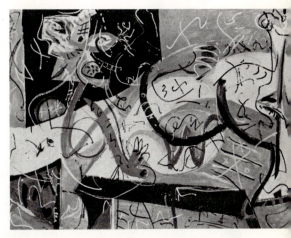

402. ARSHILE GORKY. *Portrait of Master Bill*. c. 1937.
Oil on canvas, 52 × 41 ⅛″.
M. Knoedler & Co., New York City

403. JOHN GRAHAM. *La Dame en Blanc*.
Oil on canvas, 24 × 20″.
Andre Emmerich Gallery, New York City

404. JACKSON POLLOCK.
Stenographic Figure. 1942.
Oil on canvas, 40 × 55 ¾″.
Collection Lee Krasner Pollock

405. JACKSON POLLOCK. *Pasiphae*. 1943.
Oil on canvas, 56 ⅛ × 96″.
Collection Lee Krasner Pollock

406. CONRAD MARCA-RELLI.
Seated Figure, Outdoors. 1953.
Paint and canvas collage, 20 × 15″.
Private collection

his purer, nonrepresentational spatial "writing" also has a backlash of suggested presences and near-imagery. Much of the power of his early work springs out of the tension of renunciation: the image is denied but something of its atmosphere and immanence remains, creating a powerful and luminous diffusion of felt content throughout the length and breadth of the canvas. It was only after Pollock had worked through and exorcised the more pointed images which referred to his own exasperations and fears that he, and then many of his fellow painters, could draw with unconscious freedom on the purer or more "abstract" aspects of Abstract Expressionism.

In 1942 Robert Motherwell introduced Pollock to Peggy Guggenheim, and that year he exhibited in a group show at her gallery the painting *Stenographic Figure*. It was a loosely knit arrangement of shapes derived from Picasso with a kind of erratic "automatic" over-writing. The colors were bizarre mauves and blue-greens, set against grays and off-whites, suggesting somewhat the high color key of Mexican papier-mâché decorations or the palette of Northwest Indian art. This was

407. RICHARD DIEBENKORN.
Man and Woman in Large Room.
1957. Oil on canvas, 71 × 63″.
Joseph H. Hirshhorn Foundation

probably the first painting in which Pollock's vermiform shapes actually broke down into energy areas and a free calligraphy. The next year, at the age of thirty-one, Pollock was given his first one-man show at the Art of This Century Gallery, and with it began a prolific period of production that carried him through eleven exhibitions in twelve years.

From the years between 1943 and 1947 date the anatomical themes and the compact compositional schemes of such paintings as *The She-Wolf*, *Pasiphae*, and the more abstract *Gothic*. Pollock had already begun to unify his pictures by "writing" freely over the surface with an energetic, whiplash line. He had learned to release a confused and opaque bitterness by sheer energy, by the very fury of his attack. The result was that he literally remade the abstract picture, and under new conditions of extraordinary intensity.

In *Pasiphae* and *The She-Wolf* Pollock's baroque energies took him to a new form of expression that relieved the dense, impacted surfaces of Picasso's late Cubism with the fluent, abstract imagery of Miró and the "automatism" of André Masson. To the Surrealists he owed not so much the form of his own distinctive all-over "writing" as the notion that the painting was to be ejected continuously, in one seeming burst. The wiggly lines and agitated movements of these two paintings recall Miró of his 1924–1926 period. Miró, however, floated his shapes on a ground, giving his pictorial incident a setting and hinting at representational illusion. His shapes kept their integrity as individualized forms despite their metamorphoses. From Miró's ingenious and inventive mind streamed an anarchic abundance of new life and pictorial incident, with an effect of multiplicity and particularity. Rooted in modern tradition, he could afford to play and pun, to sport with his own fears and to make an enchantingly witty game of them. For Pollock, on the other hand, abstract painting was an altogether more solemn and even desperate matter; he felt compelled to be more savage and self-absorbed and had nothing of the artistic playboy about him. He saw the abstract picture as an elementary expression of belief, and in this conviction lay his power and originality. Pollock's paintings groped from the particular to the general, from a chaos of expressive accents to the single statement. He dissolved and fused his vague references to a chimerical subject matter into a unified, imper-

408. GRACE HARTIGAN. *City Life*. 1956.
Oil on canvas, 6'9" × 8'2½".
Private collection, New York

sonal scheme. After the picture was completed, he named it for the chimera it still rather irrelevantly suggested. In the end the painting had become a continuous field of uniform accents where it was impossible to distinguish between scrolling lines of paint and phantasmagorias, the near and the far, the symbolic and the plastic.

Pollock's early style culminated in his predominantly black, vehemently pigmented canvases of 1945 such as *Night Mist* and *Totem Lesson II*. The latter is a large, vertical painting where he played with a grotesque abstract figuration within his own powerful system of chiaroscuro. To achieve intimations of terror within disorder and chaos seemed to be the message of this forbidding and claustrophobic work. Other paintings of the period carried Pollock's anxiety to an unrelieved extreme. After 1947, however, his gloomy and morbid intuitions were spread over a broader surface, and he surrendered most of his inner compulsions to a calm and measured lyricism. The vaguely imagistic references to his own fears and fantasies stopped crowding him and gave way to more sweeping and grandiloquent rhythms and a new clarity. His work no longer suggested presences, fearful or otherwise, or a mood of exasperation, but only a generous and impersonal flow of pictorial energy. He had won a new

breadth of feeling as he learned to master larger surfaces.

Pollock's ambition carried him far beyond the traditional unity of easel painting in search of a more monumental space and a total pictorial experience. In 1948 and the early months of 1949 he painted most often on narrow horizontal canvases with irregular patches of cobalt, cadmium red, and white against a dull reddish-brown ground. Even such an assertion of a Mondrian scheme of simple primary colors reflected an objective spirit. These long, narrow "scroll" paintings still retained something of the particularization, texture, and sensuality of his earlier work, despite their freedom, and had a balance and poise unique in Pollock's productions. *White Cockatoo* and *Summertime* are typical of this high moment; their lyricism and purity of movement remind one of the abstract yet deeply expressive gestures of modern dance.

From 1947, the year he began to paint with aluminum and commercial paints, and to "drip" as well as brush his pigment on canvas, Pollock strained against the limits of the oil medium. He began to contrive a more radical space, and invented altogether more remarkable painting effects, working on an ever more monumental scale, in a grandiose personal pointillism. As Hans Namuth's dramatic series of still photographs and the film of Pollock at work demonstrate, he painted by standing over a canvas and letting paint drip on it from above until he had achieved the rhythmic movements, varied densities, and textures desired. The results were probably the most original series of paintings of the immediate postwar period in American art. Yet they were a logical, if unexpectedly ambitious, extension of Pollock's early style. He had merely given his open, "drip" painting a larger theater; an aerated web of silver and black line, of spattered paint, against a background of delicate color diffusions and stains, replaced the old opaque, resistant pigment. Despite the lyrical sublimation of his more turgid style, something of the original tension of Pollock's feeling remained. In *Cathedral* of 1947 and in the beautiful *Lavender Mist* of 1950, there are congealed puddles of color and blotches of dark tone swimming ominously amid all the elegant rhythmic phrasing like disembodied ghosts of the artist's earlier black moods.

Pollock's predominantly silver monoliths took painting ever closer to a kind of fragile, open-form, continuous-space sculpture. (In a more serene and architectural style, the sculptor Ibram Lassaw has demonstrated that Pollock's methods and intuitions are viable in three-dimensional form.) He made paintings that approach solid relief in texture, and he also simultaneously pulverized the flat, two-dimensional effect that he had in the past been at pains to emphasize, and which had been perhaps his strongest link with Cubist surfaces. But Pollock's modernity, his mistrust

409. ESTEBAN VICENTE. *Black, Red and Gold.*
1964. Collage, 24 × 30".
Andre Emmerich Gallery, New York City

410. JACK TWORKOV. *House of the Sun.*
1953. Oil on canvas, 50 × 45".
Collection the artist

411. FRANZ KLINE. *Mahoning*. 1956. Oil on canvas, 6′ 8″ × 8′ 4″. Whitney Museum of American Art, New York City. Gift of the Friends of the Whitney Museum

of anything but the immediately given sensation, always asserted itself in the end. Even in his freest inventions he restored the flat, physical reality of the surface by letting his pigment clot or by slapping the unsized edges of the canvas with his paint-dipped palms. Sometimes the synthetic, industrial textures, the moraine of sheer pigment matter, seemed to choke his instinctive grace and lyricism, and a kind of gummy, displeasing effect resulted. At their finest, however, the great silver paintings from 1947 to 1951 breathe an easy, natural grandeur that has few parallels in contemporary American art. For the author they arouse primitive feelings associated with such sonorous phrases as "the deep" or "the starry firmament," identifying a universe beyond the human. However, any intelligible, identifiable feeling-content reveals itself fitfully in the midst of a nameless chaos, for Pollock's fine lyricism must repeatedly be wrested free from the anonymous seething of brute pigment-matter. It was one of Pollock's

signal accomplishments to give such magnitude and impressiveness to the act of painting as to make us think of the mysteries of natural creation, of that "first division of chaos" at the origin of our world.

One cannot live with such an exalted aspiration for long. Seeking the relief of a more classical dryness, Pollock in 1951 and 1952 reduced his palette to black and white and returned to the firmer unities of his first style, emphasizing draftsmanship and making his blacks bite vehemently into the unsized canvas like an engraver's line. A periodic denial of color was a persistent element in Pollock's art from the beginning.

Manet, Lautrec, and especially Matisse in his Cubist phase, gave magisterial blacks and grays a primary role, as if to dramatize the drastic, two-dimensional character of modern painting; by its very nature monochrome painting is more abstract than color. The repudiation of color is one way of returning to the fundamentals of struc-

412. ROBERT MOTHERWELL. *Summertime in Italy*, No. 8.
1960. Oil on canvas, 8′4″ × 5′10½″.
Staatsgalerie, Stuttgart

ture, as Willem de Kooning, Robert Motherwell, and Franz Kline have dramatically demonstrated. Pollock's "black" paintings were also curiously enough part of a new search for order and restraint within a vigorous contemporary style. The paintings of 1952 had a sobriety and decorum, even though some of the abstract anatomical imagery of his earlier period was revived. Among the most impressive though least ingratiating of Pollock's paintings, they left no doubt as to his power to control large spaces even with the most radically reduced pictorial means.

In the last four years of his life Pollock alternated modes, sometimes drawing in black paint, at other times creating opulent displays of refulgent color. He returned to the all-over or "skein" painting of 1948–1951, exploiting a new device of flooding his canvas with white pigment until only

narrow, ragged edges and trickles of dark tone could be discerned, somewhat in the manner of Clyfford Still. He reached no radically new conclusions after 1952, but was intent upon exploring and amplifying the many new roads he himself had opened in his first ten years of painting.

In these further explorations Pollock's work continued to point up the new set of premises in American painting. He established a new alliance with the spontaneous and the accidental, which was part of a more purposive aesthetic than that of the Surrealists. Pollock identified his creative liberties with an unmistakably American atmosphere. His paintings had begun in a fierce mood of nihilism; one has to go back to the late Soutine to find work as raw, direct, and careless of the traditional integrity of medium as the early Pollocks. He later also established his connection with Dada's mood of iconoclasm and disgust with society, first by his violent imagery, and then by his handling of tarry blacks, his non-aesthetic, industrial textures, and by embedding cigarette ends, broken glass, and bits of string in his pigment. In the end he subordinated his rancors and romantic individualism to a mood of impersonal idealism, creating finally a new abstract art form of transcendent beauty.

The bold outlines of a vital new idiom were present in Pollock's first show. His energies encompassed forms and methods derived from many sources—Picasso, Miró, Masson, and American Indian art—and symbolic references to his own feverish mood of crisis. The outcome was a body of painting with a radical new physiognomy, stamped with powerfully original feeling. Compared to its more felicitous French counterpart, in the art of Soulages, de Staël, or Mathieu, Pollock's Abstract Expressionism, even at its most refined, was unfinished, violent, full of astringencies, with a tone harsh and primitive. Yet it helped significantly to create painting modes larger than any Europe had been able to supply for more than two decades. To give personal freedom new and distinctly native artistic outlines was Pollock's great contribution. In the face of the experimental variety of previous twentieth-century European art, it has taken on the character of a major international accomplishment.

10 · Action Painting: The Heroic Generation

THE FIRST PAINTING movement to bring American artists world-wide notice after the Second World War was Abstract Expressionism, or in Harold Rosenberg's suggestive epithet coined in 1951, "Action Painting." These terms describe a loose association of artists guided by common aims who emerged during a period when the School of Paris seemed to be bereft of new ideas and dying of skill. The decline in the momentum of European innovation, and catastrophic public events on the Continent had the paradoxical effect of releasing new energies among young American artists. For a moment, it even seemed as if the main impulses of modernism had been expatriated and driven underground in this country, for the emerging American vanguard drew support and inspiration in its complex beginnings, as noted in the previous chapter, from contact in New York during the war years with a number of Europe's leading artists and intellectuals. Léger, Tanguy, Mondrian, Breton, Ernst, and Matta, among others, maintained warm and influential relationships with many of the younger Americans, and bridged the intimidating distance between them and advanced European art. A number of these European artists showed at Peggy Guggenheim's Art of This Century Gallery, and it was there that the pioneer American Abstract Expressionists Pollock, Rothko, Still, Hofmann, Motherwell, and Baziotes held their first one-man shows, between the years 1943 and 1946.

It is instructive to reflect on some of the misunderstandings concerning the postwar American avant-garde as it emerged thirty years ago, for these misconceptions will lead us to a better understanding of the original qualities in their work, and may help explain their wide international influence. While Pollock found himself being hailed as a new kind of Surrealist, Arshile

413. MATTA. *The Bachelors 20 Years Later*.
1943. Oil on canvas, 38 × 50″.
Private collection, Williamstown, Mass.

414. ARSHILE GORKY. *Agony*. 1947. Oil on canvas,
40 × 50½″. The Museum of Modern Art, New York City.
A. Conger Goodyear Fund

Gorky was showing works that were appreciated as a derivative, if extremely accomplished, imitation of current European pictorial manners, a sensitive commentary particularly on Picasso, and on Miró's abstract Surrealism. It scarcely

415. WILLIAM BAZIOTES. *Night Landscape*. 1947. Oil on canvas, 36×42″. Collection Dr. and Mrs. Isreal Rosen, Baltimore

seemed conceivable that anything of distinctive individuality could emerge from such an obvious reconstruction of European styles, unless it was to be an elegant form of parody.

The German modernist Hans Hofmann, who came to live and teach permanently in the United States in the early thirties, had also posed a problem in originality with the work he first exhibited in a 1944 one-man show at the Art of This Century Gallery. His paintings showed a discerning grasp of School of Paris design, combining Matisse's color planes and Cubist structure within a stylistic synthesis regarded as both eclectic and academic. Few critics had the foresight to credit Hofmann with a distinctive originality, so ingrained and habitual was the prejudice that American modern art was by definition secondhand and derivative. In fact, as early as 1940 Hofmann had created the first so-called drip

paintings, using a radically new kind of pictorial organization and design which anticipated Pollock's methods of subsequent years.

Other artists in the small and earnest avant-garde community of that period, notably Baziotes, Gottlieb, Motherwell, Rothko, and Still, were also considered little more than promising if somewhat unsophisticated students of European modernism. Their ventures were so crude and unfinished, by newspaper accounts, and with the exception of Motherwell they had struck out in abstract styles at such advanced ages that their conversion to radical modern art seemed to offer little hope for a mature and rich originality. The postwar period, then, was one of particular confusion and uncertainty. American artists, emerging from their preoccupations with the social themes of the Depression years, found themselves confronted by a corpus of innovation

and experiment in the achievement of international modernism which intimidated them by its discouraging completeness.

Nevertheless, in an atmosphere of postwar social crisis which, intellectually, paralleled the episode of European Existentialism, there arose rather remarkably in New York City a loose new artistic movement which managed to inject into an assimilated European modernism a new-found, native energy and confidence. A mood of continuous discovery was soon to change the prevailing character of our painting and sculpture, and would even extend its influence to European art. This prolonged episode is one of the most fascinating and vital developments in American cultural life of the century.

The artists responsible for the new and powerfully original American art of the postwar period have been called, variously, Abstract Expressionists, the New York School, or Action painters. None of these terms is entirely illuminating or adequate. Taken together, however, the descriptive epithets do suggest certain characteristic aspects of their work as it evolved: the wedding of constructed and fluid elements of abstract form with intense personal emotion; the oblique reflection of a metropolitan locale, of its energy, dynamism, and human degradation, its visual confusion and aseptic, functional order; and most significantly, the concept of the work of art as a liberating and vital action to which the artist is committed with his total personality. In the forties the principal leaders of the new movement in painting were Pollock, de Kooning, Still, Rothko, Gorky, Motherwell, Newman, Reinhardt, and Hofmann; in sculpture, Smith, Lipton, Roszak, Lassaw, Ferber, and Hare.

During the early fifties they were joined by Kline, Guston, Brooks, Louis, Nevelson, and by a rising younger generation: Francis, Rivers, Frankenthaler, Stankiewicz, and others. Some of these artists introduced decisive innovations, or made major statements; the influence they would have was unforeseen at that time. Others refined upon or consolidated the inventions of their older colleagues. All were artists of independent stature and achievement. In the late fifties and early sixties an even younger group of artists, including Johns, Rauschenberg, Oldenburg, Lichtenstein, Warhol, Kelly, Noland, and Stella, among others,

416. CLYFFORD STILL. Untitled. 1943. Oil on canvas, 38 × 28″. Collection the Artist

417. ADOLPH GOTTLIEB. *Voyager's Return.* 1946. Oil on canvas, 37⅞ × 29⅞″. The Museum of Modern Art, New York City. Gift of Mr. and Mrs. Roy R. Neuberger

418. BARNETT NEWMAN. *The Pagan Void.*
1946. Oil on canvas, 33 × 38″.
Collection Annalee G. Newman, New York City

419. THEODOROS STAMOS. *Sounds in the Rock.*
1946. Oil on composition board, 48⅛ × 28⅜″.
The Museum of Modern Art, New York City.
Gift of Edward W. Root

emerged to challenge the styles of the first and second generation of Abstract Expressionists, either by moving toward a reductive simplification of abstract form, or by enriching their painted and welded surfaces with materials taken from actual life. Other artists drew directly on popular culture and the mass communications media for their imagery and techniques of presentation. Yet Pollock, de Kooning, Newman, Rothko, Reinhardt, and Smith, rather than the great European masters of modern art, remained their models, the force against which the new generation of

artists felt compelled to react and test themselves.

In his turgid early style Pollock had wrestled with crude and vital fantasies derived from the imagery of Picasso's *Guernica* and the stock-in-trade of Surrealist monsters, but with a significant difference. A free and powerful brush dissolved his violent content, subtly transforming it into the nonrepresentational "writing" which later became his most recognizable trademark. Even his open, drip paintings after 1947, however, still bore traces of the charging energies and conflicting moods of those first vehicles of fantasy. In

420. WILLEM DE KOONING. *Pink Angels.*
1945. Oil on canvas, 52 × 40″.
Collection Mr. and Mrs. Frederick Weisman,
Beverly Hills, Calif.

421. WILLEM DE KOONING.
Woman in Landscape III. 1968.
Oil on paper, mounted on canvas, 55½ × 48″.
Private collection, Paris

422. BARNETT NEWMAN.
Genetic Moment. 1947.
Oil on canvas, 38 × 28″.
Collection Annalee G. Newman,
New York City

423. (*bottom*) CLYFFORD STILL.
No. 21. 1948.
Oil on canvas, 69 × 59½″.
Collection Kimiko and John Powers,
Aspen, Colo.

the labyrinthine coils of his whipped lines some imaginary beast—or invisible adversary—seemed trapped, struggling to be free.

To a lesser degree, Surrealism formed the paintings of Willem de Kooning, who shared leadership of the American avant-garde with Pollock, and became its most influential figure after 1952. De Kooning's first typical signature forms, such as those of the well-known *Pink Angels*, are a condensation of opposing, curved pelvic silhouettes, or imaginary anatomies in flattened emblematic form, derivative of the fluid shapes of Picasso and Miró in the early 1930s. De Kooning's content was not essentially fantastic, however, and it is only a short step in his art from images rooted in the Surrealist imagination to the fragmented and freely registered color shapes of his mature style. After 1948, the elements of violence and erotic fantasy were subdued and incorporated within a larger presence, and a

clearer formal intention dominated his work—the autonomy of the painting act itself.

The process of sublimating fantasy and personal Expressionist accents also brought visible change to the work of other members of the American vanguard in the late 1940s. Rothko, Newman, Gottlieb, and Still abandoned mythic and primitivistic content in favor of purely abstract idioms, as they discovered new resources for painting in elucidating the creative act as primary expressive content. There was a shift in emphasis from what was taking place in the artist's mind to the developing image that grew under his hand. By giving primacy to the record of the working process, the artist inevitably became something of a virtuoso performer, inviting his audience to admire his skill in improvisation, his boldness in gambling everything on a brief moment of great intensity.

This was true particularly of Pollock, Hofmann, and de Kooning, and other artists associated with them who attached special importance to speed of execution and autographic gestural marks. Their work actually embodied a new time sense as well, for it insisted that the painting be experienced urgently as a unified action and an immediate, concrete event. The painting thus came to symbolize an incident in the artist's drama of self-definition rather than an object to be perfected, a fantasy, or a structure made in accordance with prescribed rules. The term "Action Painting" thus implies engagement and liberation from received ideas of method and style, rather than merely the athleticism and improvisatory energy to which this epithet has generally been restricted.

The German-American modernist Hans Hofmann, whose influence on the New York vanguard as a teacher was immense, anticipated, even if he did not fully develop, the freer modes of Action Painting. As early as 1940, in the innovative painting *Spring,* he explored an unprecedented technique of dripping and flinging paint on the canvas, a method which Pollock was to canonize. Hofmann later distinguished between traditional concepts of fixed form and the idea of a highly mobile structure which served a process of continuous transformation and spatial movement. In his own work, paint strokes, marks, and drips instantly registered as coherent and intelligible form when they hit the canvas surface. This, of course, was the generic type of painting which revolutionized American art in the 1940s. First a widening circle of artists, then a small group of critics and connoisseurs, and finally a wider public acquired the capacity of "reading" Action Painting and its related welded-metal sculpture as an earnest and powerful new aesthetic statement.

The transition in style from the prevailing forms of Expressionist and romantic realism of the 1930s to the new abstraction was for most of the members of the new vanguard rather abrupt.

424. HANS HOFMANN.
Spring. 1940.
Oil on wood panel,
11⅜ × 14⅜".
The Museum of Modern Art,
New York City.
Gift of
Mr. and Mrs. Peter A. Rubel

Apart from Gorky, Hofmann, and de Kooning, most of the emerging generation were mature artists who had worked effectively in established styles as interpreters of the social scene before their sudden conversion to radical abstract idioms. We are reminded of their more conventional early paintings in the forties and fifties, when fragments of representational imagery reappeared in their work with frequency and intensity. Pollock's first anatomical fantasies were restored in his black-and-white paintings of 1951, as if he felt compelled to repeat his rite of passage from figuration to abstraction in order to prevent any confusion with Constructivist or intellectualized forms of nonobjective art derived from Mondrian and his followers. A romantic and Expressionist bias erupted within the new informal abstract painting of the same period in Europe, in the primitivistic figuration of Dubuffet and the grotesque inventions of Jorn, Appel, and the CoBrA group. Only the human mask, the human body, or a fantastic bestiary seemed able to convey the necessary intensity of feeling that this painting of "extreme situations" took for its principal content.

If there were elements of brutalism and Dadaist echoes in the more savage early paintings of Pollock and de Kooning, other fine artists of their generation were satisfied to seek a classical balance and restraint within a more limited repertory of pictorial means. Bradley Walker Tomlin's system of monumentalized calligraphic signs, muted in color and structurally taut, gave lucid order and shapeliness to the impulsive energies of Action Painting without any disabling loss of freedom or spontaneity. And until his last festive and rather Impressionistic works, with their loose color flakes and carefree accents, the mood of his work was one of sober restraint.

Robert Motherwell, perhaps the most articulate and literate of Action painters, helped set the high and serious intellectual tone of the movement by his critical activities as writer and editor. He, too, in part acknowledged a traditional framework of European modernist taste and sensibility. Working under the mixed influence of Picasso, Matisse, and Schwitters, he made an eloquent personal vehicle of the collage; his stark black-and-white elegies of the late 1940s and early 1950s, dedicated to the ordeal of Republican Spain, may have been decisive in the formation of Kline's more specialized manner. Motherwell's

425. JAMES BROOKS. *Tondo*. 1951.
Oil on canvas, diameter 82".
The Rockefeller University, New York City

426. LESTER JOHNSON.
Three Crouching Figures. 1968.
Oil on canvas, 68 × 96".
Martha Jackson Gallery, New York City

427. JAN MULLER. *Jacob's Ladder*. 1958.
Oil on canvas, 6'11½" × 9'7".
The Solomon R. Guggenheim Museum, New York City

fluent alternation between an amorphous style of Expressionist decontrol and a clearly defined linear structure, his view of the abstract painting as an "intimate journal," even as he was exploring a monumental format, are typical of the mixed inspiration and experimental audacity of the new abstraction.

In recent years he has enlarged his characteristic image and has combined a loose geometric structure with saturated color fields. He was once patronized by critics as primarily an intellectual artist, whose work commented in accents of refinement on the innovations of bolder spirits. He has in fact emerged as a master of that original combination of intimacy and heroic scale so characteristic of contemporary abstract expression in America, and an incomparable lyricist whose paintings strongly reject comparisons or

associations. His latest series of Opens, as he titles his new quasi-geometric work, maintains and extends with a distinctive originality the highest traditions of contemporary American painting.

429. ROBERT MOTHERWELL.
Elegy to the Spanish Republic, No. 57. 1957–60.
Oil on canvas, 7' × 9'1".
Collection Mr. and Mrs. Gardiner Hempel, San Francisco

428. BRADLEY WALKER TOMLIN. *No. 18.* 1950.
Oil on canvas, 78 × 49".
(Destroyed by fire, 1961)

430. FRANZ KLINE. *Wanamaker Block.* 1955.
Oil on canvas, 78¾ × 71¼".
Collection Richard Brown Baker, New York City

431. PHILIP GUSTON.
The Day. 1964.
Oil on canvas, 77 × 79 ½″.
Collection the artist

432. SAM FRANCIS. *Untitled*. 1969. Acrylic on paper, 31 × 43″. Andre Emmerich Gallery, New York City

433. CLYFFORD STILL. *Untitled.* 1957. Oil on canvas, 9′ 4″ × 12′ 10″. Whitney Museum of American Art, New York City

434. AD REINHARDT. *Painting*. 1950.
Oil on canvas, 30½ × 40½".
Estate of the artist

435. BARNETT NEWMAN. *Concord*. 1949.
Oil on canvas, 89¾ × 53⅝".
The Metropolitan Museum of Art,
New York City.
George A. Hearn Fund, 1968

436. AD REINHARDT. *Abstract Painting*, *Red*. 1952. Oil on canvas, 60 × 82″. Collection Mrs. Ad Reinhardt

The most dramatic evidence that a limited repertory of gesture and a monochrome palette could densely elaborate pictorial structure was to come from Franz Kline, one of the powerfully concentrated talents in the American vanguard. In his first one-man show in 1951 he demonstrated something of de Kooning's vigorous decisiveness within an essentially equivocal expressive language. By drastic simplification of image, and the reduction of his palette to black and white, Kline made his brushstroke convey with unexampled directness the surging moment of creation. Because his great ciphers immediately transmitted the energies of bodily action and the physical movement of his brush, his art seemed to express perfectly the idea of gesture and action in painting as a value system. That such a stark, heroically reduced visual rhetoric could communicate with authority and encompass the most complex meanings in the interplay of forms has been one of the enduring revelations of Action Painting.

The diversity of temperament and the range of expression among the emerging Abstract Expressionists dispel the charges repeatedly made in the past that the movement was oppressively narrow in its range of artistic personality and too specialized in means. It would be difficult to conceive of a more violent contrast to Kline's bold, unpremeditated ciphers than the quietist, searching paintings of Philip Guston. An effective romantic traditionalist in the late 1940s, Guston experienced a change of style around 1950, very much in the pattern of many leading artists of his generation who found for themselves an unsuspected originality in Action Painting. He brought to abstract painting striking attenuations of form, a compensating richness of texture which bound structure to the palpable density of the pigmented surface, and a probing intellect. His loaded, slow-moving brushstroke suspended and visibly prolonged the action gesture, extracting from it a fresh repertory of sub-gestures and meanings. Hesitations and doubts were recorded in the motor activity of painting and allowed to stand as expressive signs of an evolving drama of chaos and order, of disquiet and calm. The signs, frozen in paint, of the worked and reworked surface could be read reductively as a process of forming with color-matter, or could be legitimately enriched with existential meanings. Guston's intensely single-minded vision and severely limited range of paint marks and shapes compelled

437. **PHILIP GUSTON.** *Native's Return.* 1957. Oil on canvas, 65 × 76″. The Phillips Collection, Washington, D.C.

438. **PHILIP GUSTON.** *The Studio.* 1969. Oil on canvas, 48 × 42″. Marlborough Gallery, New York City

an exhaustive scrutiny of form in its palpable material reality. The density of his paint detail also seemed to represent an instinctive personal program of preserving for painting something of its original value as expressive language. This was in tune with a noticeable shift in American art during the middle 1950s toward concentration on pictorial means and a new mood of introspection,

439. JAMES BROOKS. *Rodado*. 1961.
Oil on canvas, 57⅛ × 78″.
Brandeis University Art Collection,
Waltham, Mass.
Gevirtz-Mnuchin Purchase Fund

440. CONRAD MARCA-RELLI.
Bar-T Corral. 1958.
Oil and canvas collage, 6′5″ × 9′6″.
Collection the artist

441. CONRAD MARCA-RELLI. *U–4* (*SCP–5–66*). 1966.
Aluminum, 48 × 46 × 6¾″.
Marlborough Gallery, New York City

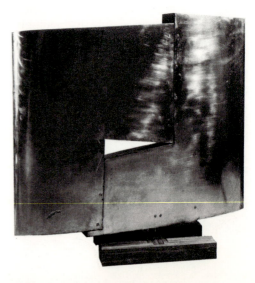

perhaps in part to offset the looser rhetorical flourishes and shallowness which were becoming endemic among the proliferating followers of Abstract Expressionism.

James Brooks is another of the greatly endowed second wave of major Abstract Expressionist artists who reached their mature style after 1950. He absorbed the innovations of Pollock and de Kooning within his recognizable, personal manner, but broadened and smoothed out something of their expressive individuality. Brooks is a painter whose emotions find their deepest expression in an impeccable sense of proportion and an appreciation of measured quantities of tone, line, and color values. Even in recent years when his forms have become more provisional, his attack blunter, and his colors muddied, the more demanding conditions he sets himself only make his felicitous resolutions and unerring formal sense seem all the more miraculous. Like so many artists of his generation, Brooks has worked at the undefined margins of current styles to escape his own formulations and the dangers of mannerism. Since 1965 he has moved away from the activism of surface and the virtuoso brushwork of conventional Action Painting, and identified himself with new and more impersonal art currents, utilizing large unmodulated shapes and closely valued color contrasts over uniform areas of surface.

Conrad Marca-Relli also found a second ma-

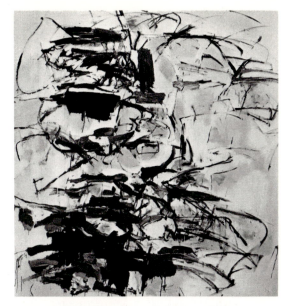

442. JOAN MITCHELL. *Mont St. Hilaire*. 1957. Oil on canvas, 80 × 76″. The Lannan Foundation, Palm Beach, Fla.

turity and creative fulfillment in the early 1950s within the new style of Abstract Expressionism. For most of the past two decades he worked with a combination of toughness and grace, in the electric manner of whipped lines, torn shapes, and smeared color that Pollock, Hofmann, and de Kooning first released in American art. Using cut-out canvas shapes attached to a canvas base with a black glue line that both demarcated and

443. LARRY RIVERS. *French Money I*. 1961. Oil on canvas, 35¼ × 59″. Collection the artist

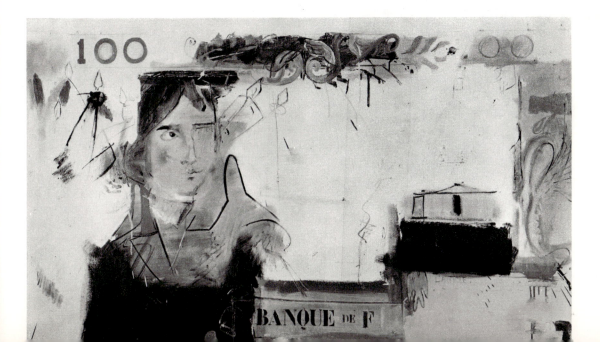

blurred their separate identities, Marca-Relli developed new and dramatic modes of juxtaposition and structure in an original collage idiom. Qualities of the elementary were mixed with refinement, and, in an early figurative mode, metaphysical allusion poetically transformed the brute physical fact of his canvas fragments. His continuing attachment to the human figure may have been sanctioned by de Kooning's *Woman* series, but the gravity of his images had more to do with de Chirico's manikins, from whom they borrowed their khaki colors, misarticulated anatomies, and stately presence. After working with white plastic surfaces and then, in recent years, in sheets of aluminum, Marca-Relli explored new forms of relief-painting and sculptural constructions which encouraged a more ordered and precise definition of image. His elegant, chaste constructions make obvious contact with hard-edge and geometric abstraction. Despite their Constructivist control, they retain the resolutely hand-fashioned quality, the refinement of tonal relationships, and the ambiguities of structure of his more spontaneous early manner.

444. CLYFFORD STILL. *Number 2.* 1949. Oil on canvas, 91 × 69″. Collection Mr. and Mrs. Ben Heller, New York City

From the late forties to the middle fifties de Kooning was a dominant force in American painting, providing a dictionary of vital pictorial ideas and a point of departure for new explorations. Pollock's liberating energies and formal radicalism gave him the status of a cult hero for young artists, and his untimely death in 1956 expanded his legend. But his direct influence was negligible until the deeper meanings of his style became apparent with the emergence of the lyrical color-field painting of the sixties. It was de Kooning's technical fluency, his aggressive assimilation of heroic figurative styles and traditional means, and his grace within a pictorial environment of violence which directly affected his own generation and a transitional one of younger artists. The open de Kooning "image," with its repudiation of "style" and studio professionalism, left room for the refined lyricism of Jack Tworkov, the structured fluencies in paint and collage of Esteban Vicente, and distinct personalizations of his idiom among an emerging group of promising young painters—Larry Rivers, Joan Mitchell, Grace Hartigan, and Alfred Leslie, among others. Their manners were too abrasively individual to be homogenized in a school, in the academic sense, yet sufficiently representative to give de Kooning's brand of Abstract Expressionism the authority of a genuine movement. As Harold Rosenberg has noted in *The Anxious Object*, vital art movements tend to release rather than stereotype individual energies: "In the shared current individuality, no longer sought for itself, is heightened Far from constricting the artist's imagination, the movement magnetizes under the motions of his hand insights and feelings from outside the self and perhaps beyond the consciousness."

As Abstract Expressionism gained currency in regional centers, it seemed identified almost exclusively with the physiognomy of the de Kooning painting, whether abstract or figurative, and for a long while the important innovations of another widely divergent group of pioneer abstractionists were neglected and denied their full impact. The painters Clyfford Still, Mark Rothko, Ad Reinhardt, and Barnett Newman, to be joined by Adolph Gottlieb after his pictograph phase, created new forms of anti-Expressionist abstraction which have become as decisive an influence since the 1960s as the de Kooning manner was in the 1950s. Although they openly rejected the

methods and aims of Action Painting, strong formal ties persisted between the two groups of artists, quite apart from their close personal associations.

For the constellation of painters identified with de Kooning and Pollock, Action Painting presented itself as an art of passionate gesture, fluent or amorphous structure, and large individual liberties. The painting could be understood as the record of an act, for the vital signs of personal involvement and spontaneous invention were left conspicuously visible. The artist's preoccupation with the process rather than the finished product was conveyed both by references to mythology and by an internalized imagery; in the case of de Kooning there were also bold assimilations of traditional figuration and the grand manner. By the late 1940s, however, the charged expressive brushwork of the orthodox Action painters, with its vehement emotional accents, had significantly given way to a new mood of breadth, refinement, and objectivity.

Pollock's open drip paintings canceled pictorial incident and evolving images within a loose web of paint whose uniform accents could be read as a "field." Disruptive image fragments or suggestions of internal psychological pressures in the violence of paint handling were submerged, and the overall effect of the painting gained in importance. The entire, evenly accented painting rectangle achieved an effect of totality, and was subtly organized in the eye of the beholder as a continuous optical field rather than a linear sequence of active forms within a hierarchical structure. This new development led to an increase in scale, and thereby in impressiveness, with the effect that in addition to operating as an absorbing drama of gesture, the painting seemed to expand beyond the limits of the frame, putting the spectator in a total environmental situation. Pollock's great paintings of 1949 and 1950, *One*, *Autumn Rhythm*, and *Lavender Mist*, and de Kooning's monumental works of the same period, such as *Excavation* and *Attic*, are not to be understood merely as gestural display or virtuoso performance. They are too sustained, profound, and deeply meditated structures for a restricted reading as cathartic, Expressionist outbursts. They also introduce a radical new factor of projection into the spectator's environment, with obvious affinities to Monet's late, enveloping water landscapes. Their sheer physical expanse manages

445. MARK ROTHKO. *No. 26*. 1947.
Oil on canvas, $33\frac{3}{4} \times 45\frac{1}{4}''$.
Collection Betty Parsons, New York City

446. ADOLPH GOTTLIEB. *Frozen Sounds II*. 1952.
Oil on canvas, $36 \times 48''$.
Albright-Knox Art Gallery, Buffalo, N.Y.
Gift of Seymour H. Knox

to erase the boundaries between the sphere of the work of art and the space which the audience occupies.

The interest in a more uniform painting field and a monolithic kind of pictorial order was already visible in the paintings of Still, Rothko, and Newman. Their art had disengaged itself from excited linear drawing, fragmentation of forms, and a dynamic gesturalism, and by the late 1940s stood at the antipodes of energetic Action Painting. Where Pollock and de Kooning articulated space on a monumental scale by the acceleration and fragmentation of form, these artists gained a potent expansive force by decelerating the motion of their small variegated shapes, and merging them into dominant islands, zones, and

boundless fields of intense, homogeneous color. Illusionistic optical ambiguities were substituted for motor activity to express qualities of momentariness and changefulness. Most importantly, the rich painterliness of the conventional Action painters gave way to thinner mediums; material sensuousness was replaced by a new kind of chromatic sensation.

Some of these significant changes can be read clearly in Adolph Gottlieb's *Duet*. There is a split between a linear activism—the sign of the hand's aggressive passage—and a more passive mode of visual perception. Action in the sense of free movement is countermanded by a different demand on the receptive faculties, and a slower rate of assimilation of the painting's components. The bottom half of the painting has the hurried tempo and helter-skelter randomness of Action Painting, but the pair of flat, glowing orange disks above conveys a more arresting kind of stability. The muffled radiance of the matched circles holds our attention; their color and the background chroma are so close in value that our eyes can scarcely tolerate their slight differentiation, and we struggle to resolve a disturbing dissonance. Color shifts have replaced drawing as the vital action of the painting, and the stylized coiling lines form only a recessive, ghostly counterpoint. These so-called "bursts" are mutants of superseded Expressionist form, in transition from their familiar content of freedom and decontrol to one of geometric stabilization.

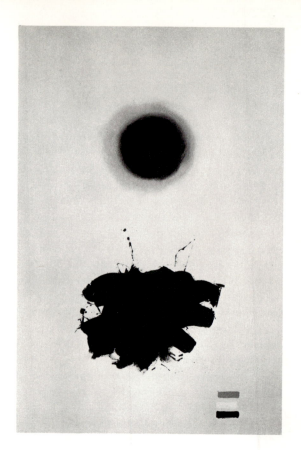

447. ADOLPH GOTTLIEB. *Bowery Burst.* 1970.
Oil on canvas, 90 × 60″.
Marlborough Gallery, New York City

Barnett Newman's immense red color field in *Vir Heroicus Sublimis* deals with pictorial decorum in an even more radical way. The familiar agitated spatial movement and self-referring signs of Abstract Expressionist painting are eliminated and grandly solemnized by a complex pulsation of high-keyed color over a pictorial field of vast expanse divided by five fine vertical bands, or "zips," as the artist liked to describe them. These fragile and oscillating stripes play tricks on the eye and the mind by their alternate compliance and aggression. Brilliantly visible yet all but subliminally lost against the vivid color field, they produce curious retinal afterimages. Their cunning equivocation subverts the concepts of division and geometric partition, as if ideas of uniform space and serial mechanical analysis were being swallowed by a new intuition of total experience. In this powerful and transfiguring visual drama, which has been aptly characterized as "the abstract sublime," the enormous expanse of red mystically subdues the mind, as any "oceanic" experience in nature moves us off our ego center. At the same time, the experience is intellectually

448. CLYFFORD STILL. *Number 5.* 1951.
Oil on canvas, 54 × 45½″.
Collection Mr. and Mrs. Anthony Smith, South Orange, N.J.

449. BARNETT NEWMAN. *Onement No. 6.* 1953.
Oil on canvas, 8′6″ × 10′.
Collection Mr. and Mrs. Frederick R. Weisman,
Beverly Hills, Calif.

450. BARNETT NEWMAN. *Jericho.* 1969.
Acrylic on canvas, base 9′6″ × 8′10″.
M. Knoedler & Co., New York City

451. BARNETT NEWMAN. *Here.* 1950.
Bronze, height 8′11¼″.
Collection Annalee G. Newman,
New York City

452. CLYFFORD STILL. *No. 3*. 1951.
Oil on canvas, 48 × 39".
Collection S. I. Newhouse, Jr., New York City

453. SAM FRANCIS. *Red and Black*. 1954.
Oil on canvas, 76⅞ × 38⅛".
The Solomon R. Guggenheim Museum,
New York City

challenging, since problems in visual interpretation are posed which require special attention and alertness. Newman's sources are momentary, despite his insistent geometry, and they also include a wealth of psychological content. His art, indeed, defines the limitations of intellectual control by analysis, and acknowledges that we are made and remade by each succeeding moment of new experience.

The five dividing lines in the painting seem to move through it at great velocity from somewhere outside the field. The canvas's framing edges act as a camera finder, isolating a part of a larger visual whole. Symbolically, the sheer physical expanse of the painting forms a bridge between the individual and a total environmental situation. Paradoxically, the monumental scale also encourages an intimate sense of involvement, for we cannot back off from the painting, or ever quite absorb it in its entirety. It eludes us even as it envelops, drawing us into a vast field of warm light and forcing us to identify with its uncompromising and aggressive chromatic life. The deliberate play of paradox and visual ambiguities denies the Constructivist gridiron order, substituting a more integral vision for analytical structuring. If Pollock's art may be said to have demythologized Surrealism, Newman's painting made the doctrinaire rationalism of geometric painting so problematic as to be no longer tenable from the contemporary point of view.

The rigor of form, the mechanical handling of surface, and the problematic character of Newman's painting seem immediately related to the "anti-sensibility" painting of a whole school of younger abstract painters today, and to the wholeness of effect and vacancy of Minimalist sculpture. Something of the same calculated insensitivity, directed toward a higher artistic purpose, was also apparent in the paintings of Clyfford Still, whose preferred forms were organic and biomorphic rather than geometric. His monumental areas of homogenous hue, whether bright or somber, his destruction of Cubist structuring and linearity, and his rejection of facility in handling have all had their considerable impact on the course of American art. In certain areas he was prescient and profoundly influential. Sam Francis's dripped and stained paint applications obviously owed their technique to the controlled accidents of Pollock's characteristic spatters. But in his early style Francis massed his congested and

dribbled kidney shapes in curtains of luminous darkness, relieved by the marginal activity of brilliant touches, and there his main debt was to Still. By 1945 Still had begun to experiment with radical chromatic reductions, pushing color expression close to invisibility by loading his canvas with opaque blacks and purples, and keeping in play only a thin and aberrant fluctuation of bright spectrum colors at the extreme edges of the canvas.

The reduction of chromatic expression to near invisibility occurred in the 1960s even more dramatically with the black canvases of Ad Reinhardt. His segmented compositional grids are so dark and even in emphasis that distinctions of form and color require the most intense scrutiny. The almost imperceptible movement the eye is allowed from one structure of geometric shapes to another, and the shifts from faint coloration to its absence, reconstitute in quintessential expressive form ideas of change and stability, activity and quiescence at the heart of much significant contemporary expression. Reinhardt's reductive means and the uncompromising severity of his impassive icons, with their painstakingly worked surfaces, are the most extreme example of purity in contemporary American painting. In their context of renunciation and austerity, the faint tremors of personal sensibility, as they can be discerned under proper light conditions, register with added force and poignancy.

More than any other artist of his generation, Reinhardt has proven prophetic of the "cool" and Minimal abstract painting of the sixties. His mood of renunciation, his tireless insistence—both in his art and in his inspired "art dogmas"—on a scheme of values congenial to the Eastern mind, in admiring vacuity, repetition, refinement, and inaction, support and confirm the most radical nonobjective painting and sculpture of today. The wonder is that Reinhardt was able to adhere strictly and steadfastly to his ascetic principles, to uphold his personal orthodoxy, and to continue viewing art in its essential function against the taste of the times, which strongly favored a drama of personal crisis and emotional release. After operating more or less underground in the fifties, his symmetrical, standardized, and disciplined academic abstraction emerged to sanction the explorations of a radical new generation, and provide an antidote to the spontaneity and the subjective storm and stress of the Action painters.

454. SAM FRANCIS. *Shining Black*. 1958.
Oil on canvas, 79⅜ × 53⅛".
The Solomon R. Guggenheim Museum, New York City

His black paintings made after 1952, with their subliminal visibility and uniform design, are even less "interesting" or engaging by way of surface detail or pictorial dynamics than those of Barnett Newman, who also had a profound impact on the Minimalists and the color-field painters. Reinhardt's statements, which vigorously repudiate Expressionist ideals and extraneous personal factors in art, have given an additional programmatic value to his rather cheerless and severe orthodoxy.

In an article in *Art News*, "Timeless in Asia," he wrote: "Nowhere in the world has it been clearer than in Asia that anything irrational, momentary, spontaneous, unconscious, primitive, expressionistic, accidental or informal, cannot be called serious art. . . . The forms of art are always preformed and meditated. The creative process is always an academic routine and sacred procedure. Everything is prescribed and proscribed. Only in this way is there no grasping or

455. AD REINHARDT. *Untitled*. 1950.
Oil on canvas, 6′4″ × 12′.
Estate of the artist

clinging to anything. Only a standard form can
be imageless, only a stereotyped image can be
formless, only a formularized art can be for-
mulaless.''

One might add by way of a qualified objection
that while the "crisis" aesthetic of Pollock and
de Kooning, with its hyperactive, seething sur-
faces, seems diametrically opposed to Reinhardt's
quietism and restraint, these antipodal artists can
in fact be related by the extremes to which they
pushed their art. Both types of artist seemed
determined to test either the Expressionist or the
doctrinaire abstract modes they inherited and to
redefine them in valid contemporary terms—de
Kooning and Pollock by their wide inclusions
of past styles and a fragmentary human subject

matter, and Reinhardt, inversely, by insisting on
sharply restricted pictorial means and an uncom-
promising abstraction.

At some far point their contradictions do meet.
De Kooning and Pollock sacrifice "personality"
to the working process, through grand and waste-
ful expenditures of energy, while Reinhardt sup-
presses the sense of ego by programmatically
expunging any signs of individual authorship.
Both forms of expression, representing the polar-
ities of American art of the fifties at its most
impressive level, are equally viable, universal, and
as applicable to the historic art process as the
ancient dualisms of romantic and classic, rational
and irrational, or, to give the dichotomy a more
contemporary relevance, pure and impure art.

Perhaps the most intensely personal style con-
structed on a basis of renunciation and self-
transcendence has been that of the late Mark
Rothko, one of the most original of the pioneer
abstract artists who emerged in the early 1940s.
His thin sheets of veiled color in roughly rectan-
gular conformation strike the same sustained note
of even-burning intensity as the color fields of
Newman and Still, but his surfaces make more
concessions to a traditional sensuousness and to
poetic sentiment. The boundaries separating
Rothko's sparse color forms and their grounds
are left deliberately hazy to allow room for ex-
pansion, and for subtle internal relationships
which generate vague suggestions of new meta-
morphic life within a structure of utmost simplic-
ity. Rothko's colors run toward intolerable
brightness or dark hues of subliminal refinement.

456. AD REINHARDT. Installation view, The Jewish Museum, New York City, 1966–67

His art is unapologetically emotional and Impressionistic, responsive to the tremolo of sensibility rather than to the conceptualism and intellectual programs which came to dominate art during the sixties. Within a generally moderate scale that mediates between the intimate easel convention and mural painting, his work conveys a grandeur and moral force unique in American art.

Although his intensely personal, poetic idiom today seems remote from current modes, which have shifted emphasis toward impersonality and anonymous fabrication, Rothko's technique of using paint as a dye, dissolving its paste in thin washes which leave the canvas weave exposed and aesthetically active, profoundly influenced a significant new direction of abstract painting. Pollock, in his black paintings on unsized canvas, and Hofmann too, had soaked liquid or thinned paint medium into unsized canvas, minimizing the pressures of the hand. Helen Frankenthaler, in the early 1950s, had begun to work consistently with diluted solutions that gave a soft luminosity to her colors. Her development of this technical innovation into a strong personal style was the direct link to the "stain" paintings of Morris Louis and Kenneth Noland, who acknowledged her influence. Rothko, however, had at an earlier date disassociated his art from the rich material paint deposits and the conventions of pigment manipulation followed by the majority of Action painters. In so doing, he opened American painting to new technical and formal possibilities which were later explored fertilely by a brilliant group of young artists.

The generation of Pollock, de Kooning, Gorky, Hofmann, Kline, Motherwell, Guston, Brooks, and others was at pains to establish the aesthetic autonomy of abstract art and to identify it with individual feeling, in the face of a provincial art of social commentary or a feeble and stereotyped academic modernism which prevailed in America during the forties. With Still, Rothko, Newman, and Reinhardt, painting underwent a purifying and cleansing ritual which rehabilitated a more rigorous formality in a curious conjunction with a sense of mystery. A vital and rebellious community of younger artists then emerged in the late fifties and early sixties, both to oppose and to build on the aesthetic and moral foundations of the pioneering generation. They sharply challenged Abstract Expressionist styles by turning

457. MARK ROTHKO. *No. 18, 1948.* 1949.
Oil on canvas, 67¼ × 55⅞".
Vassar College Art Gallery, Poughkeepsie, N.Y.
Gift of Mrs. John D. Rockefeller III, 1955

458. HELEN FRANKENTHALER. *Interior Landscape.* 1964.
Acrylic on canvas, 8'8¾" × 7'8¾".
San Francisco Museum of Art

459. MARK ROTHKO. *Browns*. 1957.
Oil on canvas, 92 × 76¼″.
Collection S. I. Newhouse, Jr., New York City

460. MORRIS LOUIS. *Floral*. 1958.
Acrylic on canvas, 8′5″ × 11′10½″.
Private collection, New York

from art back to contemporary life, to its materials and to popular imagery, and by creating a more impersonal and systematic abstract art.

Before proceeding in another chapter to consider in detail the reaction of the sixties to Abstract Expressionism, it might be well for a moment to dwell on the fluctuations in taste and in the assessment of stature of the pioneering generation brought on by the passage of time and the accelerating tempo of American art innovation. The epithet "heroic" has been used to describe the

acute sense of isolation, lack of public sympathy, and lonely vigil endured by the artists who emerged in the forties. Today their struggle tends to be overlooked, as they have been promoted from avant-garde loners to public cultural idols. The rapid acceptance of avant-garde art forms and their excessive commercial promotion have distorted the values and meanings of the art of the now distant forties, and replaced fact with fiction, perhaps inevitably, as history is reappraised and rewritten to suit contemporary tastes.

Pollock is a case in point. He has come to stand as the prime artistic symbol of the unfettered American imagination in the new Age of Affluence, which makes a celebrity of the artist of genius and rewards him lavishly, if in this instance posthumously. Pollock's key role as a touchstone in the evolution of a cultural episode of great importance is no longer in doubt. In point of fact, his reputation has been surprisingly expanded, not only in terms of popular reputation but in other ways as well. A younger generation of critics now tend to ignore his explosive temperament, and they have even gone so far as to cast him in the role of father figure of the new "cool" chromatic abstraction, and credit him with priorities in originating "stain" paintings. A somewhat simplistic line of development has been established linking Pollock's drips, Helen Frankenthaler's stains, and the color-field paintings of Louis, Noland, and Olitski. Significant stylistic links to Kline and de Kooning, though powerful and self-evident at the time of their occurrence, for example, are given short shrift, and the rich interdependence of the Action painters as their personal styles evolved is passed over in silence. The critic Clement Greenberg has made clear his conviction that de Kooning and Kline were belated Cubists of lesser stature, and this dubious judgment has proven persuasive among many younger critics and champions of the color-field painters. The new critical orthodoxy was in turn stimulated and formed, one suspects, in reaction to the rather lavish attention which de Kooning and his second-generation progeny received from Harold Rosenberg and Thomas Hess in the pages of *Art News*. Postwar American art history understandably gets reformulated frequently with the passing years, and will undoubtedly continue to be reexamined, with some reputations rising and others falling. We must be on guard, however, against formulations that are too neat or exclud-

ing, even as we are aware that when genuine innovations in art appear, they will inevitably modify our views of the past.

It now seems quite incontrovertible that the exclusive emphasis given to the Gorky–de Kooning–Kline stylistic axis—different and even antithetical though those three artists might be—tended to distract critics from paying sufficient attention to the less aggressive type of chromatic abstraction which was emerging simultaneously in the late forties from the hands of Still, Rothko, Newman, and Reinhardt. Sensitive and informed spokesmen for American art had recognized the phenomenon of a quiescent art of inaction and reflection within the agitated bosom of Action Painting, but their statements were not decisive. Professor Meyer Schapiro, among others, pointed out that tendency in a London lecture for the BBC in 1956 called "The Younger American Painters of Today." There he made a crucial distinction between Pollock's art of "impulse and chance" and Rothko's art of color sensation, between a style of energy and one of passivity. However, in view of the juggernaut influence which the de Kooning style of painting seemed to have on American art, no one could have predicted that by the late sixties Newman and Reinhardt would exert a far greater influence on the new, emerging generation.

If it is important to remain open to changing critical formulations which bring together already known information in new and more revealing patterns of relationship, then it is also important to reconstruct the manner in which past art was known and experienced among members of the creative artistic community. The achievement of Pollock is all the more considerable seen against the background of his first inchoate and self-fascinated work of the early forties, when Jungian symbols and "myth" concepts dominated ·his thought far more decisively than ideals of professional art or a Surrealist program. Pollock was a clumsy artist of immense force who traveled, tourist fashion, through a variety of artistic influences, from Benton, Ryder, and Mexican mural art to Picasso and Surrealist automatism, before finding himself. Until 1947, when he began his first open drip painting, his art was dominated by subjective impulses, and clearly burdened by egocentricity and turgid fantasy, although his originality and expressive power were also evident even in these crude beginnings. History and fash-

461. KENNETH NOLAND. *Fiord*. 1960.
Magna on canvas, 80¼ × 80¼".
Collection Mr. and Mrs. David Mirvish, Toronto

462. JULES OLITSKI. *Fatal Plunge Lady*. 1963.
Acrylic on canvas, 8'4" × 6'.
Kasmin Gallery, London

ionable success have tended to alter his image, and stylishly regroom his early work.

Similarly, it is fascinating to contemplate de Kooning's voyage of discovery, how he faltered in the thirties, immobilized by the human image, obsessively working and reworking for a whole year a single figurative painting. This extended moment of uncertainty and impasse took place between periods of facile abstraction, earlier and then later in his career. The violence and even personal torment that surfaced in the work of these two artists in the forties and fifties surely must be connected with their patterns of frustration and with a desperate search for personal identity, as well as with the cultural milieu.

After World War II, collective expression, supported by an expanding community of adherents, gained momentum, and artists could enjoy the luxury of exploring an entirely more objective content. Finally, the preoccupation with the idea of "myth," a common concern of the times in literary criticism, was also a significant factor in

463. WILLEM DE KOONING. *Seated Figure*
(*Classic Male*). 1939. Oil on canvas, 54½ × 36″.
Private collection, New York

the formulation of the new styles. It is curious how myth united the two distinct streams of Abstract Expressionism. Still, Rothko, and Newman, who called themselves the "mythmakers," were seeking in archetypes and pictographs a new kind of universal imagery, but they settled finally on a nonimagistic icon in the form of self-referrent abstract painting. When mythology became linked to the act of painting itself, to the creative process, it provided a way out for Pollock's exasperations and inner turbulence. Primitivistic or totemic configurations became something to be experienced in a personal, sensuous way for Pollock; they revealed his creative methods and honored prototypes of abstract art simultaneously. Fantasy and the findings of the unconscious mind were overcome and assimilated into a pictorial "action." In this sense, Harold Rosenberg's term was apt and useful—Action Painting became a kind of program of emergence from the tormented self for thwarted Existentialists, a sometimes desperate commitment to the act of painting by artists who had been immobilized by their own impulses and fantasies as well as by the stagnating conventions of prevailing Constructivist abstraction. At the end of the forties the mythmakers and the self-probing Existentialists, both searching for a new symbolism, made a common cause. The dealer Sam Kootz linked the two groups together in an exhibition as "intra-subjectivists"; an awkward enough phrase now, it was considered prophetic at the time of a new kind of Surrealist-oriented abstraction which nonetheless was recognizably American and contemporary. One forgets too easily how inchoate and raw the "heroic" generation's experimental efforts appeared at the time of their inception.

Pollock's *She-Wolf* and *Pasiphae;* de Kooning's first *Woman* compositions of the mid-forties; Rothko's dream landscapes, suspended between a luminous ambience and fetishistic imagery; Still's Miróesque amoeba shapes, which clung to creatural life even while asserting the prerogatives of organic abstraction—all these crude or hesitant explorations nevertheless carried enough force and individuality to clearly demonstrate the broad outlines of the new style. The momentum of advanced art was sustained both by the recognition of genuine visual novelty and a sense of mission in the air. Younger artists soon felt the influence of the new avant-garde as a unified force. One should note that artists like

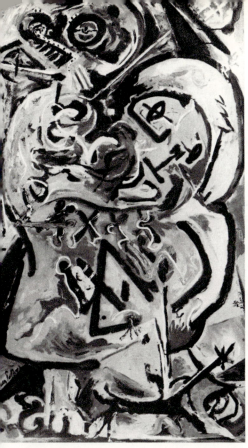

465. HANS HOFMANN.
Fairy Tale. 1944.
Oil on plywood,
60 × 36″.
Estate of the artist

464. JACKSON POLLOCK. *Totem I*. 1944.
Oil on canvas, 70 × 40″.
Collection Harry W. Anderson,
Atherton, Calif.

466. MARK ROTHKO. *Slow Swirl by the Edge of the Sea*. 1944.
Oil on canvas, 6′ 3″ × 7′ ½″. Estate of the artist

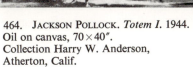

467. CLYFFORD STILL.
Jamais. 1944.
Oil on canvas,
65 × 31½″.
Peggy Guggenheim
Foundation

468.　DAVID SMITH. *Medal for Dishonor:
Propaganda for War*. 1939–40.
Bronze, 11⅜ × 9⅜".
Joseph H. Hirshhorn Collection

Arshile Gorky and Hans Hofmann (despite his primary reputation as teacher) were regarded as extremely competent and accomplished professionals by contrast, with a more facile control of their technical means. They suffered less from the gaucheries, narrowness of vision, and self-obsession which afflicted the most original personalities of the emerging new generation of abstract artists in the early and mid-forties.

Similarly, the most original American sculptor, David Smith, seemed an awkward neophyte in the early thirties when he experimented first with wood, and then in welded-iron constructions.

Paradoxically, he showed immense technical skill in his realist-symbolist *Medal for Dishonor* of 1937–1940, and again in his revival of welded sculpture immediately after the war. There was, then, no fixed pattern of individual accomplishment, no reliable standard of maturity to go by in this fertile and contradictory period of American art. On the one hand, there were a number of immensely gifted individuals moving toward strong personal styles, and on the other, a growing sense of a shared current, of a coherent collective impulse sustaining bold ventures into the unknown.

Historical accounts of this period of discovery and consolidation cannot be viewed as settled or definitive. Many aspects of the crucial episode of emergence in postwar American art are even now being hotly disputed, as the spate of letters from Action painters contesting claims and priorities which appear regularly in art journals should make abundantly clear. In a famous group photograph of the so-called "Irascible Eighteen," some of the new avant-garde artists, including Pollock, de Kooning, Rothko, Newman, Still, Reinhardt, and Motherwell, gathered in protest against the artistic policies of the Metropolitan Museum in 1951, and were recorded for posterity in the pages of *Life* magazine. Their look of stubborn determination gives one some sense of the fierce pride and tenacity of purpose of this first generation of Abstract pioneers.

The drama and magnificence of the heroic

469.　PAINTERS OF THE NEW YORK SCHOOL, 1951
("The Irascible Eighteen"). Left to right:
Richard Pousette-Dart, Theodoros Stamos,
William Baziotes, Willem de Kooning, Jimmy Ernst,
Adolph Gottlieb, Barnett Newman, Jackson Pollock,
Ad Reinhardt, James Brooks, Hedda Sterne,
Clyfford Still, Mark Rothko, Robert Motherwell,
Bradley Walker Tomlin

470. MARK ROTHKO. *No. 7.* 1960. Oil on canvas, 8′ 9″ × 7′ 9″. Marlborough Gallery, New York City

471. BARNETT NEWMAN. *Vir Heroicus Sublimis*. 1950–51. Oil on canvas, 8′ × 17′ 10″. The Museum of Modern Art, New York City. Gift of Mr. and Mrs. Ben Heller

472. ADOLPH GOTTLIEB. *Wall*. 1968. Painted steel, 27½ × 41½ × 25″. Collection the artist

473. ADOLPH GOTTLIEB. *Duet*. 1962.
Oil on canvas, 84 × 90″.
The High Museum, Atlanta, Ga.

474. ROBERT MOTHERWELL. *Open No. 37 in Orange*. 1969. Polymer paint and charcoal on canvas, 6′ 4″ × 9′ 6″. Marlborough Gallery, New York City

generation of Action painters seems in retrospect to derive from their aggressive and resolute independence in the face of institutional opposition. The provincialism of American art and its spokesmen could have fatally drained the painters' will and confidence. Robert Motherwell provides an example of a typical American artist's odyssey of the period. He apprenticed himself to the modern spirit, which in his case meant submitting to a varied combination of influences from Picasso and Schwitters to Matisse. But instead of subservience, he found freedom and his own distinctive personal accent, nothing less than an individual style. At that, his originality was perhaps less emphatic, less rich in its unfolding possibilities for future art than Pollock's, de Kooning's, or Rothko's. His intellectual curiosity and romantic identification with past vanguard heroes gave his early art its leverage and eloquence, for he saw himself as the heir of Baudelaire, Rimbaud, Picasso, and the Surrealists, many of whom he came to know intimately through the Peggy Guggenheim circle.

Perhaps inevitably with hindsight we tend to see the pioneering art of the Abstract Expressionists today in purely aesthetic terms rather than in the light of their avowed intellectual aims or personal commitments. Our changing view of their art is as much the product of more detached contemporary moods in art as it is a reaction to the now discredited but then overemphasized concentration on *angst* and self-discovery. One can appreciate the suggestion made by the historian and critic Robert Goldwater in an article in *Quadrum*[1] that the art of the Action painters be divorced from its ideological pretensions and sense of urgency in order to clarify both its sensuous qualities and persistent European affinities. With the passage of time Harold Rosenberg's analysis of the motive for this painting as a kind of liberating moral imperative seemed to lose some of its relevance and persuasiveness. As formal sophistication grew, it became increasingly important to make distinctions on the basis of quality, and to cut away some of the obfuscating ideology surrounding the first heroic generation. Ad Reinhardt, seeking a more bal-

[1]Robert Goldwater, "Reflections on the New York School," *Quadrum,* no. 8, 1959.

475. Ad Reinhardt. *Untitled.* 1949. Oil on canvas, $50 \times 20''$. Estate of the artist

476. Barnett Newman. *Death of Euclid.* 1947. Oil on canvas, $16 \times 20''$. Collection Betty Parsons, New York City

477. PHILIP GUSTON
Air I. 1965.
Oil on canvas, 72 × 78″.
Marlborough Gallery,
New York City

anced perspective, constituted himself a one-man movement for desanctifying the apocalyptic rhetoric and ridiculing the more sentimental rationalizations of the Expressionist position. However, today it once more seems appropriate to consider the moral thrust and intellectual content of the Action painters, perhaps because the pendulum has swung so far in the other direction towards art forms that are "cool," disengaged, and noncommittal.

The Expressionist view of creative activity was systematically set aside in the sixties by younger artists who preferred a factual view of the artistic process. Existentialist agonies of self-definition through art have been replaced with almost indecent haste by an anticlimactic art founded, however, on identical principles of opposition to facile solutions, but expressed in noncommittal and certainly nonevangelical terms. Nevertheless it is instructive to recall the old ethos if we wish to recover the essential meaning and thrust of Action Painting. A statement by Robert Motherwell reminds us that these artists were guided by a powerfully reformist impulse and a revolutionary morality. "Without ethical consciousness, a painter is only a decorator," he wrote in the

forties. "Without ethical consciousness, the audience is only sensual, one of esthetes."

And then there is Philip Guston's almost wistful but at the same time intellectually rigorous analysis of his own introspective pictorial process, which stumbles so felicitously towards revelation:

"What is seen and called the picture is what is left—an evidence, after repeated removals of images of good intentions. Even as one travels toward a state of 'unfreedom' where only certain things can happen, unaccountably the unknown and the free must appear. . . . The completed painting is both a friend and enemy. . . . The very matter of painting—its pigment and spaces, is so obstinate, so resistant to the will, so disinclined to assert its plane and remain still. . . . Painting seems like an impossibility, with only a sign now and then of its own light. . . . To paint is a possessing rather than a picturing."

Undoubtedly, Abstract Expressionism will one day be remembered best for its specific contributions to an evolving visual language rather than for its ideas or intellectual ambience. There is already abundant evidence, two decades after its expressive powers peaked, that the examples it provided of formal authority, sensuous freedom,

and aggressive defiance of audience expectations remain profoundly influential. These features, if not the techniques of accidentalism and the Expressionist approach, constitute a viable tradition in a period when prevailing art styles and, indeed, the concept of the art object itself have changed irrevocably. The example of the Action painters' intellectual courage has also persisted, even though their crisis rhetoric may now be discounted as inappropriate to our condition. The tough-minded rejection of easy communication or facile solutions among the new generation is a direct tribute to the Action painters' resolute will and indifference to either public or critical approval. The succeeding Pop artists, Minimalists, and color-field abstractionists have chosen, in the apt words of the critic Lucy R. Lippard, to restate their "commitment to a grueling, self-demanding ethic based on distrust of the accepted and the acceptable."

Two decades after their supreme moment of impact, the Action painters' revolutionary morality and taste for a "problematic" art seem to have left as indelible a mark on the new avant-garde as their formal innovations. The Pop artists' deliberate flaunting of "high" art traditions, the austerities and pristine absolutism of Minimalist sculpture, the physical expansiveness and perceptual overload of the color-field painters, and even the aggressive environmental incursions of "process" artists acknowledge the intellectual adventurousness and implacable will of the Action painters. Speaking for his pioneering generation, Robert Motherwell defined an attitude at the time foreign to advanced American art which has since become influential and decisive: "The specific appearance of these canvases depends not only on what painters do. The major decisions in the painting are on grounds of truth, not taste."

478. ROBERT MOTHERWELL. *Cambridge Collage.* 1963. Oil and paper on board, 40 × 27". Collection Crawford Block, Calif.

11 · Sculpture for an Iron Age

MODERN AMERICAN SCULPTURE was until very recently far less adventurous than painting, and attracted only a few outstanding personalities. Although it is true that a relatively small number of good sculptors exist even in periods of the most abundant creativity, there was still a marked scarcity of first-rate sculptural talent in the first three decades of the century.

During this time the American sculptural evolution paralleled that of painting, beginning with a group of genre sculptors whose work coincided in spirit with the Eight. In response perhaps to the social zeal of the naturalist writers and to a general reforming impulse, the Swedish sculptor Charles Haag began to model groups of strikers in heroic attitudes shortly after he settled in America in 1903. His Impressionistic surfaces,

479. ABASTENIA ST. LEGER EBERLE. *Roller Skating.*
Before 1909. Bronze, height 13″.
Whitney Museum of American Art, New York City

derived from Rodin, his vigorous handling and undisguised working-class sympathies were shared by Mahonri Young, who was doing energetic bronzes of laborers and stevedores in the same period. Later Young, like Luks and George Bellows, turned to prizefighter subjects and became celebrated for the muscular vigor of his athletes in action.

The energies of ordinary people, and of children in particular, were the themes of another of the new genre group, the sculptress Abastenia St. Leger Eberle. In 1914 she took a studio on the Lower East Side, from which vantage point she observed and made sculptures inspired by the burgeoning street life of New York's undismayed and vital lower classes.

The naturalism of the Eight gave way before the visual revolution of modernism. But it was renewed with a different accent in the romantic realism of Burchfield and Hopper during the twenties, and then again in Regionalist American scene painting, and in the urban realism of Kenneth Hayes Miller and Reginald Marsh during the thirties. Similarly, sculpture passed through a period of moderate experimentation, although by the thirties it was dominated by realistic sentiment and Expressionist mannerism once more. The tenacity of representational modes of sculpture in America, so contrary to the European experience during the same period, except perhaps in Germany, paralleled the painting situation. It may be explained by the premature dissolution of any concerted, collective movement toward the experimental, and by the absence of any single master of wide influence who might have found disciples and established an uncompromising modern style.

The pioneers in modern American sculpture were affected by radical European art forms, but without exception they gave their Continental sources a more stylized and decorative character.

480. MAHONRI YOUNG. *Organ Grinder*.
Bronze, height 10″. Permanent collection,
Brigham Young University, Provo, Utah

482. ELIE NADELMAN. *Man in the Open Air*.
c. 1915. Bronze, height 54½″.
The Museum of Modern Art, New York City.
Gift of William S. Paley

481. MAHONRI YOUNG.
Middleweight (Enzo Fiermonte). c. 1929.
Bronze, height 27″. Whereabouts unknown

Elie Nadelman, for example, who came to America from Poland in 1914, had experienced at first hand the influence of the Munich Jugendstil and the School of Paris. Between 1907 and 1914, after contact with Paris Cubism, he worked in a more analytical spirit, reducing his figures to a regularized system of curved volumes and their logical spatial echoes. He nonetheless retained a certain tapered elegance of form, and never overcame the quality of mannered refinement in his work. Essentially, his style stems from the bloodless and artificial ornament of Art Nouveau, despite an apparent commitment to the scrupulous streamlining and drastic geometric simplifications of vital modern forms. He has been rather recklessly described as a precursor of Cubism and a direct influence on Picasso, claims which are contradict-

483. ELIE NADELMAN. *Head of Baudelaire*. c. 1936.
Marble, height 17".
Joseph H. Hirshhorn Collection

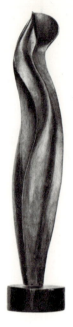

485. ROBERT LAURENT.
The Flame. c. 1917.
Wood, height 18".
Whitney Museum
of American Art,
New York City.
Gift of Bartlett Arkell

486. MAX WEBER.
Spiral Rhythm. 1915.
Bronze, height 24½".
Joseph H. Hirshhorn
Collection

484. ELIE NADELMAN. *Horse*. c. 1914.
Bronze, height 12¾".
Joseph H. Hirshhorn Collection

ed by the actual visual experience of his early work. Nadelman's monotonously repeated, uniform curves, whether in his drawings of 1906 or his sculpture of 1907, fail dismally either to articulate volume in space or to suggest even the rudiments of the new aesthetic sensibility. They bear no more profound a relation to the vital plastic inventions of Cubism than does a drafting exercise executed with mechanical-drawing tools.

Nadelman's arbitrary, stylized grace was eminently suitable, however, for the modish and witty statuettes and figures, derived perhaps from popular art traditions, which became his stock-in-trade after he settled in America at the age of

487. JOHN STORRS. *Composition Around Two Voids.*
1932. Stainless steel, height 20″.
Whitney Museum of American Art, New York City.
Gift of Monique Storrs Booz

thirty-two. It is conceivable that our native art
forms, particularly the clean, efficient lines and
chaste surfaces of Pennsylvania Dutch folk art,
may have influenced him during his residence in
this country, thus justifying America's claim to
an artist whose mature style was otherwise entire-
ly formed in the great art centers of Europe.

Gaston Lachaise is another sculptor whose
national identity is uncertain at best, but who was
assuredly one of the pioneers of modern sculpture
in America. Born in Paris in 1882, he came to the
United States in 1906. He had already studied at
the Académie Nationale des Beaux-Arts, exhib-
ited frequently at the Salon des Artistes Fran-
caises and worked for René Lalique, the designer
of Art Nouveau jewelry and objects in glass. In
America Lachaise was first an assistant to the
academician Henry Hudson Kitson, and then to
Paul Manship. In 1913 he showed the first signs
of his own distinct style, characterized by fluent
articulation of surface, massive yet weightless
volume, and masterful control of rhythmic move-
ment. In the twenties and thirties Lachaise's full-
blooded female figures grew more distorted and
expansive, until they resembled grotesquely
swollen prehistoric fertility sculpture. Lachaise,
too, preserved something of the sinuous, flowing
line of Art Nouveau, but the subtle interplay and
resolution of masses in motion gave his sculpture

far more expressive power than Elie Nadelman's.
Although primarily a modeler, Lachaise was also
adept at direct carving, a method which had gone
out of style in the first years of this century.

In the hands of William Zorach, direct carving
became an effective way of expressing a new can-
dor about the nature of the artist's materials, and
part of a search for a simple monumentality.
Zorach, and his wife Marguerite, had shown
paintings influenced by Fauvism in the Forum
Exhibition of 1916. That year, however, Zorach
turned to sculpture as his principal medium,
employing a geometric stylization related to
Cubism. His forms underwent a drastic simplifi-
cation and bent to the rule of the curve and the
right angle. Zorach was never a Cubist or a Con-
structivist sculptor; his aim was the realization
of an idealized but consistently representational
imagery, and solidly enclosed volumes. Yet the
powerful formal organization of his earliest sculp-
ture, his feeling for simplified mass and emphatic
plane, owed something to the experience of
Cubism. His critics, however, have more often
related these elements in his style to the modern
classicism of Aristide Maillol.

In the late twenties Zorach began to employ

488. GASTON LACHAISE. *Standing Woman.* 1912–27.
Bronze, height 70″.
Whitney Museum of American Art, New York City

267

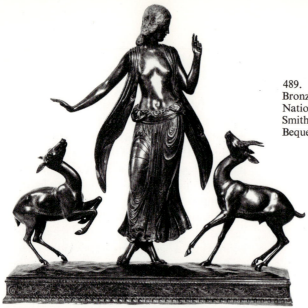

489. PAUL MANSHIP. *Dancer and Gazelles.* 1916.
Bronze, height 32¼″.
National Collection of Fine Arts,
Smithsonian Institution, Washington, D.C.
Bequest of the artist

491. GASTON LACHAISE. *Floating Figure.* 1927 (cast 1935).
Bronze, height 51¾″.
The Museum of Modern Art,
New York City

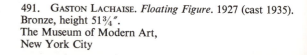

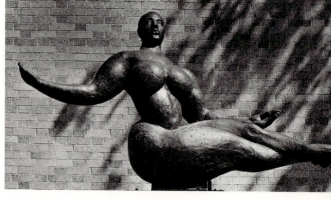

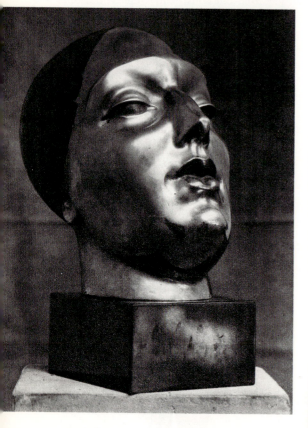

490. GASTON LACHAISE. *Head.* 1928.
Nickel-plated bronze, height 13¼″.
Whitney Museum of American Art,
New York City

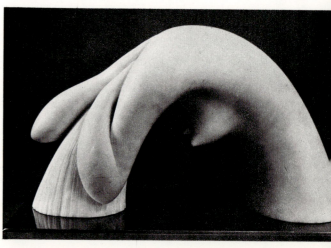

492. HUGO ROBUS. *Girl Washing Her Hair.* 1940.
Marble (original in plaster, 1933), height 17″.
The Museum of Modern Art, New York City.
Abby Aldrich Rockefeller Fund

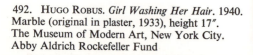

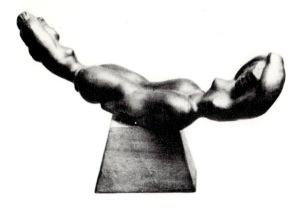

493. CHAIM GROSS. *Performers*. 1944.
Bronze, length 19″.
Joseph H. Hirshhorn Collection

cramped, compact forms. Pressed into unity by
the sculptor's forceful will, or deliberately im-
prisoned by the too narrow confines of his stone
blocks, these more constricted, angular forms
were closer to the spirit of Romanesque relief
than they were to the fluent grace and breadth of
Maillol. Like so many other American artists of
the period, Zorach seemed to be moving toward
Expressionist distortion.

A controlled Expressionism was also the basis
of the style of one of the most interesting stone
carvers who emerged in the thirties, John B.
Flannagan. Flannagan's earlier work had been
gothic images of suffering, attenuated, free-
standing figures in wood handled like bas-relief,
with affinities to both German Expressionism and
primitive Christian art. In the next decade his
style broadened, and became more ample and
rounded; in place of Expressionist torment, he
substituted an effective and personal formal mo-
tif: a winding, circular, or spiral movement which
conveyed a feeling of both enclosure and growth.
His subjects were almost exclusively drawn from
the animal and insect kingdom, although he ex-
ecuted a number of sensitive portraits and figure
compositions. Flannagan's forms emerged from
their stones as a chick from its egg, or they were
shown in cross-section, usually within a womb-
like enclosure. The cyclical movement of emer-
gence and return to the source made a modest but
convincing allegory of birth and death. Flan-
nagan's characterization of animal life was some-
times poignant and often humorous; it was
invariably acute in its observation. The visionary,
romantic art of Ryder and Morris Graves, and
the microscopic sensibilities of such American
poets as Emily Dickinson and Marianne Moore,

support and confirm the native authenticity of
Flannagan's touching, creatural realism.

He had very little influence on his contem-
poraries, although his intuitive sense that a
somewhat abstract figuration could stimulate
emotional as well as intellectual reactions may
have done something to loosen the grip of the
derivative, stylized modernism which dominated
American sculpture. Flannagan's feeling, too, for
the inherent expressive qualities of the sculptor's
materials may have anticipated a later generation.
"Often there is an occult attraction in the very
shape of a rock as sheer abstract form," he wrote.
"It fascinates with a queer atavistic nostalgia, as
either a remote memory or a stirring impulse from
the depth of the unconscious." Even in the forties,
when America's most impressive sculptors were
abstractionists and welders in metal, expressing
their deepest commitment to modernism in terms
of radical new techniques, Flannagan's search for
sculptural symbols that would coordinate a vital
abstract manner of expression with intensely in-
dividual emotion remained meaningful.

His essentially romantic art was, nevertheless,
too narrow and restricting to provide a substan-

494. WILLIAM ZORACH. *Head of Christ*. 1940.
Black porphyry, height 14¾″.
The Museum of Modern Art, New York City.
Abby Aldrich Rockefeller Fund

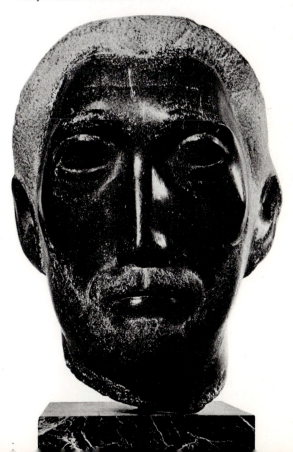

495. WILLIAM ZORACH. *Child with Cat*. 1926.
Tennessee marble, height 18″.
The Museum of Modern Art, New York City.
Gift of Mr. and Mrs. Sam A. Lewisohn

496. WILLIAM ZORACH. *Embrace*. 1933.
Bronze, height 66″.
Bernard Danenberg Galleries, New York City

497. SAUL BAIZERMAN. *Mother and Child*. 1931–39.
Copper, height 31″.
Joseph H. Hirshhorn Collection

tial basis for a general style. Flannagan had a distinctly provincial temperament, although an intensely personal one, which was only capable of a partial assimilation of the more vital form-language of his time.

That curious conflict in American art between an authentic but limited native expression and the attainment of a contemporary sophistication was never so acute as it was during the thirties. Throwing caution aside and seeking mastery of European modes put the American artist in danger of eclecticism and an empty mannerism. The lesson of modernism had been, on the whole, that the influence of contemporary European art forms tended to compromise the American artist's own peculiar angle of vision. On the other hand, those artists who ignored Europe were equally in danger from the pressures of provincialism, from the Regionalist, social-realist, or Expressionist themes of the period, which put a premium on sentimental anecdote.

A spirit of aggressive self-determination has been one of the characteristic features of much recent American art, and while it has often been a vital factor in our originality, it has also cut off many of our artists from the most generative influences of modern art. Henry James provided a valuable corrective to the general view of national artistic identity when he described the American artist as one, in effect, who is sufficiently cultivated to be a European but *chooses* to be an American. Some of our outstanding artists have undoubtedly been sincerely naive—so absorbed by their own romantic innocence that they could remain blissfully ignorant of Europe with impunity. But surely our most satisfying creative personalities have been the products of a completed assimilation of international styles, who have then applied themselves, in an act of deliberate choice, to the American experience.

Prominent in this category of moderns, Alexander Calder has been for many years a sculptor unique for his urbanity and stylistic sophistication. An apostle of modern abstract idioms during the critical period between the Armory Show and contemporary abstraction, Calder played a role similar to that of Stuart Davis. During the discouraging decade of the thirties he was one of the few American sculptors to work in the experimental spirit; he gave the important Constructivist ideal in sculpture a continuing vitality and meaning without sacrificing his own distinctly native

499. JOHN B. FLANNAGAN.
Triumph of the Egg. 1937.
Cast stone, height 12″.
Joseph H. Hirshhorn Collection

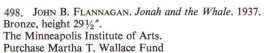

498. JOHN B. FLANNAGAN. *Jonah and the Whale*. 1937.
Bronze, height 29½″.
The Minneapolis Institute of Arts.
Purchase Martha T. Wallace Fund

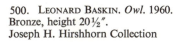

500. LEONARD BASKIN. *Owl*. 1960.
Bronze, height 20½″.
Joseph H. Hirshhorn Collection

qualities. His special gifts were a wry humor, a playful fantasy, and a wonderfully resourceful inventiveness. Most important, too, was Calder's sensitive commitment to metals, which constituted a candid admission on the part of the artist that he was inextricably a part of, and had therefore better make some relevant artistic use of, the Iron Age. The basic conception of his art became, as he put it, "the idea of detached bodies floating in space, of different sizes and densities . . . some at rest while others move in peculiar manners. . . . Symmetry and order do not make a composition. It is the apparent accident to regularity which makes or mars a work." Calder's organized formal accidents, taking place among moving ensembles of standardized metal shapes, which in themselves would have given supreme pleasure to the most austere modern engineer, took the sting out of mechanization. Using almost uniform shapes, if not sizes, cut out of sheet steel, Calder gave to modern machine civilization a new lyricism and artistic expression.

His deceptively simple and irresistible constructions have often been described disapprovingly, in our solemn age, as aesthetic playthings. Neither Klee nor Miró would have considered the term a reproach. Calder, indeed, won his first recognition as a maker of animated toys; his famous miniature circus, with its expressive wire-and-wood marionettes of big-top performers, delighted Joan Miró and attracted the enthusiastic interest of a wide circle of international artists in

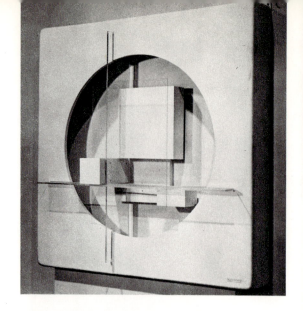

502. THEODORE ROSZAK. *Construction.* 1937.
Wood, Masonite, and plastic, 80½ × 80½ × 12″.
National Collection of Fine Arts,
Smithsonian Institution, Washington, D.C.

Paris between 1927 and 1930. During the thirties Calder continued his work in three-dimensional construction, living in Paris most of the year with occasional visits to America. Direct contacts with Mondrian and Miró were important factors in the evolution of his style. By 1932 he had put aside his representational sculpture in wire for the first ventures in those freestanding, mechanically driven structures, "stabiles," and somewhat later, the wind-propelled "mobiles" on which his major reputation is based.

Mondrian's strict, geometric schemes first turned Calder away from his representational

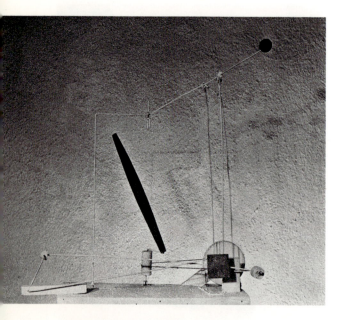

501. ALEXANDER CALDER. *Dancing Torpedo Shape.* 1932.
Mixed media, motorized, height 28″, base 10½ × 6½″.
Berkshire Museum, Pittsfield, Mass.

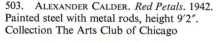

503. ALEXANDER CALDER. *Red Petals.* 1942.
Painted steel with metal rods, height 9′2″.
Collection The Arts Club of Chicago

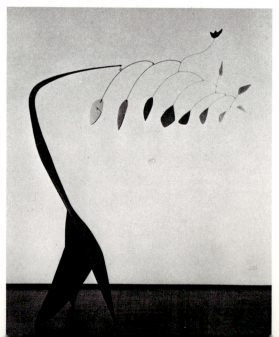

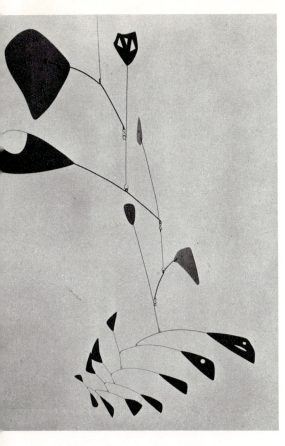

504. ALEXANDER CALDER. *Black Mobile with Hole.*
1954. Painted steel with metal rods, height 8′6″.
Collection Mr. and Mrs. Jean Davidson,
Sacramento, Calif.

505. ALEXANDER CALDER.
Polygons on Triangles (*The Nun*). 1963.
Steel plate, height 9′2″.
Perls Galleries, New York City

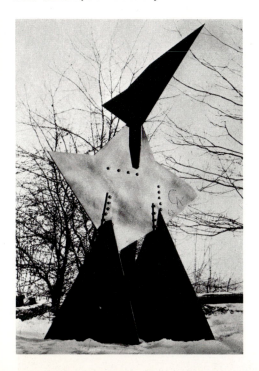

interests to abstract compositions, giving him
what he later described as "the necessary shock."
Calder has recalled in an interview the excitement
and the sense of discovery in his first visit to
Mondrian's studio, with its scrupulously clean
white walls to which the artist had tacked remov-
able paper rectangles of red, blue, and yellow.
"I thought at the time," the sculptor declared,
"how fine it would be if everything there moved,
though Mondrian himself did not approve of this
idea at all. I went home and tried to paint. But
wire, or something to twist or tear or bend is an
easier medium for me to think in." From Miró's
free forms and flattened kidney forms Calder
derived his basic vocabulary of shape, and even
found stimulation for his delightful eruptions of
humor. He digested the influence of both artists
thoroughly, however, and in a very short time the
American sculptor arrived at his own thoroughly
original idiom.

It is impossible now to think of Calder's in-
ventions apart from the American experience,
even as we grant that he is among the most inter-
national and urbane of our modern masters. His
flower-like constructions often seem a witty and
tactful commentary on the national passion for
mechanical gadgets. The mobile brings mechan-
ism into contact with a world of tenuous natural
growth and achieves an organic-aesthetic life of
its own. Its exquisite movements and endlessly
varied spatial configurations seem to obey rhyth-
mic principles which we associate with nature.
Jean-Paul Sartre has written that Calder's sculp-
tures "are at once lyrical inventions, technical
combinations almost mathematical and, at the
same time, the responsive symbol of Nature—this
great vague Nature, which throws pollen about
lavishly and will produce brusquely the flight of
a thousand butterflies. . . ." In Calder's inventive
schemes even today there is something fresh,
youthful, gay. Pragmatic procedures and an un-
apologetic materialism, in the service of an ideal
of grace, tempered by irony, might best define
the qualities of his exquisite art.

Until the sixties, Calder seemed to be moving,
with no diminution of invention or ingenuity,
along the established paths he had laid out for
himself in Paris some thirty years before. In the
past decade, however, his magnificent stabiles
have become environmental in scale, and must
rank among the most impressive monumental
sculpture in metal of the century. Ideally, these

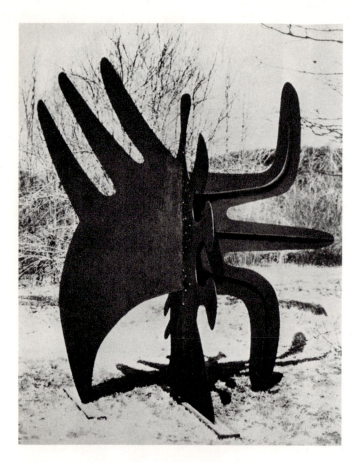

506. ALEXANDER CALDER.
Prickly Pear. 1964.
Steel plate, height 10'.
Perls Galleries, New York City

imposing and yet buoyant forms should be experienced as part of the landscape, and they are in fact large enough to provide shelter, or to be walked through and under. The enlargement of their swelling, Miróesque shapes, invariably painted either black or a sizzling orange-red, and the emphasis on their welding seams and rivets contribute to an intensified presence and formal power. Because the curving and angled forms are sheer and elegant, they associate themselves with the contemporary Minimalist sculptors, who also use biomorphic or geometric shapes on a vast scale to achieve contradictory effects of anti-gravitational lightness, and an illusionist play of sensuous surface. As has so often been the case with a "master" of modern art, Calder manages to identify his undiminished vitality with the work of a youthful generation whose monumentalism he prophesied some time ago with his first large stabiles.

The period after World War II produced a major breakthrough in American sculptural innovation, as well as several major figures, as was the case with Action Painting. Sculpture has shared with painting many of its seminal insights, but in the early sixties the revolutionary changes in sculptural idioms seemed even more dramatic, since they involved radical redefinition of the nature of the medium itself. Assemblage, "junk sculpture," and new types of structures which profited from visual ambiguity have created fresh artistic alignments, blurring traditional distinctions between painter and sculptor. The visual ideas treated by painting and sculpture now seem surprisingly interdependent, as they once were in the Baroque age, another period marked by an extraordinary surge of energy and fertile invention that often transgressed the integrity of individual artistic mediums and brought them into a new synthesis.

Shortly after the Second World War, an idiom of fluid metal construction emerged as the most powerful tendency in advanced American sculpture. Freely adapting from Surrealism its addiction to accident, welder-sculptors built open forms in a variety of techniques that combined improvisation, new kinds of surfaces, and the formal ideals of modern Constructivist tradition.

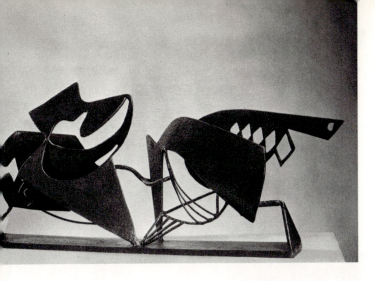

507. DAVID SMITH.
Construction in Bent Planes. 1936.
Iron, $13 \times 32\frac{1}{2}''$.
Estate of the artist

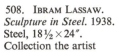

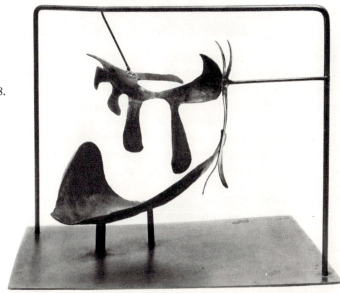

508. IBRAM LASSAW.
Sculpture in Steel. 1938.
Steel, $18\frac{1}{2} \times 24''$.
Collection the artist

509. REUBEN NAKIAN.
The Rape of Lucrece. 1953–58.
Direct steel (by the artist–not
fabricated), height 12′.
Egan Gallery, New York City

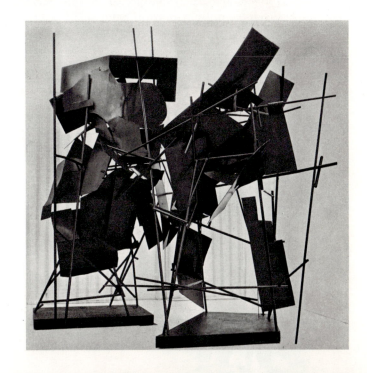

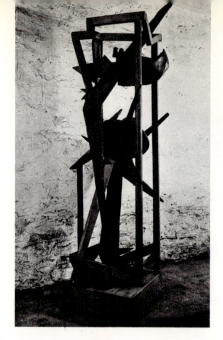

510. (*left*) SEYMOUR LIPTON.
Imprisoned Figure. 1948.
Wood and sheet lead,
height 84¾".
The Museum of Modern Art,
New York City.
Gift of the artist

511. (*right*) DAVID HARE.
Magician's Game. 1944.
Bronze, height 40¼".
The Museum of Modern Art,
New York City.
Gift of the artist

Many of the first ventures were fantasy-ridden and aggressive in handling, despite an overriding concern with the expressive potential of medium. The new work was not all exasperation or strident feeling, however, and allowed for a variety of moods, from dramatic emotionalism to quietism. Ibram Lassaw's first metal sculptures of the early 1950s were intricate cage constructions which delicately fused grids in three dimensions to create an atmosphere of luminous serenity. David Smith worked in a coarser, more capacious idiom that incorporated allusions to fantastic anatomies, personal mythologies of predatory birds or fleeing specters, and "found" machine parts. His extravagant romantic rhetoric was kept within bounds by a mastery of lucid Constructivist form.

Seymour Lipton established an unexpected relationship between the organic forms of nature, which dramatized the life processes, and the revealed dynamics of the creative act. Herbert Ferber's imagery was thorny and barbed but spatially liberated; David Hare's hybrid forms made overt references to Dadaist discontinuities and to the pull of primitive cultures. Theodore Roszak invented a language of potent new sculptural symbols analogous to clutching tree roots or bone and skeletal structure, and his violent images acquired a special power and durability in welded steel. Like the Abstract Expressionist painters, these sculptors were driven by an ambivalent sense of forging urgent personal images while yet adhering to the main line of European modernism. For the younger generation that followed them, it was their "unfinished" imagery, and technical laissez faire, in defiance of traditional sculpture methods, which proved most liberating.

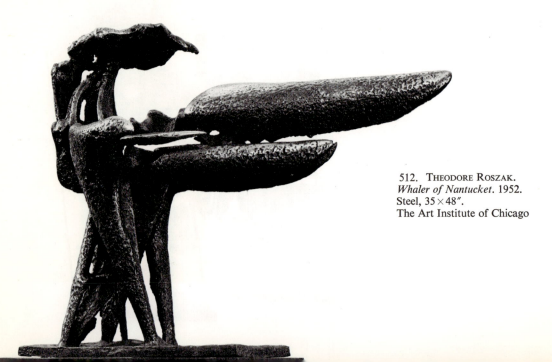

512. THEODORE ROSZAK.
Whaler of Nantucket. 1952.
Steel, 35 × 48".
The Art Institute of Chicago

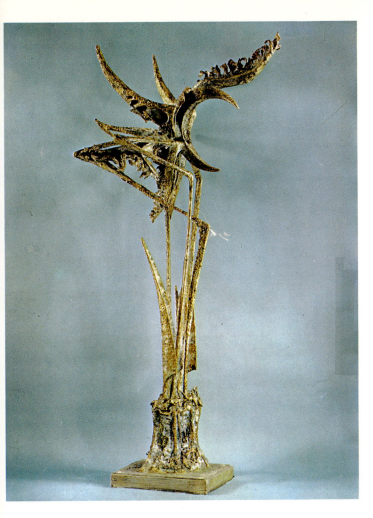

513. THEODORE ROSZAK. *Sea Sentinel*. 1956.
Steel and bronze, height 8'9".
Whitney Museum of American Art,
New York City

514. HERBERT FERBER. *Sun Wheel*. 1956.
Brass, copper, and silver solder, height 56¼".
Whitney Museum of American Art, New York City

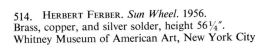

515. IBRAM LASSAW. *Clouds of Magellan*. 1952. Welded bronze and steel, $52 \times 70 \times 18''$.
Collection Philip Johnson, New York City

516. SEYMOUR LIPTON. *Laureate*. 1968.
Nickel-silver on Monel metal, height 12′6″.
Performing Arts Center, Milwaukee, Wis.

517. ISAMU NOGUCHI. *The Opening*. 1970. French rose and Italian white marble, 26 × 27″.
Cordier & Ekstrom Gallery, New York City

518. LOUISE BOURGEOIS.
Noir Veine. 1968.
Marble, 23 × 24 × 27″.
M. Knoedler & Co., New York City

However, the romantic indulgences in form and the exalted idea of the artist as a hero whose passions might enlist one's sympathies no longer seemed applicable to their own situation.

One of the venerable pioneer figures who exercised a direct influence on work of the new sculpture generation was Reuben Nakian. Like so many American avant-garde artists, he had been a technically accomplished traditionalist until the early 1940s, and then underwent a revolution in style. Later in that decade, he began to improvise freely in plaster, developing mythological subjects (recognizable themes of seduction in baroque, twisting diagonals) which he gouged, pressed, and kneaded until they functioned as loose, amorphous, abstract forms. Then, in 1953, he experimented with burlap stretched on chicken wire, dipped in glue and quick-setting plaster. His forms were close in spirit to de Kooning's, and their impermanence of surface, casualness of technique, and materials seem now to have anticipated the primitivist, glued-paper constructions of Oldenburg. Before the object could become sculptural, sculpture had to establish its identity with the object, and by 1960 Nakian's thin plaster shells seemed to resemble casual assortments and bundles of stiffened rags. These inventions, later cast in bronze, represented a major departure from the direct metal techniques and the alternately linear or Cubist structural forms of the leading sculptors of his generation. In the art of de Kooning, too, a similar reversal was experienced as the wall of paint he erected became so literal in its material

519. REUBEN NAKIAN. *Ecstasy*. 1946–47. Bronze, height 12½".
Joseph H. Hirshhorn Collection

densities as to deny space its transforming function and took on the quality of an inert object mass.

David Smith was the first American sculptor to work consistently in what was to become a widely influential mode, that of welded metals. In 1933, shortly after he had been deeply impressed by an issue of *Cahiers d'Art* devoted to the iron constructions of Picasso and Gonzales, Smith borrowed welding equipment and did his first crude metal sculpture. He had already studied painting with modernist Jan Matulka at the Art Students League, and had begun to break away from painting into a form of painted wooden construction related somewhat to Picasso's hybrid construction-collages of 1914. Explaining his own development, Smith wrote:

520. REUBEN NAKIAN.
Leda and the Swan. 1960–61.
Terra cotta, length 14".
Private collection, New York

521. REUBEN NAKIAN. *Olympia*. 1961.
Bronze, height 72″.
Whitney Museum of American Art, New York City.
Gift of the Friends of the Whitney Museum

522. DAVID SMITH. *Royal Bird*. 1948.
Stainless steel, 21¾ × 59″.
Walker Art Center, Minneapolis.
T. B. Walker Foundation Acquisition, 1952

While my technical liberation came from Picasso's friend and countryman, Gonzales, my esthetics were influenced by Kandinsky, Mondrian and Cubism. My student period was involved only with painting. The painting developed into raised levels from the canvas. Gradually the canvas became the base and the painting was a sculpture. I have never recognized any separation between media except one element of dimension.

My first steel sculpture was made in the summer of 1933, with borrowed equipment. The same year I started to accumulate equipment and moved into the Terminal Iron Works on the Brooklyn waterfront. My work of 1934–36 was often referred to as line sculpture, but to me it was as complete a statement about form and color as I could make. The majority of work in my first show at the East River Gallery in 1937 was painted. I do not recognize the limits where painting ends and sculpture begins.

Smith then followed an unenviable, lonely, and pioneering course in American sculpture. He always worked directly in iron and steel without a surfacing of bronze, brass, or nickel silver. His rugged architectonic schemes were both more closely related to Constructivism, and more laden with symbolic references, than the comparable welded sculpture of Lipton, Ferber, Roszak, or Lassaw. For Smith, steel had striking natural attributes and certain positive values. "The metal," he wrote, "possesses little art his-

523. DAVID SMITH.
Hudson River Landscape. 1951.
Steel, length 75".
Whitney Museum of American Art, New York City

524. DAVID SMITH. *Cathedral*. 1950.
Painted steel, height 34½".
McCrory Corporation, New York City

tory. What associations it possesses are those of this century: power, structure, movement, progress, suspension, destruction, brutality."

Iron and steel are malleable and yet have a stubborn refractoriness: they may be easily cut, forged, and shaped by the oxyacetylene torch, and they also powerfully assert their permanence, and arouse sensations directly related to our industrial age. Thus the medium combines the advantages of contemporary painting or the painted collage, with the enduring, intrinsic appeal of the sculpture medium as structure and space enclosure.

Smith always made a point, at times even a fetish, of dramatic content, loading his structures with a wealth of symbolic references; in the early and middle forties, he was characterized rather appropriately as a "social Surrealist." His artistic strength, however, derived from a remarkable mastery of structure, rhythmic movement, and a varied play of sculptural silhouettes. At that time the artist insisted quite properly on the necessity of dramatic content as a necessary spur to plastic invention. If his imagery was decidedly anecdotal at times, his symbolism was also a fertile source of his expressive individuality.

Unlike Gonzales, whom he first emulated, Smith showed more candor about his materials and their raw, untransformed qualities. His forms were harsh, and physical, and resisted conventional aesthetic criteria. Gonzales, on the other

525. FREDERICK KIESLER. *Galaxy*. c. 1951.
Wood construction, height 12′.
Private collection, New York

526. DAVID HARE. *Juggler*. 1950–51.
Steel, height 80¼″.
Whitney Museum of American Art,
New York City

hand, was sometimes trapped by seductive surface, by patinated texture, and by the operation of his own essentially cultivated sensibilities. He let his raw industrial materials assert themselves, but only to add force to an essentially contemplative, refining formalism. Smith's elementary force and assertive materialism go beyond the limits of the permissible defined by modern European tradition. But his work at its best also has the power to show us the expressive limitations of traditional taste and refinement.

Certainly a large part of Smith's public appeal in the middle years was his very personal frame of allusion. His analysis of the sculpture *Cathedral* of 1950, as related to the artist-critic Elaine de Kooning and ably transcribed by her in an article in the June, 1950 number of *Art News,* may amaze us by the degree to which the artist encouraged specific associations for his abstract imagery. The work in question is an open metal cage, with appended plaques and a varied ensemble of structural elements. At the center, supported by a fluted column, is a vertical form in the shape of a fork gripping with its tines a number of sagging, turnip-like objects reclining in vegetal quietude on a stepped base. One of the upright plaques has been cut away at the center to make an empty silhouette resembling the human form, and it is bisected by a curving metal spine; on an iron ring to one side rests a skeletal, ribbed figure. These forms were interpreted by the artist as a social drama of predatory violence, in which the main fork-like figure was to represent a cathedral which was in turn "a symbol of power—the state, the church or any individual's private mansion built at the expense of others." The prone forms were to be read as a "symbol of sacrifice," "man subjugated."

In the mid-forties Smith had been even more preoccupied with symbolism and social content. At that time he cast in bronze a sculpture called *The Rape,* showing an outstretched female figure menaced by a cannon on wheels; the ambiguity of the cannon as symbol of two types of aggression, both war and sex, was inescapable. In an appreciation, Stanley Meltzoff interpreted the violent sculptural pun as a reflection of Smith's interest in Joyce's *Finnegans Wake.* "Using adjectives found in the first chapter of *Finnegans Wake,*" Meltzoff conjectured, "Smith's cannon is 'sexcaliber' and 'camiballistic.' The cannon, like Joyce's Sir Tristram, is a '*violer d'amores,*'

an amoral musical amorist, part viola and part violater."

Smith's imagery also invokes a more general Surrealist atmosphere, and some of those conventions used to convey apprehension by both Picasso and Alberto Giacometti. Although the imagery of *Cathedral* is reminiscent of Giacometti's *Palace at Four A. M.,* the impact of the forms is, needless to say, less subtle, literary, or programmatic. There is a refreshing colloquialism and robust humor in Smith's adaptations, more of the "tall tale" and native burlesque than the Surrealist horror theater. Despite his continuing social preoccupations and use of Surrealist devices, Smith was primarily a constructor of plastic forms which are most rewarding when considered in their architectonic aspect. In this light *Cathedral* effectively deals with a modern structural problem in open, platform sculpture, and is full of unexpected and original invention outweighing its obvious borrowings from Surrealist imagery.

In the late fifties, Smith showed less concern with symbolism. There remained residual ties to Surrealism in his "found" objects—those parts of actual machinery or their convincing facsimiles which he incorporated into his work—and in the suggestions of an aggressive life in the forms themselves. He also worked at times during this period in a bare, linear style which depended largely on rhythmic invention and a balance of dynamic movements springing from a single

527. DAVID SMITH. *Agricola V.* 1952.
Bronze, 35½ × 28″.
Collection Mr. and Mrs. Eugene M. Schwartz,
New York City

528. DAVID SMITH. *The Rape.* 1945.
Bronze, 9 × 5⅜ × 3½″.
Collection Mr. and Mrs. Stephen D. Paine, Boston

529. DAVID SMITH. *Zig IV July 7—1961.* 1961.
Painted steel, 94⅞ × 76½″.
Lincoln Center for the Performing Arts,
New York City

fulcrum. *Australia* and many sculptures in the *Agricola* series are among his most successfully realized ventures in this idiom. Smith also created monumental standing figures, curiously suggestive of primitive totems, in which large steel cusps and trough-like lengths of metal are disposed in a system of weights and counterweights rising from a tripod or single metal

530. DAVID SMITH. *Cubi XXVIII*. 1965.
Stainless steel, 9′ × 9′ 4⅛″. Norton Simon, Inc.,
Museum of Art, Los Angeles

531. DAVID SMITH. *Cubi XIX*. 1964.
Stainless steel, height 9′ 5⅛″.
The Tate Gallery, London

column. These *Tank Totems* (so called because the disk forms were actual readymade plating used in boiler construction) must rank with the most original and monumental contemporary sculpture in America of its period.

Then, at the end of the fifties, Smith also experimented with flat, attenuated steel bars and slabs of irregular contour, rising to great heights, like totems denuded of their imagery and symbolism. The ruthless process of formal reduction continued into perhaps his most significant period of production, from 1960 until his death in 1965. In these years he created, among others, his magnificent "Cubi" series, structures allied to sculptural Cubism, as their rubric suggests. Their monumental scale, economy, expressive power, and the scintillation of light on their wire-brushed and burnished surfaces elicit quite different responses, however, from the refined chamber music of historical Cubism. With their shining cubic masses in stainless steel, these last climactic works were classical in their order and lucidity, and severely nonpersonal. Surprisingly, too, insubordinate energies seemed to be released by the vast scale and illusionistic surface effects, which offset an otherwise restricted range of artistic

decisions regarding balance, structure, and size of component masses.

Smith's continuing devotion to industrial materials, from painted T-beams to his welded and polished boxy forms in stainless steel, and his passion for a simplified but ambiguous geometric order, directly transformed the work of the influential English Structurist sculptor Anthony Caro, who taught at Bennington College in the sixties and worked closely both with Smith and with their painter friend Kenneth Noland. The inflated scale, open forms, spatial torsions, and, above all, highly reductive means of the new style of "Primary Structures" which emerged after Smith's death were prophesied by his radical change in style. It is characteristic of David Smith that he was able to reappraise himself in terms of the changing aesthetic climate of his age, just before his untimely death. His passion for a new kind of austere yet sensuous, heroic but personal art of geometric form echoed the preoccupations of his younger artist friends in painting, and also showed young sculptors a new path to the future.

David Smith had been first on the scene in welded sculpture, but to artists like Lipton, Lassaw, and Ferber, his idiom of found and

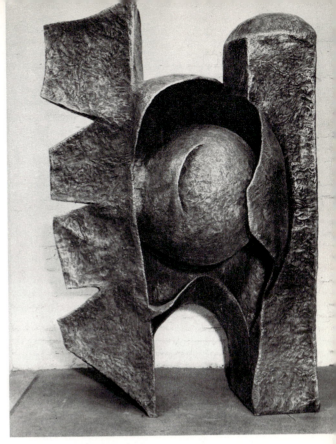

532. SEYMOUR LIPTON. *Empty Room*. 1964.
Nickel-silver on Monel metal, height 76″.
Anonymous collection

533. SEYMOUR LIPTON. *Gateway*. 1964.
Bronze on Monel metal, height 76″.
Marlborough Gallery, New York City

forged shapes, and his almost exclusive interest in iron and steel, proved restricting. In their own distinctive styles they began to enlarge the possibilities of contemporary sculpture within a more fluid idiom which utilized metal alloys. They fashioned their surfaces by burning and welding, or by flowing molten metals over hammered forms of a more spontaneous, improvisatory character. Such methods afforded them certain advantages, which could be exploited according to the dictates of their individual temperaments and technical ingenuity. Accessible to them was a new freedom comparable to that of the modeler who builds up form progressively from a core; they also encountered the fruitful resistance of direct cutting without its constraints, since the fluid welding techniques with a variety of metal alloys allowed wide revision and supplementary invention.

Self-taught, Seymour Lipton began the independent study of sculpture in 1932, and by the end of the decade was carving wood figures, violent in their distortions and charged with an accusatory social content. From 1940 to 1942 he completed such pieces as *Refugee* and *Breadline*, in stone and wood respectively, and had carried

his expressive language to a point of near-abstraction. Writing of this period, Lipton described his growing preoccupation with themes of struggle, first in society and then in universal nature:

In the late thirties I made wooden pieces based on social problems, the formal mood stemming from such things as Gothic bestiary, Hieronymous Bosch, German Expressionism and primitive sculpture. The prevailing feeling was one of fierceness. I soon found wood and social problems too limiting for my creative freedom. I went to metal casting. Leaving the human figure in 1942, I began using skeletal forms, horns, pelvis, first in bronze and then in lead construction, etc., to convey the basic struggles in nature on a broader biological level. Aeschylus had always been for me a guiding force of tragic, poetic catharsis.

Gradually the sense of the dark inside, the evil of things, the hidden areas of struggle became for me a part of the cyclic story of living things. The inside and outside became one in the struggle of growth, death and rebirth in the cyclic renewal process. I sought to make a sculpture as an evolving entity, to make a thing suggesting a process.

It was in 1945 that Lipton first began to work in sheet lead, evolving the basic techniques and the abstract imagery which became the core of

his style. Such pieces as *Moloch* and *Wild Earth Mother*, dating from this period and shown in his first exhibition of metal sculpture in 1948, were composed of aggressive shapes of crushing power. These somber, weighty forms, with their angular contours and heaving surfaces in which gaping holes were torn or ragged troughs scored, seemed like grotesque primordial shapes reborn in the Age of the Machine. While there was some lyrical relief in the handling of surfaces, the artist rarely yielded to "softness." He seemed to wish to inveigh against life in a dolorous spring ritual of birth and death. Despite Lipton's indulgence of his more violent instincts, he achieved an expression not merely of elemental savagery but also one marked by disciplined craftsmanship and formal control.

After 1950 Lipton's sculptures relinquished something of their more obvious, violent romanticism. His emotion became more objective, his work lighter in spirit. In place of the turgid pyramidal and pelvic shapes derived from fantasies on human anatomy he substituted thin, curving shells of sheet steel, which he covered with varying deposits of bronze or nickel silver to enhance both textural interest and structural strength. Andrew Ritchie explained the change in mood and methods: "Reflecting a new-found faith in

534. ISAMU NOGUCHI.
Stone of Spiritual Understanding. Cast 1962.
Bronze and wood, height 36″.
The Museum of Modern Art, New York City

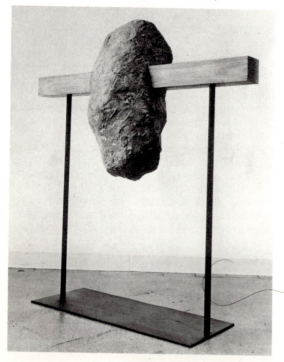

the regenerative process of nature the artist leaves the human figure, with all its recent connotations of hate and death, and looks instead to plant forms, in bud and expanding under pressure of the life-force. And it is to such biological imagery that his sculpture has become devoted."

In the past two decades Lipton has executed a great number of important sculpture commissions. Among these are two for the architect Percival Goodman's Temple Israel, in Tulsa, Oklahoma (1954), and Temple Beth-El, in Gary, Indiana (1955); one for Skidmore, Owings, and Merrill's Inland Steel Building in Chicago (1956); and *Archangel*, commissioned for Lincoln Center (1963). The *Menorah* for the Tulsa temple and formally related pieces such as *Pioneer* (1957) are monumental in scale and feeling, with a breadth of generalization unique in Lipton's work. These sculptures give us a glimpse of a new mood, positive, logical, proof against even the most contentious play of emotion.

The monumental *Archangel*, which has become a well-known public symbol for New York's cultural center and Philharmonic Hall, alludes to musical instruments which are also "winged presences," in the artist's words. The mythology seems entirely appropriate to a temple of music. But the symbols also recall leaves and tree limbs, and restate the combined mechanical, botanical, and sexual metaphors of many other sculptures by the artist in a typical form, which one critic has aptly characterized a "plant-machine." Curving surfaces of thin fragility are violently penetrated and torn by a predatory, screw-like shaft in an allegorical drama of vulnerability and aggression that at the same time celebrates the creative process itself. The artist's dramatic identification with the life force in a loaded Surrealistic image that surprisingly unites the world of mechanics to that of natural processes is reminiscent of Dylan Thomas's metaphor for poetic creation and for the thrust of his own life in the lines: "The force that through the green fuse drives the flower/Drives my green age; that blasts the roots of trees/Is my destroyer."

Lipton's relationship to Thomas's visionary, intellectually charged poetry is more than casual, for the artist has long admired the poet. The sculptor reveals his psychic life through striking concrete imagery and symbols which are liberating in the way of so much of modern artistic expression, in its heroic attempt to mediate the

535. IBRAM LASSAW. *Metamorphoses*. 1955.
Chromium bronze, 73 × 50″.
Collection the artist

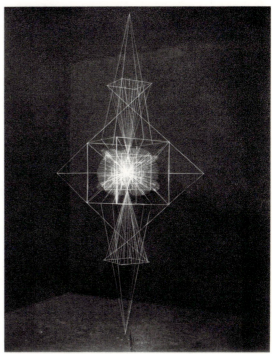

537. RICHARD LIPPOLD.
Variation Number 7: Full Moon. 1949–50.
Brass rods, nickel-chromium, and
stainless-steel wire, height 10′.
The Museum of Modern Art, New York City.
Mrs. Simon Guggenheim Fund

536. IBRAM LASSAW. *Equinox*. 1963.
Nickel-silver and phosphor bronze, height 84″.
Collection the artist

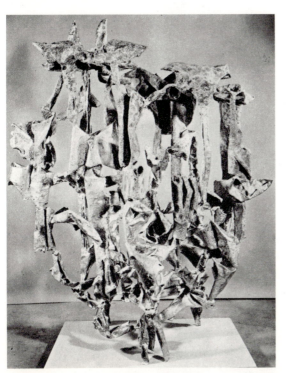

discontinuities between a threatened inner world
and an expanding range of cultural and technical
information. He has a capacity to dilate grandly
on large themes, and at the same time to focus
narrowly upon some small corner of experience.
These polarities of expressive content pull one
up short time and time again, for it is just when
Lipton's work seems most obvious that it dis-
obligingly slides off into the most mercurial and
oblique constructions of thought and fancy. The
recent *Gateway* is a crudely primitivistic, almost
elephantine evocation of a seed bursting its pod,
a theme of renewal and regeneration which the
artist has often reiterated, translated into an
undetailed form of brutal power and menace.
Yet with what lightness the balled seed floats in
the space of its chamber! We are compelled to
view the same form as now crabbed, now capa-
cious, of a visceral intensity, and of a flower-
like delicacy. These formal contrarieties are

supported by a wealth of analogues drawn from organic nature, the mechanical world, and sexual life. Polarization of form into male and female symbols is an obsessive feature of his art, as it has been for so many of the greatest sculptors of this century, and is one source of its atavistic power.

For more than a decade Seymour Lipton has been an established master of a vital new sculptural tradition. His innovations were obscured for a time by the dramatic and competitive advances of Abstract Expressionist painting, but today they can be better appreciated. Their inventive capacity and richness of existential meanings place his sculpture among the supreme achievements of postwar American art.

Ibram Lassaw has probably been a respected member of more significant professional associations and movements, from the American Abstract Artists group founded in the thirties to the "Artist's Club" of recent history, than any American artist since Ad Reinhardt—who once boasted of having been an avant-garde artist for thirty years. Lassaw began to work abstractly as early as 1931, in drawings, and was welding open-form sculpture by 1933, although not in his familiar stylistic terms. His *Sculpture in Steel* of 1938 is a cage construction with frond-like forms projecting from simulated rafter, post, and platform in three different directions. This early work also illustrates a preoccupation with competing geometric and biomorphic formal systems which has persisted throughout the artist's career. It seems as fresh and original today, as was apparent when the Whitney Museum recently displayed the work in an interesting exhibition of thirties' art in America.

Lassaw has always felt the need to breathe new life into the Constructivist tradition by fusing with it organic forms generated with more spontaneity than geometric abstraction permitted. Some of his other surprisingly mature, and even prophetic, experiments in various mediums have been discussed by the artist himself in a statement for the English magazine *Leonardo*. It provides an intriguing summary of his past expressive modes, which very often forecast the artistic directions of the sixties:

Brazing, 1937. Using a discarded refrigerator motor, a compressor and city gas, I succeeded in brazing together iron rods to which I fastened carved wooden shapes.

Shadow boxes, about 1938. There was a series of wooden shadow boxes, each with a light inside, concealed from direct view. In some were painted metal shapes; in others, wires or wooden forms.

Acrylic plastic, 1943. There follows in the work of the next few years a number of steel and plastic constructions. The stainless steel three-dimensional framing was set with shapes made of half-inch-thick lucite. The colors were obtained by applying dye directly to the surface. During 1948, I made some sculptures entirely of intersecting planes of plastic.

Wire structures, 1950. I covered wire with sheet copper and then coated it with solder, building up texture and modelling.

It is always tempting to revise controversial priorities in assessing the development of artistic innovations. The usual test in assigning individual responsibility for change is how consistently an artist has built upon a particular discovery—that is, how decisive to his own development some formal experiment ultimately proved to be. Lassaw is an interesting exception, however. His work of the thirties anticipated some of the current experimentation in plastics, and simple,

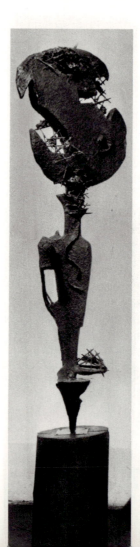

538. HERBERT FERBER.
He Is Not a Man. 1950.
Lead and brass rods,
height 72″.
Estate of Mark Rothko

cage-like Primary Structures, not to mention the welding techniques of the forties. His early experiments suggest that in a properly interacting and responsive artistic community what finally emerges as decisive change embodied in a single spectacular career is part of a shared impulse. It is very often the sum of many tentative and courageous experiments by numerous fellow artists who may enjoy less dramatic public recognition than one or two lionized avant-garde leaders. A few welder-sculptors, particularly David Smith, had already begun to make major reputations for themselves by the late forties, but Lassaw, despite his relevant contributions to current modes of innovation, did not arrive at a decisive individual style until 1950. His sculpture *Milky Way* was the significant turning point of that year, opening a new line of development for him. It revealed an original idiom of space-writing in metal, combining the fluencies of Pollock's skeins of flung paint with the architectonic bias of Constructivist tradition. The air of tentativeness which that sculpture embodies, its clear rejection of speed of execution or blind impulse, and the searching, slow evolution of its forms established relationships between Lassaw's work and the painting of Philip Guston, who also emerged in a new abstract style in the early fifties. Both were fine lyricists, and seemed intent on reinstating a more considered and structurally articulated art in place of the facile gestures of Action Painting, which were already becoming shallow, academic clichés.

Milky Way, however, was still technically awkward and contrived, with its plastic mixture dripped upon and built up over a metal armature. The next year, after his first selling success, Lassaw bought more sophisticated welding equipment. Using alloys of bronze, brass, and nickel silver, as well as chemicals, he created a permanent palette of colors ranging from burnished gold to corrosive, acidulous greens and rusty magentas of somber brilliance. During the next five busy, productive years, he evolved his basic formal types: first, exquisite linear space structures in three dimensions, of which the dazzling *Clouds of Magellan* is a luminous example; then came coral-like accretions of more massive, nubbly forms, with awkward stems sprouting into a strangely haunted undersea vegetation of lacy shape and delicate hue. These open spatial structures were followed by box forms made of layers

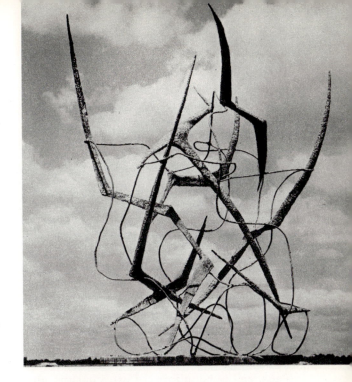

539. HERBERT FERBER. *Cage*. 1954. Lead, height 54″. André Emmerich Gallery, New York City

of winding metal foil, penetrated by ragged interior windows, rather like a Chinese puzzle or a Surrealist nest of boxes. *Equinox*, a monumental sculpture of the early sixties, best illustrates the last phase, which began in the mid-fifties and completes the quartet of formal types. It is composed of what the artist calls "volumes," sheets of bronze or brass which have been bent and hammered into massive organic shapes and then built up by brazing their surface with deposits of molten and burnished alloys.

The directions thus established persisted through the sixties, a period rich in technical discoveries. There is a grave, almost immutable air of permanence in Lassaw's most recent sculptures; they seem to have passed from the tenuous order of aesthetics to an organic sphere. The artist has been for many years a disciplined and sincere adherent of Taoist and Zen teachings, the psychology of Jung, and the esoteric wisdoms of Eastern thought. He envisions his work not so much in the context of the cultural order as the natural. "The reality I see before me," he has written, "is a living organism, and I believe all its parts are ultimately in ecological interdependence. I, as a man and an artist, participate in it according to my nature. . . . The universe performs its divine work of art with both galactic clusters and sub-atomic particles. Life is enacted

moment by moment, an illimitable network of energy transactions." Lassaw's sculpture has the power and the poetry to accommodate such a sweeping philosophical rationale and still persuade us that it belongs in the mainstream of the most creative episodes in postwar American sculpture.

Following the course of many other American artists of his generation, Herbert Ferber had been influenced by the social preoccupations of the depression years and by the general movement of Expressionism. After studying at New York's Beaux-Arts Institute of Design between 1927 and 1930, he began to carve in wood and stone massive, full-blown nudes of a restrained sensuality, with affinities to the sculpture of both Maillol and Zorach. In 1928 he traveled in Europe, where he discovered Barlach and German Expressionism, saw Negro sculpture in the Musée de l'Homme in Paris, and came to love the naive imagery and powerful, compact forms of Romanesque sculpture. Upon his return, Ferber turned to themes of individual figures and groups carved in straining attitudes underscoring their symbolic character as

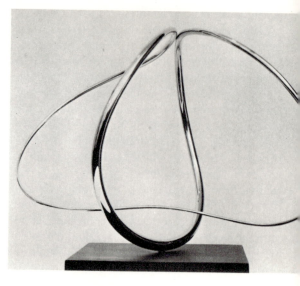

540. JOSÉ DE RIVERA.
Construction No. 103. 1967.
Bronze, height 9¼″.
Collection Mr. and Mrs. Lionel R. Bauman,
New York City

541. HERBERT FERBER. *Three Arches.* 1966. Epoxy, 10′6″×15′. André Emmerich Gallery, New York City

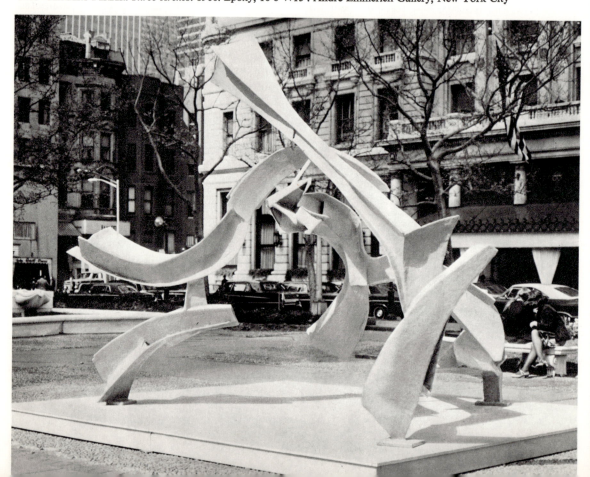

vehicles of social protest. The frontality of his forms, and a figurative convention approaching grotesque caricature, linked them to ecstatic Romanesque sculpture. By the early forties Ferber's increasingly violent distortions had nearly dispensed with recognizable subject matter, and his figures were reduced to an effective formula of near-abstract curvilinear forms. In 1945 he broke completely with representation, and for a time with sculpture. For a number of months he did no carving at all but instead executed countless drawings, conceived under the combined influence of the English sculptor Henry Moore and Picasso's fantastic abstract anatomies.

Between 1945 and 1947 Ferber experimented in wax and cement, lead, and other metals. *Hazardous Encounter* and *Apocalyptic Rider* of 1947, both executed in plaster and cast in bronze, dramatized the search for vehement expression, surging movement, and disquieting imagery that was also present in the contemporary sculpture of Roszak, Lipton, and a number of other Americans. His shapes suggested claws, teeth, thorns, a violently uprooted tree—shapes which would have made ideal stage properties in the threatening imaginary landscapes of Picasso or Miró.

By 1949 Ferber's style had reached full power as he boldly juxtaposed spiky forms, thin twists of metal, and bulging tubular frames. *Horned Sculpture* is an excellent example; its stark, bonelike, vertical trunk vaguely suggests both a primitive idol and a destitute but obstinate oak, riven by lightning, denuded of most of its leaves but still bravely contesting the elements. A network of small rods and an even finer complex of crisscrossing metal slivers bind the shapes and varied spatial silhouettes into a unity.

The artist proceeds by stages, from a line or wash drawing to a small working model, and then attacks the final large-scale sculpture as an independent structure, often discarding or elaborating on special features of his model. He cuts with automatic shears appropriately shaped strips from sheet copper or brass. The flat strips are welded into long, narrow, V-shaped troughs and sharply angular zigzags, or they are bent and hammered into a variety of curved shapes. The individual elements are then welded together into an open construction of geometric and organic forms. During this process, Ferber uses the torch to cut into or build out his surfaces in irregular protuberances. In this way, he can simultaneously

542. ISAMU NOGUCHI. *Humpty-Dumpty*. 1946. Ribbon slate, height 58¾". Whitney Museum of American Art, New York City

543. ISAMU NOGUCHI. *The Self*. 1956. Cast iron (first casting), height 34¼". The Tate Gallery, London

544. Isamu Noguchi. Courtyard, Beinecke Rare Book and Manuscripts Library, Yale University, New Haven, Conn. 1960–64

545. Joseph Cornell. *L'Egypte de Mlle. Cleo de Mérode* (open). 1940. Mixed media construction, closed $10\frac{5}{8} \times 7\frac{1}{4} \times 4\frac{3}{4}''$. Collection Mr. and Mrs. Richard L. Feigen, Bedford Village, N.Y.

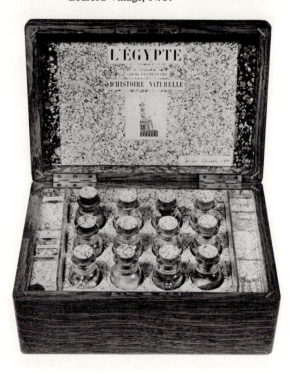

introduce new structural tensions and provide himself with occasions for the invention of interesting new shapes and rhythms, which may either reassert his original forms or actively oppose them. Such a method of working requires a special alertness, since the sculptor is tempted to yield to his more enthusiastic impulses as he follows his model. A mere enlargement, with the artist passively accepting his original plan and methodically reproducing it, is liable to be monotonous. The change in scale in itself, however, creates unforeseen formal opportunities.

From 1949 to 1954 Ferber continued to work in open, linear forms. He sometimes rotated a number of varied structural elements around a rising column of metal, emphasizing a more conventional Constructivist aesthetic, as in *Flame* of 1949. Alternately, he expressed a sense of growth in organic shapes derived from nature. One of the most commanding sculptures of these years, *He Is Not a Man* (1950), was unusual for its explicitly Surrealist atmosphere. In 1951 came the first ambitious architectural commission, a large project, measuring eight by thirteen feet for the façade of a synagogue in Millburn, New Jersey. An armature of plumbing pipe was enclosed in light shells of copper, soldered together, and then brazed with lead. The freely twisting, spatulate forms, suggesting flickering tongues of flame, were pierced and delicately connected by bundles of thin copper rod. This device served to float the heavier forms and gave the massive structure an air of weightless suspension, providing a notably successful solution to the problem of vital architectural sculpture.

Recently Ferber has sought greater simplicity in his forms, although he still puts them through complex rhythmic gyrations. One of his interesting experiments has been with roofed sculpture, in which long, twisting leaf forms are suspended from a rectilinear plate above, parallel with the sculpture's base, or cantilevered from a shield set at an angle to the base. The result is an even more daring antigravitational effect and a new ex-

pressive freedom in the pure springing movement of form in space. These golden shapes, set boldly at liberty from their structural frames, approximate in three dimensions something of the split-second spontaneity of gesture found in the more dramatic examples of Abstract Expressionist painting. Ferber has also continued a form of transparent metal collage, using indeterminate wafer-thin shapes which resemble torn papers and function almost as painterly accents against an irregular mesh network. And with notable success, he has created heroically scaled interior environments, perhaps taking a cue from his friend, the Mexican sculptor-architect Mathias Goeritz, who experimented boldly in the fifties with architectural environments and forms extended impartially from floors, walls, and ceilings.

While sculptors using welded metals have dominated the American scene, there has also been vigorous creative work with more traditional materials. The Japanese-American Isamu Noguchi, at one time an apprentice to Brancusi, worked during the forties in a variety of polished stones. He demonstrated a suave and fluent mastery of abstract idioms, with Surrealist overtones, deftly creating interlocking systems of flattened biomorphic forms derived perhaps from Arp or Miró. He has also made freestanding terracottas in rounded, doll-like shapes, and has ingeniously grouped on a vertical post varied *kasama* forms, the durable earthenware that has for centuries been used in Japan for kitchen vessels. The tension between the naive conventions of popular art forms and a sophisticated modernity give these playful inventions a distinct individuality. Noguchi is a master of elegant form and refined materials, including a wide variety of carved stones, from whose surfaces he seems able to coax a special sensuous poetry, no matter how severely geometric his structure.

Among the most rare and mysterious figures in American sculpture is Joseph Cornell, who since the thirties has been making box constructions which deserve to be placed on the highest level of contemporary American creation. His work combines the structural austerities of Constructivism with the fantasies of Surrealism and utilizes subtle painting and collage techniques. His boxes are deceptively modest and extremely personal; actually, they are also as subtly articulated in formal terms as the best three-dimensional structures of the Dutch or Russian Constructivists.

However, the almost amateurish-looking, unadorned forms house the most surprising and entrancing romantic bric-a-brac: pasted fragments of nostalgic photographs, scenes from a Victorian "grand tour," a Surrealist "poetic object," or snatches of a counterfeit but somehow touching modern mythology culled from astrological illustrations. The curious fusion, at poetic intensity, of precious sentiment, bizarre imagery, and a stern formal rectitude gives Cornell's constructions a quality entirely their own. If these boxes are so compelling, it is because they have a quality of authentic experience. They consecrate the monkish life of art, a life more often than not of renunciation and crushing isolation, which finds its creative meaning in the assiduous cultivation of childhood memories, fantasy, and images of desire. At one time the boxes seemed too private and confined in sensibility to occupy the mainstream of American art, rather like a highly personal and quixotic diary. Cornell, however, has become an honored precursor for, if not a direct influence upon, such works as Louise Nevelson's "junk" assemblages and Johns's targets with anatomical casts mounted above them. Certainly Samaras's containers of fantasy and dream, and other enigmatic constructions or poetic documentation in contemporary American

546. JOSEPH CORNELL. *Hotel de L'Etoile.*
Construction, 19 × 14 × 5".
Collection Eleanor Ward

547. LUCAS SAMARAS. *Box No. 43*. 1966.
Mixed media, 12×9×9″.
Collection Robert Halff and Carl W. Johnson,
Beverly Hills, Calif.

548. LUCAS SAMARAS. *Box No. 41*. 1965.
Wool and wood, 17×24¾×10¼″.
Collection Howard and Jean Lipman, New York City

art, suggest that a tortured "gothic" inwardness
may be as native to our culture as grandiose
aspiration, physical power, or heroic action.

In sculpture, as in painting, the postwar period
was for the American avant-garde one of exciting
ventures and new beginnings. For the first time
since the Armory Show, and perhaps in a more
decisive manner, American sculpture collectively
found a voice and began to contribute significant-
ly to international art. Its innovations had
achieved worldwide recognition by the mid-
fifties. "How many people know," an English
critic commented on an American exhibition in
London, "that Britain's recent iron age of sculp-
ture was anticipated in America? The sculpture
at the Tate Gallery in *Modern Art in the United*

States is a reminder that Butler, Chadwick and
Clarke were preceded by David Smith (by more
than ten years) and by Herbert Ferber, Seymour
Lipton, Theodore Roszak and Ibram Lassaw
(with smaller priorities). They formulated a com-
mon answer to the problem (later resolved here
in much the same way): how to make iron sculp-
ture without being a Constructivist."

Nearly a hundred years earlier Henry James
had spoken of the "terrible burden" imposed on
the American artist by his provincial isolation
from Europe. The American artist nonetheless
had to test himself by Continental aesthetic cri-
teria, for they represented the highest standards
of contemporary civilization; but he also had to
fight "against a superstitious valuation of
Europe." The basis of his independence—a de-
tachment from his Continental sources—was the
very cause of a deep sense of inhibition and
inferiority. But James looked to the future with
hope. The American, he wrote, has to deal "more
or less, even if only by implication, with Europe;
whereas no European is obliged to deal in the
least with America. No one dreams of calling him
less complete for not doing so . . . but a hundred
years hence—fifty years hence perhaps—he will
doubtless be accounted so."

By the fifties, American sculptors could point
with justifiable pride to the virtual fulfillment in
the visual arts of James's prophecy. It was then
that their innovations became a shaping force in
world art and their vitality proved so refreshing
and liberating, helping to dispel the thickening
mists of artistic caution, complacency, and
fatigue.

The triumph of American Abstract Expres-
sionism, both in painting and sculpture, was to
be relatively short-lived, capturing the public
imagination and the loyalties of advanced artists
for less than a decade. Arguments about national
schools and individual reputations, or about
priorities in matters of innovation, were soon
thrust aside by more critical issues and radical
attitudes of confrontation which both under-
mined the social fabric of the art world and ques-
tioned the very nature of the art experience. Many
of the most vital young sculptors to emerge since
the mid-sixties do not make sculptural "objects"
in a conventional sense at all, and their activities
have stirred serious doubts about the ability of
the art of sculpture to persist in its traditional
role and definition.

549. ALEXANDER CALDER.
The 100 Yard Dash. 1969.
Painted steel plate in two
freestanding parts, height 14′.
The Baltimore Museum of Art.
Promised future gift

550. ALEXANDER CALDER.
The Orange Panel. 1943.
Oil on wood, sheet metal, and wire,
motorized, 36×48″.
Collection Mrs. H. Gates Lloyd,
Haverford, Pa.

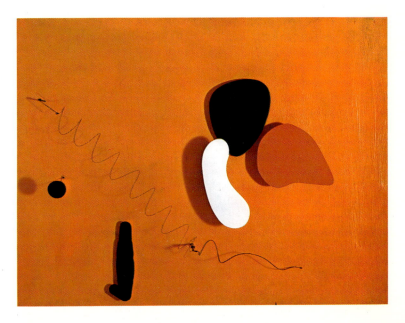

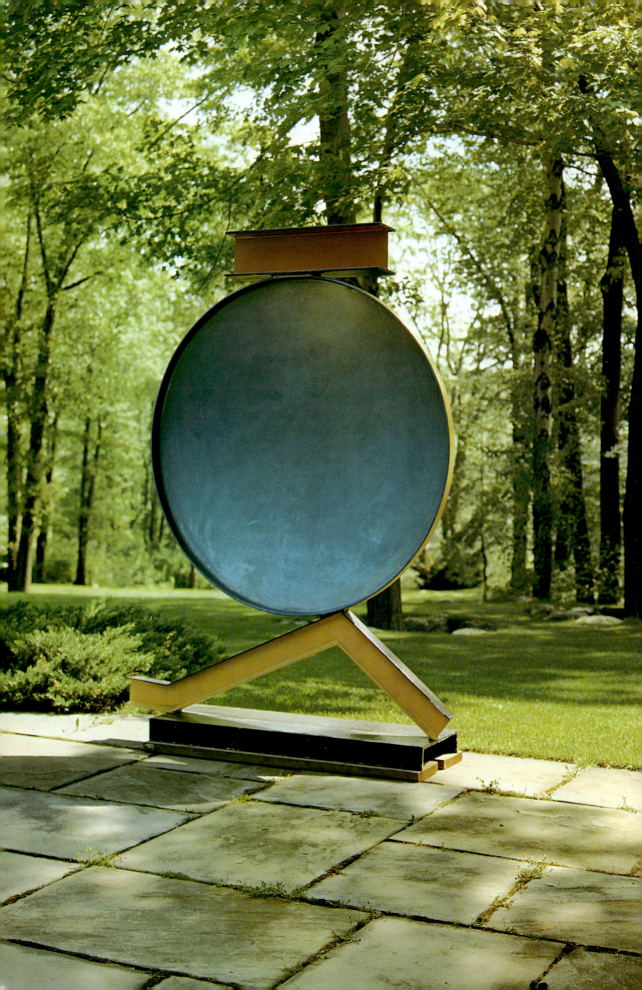

551. (*facing page*) DAVID SMITH.
~ec-Dida Day. 1963.
~olychromed steel,
~~⁷⁄₈ × 65¼ × 18″.
~ollection Mr. and Mrs.
~harles B. Benenson, Greenwich, Conn.

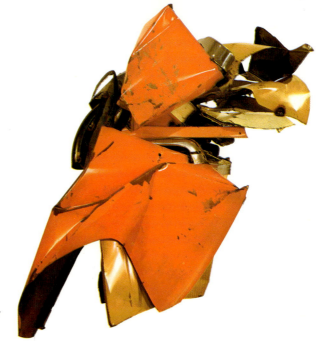

552. JOHN CHAMBERLAIN. *Sweet William*. 1962.
Metal, height 69″.
Los Angeles County Museum of Art.
Gift of Mr. and Mrs. Abe Adler. Given in memory
of Mrs. Esther Steif Rosen through
the Contemporary Art Council

553. MARK DI SUVERO.
Untitled. 1971.
Steel, height c. 30′.
Collection the artist

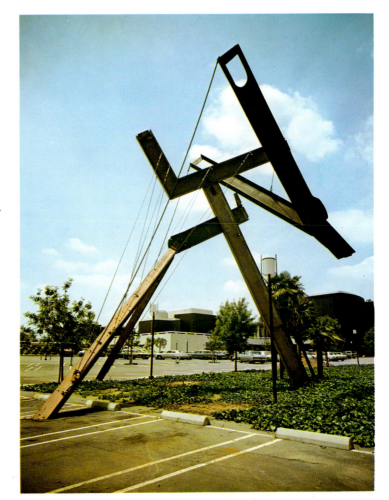

554. JOSEPH CORNELL. *Sun Box.* c. 1955. Painted wood, metals, and cork, 7¾ × 12⅞″.
Collection Mr. and Mrs. B. H. Friedman, New York City

12 · Postwar Architecture, 1945 - 1960

AMERICAN PAINTING SURFACED after 1945, infused with a new energy that was partly derived from the stimuli of European artists who had spent the war years in New York. But its new strength was also partly a consequence of its own inner growth, a natural process of maturation which allowed it to shuck its affected provinciality and its feelings of inferiority to contemporary European movements. The process of stimulation by European émigrés had begun in the late thirties and early forties, and it continued through and past the end of the decade.

The triumph of the new architectural idiom, if admittedly often only on a formalist level, was accomplished initially through a takeover of the architectural schools, swiftly executed coups d'etat that met little resistance and were frequently abetted by sympathetic university administrators. Secondly, beginning with Lever House, New York (1950–52), by Skidmore, Owings and Merrill, large commercial enterprises opted for a contemporary image for their corporate headquarters, "new" in this case being the Miesian reduction and codification of the International Style's steel-and-glass formula. There was no turning back from this step; it was uniformly followed by commerce, banking, industry, and other normally conservative institutions. Even the federal government, though still capable as late as the sixties of follies such as the Rayburn Office Building, Washington, D.C., looked to freshen its image by means of contemporary design and secured Mies to design Chicago's new Federal Center. However, the latent cynicism, speculative interests, and self-serving nature of this broadened patronage soon exacted a frightening toll in the rapidity with which modern design, even in expert hands, turned into an opportunistic cliché. Consequently, no sooner had it achieved worldly success than the new architecture found itself face to face with a crisis that can only be called inflationary and that, before 1960, demanded a reexamination of methods and goals. Beginning in the late fifties, and with varying degrees of success, numerous architects sought to design or to rationalize themselves out of the bind produced by slick, pared-down contemporary commercial design.

But this is to get ahead of the story. The domestic designs of the forties, relatively small in number as well as modest in size, illustrate the diversity of choice available within the modern idiom. Probably the most widely admired domestic architect at that time on the East Coast was Marcel Breuer, who further developed the type of frame dwelling that he and Gropius had introduced upon their arrival in the late thirties. In the Geller House, Lawrence, Long Island (1946), he employed a reverse pitch, or "butterfly," roof, breaking with the flat roof (or deck) tradition of the earlier International Style. The vertical wood siding, instead of being painted white, was stained a dark hue (this feature had first appeared in a Gropius-Breuer house of 1940 but became commonplace only after the war), and this natural surface was played off against a rough fieldstone fireplace wall. Although devices such as ribbon windows and floor-to-ceiling glass panels were preserved from the old modernist tradition, the crystalline geometric image was muted, replaced by a somewhat grudging picturesque effect.

A much more overt romantic naturalism, a rather literal effort to return to the traditions of the nineteenth-century wooden cottage with a Maybeck-like extravagance in the elaboration of the roofs, can be found in the California houses of Harwell Hamilton Harris. A prominent architect of the day, he specialized in brittle-detailed timber designs whose rustic look was at odds with the local modernist style previously

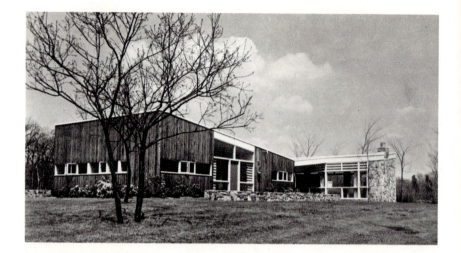

555. MARCEL BREUER.
Geller House,
Lawrence, Long Island,
N.Y. 1946

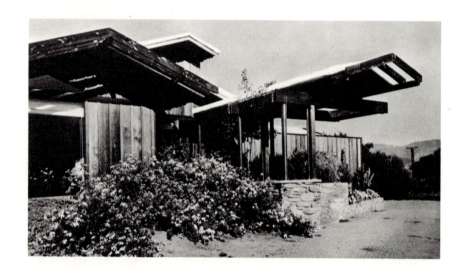

556. HARWELL
HAMILTON HARRIS.
Clarence Wyle House,
Ojai, Calif. 1948

557. WILLIAM
W. WURSTER.
Schuman House,
Woodside, Calif. 1949

558. CHARLES EAMES.
Eames ("Case Study") House,
Santa Monica, Calif. 1949

popularized by Neutra. Another, not as idio-syncratic, type of natural-finished house is represented by the Bay Region mode of William W. Wurster, whose designs are less fussy than Harris's. In Wurster's work plainness becomes a virtue, structure and massing are kept simple, and structural components themselves are reduced and expressively underplayed. In its own way, Wurster's appropriately homely architecture is as reductive as that of earlier European modernists, though his style (or lack of it) is a world removed from their clear, machine-inspired finishes.

California is a land of contrasts, no less in architecture than in any other field of activity. Thus it is scarcely surprising to find there both the most naturalistic, rough-finished houses outside the work of Wright and the most industrially oriented dwelling of the period. Charles Eames's "Case Study" House (the label refers to a program to encourage contemporary design organized by the magazine *Arts and Architecture*), Santa Monica (1949), provides a stark clarity and a regular geometry that differ strikingly from the rather shapeless, almost awkward massing of Bay Region work. The metal columnar supports are of extreme thinness, giving the whole an exaggerated linearity,

although Eames's linearity creates an effect unlike that of Breuer or Harris.

Eames's house was built of off-the-shelf in-dustrial components to demonstrate what might be accomplished by incorporating a selection of factory-produced elements in a custom-designed house—an experiment that curiously had no sequel, perhaps because it came at a time when architects remained self-indulgent in specifying designed components for even the most indus-trial-looking houses. Had the Eames house been built a decade later, when internationally influ-ential movements such as Archigram were calling for a fresh, even iconoclastic reexamina-tion of the possibilities of industrializing archi-tecture, its reception might have been more enthusiastic.

Mies van der Rohe's Farnsworth House, Plano, Illinois, designed in 1946 but not com-pleted until 1951, was at the time widely dis-cussed—but generally as a *building* rather than as a *house*. Perhaps the most perfect, templelike design in the history of recent architecture, with its regular procession of white steel columns holding a rectangular glass cube above the site, it was a fascinating concept, suggestive of a new world of remote, imperturbable autonomy. As one of the most beautiful art objects of the twen-

559, 560. Ludwig Mies van der Rohe.
Farnsworth House, Plano, Ill.
Exterior and plan. Designed 1946; completed 1951

561. Philip Johnson.
Glass House,
New Canaan, Conn.
1947–49

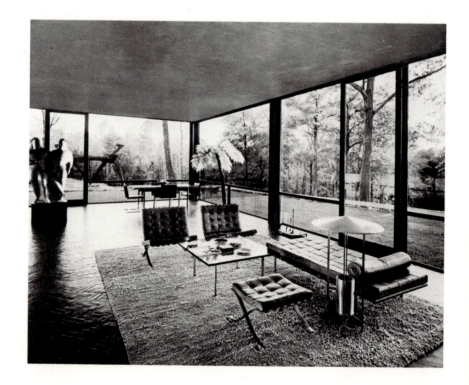

tieth century, thanks to the determination of the architect to apply his universal system (irrespective of incidental considerations), and the willingness of the client to accept the architect's role as benevolent autocrat, the Farnsworth House is somewhat inconsequential on a functional level. It was a historic monument almost from the very moment of inception of the design; and notwithstanding its worthy successors, chiefly from the hand of Philip Johnson, the vision of a form so ideal and esoteric could have little positive effect on contemporary domestic design. Nonetheless, in the fifties and sixties functionally appropriate fragments of this impeccable vision appeared in entrance lobbies of office buildings throughout the country. The Farnsworth House and its progeny even may have had an adverse effect on public receptivity to modern domestic design. The notion of the glass box was simplistic, easily grasped, a highly specialized solution that could be *mis*taken as representative of modern design's supposed intransigence.

Johnson's own house at New Canaan, Connecticut (1947–49), is almost too candidly based upon the Miesian paradigm, despite important differences of detail, and after the passage of twenty years it has become but one of several components in a varied architectural landscape, including a guest house virtually devoid of windows, an underground art gallery, and a miniature pavilion in an artificial lake. These components, forming a single country estate and striking in themselves, nonetheless lack many circumstantial elements of customary domestic architecture and thus deprive the whole and the parts of a sense of reality. Johnson's and Mies's houses, each in its own way represents an eccentric, speculative strain in twentieth-century architecture, an important and characteristic factor in an idiom that often is erroneously thought to be inevitably practical and down-to-earth.

Also eccentric, and in other ways equally determined to explore alternative modes of domestic design is the Dome Desert House, Cave Creek near Phoenix (1950), by Paolo Soleri and Mark Mills. It is an effort to come to grips with the special requirements for survival in a desert environment. Johnson's house is in effect a greenhouse turned inside out, with the plants outside and the people inside, sheltered from the elements and able to watch but not participate in the ebb and flow of the seasons. The dome of the Soleri and Mills house is partly opaque and can be rotated to protect against the

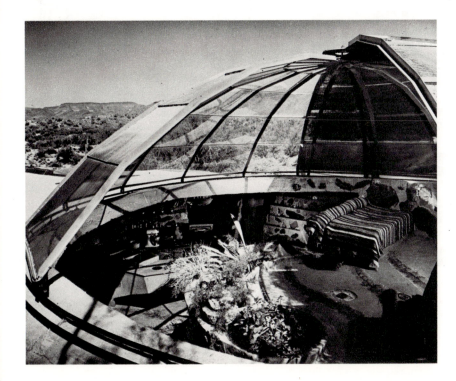

562. PAOLO SOLERI AND MARK MILLS. Dome Desert House, Cave Creek, Ariz. 1950

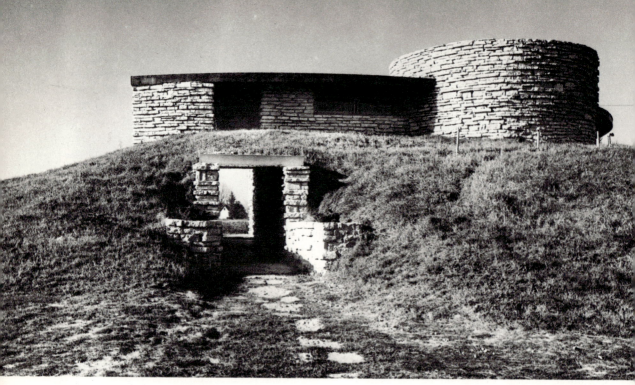

563, 564. FRANK LLOYD WRIGHT.
Second Herbert Jacobs House, Middleton, Wis.
Exterior and plan. 1948

565, 566. ALVAR AALTO. Baker House Dormitory,
Massachusetts Institute of Technology,
Cambridge, Mass.
Exterior and plan. 1947–49

sun or partly rolled back to take advantage of the breeze. The main body of the house is below the level of the desert to insulate against excessive heat or cold. The basic attitude of the Dome House is at odds with that of the Glass House. The Glass House is hypercivilized, a means of shelter from the environment, providing for visual but not actual contact with surrounding nature, while the Dome House indicates a more direct, primitive, tactile contact with site and climate, momentary changes in weather requiring a definite response from the occupant. Thus the ongoing contemporary architectural polemic: one extreme reaching for a greater refinement and calculation of design, the other seeking ways that seem almost primitivistic in their effort to restore unimpeded contact between man and the environment. It is the modern version of a persistent schism in American intellectual life: the pull between town and country, between the urban and rural (with the suburbs forming a limbo that may yet submerge both), and, today, the struggle between modes of living that are establishmentarian and media-oriented and those that offer a more direct and simple interaction between nature, man, his products and artifacts. Although these attitudes imply, indeed demand, alternative architectures, it would take another decade, until the 1960s, for this fundamental condition to become apparent.

In the areas between these two poles, other types of contemporary domestic design were possible. The indefatigable Wright never lacked for new images in his later work. Although the Usonian type continues in these years, one is continually struck by the more unusual configurations such as the second Herbert Jacobs House, Middleton, Wisconsin (1948). The plan is based on a large segment of a circle together with several small ones. Incorporated into the hillside by an artificial mound, the house is archaizing in much the same way as is the Soleri-Mills Desert House. Other advanced domestic work of the forties and early fifties has a leaner look than Wright's bountiful approach to form permitted.

This quality of brittleness, then typifying the most diverse trends in domestic architecture, also influenced large-scale commercial and institutional work at the beginning of the fifties, but with limited success. The resulting urban structures lacked the very diversity and sense of

exploration apparent in houses. There seemed to be few possibilities, and these were chiefly based upon the Miesian system, which offered the virtue of structural clarity and a certain nobility of proportion that was often absent in the work of followers. The sole available alternative to the studied formality and industrial simplicity of Mies's glazed prism for urban-scaled buildings was the brick-clad, conventionally fenestrated Baker House Dormitory for M.I.T., Cambridge, Massachusetts (1947–49), by the Finnish architect Alvar Aalto. The noteworthy features of this structure are the undulating façade along the Charles River and the external articulation of the staircases on the opposite façade. These two devices were unusual responses to program and site, and thus did not seem to allow of general application. A building such as Baker House could not provide a necessary formula as did the Miesian system, a basic formula which a large,

567. LUDWIG MIES VAN DER ROHE.
Lake Shore Drive Apartments, Chicago.
1949–51

impersonal firm would need in order to function. It was this sort of pressure a half-century earlier that had led McKim, Mead and White to adopt a simplified Roman classicism with its system-determined repertory of forms. The corporate design offices of mid-century were only responding similarly to the need to standardize quality in the face of rising quantitative demand.

Lever House, New York (1950–52), was the first popular success from the firm of Skidmore, Owings and Merrill, several of whose partners have since become contemporary tastemakers through their presence on public boards and commissions on planning and the arts. More than Mies himself, they were responsible for popularizing his distinctive, reductive solution. They even simplified his glass-and-steel vocabulary, and toward the end of the decade they modified the grid façades of their slablike towers with various devices, never relenting in the

ordered repetition of standard elements, never sacrificing to a momentary decorative whim. Other large firms, like Harrison and Abramovitz, have evidenced nothing approaching the corporate homogeneity of Skidmore, Owings and Merrill, and the smaller, more individualized offices of a Philip Johnson or an Eero Saarinen seem nothing if not capricious by comparison.

In fact, it was because of this instability which grew as the fifties waned, because of this urgent search for a path in which contemporary architecture ought to grow or evolve beyond the confines of the Miesian, that much of the architecture of the late fifties and early sixties retains its interest. What had been known for a half-century as "modern architecture" was experiencing growing pains and middle-aged doubts. Some wanted to prettify and decorate the stark geometries of glass-box modernism, others wanted to introduce the challengingly complex geometric configurations of Le Corbusier or the sensuously undulating forms of German Expressionism, or return to various strains of the contemporary tradition.

New York's Seagram Building (1955–58), in which Johnson collaborated with Mies, was the paragon of postwar skyscraper design. A sheer tower, it takes up but half the site and faces an open plaza on Park Avenue, diagonally across the avenue from the earlier, less *echt* Lever House; it is supported in back by a cluster of lower blocks. The plaza is a podium raised above the street grade, leading to the elegantly proportioned glass-walled lobby (on the same level) where the elevator enclosures form discrete, freestanding solid masses. In their geometry, Miesian skyscrapers almost invariably avoid the step-back outline topped by slender towers or pinnacles, characteristic features of the 1920s which were ridiculed by fashionable mid-century taste. These up-ended rectangular cubes, with pronouncedly gridlike envelopes and carefully expressed structural frames, recalled instead the earlier office buildings of the first Chicago School. Appropriately, Chicago designers hewed to the Miesian paradigm longer and more faithfully than architects elsewhere, with the result that while several historic structures in the Loop have been lost, they have generally been replaced by recent works of respectable design in an idiom fitting the historical tradition of the neighborhood.

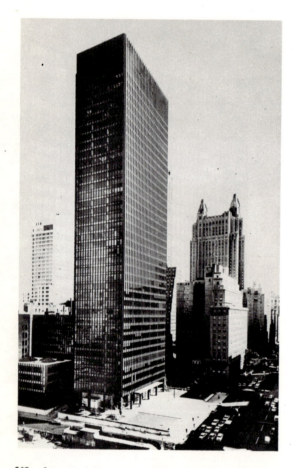

568. LUDWIG MIES VAN DER ROHE AND PHILIP JOHNSON. Seagram Building, New York City. 1955–58

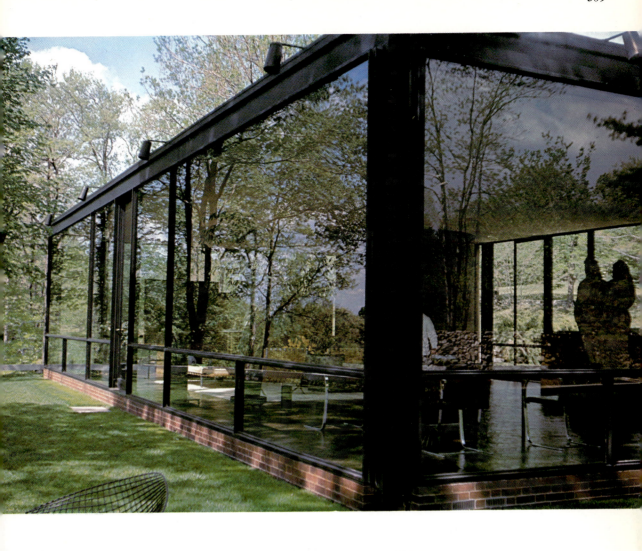

569, 570. PHILIP JOHNSON.
Glass House (*above*), 1947–49,
and Pavilion (*left*), 1962,
New Canaan, Conn.

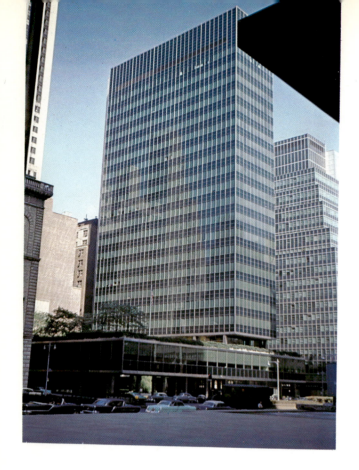

571. SKIDMORE, OWINGS AND MERRILL.
Lever House, New York City. 1950–52

572. East Side, New York City, looking north and west from about Thirty-ninth Street.
Photograph 1961

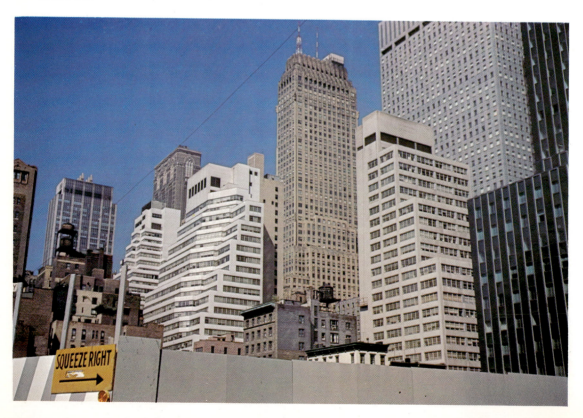

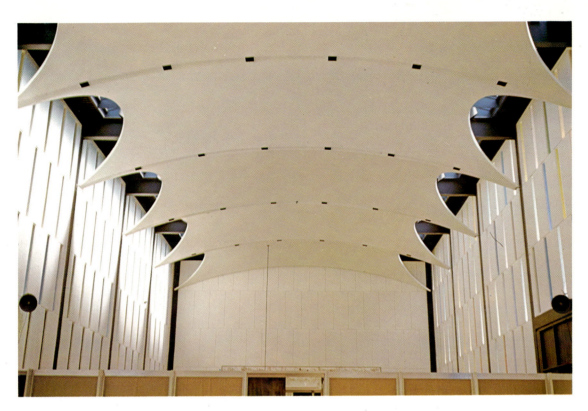

573. PHILIP JOHNSON. Kneses Tifereth Israel Synagogue, Port Chester, N.Y. 1956

574. EERO SAARINEN. Administration Building, John Deere and Company, Moline, Ill. 1961–64

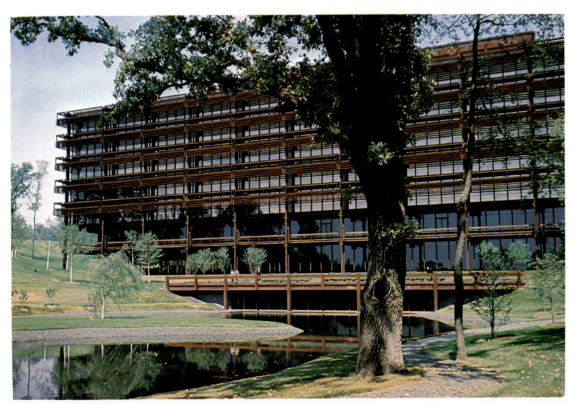

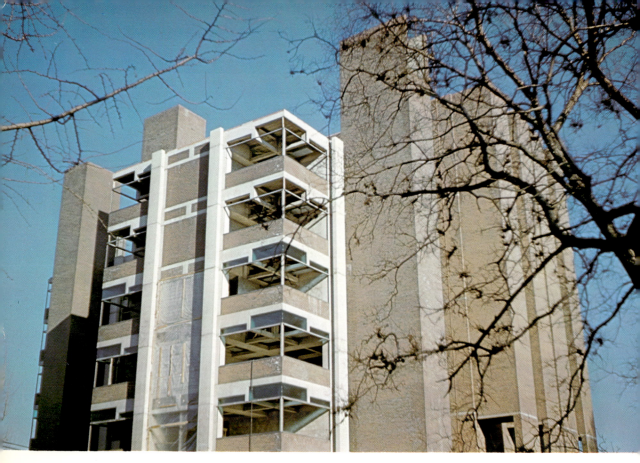

575. LOUIS I. KAHN. Richards Medical Research Building, University of Pennsylvania, Philadelphia.
View of tower under construction, showing concrete frame later hidden by glass. 1957–60

576. LOUIS I. KAHN. Unitarian Church, Rochester, N.Y. 1959–62

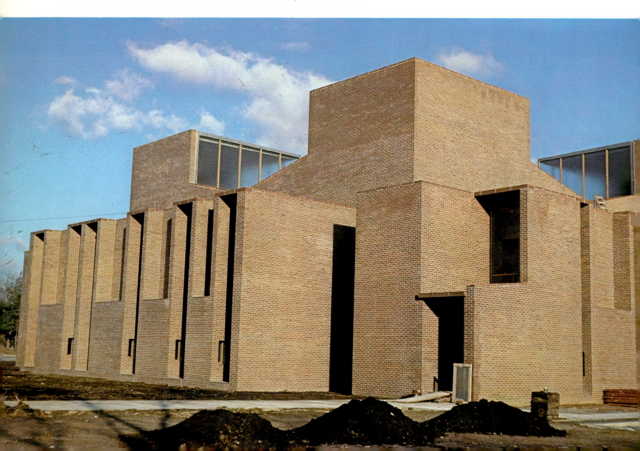

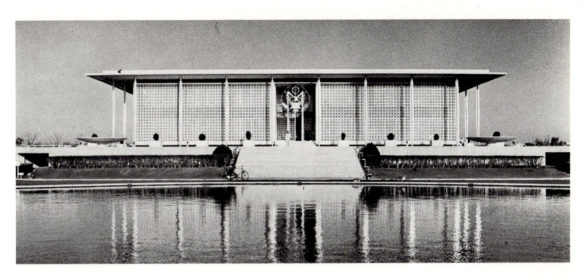

577. EDWARD DURELL STONE. United States Embassy, New Delhi. 1957–59

578. MINORU YAMASAKI. Reynolds Metals Building, Detroit. 1958

The great drawback of this pristine, formalist mode is its lack of urban sociability. Cubic glass towers preserve an almost surrealistic newness, even after decades, which makes their neighbors look unnecessarily tawdry by comparison. Moreover, these mid-century skyscrapers are often placed in windswept plazas or on raised podiums, thus visually separating their entry from the street. This is in opposition to buildings of the thirties such as Rockefeller Center, where the entrances are not only closely related to the space of the street but lead to interior concourses and arcades that are in effect con-

tinuations of the exterior street space rather than isolated foyers or confined corridors.

It was inevitable that architects would become restless with this exacting, restrictive mode (and not because of its functional drawbacks), and although Mies himself never abandoned it, the late fifties saw many deviant gestures toward what might generally be called enrichment. It is at this juncture that a cryptic academicism begins to cloud the image of contemporary design. In the name of variety, individuality, humanization, or a host of other banal slogans and clichés, designers began to deck out their

579. PHILIP JOHNSON. Sheldon Memorial Art Gallery, University of Nebraska, Lincoln. 1960–63

580. Lincoln Center, New York City. *Left to right:* New York State Theater, 1964, by PHILIP JOHNSON; Metropolitan Opera House, 1966, by WALLACE K. HARRISON; Vivian Beaumont Theater, 1965, by EERO SAARINEN; Philharmonic Hall, 1962, by MAX ABRAMOVITZ

basic cubic forms—and often to confuse them as well—with all manner of grilles, fins, screens, shadow devices, some no more substantial than the annually changing chrome ornamentation of automobiles (whose bodies tended to remain constant for at least several design years). Edward Durell Stone and Minoru Yamasaki were the earliest in this genre (United States Embassy, New Delhi, 1957–59; Reynolds Metals Building, Detroit, 1958) and initially won high praise; although the luster of their work paled quickly in the eyes of other architects and critics, they have remained exceptionally successful with public and corporate clients down into the 1970s.

From the late 1950s onward, Philip Johnson has several times attempted to convert the latent classicism of Mies's modular steel-frame mode into a more formally monumental architecture, feeling, with justification, that this genre generally had eluded satisfactory solutions since the demise of the academic classicism successfully practiced by McKim, Mead and White as recently as the early twentieth century. Works such as the illusionistically vaulted Port Chester Synagogue, New York (1956), or the façades for the Amon Carter Museum, Fort Worth (1961), and the Gallery of the University of Nebraska, Lincoln (1960–63), remain, however, tentative, isolated works that had no important issue. The whole effort to establish a contemporary monumentality was likely discredited by the three ill-proportioned, faultily coordinated façades of Lincoln Center, New York (1957–66), individually the works of Johnson, Wallace K. Harrison, and Max Abramovitz. Here the architects seemed to have been dreaming of re-creating an eighteenth-century classical square with harmonious façades. Alas, the competitive atmosphere of mid-century modernism was inhospitable to the kind of spontaneous cooperation and instinctive tradition of mutual consideration necessary for the success of so ambitious a project in urban design. Even worse, Lincoln Center seems irrelevant to the familiar grid plan of New York, as the buildings antagonistically turn their backs on the streets and avenues—an instructive contrast to the design of Rockefeller Center, where a conglomeration of newly styled buildings was made to fit comfortably into the midtown grid of streets, to contribute to its character rather than oppose it.

Eero Saarinen was the most restless of architects active in this period, and though his quest was sincere his work is remarkably uneven. The ambivalent quality in his design is certainly as much, if not more, a product of the times as of his own insecurity. Not an intellectual designer on the order of Johnson, nor out of the old functionalist tradition like Breuer, Saarinen was a skillful creator of pictorial and spatial effects. He began as a partner of his father, Eliel; again unlike Johnson, who had been trained at Harvard under Gropius and Breuer and had an even longer-standing commitment to the International Style through his work as author and critic, Saarinen had been trained in the traditional mode at Yale in the 1930s. So like most of his generation he was predisposed to adopt the pictorial aspects of modernism rather than its formal purity and intellectual discipline (the same could be said for architects such as Harrison or Stone). Eero Saarinen's first major achievement independent of his father's practice was the General Motors Technical Center, Warren, Michigan (1948–56), a grouping of low rectangular buildings around an enormous lagoon, superficially in the style of Mies's I.I.T. Saarinen did not make use of a regular module to create a rhythmically proportioned uniform pattern for his façades; he instead resorted to a variety of colors and patterns to create a pictorial effect. The center was nevertheless welcomed as an outstanding addition to the burgeoning list of notable new buildings in the Miesian mode, and its architect marked down and classified accordingly.

Shortly afterward Saarinen unsettled many of his original admirers with the design of Kresge Auditorium for M.I.T., Cambridge, Massachusetts (1953–56), where he arbitrarily enclosed the complex spaces of a theater within the form of a low-slung dome supported at three points on a stepped brick podium. After M.I.T., Saarinen went from one commission to another without leaving behind a particular, personal impression. His defense was that he was looking for an individual style to fit each job, a justification which had the ring of logic. Each building tended to be a new beginning, with all the awkwardness and unresolved details that such a wasteful process implied. Each tended to be, above all else, a graphic, emotion-packed, or somehow "relevant" communicating image. The TWA Terminal at Kennedy Airport, New York

581. EERO SAARINEN. General Motors Technical Center, Warren, Mich.
Styling Administration Building (*left*) and Styling Auditorium (*right*). 1948–56

582. EERO SAARINEN. Kresge Auditorium, Massachusetts Institute of Technology, Cambridge, Mass. 1953–56

(1956–62), is a familiar and even largely successful instance. Saarinen wished to provide an emblematic design that would stand out in the midst of the banal, low-voltage, pseudo-Miesian design of the other terminal buildings at Kennedy, two of them by Skidmore, Owings and Merrill. He wanted something that expressed flight, and he found it in a sketch by the German Expressionist Erich Mendelsohn: a broad, soaring concrete shell roof (soaring, that is, as high as was permitted by the airport control tower's need for an unobstructed view of the runways). To the engineers was left the problem of making the beast stand, once Saarinen and his staff had created a distinctive exterior image and a provocative, expressive series of flowing spaces on the interior.

Of the architects of the fifties and early sixties, only one manages to rise above the parochial diversity and rash of transient solutions: Louis I. Kahn. An older figure on the scene, he had been trained in the academic tradition at the University of Pennsylvania in the 1920s. Ill at ease with various manifestations of modernism, he nonetheless came under the aegis of George Howe (designer of the PSFS skyscraper) and, after the lean years of the Depression, became his partner by 1941. Kahn's first reputation was established among his students at Yale and at Pennsylvania, and his speculative projects were published in the early fifties in the Yale student magazine, *Perspecta*. Almost as a by-product of his years of teaching at Yale was the design of his first major building, the university art gallery (1951–54). Outwardly Miesian in its severe glass-and-brick cube, as any up-to-date building of the period was expected to be, on the interior it offered a number of novel, unclassifiable features. The tetrahedral web structure of the concrete ceiling slab was his first, tentative effort to split away from the ubiquitous planar surfaces customary in contemporary practice. Kahn, in fact, remained a somewhat alienated, unfulfilled designer until the climate of changing taste in the late 1950s gave him the courage to break cleanly with just about every formal and syntactic cliché, especially the Miesian package. In his speculative projects he toyed with unusually shaped, diagonally braced skyscrapers or bulky cylindrical towers whose mass was a world removed from the lean, hungry look of most contemporary work. His plans were formal,

even Beaux-Arts classic in their inspiration, with separate, distinct spaces arranged in progressive sequences—the antithesis of the open plan and flowing spaces hallowed by decades of use in twentieth-century architecture.

Kahn's breakthrough came with the design and construction of the Richards Medical Research Building, University of Pennsylvania, Philadelphia (the first portion of which was constructed in 1957–60). A conglomerate mass of concrete, brick, and glass towers, of an unusually accentuated vertical bulk, and based on a novel construction system of precast concrete ceiling-and-floor members, Kahn's building eschewed popular architectural idioms of the time. With a single building he created a design subculture that won an enthusiastic response from young architects and students, evoked opinions of cautious reserve from the profession, and was for the most part ignored by the media and the big clients. Kahn's accomplishment went far beyond the realization of his personal philosophy concerning the design process; for the first time in several decades of modern design, the Richards Laboratories achieved a spontaneous monumentality and a sculpturesque dignity—qualities that many were then seeking, with limited success. Kahn's way of handling strong, simple, palpable masses (as opposed to tidy, linear, and planar forms of conventional modernism), was continued in his Unitarian Church, Rochester, New York (1959–62), and in the dormitories for Bryn Mawr College, Bryn Mawr, Pennsylvania (1961–65). Not since the early works of Frank Lloyd Wright, such as his Unity Church, Oak Park, had a progressive architect handled tactile, solid-seeming volumes with such assurance. With this group of buildings Kahn established a clear-cut alternative to the tradition spawned by the International Style over the previous four decades, one with implications that even in the 1970s have not been completely explored.

In 1959 Frank Lloyd Wright died at the age of ninety-two. Although he had been active until the end and was respected and admired by the entire profession, his designs had a steeply decreasing rate of influence—and this despite the public's notion of modern architecture, which then was largely derived from news and magazine reports of his final works, including the posthumous completion of the Guggenheim

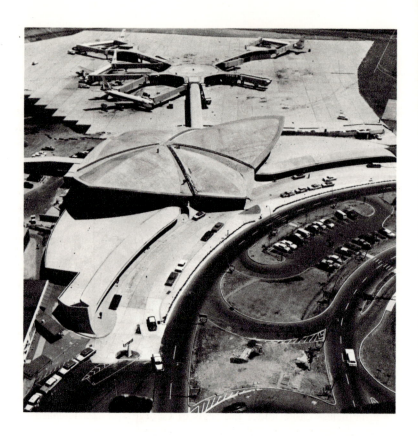

583. EERO SAARINEN.
TWA Terminal,
John F. Kennedy
International Airport,
New York City. 1956–62

584. Interior of TWA
Terminal

Museum. The active role of the "heroic" genera-
tion and the aura cast by their continuing pres-
ence on the scene was beginning to taper off.
Unlike American painting, which entered the
postwar period with a slew of artists who were
just reaching their creative majority, American
architecture during this decade and a half was
largely dominated by the presence, activity, and
continuing influence of earlier greats: Wright,
Gropius, Mies, and, though his work here was
severely limited, Le Corbusier. Toward the end
of the fifties, their omnipresent shadows began
to wane; Gropius and Mies remained active
until their deaths in 1969, but Gropius played
less and less of a role in his firm, The Architects'
Collaborative (TAC), and Mies was partly
forgotten, chiefly because he stubbornly refused
to change. Only the influence of Le Corbusier
seemed to last into the 1960s, thanks to the
construction of his Carpenter Center for Har-
vard University, completed in 1964.

At the beginning of the postwar period, most
younger American architects had preferred to
remain in the shadows of these almost legendary
heroes of the original modern struggle. Only
slowly did they seek a place of their own, and
frequently their work suggests that they were
not completely prepared for the responsibility.
Or, perhaps, it was not that they were ill-
prepared but that they were intimidated by their
devotion to a group of ideals and a handful of
prophets. Their education, whether classical or
modernist, and their early experience, primarily
in domestic construction, left them with little or
no experience to cope with the scale of opera-
tion of the post-1950 urban and suburban build-
ing boom, its manipulative speculation, its use
and misuse of federal and other government
grants, and the galloping inflation of construc-
tion costs. The idealism of these young architects
was swept up by the dizzying success of modern-
ism's adoption by all the institutions of power,
and by the subsequent realization that despite
their efforts to create and propagate a new
architecture, they were merely being asked to
design the emperor's new clothes.

Consequently, in postwar architecture there is
nothing approaching the grand gesture of
Abstract Expressionism, no sense of having
created a special epoch, one apart, yet descended,
from earlier endeavors. Only Louis Kahn can be
mentioned alongside the painters of the time.

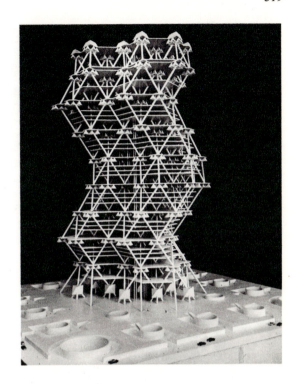

585. LOUIS I. KAHN. Model for skyscraper. c. 1956

586. LOUIS I. KAHN. Plan of plaza for skyscraper
project. c. 1956

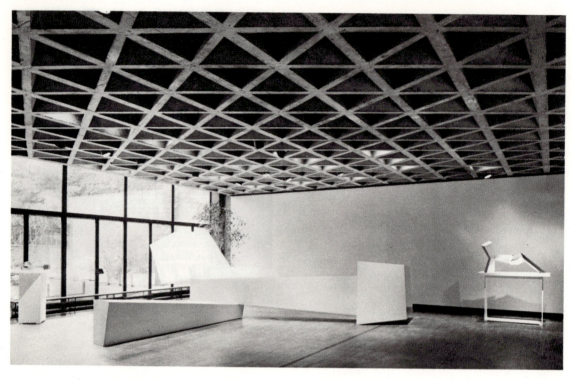

587. Louis I. Kahn. Yale University Art Gallery, New Haven, Conn. 1951–54.
Interior, showing installation of exhibition of *James Rosati Sculpture*, 1970

588. Louis I. Kahn.
Plan of Richards Medical Research Building,
University of Pennsylvania, Philadelphia

589. Louis I. Kahn. Plan of Unitarian Church,
Rochester, N.Y.

These artists had, in effect, freed themselves from their own insecurities concerning the "superiority" of Europe, while their contemporaries, the architects, were still carrying the freight of a modernism exported from Europe. For better *and* worse, they had become the proponents of a contrived, somewhat denatured reinterpretation of an earlier heroic age, whose encounters had taken place several thousand miles away. Thus

American architects had, over two generations, been doubly deprived: cultural isolationism had kept them from participating in the early achievements of the International Style during the twenties and thirties, and in their belated effort to catch up, they had no means of sharing in anything akin to the excitement and electricity generated by the New American Painting of the forties and fifties.

13 · Pop Art and New Realism

Throughout the decade that American art was dominated by the Abstract Expressionists, unsympathetic critics looked in vain for a return to a more traditional, humanistic form that might reestablish connections with the artistic past. It was assumed that when the more specialized styles of abstraction lost their impetus, as they inevitably would, references to common reality and recognizable subject matter would be restored. The fragmentary, distorted human imagery of de Kooning's *Woman* series, which momentarily stimulated a new kind of improvisatory, abstract-figurative art among San Francisco Bay region artists—among them Richard Diebenkorn—and Pollock's fitful anatomical allusions encouraged the forlorn hope that a major humanist trend, repudiating Action Painting, was gathering strength. What emerged in fact at the end of the fifties and in the first years of the next decade was an original and irreverent parody of the "vulgar" techniques, imagery, and artifacts of commercial culture, in the form of Pop Art.

Pop Art rejected both traditional figuration and the idealism and introspection of the previous Abstract Expressionists, although it often retained the large scale, color-saturated surfaces, and spatial ambiguities of its predecessors. Pop Art's mood of extroversion and anti-individualism and above all its apparent acceptance of the values of mass society gave it the reputation of scandal and notoriety among the audience for serious vanguard art. Supporters of the older abstract generation attacked Pop Art's subservience to all the conformist elements in American life which the Action painters had passionately repudiated. In retrospect, it now seems curious that the strong "anti-art" element in Pop, although disguised as slavish imitation of a debased commercial art, should have so outraged the previous vanguard. Similar strategies for desanctifying the

pretensions of "high" art had in the past been considered quite acceptable when exercised by the ironist Dadaists, or by Léger, who admired and emulated industrial artifacts. One of the first advocates of Pop Art, the late critic G. R. Swenson, noted relevantly that the revived interest in common objects could be linked to abstract art, and that both were valid expressions of the artist's relationship to a changing technological society: "Art criticism has generally refused to say that an object can be equated with a meaningful or

590. WILLEM DE KOONING. *Woman II*. 1952.
Oil on canvas, 59 × 43".
The Museum of Modern Art, New York City.
Gift of Mrs. John D. Rockefeller, III

591. LARRY RIVERS.
Washington Crossing the Delaware.
1953. Oil on canvas, 6' 11⅝" × 9' 3⅝".
The Museum of Modern Art,
New York City

592. LARRY RIVERS.
Double Portrait of Berdie. 1955.
Oil on canvas, 70¾ × 82½".
Whitney Museum of American Art,
New York City

esthetic feeling, particularly if the object has a brand name. Yet, in a way, abstract art tries to be an object which we can equate with the private feelings of an artist. . . . Many people are disturbed by the trend towards depersonalization in the arts. . . . They fear the implications of a technological society. . . . A great deal that is good and valuable about our lives is that which is public and shared with the community. It is the most common clichés, the most common stock responses which we must deal with first if we are to come to some understanding of the new possibilities available to us in this brave and not altogether hopeless new world."

Pop Art's disconcerting alliance with the objects and visual modes of consumer society did not appear *ex nihilo,* but was prepared by a gradual drift away from the gestural, painterly modes of Action Painting towards a more inclusive environmental art, which took into account the impact of popular culture and mass-produced objects on artistic consciousness. In fact, the first significant evidence of adulterations in art derived from the surrounding urban environment could be observed in de Kooning's aggressive *Woman* series. His dominant image evolved in the late forties from a collage method that juxtaposed fragmentary commercial illustrations of lip-sticked mouths with transpositions in paint of mass-culture sex idols and film stars. Something of the blatancy of his visual sources remained unassimilated in his paintings, and the disrupting references to the real world were left poetically suspended in the freely handled paint medium.

Working under the influence of de Kooning's equivocal figuration, Larry Rivers in the early fifties began to reappraise the pictorial cliché by turning to debased and heretofore compromised prototypes of American patriotic lore and the inflated visual rhetoric of the salon grand manner. His historically important *Washington Crossing the Delaware* of 1953 transformed a banal theme into a refreshing expressive vehicle. By reviving a familiar pictorial stereotype and using it to offset the gestural marks and brushy invention of the orthodox Action Painting style, he managed to introduce a genuine innovation. The visual cliché became a significant factor in American abstract art by the mid-fifties.

Standardized imagery taken from popular and topical sources or from familiar folklore turned Expressionist abstraction away from a preemp-

593. ROBERT RAUSCHENBERG. *Charlene*. 1954.
Combine painting in 4 sections, 7′5″ × 9′4″.
Stedelijk Museum, Amsterdam

594. ROBERT RAUSCHENBERG. *Coexistence*. 1961.
Combine painting, 60 × 42″.
Galerie Beyeler, Basel

new reconciliation of art and life was Robert
Rauschenberg.

In the middle fifties Rauschenberg painted with
the free brushstroke of de Kooning's Action
Painting, but began to load his canvases with rags
and tatters of cloth, reproductions, thinly over-
painted comic-strip fragments, and other collage
elements of waste materials. His packed surfaces
were worked over in the characteristic gestural
language of the prevailing abstraction, but paint-
erly expressiveness enjoyed reduced powers and
prerogatives in the context of an artistic structure
choked with alien matter. The intensified use of
heretofore scorned, sub-aesthetic materials chal-
lenged the hierarchy of distinctions between the
"fine art" status of the traditional art object and
untransformed brute materials drawn from the
urban refuse heap. "Junk art," as the critic
Lawrence Alloway described this mode, gathered
momentum in the late fifties and was given added
emphasis in the conglomerates of rusting ma-
chine discards of Richard Stankiewicz's sculpture,
in Robert Mallary's textured surfaces of splin-
tered wood, resins, and sand-mixed pigments, and
in John Chamberlain's crushed and shaped sculp-
tures of polychrome auto-chassis fragments.

New meanings can be inferred from the char-
acteristic use of disreputable-looking and beat-up

595. ROBERT MALLARY. *Untitled*. 1965–66.
Bronze, 30 × 20″.
Allan Stone Gallery, New York City

tive painterly invention; the ideal of making each
canvas a unique and unrepeatable experience was
thus challenged. The expansion of pictorial im-
agery to include external visual reality, historic
art sources, material objects, and finally, com-
mercial art conventions, soon undercut the pre-
dominantly abstract character of American art.
One of the decisive figures in bringing about the

"junk" fragments in Chamberlain's sculpture *Wildroot*. Although there are obvious links with de Kooning's colliding brushstrokes, and an echo of his verve and energy in securing a precarious momentary order from chaotic fragments, Chamberlain's choice of throwaway materials is motivated by considerations beyond the aesthetic. Junk art opened up a new relationship with urban experience only hinted at in de Kooning's collage method, and it was conditioned by contemporary attitudes towards the mass-produced object. While no explicit critical commentary was intended, an orientation to the idea of planned obsolescence, which quickly junks and replaces objects of the assembly line, exists at least by implication. Automobile debris, like the decayed matter in Rauschenberg's "combines," represents the last stage in the object's cycle from manufacture to functional use and finally to uselessness as waste. The poet Randall Jarrell has noted that we speak of planned obsolescence, but it is more than planned; it is an assumption about the nature of contemporary American reality. By incorporating throwaway materials in his art, the artist acknowledges that inexorable process, and also assimilates it to the different uses of art. The very worthlessness of street litter makes it peculiarly adaptable to the art process, which by its nature treats of gratuitous, nonfunctional objects.

The new interest in the material environment was first articulated by Allan Kaprow, one of the leading advocates of literal experience in art. In an article of 1958, "The Legacy of Jackson Pollock," he proposed "a quite clear-headed decision to abandon craftsmanship and permanence" and advocated "the use of . . . perishable media such as newspaper, string, adhesive tape, growing grass, or real food" so that "no one can mistake the fact that the work will pass into dust or garbage quickly."[1] Later used as a rationale for a new kind of nonverbal, intermedia theater and performance art called "Happenings," Kaprow's statement originally was intended to bring the creative artist into more fertile interaction with the actual world around him, and to open a new dialogue with overlooked commonplace materials of the environment. From Pollock's example he extracted a precedent of incorporating waste material in his pigment, as well as finding there a quality of environmental "sprawling," which broke down barriers between art and actual experience in his large canvases. Kaprow's inventory of objects of new expressive potential suggested that art no longer be considered a self-contained, autonomous entity divorced

[1]Allan Kaprow, "The Legacy of Jackson Pollock," *Art News,* October, 1958.

596. RICHARD STANKIEWICZ. *Kabuki Dancer*.
1956. Iron and steel, height 80¼".
Whitney Museum of American Art, New York City.
Gift of the Friends of the Whitney Museum

597. JOHN CHAMBERLAIN. *Wildroot*. 1959.
Metal construction, height 60".
Allan Stone Gallery, New York City

598. ALLAN KAPROW. *Penny Arcade* (detail). 1956. Assemblage with sound and light (destroyed)

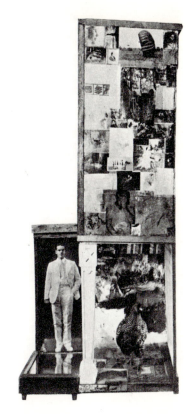

599. ROBERT RAUSCHENBERG. *Untitled*. 1955. Construction, $86 \times 38 \times 26\frac{1}{2}''$. Collection Giuseppe Panza di Biumo, Milan

600. CLAES OLDENBURG. Snapshot from the Happening "The Street," 1960

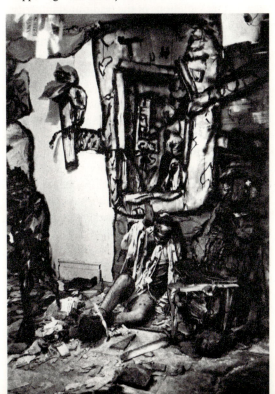

from life, but continuous with it. "Pollock," he wrote, "left us at the point where we must become preoccupied with and even dazzled by the spaces and objects of our everyday life. . . . Not satisfied with the suggestion through paint of our other senses, we shall utilize the specific substances of sight, sound, movement, people, odor, touch. Objects of every sort are materials for the new art: paint, chairs, food, electric and neon lights, smoke, water, old socks, a dog, movies, a thousand other things which will be discovered by the present generation of artists. Not only will these bold creators show us, as if for the first time, the world we have always had about us but ignored, but they will disclose entirely unheard-of happenings and events, found in garbage cans, police files, hotel lobbies, seen in store windows and on the streets, and sensed in dreams and horrible accidents." It was in a similar spirit that Rauschenberg described his method of working as a collaboration with materials, and made his oft-quoted statement, which became a slogan of the radical new realism: "Painting relates to both art and life. Neither can be made. (I try to act in the gap between the two.)"

The junk materials which Rauschenberg, Kaprow, and others established in a new aesthetic context could be read as a symbol of alienation from the dominant folkways of an aggressive consumer's society which extravagantly valued a gleaming, ersatz newness in its possessions. By

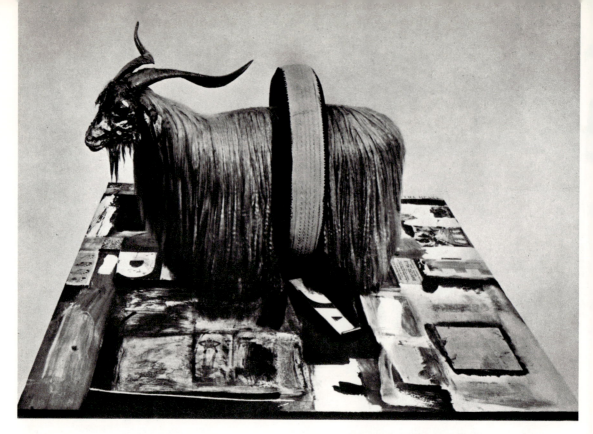

601. ROBERT RAUSCHENBERG. *Monogram*. 1959.
Combine with ram (angora), 48 × 72 × 72".
Moderna Museet, Stockholm

602. ROBERT RAUSCHENBERG. *Coca-Cola Plan*. 1958.
Combine painting, 27 × 16 × 6".
Collection Giuseppe Panza di Biumo, Milan

forcing a confrontation with derelict and despicable object fragments, these artists effectively countered a culture maniacally geared to the creation of an artificial demand for new products. Their strategies cunningly posed troubling questions about the nature of the art experience and at the same time commented on the social context of urban life and mass culture which gave rise to such blatant violations of the traditional integrity of medium. Rauschenberg radically deepened the alliance with the image world of popular culture and with articles of daily life by incorporating Coke bottles, stuffed animals, rubber tires, and miscellaneous deteriorating debris into his work; and against these shocking intrusions, painterly qualities and the fluid formal organization of Abstract Expressionism operated. Unlike the poetic objects of the Surrealists, his debris was not calculated to shock by its incongruity primarily; its associational and fantastic meanings, in fact, were minimized. Junk was used in an optimistic matter-of-fact spirit, and if social commentary could be read into the content, it was on an elementary and unspecific level, referring to nothing more than the life cycle of objects in our periodical culture, and their rapid decline into waste as the flow of new goods pushes them aside.

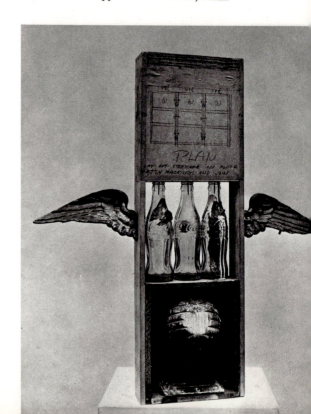

Rauschenberg attached ladders, chairs, and other objects—whole or in part—to his paintings with no transition other than the passage of paint over them, and thus kept the dialogue between art and everyday reality open and unresolved. Paint itself was given no position of special privilege, but treated as a physical fact among others, thus subverting the gestural handling and spontaneity of the Action Painting it imitated, or parodied. As Rivers in a sense mechanized de Koon-

and paint marks, down to the most minute detail, dispelled the ideal of spontaneity to which the Action painters gave such emphasis. In another, even more celebrated gesture, Rauschenberg dramatically dissociated himself from the Expressionist ethos by erasing a de Kooning drawing, a gift from the artist, and calling it *Erased de Kooning Drawing*.

Most recently, Rauschenberg has created first paintings, then prints, and finally rotating plastic

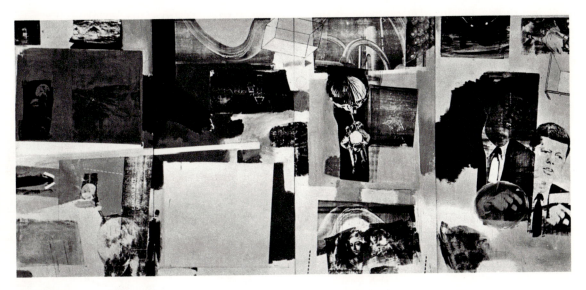

603. ROBERT RAUSCHENBERG. *Axle*. 1964. Oil on canvas, 4 panels, entire work 9′ × 20′. Collection the artist

ing's fluent graphic notation into an instrument of uniformity and repeatability, so Rauschenberg directly took over Rivers's sensitive scribbles, washes, and erasures, particularly in his own transfer drawings and rubbings, to further empty sensibility of personal content. By a process of depersonalization, the individually inflected language of gesture in drawing and painting became rather standardized, and merely symbolic of a certain class of activity; the tritest imagery and mechanical reproductions gained a vivacity, energy, and inventive potential they had never known.

Factum I and *II* are often cited as examples of Rauschenberg's dramatic gesture of subverting Action Painting techniques and content. Each of the two versions of the same subject combines collage fragments of a faded newspaper photograph of President Eisenhower with passages of free abstract painting. The repetition of imagery

604. ROBERT RAUSCHENBERG. *1/2 GALS/AAPCO*. 1971. Cardboard and plywood with rope, 89 × 78 × 10½″. Leo Castelli Gallery, New York City

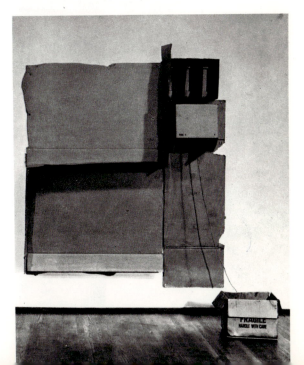

disks with overlayed images, all utilizing commercial silk-screened imagery. The images are common and recognizable personalities, and scenes from topical illustrated journalism such as athletic events, news photos of fires or accidents, or inconsequential pictures of the urban landscape. The blurring of photographic images gives an effect of aesthetic distancing and news media anonymity, even when the individual figures are well-known personalities. In the athletic scenes the issue of the action is still in doubt, or the movement interrupted and incomplete. None of the images are resolved, for if they were, they would permit us to focus on individual elements as anecdote, with a distracting intensity both visually and psychologically. That would compromise the tense balance the artist seeks between his subject matter and his heightened awareness of process, for the reproduction itself is an important part of the work's message.

The formal innovations of Jasper Johns have had an even more far-reaching influence than Rauschenberg's in bringing on the radical new objective art of the sixties. His historic paintings of flags and targets, first exhibited in 1957, and his subsequent maps, rule-and-circle devices, and other subject matter created new forms of representation from a commonplace imagery. Many of his structures elucidated the creative process itself in a challenging intellectual kind of interrogation, breaking down and reconstituting elements of illusion and literal fact, and inviting the audience to participate in re-forming the magical unities of aesthetic experience. In *Painting with Two Balls*, the canvas slit, pried open by the wooden balls, destroys the inviolable flatness which the paint surface, parodying Abstract Expressionistic brushwork, is at pains to emphasize. The interplay between flatness and perforated depth, between the free brush and the mechanical lettering, evokes many paradoxes of representation and signification.

The title of the painting is meticulously lettered by hand at the bottom of the work and thus becomes part of its explicit content. The verbal legend contributes to the mix of different levels of conceptual and visual reality, and it also shocks us by its elementary forthrightness. The work de-

605. JASPER JOHNS.
Painting with Two Balls. 1960.
Encaustic on canvas
with assemblage, $65 \times 54''$.
Collection the artist

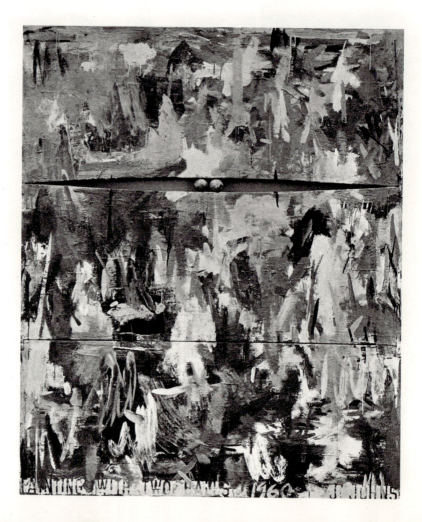

scribes and documents itself with a dead-pan explicitness, as if to say that painting can be plain fact as well as metaphor. If Action Painting could be said to symbolize the "hand-made" work, and thereby to certify values of individual freedom and personal authenticity, then Johns's new spirit of factualism symbolizes a game of confounding identities where fact and object have enhanced status, coequal with the evocative and associative powers of painting. The new objective mood which Johns introduced with such éclat coincided with the more intellectually controlled abstractions of his contemporaries, Kelly, Noland, and Stella. All conceived of the work of art with more conceptual rigor than the Action painters; for them it was less a mode of self-discovery or self-definition than a specific set of facts, or a controlled formal system.

Johns's American flags in particular showed new and startling possibilities of image elaboration by making over the devalued currency of visual clichés which had become merely formal and empty of content due to overexposure. The commonplace is a potential vehicle of art because we are visually blind to its possible meanings; its content includes the apathy which the spectator brings to it. Any dramatic alterations of a cliché gain an added force from the element of spectator surprise and from its low credibility as a source of fresh experience. As Abstract Expressionism and its cult of unique and privileged experience became an empty stereotype, the commonplace image itself took on fresh possibilities of fantasy and expressive life.

Johns's first characteristic and innovative image was the target. In two separate versions, fragmentary painted casts of body parts and a repeated partial mask of the face were set in a series of boxes over a centered bull's eye. The sober formality of his hypnotic form and the subdued human associations of his casts created a powerful interplay of thwarted alternatives; human feeling was suspended, in effect, between the waxworks and a dehumanized geometry, the body's cage and a mental prison, and either image system proved curiously opaque and enigmatic. One expected to be able to decode messages from secret regions of the psyche, but they were effaced in "impersonality," in the received and sanctified modern fashion.

Johns not only invented new representations of things but converted objects into artful fac-

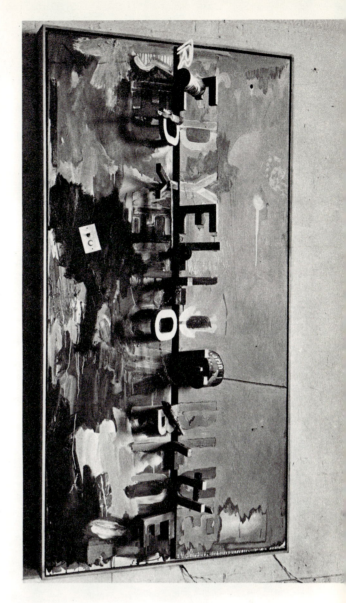

606. JASPER JOHNS. *Field Painting*. 1964.
Oil on canvas, wood with objects, $72 \times 36\frac{3}{4}''$.
Collection the artist

similes. His mounted flashlight and Savarin coffee cans with paint brushes are painted casts in bronze of actual objects. They differ in intention and impact from the readymades of Duchamp, who has been an important confirmation rather than a source of Johns's imagery. By designating a bicycle wheel or a bottle dryer a work of art, Duchamp expressed the artist's sovereign prerogative to make art fit his own arbitrary definitions, and also used commonplace objects to launch an attack on the pretensions of museum culture.

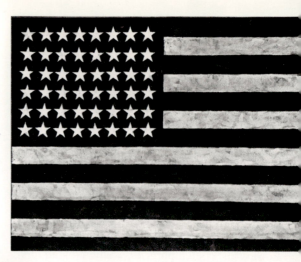

607. JASPER JOHNS. *Flag*. 1958.
Encaustic on canvas,
41¼ × 60¾″.
Collection Mr. and Mrs. Leo Castelli,
New York City

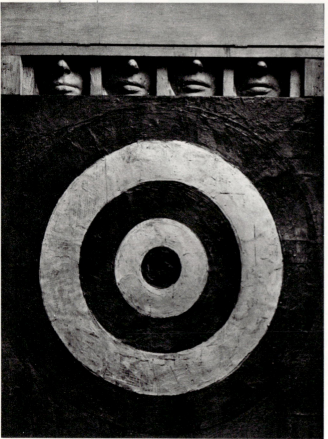

608. JASPER JOHNS. *Target with Four Faces*.
1955. Encaustic, collage, and canvas with
plaster casts, 30 × 26″.
The Museum of Modern Art, New York City.
Gift of Mr. and Mrs. Robert C. Scull

609. JASPER JOHNS. *Flashlight*.
1960. Bronze and glass,
4⅞ × 8 × 4½″.
Collection Mr. and Mrs. Irving Blum,
Los Angeles

Johns concerns himself to a much greater degree with the old romantic game of illusionism. In more relevant contemporary terms, his art acknowledges in a manner different from Duchamp's the distinction between the work of art as a unique creation and its current devaluation by the ubiquitous reproduction. Individuality of touch and "fine art" handling remain a marginal and furtive activity in Johns's sculpture "combines"; the facsimile object enters the context of art by reason of its expressive and sensitively painted surfaces, in which we recognize the operation of traditional sensibility.

The sense of averted and hidden meanings links Johns's constructions to Joseph Cornell's more personal box constructions. Cornell's Victorian poesy and riddles echo the preoccupations of another generation for whom the free associations of Surrealism provided a liberation. Johns belongs to a new age of dissociation of thought and feeling, and his inventions deal more rigorously with the work of art not as an object of sentiment or fantasy but as a problem in formal structure and meaning. From his constructions, however, have evolved a host of mysterious object ensembles in boxes and containers that invite examination at close quarters and depend on unexpected Dadaist displacements of shape, texture, and function. Often the observer is invited to alter the arrangement or organization of such ensembles, in the spirit of both play and discovery, as for example in the boxes of George Brecht. Robert Morris's early lead plaques with appended wire, metal scrap, measuring rules, or inscriptions taken from Marcel Duchamp's notes in *The Green Box* for his *Bride Stripped Bare by Her Bachelors, Even* are an homage both to "chance," and to Johns's leadership in converting impossible substances and surface textures into art. Lucas Samaras's more aggressive boxes are beset and booby-trapped by massed common pins and razor blades, as well as by delicate shells, stones, bits of colored glass, and assorted paraphernalia of sensuous and erotic mystery and childhood memory. The Surrealists' love of the enigmatic and the occult contributes to the atmosphere of Samaras's constructions, but so, too, does the action principle of postwar American art, with its conviction that art and life must be conquered dangerously, each by means of the other. Objects that wound or threaten, and coarse yarn in unsubtle primary colors explode a private dream world of exquisite sensation and ingenious calculation. The work of art as a secret refuge of the psyche or as a nostalgic collection of treasured trophies is transformed by the act of risk-taking at more significant formal and expressive levels.

The mixed sculptural and drawing modes, the interplay of literal object and pictorial illusion in the lifesize manikins and *tableaux vivants* of Marisol are also very much indebted to Johns. Marisol's brilliant theater explicitly makes use of autobiography; self-portraits and fantasies enter freely into the work and are a major feature of it. The artist is her own heroine, but she emerges fiercely alienated in arbitrary or hallucinated images strangely dissociated from feeling. To be able to view oneself as a spirit object or as human furniture is the far-out point of impersonality of her fantastic and powerful sculpture. Apart from herself, principal subjects of Marisol's magical transformations and very considerable formal ingenuity have been American folklore, the hipster world, and caustic caricatures of world leaders.

Jim Dine occupies a unique position among those artists emerging after 1960 who have been associated loosely, and in his case perhaps exaggeratedly, with Pop Art. His paintings with object attachments and his environments have an abrupt power which rebukes the indirection and muted poetic sentiment of his first mentor, Johns. Dine extends the paradoxical play between literal experience and illusionistic representation by regenerating, with a rivaling skill, the painterly direction of Action Painting, then assimilating it to a wide repertory of objects rich in human association of personal use or admired strength. His household furniture, portions of room environments, bathroom cabinets, tools, palettes, and robes are meant to be enjoyed for their expressive power within the formal scheme of his constructions, and are not underscored for their scandalous potential. They do strike an overtly aggressive note (an axe plunged in a plank, a saw bisecting a blue field of paint) and release sexual fantasy. His prosaic directness and mechanical resourcefulness are in the American grain, more related in temper to David Smith perhaps than to Johns, and thus free of the hermeticism that has been one of the liabilities of Johns's style for his followers. Dine's purposeful unsubtlety has been characteristic of the mode of realism in the past, whenever

610. JIM DINE. *Hercules Bellville*. 1969.
Acrylic on canvas with objects, canvas 84×84″.
Collection Dr. and Mrs. Sidney L. Wax,
Thornhill, Ontario

611. JIM DINE.
Hatchet with Two Palettes, State No. 2. 1963.
Oil on canvas with wood and metal, 72×54×12″.
The Harry N. Abrams Family Collection,
New York City

612. JIM DINE.
Nancy and I at Ithaca (Straw Heart).
1966–69. Sheet iron covered with
straw, 60×70×12¼″.
Sonnabend Gallery, New York City

a preceding style tended to become ritualized by a particular individual sensibility. His almost programmatic "brutalism" is, however, only one note in a virtuoso range of effects which include exquisitely controlled draftsmanship, powerfully expressive color, and the skilled mastery of large expanses of evenly accented surface.

Along with Kaprow, Oldenburg, Robert Whitman, and others, Dine was a pioneer of those spontaneous, plotless theater events, "Happenings." In exhibitions at the Judson and Reuben Gallery in the late fifties and early sixties, he participated "in a kind of Action Painting with living materials," as the critic Suzi Gablik put it. The emphasis was much more on extravagant massings and juxtapositions of shoddy urban materials, handled with an Expressionist looseness, than on a structured dramatic situation. He and Oldenburg are probably the only artists associated with this crude and vital artist's theater, and with the more Expressionist forms of Pop Art which emerged from it, who can also be said to have prefigured the "process art" of the late sixties. Dine's cult for objects of an aggressive and active character, the ways in which he uses them to act out his feelings, and the unself-conscious correlation of traditional mediums and environmental materials are all strangely prophetic of the antiformal art of direct experience and confrontation emerging in recent years. Perhaps it is because his work has always been more personal and autobiographical, warm and expressively physical, whereas Pop Art is hard, impersonal, and deliberately sterile-looking, like the commercial packaging and imagery it emulates. In an interview Dine has emphasized this point: "Pop is concerned with exteriors. I'm concerned with interiors when I use objects, I see them as a vocabulary of feelings. I can spend a lot of time with objects, and they leave me as satisfied as a good meal. I don't think Pop artists feel that way. . . . What I try to do in my work is explore myself in physical terms—to explain something in terms of my own sensibilities."

Claes Oldenburg is another artist usually identified with Pop Art who occupies a special position by reason of his inventive re-creations and

613. JOSEPH CORNELL. *Pharmacy.* 1943.
Construction, 15¼ × 12 × 3⅛".
Private collection

614. GEORGE BRECHT. *Repository.* 1961.
Wall cabinet containing miscellaneous materials,
40⅜ × 10½ × 36".
The Museum of Modern Art, New York City.
Larry Aldrich Foundation Fund

615. ROBERT MORRIS. *Untitled*. 1963.
Wood and rope, 15¾ × 5⅝ × 3½″.
Collection Samuel J. Wagstaff, Jr., Detroit

616. LUCAS SAMARAS. *Box No. 3*. 1962. Wood,
pins, rope, and stuffed bird, 24½ × 11½ × 10¼″.
Whitney Museum of American Art, New York City.
Gift of the Howard and Jean Lipman Foundation

transformations of the object. Indeed, his wide-ranging interests and inventive energies make him perhaps the single most important innovator of the 1960s. He was educated in Abstract Expressionism, but broke with that movement around 1959, opening paths to a variety of new expressions, including Pop Art. With the "Happening" he extended Action Painting into a form of improvisational Expressionist theater, but he is best known for the gigantic ersatz food constructions in painted canvas and plaster which he created after 1960. The surfaces of these bloated, dropsical facsimiles of the lunch and drugstore counter were at first freely handled in the splatter-and-splash technique of Action Painting, but the reference to their real-life models was inescapable. A repeated emphasis on comestibles seemed rather innocently to draw on the preoccupation of advertising, along with the infantile oral obsessions of Americans, and Oldenburg's subject matter became the basis of similar themes handled in the more conventional terms of easel painting by Wayne Thiebaud and others. Oldenburg also created a series of free translations of commercial trademarks, among them that of Seven-Up, in vast enlargement. His early themes were the consumer commonplaces of standard brands, but

his handling was deliberately chaotic and low in legibility, like the surfaces of Action Painting.

The cult of literal experience that appeared with Rauschenberg's objects became in Oldenburg's hands less diffuse, focusing on sets of objects with greater symbolic depth and meaning. The American food package, through its ubiquitousness and derived associations in the context of advertising, has become a symbol of insatiable craving for gratification. But a synthetic ugliness and anonymity stifle its suggestions. As the formal powers of Oldenburg's original style zestfully expanded, so did the actual size of his inventions—to the point of farcical exaggeration. His giant hamburgers transformed food into a dream object so outrageous in scale as to seem comical. The aggrandizing impulse of Abstract Expressionism seemed to have run amuck at the lunch counter.

Oldenburg's ingenious fabrications coincided with Robert Mallary's abstract reconstructions of clothes and splintered wood slats in grotesque falling attitudes that stood halfway between Kline's calligraphy and the antics and pratfalls of vaudeville comics. Improvisation and personification augmented each other in a rhetoric so inflated that they reversed themselves into stage farce.

617. MARISOL. *Baby Boy*. 1962–63. Wood and mixed media, 88 × 31 × 24″. The Albert A. List Family Collection, New York

618. MARISOL. *The Party*. 1965–66. Mixed media, 15 figures, entire group 9′11″ × 15′8″ × 16′. Collection Mr. and Mrs. Robert B. Mayer, Winnetka, Ill.

In recent years, Oldenburg's objects have been renovated, and have "improved" on man-made nature. The ambience has shifted from the downtown secondhand-clothes emporium or open food markets to the uptown department store milieu. A series of soft telephones, toasters, and typewriters made in the mid-fifties of shiny vinyl plastic look freshly manufactured, slick, and grossly opulent instead of derelict or decayed. The object is of a mechanical character, to be consumed by use rather than assimilated physiologically. It enters the new context of art in a virginal state before it has been caught up in the consumer cycle from use to junk. But these creations are as outrageous as ever, both in their immensity of scale and in their contradiction of the normal properties of the things they dissemble. We identify telephones by their hard and metallic qualities, but Oldenburg's are collapsed and baggy shells, all epidermis and no working parts. They stand on the threshold of animistic and magical life but can never quite slip out of their utilitarian identity, and this fine nuance is their whole point: they are objects divorced from function. By taking them through such a poetic metamorphosis and making them useless, Oldenburg associates his telephones, typewriters, and appliances with the art object, which is by definition gratuitous. His dummies and substitute objects create a rich play of shifting identities which enters into the very fabric of the art object itself.

Oldenburg's first improvisational object-sculptures were motivated by the desire to break down the barriers between art and life, and thus paralleled Rauschenberg's stated intention. Using impermanent urban litter in Expressionist forms which he called "Street Art," he also made contact with the amorphous material conglomerates of Dubuffet's assemblages, and with that artist's spirit of "celebrating disparaged cultural values." By promoting subaesthetic materials to the status of art while still retaining their identity as street refuse, he both attacked the pretensions of "high" art and gave his anti-art forms a new kind of aesthetic viability. His acceptance of the urban milieu, no matter how squalid or chaotic, and his keen sense of the interaction of art and life were conveyed in a number of poetic statements, for he is a gifted writer and has for years kept a fascinating journal registering his impressions of the world:

I am for an art that is political-erotical-mystical, that does something other than sit on its ass in a museum.

I am for an art that grows up not knowing it is art at all, an art given the chance of having a starting point of zero.

I am for an art that embroils itself with the everyday crap and still comes out on top.

I am for an art that imitates the human, that is comic, if necessary, or violent, or whatever is necessary.

I am for an art that takes its forms from the lines of life, that twists and extends impossibly and accumulates and spits and drips, and is sweet and stupid as life itself. I am for an artist who vanishes, turning up in a white cap, painting signs and hallways. . . . I am for an art that is smoked,

619. CLAES OLDENBURG.
Pastry Case I. 1962.
Plaster, glass, and enamel,
$20\frac{3}{4} \times 30 \times 14''$.
Collection Mr. and Mrs. Morton Neumann,
Chicago

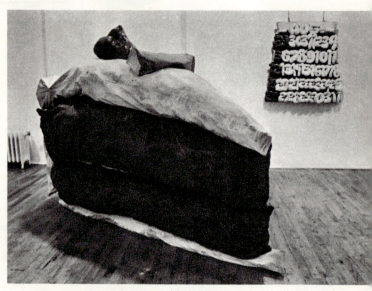

621. CLAES OLDENBURG. "*Floor Cake*" (*Giant Piece of Cake*). 1962.
Painted canvas filled with foam rubber, $5' \times 9' \times 4'$.
Collection Philip Johnson, New Canaan, Conn.

620. ROY LICHTENSTEIN.
Ice Cream Soda. 1962.
Oil on canvas, $64 \times 32''$.
Collection Myron Orlofsky,
White Plains, N. Y.

622. WAYNE THIEBAUD. *Hotdog.*
1964. Oil on canvas, $11 \times 13''$.
Collection Robert Elliott,
Washington, D.C.

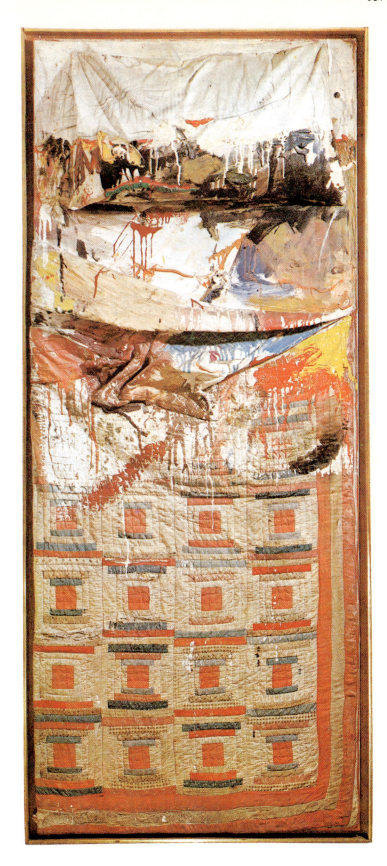

623. ROBERT RAUSCHENBERG.
Bed. 1955.
Mixed media, 74 × 31″.
Collection Mr. and Mrs. Leo Castelli,
New York City

624. EDWARD KIENHOLZ. *The Wait*. 1964–65. Assemblage and mixed media, 6′8″ × 12′4″ × 6′6″.
Whitney Museum of American Art, New York City. Gift of the Howard and Jean Lipman Foundation

625. RED GROOMS.
The Discount Store—Guns for Sale. 1971.
Mixed media. Collection the artist

626. ROBERT RAUSCHENBERG.
Buffalo. 1964.
Oil on canvas, 96 × 72″.
Collection Mr. and Mrs. Robert B. Mayer,
Winnetka, Ill.

627. LARRY RIVERS.
Dying and Dead Veteran.
1961. Oil on canvas, 70 × 94″.
Wasserman Family
Collection, Chestnut Hill,
Mass.

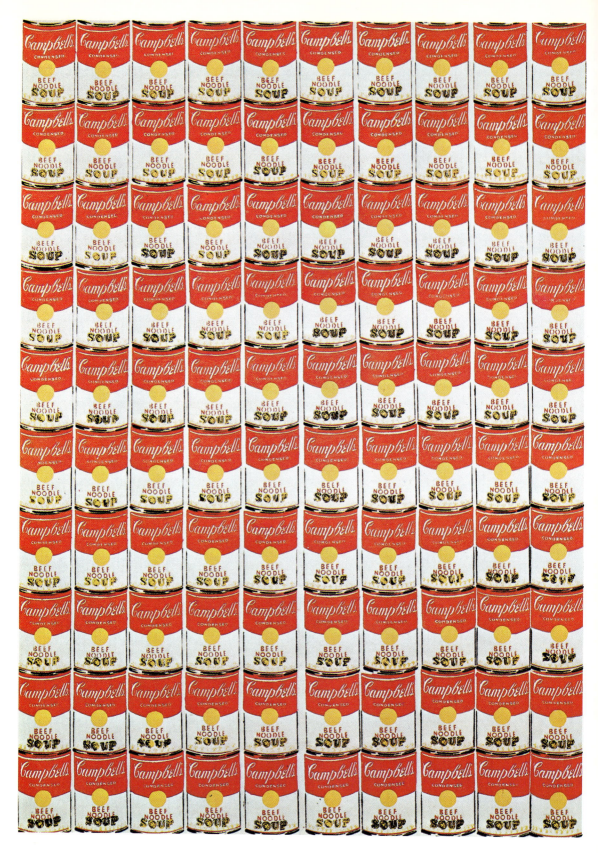

628. ANDY WARHOL. *One Hundred Campbell's Soup Cans*. 1962. Acrylic on canvas, 82 × 52″.
Collection Karl Ströher, Darmstadt, West Germany

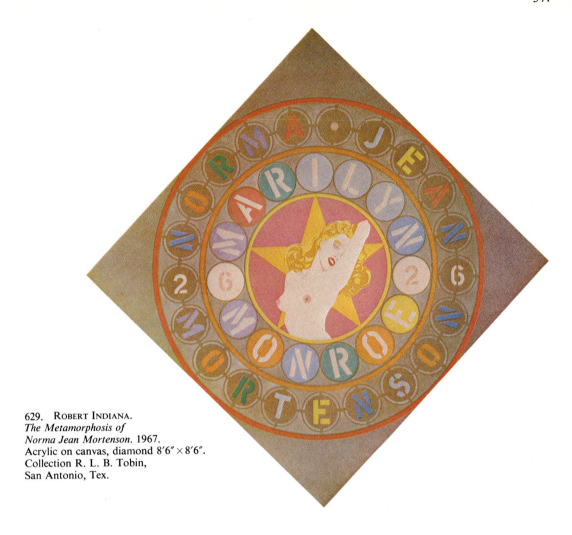

629. ROBERT INDIANA.
*The Metamorphosis of
Norma Jean Mortenson.* 1967.
Acrylic on canvas, diamond 8′6″ × 8′6″.
Collection R. L. B. Tobin,
San Antonio, Tex.

630. JAMES ROSENQUIST. *Marilyn Monroe I.* 1962.
Oil and spray enamel on canvas, 93 × 72¼″.
The Museum of Modern Art, New York City.
Gift of Sidney and Harriet Janis

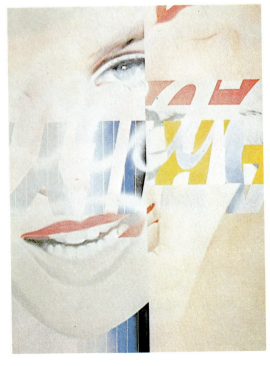

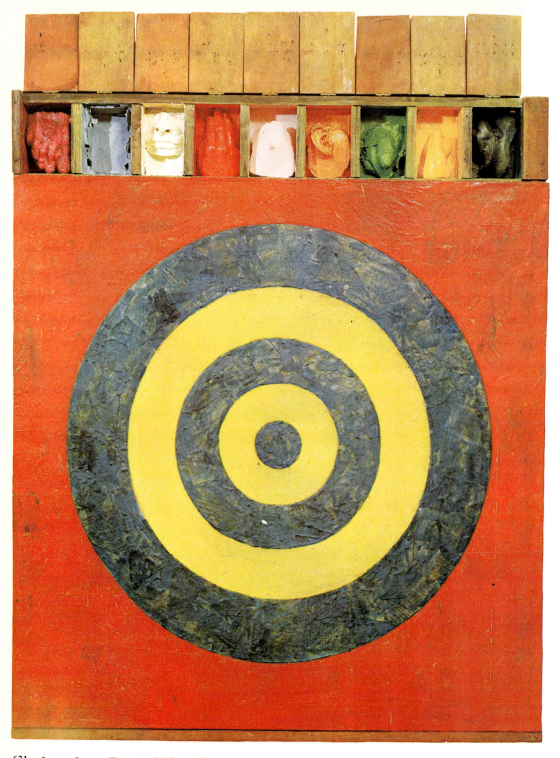

631. JASPER JOHNS. *Target with Plaster Casts.*
1955. Encaustic collage on canvas with wood construction and plaster casts, $51 \times 44 \times 3\frac{1}{2}''$.
Collection Mr. and Mrs. Leo Castelli, New York City

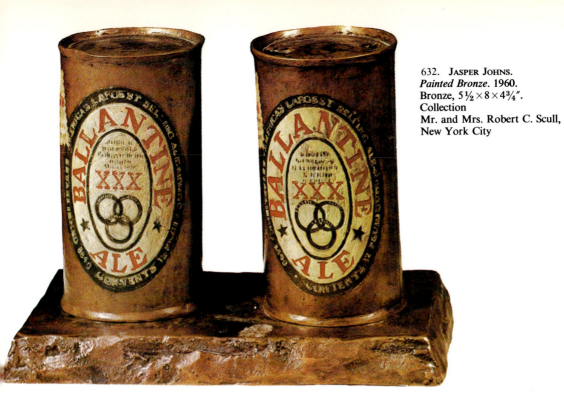

632. JASPER JOHNS.
Painted Bronze. 1960.
Bronze, $5\frac{1}{2} \times 8 \times 4\frac{3}{4}''$.
Collection
Mr. and Mrs. Robert C. Scull,
New York City

633. H. C. WESTERMANN.
Westermann's Table. 1966.
Plywood, bolt, and books,
height $44\frac{3}{4}''$.
Galerie Claude Bernard, Paris

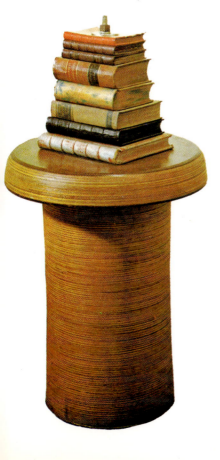

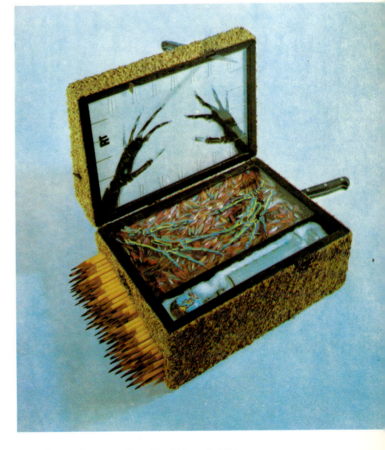

634. LUCAS SAMARAS. *Box No. 48* (open). 1966.
Mixed media, closed $11 \times 14\frac{1}{2} \times 9\frac{1}{4}''$.
Collection Julie and Don Judd, New York City

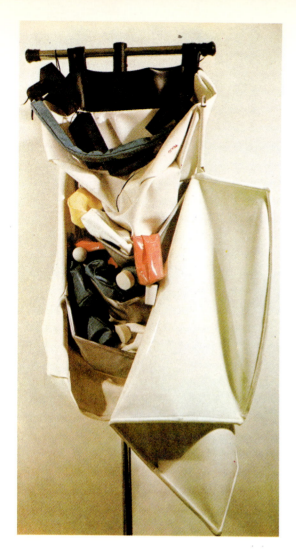

635. CLAES OLDENBURG.
Vinyl Medicine Chest. 1966.
Vinyl, Plexiglas, and kapok, $35\frac{1}{2} \times 24 \times 6\frac{1}{2}''$.
The Harry N. Abrams Family Collection,
New York City

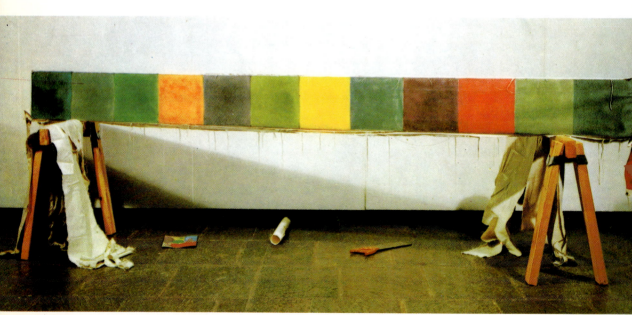

636. JIM DINE. *Saw Horse Piece*. 1968–69. Oil, canvas, wood, and metal, $4' \times 12' \times 3'$.
Sonnabend Gallery, New York City

like a cigarette, smells like a pair of shoes. I am for art that flaps like a flag, or helps blow noses, like a handkerchief. I am for an art that is put on and taken off, like pants, which develops holes, like socks, which is eaten, like a piece of pie.[1]

Most recently Oldenburg has been designing and drawing, with great elegance and wit, imaginary urban monuments—a toilet ball for the Thames, a teddy bear for Central Park, a mammoth block of cement for a downtown street intersection, among others. These visionary inventions are grafts of the fantasies of childhood on an urban environment whose dehumanization, overcrowding, and apparently hopeless problems of litter, traffic congestion, crime, and pollution resist rational solution. The irrationality of the man-made environment, with its threat to human survival, makes Oldenburg's visual gibes seem humane and plausible by comparison. At least his own fetishes, no matter how regressive or infantile, have been humanized, and are sustained by the values of authentic personal experience. The language of the nursery shows us an adult world through the eyes of a child—as in Blake's "Songs of Innocence." Indeed, his ironic visual com-

[1]Claes Oldenburg, *Store Days* (New York: The Something Else Press, 1967).

mentary becomes a vigorous form of criticism of an impotent society which refuses to save itself from itself. Oldenburg's re-creations of food are appealing, as Lucy Lippard noted, "because they combine gaiety and elephantine sadness." His new monuments are far more pessimistic, and convey a mood of black humor more appropriate to our condition.

The dehumanizing impact of our surroundings supports the uncanny and moving sculpture of George Segal. His is a dramatic art that defies conventional distinctions between sculpture and painting, object and environment, visual elaboration and poetic sentiment. Segal's human images often seem a vulgar intrusion on a brightly lit, artificial urban landscape that takes no heed of man and has only a marginal place for him. His ghostly human replicas are pieced together from castings of friends who have been patient enough to leave their impressions in plaster. The surfaces

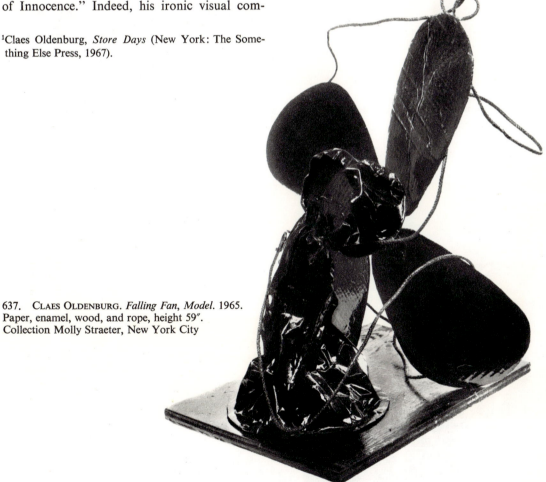

637. CLAES OLDENBURG. *Falling Fan, Model*. 1965. Paper, enamel, wood, and rope, height 59″. Collection Molly Straeter, New York City

638. ROBERT MALLARY. *The Cliffhanger*.
1963. Fabric impregnated with polyester, height 92″.
Collection the artist

639. LUCAS SAMARAS. *Rag Sculpture*.
1959–60. Burlap and plaster, length 11″.
Collection the artist

640. WILLIAM KING. *New People*. 1966.
Vinyl, figures each c. 14″.
The Harry N. Abrams Family Collection,
New York City

641. CLAES OLDENBURG. *Soft Typewriter*. 1963.
Vinyl, kapok, cloth, and Plexiglas, 27½ × 26 × 9″.
Collection Alan Powers, London

643. CLAES OLDENBURG. *Céline Backwards*. 1959.
Papier mâché, 30¾ × 39⅝ × 5″.
Collection the artist

642. CLAES OLDENBURG. *Model (Ghost) Typewriter*.
1963. Cloth, kapok, and wood, 27½ × 26 × 9″.
Collection Karl Ströher, Darmstadt, West Germany

644. CLAES OLDENBURG. *Toy Box*. 1962.
Mixed media, 10 × 36 × 24″.
Collection Mr. and Mrs. Robert B. Mayer,
Winnetka, Ill.

of the molds are freely manipulated, shaped, and
expanded by hand in quick-drying plaster, with
something of the amorphousness of a Reuben
Nakian sculpture. These stolid and insensible
dream figures dwell in the lonely limbo created by
the chrome-and-neon vacancies of a public world
of gas stations, cleaning establishments, and
mass-transportation vehicles, or occupy the pri-

vacy of a home where they tend themselves blindly
and absorbedly as animals do, and wait impas-
sively for some external stimulus to move them
off dead center. The subtly modulated surfaces of
Segal's plaster robots are, like Oldenburg's object
fabrications, quite literally shells. They make no
explicit social commentary, and their "message"
is their theatrical presence and illusion in an en-

645. CLAES OLDENBURG. *Proposed Colossal Monument for Park Avenue, New York: Good Humor Bar.* 1965. Crayon and watercolor, 23¾ × 18″. Collection Carroll Janis, New York City

646. CLAES OLDENBURG. *A Bedroom Ensemble* (detail). 1963. Wood, vinyl, metal, fake fur, and other materials, entire room 10′ × 17′ × 21′. Sidney Janis Gallery, New York City

vironmental situation. Humanly anesthetized, they simply exist as objects exist. Their most vivid identities and energies are aesthetic; since they are denied the energy of action, they can serve the gratuitous life of the work of art, just as Oldenburg's dispossessed and poetically suspended objects do.

The acute sense of alienation at the heart of George Segal's environmental sculpture has produced other variations on the human figure in the context of contemporary urban life of poetic intensity and power. Richard Lindner's paintings translate the gaudy parade of the New York street into an intense drama of compulsive imagery and abstract patterning. In *One Way* traffic lights and a striped safety barrier make a formal display of such distracting brilliance that it takes on a symbolic function, creating a Disneyland setting for a dreamlike New York scene. The policeman, a brutalized representative of law and

647. GEORGE SEGAL. *The Gas Station* (detail). 1963. Assemblage, 8′6″ × 24′2″ × 4′. The National Gallery of Canada, Ottawa

648. GEORGE SEGAL. *Bus Riders.* 1964.
Plaster, metal, and leather, 7′×4′×9′.
Joseph H. Hirshhorn Collection

649. GEORGE SEGAL. *The Execution.* 1967.
Mixed media, 8′×11′×8′.
The Vancouver Art Gallery, Vancouver

order, sets off a lady of the night in fetishistic boots.

Perverse and erotic imagery of this genre has broken to the surface in much recent American art with sharp explicitness, just as it has in literature, sanctioned by the insistent prurience of so much commercial advertising, which reduces modern man and woman to their sexual identities alone. What was once forbidden subject matter has now become a commonplace which some artists choose neither to ignore nor idealize but adapt to their own valid expressive purposes. The difference between Lindner's vicious females and the mechanized sex idols of the mass media is one of formal intensity and emotional catharsis. He carries the routine process of depersonalization of the female to one plausible conclusion, creating a terrifying Freudian maenad who rivals the decadence and animal brutality of George Grosz's Berlin-period prostitutes. Yet Lindner's fantastic creatures are puppets in an aesthetic game whose ground rules have been established by the innovations of a variety of forms of contemporary abstract painting and Pop Art, which they echo and extend.

In the 1960s the increasing rate of technological change and the proliferation of mass communications converged with the diminishing momentum of Abstract Expressionism to inspire in the Pop Art movement a fresh kind of American experience, one which took account of the mounting crisis of individual identity. This crisis has had a particular meaning for American artists, even if it has not been systematically articulated by them. Americans have been subjected intensively to patterns of voluntary collectivization and conformity, symbolized by the organization man, whose fetishes are statistics about group behavior and an irrational worship of possessions. One writer has put it that the social center of gravity is shifting and no longer lies in the individual but in the relations between things. The individual's integrity and identity have been further threatened by the stupefying power of mass communications, which have made banality the content of a major advertising industry. Never to such an extent has the real world been reproduced, duplicated, and anticipated by fictions in the public domain. The accelerating impact of mass media on private areas of experience directly precipitated the Pop Art revolution.

In a typically perverse and outrageous statement made during an interview with the critic G. R. Swenson, Andy Warhol captured the new mood from his own admittedly extreme viewpoint, and in his own toneless, metronomic prose rhythms: "Someone said that Brecht wanted everybody to think alike. I want everybody to think alike. But Brecht wanted to do it through Communism, in a way. Russia is doing it under

650. RICHARD LINDNER. *Leopard Lily*. 1966.
Oil on canvas, 70 × 60″.
Wallraf-Richartz-Museum, Cologne

652. NANCY GROSSMAN.
Head (*3 Horns*). 1968.
Leather over wood, height 16″.
Collection
Howard and Jean Lipman,
New York City

651. RICHARD LINDNER. *The Street*. 1963. Oil on canvas, 72 × 72″.
Collection I. M. Pei, New York City

government. It's happening here all by itself without being under a strict government; so if it's working without trying, why can't it work without being Communist? Everybody looks alike and acts alike, and we're getting more and more that way.

"I think everybody should be a machine.
"I think everybody should like everybody."
Is that what Pop Art is all about?
"Yes. It's liking things."
And liking things is like being a machine?
"Yes, because you do the same thing every time. You do it over and over again."[1]

The Pop artists have taken their imagery directly from the billboard, the supermarket, the comic strip, road signs, television, movies, and other popular sources. The public dreams through the mass media, and the Pop artist has re-created everyman's fantasies and euphoric reality substitutes, exploiting both their associational content and their formal potential in terms of the flat design and condensed sign language of modern art. The imitative form and content of Pop Art have been the subject of heated dispute among artists of the older generation, who have charged that Pop artists do not expand sufficiently on their visual sources, and therefore confirm all the mechanical and anti-individualistic tendencies in American life and culture against which the Abstract Expressionists, by contrast, proposed a loud dissent. Since Pop Art has generally been "cool" and ironic rather than openly subversive of the established order—a rule to which the explicit eroticism of Tom Wesselmann's *Great American Nude* series is the exception—it has also been criticized, not without wit, as the neo-Dada of the Age of Affluence. The older avant-garde audience, feeling its values threatened, has preferred a restricted view of Pop Art as an entertainment. The emergence, however, of a number of strongly individual artistic personalities and their shared patterns of development have made it impossible to ignore this artistic phenomenon or to set arbitrary limits on its expressive possibilities, influence, or growth.

Pop Art made its dramatic public debut in 1962 with the one-man shows of Roy Lichtenstein,

653. FRANK GALLO. *Girl on Couch*. 1967.
Epoxy, $48 \times 51 \times 40''$.
The Art Museum, Princeton University,
Princeton, N.J.

654. MEL RAMOS. *Monterey Jackie*. 1965.
Oil on canvas, $60 \times 50''$.
Collection Mr. and Mrs. Russ Soloman,
Sacramento, Calif.

[1]G. R. Swenson, "What Is Pop Art? Interviews with Eight Painters (Part I)." *Art News*, November, 1963.

655. TOM WESSELMANN.
Great American Nude No. 74–7.
1965. Painted, molded plastic
relief, 34½ × 43″.
Collection Bernard Cooper,
Los Angeles

James Rosenquist, Andy Warhol, Tom Wesselmann, and Robert Indiana. An offended shock was experienced by many artists and almost all critics confronted by an imagery which scarcely seemed to transform its sources: newspaper comic strips (Lichtenstein); billboards (Rosenquist); repeated or isolated commercial brand symbols (Warhol); montages in strong relief of food products (Wesselmann). The more obviously aesthetic intention of Robert Indiana's lettered signs and directional symbols was found only slightly more acceptable, since he, too, took over explicit and routine commercial imagery, road signs, and mechanical type faces. Image banality was matched as a source of provocation by the apparent indifference of Pop artists to individualized handling, and their uncritical enthusiasm for the bald visual stereotypes of commercial illustration. Mechanical image registration in current styles of commercial art ran strongly counter to the accumulated store of knowledge, craft, and painterly

656. ANDY WARHOL.
Marilyn Monroe. 1962.
Oil, acrylic, and silkscreen
enamel on canvas, 20 × 16″.
Collection Jasper Johns,
New York City

657. JAMES ROSENQUIST.
Nomad. 1963.
Oil on canvas, 7′ × 17′6″.
Albright-Knox Art Gallery,
Buffalo, N.Y.
Gift of Seymour H. Knox

658. TOM WESSELMANN.
Still Life No. 36. 1964.
Oil and collage on canvas,
4 panels, entire work 10′ × 16′¼″.
Whitney Museum of American Art,
New York City

659. TOM WESSELMANN.
Bedroom Tit Box. 1968–70.
Oil, acrylic collage, and
human breast, 6 × 12 × 8½″.
Sidney Janis Gallery,
New York City

expressiveness built up by previous generations. Those with a vested interest in established art forms were prepared for Expressionistic rawness in "high" art, but slickness was considered meretricious and intolerable.

With the passage of time, however, it has become clear that the Pop artists were genuine and powerful innovators, whose styles were directly related to current modes of hard-edge and optical abstraction. Most significantly, their interest in the mass media can now be understood as selective and discriminating rather than servile imitation or mere documentation. The mass communications media were regarded as a dynamic process and a rich source of artistic metaphor rather than a fund of stereotyped techniques to be accepted uncritically and reproduced by rote. By monumentally dilating a detail, Rosenquist discovered iconic possibilities in a commercial sign fragment, and created confusing, alternative readings for his compartmented paintings. They can be associated both with the ambiguous legibility of contemporary abstraction and with the deliberate visual confusions and non sequiturs of Surrealism. Lichtenstein slowed down the cartoon image by enlarging it; his overstated Benday screen dots play a conspicuously formal role, and he compels our attention to medium and process. His art is "about" art and style despite its debased, lowbrow subjects and mechanical appearance. Another kind of distance was achieved by Lichtenstein in his choice of somewhat out-of-date comics. Modern life speeds up the sense of time's passage, and makes us more sharply aware of changing styles and events and of the obsessional interest of the consumer public in change and novelty. Such intuitions are at the heart of much Pop Art. The communications media have become a collective vehicle of instant history-making, contracting time and space into a blurry, continuous present, and giving even the recent past the nostalgic, dated look of *ancien régime*.

Warhol's repeating images of car crashes, movie stars, or soup cans are snatched from the march of news events, the daily unfolding of the celebrity pageant, or the life cycle of processed articles and food. His *Death and Disasters* series plays upon the news media's custom of repeating horror scenes until the spectator's responses are finally numbed. "When you see a gruesome picture over and over again," he has noted, "it doesn't really have any effect." The iconic gravity of his silkscreened imagery counters the transient character of the ephemera which his art registers. He has also constructed food and soap cartons of painted wood, stacked to imitate a supermarket storeroom. These objects exist by a nuance of contradiction between the actual object and its simulations, and the artist's fine calculation of his audience's different responses to each. Warhol destroys the functional credibility of a store package whose legend, image, and shape we know by heart, but which we refuse to accept in the context of art. The original model and its wooden painted dummy both float in our minds for an instant, in

660. ROY LICHTENSTEIN. *Whaam!* 1963. Magna on canvas, 2 panels, entire work 5′8″ × 13′4″. The Tate Gallery, London

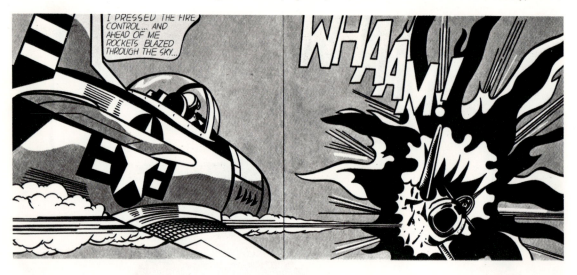

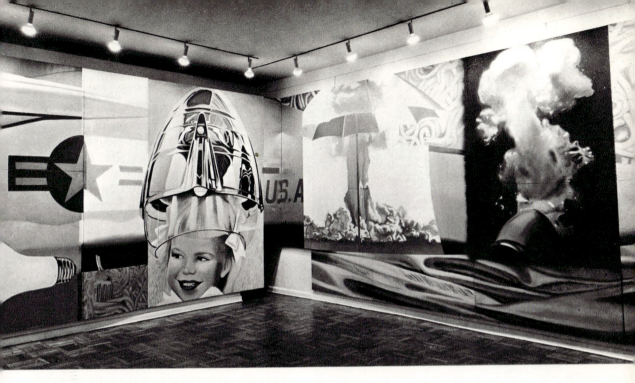

661. James Rosenquist. *F-111* (detail). 1965. Oil on canvas with aluminum, entire work 10′ × 86′.
Collection Mr. and Mrs. Robert C. Scull, New York City

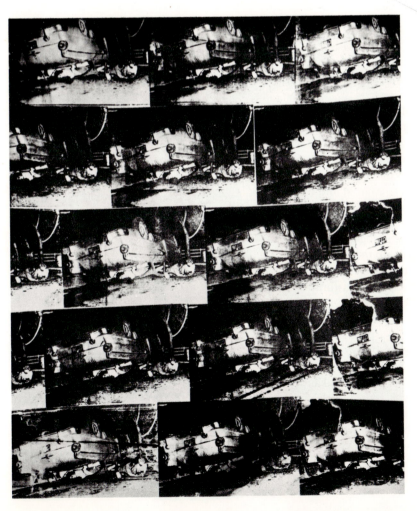

662. Andy Warhol.
Orange Disaster. 1963.
Acrylic and silkscreen enamel
on canvas, 9′2″ × 6′10″.
Leo Castelli Gallery,
New York City

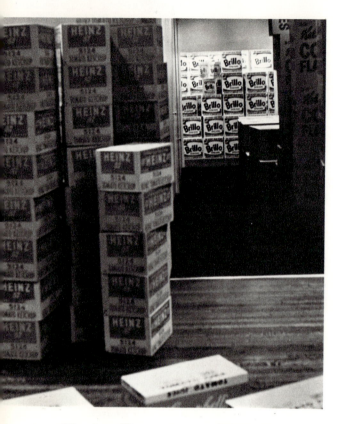

a form of optical abstraction that can be linked to Newman, to Albers, and to Vasarely. Indiana's precise shapes and intensely active color can be even more directly associated with the work of his contemporary Ellsworth Kelly. Lichtenstein's parodies on Picasso, Mondrian, the Action painter's "brushstroke," and "modernistic" sculpture of the thirties, as well as the comic strip, combine an intense aestheticism with the mechanical kind of sensibility which he has now made viable for art. The examples of Indiana and Lichtenstein link American Pop Art directly to the most ambitious forms of contemporary abstraction rather than to an anecdotal realism of a more traditional character.

Of great interest is the nature of the Pop artist's media sources. The TV screen, the advertising blow-up, the blurred wirephoto, the comic strip, all provide relatively crude images, low in definition, whose character as media is therefore constantly present. Marshall McLuhan, the analyst of the revolutionary impact on human perceptions made by mass communications media, has

663. ANDY WARHOL. *Heinz and Brillo Cartons.* View of exhibition at the Stable Gallery, New York City, 1964

664. ROBERT INDIANA. *The Marine Works.* 1960–62. Wood and mixed media, 72 × 44″. The Chase Manhattan Bank, New York City

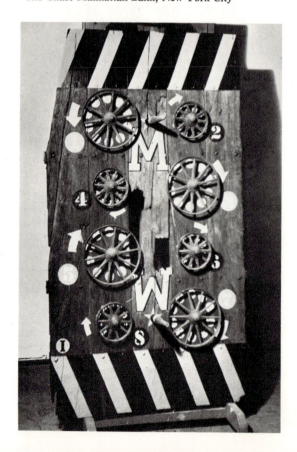

a kind of free-fall state without normal attachment. This is but another ingenious and effective way of elucidating in public the rudimentary alienations of the artistic process, and inviting active audience participation. As the Impressionists mixed colors optically on the retina of the beholder's eye, for greater immediacy, so Warhol mixes a known detergent or food package and its simulacrum in the mind, transposing a prepared image from the context of life into the context of art. Lichtenstein has noted in relation to his cartoon enlargements that the closer the transformed image is to its original model, the more critical, risky, and demanding for the viewer becomes the act of artistic re-creation.

Robert Indiana's lettering and signs are organized in more traditional pictorial terms but play on dual sets of responses to both verbal and visual information. His vivid retinal flickers, dissonances, and emblematic forms scintillate, scramble, and then unscramble color structure in

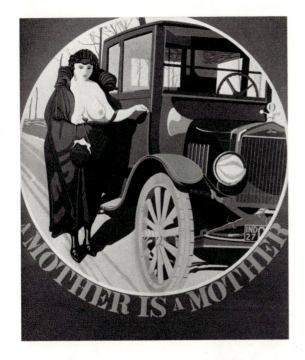

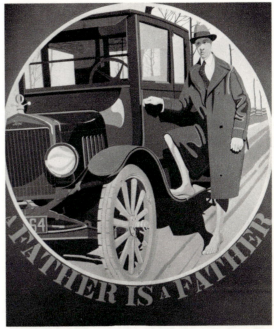

665. (*top left*) ROBERT INDIANA. *Mother.* 1963–67.
Oil on canvas, 72 × 60″.
Collection the artist

666. (*top right*) ROBERT INDIANA. *Father.* 1963–67.
Oil on canvas, 72 × 60″.
Collection the artist

667. (*middle*) ALLAN D'ARCANGELO. *Road Block.* 1964.
Acrylic on canvas with construction, 81 × 65½ × 8″.
Collection Mr. and Mrs. Miles Q. Fiterman,
Minneapolis

668. (*bottom*) EDWARD RUSCHA.
Standard Station, Amarillo, Texas. 1963.
Oil on canvas, 5′5″ × 10′1½″.
Collection Brooke H. Hopper, Los Angeles

noted that such imagery, low in content and information, "shares a participational and do-it-yourself character." The usual prototypes on which Pop Art draws are "cool," dynamic, and coarse, despite their mechanically processed look. They require audience activity and completion, and thus constantly recall to us their character as an expressive process. Somewhere in the background of Pop Art, too, is lodged a critical awareness of mass media's tendency toward repeatability and uniformity, which in turn compromises the very idea of the "original." The reproduction process, then, is very much part of the problematic intellectual content of Pop Art.

Today, the sociologist Daniel Boorstin has pointed out, the "original" has acquired a tech-

669. (*top*) JAMES ROSENQUIST. *Horizon Home Sweet Home*. 1970.
Oil on canvas, Mylar, and fog, each panel 8′6″ × 3′4″.
Leo Castelli Gallery, New York City

670. (*middle*) ROY LICHTENSTEIN. *Peace Through Chemistry*. 1970.
Oil and Magna on canvas, 8′4″ × 15′.
Collection the artist

nical or esoteric status as mere prototype or matrix from which copies can be reproduced. A public that cheerfully accepts Van Gogh's *Sunflowers* in countless reproductions may be quite unprepared for the demands on individual responses required by the obscure and rarely seen original. The printing revolution and the more recent flood of pictorial reproductions have helped dispel the notion that uniqueness is indispensable to art, and thus have created, along with

671. ROY LICHTENSTEIN.
Modern Sculpture with Glass Wave. 1967.
Brass and glass, height 91″.
Leo Castelli Gallery, New York City

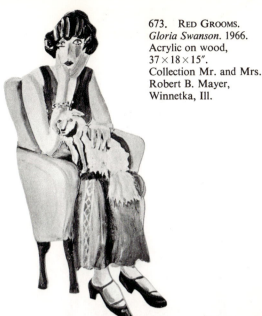

673. RED GROOMS.
Gloria Swanson. 1966.
Acrylic on wood,
37 × 18 × 15″.
Collection Mr. and Mrs.
Robert B. Mayer,
Winnetka, Ill.

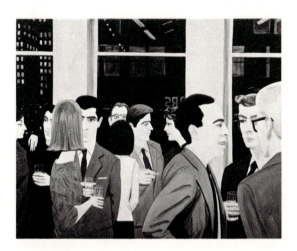

672. ALEX KATZ. *Cocktail Party*. 1965.
Oil on canvas, 76 × 96″.
Collection Alberto Ulrich, Taxco, Mexico

674. HOWARD KANOVITZ. *The New Yorkers II*. 1966.
Liquitex on canvas, 70 × 93¾″.
Collection Jerry Leiber and Mike Stoller,
New York City

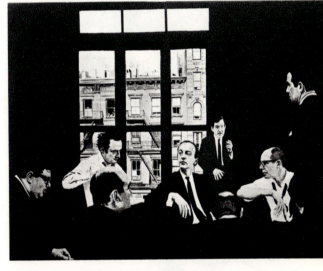

other elements of urban mass culture, an alternative "low" popular tradition to "high" art. The Pop artists did not merely repeat the forms and content of mass media, but selected and abstracted certain significant elements which were then radically transformed. The color surfaces of Rothko, Still, and Newman, and their perceptual ambiguities, the "environmental" emphasis of so much current art, beginning with de Kooning and continuing with greater emphasis in the attention Rivers, Rauschenberg, and Johns lavished on the common object, prepared the way for these vital and original assimilations of the stereotyped forms of popular culture. Another fascinating and entirely native precedent has existed in American art for some time, anticipating the incorporation of visual clichés and lettering in an emblematic and standardized subject matter: the lively, brash, vernacular style of Stuart Davis, who fused Léger's Cubism with the surfaces of American life.

No longer a faithful mirror of the world of popular culture, Pop Art lost momentum as a group style after 1965. Individual artists associated with it, on the other hand, have become increasingly resourceful, even as they seem to be losing touch with the original impulse which inspired them. Oldenburg, Lichtenstein, Rosenquist, Warhol, Wesselmann, and Dine have all continued to develop and to expand their creative worlds in surprising ways. Oldenburg's "soft" forms now exert a powerful influence on contemporary abstract sculpture; the ersatz, commercial surfaces and synthetic textures of Pop Art have directly affected other abstract expressions, especially in sculpture, and encouraged new intermedia experiment. Reversing the current of influence, geometric and Minimalist sculptural forms

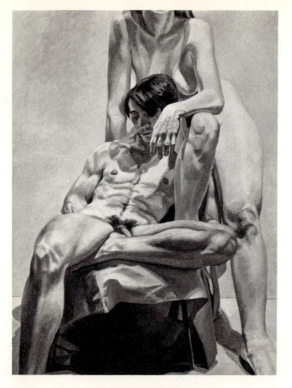

675. PHILIP PEARLSTEIN.
Models in the Studio. 1965.
Oil on canvas, 72½ × 53¾".
Allan Frumkin Gallery, New York City

currently popular have also influenced a number of the Pop artists. There has been, in fact, a very lively interaction between the apparently antithetical modes of abstraction and the representation of Pop Art, to their mutual benefit.

Obviously the durability of the work of individual Pop artists, if not their original group identity, is based on sound formal values. Pop Art in America was always much more than a shallow representationalism or a parody of popular culture, as its detractors have charged. At least two major Pop artists today continue to extend the boundaries of art: Oldenburg and Lichtenstein. As has so often been true in the past, their work has far transcended the visible possibilities and the limited expressive goals of the general movement which formed them. The original assumptions of Pop Art are no longer adequate to describe these artists or their wide range of invention and formal mastery.

The attitudes of irony and wit established by Pop Art and its exploration of commonplace subject matter have been a significant influence in the rise of new forms of figurative art in recent years. The latest "new realism" depends on photographic sources and commercial advertising imagery, but it has made illusionistic art once again

677. WAYNE THIEBAUD.
Girl with Ice Cream Cone. 1963.
Oil on canvas, 48 × 37".
Allan Stone Gallery, New York City

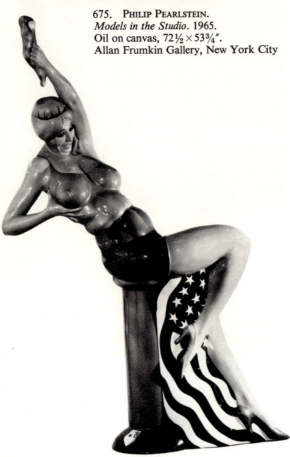

676. LUIS JIMINEZ.
Statue of Liberty. 1971–72.
Polyester Fiberglas,
height 7'3".
Collection the artist

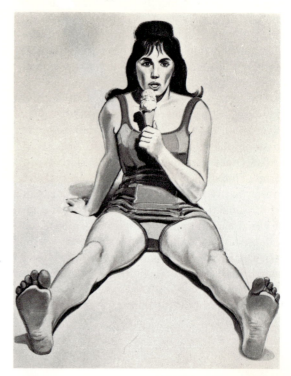

678. ALLAN D'ARCANGELO. *Highway No. 2*. 1963. Acrylic on canvas, 72×81″.
Wasserman Family Collection, Chestnut Hill, Mass.

679. ALEX KATZ. *Paul Taylor Dance Company.* 1969. Oil on canvas, 9′6″ × 19′6″.
The Fischbach Gallery, New York City

680. MARISOL. *Women and Dog.* 1964. Wood, plaster, synthetic polymer paint, and mixed media, 72 × 82 × 16″.
Whitney Museum of American Art, New York City. Gift of the Friends of the Whitney Museum

681. RICHARD LINDNER. *Hello*. 1966. Oil on canvas, $70 \times 60''$. The Harry N. Abrams Family Collection,
New York City

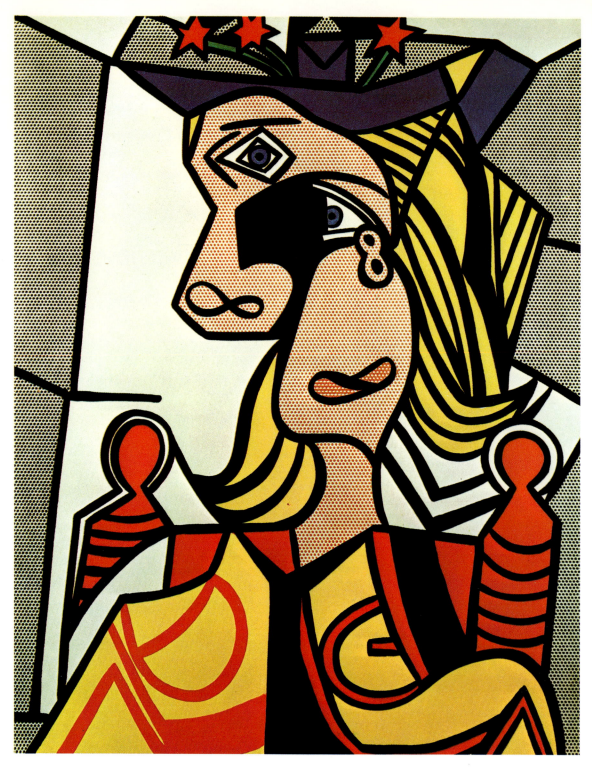

682. ROY LICHTENSTEIN. *Woman with Flowered Hat*. 1963. Oil on canvas, 50 × 40″.
Collection Miss Vivian Tyson, New York City

683. HOWARD KANOVITZ. *Mazola and Ronzoni.* 1969. Polymer, acrylic, canvas, and wood, 35½ × 46½". Collection Galleri Ostergren, Malmö, Sweden

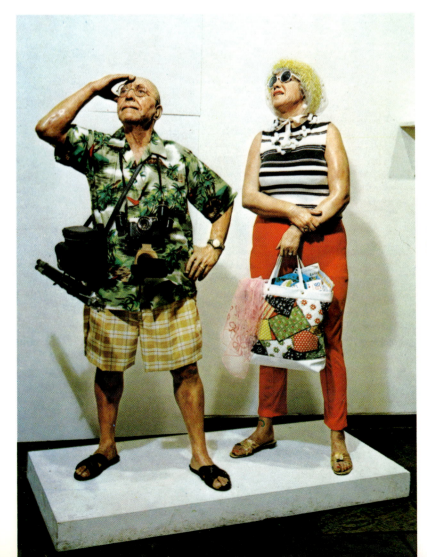

684. DUANE HANSON. *Tourists.* 1970. Fiberglas and polychromed polyester, 64 × 65 × 47". Collection Saul Steinberg, Hewlitt Bay Park, N.Y.

685. ROBERT COTTINGHAM. *Art*. 1971.
Oil on canvas, 84 × 84″.
O. K. Harris Works of Art,
New York City

686. JOHN DE ANDREA. *Reclining Figure*. 1970. Polyester resin polychromed in oil, 20 × 78 × 20″.
Private collection, New York

687. JOHN KACERE.
Untitled (*Post-Card View*). 1970.
Oil on canvas, 60 × 66″.
Collection Warren Benedek,
New York City

688. TOM WESSELMANN. *Great American Nude No. 70*. 1965. Liquitex on canvas, 75 × 60″.
The Harry N. Abrams Family Collection, New York City

689. John Clem Clarke. *Judgment of Paris.* 1969. Acrylic on canvas, 5′5½″ × 10′2″.
University of California Art Museum, Berkeley

690. MALCOLM MORLEY.
The "United States" with New York Skyline. 1965.
Liquitex on canvas, 45½ × 59½".
Collection Mrs. Ethel Kraushar, Lawrence, N.Y.

691. RICHARD ESTES. *Victory Theatre.* 1968.
Oil on panel, 32½ × 24".
Collection Mr. and Mrs. Stephen D. Paine, Boston

viable without going to the lengths of fantastic invention or satirical commentary so often an explicit factor in Pop Art. Any sort of distortion or caustic social commentary is avoided in the effort to deal with the actual world, even when it

is viewed at second hand through the camera lens.

Photographic reduction was already implied in the simplified definitions of art world personalities, who were among the favorite subject matter of Alex Katz since the late fifties. His large, stagey compositions of friends and recognizable figures from the art world coterie assembled at cocktail parties combined a deliberate naiveté of manner with a mechanized technique. The simplified but strongly personal and poetic style anticipated the elementary visualizations of the Pop artists, although Katz also retained something of the unpretentious and innocent idealism of Winslow Homer's American scene.

Variants of realism in recent years combine the severely simplified formal organization of contemporary hard-edge abstraction with a subject matter taken from photographic sources. It is the simple factualism and flat insipid reality of the photographed image which provide the prototypes for this new realism, rather than the traditional example of realistic painting. Howard Kanovitz's life-like ensemble of faces in *The New Yorkers* belongs to members of the New York art world in the early sixties, grouped around the late poet-curator Frank O'Hara, but they have been treated with a formal rigor which puts aesthetic distance between ourselves and the models' recognizability. Kanovitz has described his role as that of "a stage director casting and arranging tableaux of arrested action." In his most recent work, such as *The Studio*, he tested his confrontations of fact and illusionistic fiction in the actual environment by painting *trompe-l'oeil* accessories, props, and personae taken from his private world of home and studio, and giving them three-dimensional existence as freestanding sculptural forms.

Both its intense fidelity to photographic or real-life models and its equally insistent formal structuring identify the new realism as an art pushed to extremes. Philip Pearlstein's powerful nude studies are harsh, deliberately ugly, anti-idealistic in their anatomical elaboration, and brutally explicit in their sexuality. The abrupt, angular croppings of his figures add a further tension to his compositions. Jack Beal's nudes achieve a kind of dehumanization by another route: his seductive figures are lost in a dazzling web of patterned furniture accessories or flamboyant color passages. Malcolm Morley works from the most banal color reproductions of photographed cruise

692. CHUCK CLOSE. *Self-Portrait*. 1968.
Acrylic on canvas, 8'11½" × 6'11½".
Walker Art Center, Minneapolis

693. ALFRED LESLIE. *Alfred Leslie*. 1966–67.
Oil on canvas, 9' × 6'.
Whitney Museum of American Art, New York City.
Gift of the Friends of the Whitney Museum

ships or resort posters, but his sensuous scenes of holiday pleasure are contradicted by his dispassionate, meticulous handling of detail, and his interest in the reproduction process for its own sake. In a more powerfully painterly manner, Alfred Leslie creates monumental figure portraits in such vast enlargement as to oppress the viewer with their bulk. Chuck Close's pitilessly magnified close-ups of his literally photographed heads, transposed on canvas from an opaque projector, tend to lose recognizability and credibility at close quarters. Clearly, there are irrational visual and intellectual cross-currents at work in the new realism, operating in a complex tension, establishing affinities closer to the ironist qualities of contemporary abstraction and Pop Art than to traditional realism. Even the soft-focus lyricism of John Clem Clarke's contemporary nudes, posed in reenactments of classical mythological themes, comment wittily on both the new sexual freedom and the irrelevance of a traditional iconography.

Like Pop Art and the new abstraction, with their problematic intellectual content, the new post-Pop realism offers no simple solution of a nostalgic return to the figure or to an outlived classical humanism. It confronts the second-hand visual experiences and media sources in our culture with the same unsettling honesty which is given to traditional examples of realism. So long as realism maintains such a refreshing candor, and keeps open a dialogue with problems of some contemporary urgency in regard to representation, it promises to remain a vital alternative during a period otherwise dominated by increasingly abstract and dematerialized expressions of the artistic spirit.

694. JOHN SALT. *Demolished Vehicle (Fat Seats)*.
1970. Oil on canvas, 53⅛ × 78⅜".
Collection Dr. Hubert Peeters, Bruges, Belgium

695. DUANE HANSON. *Motorcyclist*. 1969. Fiberglas and polyester mixture with mixed media.
Collection Mr. and Mrs. Robert B. Mayer, Winnetka, Ill.

14 · The Aesthetics of Boredom: Abstract Painting Since 1960

DURING THE SIXTIES the *angst*-ridden and expressionist outbursts of the best of contemporary art gave way to a new common sensibility based on a conscious program of emotional disengagement, formal rigor, and anonymity of authorship. The change was nothing less than sensational from Action Painting's agitated brushwork, subjective intensities, and headlong identification with the "act" of creation, to the muted surfaces, reduced forms, and strict intellectual control of so much contemporary abstract painting and sculpture of the "cool" persuasion.

A corresponding shift in literature has been noticeable, with the deliberate abandonment of emotional content and a toneless recital of fact in the French "objective" novels, which tend to substitute "things" and events for action and the psychology of human motivation. Alain Robbe-Grillet, one of the literary leaders in the neutralization of the human factor in art, declared: "Now the world is neither meaningful nor absurd. It simply is." Other parallels in the drift toward a "contentless" art and a radical new objectivity have been apparent for some time in the dance of Merce Cunningham, the emptiness and "silences" of John Cage's music, and more recently, in the unrelieved tedium of the underground movies of Pop artist Andy Warhol.

Behind the dead-pan disenchantment and, at times, excruciating boredom of recent vanguard art forms, however, are liberating and positive intentions, rather than some simple nihilism. A sympathetic critic of the new tendency, Susan Sontag, emphasized this point in an important essay exploring the motives and meanings of the anti-Expressionist art of the sixties, "The Esthetics of Silence": "Cultivating the metaphoric silence suggested by conventionally lifeless subjects (as in much Pop Art) and constructing 'minimal' forms that seem to lack emotional resonance are in themselves vigorous, often tonic choices."[1] The boredom of rudimentary forms lacking much visual interest, or of standardized compositional elements from which manual evidence of distinctive authorship has been eliminated, also tests the "commitment" of the art audience at a time when there is too facile an appreciation of culture. Thus,

[1]Susan Sontag, *Styles of Radical Will* (New York: Farrar, Straus and Giroux, 1969).

696. ANDY WARHOL. *Cow Wallpaper*. Exhibition at Leo Castelli Gallery, New York City, 1966

697. GEORGE SEGAL. *The Movie Poster*. 1967.
Mixed media, 74 × 28 × 36″.
Collection Kimiko and John Powers, Aspen, Colo.

the rigorous objectivity of the new art evokes the heroic days of early twentieth-century modernism; Erik Satie's music, Gertrude Stein's impassive "idiot" prose, and even Picasso's Cubist forms also drastically reduced and denuded the means and effects of art in the effort to challenge the assumptions of their audience.

One of the constant aims of modern art has been to emphasize the gap between creative consciousness, with its demanding intellectual program and uncompromising moral standards, and a voyeuristic mass audience relentlessly determined to assimilate even the most shocking artistic products. To escape his audience, the artist stresses negation, asceticism, and marginal communication. A deliberate understatement of means is Samuel Beckett's aim when he speaks of his "dream of an art unresentful of its insuperable indigence and too proud for the farce of giving and receiving." Elements of humility and self-abnegation in art of high seriousness had been evident for some time in the postwar period, and even before. In the twenties Duchamp called his only attempt at film-making "Anemic Cinema," and Beckett had proposed the idea of an

"impoverished painting," a painting which is "authentically fruitless, incapable of any image whatsoever." Jerry Grotowski's manifesto for his Theatre Laboratory in Poland, seen recently in action in New York, was called "Plea for a Poor Theatre." And recent "process" art in Europe, which uses subaesthetic, common environmental materials, has been described as "Arte Povera." The rubric acts both to subvert the glamorous pretensions of modernism, which has become the object of acquisitive greed as status symbol, and to wipe the slate clean of the inevitable corruptions of expressive language in the now extensive history of the modern movement. Yet, as Miss Sontag makes clear, these programs for the impoverishment of art are as much "strategies for improving the audience's experience" as they are simplistic rejections of popular acceptance. "The notions of silence, emptiness, and reduction," she writes, "sketch out new prescriptions for looking, hearing, etc.—which either promote a more immediate sensuous experience of art or confront the artwork in a more conscious and conceptual way." It is this combined psychology of the tabula rasa and a more attentive perception of art's internal meanings which links the influential new literalism evident in the work of Jasper Johns, with its clear legibility and its repertory of reconstituted commonplace imagery, with the audacious emptiness and concreteness of the virtually blank or invisible canvases of Rothko, Newman, and Reinhardt. Together, these examples have been decisive in prefiguring the new directions of American abstract art of the sixties.

The reaction to a gestural and Expressionist art was already in the making among the Abstract Expressionists themselves in the fifties. This was noted by a number of critics. In a lecture on the new American painting in 1956, Professor Meyer Schapiro contrasted Pollock's and de Kooning's restless complexity to Rothko's bare and inert painting. "Each," he wrote, "seeks an absolute in which the receptive viewer can lose himself, the one in compulsive movement, the other in all-pervading, as if internalized sensation of a dominant color. The result in both is a painted world with a powerful immediate impact." The influence of the less "existential" action painters Still, Rothko, and Newman, however, was limited by the extraordinary widespread impact de Kooning had on second-generation American abstract artists. It wasn't really until the sixties, when the

698. JASPER JOHNS. *Grey Numbers.* 1957.
Encaustic on canvas, 28 × 22".
Private collection, New York

699. MARK ROTHKO.
Violet, Black, Orange, Yellow on White. 1949.
Oil on canvas, 80½ × 66".
Marlborough Gallery, New York City

impetus of conventional Action Painting ran down, that the search began among the younger generation for different antecedents. Newman, Rothko, and Still already had their own small but appreciative audience in the older avant-garde generation, and on the West Coast, especially around San Francisco during the fifties. They acquired a far more significant following among younger artists in the next decade, with the decisive shift in sensibility away from an Expressionist art to a more ordered and intellectually controlled abstraction. Only with hindsight can we see how prophetic and in advance of their own time were such radical phenomena as Newman's narrow, vertical canvases, which transformed painting into a tangible structural object and were thus direct forebears of Minimalist art—anticipating the "deductive" structures of Frank Stella, in Michael Fried's apt term. Equally unprecedented were the black-on-black, nearly invisible monotonal structures of Ad Reinhardt, from 1954 on. Robert Rauschenberg's adjoining panels of identical bare white canvas, exhibited in 1951, and Ellsworth Kelly's

horizontal arrangement of a uniform sequence of red, yellow, black, white, and blue of 1952 also stressed the simple object qualities of a painting ensemble entirely divorced from Expressionistic attitudes and devices of pictorial elaboration.

It was not until 1961, when H. H. Arnason proposed the term "Abstract Imagists" for artists in his exhibition at the Guggenheim Museum who were not Expressionists, that critics and curators formally acknowledged the fact that "Action Painting" did not adequately describe the work of such artists as Newman and Rothko and many younger artists who employed hard edges, unitary images, symmetrical or repeated modular forms, and broad, undetailed expanses of flat color. In the early sixties there was a sharpening focus on color-field abstraction, in both criticism and exhibition activity. Clement Greenberg proposed the color-image paintings of Morris

701. FRANK STELLA. *The Marriage of Reason and Squalor*. 1959.
Oil on canvas, $7'6\frac{3}{4}'' \times 11'3\frac{3}{4}''$.
The Museum of Modern Art, New York City. Larry Aldrich Foundation Fund

702. ROBERT RAUSCHENBERG. *White Painting*. 1951.
House paint on canvas, 7 panels, entire work $6' \times 10'6''$.
Collection the artist

700. BARNETT NEWMAN. *The Wild*. 1950.
Oil on canvas, $95\frac{3}{4} \times 1\frac{5}{8}''$.
The Museum of Modern Art, New York City.
Promised gift and extended loan from the Kulicke family

Louis and Kenneth Noland in particular as alternatives to an exhausted Expressionist art. The Jewish Museum, in a 1963 exhibition obviously influenced by the Greenberg aesthetic, defined the growing anti-de Kooning reaction under the title "Toward a New Abstraction." Among the artists shown were Kelly, Louis, Noland, Held, Parker, and Stella. The following year Greenberg himself organized an exhibition at the Los Angeles County Museum called "Post Painterly Abstraction," which explored the new movement in contemporary art "towards a physical openness of design, or towards linear clarity, or towards both."

By the late fifties the alternatives to Action Painting were sharply visible and at hand. In the older generation there were the chromatic abstract artists Newman, Rothko, Gottlieb, Still, and, just emerging in his geometric, monochrome style, Ad Reinhardt. An entirely new line of development, stained-color painting, had also crystallized in deliberate opposition to de Kooning's brushstroke technique and opulent painterliness. It seemed to have evolved first as a form of unpremeditated lyricism from Helen Frankenthaler to Morris Louis, and then to have assumed a more structured and geometric form in the work of Kenneth Noland. Another large group of artists showed an increasing interest in sharp formal

704. ELLSWORTH KELLY. *Red, Blue, Green, Yellow.* 1965. Oil on canvas, $86 \times 53\frac{1}{2} \times 86''$. Collection Mr. and Mrs. Robert B. Mayer, Winnetka, Ill.

definition, immaculate surface, and clarity of design. The freewheeling invention, painterly spontaneity and general messiness of the Action painters clearly constituted a new "Academy" against which the emerging anti-Expressionist generation vigorously reacted. The phrase "hard-edge" became popular, and was used to describe such artists as Ellsworth Kelly, whose decisive development had taken place, interestingly enough, in Paris rather than in New York, entirely removed from the American orbit of Action Painting.

The anti-Expressionist reaction was based on a new regard for formal ordering, and a classical sense of restraint. That classical disposition, however, did not identify itself with traditions of geometric abstraction or Constructivism deriving from Mondrian and Malevich. Although the Expressionist means and personal commitment of Action Painting were repudiated, the new, more controlled and objective modes did incorporate the large-scale canvas and something of the heroic spirit of the New York School. In place of the drama of personal creativity, or the almost physical involvement with expressive medium, young-

703. FRANK STELLA. *Les Indes Galantes.* 1962. Alkyd on canvas, $71\frac{1}{2} \times 71\frac{1}{2}''$. Collection Mr. and Mrs. Robert B. Mayer, Winnetka, Ill.

er artists made conceptualism and objectivity their controlling ideas. In the context of this reaction against a discredited spontaneity and romantic pictorial rhetoric, the quietist branch of Action Painting gained new prestige and influence among the young. And today, despite the increasingly sophisticated taste for anonymous fabrication and experiment in new mediums derived from modern technology, Newman and Reinhardt especially continue to exert a significant influence on the new generation. Newman has provided a point of departure for a color-saturated art of romantic expressiveness, and Reinhardt has done the same for a more self-contained, conventionalized, and repetitive or serial art, in which sensuous color plays only a marginal role.

Since the sixties, anti-Expressionist abstraction can be classified in terms of the following useful but by no means exhaustive categories.

706. BRICE MARDEN. *For Pearl.* 1970.
Oil and wax on canvas, 3 panels, entire work 96 × 98¼".
Collection J. Patrick Lannan, Palm Beach, Fla.

707. DAVID NOVROS. *Untitled.* 1967–68.
Acrylic lacquer on Fiberglas, 7'7" × 16'9".
The Lannan Foundation, Palm Beach, Fla.

1) *Color-field painting* describes the lyrical "soak-and-stain" abstractions of Helen Frankenthaler and Morris Louis, the more rigorous geometric forms of Kenneth Noland, and the tangible atmospheric color haze of Jules Olitski.

2) *Hard-edge painting* is the epithet taken from a late fifties' exhibition title, and can be applied broadly to the clearly contoured forms of the painters Ellsworth Kelly, Leon Polk Smith, Al Held, and Frank Stella, among many others. The term is descriptive and only partially illuminating, but it must stand for the moment to describe a more precisely engineered and calculated painting of immaculate surfaces emerging just before 1960.

3) *The shaped canvas* category includes artists like Charles Hinman, Paul Feeley, and also Stella who extended their painting surfaces into three-dimensional space. All these classifications— color-field, hard-edge, shaped canvas—are set

705. HELEN FRANKENTHALER.
Orange Proscenium. 1968.
Acrylic on canvas, 8'9½" × 5'8".
Kasmin Gallery, London

708. JACK YOUNGERMAN.
Black Yellow Red. 1964.
Oil on canvas, 54 × 42″.
Betty Parsons Gallery,
New York City

709. ELLSWORTH KELLY.
Rubber Tree. 1958.
Pencil, 23 × 29″.
Collection Mr. and Mrs. Pierre de Croisset,
New York City

710. LEON POLK SMITH.
Constellation. 1968–69.
Acrylic on canvas, 86½ × 54½″.
The Solomon R. Guggenheim Museum, New York City

711. MYRON STOUT. *No. 3. 1957*. 1957.
Oil on canvas, 26 × 18″.
Museum of Art, Carnegie Institute, Pittsburgh

712. SVEN LUKIN. *Gypsy Cross*. 1968.
Enamel and synthetic polymer on wood,
73¾ × 88½ × 4″.
Whitney Museum of American Art,
New York City.
Gift of Philip Morris, Inc.

down in the chronological order in which they were brought before the public through exhibitions or critical texts.

4) *Monochromatic painting* acknowledges the influence of Ad Reinhardt; the mode was decisive in the development of such younger artists as Robert Ryman and Robert Mangold. It also anticipated the polychrome structures of John Mc-Cracken.

5) *Optical painting* is, of course, the type of art based on perceptual dynamics and retinal scintillation explored by William Seitz's Museum of Modern Art exhibition of 1965, "The Responsive Eye," which included European pioneers such as Victor Vasarely and the American Josef Albers, along with such younger American artists as Richard Anuszkiewicz. The visual dynamics in the work of many color-field and hard-edge painters like Gene Davis and Ellsworth Kelly, and even Rothko, Newman, and Reinhardt before 1954, can be considered optical too. These artists depend on close-valued color contrasts, afterimages, and subliminal color effects, all of which are designed to stress the importance of the act of perception itself.

6) *Systemic painting* refers to an art of repetitive and standardized imagery, or nonrepresentational forms, lacking in variation; its stereotyped configurations adhere to some clearly visible organizing principle. Modular forms, uniform or unaccented grids, and similar devices have also been used in recent sculpture by the Minimalists and Primary Structurists. Lawrence Alloway was responsible for originating the term "systemic painting," when he presented and elucidated the new tendency in an influential exhibition bearing that name at the Guggenheim Museum in 1966.

The young artists who embrace this direction manifest widely varying intellectual interests and habits of mind ranging from ironic, Duchampian commentaries on the problematic nature of art to a strong technological bias. Some have been attracted to modern logic, mathematics, and information theory, in an effort to reestablish a simple factual or ideational basis for painting; others have used their art to subvert logic, and still others have made a new alliance with the techniques of manufacture available in an advanced technological society. In many instances, their experimentation has blurred the boundaries between painting and sculpture. All of these radically objectivist painting ventures share common

713. RICHARD ANUSZKIEWICZ. *Coruscate.* 1965. Liquitex, 24 × 24″. Collection Harold and Alice Ladas, New York City

714. MON LEVINSON. *The Source III.* 1970. Cast acrylic and light, 5′ × 10′ × 5¼″. Collection the artist

stylistic traits both with the more literal sculpture object and with the repetitious, mechanically reproduced imagery of Pop artists like Andy Warhol.

While Rothko, Newman, and Still were painting large color fields of saturated hue as early as the late forties, chromatic abstraction only gathered decisive force as a general trend at the close of the fifties. Beginning with her abstract landscape *Mountains and Sea* of 1952, which was probably influenced both by Rothko's dye technique of color application and Pollock's "black" paintings on unsized canvas, Helen Frankenthaler's improvisatory, lyrical abstractions pointed toward a new direction in American art. Her first paintings in the new manner were tentative

and extremely personal, but they clearly rejected the lush painterliness and directed manual energies of the de Kooning-style Action Painting. By pouring or trickling paint on canvas, and thus enlarging the accidentalism of the Abstract Expressionists while at the same time shrinking their repertory of gestural marks, Frankenthaler opened up a new set of formal alternatives. Her thinned washes and stains, with their vibrant luminosity, led to Morris Louis's overlapped veils of translucent color and to the more cleanly structural emblem forms of Kenneth Noland. In the process of depersonalizing and codifying the Action painters' autographic and Expressionist brushstroke, this significant trio of artists managed to create a new kind of color painting divorced from drawing, and injected new intellectual meanings into the art of their time.

By age and origin Morris Louis should be associated with the great innovating generation of Pollock and Rothko, with whom he shares many formal characteristics. But his main impact has been felt in the past decade, for his patent anonymity of style and optical dynamics helped to release new energies among a younger group of artists. In his first mature work of 1954, Louis flowed thin films of plastic pigment on unsized

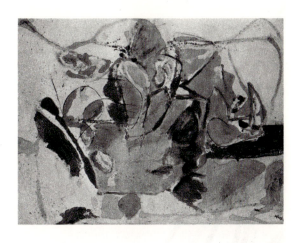

715. HELEN FRANKENTHALER. *Mountains and Sea*. 1952. Oil on canvas, 7′2⅞″ × 9′9¼″. Collection the artist

canvas to form faint, muted color shapes reminiscent of Action Painting in appearance, but far less active or aggressive. The even consistencies and the transparency of his diaphanous color shapes, their slowed velocities and relatively indeterminate flow—defining edges were formed cunningly by the natural process of drying rather than by any expressive inflection of the hand—paralyzed the urgent expressiveness of Action Painting. Individual color notes seemed to detach

716. MORRIS LOUIS. *Tet*. 1958. Acrylic resin on canvas, 7′9½″ × 12′7½″. Whitney Museum of American Art, New York City. Gift of the Friends of the Whitney Museum

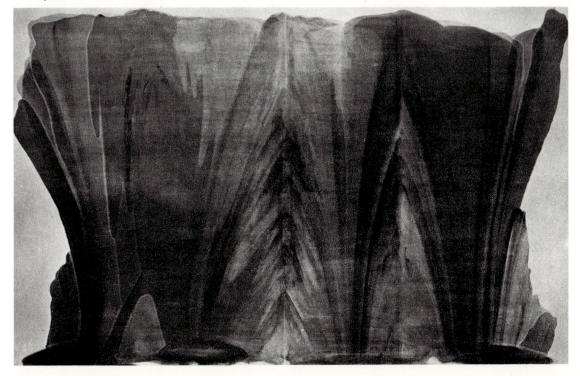

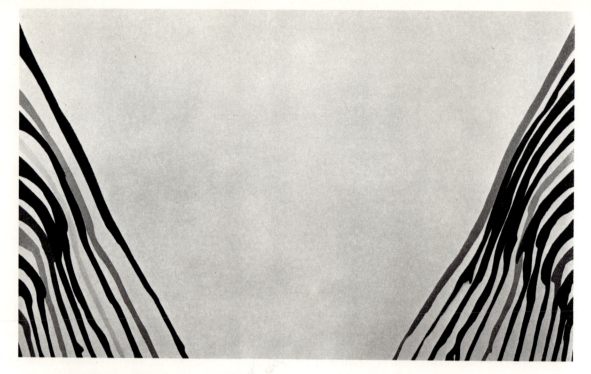

717. MORRIS LOUIS. *Sigma*. 1961. Acrylic resin on canvas, 8'7" × 14'.
Collection Mr. and Mrs. Eugene M. Schwartz, New York City

themselves with an extraordinary limpidity and distinctness from a swarming melee of color forms, despite their chaotic intermingling. Pollock's spatter-and-splash technique was magnified and played back in slow and disembodied motion, with an extraordinary new emotional reserve.

In *While*, transparent overlays of color give way to open and clearly differentiated ribbons of distinct hue and shape. These elegant, fragile tendrils of brilliance no longer serve internal psychological pressures but set off instead a chain reaction of objective phenomena in which the artist's traditional dominance is minimized. Paradoxically, however, color gains a richer role as its energies are liberated from "handwriting," palpable material texture, and emotional accent.

Louis's new manner, in effect, shifted the narrative focus from the first to the third person; color was given a more autonomous function and treated as an externalized phenomenon rather than an emotional vehicle. The mistrust of a personal "handwriting" in painting corresponded to the suspicion voiced by the French novelist and essayist Nathalie Sarraute of object-symbols steeped in personality. These, she held, could no longer be considered reliable facts. Like the New Wave French novels and films, American art in the 1960s turned away from human psychology to

a radically dehumanized view of reality. In the process of releasing new color energies, Louis isolated and standardized the gestural liberties of Action Painting, transforming their characteristic function and content into a new iconic form. Impulse and anxiety yielded to a mood of objectivity, renewed respect for ordering intelligence, and personal disengagement. In their simplicity, sensuous fullness, and boldness of scale his paintings belong to Abstract Expressionism; but their optical rather than material emphasis, and factual rather than psychological view of the artistic process identify them with an emerging younger generation of objective tendency.

Kenneth Noland was associated with Louis in the group of Washington color painters, but his targets, repeating diagonal swathes of color, chevrons, and, most recently, horizontal stripes of vast expanse, all contributed to the formation of a more strict, formal art, despite the qualities of chromatic brilliance which he shared with Louis. As Alan Solomon noted, "By contrast, Noland's paintings, although they are just as deeply committed to pure color sensation, confront us with a certain toughness, a certain psychological complexity, which makes them much more than an untrammeled delight for the eye." In Louis's floral paintings and color columns, some evidence

719. GENE DAVIS. *Raspberry Icicle*. 1967.
Acrylic on canvas, 10′ × 20′.
National Collection of Fine Arts,
Smithsonian Institution, Washington, D.C.

718. MORRIS LOUIS. *Pillar of Fire*. 1961.
Plastic and paint on canvas, 92 × 47⅝″.
The Harry N. Abrams Family Collection, New York City

of accident as a natural occurrence beyond the individual's control remained residual; the artist let paint have its way with him up to a point, in the interest of pursuing complex and proliferating sensations, whose individual notes and interminglings were relished with an almost extravagant symbolist delight. Noland's art is intellectually more demanding; his sensuous attenuations of color forms occur in a situation of ambivalence, and answer to internal pressures for order. His emblematic forms create a remorselessly circumscribed yet fluid order, keeping our attention intensely occupied in a problematic dualism of structure and chromatic elaboration. He insists that we stay hypnotically within the repeating

circles, angles, or parallel color stripes, and excludes associational subtleties. His insistent formalism is relieved, however, by the soft luminosities of thinned plastic pigments, so that an alternating current is established between focus and dispersion, between concentration within his structural framework and the resonating expansion of color forms to the limits of their fields. The use of thinned pigment is another variation on modes of dealing with the problem of movement on the flat modern painting surface. As paint sinks into the canvas weave more readily, its color brilliance must be pitched higher to draw it forward and restore the necessary oscillation in depth.

An important feature of the new color-field painting has been the progressive dematerialization of the art object. Jules Olitski's influential large spray paintings have made their particular impact by diffusing the luminous effect of color so that both the rectangular boundaries of the frame and the material substance of the paint seem almost incidental to the perceived intensities of continuous color sensation. In his earlier paintings, Larry Poons's vibrating, elliptical dots on saturated color fields, with their resonating light halations, also created a new mode of communicating almost disembodied optical energies. The shift in emphasis from the visible, material data of creative action to the perceptual experience itself also legitimized new media explorations. Robert Irwin's subtly modulated and curved color disks, which extend out from the wall forming a background of overlapping shadows, divorce color illusion from techniques of paint application. The augmented presence of his shimmering color apparitions exists in some not readily located psycho-physical region, suspended between the

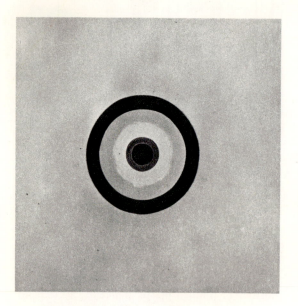

720. KENNETH NOLAND. *Cycle*. 1960.
Oil on canvas, 69½ × 69½".
Collection Everett Ellin, New York City

721. KENNETH NOLAND. *Golden Day*. 1964.
Acrylic on canvas, 72 × 72".
Collection Ed Cauduro, Portland, Ore.

contoured disk, the observer's retina, and the form-giving intelligence of the artist. Irwin has been one of the influential figures in Los Angeles painting since the mid-sixties.

As painting showed itself capable of dispensing with traditional mediums, paint and canvas themselves became increasingly superfluous. Other West Coast artists like Larry Bell, Ron Davis, Craig Kaufmann, and Douglas Wheeler have created subtly inflected color continuums from sheets of faintly colored optical glass, vacuum plastic molds, and light projections respectively, often discovering new expressive potential in the materials and processes of contemporary industrial technology. It seems that the more emphatically contemporary abstract painting reminds us

of its simple object status, the more it is impelled to identify itself as pure visual illusion, whose protean sources impartially include both modern industrial technology and recent "art history."

Among the artists identified with hard-edge painting, Ellsworth Kelly was perhaps the first in point of time to discover both the power of pure undetailed color surface and the shaped canvas. As early as 1952, he painted a series of joined vertical canvas panels in separate flat hues as prosaic and familiar as a horizontal commercial color chart. The next year, fascinated by the arch of a Paris bridge and its reflection in the water, Kelly made the first shaped canvas, fusing an empirical observation of nature with the Constructivist tradition. In later years, his flat,

722. KENNETH NOLAND. *Via Blues*. 1967. Acrylic on canvas, 7'6⅛" × 22'.
Collection Mr. and Mrs. Robert A. Rowan, Pasadena, Calif.

723. HELEN FRANKENTHALER. *Flood.* 1967. Synthetic polymer on canvas, 10'4" × 11'8".
Whitney Museum of American Art, New York City. Gift of the Friends of the Whitney Museum

724. MORRIS LOUIS. *Green by Gold.* 1958. Acrylic on canvas, 8' × 12'.
Collection Mr. and Mrs. Eugene M. Schwartz, New York City

725. Jules Olitski. *High A Yellow.* 1967. Acrylic on canvas, 7'8½" × 12'6".
Whitney Museum of American Art, New York City

726. KENNETH NOLAND.
April's Equal. 1971.
Acrylic on canvas, $89 \times 46\frac{1}{2}''$.
Collection S. Sidney Kahn,
New York City

727. FRANK STELLA.
Lanckorona III. 1971.
Relief, mixed media, $9' \times 7'6''$.
Lawrence Rubin Gallery, New York City

728. ELLSWORTH KELLY.
Two Panels: Black with Red Bar. 1971.
Oil on canvas, 5'8" × 10'.
Sidney Janis Gallery, New York City

729. LEON POLK SMITH.
Correspondence Blue-Scarlet.
1964. Oil on canvas, $68 \times 53''$.
Collection Dr. and Mrs.
Arthur Lejwa,
New York City

730. RAYMOND PARKER.
Untitled. 1969.
Oil and acrylic on canvas, $7'10'' \times 9'$.
The Fischbach Gallery, New York City

731. SAM GILLIAM. *Carousel Form II*. 1969. Acrylic on canvas, dimensions of canvas 10' × 75'. Jefferson Place Gallery, Washington, D.C.

732. FRANK STELLA.
Sinjerli Variation I. 1968.
Fluorescent acrylic on canvas, diameter 10′.
The Harry N. Abrams Family Collection,
New York City

733. JACK YOUNGERMAN.
Roundabout. 1970.
Acrylic on canvas, diameter 96″.
Albright-Knox Art Gallery, Buffalo, N.Y.
Gift of Seymour H. Knox

734. GENE DAVIS. *Moon Dog*. 1966. Oil on canvas, 10′ × 16′. Brandeis University Art Collection, Waltham, Mass.

735. JOSEF ALBERS. *Homage to the Square: Apparition.* 1959. Oil on board, $47\frac{1}{2} \times 47\frac{1}{2}''$.
The Solomon R. Guggenheim Museum, New York City

736. RICHARD ANUSZKIEWICZ.
Entrance to Green. 1970.
Acrylic on canvas, 9′ × 6′.
Sidney Janis Gallery, New York City

737. ELLEN CIBULA.
Wave Series No. 8. 1969.
Liquitex on canvas, 9′3″ × 9′3″
O. K. Harris Works of Art,
New York City

738. CHARLES HINMAN. *Kookaburra*. 1969. Acrylic on canvas, 6′11″×17′×6″. Richard Feigen Gallery, New York City

739. LUDWIG SANDER. *Cherokee III*. 1968.
Oil on canvas, 60 × 66″.
Collection Mr. and Mrs. Eugene M. Schwartz, New York City

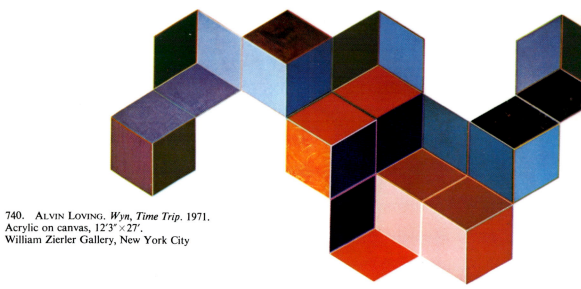

740. ALVIN LOVING. *Wyn, Time Trip*. 1971.
Acrylic on canvas, 12′3″ × 27′.
William Zierler Gallery, New York City

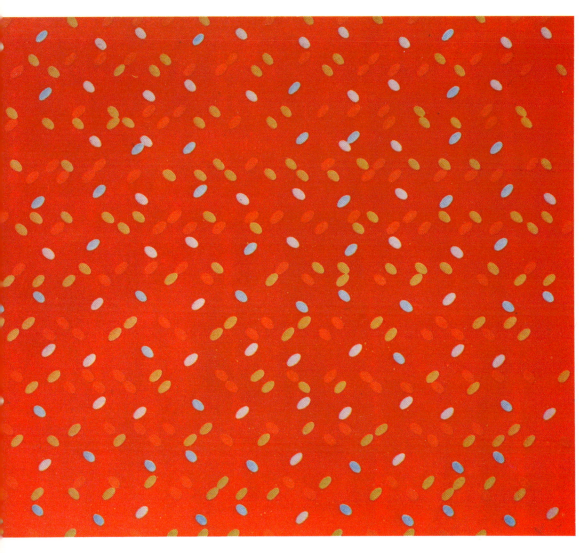

741. LARRY POONS. *Nixe's Mate.* 1964.
Acrylic on canvas, 5′10″ × 9′4″.
Collection Mr. and Mrs. Robert C. Scull, New York City

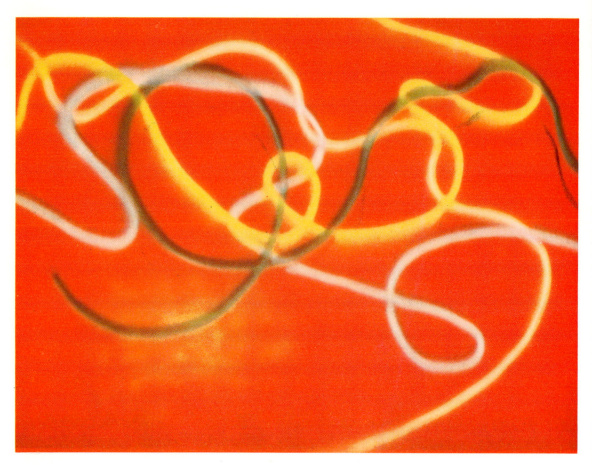

742. DANIEL CHRISTENSEN. *Red-Red*. 1968. Acrylic on canvas, 7′ × 10′. Collection Mr. and Mrs. Robert A. Rowan, Pasadena, Calif.

743. RON DAVIS. *Vector*. 1968. Fiberglas, 5′ × 12′. The Tate Gallery, London

744. WALTER DARBY BANNARD. *Driving Through No. 5*. 1968. Oil on canvas, 66 × 99″. Private collection, Boston

745. CRAIG KAUFFMAN. *Untitled* (*Magenta*). 1968.
Vacuum-formed Plexiglas and sprayed acrylic lacquer, 43 × 89¼″. The Pace Gallery, New York City

746. ROBERT IRWIN. *Wall Disc*. 1969. Acrylic on cast acrylic, diameter 54″.
Rhode Island School of Design, Providence, R.I. On long-term loan from George H. Waterman, III

swelling color shapes set within the rectangular format were scrupulously clean of detail and surface irregularities that would betray any manual gesture. As in his horizontal sequence of color panels, the effect, far from being mechanical, was to introduce a new kind of sensuousness into contemporary art.

Even Rothko's and Newman's faintly modulated color fields seem atmospheric and illusionistic in their ambiguous spatial depth by comparison with Kelly's matter-of-fact and unaccented monotonal areas. His recent interacting and abutting color rectangles present themselves as cleanly demarcated, tangible facts, owing to their simple juxtaposition and contrast. Yet the bilateral divisions of his canvases create a complex tension. The vast expanse of intense hue builds pressures which contravene the obvious formal logic. At their common boundaries, the color rectangles exert an extraordinary force, both repelling each other and merging in a unified effect as a totality. With their fine edges and subtle color oppositions, his paintings maintain a precarious equilibrium between parts and whole, between an uncontained optical scintillation and

747. Jules Olitski. *Beyond Bounds*. 1966. Acrylic on canvas, 92¼ × 62″. Kasmin Gallery, London

748. Larry Poons. *Untitled*. 1967. Acrylic on canvas, 8′6″ × 12′9″. Van Abbemuseum, Eindhoven, Holland

749. RON DAVIS. *Paolo*. 1968.
Fiberglas, 5′ × 12′.
Collection Mr. and Mrs. Joseph A. Helman,
St. Louis, Mo.

750. CRAIG KAUFFMAN. *Untitled*. 1969.
Sprayed acrylic lacquer
on heat-rolled Plexiglas, 73 × 50″.
The Pace Gallery, New York City

751. LARRY BELL. *Untitled*. 1968.
Vacuum-plated glass and metal, 20 × 20 × 20″.
The Pace Gallery, New York City

a kind of flat-footed, redundant statement of the
simple rectangle. The interplay of clear legibility
and those features which contradict it, especially
the subtle voluptuousness of color surface and the
imposing scale of the work, suggests a haunting
connection still with the Abstract Expressionist
color-field painters, even though machined edges,
flatly applied color, and uninflected surface are

so at variance with that mode. But such evident links as heroic scale and continuous dynamic action and self-renewal persist in Kelly's simple imagery, despite the geometric stability of his forms.

In their shaped canvases, Stella, Kelly, Feeley, Lukin, Hinman, Williams, and others have created a new hybridization of illusionistic pictorial space and the three-dimensional object. The contoured or notched stretcher provides a literal emphasis on the physical properties of the canvas, while color planes act to elaborate a more traditional kind of pictorial metaphor. Hinman's elegantly poised and tipped box-like volume of stretched and pinned canvas can be read both as suspended color plane and solid form, with cast shadows seen in perspective. The apparently uncomplex structure poses problems of identity, for we are compelled to understand it ambiguously as volume and flat plane. The reversal of conventional pictorial illusionism into a denotative object may be taken as a sign of the exhaustion of one kind of visual convention and its replacement by a more structural mode; neither sculpture nor painting, it subtly fuses the two different rationales of expression.

Perhaps the most decisive impulse in creating a new kind of literal painting-object has come from Frank Stella. Beginning with his black pinstripe paintings of 1960, and continuing through his latest protractor patterns of segmented arcs in vivid acrylic color, he has managed to reverse the role of geometry and of Bauhaus design principles in contemporary art. Ideas of structural development and hierarchical ordering were neutralized by his symmetrical, repeating grids, and uniform or coded color stripes; in their place emerged a more unified impression of the entire canvas shape as a single image, which supplanted the outworn compositional devices of conventional geometric abstraction. By extinguishing pictorial variety, development, and climax, his early work opened up new expressive possibilities, which have helped force a fundamental change in artistic outlook. Stella's series paintings and permutations of V's, parallelograms, rhomboids, hexagons, and circle fragments have constantly deemphasized traditional composition by repetition and standardization of shape, thus transferring emphasis to the holistic experience of the painting as a single object. The particular kinds of opacities and redundancies which make his sur-

752. ELLSWORTH KELLY. *White on White*. 1950. Oil on wood, 39¼ × 27½".
Collection the artist

faces and patterns look so predictable, impassive, and sterile have actually generated an original and influential contemporary art.

Stella himself has emphasized the simple factuality of his paintings: "My painting is based on the fact that only what can be seen there *is* there. It really is an object." Yet the object qualities of his shaped canvases, with their deep, contoured stretchers, paradoxically seem to give pure color sensation enhanced prerogatives. Despite the elementary, academic artifice of overlapped curves, his recent protractor paintings provide a complex and powerful visual experience; the throbbing acid-bright colors of these intricate chromatic structures never seem to exhaust their visual interest or metamorphic potential.

Beginning with Yves Klein in Europe, and Ad Reinhardt in America in the middle fifties, color itself was treated as a problematic element in painting. The art audience's seriousness was severely put to the test by bringing the spectator as close to the contemplation of nothing, of an un-

753. ELLSWORTH KELLY. *Red, Yellow.* 1968.
Oil on canvas, 95 × 68″.
Collection Mr. and Mrs. Henry Feiwell,
Larchmont, N. Y.

754. ELLSWORTH KELLY. *Untitled.* 1960.
Oil on canvas, 86 × 48″.
Collection Mr. and Mrs. Melvin Kolbert,
Huntington Woods, Mich.

755. RONALD BLADEN. *Black Triangle.* 1966.
Painted wood (to be made in metal),
9′4″ × 13′ (across top) × 10′.
Collection Mr. and Mrs. Morton Hornick,
New York City

756. NEIL WILLIAMS. *Rollin Stoned*. 1966.
Mixed media on cotton duck, 8′ × 9′.
Collection the artist

757. CHARLES HINMAN. *Poltergeist*. 1964.
Synthetic polymer paint on canvas, mounted on
wood armature, 98¾ × 61⅞ × 16⅜″.
The Museum of Modern Art, New York City.
Larry Aldrich Foundation Fund

758. PAUL FEELEY. *Sculpture Court*. 1966. Painted wood, 9 pieces, each 21′ × 5′ × 5′. Estate of the artist

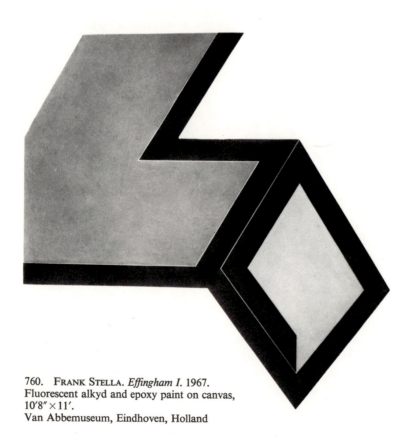

759. FRANK STELLA. *Ileana Sonnabend*. 1963. Oil on canvas, 7′5″ × 10′7″. Collection the artist

760. FRANK STELLA. *Effingham I*. 1967.
Fluorescent alkyd and epoxy paint on canvas,
10′8″ × 11′.
Van Abbemuseum, Eindhoven, Holland

761. LARRY ZOX.
Diamond Drill Series, Putt. Putt Maru. 1967.
Acrylic and epoxy, 80 × 64".
Greenville County Museum of Art, Greenville, S.C.

762. NICHOLAS KRUSHENICK. *Godzilla.* 1970.
Acrylic on canvas, 40 × 50".
The Pace Gallery, New York City

differentiated color rectangle, as possible. By insisting on a single-color image with a minimal articulated content, these artists and others who followed their example aggressively challenged current perceptual levels in art. As so often has happened in modern art, one impulse invited its own contradiction, thus negatively defining itself.

The emphasis at first on vivid, brilliant color saturation was reversed into the cancellation of chromatic sensation altogether. Klein's effulgent blue monochromes and Reinhardt's blue and red single-color paintings led remorselessly to the latter's "black painting," and seemingly to a form of anti-painting. The uniform, uninflected, and homogeneous qualities of Reinhardt's monotonal dark paintings, beginning in 1954, were related both to an emerging "single image" style of painting, and to the centered, symmetrical forms of the structurist sculptures which followed. The aspiration toward a more total vision, discarding the detailed definition of fragmentary parts of de Kooning, Pollock, and Kline, made itself felt almost at the same moment that a more objective view of the artistic process was proposed first in the work of Johns, then of Stella, and then of Don Judd in sculpture.

Another kind of monochrome painting and polychrome sculpture in one intense hue were introduced at a much later date, towards the end of the sixties, by Robert Mangold, John McCracken, and Robert Ryman, who pushed on beyond even the marginal illusionism of Klein and Reinhardt. Mangold's tinted, sprayed, shiny Masonite boards in eccentric shapes with ruled, subdivided interior circle segments gave the painting surface the mirror-like opaqueness and finish of commercial products. John McCracken's gleaming lacquered slabs of vivid color hovered ambiguously between pictorialism and object status. Ryman's dryly brushed, whitened surfaces permitted the rough texture of the linen canvas to assert itself physically at its unpainted, irregular edges, thus also calling attention to its object character. However, the derelict softness of his form, its tendency to lose shape and stiffness, suggested another kind of metamorphic potential, associated with the current of anti-formal, "process" art. Process art, with its more casual attitudes towards formal statement, emerged in reaction to a preceding dominant structural bias in painting and sculpture. Thus monochromism was utilized in these three instances to achieve quite unrelated aesthetic aims: to suppress the connotative, expressive meanings of surface, to underline the object status of a highly finished artifact, and to allude to the rudimentary art process.

In the creation of an illusionist art from schematic geometricized forms, Al Held occupies a unique and independent position. His art of the

763. ROBERT MANGOLD.
1/6 Grey-Green Curved Area. 1966.
Oil on Masonite, 48 × 48″.
Private collection

764. RICHARD TUTTLE. *Drift 3*. 1965.
Painted wood, 27 × 52 × 1½″.
Collection the artist

765. RONALD BLADEN. Installation view of a one-man
show at the Green Gallery, New York City, 1962

766. AL HELD. *Ivan the Terrible*. 1961.
Acrylic on canvas, 12′ × 9′6″.
André Emmerich Gallery, New York City

mid-sixties invested a few bare Euclidian figures
with a blunt tremendousness that was a matter of
large scale, massive shape, and an insistent mate-
rial sensibility. Until two years ago, he built up
his surfaces with an almost obsessional deliber-
ateness, layer by layer, scraping, sanding, and
then re-covering them with paint in assertive
texture and relief, until the painting attained an
almost sculptural presence. It was work of this
kind, along with the clumsy hand-made color
forms in painted wood of Ronald Bladen, which
the critic Irving Sandler described in an exhibi-
tion catalogue as "Concrete Expressionism." He
proposed the exhibition and the artists it de-
scribed as a visibly more emotional alternative in
form-making to the bland, impassive structures of
Stella and others associated with him, whose art
was derogated in terms of its "utter futility and
boredom." The untrustworthy character of such
moralistic readings of new art became clear when
Held later moved towards a reduced and deper-
sonalized type of composition, laying down uni-
form black lines to form a monkey puzzle of
overlapped, transparent grids in three-dimension-
al perspective, and when Bladen began to build
monolithic cubic structures with machine-fin-
ished or industrially uniform surfaces.

The optical art of Vasarely, Albers, and others

767. AL HELD. *B/W XVI*. 1968.
Acrylic on canvas, 12′ × 14′.
Everson Museum of Art, Syracuse, N. Y.

working in their direction investigated perceptual dynamics and the potential of both color images and black-and-white linear elaborations to activate vision. The aggressive confrontation of color forms more often created complex pulsations of light and movement, with intensified side effects of fusion or dispersion, which turned the canvas surface into an extremely lively and responsive vehicle. "Op Art" of this type also has a problem-solving character which involves the audience in new modes of interaction with the work of art, as they are in effect invited to understand its governing system. There has also been a calculated scientism in the rationale of optical art. Emphasizing retinal impressions and a kind of simplistic visual psychology, it tends to disguise an increasingly formal stereotyping in a mystique of phenomenalism. As an influential movement, Op Art has aroused far more sympathy in Europe than in America both because of its scientific leanings, and the fact that its precedents in Constructivist and kinetic art were somewhat more alien to postwar American traditions.

Albers, however, represents a special case in American abstract painting. When Hitler closed the Bauhaus where Albers was the youngest master-teacher, he moved on to Black Mountain College. There, in an American ambience, he began his patient color researches and exploration of visual illusionism, which were to culminate in a new kind of abstract art during the decade when he directed the Yale Art School, between 1950

768. GEORGE ORTMAN. *Peace I*. 1959.
Painted canvas on wood, collage construction, 54 × 54″.
Collection Carl Van der Voort, Ibiza, Spain

and 1960. In advance of Vasarely and the Parisian-based visual research group, he created a dynamic perceptual type of painting, redirecting Bauhaus Constructivism into a more ambiguous kind of abstract art which took unprecedented account of individual psychology and the wealth of emotive content buried in the complexities of visual experience. Since 1949 he has repetitively, almost compulsively been doing the same thing superlatively well, and that is painting nests of

769. JOSEF ALBERS. *Single Answer*. 1960.
Oil on board, 24 × 24″.
Collection Dr. and Mrs. N. B. Epstein,
Hamilton, Ontario

770. JOSEF ALBERS.
Structural Constellation NHD. 1957.
Incised vinyl, 19¼ × 25¾″.
Collection Mira Godard, Montreal

color squares in different dominant hues and
sizes, and identical modular formats. His cele-
brated *Homage to the Square* theme is perhaps the
first unequivocal example of "serial" composition
in American art. It has occupied him exclusively
as a compositional structure for over two decades,
and has no match for constancy of purpose, incor-
ruptibility, and sheer obsessiveness except per-
haps the example of Mondrian's famous grid.
Albers's squares of infinitely varied and nuanced
color are, in effect, his *The Art of Fugue*. Like

Bach, he has a genius for stating and restating the
same themes and variations, without exhausting
their vitality or mercurial unpredictability. Each
time his color square is reborn in a new guise so
inevitable and right that it seems the ultimate and
perfect one, until yet another comes along.

Systemic painting, along with the new Mini-
malist and structurist sculpture, combines the
illusionism which optical art made into a para-
doxical game with severely reductive structural
elements. Stella and Don Judd first described
their work as objects, and refused to submit it to
interpretation, insisting on its lack of association-
al or traditional expressive content. Many of the
artists who have been described as Minimalist
or Systemic, both painters and sculptors—Agnes
Martin, Jo Baer, Will Insley, Darby Bannard,
Larry Zox, Ronald Bladen, Robert Morris, Carl
Andre, Sol Lewitt, Dan Flavin, Robert Smithson,
and others—share the common characteristic of
using extremely simplified forms, usually of a
geometric character, either in a single concen-
trated image configuration or in serial runs or
sets. Often one's sense of the form and its contents
do not coincide. In fact, a bland and neutral-
looking, geometricized object may be the vehicle
for an aggressive assault on the spectator's sense
impressions, through color saturation, rhythmi-

771. (*left*) ALFRED JENSEN.
The Acroatic Rectangle, Per 12. 1967.
Oil on canvas, 71½ × 50¾″. Collection the artist

772. (*middle left*) JO BAER.
Tiered Horizontals, Aluminum (Diptych). 1968–69.
Oil with Lucite and aluminum on canvas,
2 panels, each 11′ × 7′. Collection the artist

773. (*bottom left*) WILL INSLEY. *Wall Fragment.* 1966.
Acrylic on Masonite, 8′ × 8′.
Collection the artist

774. AGNES MARTIN. *Bones Number II.* 1961.
Oil on canvas, 72 × 48″.
Collection Betty Parsons, New York City

cally repeating imagery, or immense scale. The
repetition of imagery, and the element of deliber-
ate vacancy or inertial stasis also characterize
contemporary film, dance, and music, as previ-
ously noted. These devices are both cathartic,
designed to purge the old sentimental content
from art, and formally innovative in the new focus
of vision they propose.

Minimalism presents us with the curious para-
dox of young artists who are making deliberately
inexpressive art, and radically dispensing with
nonessentials, in order to achieve a new kind of
freedom of gesture and conceptual confrontation

775. PHILIP WOFFORD. *Accoma Return*. 1969.
Synthetic polymer, ashes, and dirt on canvas,
6'11½" × 8'6¼". Whitney Museum of American Art,
New York City

776. LARRY POONS. *Cutting Water*. 1970.
Acrylic on canvas, 7' × 5'4".
Collection Jack Silverman, Chicago

777. CY TWOMBLY. *Untitled*. 1969.
Oil and crayon on paper, 30 × 40".
Collection Mr. and Mrs. Leo Castelli,
New York City

with the art experience. The rejecting, negating
character of serial repetitions, and the rigorous
conceptualism of the new art establish affinities
with a difficult artist of the older generation, Ad
Reinhardt. As happens so often in art, new aes-
thetic aims came into being in apparent reaction
to past excesses, in this case to the increasingly
mannered forms of Abstract Expressionism. The
positive affirmations of the new abstraction were
obscured in the beginning by its destructive im-
pulses and iconoclasm, elements which we have
often before encountered in innovative modern
art. With the Minimalists and some of the ab-
stract painters, one is at times so acutely aware of
the elements of irony, mockery, and inflation in
their forms that factors of finesse and bold
architectural scale are overlooked.

The swing to objectivism in abstraction, typi-
fied by the structures of Stella and the common-
place, emblematic forms of Noland, among
others, has its parallel in the decisive new spirit of
factualism in figurative art, first in the critical
work of Jasper Johns, and then in Pop Art. All of
these artists, both abstract and representational,
conceived of their art less as a mode of revelation
or self-discovery, as had the Action painters, than
as a set of specific facts, or a carefully controlled
and legible system to be patiently elaborated.

Despite the significant advances here described,
abstract American painting today seems to be
undergoing a more severe crisis than any since the
Second World War. The color-field painters,
shaped-canvas makers, and Minimalists are all
suffering from the same malady: the exhaustion

of those specialized conventions which define traditional modes of painting and pictorial illusionism. The radical distinctions of even the recent past between painting and sculpture no longer hold true; each mode is rapidly becoming a hybridized version of the other; and sculpture, especially in its more severe, geometric reductions, has shown itself to be a potent influence in establishing new formal conventions. As painting has drawn closer to sculpture, it has abandoned many of its old powers and prerogatives. It has given a more literal accounting of the painted surface as an object, without becoming an outright, freestanding, or necessarily sculptural form. On the other hand, artists who began as dedicated painters have now embarked on radical experiments in mediums ranging from plastics to light projections. It all seems to be part of a campaign to dematerialize and desanctify the painting-object. Between such radical and devastating wrenches in opposite directions, painting has understandably shown neither a strong persistence in a single mode, with the possible exception of a small cluster of color-field painters, nor any very great stability.

There are a few hopeful signs—such as the recent one-man show of Larry Poons, the continu-

779. Joseph Kosuth. *Art as Idea as Idea*. 1966. Mounted photostat, 48×48″. Collection Dorothy and Roy Lichtenstein, New York City

ing lyrical abstraction of Helen Frankenthaler, and the resurgence of romantic abstraction among some younger artists—that a slight but not decisive shift to a more "painterly" painting has taken place. However, the general tendency today is to seek radical redefinitions of different mediums, to test their content, values, and expressive means. In the face of these challenging confrontations, abstract painting has sought new accommodations with on the one hand, three-dimensional structures, and on the other, intermedia experiments and new materials—accommodations which effectively destroy its traditional character as pictorial illusionism. Despite the importance of such inventive personalities as Johns, Noland, and Stella, for the moment one is forced to conclude that the most vital new avant-garde expressions among the younger generation are in structurist sculpture and in Conceptual and process art. Judd, Morris, Carl André—and possibly Duchamp—have replaced Johns, Noland, and Stella as the source of new creative impulses and ideas. The most significant new art that flourishes in America today is three-dimensional in form, ideational or informational in content, and related directly to the physical environment or to industrial technology; traditional painting, for the moment, seems to be facing a mortal crisis, with no immediate relief in sight.

778. Arakawa.
Critical Mistake: Do You Like This Painting? 1969.
Oil on canvas, 42×30″.
Collection the artist

15 · Recent Sculpture: Assemblage, Minimalism, and Earthworks

A SERIES OF UNPRECEDENTED DEVELOPMENTS, defying established conventions in the three-dimensional medium, has enlarged the range of American sculptural expression since 1960 almost beyond recognition. As Abstract Expressionist influence in painting waned in the late fifties, the open-form, welded sculpture which it had helped make the prevailing trend also lost its momentum and the power to form younger artists. Most of the sculptural innovations of the sixties arose from the dilemmas of painting, that is, from essentially pictorial problems translated into physical and actual spatial form, rather than from the example of abstract sculpture. Despite the keen interest of the young in David Smith's last *Cubi* series, other welder-sculptors of the fifties had little impact on the new generation. Rather, the "field" painting of Rothko, Newman, and Still, the monochromes and "nonrelational" compositions of Ad Reinhardt, the junk assemblages or "combines" of Rauschenberg, and Jasper Johns's objectivism all began to assert their separate influences and to carry the weight of admired precedent. Frank Stella's redundant geometric patterns and projections of actual canvas shapes provided another influential point of departure for a number of young artists seeking fresh solutions within an anti-Expressionist style.

By the close of the sixties, however, the remarkable variety of sculpture challenged the dominance of painting and had so expanded traditional definitions of its medium that, in the words of the critic Lucy Lippard, it could as easily be discussed as "dust, literature, accident, nature, scientific illustration, theater, dance, or pedagogy" as sculpture. Increasingly, sculptors abandoned articulated volume or the physical presence traditionally associated with the sculpture object. Instead, it became customary to regard sculpture as a "non-object": a process in time, a performance, an idea, or an action rather than a tangible physical structure.

The artists responsible for this radical change can be divided into a number of different groupings, although sometimes the categories and their occupants may seem to contradict each other. Some influential individuals, of whom Robert Morris is perhaps the most dramatic case in point, traduced one type of innovative form with another, bolder one before the impact of their original impulse had time to establish itself. The rapidity and abruptness of artistic change in the sixties was unusual even in a period accustomed to the swift collapse of superseded styles into inglorious obsolescence. This may have reflected the extent of a pervading sense of social despair and impotence about solving critical human and environmental problems. The old optimistic, liberal ideologies and hopes that sustained artists for so long seemed irrelevant to the mounting crisis we faced. A widespread sense of unease about our capacity to survive has perhaps affected and accelerated the rate of artistic change, pushing artists into more extreme formal solutions. The wildly unprecedented character of American sculpture today, especially in its conceptual phases and in its grandly impractical outdoors and ecological manifestations, quite eclipses the radical destructuring of inherited forms and "anti-art" outrages perpetrated by the Dadaists. Some correlation is suggested, then, between art's current extremism and the social misgivings of the young, with their entirely justified, if apocalyptic, environmental fears.

First among the major sculpture groupings of the decade were Assemblage and environmental

780. LOUISE NEVELSON. *Sky Garden.* 1959–64.
Painted wood, 88 × 50″.
Private collection, Rome

sculpture, which were popularized in a 1961 Museum of Modern Art exhibition demonstrating the adulteration of invented forms with untransformed object fragments taken from the actual world (Nevelson, Stankiewicz, Kienholz, Conner, Di Suvero, Chamberlain, Bontecou). In reaction to the loose gestures and improvisational surfaces of welded sculpture, and the identification of autographic touch with values of personal authenticity, there arose Minimalism, or Primary Structures, a style whose simplistic geometry dominated the middle years of the decade (Tony Smith, Judd, Morris, Bladen, Lewitt, Andre, Flavin). Almost immediately a reaction against the rationalized order of Minimalist sculpture, with its industrial methods of fabrication, made itself known in the adoption of flexible materials and anti-formal methods on the part of a group of young artists and some versatile older sculptors who often straddled more than one tendency at a time (Oldenburg, Morris, Hesse, Serra, Saret, Sonnier). A different kind of repudiation of technology emerged in a new and grandiose naturalism, a veritable return to nature, in Land Art or Earthworks (Smithson, Heizer, De Maria, Oppenheim).

Other significant developments examined the relationship between art and idea in a conceptual framework that retained only residues of the object or dispensed with it altogether (Lewitt, Huebler, Kosuth, Weiner). Conceptual Art also managed to deal in a variety of surprising new ways with the critical subject of time in art, by introducing "process" and even performance activities into the experience of the work. The new performance art found a precedent in the early theater pieces and Happenings of the period around 1960 (Kaprow, Dine, and Oldenburg). Today, its emphasis and psychology of expression have shifted in a number of ways to include film and videotape (Sonnier, Serra, Nauman), and also a more self-serving kind of exertive pantomime of gesture and action, Bodyworks, which utilizes the artist's physical movements (Acconci, Nauman, and others). Finally, of course, there is the vast impact of electronic technology on many different kinds of artists. Among other things, advances in engineering and computer science have revolutionized existing conventions of light and motion sculpture (Rickey, Lye, Antonakos, Chryssa), and have opened up entirely new areas of programed art by placing information systems and the most sophisticated communications techniques in the hands of the contemporary artist. These loose groupings are scarcely exhaustive; they can only begin to suggest the range and types of activities which have gained critical attention and belong to the accepted repertory of sculptural form today.

Foremost among the environmental sculptors has been Louise Nevelson. Her work repre-

781. MARK DI SUVERO. *Hank Champion.* 1960.
Wood, height 10′.
Collection Mr. and Mrs. Robert C. Scull, New York City

782. RONALD BLADEN. *The X.* 1967.
Painted wood (to be made into metal),
height 22′ 8″. Corcoran Gallery of Art,
Washington, D.C., on loan from
The Lannan Foundation, Palm Beach, Fla.

785. ALAN SARET. *Untitled.* 1971.
Wire, straw, rubber, cloth, height c. 4′6″.
Collection the artist

786. ROBERT SMITHSON.
Asphalt Rundown, Rome. 1969

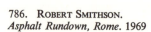

783. TONY SMITH. *Cigarette.* 1961–66.
Plywood (to be made into steel), height 15′.
M. Knoedler & Co., New York City

784. ROBERT MORRIS. *Untitled.* 1965.
Fiberglas, each section base 3′ × 3′, height 2′.
Collection Virginia Dwan, New York City

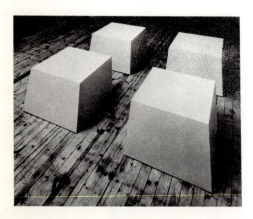

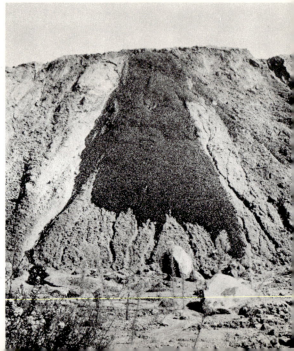

787. LOUISE NEVELSON. (*left*): *An American Tribute to the British People*. 1960–65. Painted wood, 10′2″ × 14′3″.
The Tate Gallery, London. (*right*): *Sungarden No. 1*. 1964. Painted wood, height 72″.
Collection Mr. and Mrs. Charles M. Diker, New York City

788. JAMES ROSATI. *Lippincott I.* 1965–67. Painted Cor-Ten steel, height 9′. Anonymous collection

789. GEORGE SUGARMAN. *The Venusgarden.* 1970. Polychromed aluminum, height 9′. Collection Max Palevsky, Los Angeles

790. Tony Smith. *Moses.* 1969. Painted steel, height 15′. Princeton University, Princeton, N. J.
John B. Putnam Memorial Sculpture Fund

791. LARRY BELL. *Memories of Mike*. 1967.
Vacuum-plated glass, 24¼″ cube.
Collection Mr. and Mrs. Arnold Glimcher,
New York City

792. JOHN McCRACKEN. *Untitled*. 1970.
Wood, Fiberglas, polyester resin, height 96″.
Sonnabend Gallery, New York City

sents a sharp departure from the methods of the welder-sculptors with whom she is otherwise identified by age and achievement. Nevelson's "walls" contain commonplace objects in stacked and interconnected boxes and crates. Newel posts, finials, parts of balustrades, chair slats and barrel staves, bowling pins and rough-cut wood blocks, sprayed in a uniform white, black, or gold, are some of the myriad components which she cunningly sets in the shallow recesses of her additive, cubistic constructions. For all their intricacy and ingenuity of formal relation and dazzling variation of shape, her walls achieve both a powerfully unified impact and liberating possibilities of expansion. They operate forcefully upon the spectator and his own spatial environment. The rigorously formalized structures also have the air of being a collection of treasured trophies; Cornell's mysterious boxes and Johns's target constructions stand in some relationship to them, though neither was a direct influence.

Nevelson's elegance of form and workmanship is offset by the sense, at first glance, that her walls have been contrived from manufactured objects which carry no special personal meaning. The process of formalization is enforced by the very selection of objects, for their banality has already moved them closer to purification and muted the poetry of association. Effects of weathering and aging and marks of human use persist, to a degree, and surround the fragments with an aura of privileged status. The fact that discarded objects, taken out of the stream of life and use, have been assembled with such lucid precision creates a subtle interplay between personal identification and the overriding considerations of design. The repeating, only slightly varied structures within the larger whole suggest continuing mental effort despite their formal elegance, as if a problem had to be restated and did not admit of final solution. Nevelson's ensembles function finally with the "metaphysical" ambiguity of a de Chirico still life, where geometric style acts as a source of poetic mystery rather than of clarity and precision. The same unerring balance of expressive power and hermeticism continues to sustain Nevelson's inventions today. Even her large, public outdoor sculptures, usually cast in Cor-Ten steel, and the transparent Lucite structures of recent years carry the personal stamp of her early works

793. VITO ACCONCI.
Blindfolded Catching Piece. 1970. Film strip.
Collection Pieter Sanders, Schiedam,
The Netherlands

794. KEITH SONNIER. *Head, Feet, and Hands.*
Videotape. View of exhibition at
Leo Castelli Gallery warehouse,
New York City. 1970

despite their heroic scale and look of impersonal fabrication.

A more conspicuous formality, with pointed psychological overtones, has been a noticeable feature of the sculpture of many artists of the younger generation who make use of junk materials and interact with their environment. Edward Higgins's humanoid forms in welded steel and smooth white plaster balance a rigorous Constructivism against soft curves and sensuous surfaces whose blandness disguises the organic vulnerability of his shapes. An impression per-

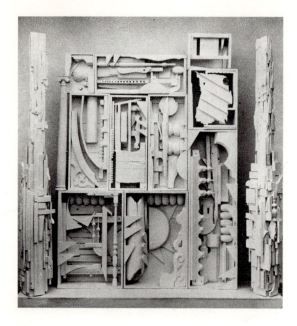

795. LOUISE NEVELSON.
Dawn's Wedding Chapel III with Two Columns. 1959.
Painted wood, height 9′3″. Whereabouts unknown

796. LOUISE NEVELSON.
Atmosphere and Environment XII. 1970.
Cor-Ten steel, height 16′.
Fairmont Park Association, Philadelphia

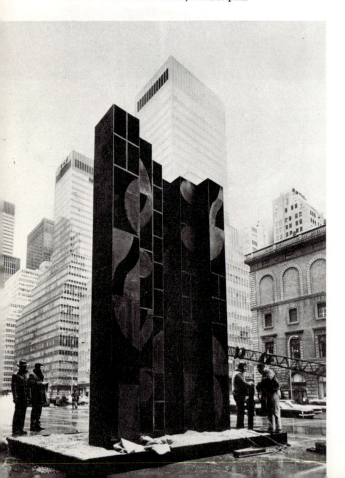

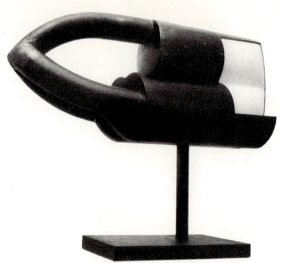

797. EDWARD HIGGINS. *Manifold IV*.
Steel and plaster, height 31″.
The Museum of Modern Art, New York City

sists of flesh imprisoned in metal, no matter how imperturbable his surfaces or mechanical his methods. His sculpture works its essentially magical effects even on structural and optical levels. It is immaculate and yet totemistic in the semi-Surrealist provocations of its formal embellishments.

Limited in meanings to their constructed aspect, Gabriel Kohn's laminated and meticulously crafted abstract wooden forms belong to a new objective tendency. Despite their ranked, symmetrical formal orders and clean definition, they nonetheless suggest personal metaphors, for they seem more the product of a mood of tension than of some doctrinaire program.

Lee Bontecou's savage constructions of canvas, metal, and wire regularize and codify within a highly personal formal system the tears, bulges, erosions, and accretions of the waste materials associated with Assemblage. Strong elements of fantasy are brought to terms with a structural aesthetic and emblematic form. The aggression of her earlier images (jagged saw teeth, suggesting mouths; sealed-off or grated apertures, evoking mystery and frustration) and their coarsely textured surfaces have an irrational intensity about them. She uses obtrusively inelegant materials and junk components with a surgical precision, but her forms manage to remain intensely primitivistic. They expand in scale as their deep relief elements are emphasized, and thus attain a dramatic, environmental presence. Surface detail, texturing, and pictorial illusionism support their environmental versatility, for they

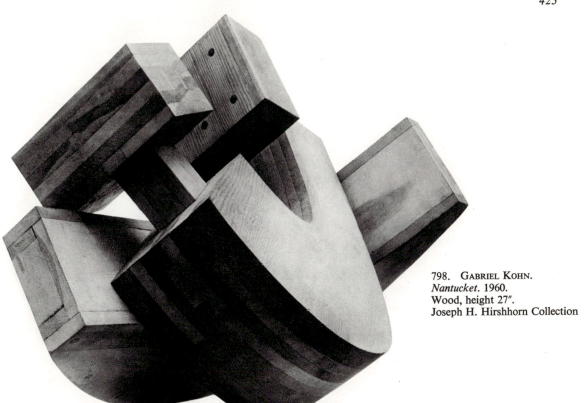

798. GABRIEL KOHN.
Nantucket. 1960.
Wood, height 27".
Joseph H. Hirshhorn Collection

799. LEE BONTECOU. *Untitled*. 1962.
Welded steel with canvas, 44 × 35 × 15".
Moderna Museet, Stockholm

function both as sculpture objects and as a rather threatening dream imagery. Bontecou's more recent works explore an imaginary kingdom of animistic forms, first in painted plastic relief and then in freestanding or suspended glass sculptures of great delicacy. The brutality of her early images has given way to a magical world of flowers and fish, her own private bestiary of fantastic flora and fauna.

First among the new generation of sculptors to use urban discards and metal scrap with a highly personal, creative intensity in Assemblages of welded metals and found machine parts was Richard Stankiewicz. His experiments coincided in time with those of Rauschenberg, though he worked in freestanding and ultimately more homogeneous form. His discovery of the imagistic possibilities of smashed typewriters, battered metal scrap, rusting boiler parts, and mechanical equipment perhaps sanctioned Bontecou's mechanized fetishes. Behind Stankiewicz's art is a parenthood that includes the metal sculpture of Picasso, Julio Gonzales, and David Smith, and the machine fantasies of Picabia. For Stankiewicz, however, the machine is simply an object with a history of use and deterioration; it does not function in his art either as a symbol of hope for human betterment or as an impertinent reminder of industrial society's destruction of human values. His technical innovations and caricatural energies are directly related to Jean Tinguely's brilliant kinetic animations and ironic deflations of the machine.

John Chamberlain was also known as a junk sculptor, but his art moved toward greater uniformity in image formation and technical consistency. He improvised boldly with the crushed, derelict discards of auto-body parts, taking advantage of both their color and composite shape possibilities. Then, his work changed from scarred and battered vintage surfaces, without much chromatic vividness, to brand new auto fenders glistening with fresh coats of factory paint. The effect of the newly manufactured and synthetic object associated these forms with the fresh-looking vinyl artifacts of Claes Oldenburg. In his first phase, Chamberlain had crossed his sculpture with a painterly rhetoric derived from de Kooning's jarring mixture of chromatic dazzle and painterly opulence. He never allowed the observer to forget that he was bending sheets of a real automobile chassis, even though his com-

800. RICHARD STANKIEWICZ. *Untitled*. 1960.
Steel, height 36″.
The Singer Company Collection, New York City

801. JOHN CHAMBERLAIN. *Tippecanoe*. 1967.
Galvanized steel and aluminum, height 40″.
Collection David Whitney, New York City

802. JOHN CHAMBERLAIN. *Héng*. 1967.
Urethane, height 54″.
Collection Mickey Ruskin, New York City

pacted metal forms looked very much like de Kooning's colliding waves of paint. His art was thus environmental, because it inescapably referred to the urban litter heap. Recently he has moved from a preoccupation with destitute junk objects to a sparer kind of crushed Assemblage of homogeneous, galvanized aluminum, after experimenting briefly with soft polyurethane foam and transparent plastic.

Only California, with its long-standing traditions of creative eccentricity and "funk" art, could have produced the mordant and altogether memorable tableaus of Edward Kienholz. His bizarre Assemblages of simulated human detritus and appalling environmental details of horror present vicious allegories on human disorder and cruelty. They can be viewed as the grotesque gothic-realist counter-current to the mindless California fascination with a world of hot-rods, baroque car designs, high-polish craftsmanship and other evidences of a shallow, ersatz visual culture. Kienholz's brutal visual anecdotes belong to an American moralizing tradition and comment on such topics as the abortion underground, patriotism, eroticism, and psychic disintegration. His almost unbearable *The State Hospital* apparently grew out of his brief experience as a hospital attendant in an asylum. The same sense of revulsion and similar horrific, physical detail are apparent in *Back Seat Dodge—38*, a cruel swipe at the romance of Lovers' Lane and, more generally, at American violence. The "black" Assemblages and profoundly pessimistic mood of Bruce Conner, another California artist, are also calculated to unnerve the squeamish. His vaguely humanoid, burnt, body-like lumps of black wax suggest a cataclysmic vision of destruction and holocaust. H. C. Westermann, originally from Chicago, is another regional master of Assemblage. He turned away from nostalgic objects at an early date to create newer looking popular imagery, as in his chaste transformation of America's most popular drink into a sacred image in *White for Purity*. With such strategies and images, he anticipated Pop Art almost a decade before it officially came on the scene in America.

The mix of brute materials, or facsimiles of them, with illusionistic pictorial effects characterizes the different work of three other gifted sculptors: George Sugarman, Mark di Suvero, and Peter Agostini. Sugarman extends colorful jigsaw ensembles of brightly painted wooden forms into the environment, laterally along the floor or at odd angles into space, so that our accustomed points of reference to pedestal sculpture become disoriented. Bright, flat color surfaces and the mechanical intricacies of his shapes relate them to commercial artifacts and educational toys, which test the rudimentary abilities of the child to connect parts to wholes. These associations of play and problem-solving are incorporated into works of immoderate scale and insubordinate structural energies, especially in the large public sculptures Sugarman recently made in painted Cor-Ten steel under the auspices of the industrial fabricator Lippincott.

Mark di Suvero creates hulking, open forms in rough-hewn planks, beams, and steel rods that balance precariously in asymmetrical compositions. His objects—chairs, buckets, chains, hoops—are brute and untransformed, inserted into daring systems of equilibrium with minimal alterations in their original physical character. They so expand in monumental scale that their impact is finally architectural. Agostini works in quick-setting plaster from casts of light and buoyant objects which occupy space without exerting much weight: balloons, tires, umbrellas, pillows, and crumpled rags. The element of weight has been denied its characteristic association with sculptural volume, but lightened mass

803. EDWARD KIENHOLZ. *The State Hospital.* 1964–66. Mixed media, height 8′. Moderna Museet, Stockholm

804. BRUCE CONNER. *Medusa.* 1960.
Wax, nylon, hair, cardboard, wood, height 10¾″.
Whitney Museum of American Art, New York City

805. EDWARD KIENHOLZ. *Back Seat Dodge—38.* 1964.
Mixed media, height 5′6″.
Collection Lyn Kienholz, Los Angeles

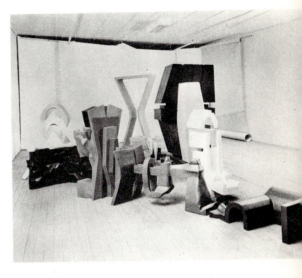

807. GEORGE SUGARMAN. *Two-in-One*. 1966.
Painted wood, 7′6″ × 23′6″.
Collection the artist

806. H. C. WESTERMANN.
White for Purity. 1959–60.
Mixed media, height 44½″.
Collection Mr. and Mrs. Henry M.
Buchbinder, Chicago

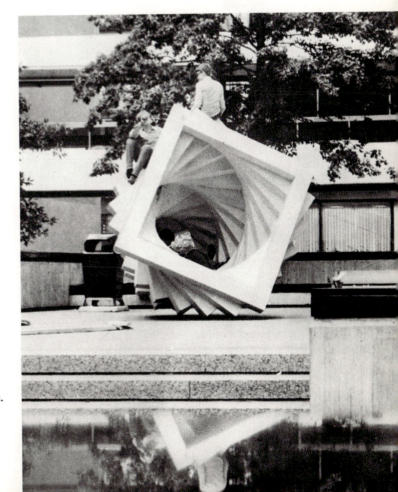

808. GEORGE SUGARMAN.
Square Spiral. 1971.
Painted Cor-Ten steel, height 9′3″.
Lippincott, Inc., North Haven, Conn.

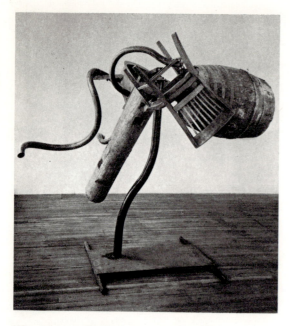

809. MARK DI SUVERO. *Stuyvesantseye*. 1965.
Mixed media, height 92″.
Walker Art Center, Minneapolis

810. PETER AGOSTINI. *Summer's End*. 1964.
Plaster, height 60″.
Collection the artist

is converted into spatial energy. Agostini's methods of casting require the instant decision-making of Action Painting. The dual identities of his shapes as sculptural forms and as replicas of recognizable readymade objects, and their chalky appearance, associate them with Oldenburg's "ghosts," which duplicate in coarse,

whitened canvas his black and shiny plastic artifacts.

During the mid-sixties a new mood of self-scrutiny and reappraisal created a situation of uncertainty for avant-garde sculptors in which painting, sculpture, architecture, and engineering converged, often paradoxically, in unprecedented aesthetic objects which eluded traditional definitions. A stylistic synthesis emerged finally in the form of Minimal Art. Although this term describes certain examples of shaped canvas, monochrome painting, and a drastically simplified, "cool" geometric art generally, it was identified especially with the severely structurist art which attained general public recognition in the exhibition "Primary Structures," organized by Kynaston McShine at New York's Jewish Museum in the spring of 1966. The exhibition demonstrated a new common sensibility and carried the weight of a visual manifesto for a new aesthetic viewpoint.

This exhibition had in fact been preceded by a number of influential one-man shows in New York by Don Judd, Robert Morris, and Dan Flavin which already provided abundant evidence that a new type of easily perceived yet mentally complex geometric form—symmetrical, box-like, and unadorned—had begun to emerge. Walter de Maria and Robert Morris made what could be described as Minimal Art as early as 1961, some years before the term itself was invented. Tony Smith's first polyhedrons in painted plywood mock-ups apparently preceded even these primitive ventures, although he was as unknown to the young structurists as they were unfamiliar to him. The new reductive, impersonal trend in sculpture appeared officially in the first museum show devoted to art of this character, the "Black, White and Gray" exhibition organized by Sam Wagstaff at the Wadsworth Atheneum in Hartford. That was followed in early 1965 by the exhibition "Shape and Structure," assembled at the Tibor de Nagy Gallery in New York by Frank Stella and Henry Geldzahler.

At the Jewish Museum the following year, Judd's standardized, repeated, boxy aluminum permutations in colorful motorcycle paint, Morris's identical L-shaped volumes in gray-painted plywood, and Bladen's more heroic and personal drama of tilted, thrice-repeated rectangular volumes in black-painted plywood and

811. View of group exhibition, Green Gallery, New York City. 1963. (Don Judd sculptures in foreground, left and right)

812. DON JUDD. *Untitled.* 1963.
Wood and metal, height 48″.
Collection Julie Judd, New York City

metal were singled out particularly as the enigmatic ciphers of artistic change and immediately precipitated heated critical debate. The suppression of the "hand" of the artist (many of the forms displayed were fabricated in industrial shops from the artist's specifications), an addiction to architectural scale, and the impassive character of these structures all contributed to form an impression in the public mind of powerful scale, deliberate vacancy, and hermeticism. Simplified gestalts of outsize geometric shapes curiously invoked the ironic spirit of Duchamp, and they might even be understood, with some effort, to carry implications of social criticism. A case could be made that the "good design"

813. TONY SMITH.
Playground. 1966.
Plywood (to be made into steel), height 64″.
Fischbach Gallery,
New York City

814. RONALD BLADEN. *Untitled.* 1967
(after a version in wood, 1965).
Painted aluminum, height 9′.
The Museum of Modern Art, New York City.
James Thrall Soby Fund

815. JAMES ROSATI. *Shorepoints II.* 1967–70.
Painted steel, length 15′.
Marlborough Gallery, New York City

816. LYMAN KIPP. *Boss Unco.* 1967.
Painted plywood, height 14′ (destroyed)

concepts of the Bauhaus, with their immaculate Constructivist bias, had gotten out of hand. What in the twenties was conceived as a small-scale, intimate, formal principle had now been monstrously inflated into an environmental art calculated to overpower and subdue the spectator, at least in the view of unfriendly critics.

Nevertheless, it was quite clear that the new anonymous, structurist art engaged many of the most forceful new talents in America. Exciting possibilities of invention dramatically opened up, ranging from the spatial power and giantism of Grosvenor's immense, cantilevered beams or Bernard Rosenthal's monumental Cor-Ten steel cubes, poised on their diagonal tips, to the precious refinement of Bell's intimate, alternately opaque and transparent glass boxes. Like any genuine new movement worthy of the name, structurist sculpture offered its own set of admired precedents, if not a direct inspiration: the classical simplicities of the architect-sculptor Tony Smith, the last monumental *Cubi* series of David Smith, and the elegant polychrome forms of the Englishman Anthony Caro. The American structurist aesthetic also found a parallel development in the constructions of a new generation of English sculptors working in painted metal and plastic, often on an architectural scale, among whom Philip King and William Tucker were outstanding.

The phenomenon of Minimalism represented a return by the artist to essentials of geometric structure as well as more detached aesthetic

817. ROBERT MORRIS. *Untitled.* 1965.
Painted plywood, height 96″.
Leo Castelli Gallery, New York City

820. BERNARD ROSENTHAL. *Alamo*. 1966.
Painted Cor-Ten steel, height 15'.
Department of Parks, New York City

818. ROBERT S. GROSVENOR. Left: *Transoxiana*.
Right: *Topanga*. Both 1965. Wood and steel,
height 10'. Collection the artist

819. ALEXANDER LIBERMAN. *Toll*. 1967.
Steel, height 60".
Collection Mr. and Mrs. Robert Spitzer,
New York City

attitudes. In part the change was a reaction to the ego-centered Abstract Expressionism of the fifties. But other factors accounted for the bare, unaccented surfaces and ambiguous illusionism which gained favor. Despite their simplified forms, Minimal structures betrayed an interest in the optical dynamics of elusive shape and edge that created perceptual ambiguities, defying weight, mass, and material substance. There were, in fact, two distinct sides to the new art: on the one hand, its "primary" character seemed related to the general deemphasis of art content, a tendency already apparent in the repetitive banalities of Warhol, or in French New Wave films and novels. Richard Wollheim explained the "low" art content of the new forms in the article of 1965 which gave the movement its name;[1] he related it both to the commonplace, manufactured "readymades" of Duchamp and to the "undifferentiated" effects of the canvases of Reinhardt, among others. Thus, Minimalism became the hybrid offspring of Dadaist irony and the Constructivist, or Suprematist, tabula rasa.

Stella's work around 1960, as noted earlier,

[1]Richard Wollheim, "Minimal Art," *Arts Magazine,* January, 1965.

had anticipated the nonrelational compositions and concrete object qualities of the sculpture that emerged only in mid-decade; his sense that the energies of abstract pictorial art and illusionism were, in fact, running down reflected a feeling that was pervasive among artists in the early sixties. As Stella later put it: "It's just that you can't go back. It's not a question of destroying anything. If something's used up, something's done, something's over with, what's the point of getting involved with it?" Robert Morris acknowledged some years later that Stella's expressionless, holistic black-striped canvases of 1960 defined the new parameters of painting for him. For Morris, Stella's "ideas of the grid, symmetry and the non-hierarchic" anticipated a new mode of defining and making art by emphasizing "the way things are made." They formed a bridge from painting to a new kind of antisculptural sculpture.

The disenchantment even with the traditions of formerly admired abstract painting was brilliantly articulated in the blunt, opinionated, but extremely influential criticism of Don Judd. His critical writing and art reviews of 1962 and 1963 helped precipitate a new consciousness in art, as much as any other intellectual activity of the period, and predicted a different kind of self-contained, concrete, three-dimensional art based on a simplified form-gestalt. Judd's antipathy to illusionistic painting as such, expressed cogently and without compromise as early as 1962, was later summarized in perhaps his best-known article in 1965, "Specific Objects." "The main thing wrong with painting," he wrote, "is that it is a rectangular plane placed flat against the wall." Judd noted that under certain conditions even a painting could be understood as an object, and therefore transformed into a potential sculpture, since in his eyes its illusionistic character failed to dominate perception: "A rectangle is a shape itself; it is obviously a whole shape; it determines and limits the arrangement of whatever is on or inside it."

In the same article Judd stated: "Half or more of the best new work in the last few years has been neither painting nor sculpture." His rather dogmatic but illuminating analysis identified for the first time a holistic art where the complex and hierarchic interrelations within a form counted for less than the "field," or its totality. Depicted pictorial space was derided (in the tried and true

821. DON JUDD. One-man show, Whitney Museum of American Art, New York City. 1968

822. DON JUDD. *Untitled* (8 boxes), 1968. Stainless steel, each 48″ cube. Collection Miles Fiterman, Minneapolis

823. DONALD JUDD. *Untitled*. 1967. Painted galvanized iron, height 15″. Leo Castelli Gallery, New York City

evangelical American spirit of puritanical rejection), and linked to corrupt old-world practices; Judd identified the new object character of art with a cleansing, reform spirit: "Three dimensions are real space. That gets rid of the problem of illusionism and of literal space, space in and around marks and colors—which is riddance of one of the salient and most objectionable relics of European art."

Judd's own creative example proved even more influential than his critical dogmas when in 1963 he began to make and show work in his new style—a more arbitrary kind of wall relief, in abstract form, of painted wood and metal. Shortly thereafter he fabricated metal forms either of a blocky, unitary character, or in modular, repetitive serial schemes, probably reflecting the anticlimactic compositional forms of Stella. At times Judd used unadorned industrial surfaces, with no color. Increasingly, however, he experimented with artificial, fluorescent, commercial colors, especially in the years after 1964. The asceticism of his structures, with their elementary box-like forms or serial permutations, was countered by the play of colored surface as he explored the seductive possibilities of what came to be a surprisingly wide range of industrial materials, techniques, and chroma. Even though his works after 1965 were almost invariably made to specification by industrial fabricators, and utilized materials without traditional fine arts associations, such as aluminum, cold-rolled steel, Plexiglas, stainless steel, galvanized iron, and brass, each new sculpture created an impression of distinctive individuality and of sensuous fullness.

Judd's Harley-Davidson motorcycle paint colors and other brilliant commercial hues helped conceal the metallic properties of his materials and created the illusion of lightness and weightlessness. In addition, by depending upon industrial workshops for his completed structures, Judd in a sense polemically criticized the past insistence by artists of the fifties on the intimacy of touch and, through facture, on values of personal authenticity. Abstract Expressionist sculptors, including even David Smith, had made this sense of Existential involvement in the artistic process their canon. Judd's more factual and detached attitude towards the art-making process, in conjunction with his outspoken criticism, dramatized perhaps the most

824. ELLSWORTH KELLY. *Pony*. 1959.
Painted aluminum, height 64".
Dayton's Gallery 12, Minneapolis

825. CLEMENT MEADMORE. *Around and About*. 1971.
Painted aluminum, height 84".
Private collection

826. PAUL FRAZIER. *Cuboid Shift No. 2*. 1967.
Painted plywood, height 8'4".
Collection the artist

significant change in the mood of the art of the sixties, an objectivist trend also exemplified by the paintings of Johns, Noland, Kelly, and Stella, and the emotionally neutralized structures of Robert Morris, Tony Smith, and related sculptors.

The Minimalist aesthetic of "less is more," to adopt Mies van der Rohe's famous phrase, seemed to arise from a sense that illusionist pictorial tradition had been exhausted and that a new kind of wholeness of vision was called for. The critic Lucy Lippard observed that Judd stressed "single-mindedness, physicality, wholeness and direct confrontational experience." Robert Morris, on the other hand, was far more cerebral in his approach to simplified sculptural form. He came to a similar radical position by an entirely different intellectual route. By the mid-sixties his own forms had become quite as devoid of detail, as basic-geometric in shape and obsessively primary in their emphasis on wholeness as Judd's. They were, however, motivated by a sense of irony and subversive game-playing closer in spirit to Duchamp than to such formal purists as Reinhardt or Malevich. Significantly, Morris described the first unequivocal examples of Minimal Art in his *oeuvre*, in 1961, as "blank form," thus suggesting his own awareness of their perceptual form and intellectual content of deliberate vacancy. His paradoxes can be related to the thought of the man who probably influenced the shift in aesthetic strategy, through the performing arts especially, more than any other single figure, the composer John Cage. About this time Cage was quoted as saying: "I have nothing to say and I am saying it," summarizing in an absurdist pun the spirit not only of his own work and that of many youthful contemporaries, but of an entire cultural episode.

In the winter of 1964–1965 Morris held two separate shows at the pioneering Green Gallery in New York, shows which at the time seemed inconsistent and even contradictory. In retrospect, however, they both demonstrate a related, complex concern with the artistic process, and reveal the taste for mental gymnastics which has become the hallmark of Morris's versatile style, or styles. His first one-man show in December, 1964, consisted of lead and Sculpmetal reliefs which clearly referred to Johns and Duchamp. Measuring and informational devices, examples of a stylishly "cool" eroticism, and a heightened

sense of his own creative procedures—evident in a wooden structure with a tape playing the sound of its own noisy carpentry during construction—all these cunning strategies underlined Morris's ironic, alertly contemporary intelligence. His other show of the following year was limited to a few large, bland geometric forms in gray-painted plywood. Some were identical structures placed in different floor positions; others used the gallery room interior as a compositional area, slicing it with monotonously unvaried surfaces, in beam and corner pieces, and incorporating its subdivided spaces into the total ensemble of positive forms and voids. It seemed a curiously vapid kind of geometric art, but in fact it was to have a far more catalytic effect and explosive influence than the first exhibition.

Interestingly, these contradictory types of art provided exemplary models of a hermetic private art on the one hand, and an inflated public art of monumental scale on the other. One sculpture type was entirely impersonal, while the other stressed psychological and even autobiographical elements. It is Morris's analytical and problem-solving intellect which unifies his prolific invention and imposes a consistent logic and identity on its protean character. After 1965, Morris's work became even less predictable, but he remained unfailingly innovative in his varied performance activities (in the dance), in his large-scale, modular sculpture, and then in his multifarious excursions into "anti-form"—the random pilings of felt, mirror works, Earthworks, and the dematerialized steam environments and other brilliantly original projects in ecology, communications, and information systems which followed in rapid succession.

Morris began his New York activities in association with a small group of artists, dancers, and musicians who had worked closely together in San Francisco. This fact may have something to do with the range and character of his artistic evolution since 1961. With Walter de Maria, La Monte Young, and Yvonne Rainer, he collaborated in many performance situations staged in the Judson Memorial Church, which became the center of the new dance group. Morris choreographed and performed in a number of dances between 1963 and 1966, including the sensational 1965 performance with Yvonne Rainer, *Waterman Switch*. In it, the two dancers performed naked, but somehow pressed together so cun-

827. ROBERT MORRIS.
Untitled. 1964.
Lead, 21 × 15½ × 1¼″.
Collection Richard Bellamy,
New York City

828. (*middle*) ROBERT MORRIS. View of one-man show,
Green Gallery, New York City. 1964

829. (*bottom left*) ROBERT MORRIS. *I–Box.* 1962.
Painted wood and photograph, height 19″.
Private collection, New York City

830. (*bottom right*) ROBERT MORRIS. *Pace and Process*
(photograph of artist riding), taken at
Place and Process show, Edmonton, Canada. 1969

831. TONY SMITH.
Die. 1962.
Steel, 72″ cube.
Collection
Samuel J. Wagstaff, Jr.,
Detroit

832. SOL LEWITT.
7 Part Variation of 2 Different Cubes. 1968.
Painted plastic and wood, 9 × 23 × 23″.
John Weber Gallery, New York City

ningly, as they inched with excruciating deliberateness across the stage, that they made a chaste, unoffending portmanteau sculpture group in slow motion. Perhaps even more significant than the explicit if cold eroticism of this exquisitely formal dance were some of the underlying ideas behind it and related performances by the Judson Church group.

Any kind of body movement or action was considered acceptable, whether trained or untrained, professional or not; the smooth, unaccented continuity of dance movements gave a somewhat bewildering sameness of tempo and energy level to the performances, resulting in a sense of stasis and arrested energies. The critic Jill Johnston dubbed the Judson group as "all-over dance," possibly taking her cue from the frozen athleticism and equilibrium of Pollock's all-over painting, with which the idea of a homogeneous field was first associated. The bland monotony of the new dance seemed to defy balletic tradition in very much the way that the new objectivist and undramatic formal trends in

833. DAVID WEINRIB. *Clear Center*. 1968. Cast plastic, height 27″. Royal Marks Gallery, New York City

834. BERNARD ROSENTHAL. *Odyssey*. 1969.
Painted aluminum, height 98″.
Middleheim Museum, Antwerp

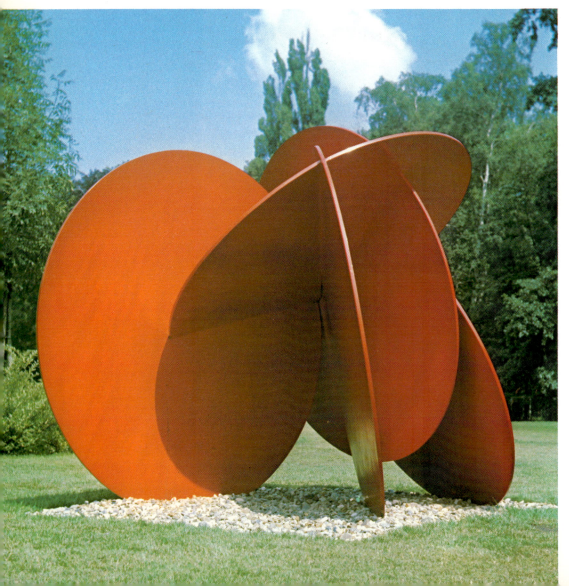

835. DON JUDD. *Untitled.* 1971.
Hot rolled steel, height 2′ 8¾″, diameter 15′.
Collection the artist

836. RICHARD SERRA. *Moe.* 1971.
Hot rolled steel, height c. 96″.
Leo Castelli Gallery, New York City

837. ROBERT MORRIS. *Untitled*. 1968. Mixed media, surface area 26′ × 20′. Collection Philip Johnson, New York City

the visual arts broke with their own traditions. Apparently Morris evolved his first so-called blank-form sculpture, a piece called *Column*, as a dance prop in 1961, and he later described it with the same kind of deadpan and child-like simplicity of language which John Cage and Jasper Johns had already made familiar: "A column with perfectly smooth rectangular surfaces, 2 feet by 2 feet by 8 feet, painted gray."

Column was also notable because the artist allowed its final form and character to be determined by the materials and the working artistic process. The standard size of a plywood sheet accounted for its dimensions, since the sheet was cut into four equal sections, joined together, cemented, sanded down, and then painted with Merkin Pilgrim Gray paint. *Column* and six other related structures in gray-painted plywood were brought together in Morris's Green Gallery one-man show in 1965. The exhibition was extraordinary not only for the simplified geometry of its forms, but also because the structures were carefully positioned to activate the room space. Indeed, they were conceived perhaps for the first time as "situational" sculpture, or sculpture *in place*, rather than as studio sculpture constructed without considering the gallery area they were to occupy.

Morris deliberately used the most easily perceived and understood shapes, the simpler polyhedrons—cubes, pyramids, rectangles, beam forms—partly because he was reacting against the associational values and the cult of spontaneity of the previous artistic generation. His Euclidean forms also lent themselves to conceptual reconstruction from any perspective or partial view. As one moved around his pieces, the works might change *perceptually* with the angle of vision, but, *conceptually,* one could still keep the simple form-gestalt in mind without difficulty. The *whole* form of a structure could be remembered even as the dynamics of vision only revealed successive fragments of it. The conceptual simplicity of his primary art thus suggested—at least to some observers—that it was meant to be *thought about* as well as *looked at*. The interest of the forms for their own sake diminished, too, with modular variations and serial repetitions in later work by Morris, and even more decisively in that of Sol Lewitt, who seems to have been the first artist to use the expression Conceptual Art to describe both a new

838. PAUL VON RINGELHEIM. *Thrust* (maquette for steel sculpture designed to span a 4-lane highway, on a scale of 1: 60). Satin finished stainless steel, height 16″. Collection the artist

839. FORREST MYERS. *For Leo*. 1968. Welded aluminum, height 16′. Collection Mr. and Mrs. Lionel Bauman, Stamford, Conn.

840. DAN FLAVIN.
Coran's Broadway Flesh. 1962.
Incandescent lights and
oil on board, 42⅛ × 42⅛ × 9⅞″
Collection John W. Weber,
New York City

841. DAN FLAVIN. Installation view,
Green Gallery, New York City. 1964

842. DAN FLAVIN. *Pink and Gold*. 1968.
Neon lights. Museum of Contemporary Art,
Chicago

kind of art and a new set of attitudes toward art. Thus, as the sculpture object was transformed from its "anxious" state in the hands of the Abstract Expressionists, and achieved geometric stability, it almost simultaneously seemed to dispense with the need to assert its physical status, under the pressure of a radical new aesthetic ideology.

The idea of executing sculptural forms *in situ,* as situational and therefore impermanent structures designed to function outside the studio environment, became a dominant feature of the art of the sixties. Carl Andre was the first artist to use the term "post-studio" sculpture to rationalize what Robert Morris, Dan Flavin, and he had begun to do by way of breaking down the conventional rationales linking the artist and his work in the studio. "We may actually be seeing the end," Andre wrote, "not of gallery or museum art, but the end of studio art." The identification of the art activity with an indoor or outdoor site, and with a nonvisual, conceptual idea, became decisive when artists freed themselves from the limitations of the studio mentality.

Besides Morris's two interchangeable painted plywood L-forms placed in different positions at the Jewish Museum's "Primary Structures" show, important works by Dan Flavin and Carl Andre helped define the new type of situationally specific sculpture. In the case of all three artists, their invitation from the Museum to exhibit elicited "proposals" for structures, which were to be designed and fabricated especially for the show, rather than completed works. Since the character of the work directly depended on a particular exhibition request, or situation, the piece existed only when it was literally made *on the spot.* These early proposals were carefully worked out in diagrams or detailed drawings with specifications that resembled engineering plans, but later, as this procedure became common, a more cursory kind of letter with specifications from the artist was usually sufficient.

Flavin's *Corner Monument* employed a double pair of standard-size 8-foot red fluorescent light fixtures installed horizontally in a gallery room corner. Along with Andre's single unbroken line of 137 unjoined firebricks, 34 feet long, it was certainly one of the more baffling "proposals" of the provocative Jewish Museum show. These works and Morris's repeated L's

served notice that a profound change had taken place in the character of art by the mid-sixties. Flavin arrived at his new methods after working for three years on a series of "electric light icons," square, shallow Masonite boxes painted in one color on their frontal surfaces and punctuated with regular and continuous rows of incandescent light bulbs at their edges. By the time of his first one-man show in 1964 at the Green Gallery, he found a new and surprising use for commercial fluorescent light tubing. He proceeded to arrange his tubes in the gallery as if they were in his studio. His placement of them became a problem similar to Morris's sculpture arrangements when he held his show in the Green Gallery. "Realizing this," Flavin wrote, "I knew that the actual space of a room could be broken down and played with by planting illusions of real light (electric light) at crucial junctures in the room's composition."

Flavin envisaged each of his succeeding exhibitions as a total ensemble and the exhibition space as an entity within which his fluorescent tubes, often radiating an austere white light but sometimes glowing with subtle color, created luminous zones of irradiation related to each other and to the overall room container. The rather clinical and chaste quality of his non-colored light in early works, with their meditative atmosphere, set Flavin apart from the more sensational manipulators of luminist art, or of pulsating light environments, in a period dominated by the faddist interest in eye-popping intermedia shows. The artist's cleverly wrought intellectual propositions, acerbic wit, and sense of dedication to a highly principled art form were only rivaled by Ad Reinhardt's previous example of moral integrity. His speculative concerns were close to the theoretical interests of Morris, Judd, and Andre, and their work paralleled his own in providing a new framework for both artistic practices and attitudes.

Many of the problems that distressed an audience which rejected the monoliths or serial repetitions of Minimal Art were raised again with Flavin's proposals and their materialization in arranged light tubes. His standardized commercial lighting seemed gratuitously puritanical, and its unassimilated "thingness" was as difficult to translate into the sensuous abundance and variety expected of art as the monochrome surfaces of Ad Reinhardt or the silences of

John Cage. Flavin's work was judged to be as close to absurdity as the interminable Warhol movies, the nearly invisible black surfaces of Reinhardt's paintings, or Morris's blank-form sculpture. His vacancy and redundancy were, however, used by sympathetic avant-garde critics to invoke such historic examples of reductive art as the all-white compositions of Malevich and Yves Klein's "Le Vide" exhibition in Paris in the late fifties, which consisted of nothing more than the bare white walls of his art gallery, with only the baffled spectators to provide the action. Like these examples, the modular forms of Minimal sculpture and the nonvisual communications of Conceptual Art which followed, Flavin's light composition implied a more important experience than either its intrinsic materials or its compositional arrangement could at first reading sustain.

Interestingly, while Flavin's luminosities were at first invariably austere, he later experimented with such luscious chromatic mixes as *Peachblow,* a rectilinear corner piece shown at the Dwan Gallery in 1968, which created a rosy, flesh-colored haze strongly reminiscent of the exquisite color blending of Olitski's spray paintings. A more aggressive light environment of the same period—which Flavin in a statement in the exhibition catalogue called a "broad bright gaudy vulgar system"—was *Pink and Gold;* it alternated rose and gold eight-foot fluorescent lamps on six walls of the Museum of Contemporary Art in Chicago, filling the empty space with vibrant shades of red-orange.

Compared even to the sculpture of David Smith and Anthony Caro or the centered, single images of Noland or Stella, the work of Flavin and Morris was "anti-formal" despite its superficial geometric character. Composition, color, and art history were all neutralized, and association with any structured formal system played down or eliminated. Flavin's light arrangements reiterated the contours of the interior gallery space which they illuminated, like Morris's blank-form sculpture. These lamps, then, had more to do with conceptual idea, site, and methodology than with the familiar form language of modernist abstraction. Behind their "readymade" forms, anti-art character as gesture, and indifferent design lay a nonhierarchic, democratic principle. "I believe," wrote Flavin, "that art is shedding its

843. CARL ANDRE. *64 Pieces of Magnesium.* 1969. Magnesium, 64 × 64″. John Weber Gallery, New York City

844. ROBERT MORRIS. *Untitled.* 1968–69. Aluminum, height 36″. Leo Castelli Gallery, New York City

845. WALTER DE MARIA. *Bed of Spikes.* 1969. Stainless steel, height of each spike 15″. Kunstmuseum, Basel

vaunted mystery for a common sense of keenly realized decoration . . . we are pressing downward toward no art—a mutual sense of psychologically indifferent decoration—a neutral pleasure of seeing known to everyone."

With a similar disregard for the traditional uses of medium and mistrust of the artist's creative *machismo,* Carl Andre—the first confessed "post-studio" artist—described his work as "atheistic, materialistic, and communistic." He wrote: "It is atheistic because it is without transcendent form, without spiritual or intellectual qualities; materialistic because it is made out of its own materials without pretension to other materials. And communistic because the form is equally accessible to all men." When Andre laid down his 34 feet of unattached firebricks on the floor of the Jewish Museum or, in 1968, a much longer row of 184 bales of hay extending 500 feet across an open field, he was elaborating the idea of site as sculpture which had already been prefigured by Morris and Flavin. In these works and in *Reef,* which consisted of brightly colored, identical styrofoam blocks placed side by side at the Whitney Museum's 1969 exhibition "Anti-Illusion: Procedures/Materials," filling the floor between two walls of a large gallery, he arrived at a new spatial concept. An admirably condensed and characteristically oracular statement described his indifference to the materials he had selected as such, or to their potential for aesthetic development in traditional terms:

The course of development
Sculpture as form
Sculpture as structure
Sculpture as place.

As the Whitney's curator James Monte noted in his catalogue introduction: "The act of conceiving and placing the pieces takes precedence over the object quality of the works."

Andre's situational sculpture relieved the sculptor of the dominating concerns of the artistic past with materials, art history, composition, and formal exposition. Andre participated in the prophetic Tibor de Nagy Gallery exhibition of 1965, "Shape and Structure," where

846. CARL ANDRE. *Log Piece* (portion). 1968.
Length of entire piece c. 100'.
Aspen, Colo.

847. CARL ANDRE. *Cedar Piece*. 1964 (after destroyed piece, 1960). Cedar, height 72″. Collection John W. Weber, New York City

848. CARL ANDRE. *Reef*. 1969–70 (original 1966). Styrofoam, 20″ × 10′. Collection Heiner Friedrich, Cologne

849. TONY SMITH. *Smog*. 1969. Painted wood (to be made into steel), height 82″. M. Knoedler & Co., New York City

Morris showed one of his first Minimalist structures. Andre's entry, called *Timber Piece,* aroused considerable interest with its almost identical sections of rough-cut lumber in variable patterns, and established him as a member in good standing of the new movement toward a stark and rudimentary structuralism. Interestingly enough, in his evolution he had in the late

fifties been close to Frank Stella, a classmate at Andover. Andre then began making stepped and mortised timber constructions, such as *Cedar Piece*. Their mirror-reflection structure, with echoing inverted pyramidal forms, seemed related to Stella's geometric configurations in his black-striped painting of 1959 and after. Later, Andre credited Stella with introducing

him to the idea of wholeness and a gestalt simplicity in his view of the art object, explaining that he "arrived certainly through the example and teaching of Frank Stella at something which I call anaxial symmetry. This is the kind of symmetry in which one part can replace any other part."[2]

It was Stella who brought him to a critical realization which he later expressed in this way: "The thing I was cutting was the cut. Rather than cut into the material, I now use the cut in space." Another valuable clue to Andre's concept of form as a continuum was his fascination with Brancusi's *Endless Column*. Brancusi had shown a similar disregard for detailed elaboration and preferred to maximize the impact of his repeating form vertically, by extending his standardized, rough-cut diamond shapes into space. Andre's notched and serrated wooden-beam constructions of the late fifties were clearly made under the combined influence of Brancusi and Stella. With characteristic candor, he later wrote of his Jewish Museum piece, *Lever*: "All I'm doing is putting Brancusi's *Endless Column* on the ground instead of in the sky. Most sculpture is priapic with the male organ in the air. In my work, Priapus is down on the floor. The engaged position is to run along the earth."

Horizontal orientation seemed to offer more opportunity of spatial extension. "The ideal piece of sculpture is a road," Andre declared when he began to use the gallery floor as the plane for logs, styrofoam bars, magnets, bricks, metal squares, and "scatter pieces" of old nails. Commonplace materials were set down on the floor area in effect to democratize his art, by leveling and humbling the traditional vertical, anthropomorphic view of sculpture. When artists later moved into the landscape quite literally with Earthworks, somewhat the same philosophy guided their sense of vastly enlarged scale and their essentially bird's-eye or aerial viewpoint. Composing brute, non-art materials in checkerboard patterns of metal squares like rugs, Andre destroyed any possible identification of his flattened, ground-hugging art with pedestal sculpture and with the standing homunculus who gave sculpture its human scale and orientation.

Instead, he forced the viewer into a new relationship with sculptural form, including thermal and bodily sensations produced by walking over large square mats composed of unattached metal slabs of aluminum, copper, steel, lead, or zinc, whose different conductive qualities were discernible even through the soles of one's shoes.

Of great importance was Andre's attitude of indifference towards the aesthetic unity and transformable character of his materials. Not only were the distinct "particles" of his structures, in his terminology, commonplace and readily available materials, but they carried neither technological nor Surrealist associations. He utilized "things in their elements, not in their relations," as he put it, and allowed them maximum independence. His selected material units were not viewed as necessarily assimilable to the art process; they were in fact chosen for their neutrality, and the spectator was encouraged to consider them in terms of their phenomenological interest rather than of their sensuous surface or possible material seductiveness. They were things like any others, apparently not even affected by the contextual change of entering an art situation. Different qualities to the touch, or as experienced underfoot, were supported by mental cognition of the clear distinctions between the various elements. Yet an identical module and composition size tended to erase even these slight distinctions. Although the following statement suggests circumlocution, the fact is that Andre's scatter pieces—and their elaborate rationale—had much to do with the increasingly permissive use of materials in new sculpture of the late sixties.

In his utterance, Andre proved uncannily prophetic, too, of the developing obsession with nonvisual art forms and the new theoretical principles that finally made the mind itself the artist's studio. "My general rule," he wrote, "is to find a particle and from that selection or discovery of a single particle, to create a set of them in which the rule for joining the particles together is characteristic of the single particle. . . . I purposely do not glue, and I do not join and I do not drill or weld. . . . The scatter pieces were a solution to the problem of taking a very small particle and combining it by a rule which was characteristic of the first particle, a rule for the whole set of particles but if the particle itself is too small to maintain coherency in a large

[2]Enno Develing, "The Course of Development," in *Carl Andre*, exhibition catalogue, Haags Gemeentemuseum, Holland, 1969.

850. ROBERT SMITHSON.
A Non-Site (*Indoor Earthwork*). 1968.
Painted aluminum with sand, diagonal 65½″.
Collection Virginia Dwan, New York City

851. MICHAEL HEIZER. *Slot.* 1968.
Backfill, height 1′, surface area 6′ × 12′.
El Mirage, Mojave Desert, Calif.

852. ROBERT SMITHSON. *Spiral Jetty.* 1970. Rock, salt crystals, earth, algae, coil length 1500′.
Great Salt Lake, Utah

array, then the scatter of the particles *is* their coherency.... The scatter pieces can move because how they are is not more interesting one time than another time, because within the general range of the rule of one particle, or one particular subgroup of particles, their properties are in a general relationship, not a frozen and fixed relationship."

The emphasis on location by Morris, Andre, and Flavin, and their indifference to the "fine arts" character of their materials, found support and a logical extension in the efforts of a young, idealistic avant-garde sickened by the commercialism of the art world of the late sixties. Out of a new dissenting mood came another notable break with tradition in the form of Earthworks, or Land Art. One of its leading practitioners, Robert Smithson, concisely described the role reversal of art and nature: "Instead of putting a work of art on some land, some land is put into the work of art." Many of the creators of Earthworks, among them Morris, De Maria, and Smithson, had first made Minimal sculpture in which the discrete object became increasingly sublimated by reason of serial emphasis or understatement of the forms involved. Nonetheless, it still seemed curious that these younger artists could so abruptly remove themselves from the studio to the outdoors and begin to investigate geological or mineral matter, a realm of inchoate amorphous forms, when they had scarcely finished elaborating an antithetical system of highly ordered studio artifacts under the aegis of Minimalist art.

A number of factors were involved in the abrupt change. There was a rising disenchantment with the same urban culture and industrial technology which in a more innocent moment had accounted to a great extent for the prefabricated character and geometric structures of Minimalism. The revived interest in deserts, mountains, geological strata, and primal states of matter not only betrayed a certain romantic primitivism, but could also be rationalized in terms of the social conditions of a world in uneasy transition. The prospect of giving form to shapeless brute matter appealed to artists who felt they had begun to exhaust the human possibilities of a willed, anthropomorphic and egocentric art.

The deceleration of art into rudimentary organic forms could thus be viewed as a flight from the dynamism of the electric age. Andre's particle forms, Smithson's deflation of cultural artifacts and formal exposition and his interest in a negative, entropic principle all represented a shift in attitude perhaps best evoked by the biological term "de-differentiation." This has been defined as "the reversion of specialized structures to a more generalized or primitive condition, often as a preliminary to major change." The choice of simple, undetailed forms in Minimalism continued with the new Land Art, which turned its back on a mechanized and stagnating urban environment. One of the strongest motives in the artist's flight to the wilderness clearly must have been some deep need to regain spiritual perspective in a situation of undistracted self-communion, out in the vast open spaces of untouched nature. A leading Earthworks artist, Michael Heizer, intoned: "In the desert I can find that kind of unraped, peaceful, religious space that artists have always tried to put in their work."

There were plentiful precedents for working the land in nature traditions dating back in time to the Egyptian pyramids, ziggurats, Stonehenge (with which Andre said he had felt some kinship on a visit in 1954), American Indian sand painting (an influence on Pollock) and burial mounds (which both Barnett Newman and Tony Smith admired), Zen rock gardens, not to mention Gutzon Borglum's presidential heads on Mount Rushmore. Perhaps even more important, as Willoughby Sharp pointed out in the catalogue foreword for his pioneering 1969 "Earth Art" exhibition at Cornell, there were even closer examples which directly influenced the American avant-garde: "Duchamp's *Dust* (1920), the pebbles in Pollock's 1950 glass painting, and Rauschenberg's so-called *Nature Paintings* of 1953." The first (unexecuted) Earthworks proposal of the sixties was Walter de Maria's wry *Art Yard* proposal of 1961, which began: "I have been thinking about an art yard I would like to build. It would be sort of a big hole in the ground. Actually, it wouldn't be a hole to begin with. That would have to be dug. The digging of the hole would be part of the art. Luxurious stands would be made for the art lovers and spectators to sit in." Other important contemporary influences were Allan Kaprow's Happenings, with their emphasis on dispersive

853. WALTER DE MARIA. *50 M³*. 1968.
1600 cubic feet of earth. Installation view,
Heiner Friedrich Gallery, Munich

materials in large-scale environmental situations, and the speculative writings of Robert Morris, which questioned the nature of sculptural experience.

Land Art did not become official until successive Earthworks shows were held at the Dwan Gallery and Cornell University, in 1968 and 1969 respectively. The potential of natural forms and large-scale land masses as artistic mediums was discovered and exploited. Morris had speculated after his 1964 Green Gallery show: "Why not put the work outside and further change the terms?" In 1966, he made an unexecuted plaster model of what was intended as a large circular

form of sod-covered earth, *Project in Earth and Sod*. That same year Smithson became artist-consultant for an architectural firm charged with building the Dallas–Fort Worth Regional Airport, and he proposed a *Tar Pool and Gravel Pit* as his project. He also invited other artists, including Morris and Lewitt, to contribute proposals. Carl Andre in 1967 poured sand through a hole in the ceiling to form a small conical earth pile in the "Monuments and Tombs" exhibition at the Museum of Contemporary Crafts in New York.

Perhaps the conclusive evidence of a significant shift in art's orientation came with the Dwan exhibition. It included Lewitt's careful record of the burial of a steel cube which he had sunk in the earth "at the Visser House in Bergeyk, Holland." In the show he presented an exhaustive photographic documentation of the cube disappearing into excavated earth. The exhibition also included photos of Walter de Maria's one-man show at the Heiner Friedrich Gallery in Munich. There he had presented a roomful of wall-to-wall dirt, 1,600 cubic feet in all; there were also photos of two mile-long, parallel chalk lines, 12 feet apart, which De Maria had traced in the Nevada desert. In one photograph, the artist was seen spread-eagled, face downward in the sand, between the rapidly converging lines. Oldenburg was represented with his witty *Worm Earth Case*, a Plexiglas box filled with topsoil and nightcrawlers. One of the most remarkable and prophetic pieces

854. ROBERT MORRIS.
Earthwork. 1968.
Earth and mixed media, height 24″.
Installation view, Dwan Gallery,
New York City

855. PETER HUTCHINSON.
Paricutin Volcano (detail). 1970.
Bread and mold, weight 450 lbs.,
length 250'. Collection John Gibson,
New York City

in the show, indicative of future concerns with limp materials and random piles of other substances besides earth, was Morris's heap of dirt, industrial scraps, tar, and petroleum jelly, dumped unceremoniously in the middle of the gallery.

At Cornell the following year, a collection of earth-oriented artists were invited to work outdoors in the actual landscape. The large scale and obvious unsuitability of their projects for conventional gallery or museum situations gave the show even more dramatic éclat. As an example, Hans Haacke, a German-born artist

residing in New York, created a rapidly growing grass mound indoors, and outdoors he strung a cord beneath a freezing waterfall to collect ice. As early as 1963, Haacke had conceived of new applications of "systems" to art and to natural phenomena, which he subjected to conditions of change in permissive environmental situations. Having abandoned the illusionism and willed artifice of conventional art, he turned to the forces of nature as his prime subject or "system."

Haacke was known for his indoors "condensation boxes," which, reacting to changing temperature conditions, produced a continuous process of condensation of a little distilled water; the ever-varied patterns of droplets of moisture forming on the interior Plexiglas surfaces of his transparent cubes were visible graphs of these conditions. In these containers, he worked with imperceptible environmental changes over long periods of time. Thus his art was critically involved with time as well as with patterns of physical transformation, an increasingly important factor in Earth Art, "process" art, and Conceptual Art. The interest in systems, whether physical, biological, cybernetic, or finally societal, later continued with Haacke's serial photographs of seagulls attracted to food put out for them at Coney Island. Recently, Haacke proposed a museum show listing property holdings in Manhattan, with photographs of slum and middle-class real estate—a system which inevitably would have revealed the inter-

856. WALTER DE MARIA.
Mile Long Drawing. 1968.
Parallel chalk lines 12' apart.
Mojave Desert,
Calif. (destroyed)

857. HANS HAACKE. *Ice Stick*. 1966.
Mixed media in copper refrigeration unit,
height 70″. Art Gallery of Ontario, Toronto

locking character of ownership and might have embarrassed some church groups implicated as slumlords. Although there was no explicit social commentary or criticism in the work, the proposal was sufficiently controversial for the Guggenheim Museum to object strenuously to the artist's social "system," and finally to deny him a long-planned and carefully prepared one-man show in the spring of 1971. This act of rejection caused a good deal of hard feeling in the art world for a time, and briefly inspired a boycott of the museum by a large group of leading vanguard artists and critics. The circumstances of the conflict between establishment values and the individual artist are of interest in themselves, but they further suggest that the nature romanticism of Earth Art anticipated Conceptual Art with its systems approach; both methods disclosed a critical or polemical content which could be directed at the ecology in general or at specific patterns of human behavior.

At Cornell, Dennis Oppenheim used a power saw to inscribe channels in a frozen lake in a kind of grandiose outdoors intaglio. Smithson created one of his familiar Non-Sites, a mirror arrangement with gravel piles, opening a dialogue between place, matter samples, and the illusionistic artifice of his mirrors. These were the elements he had already begun to explore with great originality in his New York shows.

Earlier, he was linked with Primary Structurists and Minimalists by reason of the uniform,

858. HANS HAACKE. *Shapolsky et al Manhattan Real Estate Holdings—a Real Time Social System as of October 1, 1971*. Photograph and the following description were to have been displayed at the Solomon R. Guggenheim Museum, New York City, in 1971:

228 East 3rd Street
"Block 385, Lot 19
24 × 105′, 5-story walk-up old law tenement

Owned by Harpmel Realty, Inc., 608 East 11th Street, New York City.
Contracts signed by Harry Shapolsky, President (1963); Martin Shapolsky, President (1964).

Acquired from John The Baptist Foundation c/o The Bank of New York, 48 Wall Street, New York City, for $237,000 (also 5 other properties).

$150,000 mortgage (also on 5 other properties) at 6% interest as of Aug. 19, 1963, due Aug. 19, 1968; held by the Ministers and Missionaries Benefit Board of The American Baptist Convention, 475 Riverside Drive, New York City.

Assessed land value $8,000, total $28,000 (1971)."

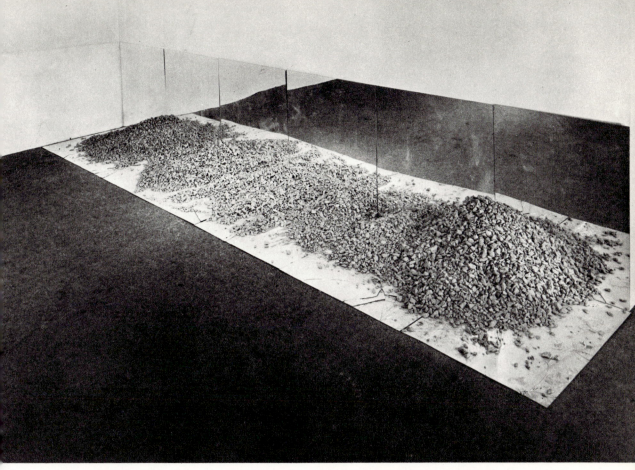

859. ROBERT SMITHSON. *Gravel Mirror with Cracks and Dust.* 1968. Mirror and gravel, 3′ × 18′ × 3′.
John Weber Gallery, New York City

860. ROBERT SMITHSON.
A Non-Site (Franklin, N.J.). 1968. Aerial map, photograph

861. ROBERT SMITHSON. *Six Stops on a
Section 4. Mt. Hope* (detail). 1968.
Painted steel bin with sandstone, 8 × 24 × 8″.
John Weber Gallery, New York City

modular forms he favored, inspired by his interest in crystallographic structure. Then, he pursued a more challenging and lucid art of a strongly conceptual character. His Non-Sites translate the traditional idea of the artist planted in the landscape before an outdoor motif into a new set of contemporary operations and coordinates whose surprising terminus might be no more than a bin of rock samples. Among the abandoned quarries and mining wastes of New Jersey and Pennsylvania, Smithson collected rock fragments. He then arranged them in random piles for his gallery exhibitions, in anonymous, fabricated metal or wood containers.

As a kind of internal commentary, the bins of brute materials were documented and amplified by site plans and blow-ups of topographical and geological maps of the areas where they had been excavated. With an Instamatic color camera, which for Smithson played a role comparable to the sketch pad of artists on the nineteenth-century grand tour, he photographed his sites and rock samples. Multiple levels of his chosen slice of reality and of the art process were thus set before the spectator: a diagram or site plan, photographic record, and finally the geometricized bin of rock fragments. Smithson's interest in nonurban rubble and natural waste had primitivistic and picturesque implications. His collections could be read as a reproach to urban experience and to the kind of sophisticated art, oriented to industrial technology, which it fosters.

Smithson's probing of the timeless wastes of geological nature was essentially a romantic enterprise, anti-technological in spirit, allied to the efforts of other Earthworks artists who took the whole earth as their studio. They have built immense mounds, moved huge boulders, cut mile-long trenches in tracts of desert land, and drawn in nature on a vast scale using the formal design models of modernist abstraction. Like the products of modern technology, these visual conventions are in themselves a late refinement in the evolution of man's mind; but they seem to lose themselves ineffectually in the pitiless wastes of nature. The defeat of modern abstract art by nature seems to be one possible reading of the symbolism of the new art. There is also perhaps an element of Duchampian irony in Smithson's personal, quixotic rationalism. His aesthetic systems have built into them a certain inconclusiveness and futility, for they demonstrate that intellectual propositions, data gathering, and abstraction all leave us finally with only a handful of dust or rocks, even when the conception underlying the act is clearly controlled by a fine artistic intelligence.

The son of a geologist, Michael Heizer has a background of familiarity with the world of nature. The giant trenches which he has gouged into the Nevada and California desert, his "depressions" or "negative objects," as he calls them, may be viewed as a form of protest against the overcrowded modern world of artifacts and art objects. Unlike most of the Earth artists, he is indifferent to a systematic documentation of his large-scale Earthworks, although he usually brings back photographs, slides, and a cursory film record of his excavations. In a recent vast enterprise of earth moving, *Double Negative,* where in two square miles of desert he excavated some 40,000 tons of sand and rock, the full impact of the completed project was reserved for those who could actually experience it directly. The sense of its grandeur thus becomes as inaccessible and abstract as the feat of conquering some particularly remote and dangerous mountain peak which only the rare, intrepid mountaineer who has actually made such a climb can fully experience, and then only inadequately report. A good deal of the quality and impact of Heizer's "works" must simply be taken on faith, since few of us will ever visit his sites; the forms themselves are simple-minded, and the photographs generally unrevealing. The scale, loneliness, and ambition of his projects nevertheless do manage to impress, even when their power is only dimly reflected in photographs. Like the Ohio Indian mound builders' 1,200-foot Great Serpent, a work of this kind can never be taken in all at once; it is best appreciated from an aerial view, although the on-site experience, at eye level, is undoubtedly even more grandly overwhelming.

The scale of immense outdoors works is best contemplated in the context of Marshall McLuhan's shrinking "global village." Visual scale and information are constantly contracting as the demands of the communications network tame their grandeur. Unimaginable technological advances now make almost any conceivable physical act seem possible, and our conception

862. **Dennis Oppenheim.**
Canceled Crop. 1969.
Grain field, 1000′ × 500′.
Finsterwolde, The Netherlands

863. **Christo.** *Wrapped Coast, Little Bay, Australia.* 1969. Surface area of entire project 1,000,000 square feet

of the immeasurable has been seriously compromised. The hyperbolic habits of large-scale outdoors thinking are dramatized by Heizer's own observation that even nuclear explosions can now be rented. Nonetheless, Heizer still holds out some hope for the mystery of the illimitable, the everlasting Pascalian abyss. "Man will never create anything really large in relation to the world—only in relation to himself and his size," he writes. "The most formidable objects that man has touched are the earth and the moon. The greatest scale he understands is the distance between them, and this is nothing compared to what exists." The sense of a shrinking world only enlarges the awesomeness of the remaining infinitude of space and time, and the persistent idea of immeasurability connects Earth Art still to romanticism, which viewed man as a mere dot in the cosmos.

Dennis Oppenheim has also experimented widely with Earthworks, distribution pieces of scattered materials, and most recently with Bodyworks, which are self-referential events utilizing his own physique. He has plowed wheatfields in simple geometric forms, covered a parking lot with rock salt, and created from a small excavation of the foundations of a museum a finely ground sample, arranged in tidy, concentric piles, of its component physical materials. There may well be an element of aggression in thus shrinking a museum down to a neatly geometric mound of its patterned, refined rubble. Yet it is the strongly anti-urban and environmental sensibility of Oppenheim's "sculpture" which leaves the most durable impression. Not only does his art present refreshing solutions to exhausted sculptural conventions, but it demonstrates a new concern for the world's ecology in the effort to revive a more meaningful interaction between man and nature. Earthworks remind us dramatically and rightfully of the natural order of reality, and our indissoluble bonds with nature. A psychoanalyst recently made perhaps the most meaningful if obvious commentary on this strange artistic phenomenon: "The works of these innovators are an attempt to be as big as the life we live today, the life of immensity and boundless geography. But it's also the manifestation of a desire to escape the city that is eating us alive, and perhaps a farewell to space and earth while there are still some left."

864. ALAN SARET.
Untitled. 1970.
Building cornices and doors
of wood and glass, height 10′.
Collection the artist

865. MARJORIE STRIDER. *Window Work*. 1970. Urethane foam and venetian blinds, as shown at the Whitney Museum of American Art, New York City.
Height 4′9″, length 13′1″. Collection the artist

866. RICHARD VAN BUREN. *Untitled*. 1970. Fiberglas and mixed media, 9'3" × 15' × 6".
Bykert Gallery, New York City

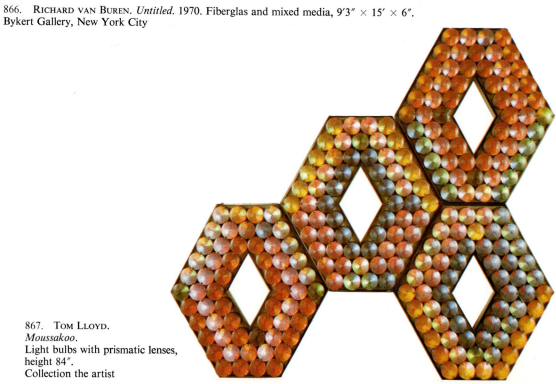

867. TOM LLOYD.
Moussakoo.
Light bulbs with prismatic lenses,
height 84".
Collection the artist

868. DE WAIN VALENTINE. *Concave Circle*. 1970.
Cast polyester resin, height 94″.
Collection the artist

16 · Art as Action and Idea

As THE EARTHWORKS ARTISTS tended to emphasize the post-facto, documentary character of their outdoors monuments, it became clear that a dialectic was encouraged between artistic event and idea. For example, in his *Below Zero Snow Projects,* Dennis Oppenheim had workmen cut irregular circles into the snow and ice of a frozen river in Maine. *Annual Rings* was the name of one of these impermanent projects; the evidence of the event disappeared with the onset of spring, and only the photographic record remained. The artist described his activities in this way: "I am feeding alien topographical information onto a different land area. I'm turning a biomorphic object into a geometric object." John Gibson, a dealer who tried to arouse the interest and backing of patron-collectors for a number of these vast Land Art projects, described Oppenheim's schemes as a kind of "visionary sculpture," and himself as an "idea broker." Earth Art thus showed a tendency to become increasingly disembodied, to sublimate into a kind of cerebral memory art along the lines of the program which the English artist Richard Long announced in his carefully explicit title, and then dutifully executed: "Walking a Straight Line for Ten Miles, SW England, Shooting Every Half Mile. Out. Back." The shooting in question was done every half mile as programed, with a camera aimed down at the ground. The visual record became the artistic proof of the activity and, indeed, in the end the photographic medium often seemed as significant as the live project.

It took only one more step to invest the idea or "concept" with more importance than either the event or its photographic record, although usually some sort of visible or verbal evidence remained even when essentially nonvisual activities were represented. The process of dematerialization became a major feature of the Conceptual Art of the late sixties, and it was brilliantly summarized in an influential article.[1] Certain aspects of Primary Structure art had already paved the way for the deemphasis of the art object as product, and its reinvestiture as "process." The reduction of forms to simple geometric entities which could be taken in at once as a single-image gestalt had obvious connections with Conceptual Art.

The logic of the transition to conceptualism was explained some years later by the artist Ian Wilson, whose interest in art as "oral communication" and information rather than visual form can be traced back directly to the idea content that underlay his Primary Structures. "I am not a poet," he wrote, "and I'm considering oral communication as a sculpture. . . . If you take a cube, someone has said, you imagine the other side because it's so simple. And you can take the idea further by saying you can imagine the whole thing without its physical presence. And you still have the essential features of the object at your disposal. . . . You're just moving this idea of taking a primary structure and focusing attention on it."

A telling blow in the destruction of the object was dealt by experimentation with impalpable or invisible forms. In the early sixties, Sol Lewitt had fabricated a metal cube and then buried

[1] Lucy Lippard with John Chandler, "The Dematerialization of Art," *Art International,* February, 1968.

it in the ground in Holland. Like so many later acts of Conceptual Art, the unfolding process of visual disappearance was documented in a series of still photographs, and once again the documentation raised questions as to which aspect of the sequence of events constituted the essential art experience: the physical cube itself, the act of burial, the photographic medium (with its grainy imperfections of surface and seemingly haphazard sequence of shots), or memories of the event in the mind's eye of observers. In a similar act, which inevitably recalls the Dadaists' solemn hoaxing of a gullible public, Claes Oldenburg in 1965 commissioned two professional gravediggers to excavate a sizable rectangular hole in the earth behind the Metropolitan Museum in New York, near the monumental obelisk, "Cleopatra's Needle"; after they had finished digging, he had his gravediggers fill in the hole. This so-called *Placid City Monument*, like Lewitt's invisible metal cube, was equally intriguing for its conceptual emphasis and for a continuing attachment to the conservative, Euclidean form-language of abstract Constructivist tradition.

871. RICHARD SERRA.
Pulitzer Piece (one of three plates). 1971.
Cor-Ten steel, 5′ × 60′ × 2″.
Collection Joseph Pulitzer, Jr., St. Louis, Mo.

870. MICHAEL HEIZER. *Double Negative*. 1969.
40,000 tons of displaced earth, River Mesa, Nev.

To an extraordinary degree in the last years of the decade, idea rather than physical mass or visual definition became the controlling feature of new art. Lewitt described the idea as "the machine that makes the work."[2] The artist's aim, he wrote, is "not to instruct the viewer, but to give him information. Whether the viewer understands this information is incidental to the artist. . . . He would follow his predetermined premise to its conclusion, avoiding subjectivity. Chance, taste, or unconsciously remembered forms would play no part in the outcome. The serial artist does not attempt to produce a beautiful or mysterious object but functions merely as a clerk cataloguing the results of his premise." The object thus became the visual residue or end product of a highly calculated and rationalized action. Much of the traditional satisfaction with sensuous form and composition was replaced by the pleasure of

[2]Sol Lewitt, "Paragraphs on Conceptual Art," *Artforum*, Summer, 1967.

872. SOL LEWITT. *Untitled.* 1966.
Baked enamel and aluminum, 60″ cube.
John Weber Gallery, New York City

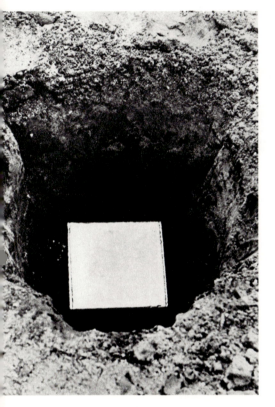

873. SOL LEWITT. *Box in the Hole.* (Photographic report
on a cube that was buried at the Visser House
in Bergeyk, The Netherlands, July 1, 1968),
from a notebook prepared for the
Earthworks exhibition, Dwan Gallery,
New York City. May, 1968

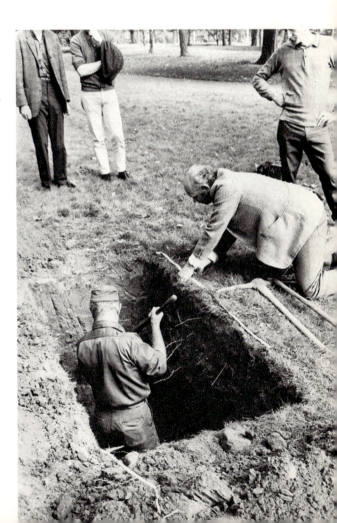

874. CLAES OLDENBURG. *Placid City Monument*
(executed by professional gravediggers, October 1,
1967, in Central Park behind the Metropolitan
Museum of Art, New York City). Artist's descrip-
tion of work:
"1. 108 cubic feet of Central Park excavated and
reinserted.
2. Underground sculpture, consisting of the
material in an excavation 6′ × 3′ × 6′ deep, in
Central Park, and reinserted.
3. Environmental sculpture, consisting of the
material in an excavation, its relationship to its
surroundings and all related objects, persons, and
events—past, present, and future.
4. An event, consisting of the breaking of Central
Park ground and its consequences—from the action
of the shovel through the actions of press and
bureaucracy.
The work is a gift to the City of New York by the
artist."

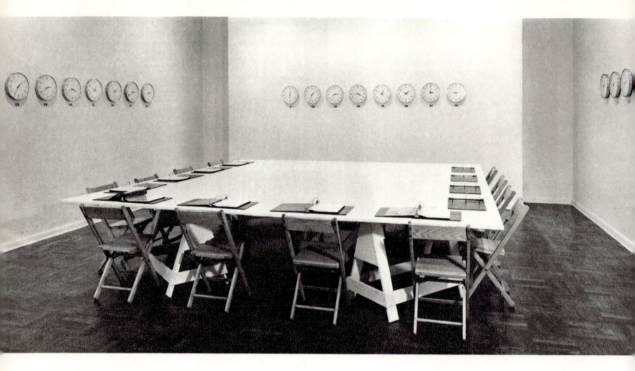

875. JOSEPH KOSUTH. *The Eighth Investigation*
(*AAIAI*), *Proposition Three*. 1971.
24 clocks and 12 notebooks.
Sponsor: Count Giuseppe Panza di Biumo, Milan

almost blindly working out an intellectual prob-
lem. Despite the cerebral emphasis, even the
end product's character remained "intuitive,"
in Lewitt's words.

The attitude behind Conceptual Art is com-
plex in its origins and motivations. On one level,
it represents a familiar pattern of questioning the
formal premises of past art—indeed, even those
of Minimalism. On another, it is a point of view
clearly involved with science, technology, and
sophisticated communications systems, directly
as well as metaphorically. Communications
techniques and information systems have given
an increasingly depersonalized and abstract
character to our highly organized industrial
society in the electronic age. In his controversial
and intellectually challenging book *Beyond
Modern Sculpture,* Jack Burnham argued that
new art expressions were transitional to the new
cultural forms of a utopian society in the mak-
ing, and that strange and unfamiliar art repre-
sented the "passing to a new form of civiliza-
tion." He argued that sculpture would
progressively abandon individual objects and
traditionalist preoccupations with physical
scale, volume, mass, presence, or expressiveness,

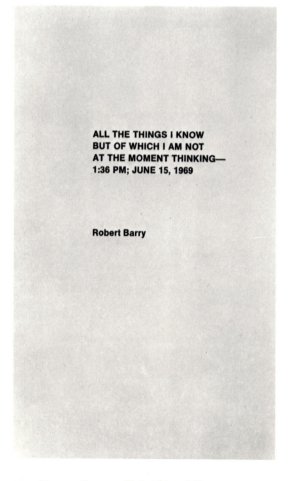

ALL THE THINGS I KNOW
BUT OF WHICH I AM NOT
AT THE MOMENT THINKING—
1:36 PM; JUNE 15, 1969

Robert Barry

876. ROBERT BARRY. *All the Things I Know . . .*
A page from *Changing: Essays in Art Criticism,*
by Lucy R. Lippard, p. 297

until it became dematerialized entirely and evolved into yet unknown forms closer to the informational systems and patterns of organization that control our automated lives in an irreversibly technological society.

Artists like Douglas Huebler and Lawrence Weiner typified one particular method of subverting the familiar art object. They dealt with time-space elements alternately in a scrupulous documentary manner or with a quixotic disregard for the end result of their activities, including even the process of ratiocination itself which was presumably their major focus. Douglas Huebler's *42nd Parallel* consisted of 21 postal receipts mailed from 21 towns along the 42nd parallel between Truro, Massachusetts, near his home, and a town in California. A map of the marked towns became part of the completed work, which represented a controlled movement in time tracked across a carefully documented space. Huebler's other serial works introduced photographs of places, and sometimes simply verbal data or descriptive matter without visual form. "Art," he declared, "is a source of information. . . . The work concerns itself with things whose inter-relationships are beyond perceptual experience. Because the work is beyond perceptual experience, awareness of the work depends on a system of documentation."

Weiner is more purposefully ironic—scarcely iconic at all—in his verbal messages, propositions, and instructions, which by themselves exclusively constitute his "works." Indeed, he literally sells ideas, like a Madison Avenue creative director, often putting his would-be collector in the position of doing-it-himself. One idea he proposed and subsequently sold to a patron was: "A 2-inch-wide 1-inch-deep trench cut across a standard one car driveway." Another of his so-called "time" pieces required the following operation: "Three minutes of forty-pound pressure spray of white highway paint upon a well-tended lawn. The lawn is allowed to grow and not tended until the grass is free of all vestiges of white highway paint." In perhaps his most cryptic work, recorded in the Jewish Museum's "Software" catalogue of 1970, Weiner specified a series of rather discouraging options calculated to deepen the credibility gap between the artist and his audience by confounding one's sense of logic:

"1. The artist may construct the piece.
2. The piece may be fabricated.
3. The piece need not be built.

Each being equal and consistent with the intent of the artist. The decision as to condition rests with the receiver upon the occasion of receivership."

Weiner's Duchampian play on words and options, which comments critically upon the artist-patron relation, is not nearly so outrageous as some of the Dadaists' scurrilous puns or the insulting instructions they issued to their audiences. Despite their more deadpan and laconic language, the Conceptualist conundrums can still mystify and frustrate the spectator's interest by denying him access to a visible object, or even to a reasonable plan of action. The self-protective solipsism involved in such propositions reached an extreme of some kind in Robert Barry's whimsical "piece":

All the things I know but of which I am not at the moment thinking—1: 36 P.M., June 15, 1969, and again, in the following formulation, which would undoubtedly appeal to any fanciful child: *Something which can never be any specific thing.*

Perhaps significantly, Barry had evolved from a Minimalist painting style of single lines, to white surfaces with marked edges, to sculpture of nearly imperceptibly fine nylon lines stretched across interior or outdoor architectural spaces. Then he experimented with inert gases which he released into the landscape, and finally he evolved an art of purely verbal conceits like those above. The exclusive reliance on language probably began with Joseph Kosuth's "Art as Idea as Idea," an art system whereby the artist photocopied and then presented as enlarged wall labels definitions of abstract words taken from the dictionary. The British Art and Language group and other exponents of "Concrete Poetry" also looked upon words and oral discourse as a visualizable, tangible quantity. Reversing McLuhan, one might say with them that the message was the medium.

The unrelenting cerebralism of Conceptual Art derived from such sources as Duchamp's interest in ideas, Happenings, the propositions and "events" of the Fluxus group (a group of Neo-Dada artists active in New York in the fifties), and the Zen-influenced riddles posed by John Cage. Cage in particular had a way of

877. BRUCE NAUMAN. *Untitled.* 1967.
Rope and wax over plaster, width 26″.
Collection Mr. and Mrs. Robert C. Scull,
New York City

878. BRUCE NAUMAN.
Self-Portrait as a Fountain. 1966 (released 1970).
Photograph, 19¾ × 23¾″

awakening fresh perceptions by confronting the spectator with himself, with his own naked experience. There is, however, a significant difference from such antecedents in the use of the verbal medium by present-day Conceptual artists. Words and proposals have today been divorced from the audience and from a theatrical situation. The ideas and actions schematized have become wholly self-referring, concerned with extending the definition of art by making the artist's awareness of his own reality more acute, visible, or conceivable. The self-referential quality of the Conceptualists' propositions belongs less to the genre of audience-participation games than to a kind of nonmaterialized, visionary sculpture, which very often includes the performer's own body and physical actions. The Conceptual artist is too intent on redefining his own reality in relation to art and language to consider directly involving spectators in the creation of his piece.

Whether in word pictures or by body manipulations, which are often transmitted on film and videotape by such artists as Bruce Nauman and Keith Sonnier, he envisions himself as a solitary performer. He seems indifferent to his audience, and wilfully cuts himself off from it like a Beckett or Ionesco character, acting out his alienation in a new kind of soliloquy of verbal conundrums, or through the most elementary contact with his own physical existence, with the goal of expanding the dimensions of his own consciousness. As Michael Kirby put it: "In the new art form under discussion, the 'thing' has moved inside the body so to speak. The actions of the person himself become the object of his own attention.... Since the object of the esthetic

879. LUCAS SAMARAS. *Autopolaroids.* 1971. Pace Gallery, New York City

880. EVA HESSE. *Expanded Expansion*. 1969.
Rubberized cheesecloth and Fiberglas,
height 10′, length varies from 15′ to 20′.
M. Knoedler & Co., New York City

physical energy over a certain time period.

Between 1966 and 1969 there were a number of significant exhibitions that explored unfamiliar materials and, by implication, the dimension of time. Although these exhibitions seemed opposed in spirit to the dematerialized

881. KEITH SONNIER. *In Between*. 1969.
Plate glass, latex, light bulbs, 96 × 48″.
Collection Bruno Bischofberger, Zurich

experience has become the self-perceived behavior of an individual, I refer to the form as 'Activities': One performs 'an Activity.' "[3]

A helpful approach to the elusive and often perfunctory nature of Conceptual Art and related Bodyworks might be to analyze a simple triad of their constituent elements: materials, process, and the performance medium in time. One way or another, almost all the radical new expressions have involved either an action or its schema, and thus even physical movement or the unfolding of an "event" have dealt as much with the element of time as with space. All the "information" about a typical Minimalist sculpture, like a Don Judd box, could be absorbed in an instant of perception. But the art forms that evolved late in the sixties made the viewer more conscious of time and of artistic activity as a developmental situation. Even the new involvement with brute materials could be understood as a way of demonstrating that art was the direct product of the expenditure of

882. BILL BOLLINGER. *Untitled*. 1968.
Steel wire screen, height 8′.
Collection the artist

[3]Michael Kirby, *The Art of Time* (New York: Dutton, 1969), p. 155.

883. Installation view of group show *9 at Leo Castelli*. Works by Richard Serra (background, left and right), Steven Kaltenbach (center), and Giovanni Anselmo (foreground). Leo Castelli warehouse, New York City. 1968

884. ROBERT MORRIS. *Untitled*. 1967–68.
Felt, size variable.
Collection Philip Johnson, New York City

885. RICHARD SERRA. *Casting*. 1969.
Lead, c. 25′ × 25′.
Leo Castelli Gallery, New York City (destroyed)

art of the Conceptualists, they were in fact closely related to the space-time concerns of the more disembodied and cerebral art forms. Artists introduced flexible, nonrigid materials which lent themselves to visible manipulation. Even organic matter, whose condition could be

altered progressively in the course of an exhibition, was utilized. Artistic "procedures" or the "process" which went into the making of the work began to assume more critical interest than the end product. As early as 1966, the critic Lucy Lippard assembled an exhibition called "Eccentric Abstraction" at New York's Fischbach Gallery, and there a new kind of material object—shabby, soft, vulnerable looking, and spatially unsubstantial—made its appearance. Because of their malleable nature, these materials preserved a visible record of process as the work evolved. Among the artists Miss Lippard showed were Eva Hesse, Keith Sonnier, Bruce Nauman, Louise Bourgeois, and Alice Adams. Two years later, in 1968, Hesse, Sonnier, and Nauman joined Richard Serra, Stephen Kaltenbach, Bill Bollinger, and Alan Saret when they exhibited even freer, more dispersive works in a show organized for the Leo Castelli warehouse spaces by Robert Morris, who rationalized the new tendency in numerous *Artforum* articles under the designation of "anti-form."

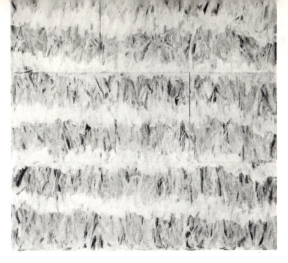

886. ROBERT RYMAN. *Untitled*. 1969.
Enamel on corrugated paper, 15′ × 15′.
Collection Gian Enzo Sperone, Milan

887. RICHARD TUTTLE.
Violet Octagon; First Green Octagon;
Red Octagon. 1967. Dyed canvas, each piece c. 55 × 53″.
Betty Parsons Gallery, New York City

888. DOROTHEA ROCKBURNE.
Gradient and Fields. 1971.
Paper, cardboard, nails, charcoal, 55 × 96″.
Bykert Gallery, New York City

The new kinds of interaction evident between materials, the time element, and artistic process —with the added temporal situation of the gallery exhibition itself included, since it was ephemeral and unrepeatable—were suggested by the critic Max Kozloff in his review of the exhibition Morris had arranged: "Instead of being dismantled, unhooked, dollied, and crated, these sculptures will have to be rolled up (Bollinger), swept in a pile (Saret), chipped and chiseled from a corner (Serra), scraped and scrubbed from a wall (Sonnier)." Writing of the new "anti-form" aesthetic, Morris declared: "Random piling, loose stacking, hanging, give passing form to the material. Chance is accepted and indeterminacy is implied since replacing will result in another configuration. Disengagement with preconceived enduring forms and orders for things is a positive assertion. It is part of the work's refusal to continue estheticizing form by dealing with it as a prescribed end."

By utilizing flexible or extensible materials such as his random heaps of felt strips or of organic matter (which he changed daily during his Castelli exhibition), Morris implied a physical activity in time. Other materials that began to appear in contemporary exhibitions were flour, powdered graphite, hay, grease, leaves, melting ice blocks, vinyl plastic, cheesecloth, gauze, rubber, industrial flocking, and dirt; these were for the most part subaesthetic, almost despicable substances which defied the slick industrial techniques of Minimal sculpture and could be better associated with subversive "anti-art" elements. Above all, however, they had the capacity to reveal process and change either in their flexibility or in their organic mutability.

The interest in process was actually shared by a rather wide spectrum of artists by 1970, from the devotees of "anti-form" to the Conceptualists. Both groups were invited to participate in the Whitney Museum's 1969 exhibition "Anti-Illusion: Procedures/Materials," a show that demonstrated the widespread concerns of artists with less rigid materials and the new focus on the art-making process as conclusively as the "Primary Structures" show at the Jewish Museum three years earlier had installed Minimalism as a prevailing tendency. However, one should note that a lively interaction has continued between the two attitudes, between a geometric, formal art of intellectual control and a more sensuous, materials-oriented expression. There had been an earlier parallel in the fertile interaction between the spontaneous gestural paintings of Pollock and de Kooning and the more severely conceptual work of Newman and Reinhardt.

The emphasis on unusual materials was divorced completely, however, from the confessional or self-probing psychology of Expressionism. Richard Tuttle's unframed, dyed, nailed-up pieces of cloth by their very modesty commented on the status of painting as an "anxious object," thus reflecting more of a philosophical than a psychological problem. Robert Ryman's stapled wall hangings and paint on paper often seemed to parody the conventions of painting in their mechanically rendered and redundant brush strokes. Yet they somehow preserved the bare rudiments of pictorial art even as they abandoned the frame, spatial depth, illusionism, and most other features that identified it. Despite its physicality, then, much "anti-form" art was philosophically as demanding as the nonvisual experience of Conceptual Art. Both types of work gained a special interest by being borderline cases, as it were, defining the outer limits and hence the most promising possibilities of vital contemporary creation.

In addition, such related works as the lead splash pieces of Serra and the crumpled wire mesh, wooden flotsam, and rags of Saret emphasized the renewed importance of the act of creation, and this in turn could be linked to the documentary exposition of much Conceptual Art. When Serra made an excruciatingly protracted film of his barely perceptible hand movements, and Sonnier experimented with redundant and duplicating images of himself on videotape, or Nauman used the same medium to expose distortions of his features, like a child in a funhouse mirror, it was an elementary activity attenuated in time which was their common subject matter.

The situation of open possibilities which confronted artists in the first years of the seventies allowed a variety of means and many fertile idea systems to coexist, reconciling through the poetic imagination apparent contradictions. Brute materials coexisted with nonvisual idea art, random piles of non-art stuff with carefully

889. BARRY LE VA. *Cleaved Wall* (detail). 1969–70. 24 meat cleavers, entire work c. 13′ × 36′ (destroyed)

890. ROBERT ROHM. *Untitled.* 1971. Wood, rope, sandbags, drop lights, height 8′. Collection the artist

891. RAFAEL FERRER. Installation view at the Whitney Museum of American Art, New York City. *Ice and Leaves.* 1969. 15 cakes of ice, weight c. 4500 lbs. (destroyed)

892. GORDON MATTA-CLARK. *Glass-Plant.* 1970–71. "Service area in an empty elevator shaft under the sidewalk at 112 Greene Street. Top half bottle collection, later melted into glass ingots; bottom half mushroom garden. Work donated to landfill."

wrought systems of order and geometric struc-
tures fabricated by anonymous metalworkers.
The effort to make art over into something more
accessible by democratizing its unpretentious
means was opposed by the remoteness and
inaccessibility of Earthworks sites, or the her-
meticism of Conceptual Art's word games.

Whatever their loyalties or tendencies, all these
artists rejected easy means and the status quo.
They shared with the heroic generation of pio-
neers of American abstract art after the Second
World War, the Abstract Expressionists, a
willingness to push art to its limits. This has
meant more than merely testing established con-
ventions, for it has challenged the very way we
regard artistic work, its ultimate value, and the
act of perception. Nor can that intellectual
challenge be readily dismissed, no matter how
absurd or intrinsically negligible some of the
projects or proposals may seem to be at first
sight.

The terms of the evolving riddle of modern
art were boldly laid down some time ago by
Marcel Duchamp, who in 1913 envisaged a
constant war of attrition between art and non-
art: "Can one make works which are not works
of 'art'?" he asked. It seems that one can, and
the contemporary artist does so. The fact that
an unusual number of radical and publicly out-
rageous approaches have recently been tried,
from Conceptual Art to "anti-form," should
not deter us. They have become a focus of
interest and experiment on the part of so many
significant contemporary artists that this fact
alone should virtually certify them as legitimate
artistic expression.

* * * * * * * *

The dematerialization of the art object which
was evident in "situational" sculpture and
Conceptual Art found a parallel in another type
of environmental art which even more dramati-
cally captured the popular imagination: the new
marriage of art and technology. The infiltration
of the visual arts by science and engineering has
involved everything from an indefinable shift in
intellectual climate to radical alterations in
artistic imagery, procedures, and materials.
Today, we are a long way from the Victorian
view that science shrivels the soul of art, or from
Charles Lamb's famous lament that Newton

893. LES LEVINE. *Cornflakes* (photograph of 250
boxes of giant-size Kellogg's Cornflakes poured
on meadow), taken at *Place and Process*
show, Edmonton, Canada. 1969

894. RICHARD SERRA. *Frame.* 1969.
16 mm. black-and-white film with soundtrack,
length 800'. Leo Castelli Gallery,
New York City

895. BRUCE NAUMAN. *Studies for Hologram.* 1970. Silkscreen, 26 × 26″. Leo Castelli Gallery, New York City

896. NAM JUNE PAIK. *Charlotte Moorman "Bra for Living Sculpture."* 1969. Television sets and cello. Bra, collection Howard Wise, New York City

had "destroyed all the poetry of the rainbow by reducing it to the prismatic colors." The critic Douglas Davis has pointed out that even C. P. Snow's widely credited Cassandra-like prediction of the subordination of "literary culture" to "scientific culture" has been dramatically disproved by recent collaborations between artists and engineers and the dramatic assimilation to art of technology. The explosive artistic potential of electronic "software" especially is only beginning to be tested, but its impact on art is already as varied as it is pervasive.

Some artists have embraced the new findings of modern science as a saving, millennial vision, while others have turned their backs on them as threats of enslavement and regimentation for the individual. The new kinds of programed sensory stimulation typical of intermedia experiments in the sixties particularly offended those who felt that their physical and emotional responses were being managed. At the same time, however, Marshall McLuhan's view that technology has become an extension of human perception and the central nervous system gained intellectual respectability. McLuhan declared it inevitable and right for the artist to explore the expressive possibilities of man's servo-mechanisms in the communications network.

For others, mechanized environments and art, whatever their rationale, hold no more enduring interest than the multimedia clichés of the entertainment world or the discothèque. Indeed, the phenomenon of environmental art essentially seems linked to the yearning for some facile mysticism on the part of an escape-minded youth culture, and fits the same social scheme that produced deafening rock music, the cult of drugs, "be-ins," and other communal forms of contemporary primitivism.

A general pattern has been evident for some time among young people seeking emotional release from a stultifying technocracy through so-called expanders of consciousness; whether achieved by chemical, artistic, or mass-entertainment means, these experiences have become the mark of the counterculture's disenchantment with an "uptight" adult society whose sense of purpose has recently faltered. Without challenging the validity of the indictment by the young of society's oppressions, it should be made clear that the cultivation of exceptional states through vision and hallucination enjoys a long historical

tradition in bohemian life, going back in time to Samuel Taylor Coleridge and his drug-dreams, Théophile Gautier's "Club des Hachischins," and, more recently, to the Symbolists and "Decadents," and, in our time, to the Surrealists. The familiar romantic/decadent visions of "lilies of gold," "myriad butterflies," and "fireworks displays" were the nineteenth century's equivalents of contemporary psychedelic fantasy—an "artificial paradise," as Baudelaire made clear, which represented an escape "from the hopeless darkness of ordinary daily existence."

Today, however, the visual and aural shock of multimedia environments has replaced the ineffable private dreams of a languishing romanticism with a mass-cult pleasure principle. It takes the form of a heady brew of rock bands, strobe lights, free-form dance, and new kinds of audience-participation games. Nonetheless, the essential mysticism of the new participatory aesthetic can be related still to the advice Timothy Leary gave his constituency in the youthful counterculture some years ago, when he wrote: "We're trying to tell the youngsters that the psychedelic movement is nothing new . . . the hippies and the acid heads and the new flower tribes are performing a classic function. . . . The empire becomes affluent, urbanized, completely hung up on material things, and the new underground movements spring up. . . . They're all subversive. They all preach a message of turn-on, tune-in, and drop-out."[4]

Recent alterations in art forms and attitudes, conditioned by technology, also reflect a profound shift away from the old machine culture in an age which emphasizes information theory and a systems aesthetic. In his prophetic book *Beyond Modern Sculpture,* the critic Jack Burnham describes the artistic metamorphosis taking place as an evolution "from the direct shaping of matter to a concern for organizing quantities of energy and information." The new "artistic machines" of our time, for example, are responsive to stimuli programed and electrified; and our dematerialized environments have little to do with mechanistic lore. Some of these profound changes were summarized by

two exhibitions held in New York in the late sixties. The Jewish Museum in 1965 showed "Two Kinetic Sculptors: Nicolas Schöffer and Jean Tinguely," contrasting mechanical and electronic cultures and two antithetical artistic attitudes towards technology. In 1968, K. G. Pontus Hulten organized at the Museum of Modern Art an exhibition called "The Machine as Seen at the End of the Mechanical Age." Besides being an invaluable historical survey which demonstrated the important contributions of science to art—from the eighteenth-century makers of automata to the Russian Constructivists, Duchamp, and the Bauhaus—the exhibition presented dramatic new evidence of the obsolescence of machine culture today.

In relation to the modern movement, the machine had in countless ways been a fertile source of inspiration for more than half a century. Italian Futurists seized on it to express their romantic enthusiasm for speed and dynamism. Reacting violently to the mechanized mass destruction of the First World War, the Dadaists created their own version of an infernal machine in a variety of sardonic and fantastic inventions. Calder's mobiles later restored a spirit of optimism and innocent pleasure to the spectacle of first mechanical and then air-driven forms in motion. Ambivalent attitudes of high expectation and mistrust still surround the machine for those who continue to use it directly in their art. In some artists mechanization stimulates hopeful fantasies of a more perfect social order; in others, intimations of dehumanization—fears which Charlie Chaplin's film *Modern Times* unforgettably burlesqued many years ago.

In technical and formal terms the machine has had a stunning impact on traditional art forms, and it was directly responsible for the new category of motion or kinetic sculpture. A wider range of expressive possibilities opened to the artist when, in 1920, the Russian Constructivist Naum Gabo for the first time made an electrically driven sculpture. Kinetic sculpture gained impetus in the thirties with Calder's invention of the mobile, so named by Marcel Duchamp, whose "readymade" bicycle wheel of 1913, mounted on a stool in a parody of the museum art object, was in fact the first motion sculpture of the century. The historical development of kinetic experiment includes many other important episodes: Man Ray's swaying, sus-

[4]From an interview in the Southern California *Oracle,* October, 1967.

897. ROBERT RAUSCHENBERG. *Oracle*. 1965.
Construction in five parts (destroyed)

898. ERNEST TROVA. *Study: Falling Man*. 1966.
Polished silicone bronze and enamel, length 72″.
Whitney Museum of American Art, New York City

899. EDWARD KIENHOLZ. *The Friendly Grey
Computer—Star Gauge Model 54*. 1965.
Mixed media, motorized, height 40″.
The Museum of Modern Art, New York City.
Gift of Howard and Jean Lipman

900. JEAN TINGUELY. *Homage to New York*. 1960.
Mixed media, motorized. Created for the garden
of the Museum of Modern Art, New York City.
©David Gahr, New York

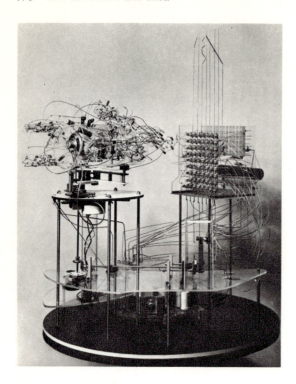

901. JAMES SEAWRIGHT. *Watcher*. 1965–66.
Metal, plastic, electronic parts, height 37".
Collection Howard and Jean Lipman, New York City

902. NICOLAS SCHOFFER. *Microtemps 11*. 1965.
Steel, Duralumin, Plexiglas, motorized, 35⅜ × 24".
Galerie Denise René, New York City

903. ROBERT RAUSCHENBERG. *Soundings*. 1968.
Silkscreen on Plexiglas with electric equipment,
3 rows of 9 panels, each row 8' × 36' × 4'6".
Wallraf-Richartz-Museum, Cologne.
The Ludwig Collection

pended coat-hangers, which innocently anticipated Calder; Tatlin's *Monument to the Third International;* Moholy-Nagy's *Light-Display Machine,* and the animated abstract films of Eggling and Richter.

But the so-called "Movement Movement," a witty epithet coined by the film-maker Hans Richter, gained its real force as a group activity only in recent years, long after its pioneers had ceased to make significant advances. Perhaps the kinetic resurgence could be understood as a reaction to the emotionally stressed, highly individualistic painting and sculpture of the postwar period with its crisis mentality and mood of anxiety. By the late fifties, there was abundant evidence on all sides, ranging from Assemblage and junk sculpture utilizing found machine parts to actual mechanically driven forms, that kinetic sculpture had entered a significant revival.

Schoffer and Tinguely, the two European kinetic sculptors shown at the Jewish Museum, were of particular interest because they defined the polarities of the movement. Tinguely remained attached to machine culture, even though his works were "anti-machine" in their ironies, hectic and uncertain in operation, and always on the verge of breakdown. He enjoyed his greatest moment of celebrity with the remarkable work he created in 1960 for the Museum of Modern Art's garden in New York. It was a suicidal machine entitled *Homage to New York,* which annihilated itself with much sound and fury, and with some unexpected help both from an internal fire and from the municipal fireman who extinguished it, supplying the *coup de grâce.* Schoffer, on the other hand, made use of the new computer technology in a mood of basic social optimism. He called a number of his ingeniously automated and programed sculptures CYSPs (derived from the words cybernetics and spatiodynamics). They moved, rotated on their bases, and projected light shows and color spectacles in response to human presence.

904. DAN FLAVIN.
Primary Picture. 1964.
Fluorescent lights,
30½ × 47″.
Galerie Ileana Sonnabend,
Paris

905. CHRYSSA. *Ampersand III*. 1965.
Neon lights in Plexiglas, height 30¼″.
The Harry N. Abrams Family Collection,
New York City

906. EARL REIBACK.
Lumia No. 4. 1966.
Motorized light sculpture,
time cycle 14 hours,
screen 24 × 32″.
Whitney Museum of American Art,
New York City

907. KEITH SONNIER. *Display II*. 1970. Mixed media with electrified light. Collection the artist

908. LES LEVINE
Contact: A Cybernetic Sculpture. 1969.
Television screens.
New York Cultural Center,
New York City

909. LUCAS SAMARAS.
Autopolaroid (six views).
1970–71.
Collection the artist

910. ERNEST TROVA.
F.M. Study:
Radio Hinge Man. 1970.
Chromium-plated bronze,
height 72″.
Collection
Arnold Scaasi,
New York City

911. L. D. HARMON and K. C. KNOWLTON. *Computerized Nude.* 1971. 50 rows of numbers with 100 fragments per row. Bell Telephone Laboratories, Inc., Murray Hill, N.J.

Such works-of-art-cum-robots were later developed by innumerable American artists who acquired familiarity with sophisticated electronic technology, transistors, and micro-circuitry. James Seawright, for example, created sculptures whose movements, electronic sounds, and light projections were generated by a visible circuitry which became part of the work's aesthetic form. His machines' movements took place in response to changes in the physical environment. (He has described his autonomous machines as "sculpture that happens also to be a machine.") Rauschenberg's *Soundings* and Howard Jones's *Sonic Games Chamber* created environmental art forms which the spectator activated, either intentionally or unknowingly. The new electronic technology made responsive environments and complex machines of this kind, activated by external environmental stimuli, possible for the first time.

At the Museum of Modern Art's machine show it became clear that despite their wit and sculptural power, Tinguely's humorous, animistic collages of discarded machine scraps, like Rauschenberg's earlier radio-controlled junk sculpture *Oracle* (1965), had been superseded by the collectivized works of a new group of artists and engineers who were exhibiting together for the first time at the Museum's show. Headed by Billy Kluver of the Bell Laboratories, the group was seeking to bridge the gap between modern science and art through the exchange of information and the creation of opportunities for joint

912. ANDY WARHOL. *Sleep.* 1966. Silkscreened plastic, 22 × 12″. Leo Castelli Gallery, New York City

experiment. They called their collaboration "Experiments in Art and Technology" (EAT). This new development, dramatized through a competition sponsored within the Museum of Modern Art's show, had actually begun two years earlier, with a series of brilliant performance spectacles organized by Kluver, Rauschenberg, dancers Yvonne Rainer, Alex Hay, and Steve Paxton, and the composer John Cage, among others. "Nine Evenings: Theater and Engineering" was presented in the fall of 1966 at the 69th Regiment Armory on Twenty-Sixth Street in New York, the same one which had once held the Armory Show. The participating artists and engineers invented, among other things, a remote-control dance piece, self-performing musical machines, and infrared-ray television cameras which managed to reveal and transmit onto an enormously magnified video screen images of members of the audience performing simple activities on cue in the dark. After the success of "Nine Evenings," the new foundation EAT was established, and a flowering in environmental and mixed media art began. The egocentricity of art, which persisted even in Tinguely's machines, had finally been subordinated successfully, it seemed, to the anonymity of science.

"Nine Evenings" did not spring from a vacuum. The event was preceded by many years of experimentation with technology by artists, composers, and performers, who attempted to use science to break down the barriers between art and its audience. John Cage was probably the guru of the new environmentalism, for his electronic music had been intimately involved with technology since the forties. He had already composed music with radios, amplifiers, oscillators, contact microphones, and even sounds picked up from outer space. At "Nine Evenings," in *Bandoneon!* his collaborator David Tudor left an ensemble of programed and responsive audio circuits, moving loudspeakers, television images, and lights to make its own random music when activated by the audience, thus creating one of America's first autonomous artistic machines.

While the emphasis on technology was a postwar phenomenon, determined by advances in electronics in particular, the idea of a total environmental theater involving the visual and performing arts dates back in modern times to the late nineteenth century and to Richard Wagner's theory of the *Gesamtkunstwerk*—the total work of art. Not only did the American sound-and-light environments on the esoteric level of vanguard art reflect these new interests, but so did popular spectacles which began to

913. KENNETH SNELSON. *Spring Street*. 1964.
Aluminum and steel, height 30″.
John Weber Gallery, New York City

914. JESUS RAPHAEL SOTO.
Vibration Metalique. 1969.
Mixed media, 10⅝ × 11¾ × 5″.
Galerie Denise René, Paris

915. MARTHA BOTO. *Labyrinthe*. 1965.
Aluminum and wood, lighted, 60 × 60 × 45″.
Collection the artist

916. CHARLES FRAZIER.
Experimental Forms for Flying Sculpture. 1965.
Wood, plastic, rubber. Collection the artist

explore a total theater concept in the sixties. At the New York Worlds Fair in 1964, and again at Montreal's Expo '67, Walt Disney placed contiguous Cinemascope screens around an auditorium and presented synchronized films in a single, unbroken, circumferential image. Stan VanDerBeek in *Moviedrome* and Jud Yalkut had already surrounded spectators with moving film and slide images, but perhaps the most spectacular and popular example of a total filmic environment was Josef Svoboda's Polyvision, displayed at Expo '67. He employed ten film projectors and twenty-eight slide projectors (with 8,000 slides) programed by a computer tape to animate with representational imagery a room full of moving screens, cubes, mirrors, and prisms, devoted to the theme of "Industrial Czechoslovakia."

The pervasiveness of environmental art systems today, whether in kinetic, luminist, or filmic form, had been prepared but not developed with sophisticated means by the pioneers of Constructivist art in the twenties. Innovation had to wait some thirty years until the current obsession with electronic technologies arose. What was perhaps equally important, in the fifties an emerging European tradition of kinetic and optical art created a new sense of the expressive possibilities of these art forms. A significant step towards an original synthesis of technology and art was provided by the famous "Movement" show held at the Denise René Gallery in Paris in 1955. There the Paris-based artists, each

of a different national origin—Soto, Agam, Vasarely, Tinguely, and Pol Bury, among others— sought new kinds of relationships and dynamic involvements with the spectator through art forms that moved or through changes induced by the spectator's eye movements. In the following decade another band of science-oriented artists, calling themselves GRAV (Groupe de Recherche d'Art Visuel), formed in Paris, also around the Denise René Gallery; they showed *Labyrinth,* a collective environment of sight and movement, in New York for the first time in 1962. Not only did their works activate the spectator's space with dynamic kinetic effects, but they also posed an artistic ideal of anonymity and scientific research. By deemphasizing the artist's egoism, and depersonalizing his creations, it was felt that art could be made more democratically

917. THOMAS WILFRED. *Lumia Suite, Op. 158* (portion of screen shown). 1963–64. Motorized light sculpture, three movements lasting twelve minutes repeated continuously with variations, entire screen 6′ × 8′. The Museum of Modern Art, New York City. Mrs. Simon Guggenheim Fund

918. OTTO PIENE.
Stage of "Manned Helium Sculpture," third event in *Citything Sky Ballet*, Pittsburgh. 1970

viable and comprehensible to the layman. In the early sixties, Boto, Morellet, Le Parc, Yvaral, and other GRAV artists produced electrically driven mobiles and light sculptures which seemed to reduce the idea of sculptural presence to pure energy flow. They thus went far beyond Calder's first clumsy, machine-driven Constructivist sculpture or Gabo's rudimentary venture in motion sculpture to evolve new kinds of kinetic art more appropriate to the dynamism of the electronic age.

"Light art" as such, or luminism, also began to make its way internationally only in the sixties. Thomas Wilfred's *Lumia Suites* of the twenties were the modern precedent of emitted light composition. (The idea of the "color organ," however, actually dates back to the eighteenth century, to the Jesuit priest and mathematician Father Castel, who made the first programed light display by using transparent colored tapes illuminated by candlelight.) The changing, amorphous color-shape patterns of Schoffer's color organ of 1960, called *Musiscope,*

which had a keyboard that the spectator could play to control its compositions, and Otto Piene's projected *Light Ballet* of 1958, did not in fact change the essentials of Wilfred's precocious invention three decades earlier in America.

The most important pioneer in postwar European light art, as in so many other areas of fertile innovation, was Yves Klein, the French Neo-Dada artist best known to the public for pressing nude girls smeared with pigment on blank canvases. By the late fifties he had created a blue-light environment which represented only one of his many strategies in a broad campaign

919. JOHN VAN SAUN. *Sterno.* 1969.
Environment of burning Sterno cans,
Richard Feigen Gallery, New York City

922. LES LEVINE. *Standard Equipment*. 1968.
Neon light tubing, height 52″.
Collection the artist

920. (*top*) CHRYSSA. *Positive-Negative*. 1965.
Neon lights and stainless steel, height 11½″.
Wasserman Family Collection, Chestnut Hill, Mass.

921. (*middle left*) STEPHEN ANTONAKOS.
Orange Vertical Floor Neon. 1966.
Neon lights and metal, height 9′.
Fischbach Gallery, New York City

923. (*middle right*) BRUCE NAUMAN.
Window or Wall Sign. 1967.
Colored neon light tubing, height 59″.
Collection Mr. and Mrs. Robert A. Rowan,
Los Angeles

to desanctify the material art object and to soak the world in I.K.B.—the initials stood for the virulent shade of blue in Klein's monochrome paintings and soon became his trademark— "International Klein Blue." Shortly after, three young German vanguard artists banded together in "Group Zero" (they included Klein's brother-in-law, Gunther Uecker) and created a loose kind of outdoor light Happening utilizing powerful arc lamps and searchlights, aluminum foil, soap bubbles, white balloons, and the mobile forms of spectators themselves. For most Americans, Thomas Wilfred's *Clavilux* color organ had existed until then only as a curiosity at the Museum of Modern Art, producing its mildly euphoric "light ballets" and streaming color compositions and anticipating, in a lower key, the soft-edged, bejeweled colors and melting shapes of the psychedelic art which arrived in the sixties. There had been other authoritative precedents for electrified art, such as Moholy-Nagy's *Light-Display Machine* of the thirties, around which a luminist tradition might have been built. However, as was the case with artistic machines and multimedia environments, it took a combination of McLuhanism and the new cult of technology in the sixties—which included the interest in the retinal dynamics of perception, in the form of optical art—to create the necessary climate in America for widespread experiment in a variety of light media.

Chryssa became the first American artist to use emitted electric light and neon rather than projected or screened light. Her imagery was also unique, since its sources were the lettered commercial signs of the urban environment, especially her preferred subjects—the lighted neon signs of Times Square. Some of her early lightbox series contained delicate neon variations on the letters W, A, and the ampersand, aligned in refulgent, parallel banks. The repeating effect of the letters produced resonating light impulses which had the effect of pulsing ripples or waves even though there was no actual oscillation. The kinetic effect was all in the eye of the beholder. Mounted in handsome dark Plexiglas boxes, the curving neon tubes, their electrical connections and interior circuitry were exposed to view. The containing, transparent cubes of light were thus not only visually potent but psychologically involving, for they could be apprehended both as finished forms and as

works-in-progress. Shortly thereafter Chryssa began to program her lightboxes to go on and off, with uncomfortably long waiting periods between the light phase and the dark. The time lapses of light added a new dimension of strain and anticipation to her cunning game of illusionism, and the work now offered itself as both presence and absence, direct and remembered experience.

Stephen Antonakos is another artist who uses neon, but in a more severely structural and monumental form than Chryssa. His intention is obviously environmental, for he means to involve the spectator physically in his zones of alternately brilliant and diffused colored light. Many artists who were later identified with the "anti-form" tendency employed light as incidental element, among them Morris, Sonnier, Serra, and Bruce Nauman, in such quasi-mystical and perhaps ironic assertions of the sacred quality of artistic function as his concentric neon sign called *Window or Wall Sign,* which reads: "The True Artist Helps the World by Revealing Mystic Truths."

Among the motion sculptors who activated material forms in such rapid movement as to create optical imagery and an effect of disembodied energies, perhaps the most remarkable has been New Zealand-born Len Lye. His "Tangible Motion Sculptures" *Fountain* and *Flip and 2 Twisters* were in essence programed machines constructed of exquisitely fine metal components of stainless steel; in motion they created dematerialized tongues of light and a flickering radiance. *Flip and 2 Twisters* whipped about in huge twenty-foot arcs, but its kineticism became transubstantiated, it seemed, in reflected light gleams which created an original kind of light ballet. George Rickey's attenuated stainless-steel blade forms, his eggbeater "space churns," and pairs or quartets of rectangular, uniform volumes move gently, driven by air currents, but their reflective, burnished surfaces also appear to melt away in motion. The sense of weightlessness and immateriality derives from the monumental scale and rhythmic control of movement which Rickey has mastered so admirably in recent years. Using clusters of vibrating steel rods, synchronized strobe lights, and sound modulators, the engineer-artist Wen-Ying Tsa'i in the late sixties created ethereal and illusionistic motion sculptures, dependent on the human

924. GEORGE RICKEY.
Two Lines Oblique, Twenty-Five Feet. 1967–68.
Stainless steel, height 25′.
Collection the artist

925. (*top right*) LEN LYE. *Fountain II*. 1959.
Steel, motorized, height with base 89″.
Howard Wise Collection, New York City

926. (*middle*) LEN LYE. *Flip and 2 Twisters*. 1965.
Steel, motorized, height 9′.
Howard Wise Collection, New York City

927. WEN-YING TSA'I. *Cybernetic Sculpture*. 1968.
Mixed media and electronic equipment, height 42″.
Collection Siv and David Fox, Rye, N.Y.

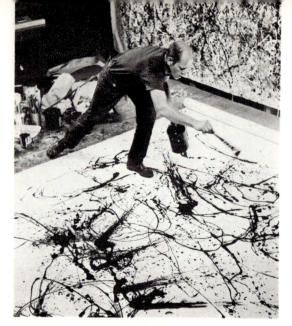

928. Jackson Pollock at work in his East Hampton, Long Island, studio. 1950

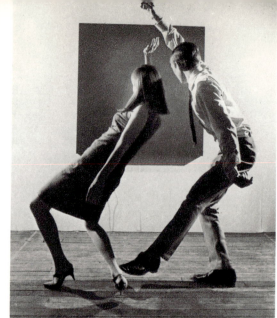

930. HOWARD JONES. *Sonic One.* 1967–68. Aluminum, electronic devices, sound, 4′ × 4′ × 3″. Private collection
"A four-foot-square neutral flat black aluminum unit that responds with sound only when someone moves in front of it. Each movement produces a frequency change. By varying one's motions, the person controls the pitch, with the possibility of creating an unlimited number of different linear sound patterns. All sound is produced by solid state generators within the piece. The interest is in the person in motion before the piece. He is the revelation."

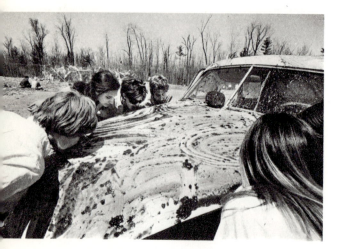

929. ALLAN KAPROW. *Household.* 1964. Happening at Cornell University, Ithaca, N.Y. ("women go to car and lick jam")

voice and emitted sounds for their shifting configurations. The motion sculptures of Len Lye and Tsa'i, in particular, with their illusionistic character, large scale, and their activation either by external stimuli or by a computer program, have transformed the isolated art object into an environmental experience once more.

Actually, "environment" in the sense of an artistically activated space has been a feature of the visual arts since Baroque ecclesiastical sculpture. Among its influential precedents in modern times were the loose arrangements of collage materials in Schwitters's *Merzbau* junk environments; El Lissitzky's Constructivist *Proun Rooms,* which he called "the junction from architecture to painting"; and, closer at hand, Claes Oldenburg's *The Store* of 1961, which re-created the interior of a Lower East Side store in an ironic commentary on derelict commercial culture. A statement made by Allan Kaprow, inventor of Happenings, during that fertile period of artistic change indicates the new interest in environmental events and the shift in focus from pictorial space to the spectator's spaces outside the painting's frame. Kaprow was drawn to the paintings of Jackson Pollock, among the older generation, and discovered in his skeins of paint an activated space and free energy which tumbled over into the spectator's physical and psychic realm. He remembered his first impression of Pollock's work as "that of an overwhelming environment, the paintings' skins rising towards the middle of the room and assaulting the visitor in waves of attacking and retreating pulsations."

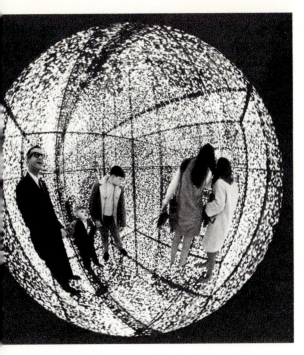

931. STANLEY LANDSMAN. *Infinity Chamber*. 1968.
Coated mirrors, 6000 lights, wood; outer casing 11′ cube.
Collection the artist

932. LUCAS SAMARAS. *Mirrored Room*. 1966.
Wood and mirrors, 8′ × 8′ × 10′.
Albright-Knox Art Gallery,
Buffalo, N.Y. Gift of Seymour H. Knox

In America the idea of a mechanically energized environment, rather than one dependent on the artist's hand-made, dispersive collage works, had to wait until the middle sixties for its flowering. The new environmental art that emerged contained a multitude of phenomena—visual and aural, kinetic, and sometimes olfactory. Some of the most obviously theatrical spaces were essentially light shows, or entertainments which tried to build a sensory overload of sight and sound designed to disorient the senses. A standard example was the euphoric light environments contrived by USCO (US Company of Garnerville), where flashing slide projections, pulsating strobe lights, Mylar sheets, and other devices created a heightened sensory experience and finally a sense of total immersion in an all-enveloping active field, rather like a planetarium visit with dramatic sound effects. A torrent of slide projections with high-decibel rock music made Andy Warhol's *Balloon Farm, Exploding Plastic Inevitable*, and the Electric Circus among the most popular ventures in multimedia. The sensation of visual imagery changing too rapidly to follow coherently and of ear-splitting music created finally a sense of identity loss within an energized enclosure, overpowering the spectator.

At Automation House, recent center of environmentalist activities in New York, one audience-participation project organized by the Architectural League was called "Environment II: Prisms, Lenses, Water, Light" of 1967, described as follows: "Here the spectator actually becomes a part of the environment, seeing and being seen through lenses, unable to avoid the effects of pulsing lights, falling water, and colors and forms reflected onto the walls." The immersion of the spectator in flashing lights, noises, and movement, or, in the case of Lucas Samaras's *Mirrored Room,* in a more meditative environment of infinite reflections of himself, was designed to create alternate moods of pleasurable distraction and a sense of being helplessly lost in a cosmos of external stimuli. Most serious artistic environments, however, such as Stanley Landsman's *Walk-In Infinity Chamber,* reflecting tiny white lights to infinity, were gentler than the multimedia of the discothèques, creating a sense of poetic release in awe and wonder of the kind one perhaps might feel in interstellar spaces. In fact, Landsman's room was described in this way by Ralph Coe, curator at the Kansas City

933. USCO. *Contact Is the Only Love.* 1963.
Mixed media, neon lights, height 8′4″.
Collection USCO

934. ROBERT WHITMAN. *Pond.*
Environment photographed at the Jewish Museum,
New York City, in 1968. Lights, aluminum, plastic,
electronic speakers. Collection the artist

Museum and organizer of the "Magic Theater" —a group of environments staged at Automation House in 1968. "The viewer leaps straight into the fourth dimension," he wrote, "what the astronauts have described as space-walks set down into a format of unbelievably compact esthetic concentration." Works like Landsman's, and Boyd Mefferd's *Strobe-Lighted Floor,* which also formed part of the "Magic Theater," invoked the "inner spaces" of the mind as well as the sense of infinite reaches of outer space. In Mefferd's work the critic Jane Livingston found "the dream-like sensation of having one's head filled with vaguely colored images which endure, multiply and actually seem to assume different shapes, and to expand and contract, to sharpen and fade."

The character of artistic environments began to change markedly in the late sixties. In 1968 Robert Whitman created one at the Jewish Museum called *Pond,* which did not invite but rather confounded the spectator's participatory instincts with its assortment of carefully positioned mirrors. Strobe lights, slide projectors, and a solemn voice intoning over a loudspeaker a series of banal words, which could also be seen flashing across screens, constituted the work. It was a mystifying experience, one that tended to turn the spectator off and move him inward rather than outside himself into a visual-auditory paroxysm of sight and sound. This kind of gentle narcissism, later to be amplified in different ways by the self-obsessed, eroticized Polaroid imagery of Samaras and the energetic Bodyworks of

935. ROBERT MORRIS. *Untitled*. 1969.
Trees, soil, wood, Cor-Ten steel, fluorescent
lights, refrigeration equipment, height 14′, depth 26′.
Installation view of *Spaces*, The Museum of Modern Art,
New York City. 1970

Acconci and Nauman, gave further evidence that the environmental impulse was becoming attenuated. In the same year Robert Morris proposed an environment called *Steam,* which offered nothing more than hot air and promised, according to the catalogue, to "fill the available space." The Pulsa collaborative, a group of seven artists from New Haven, created extensive zones of sound, pulsating light, and heat out of doors, on golf courses and at the Museum of Modern Art garden in the 1969 "Spaces" show. Pulsa's activities depended on chance stimuli in the environment interacting reciprocally with computer programing, and were responsive to such factors as human presence, traffic, and weather conditions. These light environments seemed to show concern not so much with immediate performance or aesthetic effect as with the entire ecology, both rural and urban, and even with the underlying rhythms of society itself.

The "Spaces" show organized by Jennifer Licht inevitably emphasized the progressive dematerialization of contemporary environ-

936. ROBERT MORRIS. *Steam Cloud*. Environmental structure: "steam occupies available space."
1969

937. PULSA GROUP (Oxford, Conn.).
Yale Golf Course Work.
Environment photographed in New Haven, Conn., in 1969

ments since the mixed-media activities of the late 1950s—the environments and Happenings of Kaprow, Dine, Oldenburg, and others, and the tableaux of Kienholz and Segal. Perhaps the most dramatic examples of the new trend toward immateriality in that exhibition were the virtually invisible panels of optically coated glass by Larry Bell, and the nonvisual rooms of Michael Asher, where spatial articulation and perception depended exclusively on sound waves. The acute experience of sensory deprivation and the ethereal character of these environments established ties with Conceptual Art; they encouraged a sense of isolation rather than gregarious participatory impulses, in vacant chambers better designed for meditation than action.

The contemporary artist's interest in technology has inevitably led to more ambitious collaborations with industrial corporations themselves, which recently enlarged their patronage role. The variety of types of assistance offered artists ranges from advice on materials to elaborate programs involving residence for creative individuals within an industry. New synthetic materials have also significantly expanded the possibilities of expression in painting and sculpture. The vacuum-forming process used by Craig Kauffman in his artificially colored plastic reliefs; Larry Bell's meticulously manufactured precision glass, which he produces himself with a "High Vacuum Optical Coating Machine" originally made for the Air Force; and the widespread use of such synthetics as acrylics, urethanes, and polyester resins all testify to the significant changes in the art product brought about by contemporary industrial research. Ron Davis painstakingly constructs his own acrylic reliefs, and like so many West Coast artists he has discovered new sources of sensuous surface alternately in the esoteric space industries of his region and on the Detroit assembly line. He speaks for many artists when he laments that a new Chevrolet is "more perfect" than most art made today. "There are a few Southern California artists," he says, "who seem to be trying to make perfect art, but fall short of the perfection of General Motors."

More significant have been the collaborations between artists and industry on a grand scale, even though the returns are not all in and it is doubtful that the new alliance has been completely successful. The EAT group managed to obtain considerable financial backing from a sponsor for its ambitious Pepsi-Cola Pavilion at the Osaka Worlds Fair of 1970. A structure in the shape of a geodesic dome was built that housed, among other attractions, the world's largest spherical mirror and a full-blown water cloud suspended in mid-air. Perhaps the most ambitious collaborative venture, representing the fruit of a number of years of patient research

938. LARRY BELL.
Untitled. 1970.
Glass with mineral coating,
5 panels, each 72 × 35½".
Pace Gallery, New York City

939. ANDY WARHOL. *Clouds*. 1966.
Helium-filled Mylar, each unit 47½ × 24½″.
Leo Castelli Gallery, New York City

940. CLAES OLDENBURG. *Icebag—Scale A*. 1971.
Polyvinyl, wood, hydraulic and mechanical
movements, diameter at base 18′.
Collection the artist

941. Mirror Dome at the Pepsi-Cola
Pavilion, Expo '70, Osaka, Japan,
designed by Robert Breer,
Forrest Myers, David Tudor, and
Robert Whitman of the *Experiments
in Art and Technology* Group.
A Shinto ceremony is taking place

942. NICHOLAS NEGROPONTE and
THE ARCHITECTURE MACHINE GROUP,
M.I.T., Boston. *Seek*.
Environment for gerbils made of
2″ plastic blocks contained in a structure 5′ × 8′.
Photographed at the *Software* show,
The Jewish Museum, New York City, in 1970

944. HANS HAACKE.
"Poll of Museum of Modern Art
Visitors, June 30–September 20, 1970.
Question panel, Yes-No Ballot Boxes
with automatic counters. Ballots,
socio-political environment.
The counters registered:
 25,566 (68.8%) "Yes"
 11,563 (31.4%) "No"
Number of visitors participating:
37,129 (12.4% of all Museum visitors
during *Information Show*). Governor
Rockefeller is a member and his
brother David Rockefeller is the
chairman of the board of trustees of
the Museum of Modern Art, New
York City."

943. HANS HAACKE. *Condensation Cube*. 1963–65.
Acrylic plastic, water, climatological
conditions of the environment, 11½″ cube.
Collection the artist

and a complex public-relations campaign, was Maurice Tuchman's elaborate "Art and Technology" exhibition, held in 1970 at the Los Angeles County Museum. While its aims were admirable, and individual works such as Oldenburg's miraculous, risible, inflating and deflating giant ice bag almost made the entire immense administrative nightmare seem worthwhile, a good many of the inventions finally seemed rather stale and predictable. Most of the light-and-motion environments were dated even before they had been programed, and lacked distinction or originality. The less conventional artists, from whom the most was expected—Andy Warhol or Roy Lichtenstein—seemed capable at best only of making expected Pop icons in their familiar style, if on a vaster scale.

Perhaps the most interesting and philosophically satisfying investigation of industrial technology was provided by the "Software" exhibition at the Jewish Museum, organized by Jack Burnham and sponsored by the American Motors Company. There were admittedly a number of serious malfunctions in some of the most engrossing pieces, such as the MIT architecture group's *Seek,* where a computer moved toy blocks around in interaction with an unpredictable and agitated team of gerbils who inhabited the man-made, constantly shifting environment. But the exhibition made its point and dramatically communicated a new concept. The show presented its exhibits as a means of handling and relaying information and establishing patterns of environmental interaction within a systems structure, rather than as a set of autonomous art objects. Many Conceptual and Bodyworks artists, among them Huebler, Kosuth, Levine, Burgy, Barry, Weiner, and Acconci, were included with artists conventionally associated with technology. The exhibition signaled a movement, in the formulation of curator Jack Burnham, away from art objects and towards new artistic "concerns with natural and man-made systems, processes, ecological relationships, and the philosophic involvement of Conceptual Art. All of these interests," he continued in his catalogue, "deal with art which is transactional; they deal with underlying structures of communication or energy instead of abstract appearances."

It is this basic shift in attitude that seems to have inspired a continuing flow of innovation by the most adventurous American artists in the seventies. The new conception of art as idea and action rather than as product has surely triumphed. As an example, one of the more intriguing works at the "Software" show was Hans Haacke's *Visitor's Profile,* which posed fact- and opinion-oriented questions to the viewer, whose teletyped responses were then sorted out by a computer and summarized. Haacke's interest in social patterns of organization and their mode of operation showed up again with the same cool, unerring logic in the real-estate piece he proposed for his canceled one-man show at the Guggenheim Museum. He developed these interests from earlier concerns with other systems—physical, chemical, biological, and electrical. Probably Haacke was the first artist to apply the term "systems" to contemporary art. He had already utilized a systems approach to sculpture within a diverse range of materials including air, earth, water, snow, ice, electricity, plants, animals, and abstract sociological data, all of which fall outside the traditional limits of the sculptural object. In 1968, in a talk before the annual meeting of the International Color Council in New York, he stated: "A 'sculpture' that physically reacts to its environment or affects its surroundings is no longer to be regarded as an object. The range of outside factors influencing it, as well as its own radius of action, reach beyond the space it materially occupies. It thus merges with the environment in a relationship that is better understood as a 'system' of interdependent processes."

It must seem ironic that Haacke finally took up residence in America because of its advanced technologies and atmosphere of intellectual freedom, only to find his work and ideas ignored when the first opportunity for a one-man show in an American museum presented itself. Perhaps his Conceptual Art systems are really too esoteric, rather than subversive, to achieve significant status outside of the artistic underground. Surely the Guggenheim Museum's elimination of the Haacke show would have been unacceptable to the public at large—whose sensibilities had been numbed by the unavailing protests against the war in Vietnam—had some popular cult figure of the older vanguard generation been involved instead.

It may be, however, that Haacke is one of a

number of prophetic new figures whose attitudes represent a fundamental change in the artist's approach to the aesthetic experience. He seems to belong to a rapidly emerging group of intellectually alert, violently noncommercial young artists, willing to work outside the art gallery system and trying to bridge the gap between our various "barbarians" of specialization—the scientists, planners, managers, and technicians— and the integrated, whole individual. Haacke conceives of his role as one that breaks down the barriers between man, nature, and a ruinous, runaway technology. Rather like Buckminster Fuller, he takes a comprehensive view of the life systems on this "Spaceship Earth." Sometimes, indeed, his language recalls the extravagant rhetoric of Fuller's "Worldgame" and his synergistic utopia. But Haacke's totality of vision, with its strong current of social and philosophical awareness within the larger context of modern thought, may yet turn out to be one of the few viable recipes for a new idealism, and offers a welcome plan of action in terms of our complex technological reality. In his talk before the International Color Council, previously cited, Haacke also stated: "The artist's business requires his involvement in practically everything. . . . It would be bypassing the issue to say that the artist's business is how to work with this and that material and manipulate the findings of perceptual psychology, and that the rest should be left to other professions. . . . The total scope of information he receives day after day is of concern. An artist is not an isolated system. In order to survive . . . he has to continuously interact with the world around him. Theoretically, there are no limits to his involvement."

In a society whose technicians and managers have only managed to produce superglut, in the midst of an environmental crisis which oppresses everyone in varying degrees, who among us presumes to say that Haacke's comprehensive new artistic model is fanciful, or to deny him the opportunity to test his systems aesthetic in our world in full freedom?

17 · Contemporary Architecture and Planning Since 1960

SEARCHING FOR AN AMERICAN architecture representative of the late twentieth century poses some formidable problems. The first of these is pluralism. In spite, or perhaps because, of the unanimous adoption of contemporary, nonhistorical design, which laid to rest the various skeletons of the past shortly after 1945, there are now more style options than ever before. Today's formal architectural novelties occasionally echo the imagery of Pop Art (especially of its sources in the real environment), and the forms of recent abstract painting find a scattering of correspondences in architectural design. In addition, there is the continued work of stubbornly independent figures such as Louis Kahn, whose personal style corresponds closely neither to current fashion nor to any immediately recognizable phase of traditional modernism. Most prestigious building design throughout the sixties and early seventies, however, retained a formal tradition stemming from the earlier International Style and its derivatives as established before 1960.

Although an up-to-the-minute appreciation of architecture in the 1970s would be incomplete without some reference to the works and attitudes of Tony Smith, Claes Oldenburg, Ed Ruscha, Allan d'Arcangelo, Frank Stella, Roy Lichtenstein, and Hans Haacke (to name a deliberately motley group of artists), this is not the logical place to begin this chronicle. Architecture has tended to remain the more conservative of the visual arts through much of the twentieth century, participating in few of the movements in painting, sculpture, and criticism, and these often in only a restricted way. There is no true architectural counterpart to American scene realism or to Action Painting; instead, for the past quarter-century a hefty segment of American building has been fussing over formal problems that were first stated by European abstract artists of the 1920s. And even those who

rejected the limitations of this approach tended to look for support to earlier movements in design that had little or no correspondence with pictorial art.

In this restrictive context, the work of Paul Rudolph, beginning with his design for the Yale Art and Architecture Building, New Haven, Connecticut (1958–64), is especially illuminating. Rudolph's career had commenced a decade earlier with a round of Florida houses, and in the mid-fifties his practice expanded into commercial and university work. These projects, reflecting the aesthetic uncertainties of the time, were of little significance for his subsequent career. The Yale building was another matter. Its design and construction coincided with the period of his tenure as chairman of the Department of Architecture, and in effect if not in fact, Rudolph was both client and architect on this project. The building, impressively sited on a street corner where the Yale campus touches a fringe of New Haven's downtown, was designed and redesigned, each time with an increasingly dramatic play of solids and voids, lights and shadows, resulting in an image of great power. The exposed concrete walls were developed into a surface of vertical striations that was even rougher than that inherent in raw, unfinished concrete. Everything about the design was forced and strained. Bulky sentinel towers collided with massive horizontal forms. Violent articulation of parts emphasized the deliberate overscaling of many elements. Altogether, the structure was a reaction to the precious detailing and graphic linearism of much American architecture of the past several decades.

Despite its novelty of expression, Yale Art and Architecture did not represent a new style. Rudolph had plundered some of the most memorable design features of the recent past and substituted a knowledgeable, emotional eclecticism for the hyperelegant refinements that

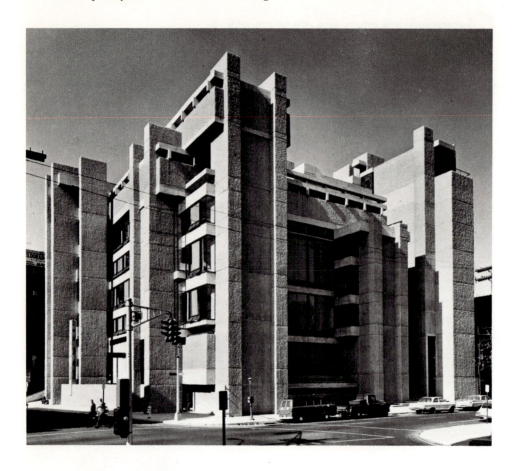

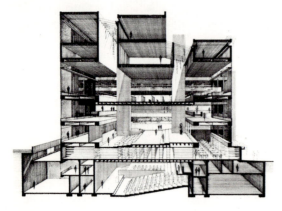

945, 946. PAUL RUDOLPH. Art and Architecture Building, Yale University, New Haven, Conn. Exterior and section. 1958–64

characterized nearly every type of design around 1960. The concrete mass had a superficial resemblance to Le Corbusier's late mode; but Rudolph's design had a more calculated look. The interlocking of rectangular solids and voids seems closer to the studied patterns of De Stijl architecture, such as Rietveld's 1924 Schroeder House; but at Yale the scale and rhetoric are vastly inflated. Moreover, one might super-impose on these previous sources the towered image of Wright's 1904 Larkin Building, Buffalo, thus obtaining an encyclopedic montage of modern masterworks. Finally, a comparison of Art and Architecture with Kahn's Richards Medical Research Building is inescapable: they were contemporaries, and both possessed suffi-cient similarities of bulky forms (clusters of vertical towers evocative of medieval San Gimignano) to suggest that they represented a trend. Superficially they did, though the two

structures were fundamentally alien, Kahn having no patience with the sort of convoluted eclecticism that had snared Rudolph

Rudolph's building seems, in retrospect, furious effort to rediscover a kind of stylistic integration, to gather up, once and for all, the main architectural currents of the twentieth century. If this kind of integration sufficed to create a modern masterpiece, then Art and Architecture (an ironic name for the building,

given the final product) would have been an unqualified success. Yet in effect that was accomplished in this mighty gesture was a demonstration of design expertise. It was almost immediately despised by those who had to work in it. Its spaces were visually aggressive, overly large or, conversely, cramped; by the late sixties, when architectural students were finding social rather than aesthetic issues to be of greater relevance, the learned formalism of Art and

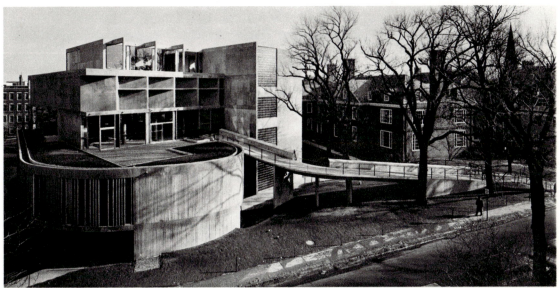

947. LE CORBUSIER. Carpenter Center for the Visual Arts, Harvard University, Cambridge, Mass. Designed 1958; constructed 1961–64

948. LUDWIG MIES VAN DER ROHE. National Gallery, Berlin. 1962–68

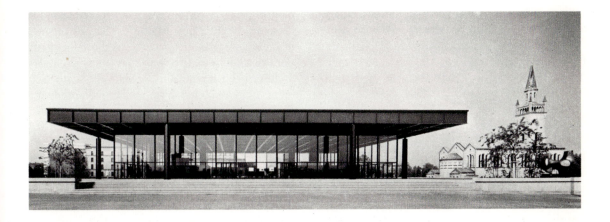

Architecture seemed preposterous, the building an irritating anachronism, an example of what *not* to do. Ironically, Rudolph had succeeded in creating one of the rare buildings of effective monumentality in the contemporary American idiom—an achievement that had eluded so many —merely to be told by his critics and, loudest of all, by the younger generation that monuments were obsolete in contemporary architecture.

The lesson of Art and Architecture remains. Once again an American architect sought to measure himself against a handful of past masterpieces, only to find himself in check. Rudolph's problem here was fundamentally no different from that faced earlier in the century by McKim, Mead and White and by all those who sought refuge in a *style*, whether old or new. The major dilemma of architecture in the sixties and seventies is the struggle between the desire for a strong, indeed an overpowering image, one aspiring toward a megastructure or superbuilding, and an increasing concern with a building's community function, especially its social and environmental relevance. The bad record that contemporary formalist architecture (or seemingly functional, vigorously designed structures) holds with the people who must use it as a tool in their daily lives suggests that much of today's design vocabulary is out of step, perhaps outmoded, no longer capable of evoking a positive response from clients and architects alike. Many would argue that modern architecture, despite its original protestations of establishing a new social order, was always an elitist concept; that, partly because of its dependence upon an esoteric, abstract art, it had never received widespread support from the masses. Early twentieth-century figures like Wright and Le Corbusier tried in the beginning to give architecture over to the common man, the individual tenant or householder, but at the end of their careers they were often designing monuments to their own fame as heroic creators.

Thus Le Corbusier, at Harvard, created his only authentic building in North America, Carpenter Center for the Visual Arts, completed in 1964. It is a cryptic building from the hand of an enigmatic architect whose works often and incorrectly passed under the guise of rational functionalism. Of rough, unfinished, poured-in-place reinforced concrete (*beton brut*),

it is tucked away on an unsuitably cramped plot between two buildings devoid of character. Le Corbusier's partly cubic form is set askew—a bluff comment on the space he had to work with. The relatively small building contains exhibition and studio space above, below, and to both sides of an open-air passage that extends through the middle of the volume. This passage, together with the connecting curved pedestrian ramps, is the key feature, functioning not as a part of the building's interior volume but as a part of the cityscape, linking the streets to the front and rear. Hence Carpenter Center aspires to the status of a megastructure, a kind of city-within-a-building, despite its small size and limited function.

Wright, too, in his final works sought to establish a new relationship between the building and its setting, but the setting that attracted him was rural rather than urban, natural rather than man-made. We have already seen how, in the second Jacobs house (1948), the site and the building were brought together as a single entity. Earlier, in Falling Water (1936), the identity of nature and building was jeopardized when the architectural forms were allowed to mimic forms from the topography. Still earlier, in the Prairie Houses of 1900, the low-lying horizontals of the house were appropriate to the flat landscape, but then they were clearly separate elements. In the twilight of his career, Wright, like Le Corbusier, aspired to a still higher order of integration for his buildings, but his is an integration more environmental than social. The Marin County Center, designed in 1957 and completed in 1963, is a long, arcuated structure (suggestive of a Roman aqueduct) stretched between two hills, the lower of which Wright planed away in order to rebuild its contour in the form of a domed pavilion. The misfortune of these noble gestures, worthy of the century of Bernini and Le Nôtre, was that many younger architects felt the need to emulate the scale and intensity of all-inclusive compositional grandeur. Rudolph's Art and Architecture Building is a doggedly bloody-minded example of this hubris, which has done so much to impede the normal evolution of recent architecture.

Mies van der Rohe, as indicated above, went his own way in splendid isolation during the decade before his death in 1969, concerned not the slightest by issues lying beyond the limits of

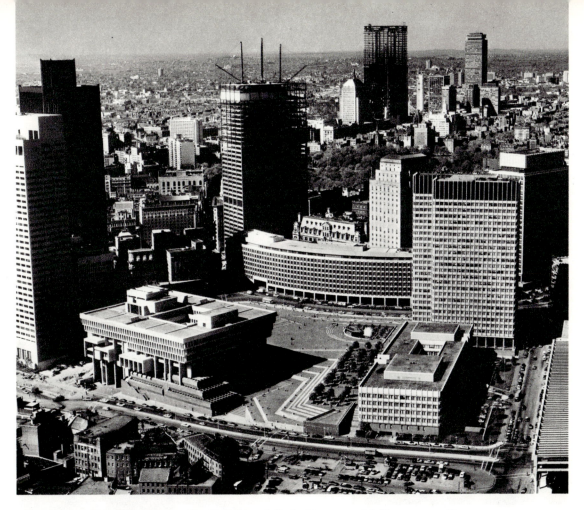

949. Government Center, Boston. City Hall (*lower left*), by KALLMANN, McKINNELL AND KNOWLES. Designed 1962; constructed 1964–69

his profession, but within those limits seeking only to be, by his own admission, a good architect. Like other contemporaries, he was a treacherous model for the young. Not surprisingly, one of his last works was one of his finest: the Berlin National Gallery (1962–68). Situating the service areas of the structure out of sight in a massive podium, Mies was free to erect a stately glass pavilion with an enormous steel entablature carried on a mere eight isolated columns. Not since antiquity, not even in the most "ideal" of Renaissance or neo-classic buildings, had an architect sought and achieved a design in such complete equilibrium of parts. And yet Mies's solution was irrelevant with respect to many urgent contemporary problems, in much the same way that the Parthenon was of no assistance (nor was it meant to be) in providing housing in Periclean Athens.

It is clear that large office buildings no longer propose the challenge for creative design that they did for nearly an entire century. This includes government projects, insofar as they concern the housing of the bureaucracy, although city halls, if given a symbolic role to play, are another matter. Boston's new City Hall, the result of a 1962 competition won by Kallmann, McKinnell and Knowles, is the nucleus of the Government Center, an urban renewal project laid out according to a master plan by I. M. Pei. One of the most ambitious efforts to re-create an American center city, it confronts us with heroic-scaled contemporary monuments to civic and commercial power dwarfing the carefully restored mementos of Colonial and Federal days, not to mention Bulfinch's State House and the urbane residential streets of Beacon Hill and Louisburg Square. Such drastic surgery upon an ancient (by America's time scale) urban fabric of narrow winding streets, already overburdened

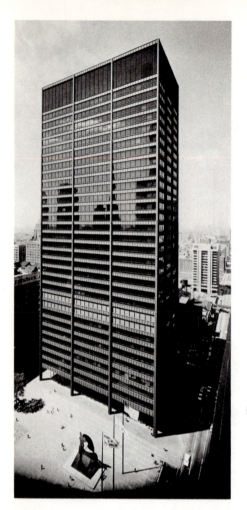

950. C. F. Murphy Associates.
Civic Center, Chicago. 1963–65.
Sculpture (*foreground*) by Picasso,
installed 1967

952. Skidmore, Owings and Merrill.
Sears Roebuck Tower, Chicago.
Topped out, May 3, 1973

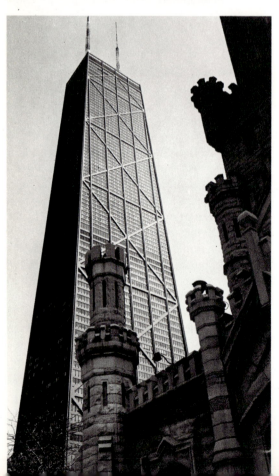

951. Skidmore, Owings and Merrill.
John Hancock Center, Chicago. 1966–69.
Water Tower (*foreground*), 1869

with tall buildings that they were never meant to adequately service, cannot heal easily or rapidly. It will probably always be something of a jolt to emerge from the narrow confines of Boylston Street into the vast paved expanse of City Hall Square. The greatest sin committed by the planners of Boston's Government Center is that they failed to provide for significant housing or for the development of shops, hotels, or places of entertainment in the area, thus ensuring the preservation of a characteristically American blight, the downtown abandoned at night and on weekends, an exclusively diurnal *cité des affaires:* all the more ironic in the case of Boston, as the Center replaces among other things the dilapidated but nonetheless multipurpose Scollay Square.

In spite of these major failings, Government Center is expertly designed and laid out. City Hall is well sited high on a corner of the sloping square and is energetically composed as its principal feature, while the surrounding office buildings, including a Federal Center by Gropius's firm, The Architects' Collaborative, are suitably banal in their several ways. The space of the square is well defined by the surrounding towers and façades, and the light standards, trash containers, and other items of "furniture" are artfully contrived. City Hall comes straight out of the late Le Corbusier tradition of richly molded reinforced-concrete structures, jacked up on *pilotis* so that its profile expands toward the top, inadvertently a kind of upside-down ziggurat. Although the building's general outline was adapted from Le Corbusier's famous convent of La Tourette, Eveux, France (1957–60), this inverted scheme makes functional sense. The public spaces are grouped at the lower level (including accommodations for the collectors of taxes, license fees, and the like), and broad stairs lead upward to the mayor's office and the council chambers. Above these are three stories of offices, largely inaccessible to the public, and these layers of the building form the massive entablature of its exterior elevation. Symbolically, the citizen's elected delegates, headed by the mayor, would seem to be supporting the municipal bureaucracy on their shoulders, the entire edifice having as its foundation the tax collectors.

Chicago, by way of contrast with Boston's extravagant design, solved the need for a new municipal building by erecting a Miesian skyscraper (by C. F. Murphy Associates, 1963–65) on a standard, unaltered rectangular site in the Loop, leaving an open plaza at street level with the happy addition of a fine sculpture by Picasso. There was no need to disrupt the grid plan of historic downtown Chicago, whereas the city fathers of Boston had to gut a neighborhood rife with cow-path lanes to get their municipal plaza. Fortunately for Chicago, its street plan evolved as it did because its original settlement was of the early nineteenth, rather than the early seventeenth, century. Consequently, the architects of its Civic Center must be congratulated for the restraint, even conventionality, with which they went about their work. Several other recent large office buildings are virtually indistinguishable from the Civic Center's sheer, rectangular tower, and those in the Loop continue, in their Miesian way, the blunt, foursquare silhouettes of earlier commercial blocks dating

953. EMERY ROTH AND SONS, PIETRO BELLUSCHI, AND WALTER GROPIUS. Pan American Building, New York City. 1963. Façade of Grand Central Terminal (*below*), 1903–13

954. MINORU YAMASAKI AND ASSOCIATES AND EMERY ROTH AND SONS. World Trade Center, New York City. 1966–74

955. PAUL RUDOLPH. Project for Graphic Arts Center, New York City. 1967

from the Sullivan era. Outside the Loop, variations on the skyscraper theme have popped up. On North Michigan, adjacent to the castellated Water Tower of 1869 (a rare survivor of the 1871 fire), Skidmore, Owings and Merrill constructed the John Hancock Center, for a brief time the highest building in Chicago (1,105 feet; completed in 1969), already surpassed by Sears Tower. A tapering but not set-back shaft, Hancock Center is on a vertical frame braced by conspicuous diagonal members, making possible the use of a lesser grade of steel throughout. A kind of megastructure, although its uniform façade does not suggest it, it contains parking, shops, offices, restaurants, and apartments.

Of all the recent tall buildings in Chicago (or elsewhere, for that matter), one of the most distinctive is Bertrand Goldberg's Marina City (1964–67), a megastructure which actually looks like one. It comprises twin towers like Mies's boxy Lake Shore Drive Apartments (1949–51), but Goldberg's design belongs to another architectural culture entirely. At first glance the circular forms with their tiers of rippling, semicircular balconies, each projecting outward from a pie-shaped apartment, seem more in accord with the

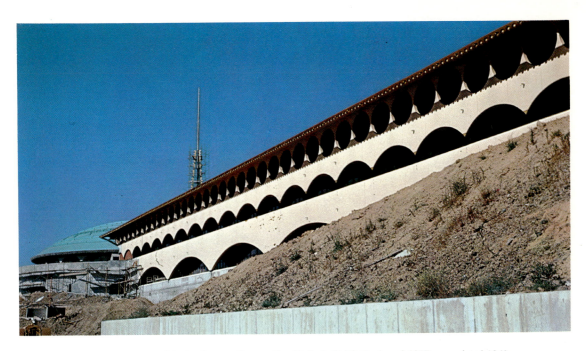

956. FRANK LLOYD WRIGHT. Marin County Center, San Rafael, Calif. Designed 1957; completed 1963

957. KALLMANN, MCKINNELL AND KNOWLES. City Hall, Boston. Designed 1962; constructed 1964–69

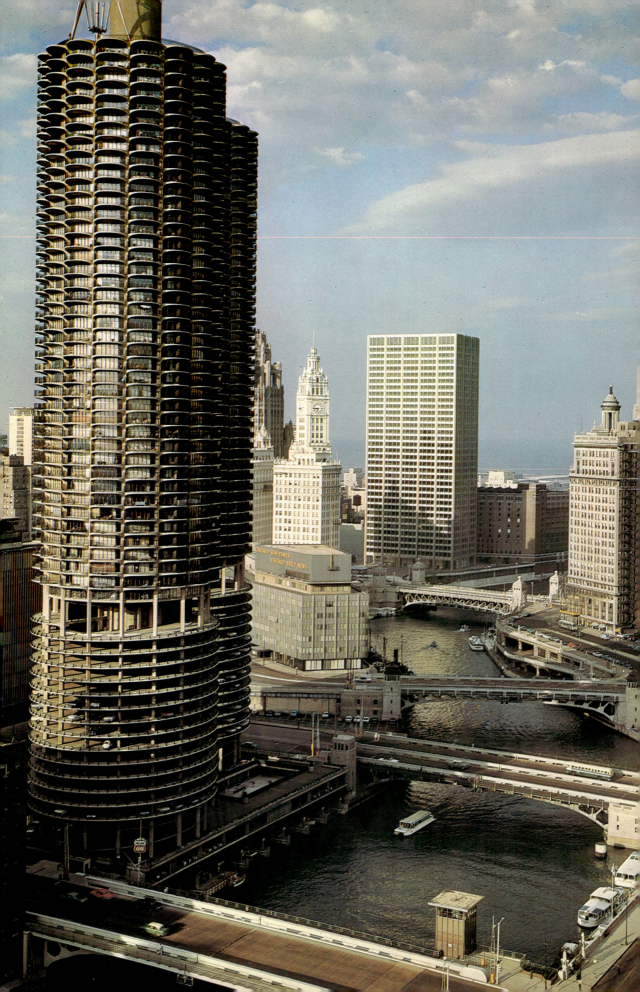

959. "Main Street," Disneyland, Anaheim, Calif. 1955

960. Simon Rodia. Watts Towers, Los Angeles. c. 1921–54

◄

958. View of downtown Chicago, north of the Loop. Marina City (*left*), 1964–67, by Bertrand Goldberg

961. LOUIS I. KAHN.
Salk Institute of
Biological Studies,
La Jolla, Calif. 1959–65

962. TONY CORNERO.
Stardust Hotel, Las Vegas. 1955–58.
Photograph from *Learning from Las Vegas*,
1972, by Venturi, Scott Brown, and Izenour

963. VENTURI AND RAUCH.
Lieb House, Loveladies, N.J. 1967

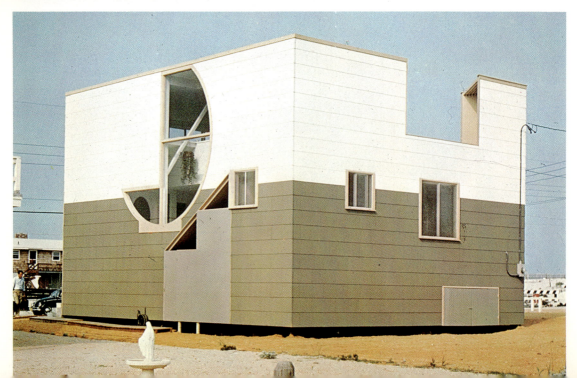

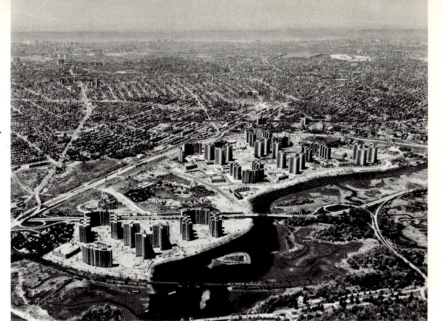

964. HERMAN J. JESSOR.
Co-op City, New York City.
1965–70

blithe stylishness of Los Angeles or the plastic elegance of Miami Beach. Yet the logic of the forms and the way, for example, the balcony curves depend upon the effective radius of the gantry crane that was used to construct the towers mark it as a Chicago product. Furthermore, the clarity with which the lower-level parking spiral is differentiated from the residential levels above is functionally appropriate, and no effort is made to gloss it over; the result is almost commonplace. Marina City, in spite of not fitting formally into the Chicago tradition, offers a number of construction features that establish its legitimacy.

New York has not been as fortunate as either Boston or Chicago in terms of its recent architectural renovation. The Pan American Building, set astride Grand Central, is not an architectural amenity in the normal sense of the word, but a sadly inconclusive form with its corners planed down. If its podium, now a somewhat tawdry dowager, could be restored to commercial viability without damage to its spatial rationale, Pan Am could become an active component of an imposing megastructure. Were Grand Central permitted to decline and finally go the way of Penn Station, however, it would be difficult indeed to find any redeeming features of urbanity in the surviving tower. The New York World Trade Center (1966–74) is a typical instance of the ruthlessness with which that city's skyline and ground-level appearance have been treated by builders. On a huge site west of

Church Street, along the Hudson River side of the downtown financial district, two identical towers rise 110 stories (1,350 feet), designed by Yamasaki with Emery Roth and Sons as architects to be the highest buildings in the world, though now surpassed by Chicago's Sears Tower. The plaza zone in which these towers are dropped again (like Lincoln Center) seems to turn its back on the historic neighborhood, and the blunt height and graceless profile of the towers have nothing to do with the once characteristic, now overpowered cluster of tapered spires that for decades dominated lower Manhattan and the harbor. The skyline of Chicago's Loop has fared better than this.

New York's skyline would have been much better served by a structure such as Paul Rudolph's project for the Graphic Arts Center (1967), an enormous megastructure, chiefly residential, likewise planned to be a feature of Manhattan's Hudson shore. Its agitated, stepback silhouette would have done no violence to the typical New York skyline, and its housing would have been a welcome addition in an area which is becoming more and more exclusively commercial. Rudolph's scheme, featuring mass-produced dwelling components assembled on a concrete frame (the architect foresaw that the various units might be produced by the mobile home industry), parallels the "hanging garden" shape of Moshe Safdie's Habitat at Expo '67, Montreal. At Habitat, the various "boxes" were mostly self-supporting, load-bearing compo-

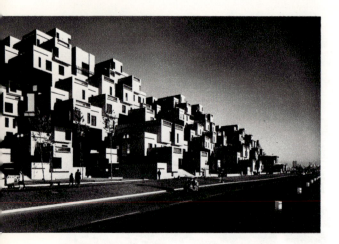

965, 966. MOSHE SAFDIE. Habitat,
Expo '67, Montreal.
Exterior view and inner court. 1967

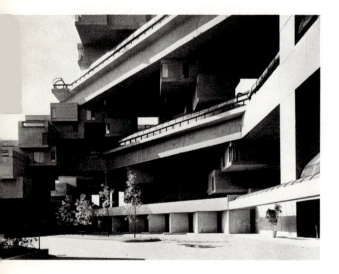

nents. In a later scheme for a New York Habitat, like Rudolph's scheme unrealized, Safdie proposed the assembly of individual cubic dwelling units on a tension-supported frame. The type as well as the location of these multiple-dwelling projects worked against their ultimate construction. Feasible in New York in the 1960s instead were the trite towers of Co-op City, located not on desirable commercial land in Manhattan but in the remote reaches of the Bronx.

Los Angeles has been seen as the type par

excellence of the late twentieth-century American metropolis. Architecturally, the region had been in the earlier days of the modern movement a major center of progressive design, though almost exclusively in the field of residential building. In the past decade, the architectural importance of Los Angeles waned as it failed to take the lead in the development of a characteristic architecture of a commercial or monumental sort. Typically, Los Angeles International Airport remains a pale version of what can be found elsewhere. In the midst of this southern California sprawl only three things stand out: Disneyland, with its architecture of escape into the past and the future; the unique Watts Towers, a monument built out of junk, refuse, and solitary human ingenuity, a work without institutional or official initiative conceived and achieved in his spare time by Simon Rodia, an immigrant laborer; and the retired Cunard liner *Queen Mary*, since the mid-1960s "beached" (actually docked) at the southern extremity of the Long Beach Freeway, serving as a convention center and tourist attraction—a monument of British design of the 1930s ending its days in a world of architectural Pop. The stupendous freeway system created for Los Angeles by the California Division of Highways represents one of the most ambitious, ongoing engineering projects of our age, comparable in scale (and almost analogous in urban function) to the aqueducts of Roman antiquity. This technological marvel, however, serves a wasteland of tract houses, roadside architecture, and ostentatiously styled public structures, whose component parts do not jell into a recognizable urban fabric. Autopia seems to spontaneously generate not conventional urban patterns of architectural density but endless linear highway strips, features of which have already been immortalized by the Pop artist Edward Ruscha. Viewed favorably, Los Angeles might prove to be the spawning ground of the city of the future as well as of a new architecture. Alas, too many as-yet-unsolved blights caused by the use of the automobile may finally stand in the way of realizing this particular urban dream.

The significance of architecture in the United States in the sixties and seventies cannot be measured solely by the drastic refurbishing of its cities. Their partial destruction is one serious consequence, as well as a wound leaving con-

spicuous scars. The annihilation of the extra-urban landscape, be it densely suburban sprawl or supposedly protected wilderness, parallels the uprooting of urban neighborhoods. The bulldozer is the great leveler of town and country, an equalizer quite without favoritism. Not surprisingly, the most striking new architects, those with arresting ideas of reforming and refounding the community, or of employing the vernacular of contemporary civilization in a more positive way, are either rebuffed in their efforts to win an audience for their projects (let alone to get them built) or have turned their backs upon the city as presently constituted. Louis Kahn, though he made some studies for the historic center of Philadelphia in the 1950s, has not only had no influence on recent urban building, but most of his work over the past decade is largely unrelated to it. Decades before, it seemed that Wright had deliberately turned his back upon the city in favor of the suburb; now, in the sixties, it seemed as if the city had

turned its back on Kahn, the one architect temperamentally capable of creating forms geared to civic monumentality. Once again urban America seemed willing to ignore an architect of genius who could replace with worthy successors many of the buildings that had been so thoughtlessly leveled, much as had been the case when Sullivan inexplicably found himself unemployed after 1900.

Kahn must certainly be ranked one of the greatest, most original designers of the second half of the century, yet his influence on the cityscape, until now, has been nil. His Salk Research Institute, La Jolla, California (1959–65), is typical in that it is removed from a major center, generally overlooked by the chroniclers of the Los Angeles area, and largely unrelated to the subculture that in succession nurtured Schindler, Neutra, Eames, and Ellwood. Kahn has the knack of producing a formal design that manages not to look formalistic; that is, the final result does not appear to be a contrived package. With

967. State of California, Division of Highways. Interchange, Santa Monica and San Diego Freeways, Los Angeles

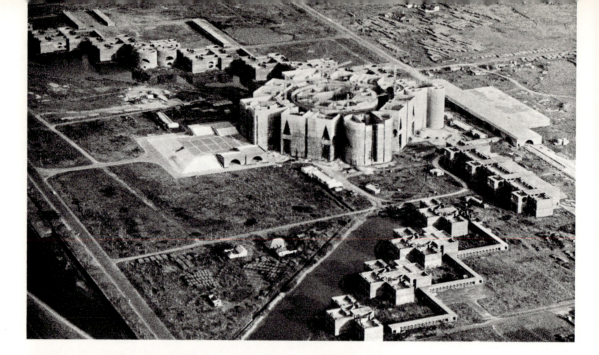

968, 969. Louis I. Kahn.
National Assembly and Hostels,
Dacca, Bangladesh.
Overall view and model of
National Assembly. Begun 1966

the Salk Institute he has designed a double range of buildings on a raised podium containing a number of individual research areas. The duplication and reduplication of function becomes the basis of the building's recurring rhythmic dignity. The nature of the building is such that, while it is sited in a dramatic landscape overlooking the Pacific, it would be equally appropriate in an urban setting. Universality had been the aim of Mies's design formula; Kahn achieves another kind of universality without the satisfaction (if it can be called that) of having codified his design shell. Restlessly searching, each new project exacts a strenuous effort in the shaping of forms and images—which are generally simple and understated, never flamboyant or expressionistic as in the manner of Eero Saarinen.

Kahn's plan for the government center at Dacca, now the capital of Bangladesh, was begun in 1966 and is the summit of his career thus far; one can only regret that he has not been commissioned to build something of this scale at home. At Dacca, Kahn's early background in Beaux-Arts planning has served him well. Now that the modernist tradition can accept alternatives to open planning and its free-flowing, integrated, overlapping spaces and interlocking forms, Kahn's self-contained capitol building, with its plazas and perspective axes, puts to shame the tentative, superficial formalism of Lincoln Center and like efforts. Kahn further developed at Dacca the stately, rhythmic procession of masses of his earlier works (Bryn Mawr, for instance). He worked diligently to realize a design based upon a traditional, academic central plan, employing plain brick walls akin more to Richardson than to Mies, and creating a monumental geometry of arches, circles, rectangular

cubes, and cylinders that suggest a family relationship with the early brick traditions of the ancient Near East or of Rome rather than with the ubiquitous thin curtain walls of the twentieth century. Much of the quality of this rich heritage is similarly exploited by Kahn in the round-arched, cycloid-vaulted galleries of the Kimbell Art Museum, Fort Worth, Texas (completed in 1972), a rare example of his recent work in the United States.

Every period in architecture may need a mythic hero, an artist who is perhaps aware of the peculiar nature of his genius. Wright was that kind of architect for an earlier, less sophisticated epoch. Kahn seems to be fulfilling a similar role in the sixties and seventies, though culture heroes are supposed to be very much out of fashion at the moment, especially with the young. They, after a decade and more of idolizing him, now tend to be impatient with his slow, laborious, Socratic design process and the insistent, characterful nature of his forms. The probity, even a certain tediousness, that is at the heart of Kahn's monumental structures becomes immediately apparent when they are compared with the work of Kevin Roche and John Dinkeloo, a partnership which represents the successor firm to the late Eero Saarinen. Their work has a discipline and control that their former employer lacked,

but with them discipline becomes a constricting rather than a constructively ordering force. Their recently completed megastructure at New Haven, Connecticut, comprising an office tower for the Knights of Columbus and an arena with parking structure above, is a fair index of the muscle-bound overdevelopment of their architecture. Seeking, with justification, to make a strong design statement in the midst of a weakly rebuilt area of a middle-sized downtown, in proximity to the intimidating forms of a freeway, they have employed grossly proportioned purple brick cylinders and massive steel beams to exaggerate the structure. First views of such designs normally provoke speechless wonder, but familiarity and reflective analysis demonstrate their underlying vulgarity and exhibitionism.

Most architects active today, including such disparate figures as Kahn and the designing partners of the Skidmore, Owings and Merrill office, have been seeking an integrated, comprehensive design, a quest which often leads to the megastructure solution whether or not appropriate in a given circumstance. The most comprehensive designer on the scene right now, who in the late sixties had become a youth hero of Pop-culture dimensions, is Buckminster Fuller. Not describable as an architect in the normal sense of the term, he has been designing

970. Louis I. Kahn. Kimbell Art Museum, Fort Worth, Tex.
Cycloid vaulted chambers with natural light fixtures. Designed 1967; completed 1972

971. Philip Johnson
and Richard Foster;
Lev Zetlin and
Associates, engineers.
New York State Pavilion,
New York World's Fair. 1964

archetypal buildings since 1927, when at the age of thirty-two he gave up a maverick career in industry to devote himself to design research. A prototypical dropout, twice separated from Harvard College, he combines the genius of the traditional Yankee tinkerer with a gift for contemporary modes of publicity and a restless, unrooted life style that keeps him on the move as visiting lecturer, consultant, and career gadfly. Perhaps better described as an inventor than as a creator, he does not so much design or build as provide systems for others. Having been stalemated in the development of industrialized housing types, he went further in his search for an ideal, comprehensive, universal building form with the "invention" of the geodesic dome in the 1940s. The dome was an ancient architectural form with cosmic implications, but Fuller was drawn to it for other reasons, such as its favorable ratio between area of surface and volume of enclosed space, and the simple rigidity of its structure in the geodesic mode. That it offered no logical opportunity for a door did not bother him in the least, though it irritated countless others in the architectural profession.

In the 1960s, he developed his comprehensive design-science into a think-tank activity which, with characteristic unflappability, he dubbed the World Game. His greatest public and official success came with the construction of the American Pavilion at Montreal's Expo '67, one of the most architecturally productive of any international exhibition. Fuller has also enjoyed a considerable underground fame with the young and with the various counter-culture movements.

To them he was a welcome guru, having for years blasted the traditional complacency of both industry and the design professions. He seemed a logical prophet as he wished to beat various "pentagons" and "rand corporations" with their own gamesmanship. Yet at the same time he has conferred with various Third World heads of state, has represented American interests abroad in places as different as Montreal, Moscow, and Afghanistan—in short, paralleling in his travels the peripatetic tradition of cold-war diplomacy from Dulles to Kissinger. He professes to have rational, worldwide solutions that would wrap up social and environmental problems by the effective functional integration of energy sources, distribution channels, and the like. Paradoxically, many of today's disaffected found what they thought to be the means of achieving the framework for a freer life in the hands of a Philosopher-King, a Design-Scientist whose sovereignty would extend above and beyond national autonomy.

Fuller's comprehensive vision, irrefutable because of the impossibility of giving it a realistic try, even to the scale of his project for a geodesic dome two miles in diameter to cover midtown Manhattan—a preposterous wedding of sacred and profane forms—is typical of much modernist architectural theory. Wright's Broadacre City had the virtue of bringing certain ideal concepts to a level where they might be usefully realized in fragments or in limited aspects. Wright's onetime disciple Paolo Soleri has reviewed these comprehensive solutions, found his mentor's Broadacre City to be absurdly

972. BUCKMINSTER FULLER. American Pavilion, Expo '67, Montreal. Geodesic dome. 1967

973. KEVIN ROCHE AND JOHN DINKELOO. Knights of Columbus Headquarters Building, 1966–70, and Veterans Memorial Coliseum (with superimposed parking structure), 1969–72, New Haven, Conn.

974. BUCKMINSTER FULLER.
Project for two-mile geodesic dome
for New York City. 1961

975. PAOLO SOLERI. Arcology "Arcosanti." Elevation

976. PAOLO SOLERI. Arcology "Babel II C." Section

wasteful of land and the radiant city of individual skyscrapers to be too inconclusive, and has proposed a solution of his own: spectacular megastructural cities for a variety of sites and landscapes (some even orbiting vehicles) which he calls Arcologies.

Soleri's Arcologies (Architecture plus Ecology) are enormous cities-as-a-single-building, capable of accommodating anywhere from a few to many thousands—their dwellings, places of work and recreation, and public spaces—at an unheard-of density. Compartments and subdivisions for the entire gamut of human activity would be housed, racklike, on superimposed platforms, arranged so that crowding would not be visible yet communication would be facilitated by shortened distances. An Arcology is a kind of "new town" concept, but a world removed from the tentative, half-hearted schemes of Reston, Virginia, or Columbia, Maryland, both recent examples of an improved suburban subdivision with a few local industries and some of the public amenities of a resort or leisure-time community. Arcologies ask people to make certain fundamental adjustments in their life style, to give up the notion of the separate, detached suburban house and disassociate their daily activities from the automobile, so integral a part of our contemporary architectural plant system. Ecologically desirable because they halt the uncontrolled consumption of land through traditional development techniques, and heroically appealing, mind-boggling designs of undeniable power and beauty, Soleri's schemes are very likely sociologically impossible, even were there to occur in the near future a revolution of habit or an environmentally forced, survival-induced concentration of populations. Soleri's dream is just that, one of the most Leonardesque of architectural utopias created in our century. Not an impossible, but surely an unlikely pattern for the future.

The fantastical aspect of Soleri's projects evokes a strong, positive if irrational response among artists, architects, critics, and those bohemian types of all generations who are basically ill-at-ease with contemporary megalopolis, motopia, and suburbia. As designs for an artists' colony or even as a research institute (the Los Alamos of the future?), they are plausible and perhaps have a place as a very specialized community design. So far as it goes, the architectural vision of the common citizen, however,

does not take in such images except as a brief entertainment on a late-night TV show. It has been the particular genius of Robert Venturi to demonstrate that the architecture of the professional schools and magazines, of architects and critics, is not the architecture of all America. He.has helped open our eyes to our characteristic everyday building shapes *as they exist*, and not as we would have them. Venturi has recoiled from any hint of a comprehensive solution in his own work. In his writings, most recently in *Learning from Las Vegas*, in collaboration with Denise Scott Brown and Steven Izenour, he has made it clear that America's true architectural vision does not lie with Soleri or Fuller (or even with Boston's Government Center) but with the fantopia of Las Vegas and Disneyland or with such standardized, universally distributed, miniature versions of these special places in the form of highway franchise design: for example, the twin yellow arches of McDonald's, a form known to, and representing the fulfillable aspirations of, anyone. This pop-culture architectural imagery is far removed from the similarly shaped, monumentally pretentious Jefferson Arch, St. Louis, a Saarinen enigma that remains, like the Washington Monument or the Lincoln Memorial, undecipherable in its meaning or association.

By recognizing the appositeness of roadside architecture and its display advertising techniques, Venturi has at last helped us to overcome the longing for the *big* civic monument—whether McKim's or Kahn's or Soleri's—and to settle for a conglomeration of the small-scaled, fragile, impermanent structures that have been, throughout history, among the most characteristic examples of native American building. There is a remarkable give-and-take between the buildings and ideas of Venturi and his circle, the aesthetic and sources of Pop Art, and even some recent abstract painting. Totally excluded from Venturi's repertory is any (but for an ironic) reference to the once sacrosanct forms of the International Style and its American progeny. As Venturi came to maturity in part under the influence of Louis Kahn, his rejection might almost have been spontaneous. In place of the familiar modernist repertory, he did not elect Kahn's revamping of the academic tradition but instead indulged in the ordinary and the overlooked. His own designs are not reproductions or imitations of these woebegone members of the architectural populace; rather Venturi seeks

977. CONKLIN AND WHITTLESEY. Village Center, Reston, Virginia. 1961

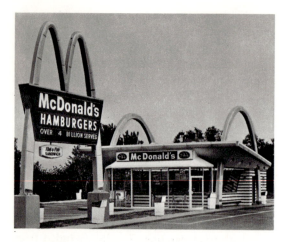

978. Architect unknown. McDonald's Restaurant.
Early version, 1950s

979. EERO SAARINEN. Jefferson Arch, St. Louis, Mo.
Designed 1949; completed 1965

to use commonplace features with a cheerful wit, an offhand ease (an effect that actually must be very carefully calculated) that is disarming. He would seem to revel in making the ordinary extraordinary. His is a very artful architecture, if only in its clever dissimulation of the architect's creative role in transforming the environment. *Learning from Las Vegas* in no way encourages the designing of suburban or metropolitan buildings as if they were tinseled casinos or

gas stations; it is more a matter of perceiving popular taste and then using it for benevolent ends, producing a market-tested product with hidden virtues instead of an architecturally virtuous (read: avant-garde, progressive, utopian, etc.) design that will likely encounter consumer resistance and ultimately rejection. In this, Venturi would seem to be the architectural profession's equivalent of Milton Friedman, ready to summarily reject elite-sponsored measures for improving "conditions" when it seems they do not work, preferring a do-nothing attitude. Venturi, however, is not a laissez-faire designer.

The Venturi House, Chestnut Hill, Pennsylvania (1962), is in the image of a Levittown model home. Yet it has never been demonstrated that this variant is especially acceptable to a mass audience, since the design has a number of quirks that surely set it apart from its common, everyday, Brand X prototype. Moreover, Venturi's species of ironic Pop architecture has irritated such establishment figures as Philip Johnson and Gordon Bunshaft (of Skidmore, Owings and Merrill), and hence finds only partial acceptability from the professional quarter. Compared with a Wrightian Prairie House or a Breuer dwelling of the late forties, the Venturi house finds itself in familial company. The "round arch" over the Venturi portico is no massbuilder's device but a coy allusion to the form as used in American monumental design from Richardson to Kahn. The same can be said for its reappearance in the Guild House, a Philadelphia apartment block (1960–63), another peculiar "ordinary" building. Try as he may, Venturi cannot help being a perceptive trained architect, cannot attain a level of innocence, and so he does the next best thing. His Fire Station #4, Columbus, Indiana (1965–67), tries to be ordinary but fails because it is set in a suburban wasteland where there is nothing nearby with which to relate. Yet it is a "correct" design; it looks like a firehouse; one can see the equipment through the glass door; besides, the sign says that it is. It does not *look* like a franchised food operation, though Venturi would maintain it is in the same genre of architecture. It isn't, of course, it's much more thanks to the artful patterning of the façade, but then, that's the irony of it all. . . . The same holds true for his ordinary (*sic*) beach house, Loveladies, New

980. VENTURI AND RAUCH.
Venturi House,
Chestnut Hill, Pa. 1962

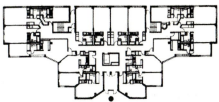

981, 982. VENTURI AND RAUCH;
COPE AND LIPPINCOTT.
Guild House, Philadelphia.
Exterior and plan. 1960–63

983. VENTURI AND RAUCH.
Fire Station #4, Columbus, Ind.
1965–67

984. Las Vegas Strip. *Clockwise, from upper left:* Dunes Hotel, 1955, by JOHN REPLOGLE (Highrise, 1960s, by MILTON SCHWARTZ); Caesar's Palace Hotel, 1966, by MELVIN GROSSMAN; Flamingo Hilton Hotel, 1946, attributed to MARTIN STERN

Jersey (1967), which ought to be compared with the rather different, classically (*sic*) modern cube of Rietveld's Schroeder House of 1924.

Whatever problems Venturi may still have in making his buildings square with his theory (and perhaps the gap between the two is one more willful irony), he has surely opened the eyes of his contemporaries; indeed, he may have opened them further than he originally intended. In any case, because of Venturi and the influence of Pop Art in general, we are probably much too prone to indiscriminately admire the gaudy architectural attire of establishments such as the Fontainebleau or Caesar's Palace, a McDonald's or a Dunkin' Donuts. Like Venturi, we have too easily been taken in by a slick confidence routine. We have at last awakened to the as-is realities of our built environment and can confront these objectively without spouting some pseudo-Ruskinian epithet. We tend to remain blind, however, to the motivations that have created our Levittown-to-Miami Beach civilization with its axis drawn straight through the heated swimming pool of a Holiday Inn. It is easy enough to fall prey to the maliciously friendly persuasion of the developer (free over-night accommodations while inspecting the future condominium home) or the casino entrepreneur (ridiculously underpriced meals, shows), all designed to anesthetize the customer while surreptitiously going after his money and giving him only a fraction of his value. It is well that we at last comprehend the positive virtues of roadside, resort, and suburban tract architecture, recognize it as fulfilling a broadly based taste and thus necessary; but it is equally vital to see this configuration as the display advertising of marginally legitimate commercial exploitations characteristic of a plastic or Kleenex civilization.

No matter how much Venturi has expanded our perception, there are many architects who will have no part of this now respectable chaos. Sensitive house builders like Richard Meier, Charles Gwathmey, and Michael Graves have skillfully revived the Bauhaus and Purist image in numerous houses of the past decade. Their exquisitely designed planar forms and reductive geometric shapes, though remaining an architecture of the elite and the affluent, show a romantic nostalgia for the heroic age of European modernism, ironically paralleling the some-

985. John Sierks;
Levitt and Sons, developers.
Levittown, Pa. 1952–58

986. Collins Avenue,
Miami Beach, Fla.,
showing Fontainebleau Hotel, 1957,
and Eden Roc Hotel, 1958,
by Morris Lapidus Associates

987. CHARLES GWATHMEY. Gwathmey Residence and Studio, Amagansett, Long Island, N.Y. 1966–67

what sentimental populism of Venturi. In the midst of these attitudes one finds the elaborate, suggestively camp domestic designs of Charles Moore, redolent with historical memory, crammed with allusions to Pop imagery and often constructed of common, ordinary materials. The "complexity and contradiction" of Moore's work—to echo an earlier literary work by Venturi—reveal an underlying instability and perhaps uncertainty on the part of the thoughtful architect of the seventies. The present is rich in choices and in perverse, contrary forces, and we can be sure that the future will offer still more. No doubt the older men and the established reputations will follow their set paths. One must assume that Philip Johnson will continue to design public buildings and office structures in an impeccable, irreproachable manner, endeavoring to get the form right once and for all. Surely Kahn will continue his design quest tirelessly, a kind of Cézanne on the contemporary architectural scene, working tenaciously with the same motifs to attain a palpable realization of his inner vision. Soleri is at present in the process of building one Arcology, near Prescott, Arizona, but the future of any others is vague.

No doubt many unknown architects, in an effort to maintain a fashionable look, will continue to imitate the pierced-screen façades popularized by Edward Durell Stone nearly two decades ago or will latch on to some new eye-catching formula. As one critic has recently noted, Stone's grilles are today more interesting as roadside imitations than as authentic works from the originating architect himself. Thus the circle turns from high fashion to low pop. Considerably more serious and durable are the sophisticated, restrained skyscrapers that issue from the offices of architectural corporate giants such as Skidmore, Owings and Merrill, who, on May 3, 1973, topped off the structural frame of their Sears Roebuck Tower, Chicago. At that moment the tallest building in the world, reaching 1,454 feet, it exceeds the height of the New York World Trade Center by more than 100 feet. Once again, as in the late twenties, the urge to achieve dizzying heights has come to the fore, and the competition may well continue, though many critics consider this vertiginous urban megalomania to be fundamentally antisocial.

Not only has architectural design become more pluralistic in the past decade; our awareness of it has increased by leaps and bounds, making the grasping and interpretation of a

988. MICHAEL GRAVES. Benacerraf House addition, Princeton, N.J. 1969

trend, now and perhaps forever, out of the question. We will contine to get more of what we already have, from smart shopping plazas to delicately romanticized modernist villas. But now that there are common interests and themes between architecture and the imagery of Pop and "new realist" painting, it seems likely that in the near future architectural design, after generally failing to recognize contemporary movements in painting and sculpture for a half-century, will once again show a greater concern for pictorial values and conceptual forms.

The American suburbanite of the 1970s has come a long way from his mythic grandfather who, just possibly, might have commissioned a Prairie House from the young Frank Lloyd Wright.

Or has he?

Bibliography

Note: *The bibliographies are arranged as follows: painting and sculpture from 1900 to 1959 (p. 525), painting and sculpture since 1959 (p. 533), and architecture of the twentieth century (p. 558). Books and articles are listed alphabetically by author and/or title. Exhibition catalogues are listed alphabetically by city and museum.*

Selected References on American Painting and Sculpture from 1900 to 1959
by Bernard Karpel
Librarian, Museum of Modern Art, New York (compiled 1959)

MODERN ART

Art Since 1945. Text by Will Grohmann, Herbert Read, Carlo Argan, J. P. Hodin, Marcel Brion, Sam Hunter, and others. London: Thames and Hudson, 1958.

BARR, ALFRED H., JR. (ed). *Cubism and Abstract Art.* New York: Museum of Modern Art, 1963.

——. *Fantastic Art, Dada, Surrealism.* New York: Museum of Modern Art, 1937.

GOLDWATER, ROBERT. *Primitivism in Modern Painting.* New York and London: Harper, 1938.

HUNTER, SAM. *Modern French Painting.* New York: Dell, 1956.

LAKE, CARLTON and MAILLARD, ROBERT (eds.). *Dictionary of Modern Painting.* London: Methuen, 1956.

MOTHERWELL, ROBERT (ed). *The Dada Painters and Poets.* New York: Wittenborn, Schultz, 1951.

RICHIE, ANDREW. *Sculpture of the Twentieth Century.* New York: Museum of Modern Art, 1952.

SOBY, JAMES T. *After Picasso.* Hartford: Mitchell; New York: Dodd, Mead, 1935.

——. *Contemporary Painters.* New York: Museum of Modern Art, 1948.

——. *Modern Art and the New Past.* Norman: University of Oklahoma, 1957.

SWEENEY, JAMES J. *Plastic Redirections in Twentieth Century Painting.* Chicago: University of Chicago Press, 1934.

AMERICAN ART AND CULTURE

AARON, DANIEL (ed.). *America in Crisis.* New York: Knopf, 1952. Chapter 9, "Rebellion in Art," by Meyer Schapiro, on the Armory Show and its influence.

America and Alfred Stieglitz. Edited by W. Frank, L. Mumford, D. Norman, P. Rosenfeld, H. Pugg. Garden City: Doubleday, Doran, 1934.

BAUR, JOHN I. H. *Revolution and Tradition in Modern American Art.* Cambridge, Mass.: Harvard University Press, 1951. (The Library of Congress Series on American Civilization.)

BOAS, GEORGE (ed.). *Romanticism in America.* Baltimore: Johns Hopkins Press, 1940.

CAHILL, HOLGER and BARR, ALFRED H., JR. *Art in America in Modern Times.* London: Methuen, 1934.

————. *Art in America: A Complete Survey.* New York: Reynal and Hitchcock, 1935.

COMMAGER, HENRY S. *The American Mind.* London: Oxford University Press, 1950.

FRANK, WALDO. *The Rediscovery of America.* New York and London: Scribner's, 1929.

GOODRICH, LLOYD and MORE, HERMAN. *Juliana Force and American Art: A Memorial Exhibition.* New York: Whitney Museum of American Art, 1949. Survey of American art from 1909 to 1948.

GRACE, GEORGE C. and WALLACE, DAVID H. *Dictionary of Artists in America, 1564–1860.* New Haven: Yale University Press, 1957.

Harvard Guide to American History. Cambridge, Mass.: Harvard University Press, 1954. Sections on cultural and intellectual trends.

HOFFMANN, FREDERICK J., ALLEN, CHARLES, and ULRICH, CAROLYN F. *The Little Magazine: A History and a Bibliography.* Princeton, N. J.: Princeton University Press, 1964. The literary, cultural, and experimental periodical in America. *Index of Twentieth Century Artists.* New York: College Art Association, 1933–1937. A bibliography on American artists.

KEPPEL, FREDERICK P. and DUFFUS, R. L. *The Arts in American Life.* New York and London: McGraw-Hill, 1933. Recent social trends monographs.

KOUWENHOVEN, JOHN A. *Made in America: the Arts in Modern Civilization.* Garden City: Doubleday, 1948.

KUHN, WALT. *The Story of the Armory Show.* New York: the Author, 1938. Supplemented by a similar article in *Art News Annual,* 1939.

LANDGREN, MARCHAL E. *Years of Art: the Story of the Art Students' League of New York.* New York: McBride, 1940.

LARKIN, OLIVER W. *Art and Life in America.* New York: Rinehart, 1949. Recipient of the Pulitzer Prize in History.

LYNES, RUSSELL. *The Tastemakers.* London: Hamish Hamilton, 1954.

MCCAUSLAND, ELIZABETH. "A Selected Bibliography on American Painting and Sculpture." In *Who's Who in American Art,* vol. 4 (1947), 611–53. Washington, D. C.: American Federation of Arts. A chronological list "from colonial times to the present," this bibliography originally appeared in the *Magazine of Art,* vol. 39 (Nov., 1946), 329–49.

MATHER, FRANK J., JR., MOREY, C. R., and HENDERSON, W. J. *The American Spirit in Art.* The Pageant of America, vol. 12. New Haven: Yale University Press, 1927.

MELLQUIST, JEROME. *The Emergence of an American Art.* New York: Scribner's, 1942.

MUMFORD, LEWIS. *The Brown Decades: A Study of the Arts in America 1865–1895.* New York: Harcourt, Brace, c. 1931. 2nd rev. ed. New York: Dover, 1955.

PACH, WALTER. *The Art Museum in America.* New York: Pantheon, 1948.

————. *Queer Thing, Painting: Forty Years in the World of Art.* New York and London: Harper, 1938.

RICHMAN, ROBERT (ed.). *The Arts at Mid-Century.* New York: Horizon, 1954.

ROURKE, CONSTANCE. *The Roots of American Culture and Other Essays.* New York: Harcourt, Brace, 1942.

————. *American Humor.* 1931.

SAYLER, OLIVER M. *Revolt in the Arts: a survey of the creation, distribution, and appreciation of art in America.* New York: Brentano's, 1930.

TOCQUEVILLE, ALEXIS DE. *Democracy in America.* London: 1835; 2 vol. ed. New York: Knopf, 1942; abridged ed. New York: Oxford, 1947.

Who's Who in American Art. Washington, D. C. American Federation of Arts, 1935–1947. New York: R. R. Bowker, 1953–present.

CRITICISM AND HISTORY IN AMERICA

BARKER, VIRGIL. *A Critical Introduction to American Painting.* New York: Whitney Museum of American Art, 1931.

BARNES, ALBERT C. *The Art in Painting.* New York: Harcourt, Brace, 1925.

BLESH, RUDI. *Modern Art U.S.A.: Men, Rebellion, Conquest 1900–1956.* New York: Knopf, 1956.

CAFFIN, CHARLES H. *How to Study Pictures.* New York: Century, 1905.

CHENEY, MARTHA C. *Modern Art in America.* New York and London: McGraw-Hill. 1938.

CHENEY, SHELDON. *A Primer of Modern Art.* New York: Boni and Liveright, 1924.

————. *The Story of Modern Art.* New York: Viking, 1941.

CORTISSOZ, ROYAL. *American Artists*. New York and London: Scribner's, 1923.

CRAVEN, THOMAS. *Modern Art—the Men, the Movements, the Meaning*. London: Williams and Norgate, 1935.

DREIER, KATHERINE S. *Western Art and the New Era*. New York: Brentano's, 1923.

EDDY, ARTHUR J. *Cubists and Post-Impressionists*. London: Grant Richards, 1915.

GALLATIN, ALBERT E. *American Water-Colourists*. New York: E. P. Dutton, 1922.

———. *Certain Contemporaries: A Set of Notes in Art Criticism*. New York and London: Lane, 1916.

HARTLEY, MARSDEN. *Adventures in the Arts*. New York: Boni and Liveright, 1921.

HARTMANN, SADAKICHI. *A History of American Art*. 2 vols., rev. ed. Boston: Page, 1932.

HENRI, ROBERT. *The Art Spirit*. Philadelphia: Lippincott, 1923; rev. ed. 1939.

JARVES, JAMES J. *Art-Hints*. New York: Harper, 1855.

———. *The Art-Idea*. New York: 1864.

———. *Art Thoughts*. New York: Hurd and Houghton, 1869.

JEWELL, EDWARD A. *Have We an American Art?* New York: Longmans, Green, 1939.

LA FOLLETTE, SUZANNE. *Art in America*. New York and London: Harper, 1929.

MACAGY, DOUGLAS (ed.). *The Western Round Table on Modern Art*. San Francisco: San Francisco Art Association, 1949. Also abridged in *Modern Artists in America* (*see* MOTHERWELL).

MATHER, FRANK J. *Modern Painting, a Study of Tendencies*. New York: Holt, 1927.

———. *Estimates in Art, Series II*. New York: Holt, 1931.

MOTHERWELL, ROBERT and REINHARDT, AD (eds.). *Modern Artists in America: First Series*. New York: Wittenborn, Schultz, 1951. Documentation by Bernard Karpel.

PACH, WALTER. *Modern Art in America*. New York: Kraushaar Art Galleries, 1928.

Painters and Sculptors of Modern America. New York: Crowell, 1942. Introduction by M. Wheeler to articles from the *Magazine of Art*.

SULLIVAN, LOUIS H. *Kindergarten Chats* (Revised 1918) *and Other Writings*. New · York: Wittenborn, Schultz, 1947.

ZAYAS, MARIUS DE and HAVILAND, PAUL B. *A Study of the Modern Evolution of Plastic Expression*. New York: "291" [Gallery], 1913.

PAINTING IN THE U.S.

BARKER, VIRGIL. *American Painting—History and Interpretation*. New York: Macmillan, 1950.

BAUR, JOHN I. H. (ed.). *American Painting in the 19th Century*. New York: Frederick A. Praeger, 1953.

——— (ed.). *New Art in America: 50 American Painters in the 20th Century*. New York: New York Graphic Society and Frederick A. Praeger, 1957. Texts also by L. Goodrich, D. C. Miller, J. T. Soby, F. S. Wight.

BOSWELL, PEYTON, JR. *Modern American Painting*. New York: Dodd, Mead, 1939.

BROWN, MILTON. *American Painting from the Armory Show to the Depression*. Princeton, N. J.: Princeton University Press, 1955. Extensive bibliography.

BRUCE, EDWARD and WATSON, FORBES. *Art in Federal Buildings*. Vol. 1: "Mural Designs, 1934–36." Washington, D. C.: Art in Federal Buildings, Inc., 1936.

CAFFIN, CHARLES H. *The Story of American Painting*. London: Hodder and Stoughton, 1908.

FLEXNER, JOHN T. *A Short History of American Painting*. Boston: Houghton Mifflin, 1950.

GOODALL, DONALD B. and KASANIN, MARC C. *Partial Bibliography of American Abstract-Expressive Painting, 1943–1956*. Los Angeles: University of Southern California, Department of Fine Arts, 1956.

HESS, THOMAS B. *Abstract Painting—Background and American Phase*. New York: Viking, 1950.

ISHAM, SAMUEL. *The History of American Painting*. New York: Macmillan, 1927. Rev. ed., 1936, with supplement by Royal Cortissoz.

JANIS, SIDNEY. *Abstract and Surrealist Art in America*. New York: Reynal and Hitchcock, 1944.

KOOTZ, SAMUEL. *Modern American Painters*. New York: Brewer and Warren, 1930.

———. *New Frontiers in American Painting*. New York: Hastings House, 1943.

MORRIS, KYLE (ed.). "Contemporary Slides, a Visual and Documentary Report on the New York Exhibition Scene." New York: Contemporary Slides, 1954–59. Mimeographed notes accompany a series of color slides. Issued in parts with cumulative index.

POHL, LA VERA ANN. *Die Entwicklung der Malerei in Amerika von 1913–1938.* Bonn: J. F. Carthaus, 1939. Dissertation for Bonn University. Bibliography.

RICHARDSON, EDGAR P. *American Romantic Painting.* New York: Weyhe, 1944.

———. *Painting in America: the Story of 450 Years.* New York: Crowell, 1956. Bibliography.

SUTTON, DENYS. *American Painting.* London: Avalon, 1948; New York: Transatlantic Arts, 1949.

WALKER, JOHN and MAGGILL, JAMES. *Great American Paintings from Smibert to Bellows, 1729–1924.* New York, London, Toronto: Oxford University Press, 1943.

WATSON, FORBES. *American Painting Today.* Washington, D. C.: American Federation of Arts, 1939.

WIGHT, FREDERICK S. *Milestones of American Painting in Our Century.* London: Max Parrish, 1949.

WRIGHT, WILLARD H. *Modern Painting: Its Tendency and Meaning.* New York and London: Lane, 1915.

SCULPTURE IN THE U.S.

BRUMMÉ, C. LUDWIG. *Contemporary American Sculpture.* New York: Crown, 1948. Foreword by William Zorach. Bibliography.

GIEDION-WELCKER, CAROLA. *Contemporary Sculpture: an Evolution in Volume and Space.* New York: Wittenborn, 1955. Biographical and bibliographical notes on Calder, Ferber, Hare, Lassaw, Lippold, Lipton, Smith.

GREENBERG, CLEMENT. "The Present Prospects of American Painting and Sculpture." *Horizon,* nos. 93–94 (October, 1947), 20–30.

———. "The New Sculpture." *Partisan Review,* vol. 16 (June, 1949), 637–42.

"Ides of Art: 14 sculptors write." *Tiger's Eye.* no. 4 (June, 1948), 73–84.

MILLER, DOROTHY C. (ed.). *Fourteen Americans.* New York: Museum of Modern Art, 1946. Includes Hare, Noguchi, Roszak, "with statements."

——— (ed.). *15 Americans.* New York: Museum of Modern Art, 1952. Includes Ferber, Lippold, "with statements."

——— (ed.) *12 Americans.* New York: Museum of Modern Art, 1956. Includes Hague, Lassaw, Lipton, De Rivera, "with statements."

MUNRO, ELEANOR. "Explorations in Form: a View of Some Recent American Sculpture." *Perspectives USA,* no. 16 (Summer, 1956), 160–72.

MUSEUM OF MODERN ART. *American Painting and Sculpture, 1862–1932.* New York, 1932. Essay by Holger Cahill.

———. *The New Sculpture: a Symposium.* New York, 1952. Unpublished typescript report of meeting. Speakers: Smith, Roszak, Ferber, Lippold; A. C. Ritchie, moderator.

RITCHIE, ANDREW C. *Abstract Painting and Sculpture in America.* New York: Museum of Modern Art, 1951. Bibliography on American art and sculpture.

SCHNIER, JACQUES, *Sculpture in Modern America.* Berkeley and Los Angeles: University of California Press, 1948.

SEYMOUR, CHARLES, JR. *Tradition and Experiment in Modern Sculpture.* Washington, D. C.: American University Press, 1949.

STONE, WARREN R. "The Contemporary Movement in American Sculpture." *Art,* no. 15 (June 9, 1955), 6–7.

TAFT, LORADO. "Modern Tendencies in Sculpture." Chicago: Art Institute of Chicago, 1921.

LITERARY AND BIOGRAPHICAL WORKS

ADAMS, HENRY. *The Education of Henry Adams.* Washington, D. C. [Privately Printed]. 1902. Other editions: Cambridge, Mass.: Riverside Press, 1918; New York: Modern Library, 1931.

ANDERSON, SHERWOOD. *Sherwood Anderson's Memoirs.* New York: Harcourt, Brace, 1942.

BEER, THOMAS. *The Mauve Decade*. Garden City: Garden City Publishing, 1926; London: Knopf, 1926.

BOURNE, RANDOLPH S. *The History of a Literary Radical*. New York: Huebsch, 1920.

BROOKS, VAN WYCK. *America's Coming of Age*. New York: Huebsch, 1914.

CANBY, HENRY S. *The Age of Confidence*. London: Constable, 1935.

COWLEY, MALCOLM. *Exile's Return: a Narrative of Ideas*. New York: Norton, 1934.

DREISER, THEODORE. *The Genius*. New York. Lane, 1915.

HAPGOOD, HUTCHINS. *A Victorian in the Modern World*. New York: Harcourt, Brace, 1939.

HOFSTADTER, RICHARD. *The Age of Reform*. London: Jonathan Cape, 1962.

HUNEKER, JAMES G. *Steeplejack*. New York: Scribner's, 1920.

JAMES, HENRY. *The American Scene*. London: Rupert Hart-Davis, 1968.

JOSEPHSON, MATTHEW. *Portrait of the Artist as American*. New York: Harcourt, Brace. 1930.

KAZIN, ALFRED. *On Native Grounds: an Interpretation of Modern American Prose Literature*. New York: Reynal and Hitchcock, 1942.

LAWRENCE, DAVID H. *Studies in Classic American Literature*. London: Martin Secker, 1924.

LUHAN, MABEL D. *Movers and Shakers*. Intimate Memoirs, vol. 3. New York: Harcourt, Brace, 1933–37.

MATTHIESSEN, FRANCIS O. *The American Renaissance*. London and New York: Oxford University Press, 1941.

MENCKEN, HENRY L. *Prejudices: Second Series*. London: Jonathan Cape, 1926.

MILLER, HENRY. *Tropic of Cancer*. Paris: Obelisk, 1935; London: John Calder, 1963.

PARRINGTON, VERNON L. *Main Currents in American Thought*. Vols. 1 & 2. London: Rupert Hart-Davis, 1963.

ROSENFELD, PAUL. *Port of New York: Essays on Fourteen American Moderns*. New York: Harcourt, Brace, 1924.

SANTAYANA, GEORGE. *Character and Opinion in the United States*. New York: Scribner's, 1920.

STEIN, GERTRUDE. *The Autobiography of Alice B. Toklas*. London: John Lane, 1933.

PERIODICALS AND SPECIAL NUMBERS

ART D'AUJOURD'HUI. Paris, June, 1951. "La Peinture aux États-Unis," edited by Michel Seuphor.

ART IN AMERICA. Cannondale, Conn., 1913–present. "Series" quarterly, devoted to the Younger Americans, e.g., "New Talent in the U.S.A." Vol. 46, no. 1 (February, 1956).

CAMERA WORK. Nos. 1–50. New York, 1902–1917. Edited by Alfred Stieglitz. Includes 3 special numbers: 1906, 1912, 1913.

DIAL. New York, 1920–29. Vols. 68–86 edited by Marianne Moore and S. Thayer.

DYN. Nos. 1–6. Mexico, 1942–44. Edited by Wolfgang Paalen.

EIDOS. Nos. 1–3. London, 1950. "A Journal of Painting, Sculpture and Design."

MAGAZINE OF ART. Washington, D. C., and New York, 1916–53. Originally the *American Magazine of Art* (1916 ff). Special March, 1949, issue: "A Symposium—the State of American Art."

PERSPECTIVES. Nos. 1–16. New York, 1952–56. Published by Intercultural Publications under a grant of the Ford Foundation.

PLASTIQUE. No. 3. Paris and New York, 1938. American number, edited by S. H. Taeuber-Arp, A. E. Gallatin, G. L. K. Morris.

POSSIBILITIES. No. 1, Winter, 1947–48. New York, Wittenborn, Schultz, 1948. One issue, edited by Robert Motherwell and others. Statements by artists of the New York School.

QUADRUM. Nos. 1–2. Brussels, Association pour la Diffusion Artistique et Culturelle, 1956–66. International magazine of modern art; foreign and English texts; American distributor: New York, Wittenborn.

TIGER'S EYE. Nos. 1–9. Westport, Conn., 1947–49. Edited by R. and J. Stephan. Includes articles by B. B. Newman (no. 1, Oct., 1947; no. 3, Mar., 1948) and others; section on "The Ides of Art" (no. 2, Dec., 1947; no. 4, June, 1948; no. 6, Dec., 1948); numerous illustrations.

"291." Nos. 1–12. New York, 1915–16. Edited by Alfred Stieglitz.

VVV. Nos. 1–4. New York, 1924–44. Edited by David S. Hare. Editorial advisers: A. Breton, M. Duchamp, M. Ernst.

ARTICLES

BALDINGER, W. S. "Formal Change in Recent American Painting." *Art Bulletin,* vol. 19 (December, 1937), 580–91.

BOLANDER, K. S. "Ferdinand Howald and His Collection." *Bulletin of the Columbus Gallery of Fine Arts,* vol. 1 (January, 1931), 7–12. Additional Howald article, May, 1934.

CAHILL, HOLGER. "Twentieth Century Art in the United States." *Marg* (Bombay), vol. 10, no. 1 (December, 1956), 46–62. "Sculpture," pp. 63–67.

COX, KENYON. "The Modern Spirit in Art" [at the Armory]. *Harper's Weekly,* vol. 57 (March 15, 1913), 10.

DASBURG, ANDREW. "Cubism—Its Rise and Influence." *Arts,* vol. 4 (November, 1923), 279–84.

DAVIES, ARTHUR B. "Explanatory Statement: the aim of the A. A. P. S." *Arts and Decoration,* vol. 3 (March, 1913), 149. The Armory Association.

DE CASSERES, BENJAMIN. "American Indifference." *Camera Work,* no. 27 (1909), 24.

———. "The Unconscious in Art." *Camera Work,* no. 36 (1911), 17.

———. "Modernity and the Decadence." *Camera Work,* no. 37 (1912), 17.

———. "Insincerity: a New Vice." *Camera Work,* no. 42 (1913), 17.

GREENBERG, CLEMENT. "American-Type Painting." *Partisan Review,* vol. 22 (Spring, 1955), 179–96.

———. "The Present Prospects of American Painting and Sculpture." *Horizon,* nos. 93–94 (October, 1947), 20–30.

——— [Reviews]. For references in *The Nation* and *Partisan Review* see listing in Goodall (under *Painting in the U. S.*).

HESS, THOMAS B. "U. S. Painting: Some Recent Directions." *Art News Annual,* vol. 25 (1956), 76–98, 174–80, 199.

HUNTER, SAM. "Painting by Another Name." *Art in America,* vol. 42 (December, 1954), 291–95.

———. "The Eight—Insurgent Realists." *Art in America,* vol. 44 (Fall, 1956), 20–22, 56–58.

"Irascible Eighteen." *The New York Herald-Tribune,* May 23, 1950, p. 18. Editorial on artists' protest to the Metropolitan Museum.

KRAMER, HILTON. "The New American Painting." *Partisan Review,* vol. 20 (July–August, 1953), 421–27.

LAFFAN, W. MACKAY. "The Material of American Landscape Painting." *American Art Review,* vol. 1 (1880), 23.

LARKIN, OLIVER. "Alfred Stieglitz and '291.'" *Magazine of Art,* vol. 40 (May, 1947), 179–83.

LEWISOHN, SAM A. "Is There an American Art Tradition?" *Formes,* vol. 21 (January, 1932), 204–205.

MCBRIDE, HENRY. "Modern Art." *Dial,* vol. 81 (July, 1926), 86–88. Also numerous reviews on the New York scene in *Dial.*

MATHER, FRANK J. "The Forum Exhibition." *The Nation,* vol. 102 (March 23, 1916), 340.

———. "Old and New Art" [at the Armory]. *The Nation,* vol. 96 (March 6, 1913), 240–43.

———. "Some American Realists." *Arts and Decoration,* vol. 7 (November, 1916), 13–16.

MELLQUIST, JEROME. "The Armory Show 30 Years Later." *Magazine of Art,* vol. 36 (December, 1943), 298–301.

MELVILLE, ROBERT. "Action Painting, New York—Paris—London." *Ark,* no. 18 (November, 1956), 30–33.

MOTHERWELL, ROBERT. "The Painter and His Audience." *Perspectives USA,* no. 9 (1954), 107–12.

———. "The Rise and Continuity of Abstract Art." *Arts and Architecture,* vol. 68 (September, 1951), 20–21.

PACH, WALTER. "The Eight Then and Now." *Art News,* vol. 42 (January 1, 1944), 25, 31.

PECKHAM, MORSE. "The Triumph of Romanticism." *Magazine of Art,* vol. 45 (November, 1952), 291–99.

ROOSEVELT, THEODORE. "A Layman's View of an Art Exhibition." *Outlook,* vol. 103 (March 29, 1913), 718–20.

ROSENBERG, HAROLD. "The American Action Painters." *Art News,* vol. 51 (December, 1952), 22–23.

ROSENBLUM, ROBERT. "The New Decade" [at the Whitney Museum and the Museum of Modern Art]. *Arts Digest,* vol. 29 (May 15, 1955), 20–23.

ROSENFELD, PAUL. "American Painting." *Dial,* vol. 71 (December, 1921), 649–70.

SCHAPIRO, MEYER. "The Younger American Painters of Today" [at the Tate Gallery]. *The Listener,* no. 1404 (January 26, 1956), 146–47.

———. "The Nature of Abstract Art." *Marxist Quarterly* (N.Y.), no. 1 (January–March, 1937), 77–98.

SCHMALENBACH, FRITZ. "American Scene" [eine neue Malereiströmung in den Vereinigten Staaten]. *Werk,* vol. 29, no. 1 (January, 1942), 25–31.

SEITZ, WILLIAM C. "Spirit, Time and Abstract Expressionism." *Magazine of Art,* vol. 46 (February, 1953), 80–87.

STEIN, LEO. "Panic in Art" [the Armory Show]. *New Republic,* vol. 1 (November 7, 1914), 20–21.

STEINBERG, LEO. "The Eye Is a Part of the Mind." *Partisan Review,* vol. 20 (March–April, 1953), 194–212.

SUTTON, DENYS. "The Challenge of American Art." *Horizon,* no. 118 (October, 1949), 268–84.

TANNENBAUM, LIBBY. "Notes of Mid-Century." *Magazine of Art,* vol. 48 (December, 1950), 289–92.

SWEENEY, JAMES J. "Five American Painters." *Harper's Bazaar,* vol. 78 (April, 1944), 76–77.

"What Abstract Art Means to Me." *Bulletin of the Museum of Modern Art,* vol. 18, no. 3 (Spring, 1951). Statements by A. Calder, S. Davis, W. de Kooning, F. Glarner, G. L. K. Morris, R. Motherwell.

WRIGHT, WILLARD H. "Forum Exhibition at the Anderson Galleries." *Forum,* vol. 55 (April, 1916), 457–71.

"Younger American Extremists." *Life Magazine,* no. 15 (October 11, 1948), 62–64.

ZAYAS, MARIUS DE. "The Sun Has Set." *Camera Work,* special number (June, 1913), 57.

EXHIBITION CATALOGUES

BUFFALO, ALBRIGHT ART GALLERY. *50th Annual Exhibition: 50 Paintings, 1905–13.* Catalogue introduction by Robert Goldwater; includes discussion of the Armory Show and American taste.

CHICAGO, THE ART INSTITUTE OF CHICAGO. *Abstract and Surrealist Art: 58th American Annual.* 1947.

LONDON, TATE GALLERY. *Modern Art in the United States: A Selection from the Collection of the Museum of Modern Art.* 1956. Organized by the International Circulating Exhibitions division of the Museum of Modern Art. Introduction by Holger Cahill, also in *Marg* (December, 1956).

MINNEAPOLIS, UNIVERSITY OF MINNESOTA GALLERY. *40 American Painters, 1940–1950.* 1951. Biographical notes.

MINNEAPOLIS, WALKER ART CENTER. *Contemporary American Painting.* 1950. Foreword to 5th Biennial by H. H. Arnason.

NEW HAVEN, YALE UNIVERSITY ART GALLERY. *Collection of the Société Anonyme: Museum of Modern Art 1920.* Associates in Fine Arts, 1950. K. S. Dreier and M. Duchamp, trustees; G. H. Hamilton, editor; notes and bibliographies.

NEW YORK, ASSOCIATION OF AMERICAN PAINTERS AND SCULPTORS. *International Exhibition of Modern Art.* 1913. The "Armory Show" catalogue; variant catalogues for Boston and Chicago exhibition. Preface by F. J. Gregg; statement by A. B. Davies.

NEW YORK, BROOKLYN MUSEUM. *The Eight.* Brooklyn Institute of Arts and Sciences, 1943. Shown November, 1943–January, 1944. Foreword by J. I. H. Baur; recollections by E. Shinn; biographical notes.

NEW YORK, CENTURY ASSOCIATION. *Robert Henri and His Pupils.* 1946. Essays by H. A. Read.

NEW YORK, THE FORUM. *Forum Exhibition of Modern Painters . . . on View at the Anderson Galleries.* Kennerly, 1916. Foreword by Alfred Stieglitz.

NEW YORK, THE GALLERY. *Art of This Century— 1910 to 1942.* 1942. Edited by Peggy Guggenheim. Supplemented by her biography, *Out of This Century,* New York: Dial Press, 1946.

NEW YORK, SOLOMON R. GUGGENHEIM MUSEUM. *Younger American Painters: a Selection.* 1954. Introduction by J. J. Sweeney.

NEW YORK, THE METROPOLITAN MUSEUM OF ART. *100 American Painters of the 20th Century.* 1950. Introduction by Robert B. Hale.

NEW YORK, MUSEUM OF MODERN ART. American Exhibitions 1930–1956. For a detailed list see *Museum Bulletin,* no. 1 (November, 1940). Selected exhibitions include:

———. *Paintings by Nineteen Living Americans.* 1930.

———. *American Painting and Sculpture, 1862–1932.* 1932. Text by H. Cahill.

———. *Americans 1942*. 1942. Edited by D. C. Miller.

———. *Romantic Painting in America*. 1943. Edited by J. T. Soby and D. C. Miller.

———. *American Realists and Magic Realists*. 1943. Texts by A. H. Barr, Jr., D. C. Miller, L. Kirstein, and the artists.

———. *Fourteen Americans*. 1946. Edited by D. C. Miller; texts by the artists.

———. *Abstract Painting and Sculpture in America*. 1951. Edited by A. C. Ritchie.

———. *15 Americans*. 1952. Edited by D. C. Miller; texts by the artists.

———. *12 Americans*. 1956. Edited by D. C. Miller; texts by the artists.

NEW YORK, NEW YORK UNIVERSITY. *Museum of Living Art: A. E. Gallatin Collection*. 1940. Collection now in the Philadelphia Museum of Art, with current catalogue.

NEW YORK, SOCIETY OF INDEPENDENT ARTISTS. *Catalogue of the First Annual Exhibition, Grand Central Palace, April 10 to May 6*. 1917.

NEW YORK, WHITNEY MUSEUM OF AMERICAN ART. American Exhibitions 1935–1955. These have included in part the following:

———. *Abstract Painting in America*. 1935.

———. *New York Realists, 1900–1914*. 1937. Text by H. A. Read.

———. *20th Century Artists . . . from the Permanent Collections*. 1939.

———. *Pioneers of Modern Art in America*. 1946. Text by L. Goodrich.

———. *The New Decade: 35 American Painters and Sculptors*. 1955. Text by J. I. H. Baur.

NEW YORK, WITTENBORN, SCHULTZ. *American Abstract Artists*. 1946. Directory-Yearbook, also issued 1938.

———. *World of Abstract Art*. 1957. Anthology.

PHILADELPHIA, PHILADELPHIA MUSEUM OF ART. *Artists of the Philadelphia Press: William Glackens, George Luks, Everett Shinn, John Sloan*. 1945. Also, article in the *Museum Bulletin* (November, 1945).

PITTSBURGH, CARNEGIE INSTITUTE, DEPARTMENT OF FINE ARTS. *Survey of American Painting*. 1940. Introduction by Homer St.-Gaudens.

RICHMOND, VIRGINIA MUSEUM OF FINE ARTS. *American Painting 1950*. 1950. Foreword by J. J. Sweeney.

SAN FRANCISCO, CALIFORNIA PALACE OF THE LEGION OF HONOR. *3rd Annual Exhibition of Painting, 1948–49*. 1949. Text by J. MacAgy.

———. *4th Annual Exhibition of Contemporary American Painting*. 1950. Texts by T. C. Have, J. MacAgy, F. S. Bartlett.

SÃO PAULO, MUSEU DE ARTE MODERNA. V BIENAL DE ARTE. *Catalogue: Guston, Smith, Francis, Frankenthaler, Goldberg, Kadish, Kohn, Leslie, Marca-Relli, Metcalf, Mitchell, Rauschenberg*. Text by Sam Hunter. Minneapolis: Minneapolis Institute of Arts, 1959.

URBANA, UNIVERSITY OF ILLINOIS. *Contemporary American Painting*. Annals issued 1948, 1950, 1951, 1953, 1955, 1957; include prefaces by A. S. Weller. Sculpture included in 1953, 1957.

VENICE, XXV BIENNALE. *Catalogo*. Venice: Alfieri, 1950. Pp. 374–386 include seven American artists; texts by D. Phillips, A. H. Frankfurter, A. H. Barr, Jr.

———, XXVII BIENNALE, AMERICAN PAVILION. *2 Pittori: De Kooning, Shahn. 3 Scultori: Lachaise, Lassaw, Smith*. New York: Museum of Modern Art, 1954. Exhibition organized by Museum of Modern Art; text and artists' statements in Italian and English.

———, XXIX BIENNALE. *Lipton, Rothko, Smith, Tobey*. 1958. Catalogue by Museum of Modern Art; texts by Sam Hunter and Frank O'Hara.

WASHINGTON, D. C., PHILLIPS COLLECTION. *The Phillips Collection, a Museum of Modern Art and Its Sources: Catalogue*. 1952. Supplemented by *A Collection in the Making*, New York: 1926.

———. *Bulletin of the Phillips Collection, 1927–1932* (issued 1929–30 as *Art and Understanding*).

———. *The Artist Sees Differently*. 2 vols., 1931.

———. *American Paintings of the Phillips Collection*. 1944.

Selected References on American Painting and Sculpture Since 1959
by Roberta P. Smith, with Nicole Sweedler Metzner

GENERAL REFERENCES

BOOKS

1. AMAYA, MARIO. *Pop Art and After*. New York: Viking Press, 1965. Selected bibliography.
2. ARNASON, H. H. *History of Modern Art: Painting, Sculpture, Architecture*. Bibliography. London: Thames and Hudson, 1969.
3. ASHTON, DORE. *Modern American Sculpture*. New York: Harry N. Abrams, 1968.
4. ———. *The Unknown Shore: A View of Contemporary Art*. London: Studio Vista, 1964.
5. BARRETT, CYRIL. *Optical Art*. London: Studio Vista, 1970.
6. BATTCOCK, GREGORY (ed.). *Minimal Art: A Critical Anthology*. London: Studio Vista, 1969.
7. ——— (ed.). *The New Art: A Critical Anthology*. New York: E. P. Dutton, 1966.
8. BURNHAM, JACK. *Beyond Modern Sculpture: The Effects of Science and Technology on the Sculpture of This Century*. London: Allen Lane the Penguin Press, 1968.
9. ———. *The Structure of Art*. New York: George Braziller, 1971.
10. CALAS, NICOLAS. *Art in the Age of Risk and Other Essays*. New York: E. P. Dutton, 1968.
11. ——— and CALAS, ELENA. *Icons and Images of the Sixties*. New York: E. P. Dutton, 1971.
12. CELANT, GERMANO. *Arte Povera*. London: Studio Vista, 1969.
13. FINCH, CHRISTOPHER. *Pop Art: Object and Image*. London: Studio Vista, 1968.
14. FRY, EDWARD F. (ed.). *On the Future of Art*. New York: Viking Press, 1970. Articles by Arnold Toynbee, Louis Kahn, Annette Michelson, B. F. Skinner, James Seawright, Jack Burnham, Herbert Marcuse.
15. GREENBERG, CLEMENT. *Art and Culture: Critical Essays*. London: Thames and Hudson, 1973.
16. HANSEN, AL. *A Primer of Happenings and Time/Space Art*. New York: Something Else Press, 1965.
17. HUNTER, SAM. "American Art Since 1945." In *New Art Around the World: Painting and Sculpture*, pp. 9–58. New York: Harry N. Abrams, 1966.
18. ———. *Neorealismo, Assemblage, Pop Art in America*. Milan: Fratelli Fabbri Editori, 1969.
19. ———. *La Pittura Americana del Dopoguerra*. Milan: Fratelli Fabbri Editori, 1970.
20. JANIS, HARRIET and BLESH, RUDI. *Collage*. Philadelphia: Chilton, 1962.
21. KAPROW, ALLAN. *Assemblage, Environments and Happenings*. New York: Harry N. Abrams, 1966.
22. KEPES, GYORGY (ed.). *Vision and Value*. London: Studio Vista, 1965–66. Series of six volumes: *Education of Vision; Structure in Art and Science; Module, Proportion, Symmetry, Rhythm; The Nature and Art of Motion; The Man-Made Object; Sign, Image, Symbol*.
23. KIRBY, MICHAEL. *The Art of Time: Essays on the Avant-Garde*. New York: E. P. Dutton, 1969.
24. ———. *Happenings, An Illustrated Anthology*. London: Sidgwick and Jackson, 1966.
25. KOZLOFF, MAX. *Renderings: Critical Essays on a Century of Modern Art*. New York: Simon & Schuster, 1969.
26. KULTERMANN, UDO. *The New Painting*. London: Pall Mall Press, 1969. Selected bibliography.
27. ———. *The New Sculpture, Environments and Assemblages*. London: Thames and Hudson, 1968. Selected bibliography.
28. LIPPARD, LUCY R. *Changing: Essays in Art Criticism*. New York: E. P. Dutton, 1971.
29. ———(ed.). *Pop Art*. London: Thames and Hudson, 1967. Articles by Lawrence

Alloway, Nancy Marmer, Nicolas Calas.

30. LUCIE-SMITH, EDWARD. *Art Since 1945.* London: Thames and Hudson, 1969.

31. POPPER, FRANK. *Kinetic Art.* Greenwich/London: New York Graphic Society/Studio-Vista Ltd., 1968. Bibliography.

32. REICHART, JASIA. *Cybernetics, Art, and Ideas.* London: Studio Vista, 1971. 1971.

33. RICKEY, GEORGE. *Constructivism: Origins and Evolution.* New York: George Braziller, 1967. Comprehensive bibliography.

34. ROSE, BARBARA. *American Art Since 1900— A Critical History.* London: Thames and Hudson, 1968. Selected bibliography.

35. ———. *American Painting: The Twentieth Century.* New York: Skira, 1969. Selected bibliography.

36. ———. *Readings in American Art Since 1900: A Documentary Survey.* New York: Frederick A. Praeger, 1968. Bibliography.

37. ROSENBERG, HAROLD. *The Anxious Object: Art Today and Its Audience.* London: Thames and Hudson 1965. 2nd ed., 1966.

38. ———. *Artworks and Packages.* London: Thames and Hudson 1969.

39. ———. *Tradition of the New.* London: Thames and Hudson, 1962.

40. RUBLOWSKY, JOHN. *Pop Art.* New York: Basic Books, 1965.

41. RUSSELL, JOHN and GABLIK, SUZI. *Pop Art Redefined.* London: Thames and Hudson, 1969.

42. SANDLER, IRVING. *The Triumph of American Painting: A History of Abstract Expressionism.* New York: Frederick A. Praeger, 1970. Bibliography.

43. TUCHMAN, MAURICE. *The New York School: Abstract Expressionism in the 40's and 50's* London: Thames and Hudson, 1969. Comprehensive bibliography.

44. WESCHER, HERTA. *Collage.* Translated by Robert E. Wolf. New York: Harry N. Abrams, 1968.

ARTICLES

45. ALDRICH, LARRY. "New Talent U.S.A." *Art in America,* vol. 54 (July–August, 1966), 22–69.

46. BANNARD, WALTER D. "Present-Day Art and Ready-Made Styles." *Artforum,* vol. 5 (December, 1966), 30–35.

47. BOCHNER, MEL. "Serial Art Systems: Solipsism." *Arts Magazine,* vol. 41 (Summer, 1967), 39–43 (*See bibl. 6*).

48. ———. "The Serial Attitude." *Artforum.* vol. 6 (December, 1967), 28–33.

49. BURNHAM, JACK. "Problems of Criticism. IX: Art and Technology." *Artforum,* vol. 9 (January, 1971), 40–45.

50. ———. "Real Time Systems." *Artforum.* vol. 8 (September, 1969), 49–55.

51. ———. "Systems Esthetics." *Artforum.* vol. 7 (September, 1968), 30–35.

52. FRIED, MICHAEL. "Art and Objecthood." *Artforum,* vol. 5 (June, 1967), 12–23 (*See bibl. 6*).

53. GLASER, BRUCE and LIPPARD, LUCY R. (eds.). "Questions to Stella and Judd." *Art News.* vol. 65 (September, 1966), 55–61 (*See bibl. 6*).

54. GOLDWATER, ROBERT. "Problems of Criticism, I: Varieties of Critical Experience." *Artforum,* vol. 6 (September, 1967), 40–41.

55. GREENBERG, CLEMENT. "Avant-Garde Attitudes: New Art in the Sixties." *Studio International,* vol. 179 (April, 1970), 142–45.

56. ———. "Problems of Criticism, II: Complaints of an Art Critic." *Artforum,* vol. 6 (October, 1967), 38–39.

57. HESS, THOMAS B. "Phony Crisis in American Art." *Art News,* vol. 62 (Summer, 1963). 24–28; 59–60.

58. JUDD, DON. "Black, White and Gray." *Arts Magazine,* vol. 38 (March 1964), 36–38.

59. ———. "Specific Objects." *Contemporary Sculpture, Arts Yearbook, no. 8* (1965), 74–82 (*See bibl. 80*).

60. KAPROW, ALLAN. "Experimental Art." *Art News,* vol. 65 (March, 1966), 60–63; 77–82.

61. KOZLOFF, MAX. "Art and the New York Avant-garde." *Partisan Review,* vol. 31 (Fall, 1964), 535–554.

62. ———. "The Inert and the Frenetic." *Artforum,* vol. 4 (March, 1966), 40–44.

63. KRAMER, HILTON. "Episodes from the Sixties." *Art in America,* vol. 58 (January–February, 1970), 56–61.

64. KRAUSS, ROSALIND. "Problems of Criticism.

X: Pictorial Space and the Question of Documentary." *Artforum,* vol. 10 (November, 1971), 68–71.

65. LIPPARD, LUCY R. "Homage to the Square." *Art in America,* vol. 55 (July–August, 1967), 50–57.

66. ———. "The Third Stream: Constructed Paintings and Painted Structures." *Art Voices,* vol. 4 (Spring, 1965), 44–49.

67. MELLOW, JAMES, R. (ed.). *The Art World, Arts Yearbook, no. 7.* New York: Art Digest, 1964. Articles by Clement Greenberg, Hilton Kramer, Don Judd, Michael Fried, Vivian Raynor, Sidney Tillim.

68. MORRIS, ROBERT. "Some Notes on the Phenomenology of Making: The Search for the Motivated." *Artforum,* vol. 8 (April, 1970), 62–66.

69. NODELMAN, SHELDON. "Sixties Art: Some Philosophical Perspectives." *Perspecta 11: The Yale Architectural Journal* (1967), 72–89.

70. PLAGENS, PETER. "Present-Day Styles and Ready-Made Criticism." *Artforum,* vol. 5 (December, 1966), 36–39.

71. REISE, BARBARA. "Greenberg and The Group: A Retrospective View, Part 1." *Studio International,* vol. 175 (May, 1968), 254–57.

72. ———. "Greenberg and The Group: A Retrospective View, Part 2." *Studio International,* vol. 175 (June, 1968), 314–15.

73. ROSE, BARBARA. "ABC Art." *Art in America,* vol. 53 (October–November, 1965), 57–69.

74. ———. "Problems of Criticism, IV: The Politics of Art, Part 1." *Artforum,* vol. 6 (February, 1968), 31–32.

75. ———. "Problems of Criticism, V: The Politics of Art, Part 2." *Artforum,* vol. 7 (January, 1969), 44–49.

76. ———. "Problems of Criticism, VI: The Politics of Art, Part 3." *Artforum,* vol. 7 (May, 1969), 46–51.

77. ——— and SANDLER, IRVING. "Sensibility of the Sixties." *Art in America,* vol. 55 (January–February, 1967), 44–57.

78. ———. "The Value of Didactic Art." *Artforum,* vol. 5 (April, 1967), 32–36.

79. SANDLER, IRVING. "New York Letter." *Quadrum,* no. 14 (1963), 115–24 (*See bibl. 77*).

80. SEITZ, WILLIAM C. (ed.). *Contemporary Sculpture, Arts Yearbook, no. 8.* New York: Art Digest, 1965. Articles by Sidney Geist, Robert Goldwater, Don Judd.

81. TILLIM, SIDNEY. "Scale and the Future of Modernism." *Artforum,* vol. 6 (October, 1967), 14–18.

82. WOLLHEIM, RICHARD. "Minimal Art." *Arts Magazine,* vol. 39 (January, 1965), 26–32 (*See bibl. 6*).

EXHIBITION CATALOGUES

83. Buffalo, Albright-Knox Art Gallery. *Plus by Minus: Today's Half-Century.* 1968. Text by Douglas MacAgy.

84. Cincinnati, Contemporary Arts Center. *Monumental American Art.* 1970.

85. Detroit, Detroit Institute of Arts. *Form, Color, Image.* 1967. Introduction by Gene Baro.

86. Hartford, Wadsworth Atheneum. *Continuity and Change.* 1962. Exhibition and foreword by Samuel Wagstaff, Jr.

87. ———. *Black, White and Gray.* 1964. Exhibition and text by Samuel Wagstaff, Jr.

88. Honolulu, Honolulu Academy of Arts. *Signals in the Sixties.* 1968. Introduction by James Johnson Sweeney.

89. Irvine, University of California at Irvine Art Gallery. *The Second Breakthrough 1959–1964.* 1969. Exhibition and catalogue essay by Alan Solomon.

90. Kassel, Museum Fridericanum. *Documenta III: Internationale Ausstellung Malerei und Skulptur.* 1964. German; foreword by Dr. Karl Branner; essays by Werner Haftmann and Arnold Bode.

91. ———. *Documenta IV: Internationale Ausstellung.* 1968. German; foreword by Dr. Karl Branner; essays by Arnold Bode, Max Imdahl, Jan Leering.

92. London, Tate Gallery. *Painting & Sculpture of a Decade 54/64.* 1964. Organized by the Calouste Gulbenkian Foundation; catalogue notes by Alan Bowness, Lawrence Gowing, Philip James.

93. Minneapolis, Walker Art Center. *Eight Sculptors: The Ambiguous Image.* 1966. Catalogue essays by Martin Friedman and Jan van der Marck.

94. Montreal, Expo '67, United States Pavilion. *American Painting Now*. Traveled to Institute of Contemporary Arts, Boston, 1967. Exhibition and catalogue essay by Alan Solomon.

95. New York, Solomon R. Guggenheim Museum. *Guggenheim International Exhibition 1971*. Exhibition and catalogue essays by Diane Waldman and Edward F. Fry. Artists' and general bibliographies.

96. New York, The Metropolitan Museum of Art. *New York Painting and Sculpture: 1940–1970*. Exhibition and catalogue essay by Henry Geldzahler; articles by Harold Rosenberg, Robert Rosenblum, Clement Greenberg, William S. Rubin, Michael Fried. Artists' biographies and bibliographies. New York: E. P. Dutton, 1969, in association with the museum.

97. New York, Museum of Modern Art. *Sixteen Americans*. 1959. Exhibition and catalogue foreword by Dorothy C. Miller; artists' statements.

98. ———. *Americans 1963*. 1963. Exhibition and catalogue foreword by Dorothy C. Miller; artists' statements.

99. ———. *The Responsive Eye*. 1965. Exhibition and catalogue essay by William C. Seitz.

100. ———. *The Art of the Real: U.S.A. 1948–1968*. 1968. Exhibition and catalogue essay by E. C. Goossen. Artists' and general bibliographies.

101. New York, Whitney Museum of American Art. Catalogues of the Museum's Annual Exhibitions (painting and sculpture in alternate years).

102. ———. *Geometric Abstraction in America*. 1962. Exhibition and catalogue essay by John Gordon.

103. Pasadena, Pasadena Art Museum. *Serial Imagery*. 1968. Exhibition and catalogue essay by John Coplans.

104. Ridgefield, Conn., Aldrich Museum of Contemporary Art. *Cool Art*. 1968. Catalogue introduction by Larry Aldrich.

105. São Paulo, Museu de Arte Moderna. VII Bienal de arte. *The United States of America: 1. Adolph Gottlieb 2. Ten Sculptors*. 1963. Exhibition and catalogue by Martin Friedman; brief biographies and selected bibliography; traveled to Walker Art Center, Minneapolis.

106. ———. VIII Bienal de arte. *The United States of America*. 1965. Exhibition and catalogue by Walter Hopps; biographies and bibliographies; traveled to Washington, D.C., 1966.

107. ———. *São Paulo 9. United States of America: Edward Hopper [and] Environment U.S.A. 1957–1967*. 1968. Essays by William C. Seitz and Lloyd Goodrich; extensive bibliography, artists' statements; traveled to Brandeis University. Published for the National Collection of Fine Arts by the Smithsonian Institution Press, 1967.

108. Seattle, 1962 World's Fair. *Art Since 1950*. 1962. United States exhibition and catalogue by Sam Hunter.

109. St. Paul de Vence, Fondation Maeght. *L'Art Vivant: 1965–1968*. 1968. Catalogue by François Wehrlin.

110. ———. *L'Art Vivant aux Etats Unis*. 1970. Exhibition and catalogue essay by Dore Ashton.

111. Urbana, University of Illinois. *Contemporary American Painting and Sculpture*. 1948–to date. Catalogues of the biennial exhibitions.

112. Vancouver, Vancouver Art Gallery. *New York 13*. 1969. Exhibition by Doris Shadbolt, text by Lucy R. Lippard; bibliography; traveled in Canada.

113. Venice, Biennale, United States Pavilion. *XXXII International Biennial Exhibition of Art: Four Germinal Painters—Four Younger Artists*. 1964. Exhibition and catalogue essay by Alan Solomon; biographies and bibliography.

114. ———. *XXXIII Biennial Exhibition of Art: Ellsworth Kelly, Helen Frankenthaler, Roy Lichtenstein, and Jules Olitski*. 1966. Exhibition and catalogue essay by Henry Geldzahler; foreword by David Scott; essay on Lichtenstein by Robert Rosenblum.

115. Washington, D.C., Washington Gallery of Modern Art. *A New Aesthetic*. 1967. Catalogue by Barbara Rose; artists' bibliographies.

116. Washington, D.C., Smithsonian Institution, National Collection of Fine Arts. *The

Disappearance and Reappearance of the Image: American Painting since 1945. 1969. Catalogue essays by Ruth Kaufmann and John McCoubrey; extensive bibliography. Circulated in Europe by the International Art Program.

117. Yonkers, Hudson River Museum. *8 Young Artists.* 1964. Exhibition and catalogue essay by E. C. Goossen.

POP ART, REALISM, ASSEMBLAGE, HAPPENINGS

ARTICLES

118. ALLOWAY, LAWRENCE. "Art as Likeness (Post Pop Art)." *Arts Magazine,* vol. 41 (May, 1967), 34–39.

119. ———. "Notes on Realism." *Arts Magazine,* vol. 44 (April, 1970), 26–29.

120. CALAS, NICOLAS. "Why Not Pop Art?" *Art and Literature,* no. 4 (Spring, 1965), 178–84.

121. CANADAY, JOHN. "Pop Art Sells On and On—Why?" *The New York Times Magazine,* May 31, 1964, pp. 7; 48–53.

122. COPLANS, JOHN. "The New Paintings of Common Objects." *Artforum,* vol. 1 (November, 1962), 26–29.

123. HESS, THOMAS B. "Collage as an Historical Method." *Art News,* vol. 60 (November, 1961), 30–33; 69–71.

124. HOPPS, WALTER. "Boxes." *Art International,* vol. 8 (March, 1964), 38–42.

125. KAPROW, ALLAN. "The Happenings are Dead—Long Live the Happenings." *Artforum,* vol. 4 (March, 1966), 37–39.

126. ———. "Pinpointing Happenings." *Art News,* vol. 66 (October, 1967), 46–47; 70–71.

127. KOZLOFF, MAX. " 'Pop' Culture, Metaphysical Disgust and the New Vulgarians." *Art International,* vol. 6 (March, 1962), 34–36.

128. KRAMER, HILTON. " 'Realists' and Others." *Arts Magazine,* vol. 38 (January, 1964), 18–23.

129. LADERMAN, GABRIEL. "Problems of Criticism VIII: Notes from the Underground." *Artforum,* vol. 9 (September, 1970), 59–61.

130. ———. "Unconventional Realists." *Artforum,* vol. 6 (November, 1967), 42–46.

131. ———. "Unconventional Realists, Part 2: Sculpture." *Artforum,* vol. 9 (March, 1971), 35–39.

132. NEMSER, CINDY. "Representational Painting in 1971: A New Synthesis." *Arts Magazine,* vol. 46 (December, 1971–January, 1972), 41–46.

133. ———. "Sculpture and the New Realism." *Arts Magazine,* vol. 44 (April, 1966), 39–41.

134. PETERSON, VALERIE. "U.S. Figure Painting: Continuity and Cliche." *Art News,* vol. 61 (Summer, 1961), 36–38; 51–52.

135. ROSE, BARBARA. "Dada Then and Now." *Art International,* vol. 7 (January, 1963), 23–28.

136. ROSENBLUM, ROBERT. "Pop and Non-Pop: An Essay in Distinction." *Canadian Art,* vol. 23 (January, 1966), 50–54.

137. RUDIKOFF, SONIA. "New Realists in New York." *Art International,* vol. 7 (January, 1963), 39–41.

138. SEITZ, WILLIAM C. "Assemblage: Problems and Issues." *Art International,* vol. 6 (February, 1962), 26–34.

139. SELZ, PETER. "A Symposium on Pop Art." *Arts Magazine,* vol. 37 (April, 1963), 36–45. Symposium held at the Museum of Modern Art, New York, December, 1963.

140. SOLOMON, ALAN. "The New American Art." *Art International,* vol. 8 (February, 1964), 50–55.

141. SWENSON, G. R. "The New American 'Sign Painters'." *Art News,* vol. 61 (September, 1962), 44–47; 60–62.

142. ———. " 'What is Pop Art?' Answers from 8 Painters, Part 1." *Art News,* vol. 62 (November, 1963), 24–27; 60–63.

143. ———. " 'What is Pop Art?' Answers from 8 Painters, Part 2." *Art News,* vol. 62 (February, 1964), 40–43; 66–67.

144. TILLIM, SIDNEY. "Further Observations on the Pop Phenomenon." *Artforum,* vol. 4 (November, 1965), 17–19.

145. ———. "Realism and 'The Problem'." *Arts Magazine,* vol. 37 (September, 1963), 48–52.

146. ———. "The Reception of Figurative Art: Notes on a General Misunderstanding." *Artforum,* vol. 7 (February, 1969), 30–33.

147. ———. "A Variety of Realisms." *Artforum,* vol. 7 (Summer, 1969), 42–47.

EXHIBITION CATALOGUES

148. Amsterdam, Stedelijk Museum. *American Pop Art*. 1964. Dutch; catalogue essay by Alan Solomon.

149. Berlin, Akademie der Künste. *Neue Realisten und Pop Art*. 1964. Catalogue essay by Werner Hofmann; bibliography.

150. Buffalo, Albright-Knox Art Gallery. *Mixed Media and Pop Art*. 1963. Catalogue foreword by Gordon Smith.

151. Houston, Contemporary Arts Museum. *Pop Goes the Easel*. 1963. Exhibition and catalogue essay by Douglas MacAgy.

152. Kansas City, Mo., Nelson Gallery–Atkins Museum. *Popular Art*. 1963. Exhibition and catalogue essay by Ralph T. Coe.

153. London, Hayward Gallery. *Pop Art*. 1969. Exhibition and catalogue by John Russell and Suzi Gablik; artists' and critics' statements.

154. Los Angeles, Dwan Gallery. *Boxes*. 1964. Catalogue essay by Walter Hopps.

155. Milwaukee, Milwaukee Art Center. *Pop Art and the American Tradition*. 1965. Exhibition and catalogue essay by Tracy Atkinson.

156. ———. *Directions 2: Aspects of a New Realism*. 1969. Catalogue essays by Tracy Atkinson and John Lloyd Taylor.

157. Minneapolis, Walker Art Center. *Figures/Environments*. 1970. Catalogue essays by Martin Friedman and Dean Swanson; biographies and bibliographies.

158. New York, Solomon R. Guggenheim Museum. *Six Painters and the Object*. 1963. Exhibition and catalogue essay by Lawrence Alloway; selected bibliography.

159. ———. *The Photographic Image*. 1966. Introduction by Lawrence Alloway.

160. New York, Martha Jackson Gallery. *New Forms—New Media I*. 1960. Texts by Lawrence Alloway and Allan Kaprow.

161. New York, Museum of Modern Art. *New Images of Man*. 1959. Exhibition and catalogue essay by Peter Selz; artists' statements; biographies and bibliography.

162. ———. *The Art of Assemblage*. 1961. Exhibition and catalogue essay by William C. Seitz; extensive bibliography.

163. ———. *Recent Painting U.S.A.: The Figure*. 1962. Introduction by Alfred H. Barr, Jr.; circulated to six cities.

164. New York, Whitney Museum of American Art. *22 Realists*. 1970. Exhibition and catalogue essay by James Monte; comprehensive bibliography.

165. Oakland, Oakland Museum. *Pop Art U.S.A.*. 1963. Exhibition and catalogue essay by John Coplans.

166. Pasadena, Pasadena Art Museum. *The New Paintings of Common Objects*. 1962. Exhibition by Walter Hopps.

167. Philadelphia, University of Pennsylvania, Institute of Contemporary Art. *The Other Tradition*. 1966. Catalogue essay by G. R. Swenson.

168. Stockholm, Moderna Museet. *Amerikansk Pop-Konst*. 1964. Swedish; catalogue foreword by K. G. Pontus Hulten; critical essays and artists' writings; bibliography.

169. Venice, XXXIV Biennale, United States Pavilion. *Venice 34: The Figurative Tradition in Recent American Art*. 1968. Exhibition and catalogue essay by Norman A. Geske; selected bibliography; exhibition traveled to Lincoln, Nebraska.

170. Washington, D.C., Washington Gallery of Modern Art. *The Popular Image Exhibition*. 1963. Catalogue essay by Alan Solomon.

171. Worcester, Mass., Worcester Art Museum. *The New American Realism*. 1965. Introduction by Martin Carey; artists' statements.

172. New York, The Riverside Museum. *Paintings from the Photo*. 1969. Introduction by Oriole Farb.

ABSTRACT PAINTING

ARTICLES

173. ALLOWAY, LAWRENCE. "Sign and Surface: Notes on Black and White Painting in New York." *Quadrum*, no. 9 (1960), 49–62.

174. BAIGELL, MATTHEW. "American Abstract Expressionism and Hard-Edge: Some Comparisons." *Studio International*, vol. 171 (January, 1966), 10–15.

175. BANNARD, WALTER D. "Notes on American Painting of the Sixties." *Artforum*, vol. 8 (January, 1970), 40–45.

176. BATTCOCK, GREGORY. "Re-Evaluating Ab-

stract Expressionism." *Arts Magazine,* vol. 44 (December, 1969–January, 1970), 45–49.

177. COPLANS, JOHN. "Post Painterly Abstraction: The Long-Awaited Greenberg Exhibition Fails to Make Its Point." *Artforum,* vol. 2 (Summer, 1964), 4–9 (*See bibl. 201*).

178. DOMINGO, WILLIS. "Color Abstraction: A Survey of Recent American Painting." *Arts Magazine,* vol. 45 (December, 1970–January, 1971), 34–40.

179. GREENBERG, CLEMENT. "After Abstract Expressionism." *Art International,* vol. 6 (October, 1962), 24–32 (*See bibl. 96*).

180. ———. "The 'Crisis' of Abstract Painting." *The Art World, Arts Yearbook, no. 7* (1964), 89–92 (*See bibl. 67*).

181. ———. "Modernist Painting." *Art and Literature,* no. 4 (Spring, 1965), 193–201 (*See bibl. 7*).

182. ———. "Post Painterly Abstraction." *Art International,* vol. 8 (Summer, 1964), 63–65 (*See bibl. 201*).

183. HUNTER, SAM. "Abstract Expressionism Then and Now." *Canadian Art,* vol. 21 (September–October, 1964), 266–69.

184. KOZLOFF, MAX. "The Critical Reception of Abstract Expressionism." *Arts Magazine,* vol. 40 (December, 1965), 27–33.

185. ———. "Problems of Criticism III: Venetian Art and Florentine Criticism." *Artforum,* vol. 6 (December, 1967), 42–45.

186. KRAMER, HILTON. "Notes on Painting in New York." *The Art World, Arts Yearbook, no. 7* (1964), 9–20 (*See bibl. 67*).

187. ———. "30 Years of the New York School." *The New York Times Magazine,* October 12, 1969, pp. 28–31; 89–90.

188. KRAUSS, ROSALIND. "On Frontality." *Artforum,* vol. 6 (May, 1968), 40–46.

189. LIPPARD, LUCY R. "Perverse Perspectives." *Art International,* vol. 11 (March–April, 1967), 28–33; 44.

190. ———. "The Silent Art." *Art in America,* vol. 55 (January–February, 1967), 58–63.

191. "The New York School." *Artforum,* vol. 4 (September, 1965). Special issue with articles by Philip Leider, Michael Fried, Lawrence Alloway, Max Kozloff, Irving Sandler, Robert Goodnough, Paul Brach, Sidney Tillim, Barbara Rose.

192. PINCUS-WITTEN, ROBERT. " 'Systemic' Paint-ing." *Artforum,* vol. 5 (November, 1966), 42–45 (*See bibl. 206*).

193. RATCLIFF, CARTER. "The New Informalists." *Art News,* vol. 68 (February, 1970), 46–50.

194. ROSE, BARBARA. "Abstract Illusionism." *Artforum,* vol. 6 (October, 1967), 33–37.

195. ———. "The Primacy of Color." *Art International,* vol. 8 (May, 1964), 22–26.

196. RUBIN, WILLIAM S. "Younger American Painters." *Art International,* vol. 4 (January, 1960), 24–31.

197. SCHORR, JUSTIN. "Problems of Criticism VII: To Save Painting." *Artforum,* vol. 8 (December, 1969), 59–61.

EXHIBITION CATALOGUES

198. Buffalo, Albright-Knox Art Gallery. *Modular Painting.* 1970. Exhibition and catalogue essay by Robert M. Murdock.

199. Cambridge, Mass., Fogg Art Museum. *Three American Painters: Kenneth Noland, Jules Olitski, Frank Stella.* Exhibition and catalogue essay by Michael Fried.

200. Eindhoven, Stedelijk van Abbemuseum. *Kompass III, New York (Painting After 1945 in New York).* 1967.

201. Los Angeles, Los Angeles County Museum of Art. *Post Painterly Abstraction.* 1964. Exhibition and catalogue essay by Clement Greenberg (*See bibl. 182*).

202. ———. *New York School: The First Generation, Paintings of the 1940s and 1950s.* Exhibition and catalogue by Maurice Tuchman; critical texts, artists' statements, extensive bibliography; book edition published with updated bibliography (*See bibl. 43*).

203. New York, Finch College Museum of Art. *Art in Process: The Visual Development of a Painting.* 1965.

204. New York, Solomon R. Guggenheim Museum. *American Abstract Expressionists and Imagists.* 1961. Exhibition and catalogue introduction by H. H. Arnason; biographies and bibliography.

205. ———. *The Shaped Canvas.* 1964. Exhibition and catalogue essay by Lawrence Alloway.

206. ———. *Systemic Painting.* 1966. Exhibi-

tion and catalogue essay by Lawrence Alloway; extensive bibliography (*See bibl. 192*).

207. New York, The Jewish Museum. *Toward a New Abstraction*. 1963. Exhibition and catalogue preface by Alan Solomon; critical texts and bibliographies on the artists.

208. New York, Museum of Modern Art. *The New American Painting: As Shown in Eight European Countries 1958–1959*. Introduction by Alfred H. Barr, Jr.; organized by the International Council of the Museum.

209. ———. *Two Decades of American Painting*. 1966. Catalogue essays by Irving Sandler, Lucy R. Lippard, G. R. Swenson, Waldo Rasmussen; organized by the International Council of the Museum; traveled to Japan, India, Australia.

210. New York, Whitney Museum of American Art. *The Structure of Color*. 1971. Exhibition and catalogue essay by Marcia Tucker; bibliography.

211. ———. *Lyrical Abstraction*. 1971. Statement by Larry Aldrich.

212. Pasadena, Pasadena Art Museum. *Painting in New York: 1944 to 1969*. 1969. Exhibition and catalogue essay by Alan Solomon; selected bibliography.

213. Waltham, Mass., Brandeis University, Poses Institute. *New Directions in American Painting*. 1963. Exhibition and catalogue essay by Sam Hunter (*See bibl. 7*).

214. Washington, D.C., Corcoran Gallery of Art. *Oil Paintings by Contemporary American Artists*. 1907–to date. Catalogues of the biennial exhibitions.

215. Washington, D.C., Washington Gallery of Modern Art. *Formalists*. 1963. Foreword by Adelyn D. Breeskin; statements by Herbert Read and Piet Mondrian.

216. ———. *The Washington Color Painters*. 1965. Catalogue by Gerald Nordland; bibliography.

ABSTRACT SCULPTURE

ARTICLES

217. "American Sculpture." *Artforum*, vol. 5 (Summer, 1967). Special issue with articles by Philip Leider, Michael Fried, Robert Morris, Barbara Rose, Robert Smithson, Max Kozloff, Sidney Tillim, James Monte, Wayne V. Andersen, Fidel A. Danieli, Jane Harrison Cone, Sol Lewitt, Robert Pincus-Witten, Charles Frazier.

218. BARO, GENE. "American Sculpture: A New Scene." *Studio International*, vol. 175 (January, 1968), 9–19.

219. BLOK, C. "Minimal Art at The Hague." *Art International*, vol. 12 (May, 1968), 18–24 (*See bibl. 238*).

220. BOCHNER, MEL. "Primary Structures." *Arts Magazine*, vol. 40 (June, 1966), 32–35 (*See bibl. 246*).

221. GRAHAM, DAN. "Models and Monuments: The Plague of Architecture." *Arts Magazine*, vol. 41 (March, 1967), 32–35.

222. GREENBERG, CLEMENT. "Recentness of Sculpture." *Art International*, vol. 11 (April, 1967), 9–21 (*See bibl. 7, 239*).

223. HUDSON, ANDREW. "Scale as Content." *Artforum*, vol. 6 (December, 1967), 46–47. (*See bibl. 250*).

224. KOZLOFF, MAX. "Further Adventures of American Sculpture." *Arts Magazine*, vol. 39 (February, 1965), 24–31.

225. KRAMER, HILTON. "The Emperor's New Bikini." *Art in America*, vol. 57 (January–February, 1969), 48–55.

226. LIPPARD, LUCY R. "New York Letter: Recent Sculpture as Escape." *Art International*, vol. 10 (February, 1966), 48–58.

227. ———. "New York Letter: Rejective Art." *Art International*, vol. 9 (September, 1965), 57–61 (*See bibl. 28*).

228. MORRIS, ROBERT. "Notes on Sculpture, Part 1." *Artforum*, vol. 4 (February, 1966), 42–44 (*See bibl. 6*).

229. ———. "Notes on Sculpture, Part 2." *Artforum*, vol. 5 (October, 1966), 20–23 (*See bibl. 6*).

230. ———. "Notes on Sculpture, Part 3: Notes and Nonsequiturs." *Artforum*, vol. 5 (Summer, 1967), 24–29.

231. PERREAULT, JOHN. "Union Made: Report on a Phenomenon." *Arts Magazine*, vol. 41 (March, 1967), 26–31.

232. PIERCE, JAMES S. "Design and Expression in Minimal Art." *Art International*, vol. 12 (May, 1968), 25–27.

233. REISE, BARBARA. " 'Untitled 1969': A Foot-

note on Art and Minimalstylehood." *Studio International,* vol. 177 (April, 1969), 166–72.

234. ROBINS, CORINNE. "Object, Structure or Sculpture: Where Are We?" *Arts Magazine,* vol. 40 (September–October, 1966), 33–37.

235. ROSE, BARBARA. "Blowup—The Problem of Scale in Sculpture." *Art in America,* vol. 56 (July–August, 1968), 80–91.

236. ――――. "Looking at American Sculpture." *Artforum,* vol. 3 (February, 1965), 29–36.

237. SMITHSON, ROBERT. "Entropy and the New Monuments." *Artforum,* vol. 4 (June, 1966), 26–31.

EXHIBITION CATALOGUES

238. The Hague, Gemeentemuseum. *Minimal Art.* 1968. Catalogue introduction by Enno Develing; text by Lucy R. Lippard; artists' statements; selected biographies and bibliographies.

239. Los Angeles, Los Angeles County Museum of Art. *American Sculpture of the Sixties.* 1967. Exhibition and catalogue introduction by Maurice Tuchman; essays by Lawrence Alloway, Wayne V. Andersen, Dore Ashton, John Coplans, Clement Greenberg, Max Kozloff, Lucy R. Lippard, James Monte, Barbara Rose, Irving Sandler; extensive bibliographies.

240. Milwaukee, Milwaukee Art Center. *Directions 1: Options.* 1968. Introduction by Lawrence Alloway; artists' statements.

241. Minneapolis, Dayton's Auditorium. *14 Sculptors: The Industrial Edge.* 1969. Exhibition organized by the Walker Art Center; catalogue essays by Barbara Rose, Christopher Finch, Martin Friedman; extensive bibliographies.

242. New York, Finch College Museum of Art. *Art in Process: The Visual Development of a Structure.* 1966. Exhibition and catalogue foreword by Elayne H. Varian.

243. New York, Fischbach Gallery. *Eccentric Abstraction.* 1966. Exhibition and catalogue essay by Lucy R. Lippard (*See bibl. 28*).

244. New York, Solomon R. Guggenheim Museum. *Guggenheim International Exhibition 1967 (Sculpture from Twenty Nations).* Introduction by Edward F. Fry; extensive bibliographies.

245. New York, The Jewish Museum. *Recent American Sculpture.* 1964. Introduction by Hans van Weeren Griek; critical essays; bibliographies.

246. ――――. *Primary Structures: Younger American and British Sculptors.* 1966. Exhibition and catalogue introduction by Kynaston McShine; bibliographies.

247. New York, New York University, Loeb Student Center. *Concrete Expressionism.* 1965. Exhibition and catalogue essay by Irving Sandler.

248. Philadelphia, University of Pennsylvania, Institute of Contemporary Art. *7 Sculptors.* 1965. Exhibition by Samuel Adams Green; critical texts; artists' biographies.

249. St. Louis, City Art Museum of St. Louis. *7 for 67: Works by Contemporary Sculptors.* 1967.

250. Washington, D.C., Corcoran Gallery of Art. *Scale as Content: Ronald Bladen, Barnett Newman, Tony Smith.* 1967. Pamphlet by Eleanor Green.

EARTH, PROCESS, AND CONCEPTUAL ART

ARTICLES

251. BATTCOCK, GREGORY. "Informative Exhibit." *Arts Magazine,* vol. 44 (Summer, 1970), 24–27 (*See bibl. 286*).

252. ――――. "The Politics of Space." *Arts Magazine,* vol. 44 (February, 1970), 40–43 (*See bibl. 285*).

253. BOCHNER, MEL. "Excerpts from Speculations" (1967–1970). *Artforum,* vol. 8 (May, 1970), 70–73.

254. BURNHAM, JACK. "Alice's Head: Reflections on Conceptual Art." *Artforum,* vol. 8 (February, 1970), 37–43.

255. CALAS, NICOLAS. "Documentizing." *Arts Magazine,* vol. 44 (May, 1970), 30–32.

256. CHANDLER, JOHN N. "The Last Word in Graphic Art." *Art International,* vol. 12 (November, 1968), 25–28.

257. GOLDIN, AMY and KUSHNER, ROBERT. "Concept Art as Opera." *Art News,* vol. 69 (April, 1970), 40–43.

258. HARRISON, CHARLES. "A Very Abstract Context." *Studio International,* vol. 80 (November, 1970), 194–98.

259. HICKEY, DAVE. "Earthscapes, Landworks and Oz." *Art in America,* vol. 59 (September–October, 1971), 40–49.

260. HUTCHINSON, PETER. "Earth in Upheaval: Earthworks and Landscapes." *Arts Magazine,* vol. 43 (September, 1968), 44–50.

261. KOZLOFF, MAX. "9 in a Warehouse." *Artforum,* vol. 7 (February, 1969), 38–42.

262. KOSUTH, JOSEPH. "Art After Philosophy, Part 1." *Studio International,* vol. 178 (October, 1969), 134–37.

263. ———. "Art After Philosophy, Part 2." *Studio International,* vol. 178 (November, 1969), 160–61.

264. ———. "Art After Philosophy, Part 3." *Studio International,* vol. 178 (December, 1969), 212–13.

265. LEWITT, SOL. "Paragraphs on Conceptual Art." *Artforum,* vol. 5 (June, 1967), 79–83.

266. ———(ed.). "Time: A Panel Discussion." *Art International,* vol. 13 (November, 1969), 20–23.

267. MEADMORE, CLEMENT. "Thoughts on Earthworks, Random Distribution, Softness, Horizontality and Gravity." *Arts Magazine,* vol. 43 (February, 1969), 26–28.

268. MORRIS, ROBERT. "Anti-Form." *Artforum,* vol. 6 (April, 1968), 33–35.

269. ———. "Notes on Sculpture, Part 4: Beyond Objects." *Artforum,* vol. 7 (April, 1969), 50–54.

270. NEMSER, CINDY. "Subject-Object: Body Art." *Arts Magazine,* vol. 46 (September–October, 1971), 38–42.

271. PINCUS-WITTEN, ROBERT. "Anglo-American Standard Reference Works: Acute Conceptualism." *Artforum,* vol. 10 (October, 1971), 82–85.

272. PLAGENS, PETER. "557,087." *Artforum,* vol. 8 (November, 1969), 64–67 (*See bibl. 295*).

273. SHARP, WILLOUGHBY. "Place and Process." *Artforum,* vol. 8 (November, 1969), 46–49.

274. SMITHSON, ROBERT. "A Sedimentation of the Mind: Earth Proposals." *Artforum,* vol. 7 (September, 1968), 44–50.

275. "Studio International Summer Show." *Studio International,* vol. 180 (July–August, 1970), 1–48. International exhibition organized by Seth Siegelaub; 37 artists chosen by 6 critics.

276. TILLIM, SIDNEY. "Earthworks and the New Picturesque." *Artforum,* vol. 7 (December, 1968), 42–45.

277. WASSERMAN, EMILY. "Process: Whitney Museum." *Artforum,* vol. 8 (September, 1969), 56–58.

278. WHITE, ROBERT and DAULT, GARY MICHAEL. "Word Art and Art Word." *Artscanada,* no. 118–19 (June, 1968), 17–29.

EXHIBITION CATALOGUES

279. Amsterdam, Stedelijk Museum. *Op Losse Schroeven situaties en cryptostructuren (Square Pegs in Round Holes).* 1968. Exhibition organized by Wim Berren; catalogue introduction by E. de Wilde; essays by Berren, Piero Gilardi, Harald Szeemann.

280. Bern, Kunsthalle. *When Attitudes Become Form: Works, Concepts, Processes, Situations, Information.* 1969. Exhibition organized by Harald Szeemann; catalogue essays by Scott Burton, Gregoire Muller, Tommaso Trini; biographies and bibliographies.

281. Burnaby, B.C., Simon Fraser University, Centre for Communications and the Arts. Untitled exhibition. 1969. Exhibition organized by Seth Siegelaub; catalogue contains projects by the artists.

282. Chicago, Museum of Contemporary Art. *Art by Telephone.* 1969. Exhibition organized by Jan van der Marck; catalogue consists of recorded telephone instructions from the artists.

283. Ithaca, Cornell University, Andrew Dickson White Museum of Art. *Earth.* 1969. Catalogue essays by Willoughby Sharp and William C. Lipke.

284. Leverkusen, Städtisches Museum. *Konzeption–Conception.* 1969. Exhibition organized by Konrad Fischer and Rolf Wedewer.

285. New York, Museum of Modern Art. *Spaces.* 1969. Exhibition and catalogue essay by Jennifer Licht (*See bibl. 252*).

286. ———. *Information.* 1970. Exhibition and catalogue by Kynaston McShine; bibliography (*See bibl. 251*).

287. New York, New York Cultural Center. *Conceptual Art and Conceptual Aspects.* 1970. Exhibition and catalogue by Donald Karshan.

288. New York, Seth Siegelaub. *Carl Andre, Robert Barry, Douglas Huebler, Joseph Kosuth, Sol Lewitt, Robert Morris, Lawrence Weiner* (called the "Xerox Book"). Published by Siegelaub-Wendler, New York, 1968; consists of one project from each artist in reply to the publisher's request to "submit a project of 25 consecutive pages, on standard 8 1/2 × 11" paper, to be reproduced xerographically and printed."

289. ———. *January 5–31, 1969.* Exhibition organized by Siegelaub and presented in an office space in New York rented for the occasion; catalogue contains statements by the artists.

290. ———. *March 1969.* Exhibition organized by Siegelaub; catalogue consists of correspondence with the artists.

291. New York, Whitney Museum of American Art. *Anti-Illusion: Procedures/Materials.* 1969. Exhibition and catalogue essays by Marcia Tucker and James Monte; bibliography.

292. Oberlin, Ohio, Oberlin College, Allen Memorial Art Museum. *Art in the Mind.* 1970. Exhibition and catalogue essay by Athena T. Spear.

293. Philadelphia, University of Pennsylvania, Institute of Contemporary Art. *Against Order/Chance and Art.* 1970. Catalogue introduction by Robert Pincus-Witten.

294. Philadelphia, Arts Council YM/YWHA. *Air Art.* 1968. Exhibition and catalogue essay by Willoughby Sharp.

295. Seattle, Seattle Art Museum. *557,087.* 1969. Exhibition and catalogue by Lucy R. Lippard; catalogue consists of notecards for each artist (*See bibl. 272*)

KINETICISM, LUMINISM, AND TECHNOLOGICAL ART

ARTICLES

296. ANTIN, DAVID. "Art and the Corporations." *Art News,* vol. 70 (September, 1971), 22–26; 52–56 (*See bibl. 323*).

297. BAKER, ELIZABETH C. "The Light Brigade." *Art News,* vol. 66 (March, 1967), 52–55; 63; 66.

298. BURNHAM, JACK. "Corporate Art." *Artforum,* vol. 10 (October, 1971), 66–71 (*See bibl. 323*).

299. CHANDLER, JOHN N. "Art in the Electric Age." *Art International,* vol. 13 (February, 1969), 19–25.

300. DAVIS, DOUGLAS. "Art and Technology." *Art in America,* vol. 56 (January–February, 1968), 29–45.

301. HAHN, OTTO. "Live Wire Academicism." *Arts Magazine,* vol. 42 (September–October, 1967), 46–67.

302. KOZLOFF, MAX. "Men and Machines." *Artforum,* vol. 7 (February, 1969), 22–29.

303. ———. "The Multimillion Dollar Art Boondoggle." *Artforum,* vol. 10 (October, 1971), 72–76 (*See bibl. 323*).

304. KLUVER, BILLY. "Nine Evenings of Theater and Engineering: Notes of an Engineer." *Artforum,* vol. 5 (February, 1967), 31–33.

305. LEIDER, PHILIP. "Kinetic Sculpture at Berkeley." *Artforum,* vol. 4 (May, 1966), 40–44 (*See bibl. 318*).

306. LIVINGSTON, JANE. "Some Thoughts on Art and Technology." *Studio International,* vol. 181 (June, 1971), 258–63.

307. KIRBY, MICHAEL. "The Experience of Kinesis." *Art News,* vol. 66 (February, 1968), 42–45; 52–53; 71.

308. PERREAULT, JOHN. "Literal Light." *Light: From Aten to Laser. Art News Annual XXXV* (1969), 129–41.

309. PIENE, NAN R. "Light Art." *Art in America,* vol. 55 (May–June, 1967), 24–47.

310. PIENE, OTTO. "Proliferation of the Sun: on Art, Fine Arts, Present Art, Kinetic Art, Light, Light Art, Scale, Now and Then." *Arts Magazine,* vol. 41 (Summer, 1967), 24–31.

311. POPPER, FRANK. "Luminous Trend in Kinetic Art." *Studio International,* vol. 173 (February, 1967), 72–77.

312. ———. "Movement and Light in Today's Arts." *Arts and Architecture,* vol. 81 (April, 1964), 24–25.

313. RICKEY, GEORGE. "Kinesis Continued." *Art*

in America, vol. 53 (December, 1965–January, 1966), 45–55.

314. ———. "The Morphology of Movement." *College Art Journal,* vol. 22 (Summer, 1963), 220–31.

315. SPEAR, ATHENA T. "Sculptured Light." *Art International,* vol. 11 (December, 1967), 29–49.

316. TUCHMAN, MAURICE. "Art and Technology." *Art in America,* vol. 58 (March–April, 1970), 78–79.

317. WHITMAN, SIMONE. "Nine Evenings of Theater and Engineering: Notes of a Participant." *Artforum,* vol. 5 (February, 1967), 26–30.

EXHIBITION CATALOGUES

318. Berkeley, University of California, University Art Museum. *Directions in Kinetic Sculpture.* 1966. Catalogue essays by Peter Selz and George Rickey; artists' statements (*See bibl. 305*).

319. Buffalo, Albright-Knox Art Gallery. *Kinetic and Optic Art Today.* 1965. Catalogue essay by Gordon Smith.

320. Eindhoven, Stedelijk van Abbemuseum. *Kunst Licht Kunst.* 1966. Introduction by Frank Popper; artists' statements.

321. Kansas City, Mo., Nelson Gallery–Atkins Museum. *The Magic Theatre: An Exhibition.* 1968. Catalogue essay by Ralph T. Coe.

322. London, Hayward Gallery. *Kinetics.* 1970. Catalogue essays by Frank Popper and Jonathan Benthall; bibliography.

323. Los Angeles, Los Angeles County Museum of Art. *A Report on the Art and Technology Program of the Los Angeles County Museum of Art: 1967–1971.* 1971. Exhibition and catalogue organized by Maurice Tuchman (*See bibl. 296, 298, 303*).

324. Minneapolis, Walker Art Center. *Light, Motion, Space.* 1967. Catalogue essay by Willoughby Sharp.

325. New Brunswick, N.J., Douglass College, Rutgers University. *Slow Motion.* 1967. Catalogue essay by Willoughby Sharp.

326. New York, The Jewish Museum. *Software.* 1970. Catalogue essays by Jack Burnham and T. H. Nelson; artists' biographies.

327. New York, Museum of Modern Art. *The Machine.* 1968. Exhibition and catalogue essay by K. G. Pontus Hulten.

328. New York, Whitney Museum of American Art. *Light: Object and Image.* 1968. Exhibition and catalogue essay by Robert Doty.

329. New York, Howard Wise Gallery. *On the Move.* 1964. Catalogue essay by Douglas MacAgy.

330. Trenton, New Jersey State Museum. *Focus on Light.* 1967. Catalogue essay by Lucy R. Lippard.

331. Worcester, Mass., Worcester Art Museum. *Light and Motion.* 1968. Artists' statements; bibliography.

SELECTED ARTISTS' BIBLIOGRAPHIES

JOSEF ALBERS

332. ALBERS, JOSEF. *Interaction of Color.* 2 vols., New Haven and London: Yale University Press, 1963. Reprinted in German, Cologne: Verlag M. DuMont Schauberg, 1970.

333. GOMRINGER, EUGEN. *Josef Albers.* New York: Wittenborn, 1968. Contains essays by Clara Diament de Sujo, Will Grohmann, Norbert Lynton, Michel Seuphor; selected bibliography.

334. SPIES, WERNER. *Josef Albers.* New York: Harry N. Abrams, 1970.

CARL ANDRE

335. The Hague, Gemeentemuseum. *Carl Andre.* 1969. Exhibition and catalogue by Enno Develing.

336. New York, Solomon R. Guggenheim Museum. *Carl Andre.* 1970. Exhibition and catalogue essay by Diane Waldman; comprehensive bibliography.

337. TUCHMAN, PHYLLIS. "An Interview with Carl Andre." *Artforum,* vol. 8 (June, 1970), 55–61.

338. WALDMAN, DIANE. "Holding the Floor." *Art News,* vol. 69 (October, 1970), 60–62; 75–79.

RICHARD ANUSZKIEWICZ

339. KARSHAN, DONALD. "Graphics '70: Richard Anuszkiewicz." *Art in America,* vol. 58 (March–April, 1970), 56–59.

340. Kent, Ohio, Kent State University, Van Deusen Gallery. *Richard Anuszkiewicz.* 1968. Exhibition catalogue.

341. LYNES, RUSSELL. "Mesh Canvas." *Art in America,* vol. 56 (May–June, 1968), 38.

MILTON AVERY

342. Baltimore, Baltimore Museum of Art. *Milton Avery.* 1952. Catalogue essay by Frederick S. Wight.

343. KRAMER, HILTON. *Milton Avery: Paintings, 1930–1960.* New York: Thomas Yoseloff, 1962.

WILLIAM BAZIOTES

344. New York, Solomon R. Guggenheim Museum. *Baziotes.* 1965. Catalogue introduction by Lawrence Alloway; comprehensive bibliography.

345. SANDLER, IRVING. "Baziotes: Modern Mythologist." *Art News,* vol. 63 (February, 1965), 28–31.

ROMARE BEARDEN

346. BEARDEN, ROMARE and HOLTY, CARL. *The Painter's Mind.* New York: Crown, 1969.

347. New York, Museum of Modern Art. *Romare Bearden: The Prevalence of Ritual.* 1970. Catalogue essay by Carroll Greene; bibliography.

348. POMEROY, RALPH. "Black Persephone." *Art News,* vol. 66 (October, 1967), 44–45; 73–75.

GEORGE BELLOWS

349. BRAIDER, DONALD. *George Bellows and the Ashcan School of Painting.* New York: Doubleday, 1971.

350. Chicago, Art Institute of Chicago. *George Bellows: Paintings, Drawings and Prints.* 1964. Exhibition catalogue.

351. MORGAN, CHARLES H. *George Bellows: Painter of America.* New York: Reynal, 1965.

THOMAS HART BENTON

352. BENTON, THOMAS HART. *An American in Art: A Professional and Technical Autobiography.* Lawrence: University of Kansas Press, 1969.

353. FATH, CREEKMORE (ed.). *The Lithographs of Thomas Hart Benton.* Austin: University of Texas Press, 1969. Bibliography.

PETER BLUME

354. Manchester, N.H., Currier Gallery of Art. *Peter Blume, Paintings and Drawings in Retrospect: 1925–1964.* 1964. Catalogue introduction by Charles Buckley.

355. New York, Kennedy Galleries. *Peter Blume.* 1968. Text by Frank Getlein.

JAMES BROOKS

356. New York, Whitney Museum of American Art. *James Brooks.* 1963. Catalogue essay by Sam Hunter.

357. SANDLER, IRVING. "James Brooks and the Abstract Inscape." *Art News,* vol. 61 (February, 1963), 30–31; 61–63.

CHARLES BURCHFIELD

358. JONES, EDITH H. (ed.). *The Drawings of Charles Burchfield.* New York: Frederick A. Praeger; published in association with The Drawing Society, 1968. Text by Burchfield.

359. New York, Whitney Museum of American Art. *Charles Burchfield.* 1956. Catalogue essay by John I. H. Baur.

ALEXANDER CALDER

360. ARNASON, H.H. *Alexander Calder.* Princeton: Van Nostrand, 1966.

361. New York, Solomon R. Guggenheim Museum. *Alexander Calder: A Retrospective Exhibition.* 1964. Catalogue introduction by Thomas Messer; bibliography.

362. New York, Museum of Modern Art. *Alexander Calder.* 1951. Catalogue essay by James Johnson Sweeney; bibliography.

JOHN CHAMBERLAIN

363. JUDD, DON. "Chamberlain: Another View."

Art International, vol. 7 (January, 1964), 38–39.

364. New York, Solomon R. Guggenheim Museum. *John Chamberlain.* 1971. Exhibition catalogue.

JOSEPH CORNELL

365. CONTESI, ALEXANDRE. "Cornell." *Artforum,* vol. 4 (April, 1966), 27–31.

366. COPLANS, JOHN. "Notes on the Nature of Joseph Cornell." *Artforum,* vol. 1 (February, 1963), 27–29.

367. New York, Solomon R. Guggenheim Museum. *Joseph Cornell.* 1967. Catalogue essay by Diane Waldman.

ALLAN D'ARCANGELO

368. ANTIN, DAVID. "D'Arcangelo and the New Landscape." *Art and Literature,* no. 9 (Summer, 1966), 102–15.

369. CALAS, NICOLAS. "Highways and Byways." *Art and Artists,* vol. 2 (October, 1967), 12–15.

ARTHUR B. DAVIES

370. FORBES, WATSON. "Arthur Bowen Davies." *Magazine of Art,* vol. 45 (December, 1952), 362–68.

371. KATZ, L. "Originality of Arthur B. Davies." *Arts Magazine,* vol. 37 (November, 1962), 16–20.

372. Utica, N.Y., Munson–Williams–Proctor Institute. *Arthur Bowen Davies, 1862–1928: A Centennial Exhibition.* 1962. Catalogue.

STUART DAVIS

373. GOOSSEN, E. C. *Stuart Davis.* New York: George Braziller, 1959.

374. Minneapolis, Walker Art Center. *Stuart Davis.* 1957. Exhibition catalogue.

375. Washington, D.C., Smithsonian Institution, National Collection of Fine Arts. *Stuart Davis Memorial Exhibition.* 1965. Catalogue.

WILLEM DE KOONING

376. HESS, THOMAS B. *Willem de Kooning.* New York: George Braziller, 1959.

377. JANIS, HARRIET and BLESH, RUDI. *De Kooning.* New York: Grove Press, 1960.

378. KOZLOFF, MAX. "The Impact of De Kooning." *Arts Yearbook, no. 7* (1964), 77–88.

379. New York, Museum of Modern Art. *Willem de Kooning.* 1968. Exhibition and catalogue essay by Thomas B. Hess; comprehensive bibliography.

WALTER DE MARIA

380. ADRIAN, DENNIS. "Walter De Maria: Word and Thing." *Artforum,* vol. 5 (January, 1967), 28–29.

381. BOURDON, DAVID. "Walter De Maria: The Singular Experience." *Art International,* vol. 12 (December, 1968), 39–43; 72.

CHARLES DEMUTH

382. FAISON, S. L., JR. "Fact and Art in Charles Demuth." *Magazine of Art,* vol. 43 (April, 1950), 123–28.

383. FARNHAM, EMILY. *Behind a Laughing Mask.* Norman: University of Oklahoma Press, 1971.

384. New York, Museum of Modern Art. *Charles Demuth.* 1950. Catalogue essay by Andrew C. Ritchie.

BURGOYNE DILLER

385. CAMPBELL, LAWRENCE. "Diller: The Ruling Passion." *Art News,* vol. 6 (October, 1968), 36–37.

386. JUDD, DON. "Exhibition at Chalette Gallery." *Arts Magazine,* vol. 37 (January, 1963), 52.

387. Trenton, New Jersey State Museum. *Burgoyne Diller: 1906–1965.* 1966. Exhibition catalogue.

JIM DINE

388. Berlin, Galerie Mikro. *Jim Dine: Complete Graphics.* 1970. Exhibition catalogue.

389. DINE, JIM. *Welcome Home Lovebirds: Poems and Drawings.* London: Trigram Press, 1969.

390. New York, Whitney Museum of American

Art. *Jim Dine.* 1970. Exhibition and catalogue essay by John Gordon; bibliography.

MARK DI SUVERO

391. GEIST, SIDNEY. "New Sculptor: Mark Di Suvero." *Arts Magazine,* vol. 35 (December, 1960), 40–43.
392. KOZLOFF, MAX. "Mark Di Suvero." *Artforum,* vol. 5 (Summer, 1967), 41–46.
393. ROSENSTEIN, HARRIS. "Di Suvero: The Pressures of Reality." *Art News,* vol. 65 (February, 1967), 36–39.

ARTHUR DOVE

394. College Park, University of Maryland, J. Millard Tawes Fine Arts Center. *Arthur Dove: The Years of Collage.* 1967. Catalogue essay by Dorothy Rylander Johnson.
395. Ithaca, Cornell University, Andrew Dickson White Museum of Art. *Arthur G. Dove 1880–1946. A Retrospective Exhibition.* 1954. Catalogue essay by Alan Solomon.
396. WIGHT, FREDERICK S. *Arthur G. Dove.* Berkeley and Los Angeles: University of California Press, 1958.

PHILIP EVERGOOD

397. LIPPARD, LUCY R. *The Graphic Work of Philip Evergood: Selected Drawings and Complete Prints.* New York: Crown, 1966.
398. New York, Whitney Museum of American Art. *Twenty Years of Painting by Philip Evergood.* 1946. Catalogue essay by Oliver Larkin.
399. ———. *Philip Evergood.* 1960. Catalogue essay by John I. H. Baur.

HERBERT FERBER

400. GOOSSEN, E. C. "Herbert Ferber." In *Three American Sculptors.* New York: Grove Press, 1959.
401. Minneapolis, Walker Art Center. *The Sculpture of Herbert Ferber.* 1962. Catalogue essay by Wayne V. Andersen; bibliography.
402. TUCHMAN, PHYLLIS. "An Interview with Herbert Ferber." *Artforum,* vol. 9 (April, 1971), 52–57.

JOHN B. FLANNAGAN

403. FORSYTH, ROBERT J. *John B. Flannagan.* Notre Dame: University of Notre Dame Press, 1963.
404. New York, Museum of Modern Art. *The Sculpture of John B. Flannagan.* 1942. Exhibition catalogue.

DAN FLAVIN

405. FLAVIN, DAN. "'. . . In Daylight or Cool White,' An Autobiographical Sketch." *Artforum,* vol. 4 (December, 1965), 20–24.
406. ———. ". . . on an American Artist's Education." *Artforum,* vol. 6 (March, 1968), 28–32.
407. Ottawa, National Gallery of Canada. *Fluorescent Light, etc. from Dan Flavin.* 1969. Exhibition and catalogue by Brydon Smith; essays by Mel Bochner and Don Judd; comprehensive bibliography.

SAM FRANCIS

408. Amsterdam, Stedelijk Museum. *Sam Francis.* 1968. Catalogue essays by E. de Wilde and Wieland Schmied.
409. Houston, Museum of Fine Arts. *Sam Francis.* 1967. Exhibition and catalogue by James Johnson Sweeney.
410. PLAGENS, PETER. "A Sam Francis Retrospective in Houston." *Artforum,* vol. 6 (January, 1968), 38–46.

HELEN FRANKENTHALER

411. BARO, GENE. "The Achievement of Helen Frankenthaler." *Art International,* vol. 11 (September, 1967), 33–38.
412. New York, The Jewish Museum. *Helen Frankenthaler.* 1960. Catalogue essay by Frank O'Hara.
413. New York, Whitney Museum of American Art. *Helen Frankenthaler.* 1969. Exhibition and catalogue essay by E. C. Goossen.
414. ROSE, BARBARA. *Helen Frankenthaler.* New York: Harry N. Abrams, 1971.

WILLIAM GLACKENS

415. DU BOIS, GUY PÈNE. *William Glackens.* American Artists Series. New York: Whitney Museum of American Art, 1931.
416. GLACKENS, IRA. *William Glackens and the Ashcan Group.* New York: Crown, 1957.
417. St. Louis, City Art Museum of St. Louis. *William Glackens in Retrospect.* 1966. Catalogue essay by Leslie Katz.

FRITZ GLARNER

418. ASHTON, DORE. "Fritz Glarner." *Art International,* vol. 7 (January, 1963), 48–55.
419. San Francisco, San Francisco Museum of Art. *Fritz Glarner.* 1971. Exhibition catalogue.
420. STABER, MARGIT. "Fritz Glarner." *Art International,* vol. 12 (Summer, 1968), 59–62.

ARSHILE GORKY

421. College Park, University of Maryland, J. Millard Tawes Fine Arts Center. *The Drawings of Arshile Gorky.* 1969. Catalogue essay by Brooks Joyner.
422. LEVY, JULIEN. *Arshile Gorky.* New York: Harry N. Abrams, 1966.
423. New York, Museum of Modern Art. *Arshile Gorky: Paintings, Drawings, Studies.* 1962. Exhibition and catalogue essay by William C. Seitz.
424. ROSENBERG, HAROLD. *Arshile Gorky: The Man, The Time, The Idea.* New York: Horizon Press, 1962.
425. SCHWABACHER, ETHEL. *Arshile Gorky.* New York: Macmillan, 1957.

ADOLPH GOTTLIEB

426. New York, The Jewish Museum. *Adolph Gottlieb.* 1957. Catalogue essay by Clement Greenberg.
427. New York, Whitney Museum of American Art and Solomon R. Guggenheim Museum. *Adolph Gottlieb.* 1968. Catalogue essays by Robert Doty and Diane Waldman; bibliography.
428. ROSENSTEIN, HARRIS. "Gottlieb at the Summit." *Art News,* vol. 65 (April, 1966), 42–43; 65–66.

MORRIS GRAVES

429. REXROTH, KENNETH. "The Visionary Painting of Morris Graves." *Perspectives USA,* no. 10 (Winter, 1955), 58–66.
430. SMITH, VIC. "Morris Graves." *Artforum,* vol. 1 (May, 1963), 30–31.
431. WIGHT, FREDERICK S. *Morris Graves.* Berkeley and Los Angeles: University of California Press, 1956.

PHILIP GUSTON

432. ASHTON, DORE. *Philip Guston.* New York: Grove Press, 1959.
433. HUNTER, SAM. "Philip Guston." *Art International,* vol. 6 (May, 1962), 62–67.
434. New York, Solomon R. Guggenheim Museum. *Philip Guston.* 1962. Catalogue essay by H. H. Arnason; bibliography.
435. New York, The Jewish Museum. *Philip Guston: Recent Paintings and Drawings.* 1966. Catalogue introduction by Sam Hunter; interview with Harold Rosenberg; selected bibliography.

MARSDEN HARTLEY

436. Amsterdam, Stedelijk Museum. *Marsden Hartley.* 1960. Exhibition catalogue.
437. MCCAUSLAND, ELIZABETH. *Marsden Hartley.* Minneapolis: University of Minnesota Press, 1952.
438. PLAGENS, PETER. "Marsden Hartley." *Artforum,* vol. 7 (May, 1969), 40–43.

ROBERT HENRI

439. HENRI, ROBERT. *The Art Spirit.* Philadelphia and London: J. B. Lippincott, 1923. Compiled by Margery Ryerson.
440. HOMER, WILLIAM INNESS. *Robert Henri and His Circle.* Ithaca and London: Cornell University Press, 1969.
441. READ, HELEN APPLETON. *Robert Henri.* American Artists Series. New York: Whitney Museum of American Art, 1931.

EVA HESSE

442. LIPPARD, LUCY R. "Eva Hesse: The Circle."

Art in America, vol. 59 (May–June, 1971), 68–73.

443. NEMSER, CINDY. "An Interview with Eva Hesse." *Artforum,* vol. 8 (May, 1970), 59–63.

444. PINCUS-WITTEN, ROBERT. "Eva Hesse: Post-Minimalism into Sublime." *Artforum,* vol. 10 (November, 1971), 32–44.

HANS HOFMANN

445. GREENBERG, CLEMENT. *Hans Hofmann.* Paris: Editions Georges Fall, 1961.

446. HOFMANN, HANS. *Search for the Real and Other Essays.* Andover, Mass.: Addison Gallery of American Art, 1948. Rev. ed., Cambridge, Mass.: M.I.T. Press, 1967.

447. HUNTER, SAM. *Hans Hofmann.* New York: Harry N. Abrams, 1963. Reprints of five texts by the artist.

448. New York, Museum of Modern Art. *Hans Hofmann.* 1963. Exhibition and catalogue by William C. Seitz; selected writings by the artist; bibliography.

EDWARD HOPPER

449. GOODRICH, LLOYD. *Edward Hopper.* New York: Harry N. Abrams, 1971.

450. LANES, JERROLD. "Edward Hopper." *Artforum,* vol. 7 (October, 1968), 44–49.

451. New York, Museum of Modern Art. *Edward Hopper Retrospective.* 1933. Catalogue essays by Alfred H. Barr, Jr., and Charles Burchfield.

452. New York, Whitney Museum of American Art. *Edward Hopper.* 1964. Exhibition and catalogue essay by Lloyd Goodrich.

ROBERT INDIANA

453. Notre Dame, St. Mary's College, Department of Art. *Robert Indiana Graphics.* 1969. Catalogue introduction by Richard-Raymond Alasko.

454. Philadelphia, University of Pennsylvania, Institute of Contemporary Art. *Robert Indiana.* 1968. Catalogue introduction by John W. McCourbey.

455. SWENSON, G. R. "The Horizons of Robert Indiana." *Art News,* vol. 65 (May, 1966), 48–49.

JASPER JOHNS

456. KOZLOFF, MAX. *Jasper Johns.* New York: Harry N. Abrams, 1967.

457. New York, The Jewish Museum. *Jasper Johns.* 1964. Catalogue essays by Alan Solomon and John Cage; bibliography.

458. ROSE, BARBARA. "The Graphic Work of Jasper Johns, Part 1." *Artforum,* vol. 8 (March, 1970), 39–45.

459. ———. "The Graphic Work of Jasper Johns, Part 2." *Artforum,* vol. 9 (September, 1970), 65–74.

460. STEINBERG, LEO. *Jasper Johns.* New York: Wittenborn, 1963.

DON JUDD

461. JUDD, DON. "Complaints, Part 1." *Studio International,* vol. 177 (April, 1969), 182–88.

462. Eindhoven, Stedelijk van Abbemuseum. *Don Judd.* 1970. Exhibition and catalogue by Jan Leering; exhibition traveled in Europe. Second catalogue by Manfred de la Motte published by the Kunstverein, Hanover, Germany, 1970.

463. New York, Whitney Museum of American Art. *Don Judd.* 1968. Exhibition and catalogue by William C. Agee.

464. Pasadena, Pasadena Art Museum. *Don Judd.* 1971. Exhibition, catalogue essay, and interview with the artist by John Coplans; bibliography (*See bibl. 53, 58, 59*).

ELLSWORTH KELLY

465. COPLANS, JOHN. "The Earlier Work of Ellsworth Kelly." *Artforum,* vol. 7 (Summer, 1969), 48–55.

466. ———. *Ellsworth Kelly.* New York: Harry N. Abrams, 1972.

467. ROSE, BARBARA. "Ellsworth Kelly as Sculptor." *Artforum,* vol. 5 (Summer, 1967), 51.

468. RUBIN, WILLIAM S. "Ellsworth Kelly: The Big Form." *Art News,* vol. 62 (November, 1963), 32–35.

469. WALDMAN, DIANE. *Ellsworth Kelly: Draw-*

ings, Collages and Prints. Greenwich: New York Graphic Society, 1971. Includes catalogue raisonné of graphics; bibliography.

EDWARD KIENHOLZ

470. Stockholm, Moderna Museet. *Edward Kienholz: 11 + 11 Tableaux.* 1970. Exhibition and catalogue by K. G. Pontus Hulten.
471. TILLIM, SIDNEY. "The Underground Pre-Raphaelitism of Edward Kienholz." *Artforum,* vol. 4 (April, 1965), 38–40.
472. TUCHMAN, MAURICE. "A Decade of Edward Kienholz," *Artforum,* vol. 4 (April, 1965), 41–45.
473. Washington, D.C., Washington Gallery of Modern Art. *Edward Kienholz: Work From the 1960's.* 1968. Exhibition and catalogue essay by Walter Hopps.

FRANZ KLINE

474. DAWSON, FIELDING. *An Emotional Memoir of Franz Kline.* New York: Pantheon, 1967.
475. London, Whitechapel Art Gallery. *Franz Kline.* 1964. Catalogue essay by Frank O'Hara.
476. New York, Whitney Museum of American Art. *Franz Kline: 1910–1962.* 1968. Exhibition and catalogue essay by John Gordon; selected bibliography.
477. SYLVESTER, DAVID. "Franz Kline, 1910–1962: An Interview with David Sylvester." *Living Arts,* vol. 1 (Spring, 1963), 2–13.

GASTON LACHAISE

478. GALLATIN, ALBERT E. *Gaston Lachaise.* New York: E. P. Dutton, 1924.
479. KRAMER, HILTON. *The Sculpture of Gaston Lachaise.* New York: Eakins Press, 1967.
480. Los Angeles, Los Angeles County Museum of Art. *Gaston Lachaise, 1882–1935.* 1963. Catalogue introduction by Gerald Nordland.

IBRAM LASSAW

481. CAMPBELL, LAWRENCE. "Lassaw Makes a Sculpture: Clouds of Magellan." *Art News,* vol. 53 (March, 1954), 24–27; 66–67.

482. SANDLER, IRVING. "Ibram Lassaw." In *Three American Sculptors.* New York: Grove Press, 1959.
483. SAWIN, MARTICA. "Ibram Lassaw." *Arts Magazine,* vol. 30 (December, 1955), 22–26.

JACK LEVINE

484. Boston, Institute of Contemporary Art. *Jack Levine.* 1952. Catalogue essay by Frederick S. Wight.
485. GETLEIN, FRANK. *Jack Levine.* New York: Harry N. Abrams, 1966.
486. WERNER, ALFRED. "The Peopled World of Jack Levine." *The Painter and Sculptor,* vol. 2 (Summer, 1959), 24–29.

SOL LEWITT

487. The Hague, Gemeentemuseum. *Sol Lewitt.* 1970. Exhibition and catalogue organized by Enno Develing.
488. LIPPARD, LUCY R. "Sol Lewitt: Non-Visual Structures." *Artforum,* vol. 5 (April, 1967), 42–46 (*See bibl. 28*).
489. REISE, BARBARA. "Sol Lewitt Drawings, 1968–1969." *Studio International,* vol. 178 (December, 1969), 222–25.

ROY LICHTENSTEIN

490. ALLOWAY, LAWRENCE and HAMILTON, RICHARD. "Roy Lichtenstein." *Studio International,* vol. 175 (January, 1968), 20–31.
491. New York, Solomon R. Guggenheim Museum. *Roy Lichtenstein.* 1969. Exhibition and catalogue essay by Diane Waldman; selected bibliography.
492. Pasadena, Pasadena Art Museum. *Roy Lichtenstein.* 1967. Exhibition and catalogue by John Coplans.
493. WALDMAN, DIANE. *Roy Lichtenstein: Drawings and Prints.* New York: Chelsea House, 1969. Includes catalogue raisonné of drawings, 1961–1969; bibliography.

RICHARD LINDNER

494. ASHTON, DORE. *Richard Lindner.* New York: Harry N. Abrams, 1969.
495. PENROSE, ROLAND. "Richard Lindner." *Art*

International, vol. 11 (January, 1967), 30–32.

496. TILLIM, SIDNEY. *Lindner.* Chicago: William and Noma Copley Foundation, 1960.

SEYMOUR LIPTON

497. ELSEN, ALBERT E. "The Sculptural World of Seymour Lipton." *Art International,* vol. 9 (February, 1965), 12–16.

498. New York, Marlborough-Gerson Gallery. *Seymour Lipton: Recent Works.* 1971. Exhibition catalogue.

499. RITCHIE, ANDREW C. "Seymour Lipton." *Art in America,* vol. 44 (Winter, 1956), 14–17.

MORRIS LOUIS

500. Boston, Museum of Fine Arts. *Morris Louis, 1912–1962.* 1967. Catalogue essay by Michael Fried.

501. FRIED, MICHAEL. *Morris Louis.* New York: Harry N. Abrams, 1970.

502. New York, Solomon R. Guggenheim Museum. *Morris Louis: 1912–1962.* 1963. Catalogue introduction by Lawrence Alloway.

503. ROBBINS, DANIEL. "Morris Louis at the Juncture of Two Traditions." *Quadrum,* no. 18 (1965), 41–54.

GEORGE LUKS

504. CARY, ELISABETH LUTHER. *George Luks.* American Artists Series, New York: Whitney Museum of American Art, 1931.

505. Newark, Newark Museum. *The Work of George Benjamin Luks.* 1934. Exhibition catalogue.

506. New York, Heritage Gallery. *George Luks, 1867–1933: Retrospective Exhibition.* 1967. Exhibition catalogue.

LEN LYE

507. MANCIA, ADRIENNE and VAN DYKE, WILLARD. "Artist as Film-Maker: Len Lye." *Art in America,* vol. 54 (July, 1966), 98–106.

508. PIENE, OTTO. "Mother Turn Off the Picture." *Artscanada,* no. 25 (June, 1968), 13.

STANTON MACDONALD-WRIGHT

509. Los Angeles, Los Angeles County Museum of Art. *A Retrospective Showing of the Work of Stanton MacDonald-Wright.* 1956. Exhibition and catalogue by Richard F. Brown.

510. Los Angeles, University of California at Los Angeles Art Galleries. *Stanton MacDonald-Wright: A Retrospective Exhibition, 1911–1970.* Exhibition catalogue; interview with the artist by Frederick S. Wight.

511. Washington, D.C., Smithsonian Institution, National Collection of Fine Arts. *The Art of Stanton MacDonald-Wright.* 1967. Catalogue introduction by David W. Scott; selected bibliography.

MAN RAY

512. Los Angeles, Los Angeles County Museum of Art. *Man Ray.* 1966. Exhibition and catalogue essay by Jules Langsner.

513. MAN RAY. *Alphabet for Adults.* Beverly Hills: Copley Galleries, 1948.

514. MAN RAY. *Self-Portrait.* Boston: Little, Brown, 1963.

JOHN MARIN

515. NORMAN, DOROTHY (ed.). *The Selected Writings of John Marin.* New York: Pellegrini and Cudahy, 1949.

516. REICH, SHELDON. *John Marin: Drawings, 1886–1951.* Salt Lake City: University of Utah Press, 1969.

517. ———. *John Marin: A Stylistic Analysis and Catalogue Raisonné.* 2 vols., Tucson: University of Arizona Press, 1970. Bibliography.

518. SELIGMANN, HERBERT J. (ed.). *Letters of John Marin.* New York: Published privately for An American Place, 1931.

MARISOL

519. CAMPBELL, LAWRENCE. "Marisol's Magic Mixtures." *Art News,* vol. 63 (March, 1964), 38–41.

520. KOZLOFF, MAX. "New York Letter." *Art International,* vol. 6 (September, 1962), 35.

REGINALD MARSH

521. GOODRICH, LLOYD. *Reginald Marsh.* New York: Harry N. Abrams, 1972.

522. New York, Whitney Museum of American Art. *Reginald Marsh.* 1955. Exhibition and catalogue essay by Lloyd Goodrich.

523. SASOWSKY, NORMAN. *Reginald Marsh: Etchings, Engravings, Lithographs.* New York: Frederick A. Praeger, 1956.

524. Tucson, University of Arizona Art Gallery. *East Side, West Side, All Around the Town: A Retrospective Exhibition of Paintings, Watercolors and Drawings by Reginald Marsh.* 1969. Catalogue essay by Edward Laning.

ALFRED MAURER

525. MCCAUSLAND, ELIZABETH. *A. H. Maurer.* New York: Published for the Walker Art Center by A. A. Wyn, 1951.

526. Minneapolis, Walker Art Center. *A. H. Maurer, 1868–1932.* 1949. Catalogue essay by Elizabeth McCausland.

ROBERT MORRIS

527. ANTIN, DAVID. "Art and Information, 1: Grey Paint, Robert Morris." *Art News,* vol. 65 (April, 1965), 22–24; 56–58.

528. London, Tate Gallery. *Robert Morris.* 1971. Exhibition and catalogue by Michael Compton and David Sylvester.

529. New York: Whitney Museum of American Art. *Robert Morris.* 1970. Exhibition and catalogue essay by Marcia Tucker; selected bibliography.

530. Washington, D.C., Corcoran Gallery of Art. *Robert Morris.* 1969. Catalogue essay by Annette Michelson; selected bibliography (*See bibl. 68, 228, 229, 230, 268, 269*).

ROBERT MOTHERWELL

531. ARNASON, H. H. "On Robert Motherwell and His Early Work." *Art International,* vol. 10 (January, 1966), 17–35.

532. ———. "Robert Motherwell: 1948–1965." *Art International* (April, 1966), 19–45.

533. HUNTER, SAM. *Robert Motherwell Collages.* Paris: Berggruen, 1960.

534. KRAUSS, ROSALIND. "Robert Motherwell's New Paintings." *Artforum,* vol 7 (May, 1969), 26–28.

535. New York, Museum of Modern Art. *Robert Motherwell.* 1965. Catalogue by Frank O'Hara; selected writings by the artist; bibliography.

ELIE NADELMAN

536. KIRSTEIN, LINCOLN. *Elie Nadelman Drawings.* New York: H. Bittner, 1949.

537. New York, Museum of Modern Art. *The Sculpture of Elie Nadelman.* 1948. Catalogue essay by Lincoln Kirstein.

REUBEN NAKIAN

538. ARNASON, H. H. "Nakian." *Art International,* vol. 7 (April, 1963), 36–43.

539. GOLDWATER, ROBERT. "Reuben Nakian." *Quadrum,* no. 11 (1961), 95–102.

540. New York, Museum of Modern Art. *Nakian.* 1966. Catalogue essay by Frank O'Hara.

541. ROSE, BARBARA. "Nakian at the Modern." *Artforum,* vol. 5 (October, 1966), 18–19 (*See bibl. 169*).

BRUCE NAUMAN

542. DANIELI, FIDEL A. "The Art of Bruce Nauman." *Artforum,* vol. 6 (December, 1966), 65–66.

543. NAUMAN, BRUCE. An interview with the artist. *Avalanche,* vol. I, no. 2 (Winter, 1971), 22–31.

544. TUCKER, MARCIA. "PheNAUMANology." *Artforum,* vol. 9 (December, 1970), 38–44.

LOUISE NEVELSON

545. New York, Brooklyn Museum. *Louise Nevelson: Prints and Drawings, 1953–1966.* 1967. Catalogue essay by Una E. Johnson; research by Jo Miller; bibliography.

546. New York, Whitney Museum of American Art. *Louise Nevelson.* 1967. Exhibition and catalogue by John Gordon; bibliography.

547. SECKLER, DOROTHY GEES. "The Artist Speaks: Louise Nevelson." *Art in America,* vol. 55 (January–February, 1967), 32–43.

BARNETT NEWMAN

548. BAKER, ELIZABETH. "Barnett Newman in a New Light." *Art News,* vol. 67 (February, 1967), 38–41; 60–62; 64.

549. HESS, THOMAS B. *Barnett Newman.* New York: Walker, 1969. Bibliography.

550. ———. *Barnett Newman.* New York: Museum of Modern Art, 1971. Monograph published on the occasion of Newman's retrospective at the Museum; comprehensive bibliography.

551. JUDD, DON. "Barnett Newman." *Studio International,* vol. 179 (February, 1970), 67–69.

552. New York, Solomon R. Guggenheim Museum. *Barnett Newman: The Stations of the Cross, lema sabachthani.* 1966. Catalogue essay by Lawrence Alloway; brief bibliography.

ISAMU NOGUCHI

553. MICHELSON, ANNETTE. "Noguchi: Notes on a Theatre of the Real." *Art International,* vol. 8 (December, 1964), 21–25.

554. New York, Whitney Museum of American Art. *Isamu Noguchi.* 1966. Exhibition and catalogue by John Gordon.

555. NOGUCHI, ISAMU. *A Sculptor's World.* New York: Harper & Row, 1968.

KENNETH NOLAND

556. CONE, JANE HARRISON. "Kenneth Noland's New Paintings." *Artforum,* vol. 6 (November, 1967), 36–41.

557. JUDD, DON. "In the Galleries: Kenneth Noland." *Arts Magazine,* vol. 38 (September, 1963), 53–54.

558. New York, The Jewish Museum. *Kenneth Noland.* 1965. Catalogue essay by Michael Fried; bibliography (*See bibl. 199*).

GEORGIA O'KEEFFE

559. Fort Worth, Amon Carter Museum of Western Art. *Georgia O'Keeffe: An Exhibition of the Work of the Artist from 1915 to 1966.* 1966. Exhibition catalogue edited by Mitchell Wilder.

560. New York, Whitney Museum of American Art. *Georgia O'Keeffe.* 1970. Catalogue by Lloyd Goodrich and Doris Buy; selected bibliography.

561. PLAGENS, PETER. "A Georgia O'Keeffe Retrospective in Texas." *Artforum,* vol. 4 (May, 1965), 27–31.

CLAES OLDENBURG

562. BARO, GENE. *Claes Oldenburg: Drawings and Prints.* New York: Chelsea House, 1969. Includes catalogue raisonné of drawings from 1958–1967; bibliography.

563. OLDENBURG, CLAES. *Claes Oldenburg: Proposals for Monuments and Buildings, 1965–1969.* Chicago: Big Table, 1969.

564. ———. *Store Days.* New York: Something Else Press, 1967.

565. ROSE, BARBARA. *Claes Oldenburg.* New York: Museum of Modern Art, 1969. Monograph published on the occasion of Oldenburg's retrospective at the museum; extensive bibliography.

JULES OLITSKI

566. FRIED, MICHAEL. "Jules Olitski's New Paintings." *Artforum,* vol. 4 (November, 1965), 36–40.

567. ———. "Olitski and Shape." *Artforum,* vol. 5 (January, 1967), 20–21.

568. Philadelphia, University of Pennsylvania, Institute of Contemporary Art. *Jules Olitski: Recent Paintings.* 1968. Exhibition and text by Rosalind Krauss (*See bibl. 199*).

PHILIP PEARLSTEIN

569. Athens, Ga., University of Georgia, Museum of Art. *Philip Pearlstein.* 1970. Catalogue essay by Linda Nochlin; chronology and selected bibliography.

570. MIDGETTE, WILLARD. "Philip Pearlstein: The Naked Truth." *Art News,* vol. 66 (October, 1967), 54–55.

571. NOCHLIN, LINDA. "The Ugly American." *Art News,* vol. 69 (September, 1970), 55–57.

JACKSON POLLOCK

572. New York, Museum of Modern Art. *Jackson Pollock.* 1967. Catalogue essay by

Francis V. O'Connor; bibliography.

573. O'HARA, FRANK. *Jackson Pollock*. New York: George Braziller, 1959.

574. ROBERTSON, BRYAN. *Jackson Pollock*. New York: Harry N. Abrams, 1960.

575. ROSE, BERNICE. *Jackson Pollock: The Works on Paper*. New York: Museum of Modern Art in association with The Drawing Society, 1969.

576. RUBIN, WILLIAM S. "Jackson Pollock and the Modern Tradition, Part 1." *Artforum,* vol. 5 (February, 1967), 14–22.

577. ———. "Jackson Pollock and the Modern Tradition, Part 2." *Artforum,* vol. 5 (March, 1967), 28–37.

578. ———. "Jackson Pollock and the Modern Tradition, Part 3." *Artforum,* vol. 5 (April, 1967), 18–31.

579. ———. "Jackson Pollock and the Modern Tradition, Part 4." *Artforum,* vol. 5 (May, 1967), 28–33.

LARRY POONS

580. KOZLOFF, MAX. "Larry Poons." *Artforum,* vol. 3 (April, 1965), 26–29.

581. LIPPARD, LUCY R. "Larry Poons: The Illusion of Disorder." *Art International,* vol. 11 (April, 1967), 22–26 (*See bibl. 28*).

582. TUCHMAN, PHYLLIS. "An Interview with Larry Poons." *Artforum,* vol. 9 (December, 1970), 45–50.

MAURICE PRENDERGAST

583. Boston, Museum of Fine Arts. *Maurice Prendergast, 1859–1924.* 1960. Catalogue essay by Hedley Howell Rhys; bibliography.

584. New York, M. Knoedler & Co. *Paintings and Watercolors by Maurice Prendergast.* 1966. Catalogue essay by Charles H. Sawyer.

ROBERT RAUSCHENBERG

585. FORGE, ANDREW. *Robert Rauschenberg.* New York: Harry N. Abrams, 1969.

586. London, Whitechapel Art Gallery. *Robert Rauschenberg: Paintings, Drawings and Combines 1949–1964.* 1964. Preface by Bryan Robertson; essays by Henry Geld-

zahler, John Cage, Max Kozloff.

587. New York, The Jewish Museum. *Robert Rauschenberg.* 1963. Exhibition and catalogue by Alan Solomon; bibliography.

588. RAUSCHENBERG, ROBERT. *Illustrations for Dante's Inferno.* New York: Harry N. Abrams, 1964.

AD REINHARDT

589. COLT, PRISCILLA. "Notes on Ad Reinhardt." *Art International,* vol. 8 (October, 1964), 32–34.

590. FULLER, MARY (ed.). "An Ad Reinhardt Monologue." *Artforum,* vol. 9 (October, 1970), 36–41.

591. New York, The Jewish Museum. *Ad Reinhardt Paintings.* 1967. Catalogue introduction by Sam Hunter; catalogue essay by Lucy R. Lippard.

592. REINHARDT, AD. "Ad Reinhardt on His Art." *Studio International,* vol. 174 (December, 1967), 265–73.

GEORGE RICKEY

593. Boston, Institute of Contemporary Art. *George Rickey: Kinetic Sculptures.* 1964. Exhibition catalogue.

594. SECUNDA, ARTHUR. "Two Motion Sculptors: Tinguely and Rickey." *Artforum,* vol. 1 (June, 1962), 16–18.

595. Trenton, New Jersey State Museum. *Sculptures by George Rickey and James Seawright.* 1969. Foreword by Zoltan Buki; essay by Rickey (*See bibl. 33*).

LARRY RIVERS

596. Chicago, Art Institute of Chicago. *Larry Rivers: Drawings 1949–1969.* 1970. Catalogue essay by Carol Selle.

597. HUNTER, SAM. *Larry Rivers.* New York: Harry N. Abrams, 1969.

598. Waltham, Mass., Brandeis University, Rose Art Museum. *Larry Rivers.* Exhibition and catalogue essay by Sam Hunter; statement by the artist; "A Memoir" by Frank O'Hara.

599. SIMON, SIDNEY. "Larry Rivers." *Art International,* vol. 10 (November, 1966), 17–24.

JAMES ROSENQUIST

600. LIPPARD, LUCY R. "James Rosenquist: Aspects of a Multiple Art." *Artforum,* vol. 4 (December, 1965), 41–44 (*See bibl. 28*).

601. Ottawa, National Gallery of Canada. *James Rosenquist.* 1968. Catalogue essay by Ivan C. Karp.

602. SWENSON, G. R. "The Figure a Man Makes, Part 1." *Art and Artists,* vol. 3 (April, 1968), 26–29.

603. ———. "The Figure a Man Makes, Part 2." *Art and Artists,* vol. 3 (May, 1968), 42–45.

THEODORE ROSZAK

604. New York, Whitney Museum of American Art. *Theodore Roszak.* 1956. Catalogue essay by H. H. Arnason.

605. ROSZAK, THEODORE. "Problems of Modern Sculpture." *7 Arts,* no. 3 (1955), 58–68.

MARK ROTHKO

606. ALLOWAY, LAWRENCE. "Notes on Rothko." *Art International,* vol. 6 (Summer, 1966), 90–94.

607. GOOSSEN, E. C. "Rothko: The Omnibus Image." *Art News,* vol. 59 (January, 1961), 38–40; 60–61.

608. London, Whitechapel Art Gallery. *Mark Rothko.* 1961. Catalogue preface by Bryan Robertson.

609. New York, Museum of Modern Art. *Mark Rothko.* 1961. Exhibition and catalogue essay by Peter Selz; bibliography.

LUCAS SAMARAS

610. New York, Pace Gallery. *Samaras: Selected Works 1960–1966.* Text by Lawrence Alloway; bibliography.

611. SAMARAS, LUCAS. *Samaras Album: Autointerview, Autobiography, Autopolaroid.* New York: Whitney Museum of American Art and Pace Editions, 1971.

612. WALDMAN, DIANE. "Samaras: Reliquaries for St. Sade." *Art News,* vol. 65 (October, 1966), 44–46; 72–75.

GEORGE SEGAL

613. GELDZAHLER, HENRY. "An Interview with George Segal." *Artforum,* vol. 3 (November, 1964), 26–29.

614. KAPROW, ALLAN. "Segal's Vital Mummies." *Art News,* vol. 62 (February, 1964), 30–33; 65.

615. TUCHMAN, PHYLLIS. "George Segal." *Art International,* vol. 12 (September, 1968), 51–53.

RICHARD SERRA

616. BAKER, ELIZABETH C. "Critic's Choice: Serra." *Art News,* vol. 69 (February, 1970), 26–27.

617. PINCUS-WITTEN, ROBERT. "Slow Information: Richard Serra." *Artforum,* vol. 8 (September, 1969), 34–39.

618. SERRA, RICHARD. "Play it Again Sam." *Arts Magazine,* vol. 44 (February, 1970), 24–27.

BEN SHAHN

619. SHAHN, BEN. *The Shape of Content.* Cambridge: Harvard University Press, 1957; New York: Vantage Press, 1960.

620. SHAHN, BERNARDA B. *Ben Shahn.* New York: Harry N. Abrams, 1972.

621. SOBY, JAMES THRALL. *Ben Shahn, His Graphic Art.* New York: George Braziller, 1957.

622. ———. *Ben Shahn: Paintings.* New York: George Braziller, 1963.

CHARLES SHEELER

623. Los Angeles, University of California at Los Angeles Art Galleries. *Charles Sheeler: A Retrospective Exhibition.* 1954. Foreword by William C. Williams; catalogue essays by Bartlett Hayes and Frederick S. Wight; selected bibliography.

624. ROURKE, CONSTANCE. *Charles Sheeler: Artist in the American Tradition.* New York: Harcourt, Brace, 1938.

625. Washington, D.C., Smithsonian Institution, National Collection of Fine Arts. *Charles Sheeler.* 1968. Catalogue essays by Martin Friedman, Bartlett Hayes, Charles Millard; bibliography.

EVERETT SHINN

626. New York, Brooklyn Museum. *The Eight.* 1943. Catalogue foreword by John I. H. Baur; essay by Shinn.
627. KENT, N. "The Versatile Art of Everett Shinn." *American Artist,* vol. 9 (October, 1945), 8–13; 35–37.

JOHN SLOAN

628. BROOKS, VAN WYCK. *John Sloan: A Painter's Life.* New York: E. P. Dutton, 1955.
629. MORSE, PETER. *John Sloan's Prints.* New Haven: Yale University Press, 1969. A catalogue raisonné of the etchings, lithographs, and posters; bibliography.
630. ST. JOHN, BRUCE (ed.). *John Sloan's New York Scene.* New York: Harper & Row, 1965.
631. ———. *John Sloan.* New York: Frederick A. Praeger, 1971.

DAVID SMITH

632. Cambridge, Mass., Fogg Art Museum. *David Smith: A Retrospective Exhibition.* 1966. Introduction by Jane Harrison Cone; bibliography.
633. GRAY, CLEVE (ed.). *David Smith by David Smith.* New York: Holt, Rinehart and Winston, 1968.
634. HUNTER, SAM. "David Smith." *Museum of Modern Art Bulletin,* vol. V, no. 2 (1957), 3–36. Catalogue and bibliography.
635. KRAUSS, ROSALIND. "The Essential David Smith, Part 1." *Artforum,* vol. 7 (February, 1969), 43–49.
636. ———. "The Essential David Smith, Part 2." *Artforum,* vol. 7 (April, 1969), 34–41.
637. New York, Solomon R. Guggenheim Museum. *David Smith.* 1969. Catalogue introduction by Edward F. Fry; brief bibliography.

TONY SMITH

638. BARO, GENE. "Tony Smith: Toward Speculation in Pure Form." *Art International,* vol. 11 (Summer, 1967), 27–30.
639. BURTON, SCOTT. "Old Master at the New Frontier." *Art News,* vol. 65 (December, 1966), 52–55; 68–70.

640. LIPPARD, LUCY R. "Tony Smith: 'The Ineluctable Modality of the Visible.' " *Art International,* vol. 11 (Summer, 1967), 24–26.
641. New York, M. Knoedler & Co. *Tony Smith: Recent Sculpture.* 1971. Interviews with the artist by Lucy R. Lippard; chronology.

ROBERT SMITHSON

642. ROBBINS, ANTHONY. "Smithson's Non-Site Sights." *Art News,* vol. 67 (February, 1969), 50–53.
643. SMITHSON, ROBERT. "Aerial Art—Proposals for the Dallas-Fort Worth Regional Airport." *Studio International,* vol. 177 (April, 1969), 180–81.
644. ———. "Incidents of Mirror-Travel in the Yucatan." *Artforum,* vol. 8 (September, 1969), 28–33.

RAPHAEL SOYER

645. COLE, SYLVAN, JR. *Raphael Soyer: 50 Years of Printmaking, 1917–1967.* New York: Da Capo Press, 1967.
646. GOODRICH, LLOYD. *Raphael Soyer.* New York: Harry N. Abrams, 1972.
647. GUTMAN, WALTER K. *Raphael Soyer: Paintings and Drawings.* New York: Sherwood, 1960.
648. New York, Whitney Museum of American Art. *Raphael Soyer.* 1967. Catalogue essay by Lloyd Goodrich; bibliography.

NILES SPENCER

649. CAHILL, HOLGER. "Niles Spencer." *Magazine of Art,* vol. 45 (November, 1952), 313–15.
650. Lexington, University of Kentucky Art Gallery. *Niles Spencer.* 1965. Catalogue essay by Richard B. Freeman; bibliography.
651. WATSON, ERNEST W. "Interview with Niles Spencer." *American Artist,* vol. 8 (October, 1944), 14–17.

FRANK STELLA

652. LEIDER, PHILIP. "Literalism and Abstrac-

tion: Reflections on Frank Stella's Retrospective at the Modern." *Artforum,* vol. 8 (April, 1970), 44–51.

653. Pasadena, Pasadena Art Museum. *Frank Stella: An Exhibition of Recent Paintings.* Catalogue essay "Shape as Form: Frank Stella's New Paintings," by Michael Fried; reprinted in *Artforum,* vol. 5 (November, 1966), 18–27 (*See bibl. 96*).

654. ROSENBLUM, ROBERT. *Frank Stella.* Penguin New Art, vol. 1. Baltimore: Penguin Books, 1970.

655. RUBIN, WILLIAM S. *Frank Stella.* New York: Museum of Modern Art, 1970. Monograph published on the occasion of Stella's retrospective at the museum; extensive bibliography.

JOSEPH STELLA

656. BAUR, JOHN I. H. *Joseph Stella.* New York: Frederick A. Praeger, 1971.

657. JAFFE, IRMA B. *Joseph Stella.* Cambridge: Harvard University Press, 1970.

CLYFFORD STILL

658. Buffalo, Albright-Knox Art Gallery. *Clyfford Still: Thirty-Three Paintings in the Albright-Knox Art Gallery.* 1966. Catalogue introduction by Ti-Grace Sharpless.

659. GOOSSEN, E. C. "Painting as Confrontation: Clyfford Still." *Art International,* vol. 4 (January, 1960), 39–43.

660. MCCAUGHEY, PATRICK. "Clyfford Still and the Gothic Imagination." *Artforum,* vol. 8 (April, 1970), 56–61.

661. Philadelphia, University of Pennsylvania, Institute of Contemporary Art. *Clyfford Still.* 1963. Catalogue essay by Ti-Grace Sharpless.

GEORGE SUGARMAN

662. GOLDIN, AMY. "Beyond Style." *Art and Artists,* vol. 3 (September, 1968), 32–35.

663. SIMON, SIDNEY. "George Sugarman." *Art International,* vol. 11 (May, 1967), 22–26.

MARK TOBEY

664. New York, Museum of Modern Art. *Mark Tobey.* 1962. Exhibition and catalogue by William C. Seitz; bibliography.

665. ROBERTS, COLETTE. *Mark Tobey.* New York: Evergreen Press, 1959.

666. SCHMIED, WIELAND. *Tobey.* New York: Harry N. Abrams, 1966.

BRADLEY WALKER TOMLIN

667. ASHBERY, JOHN. "Tomlin: The Pleasures of Color." *Art News,* vol. 56 (October, 1957), 22–25.

668. HESS, THOMAS B. "Bradley Walker Tomlin." *Art News,* vol. 49 (May, 1950), 52.

669. New York, Whitney Museum of American Art. *Bradley Walker Tomlin.* 1957. Catalogue essay by John I. H. Baur.

ERNEST TROVA

670. MELLOW, JAMES R. "New York Letter." *Art International,* vol. 13 (February, 1969), 50.

671. New York, Pace Gallery. *Trova: Selected Works, 1953–1966.* 1967. Catalogue text by Lawrence Alloway; bibliography.

672. VAN DER MARCK, JAN. "Ernest Trova—Idols for the Computer Age." *Art in America,* vol. 54 (November–December, 1966), 64–67.

ANDY WARHOL

673. COPLANS, JOHN. *Andy Warhol.* Greenwich: New York Graphic Society, 1970. Contributions by Jonas Mekas and Calvin Tomkins; bibliography. Published on the occasion of Warhol's retrospective at the Pasadena Art Museum.

674. CRONE, RAINER. *Andy Warhol.* New York: Frederick A. Praeger, 1970. Catalogue raisonné and bibliography.

675. Philadelphia, University of Pennsylvania, Institute of Contemporary Art. *Andy Warhol.* 1965. Exhibition and catalogue by Samuel Adams Green (*See bibl. 6*).

676. WARHOL, ANDY; KONIG, KASPER; HULTEN, K. G. PONTUS; and GRANATH, OLLE (eds.). *Andy Warhol.* 2nd. ed., New York: Worldwide Books, 1969. Published on the occasion of the Andy Warhol exhibition at

the Moderna Museet in Stockholm, 1968.

MAX WEBER

677. CAHILL, HOLGER. *Max Weber.* New York: Downtown Gallery, 1930.
678. New York, Whitney Museum of American Art. *Max Weber: Retrospective Exhibition.* 1949. Catalogue essay by Lloyd Goodrich; selected bibliography.
679. Santa Barbara, University of California at Santa Barbara Art Gallery. *Max Weber.* 1968. Exhibition catalogue.

TOM WESSELMANN

680. ABRAMSON, J. A. "Tom Wesselmann and the Gates of Horn." *Arts Magazine,* vol. 40 (May, 1966), 43–48.
681. Balboa, Cal., Newport Harbor Art Museum. *Tom Wesselmann: Early Still Lifes, 1962–1964.* 1970. Catalogue introduction by Thomas H. Garver.
682. SWENSON, G. R. "Wesselmann: the Honest Nude." *Art and Artists,* vol. 1 (May, 1966), 54–57.

GRANT WOOD

683. GARWOOD, DARRELL. *Artist in Iowa: A Life of Grant Wood.* New York: W. W. Norton, 1944; Greenwood, 1971.

ANDREW WYETH

684. Cambridge, Mass., Fogg Art Museum. *Andrew Wyeth: Dry Brush and Pencil Drawings.* 1963. Introduction and catalogue by Agnes Mongan.
685. Philadelphia, Pennsylvania Academy of the Fine Arts. *Andrew Wyeth: Temperas, Watercolors, Dry Brush, Drawings, 1938 to 1966.* 1966. Catalogue essay by Joseph T. Fraser, Jr.
686. WYETH, ANDREW and MERYMAN, RICHARD. *Andrew Wyeth.* New York: Houghton-Mifflin, 1968.

WILLIAM ZORACH

687. BAUR, JOHN I. H. *William Zorach.* New York: Frederick A. Praeger, 1959.
688. New York, Brooklyn Museum. *William Zorach: Paintings, Watercolors and Drawings, 1911–1922.* 1969. Exhibition and catalogue essay by Donelson F. Hoopes.

Selected References on American Architecture of the Twentieth Century
by John Jacobus

GENERAL REFERENCES

BURCHARD, JOHN, and BUSH-BROWN, ALBERT. *The Architecture of America: a Social and Cultural History.* Boston: Little, Brown, 1961.
BANHAM, REYNER. *Los Angeles: the Architecture of Four Ecologies.* New York: Harper and Row, 1971.
BLAKE, PETER. *God's Own Junkyard: the Planned Deterioration of America's Landscape.* New York: Holt, Rinehart, 1964.
BROOKS, H. ALLEN. *The Prairie School: Frank Lloyd Wright and His Midwest Contemporaries.* Toronto: University of Toronto Press, 1971.
CHENEY, SHELDON. *Art and the Machine: an Account of Industrial Design in Twentieth-Century America.* New York: McGraw-Hill, 1936.
CONDIT, CARL W. *The Chicago School of Architecture.* Chicago: University of Chicago Press, 1964.

EDGELL, GEORGE H. *The American Architecture of Today.* New York: Scribner's, 1928.
Five Architects: Eisenman, Graves, Gwathmey, Hejduk, Meier. New York: Wittenborn, 1972.
GIEDION, SIGFRIED. *Space, Time and Architecture.* Cambridge, Mass.: Harvard University Press, 1941; 5th ed. rev. and enl. 1967.
HALL, BEN M. *The Best Remaining Seats: the Story of the Golden Age of the Movie Palace.* New York: Potter, 1961.
HITCHCOCK, HENRY-RUSSELL. *Architecture: Nineteenth and Twentieth Centuries.* Baltimore: Penguin, 1958; 3rd ed. 1968.
—— and DREXLER, ARTHUR (eds.). *Built in U.S.A.: Post-War Architecture.* New York: Museum of Modern Art, 1952.
JACOBS, JANE. *The Death and Life of Great American Cities.* New York: Random House (Vintage), 1961.

JACOBUS, JOHN. *Twentieth-Century Architecture: the Middle Years 1940–65.* New York: Frederick A. Praeger, 1966.

JORDY, WILLIAM H. *American Buildings and Their Architects: Progressive and Academic Ideals at the Turn of the Twentieth Century.* Vol. 3. Garden City, N.Y.: Doubleday, 1970–72.

———. *American Buildings and Their Architects: the Impact of European Modernism in the Twentieth Century.* Vol. 4. Garden City, N.Y.: Doubleday, 1970–72.

KAUFMANN, EDGAR, JR. (ed.). *The Rise of an American Architecture.* New York: Frederick A. Praeger, 1970.

MCCALLUM, IAN. *Architecture U.S.A.* New York: Reinhold, 1959.

MCCOY, ESTHER. *Five California Architects.* New York: Reinhold, 1960.

MOCK, ELIZABETH (ed.). *Built in U.S.A., 1932–1944.* New York: Museum of Modern Art, 1944.

MUMFORD, LEWIS (ed.). *Roots of Contemporary American Architecture.* New York: Reinhold, 1952.

———. *The Highway and the City.* New York: Harcourt, Brace, 1963.

NEUTRA, RICHARD. *Wie Baut Amerika?* Stuttgart: J. Hoffmann, 1927.

PEISCH, MARK L. *The Chicago School of Architecture.* New York: Random House, 1965.

REPS, JOHN W. *The Making of Urban America: a History of City Planning in the United States.* Princeton, N.J.: Princeton University Press, 1965.

SCULLY, VINCENT. *American Architecture and Urbanism.* New York: Frederick A. Praeger, 1969.

STERN, ROBERT A. M. *New Directions in American Architecture.* New York: George Braziller, 1969.

TUNNARD, CHRISTOPHER, and PUSHKAREV, BORIS. *Man-Made America: Chaos or Control?* New Haven: Yale University Press, 1963.

Zodiac, vol. 8 (1961), special number, *America.*

Zodiac, vol. 17 (1967), special number, *U.S.A. Architecture.*

SELECTED ARCHITECTS' BIBLIOGRAPHIES

BUCKMINSTER FULLER

MARKS, ROBERT W. *The Dymaxion World of Buckminster Fuller.* New York: Reinhold, 1960.

WALTER GROPIUS

GIEDION, SIGFRIED. *Walter Gropius, Work and Teamwork.* New York: Reinhold, c. 1954.

VICTOR GRUEN

GRUEN, VICTOR. *The Heart of Our Cities.* New York: Simon and Schuster, 1964.

PHILIP JOHNSON

JACOBUS, JOHN. *Philip Johnson.* New York: George Braziller, 1962.

HITCHCOCK, HENRY-RUSSELL. *Architecture 1949–1965 by Philip Johnson.* New York: Holt, Rinehart, 1966.

LOUIS KAHN

SCULLY, VINCENT. *Louis Kahn.* New York: George Braziller, 1962.

L'Architecture d'Aujourd'hui, vol. 40, no. 142 (Feb.–Mar. 1969), special number on Kahn.

MORRIS LAPIDUS

LAPIDUS, MORRIS. *Architecture: a Profession and a Business.* New York: Reinhold, 1967.

LUDWIG MIES VAN DER ROHE

JOHNSON, PHILIP. *Mies van der Rohe.* New York: Museum of Modern Art, 1947; 2nd ed. rev. 1953.

BLASER, WERNER. *Mies van der Rohe: the Art of Structure.* New York: Frederick A. Praeger, 1972.

CHARLES MCKIM

MOORE, CHARLES. *The Life and Times of Charles Follen McKim.* Boston: Houghton, 1929.

RICHARD NEUTRA

BOESIGER, WILLY (ed.). *Richard Neutra: Buildings and Projects.* 3 vols. New York: Frederick A. Praeger, 1951–66.

WILLIAM G. PURCELL and GEORGE GRANT ELMSLIE

GEBHARD, DAVID. *The Work of Purcell and Elmslie, Architects.* Park Forest, Ill.: Prairie School Press, 1965.

PAUL RUDOLPH

MOHOLY-NAGY, SIBYL (intro.). *The Architecture of Paul Rudolph.* New York: Frederick A. Praeger, 1970.

EERO SAARINEN

SAARINEN, ALINE B. (ed.). *Eero Saarinen on His Work.* New York: Yale University Press, 1962; rev. ed. 1968.

TEMKO, ALLAN. *Eero Saarinen.* New York: George Braziller, 1962.

RUDOLPH SCHINDLER

GEBHARD, DAVID. *Schindler.* New York: Viking, 1971.

PAOLO SOLERI

SOLERI, PAOLO. *Arcology: the City in the Image of Man.* Cambridge, Mass.: M.I.T. Press, 1969.

EDWARD DURELL STONE

STONE, EDWARD DURELL. *The Evolution of an Architect.* New York: Horizon Press, 1962.

LOUIS SULLIVAN

SULLIVAN, LOUIS. *Kindergarden Chats.* Lawrence, Kans.: Scarab Fraternity Press, 1934; New York: Wittenborn, Schultz, 1947.
————. *The Autobiography of an Idea.* New York: American Institute of Architects, 1924.
MORRISON, HUGH. *Louis Sullivan, Prophet of Modern Architecture.* New York: W. W. Norton, 1935.

ROBERT VENTURI

VENTURI, ROBERT, SCOTT BROWN, DENISE, and IZENOUR, STEPHEN. *Learning from Las Vegas.* Cambridge, Mass.: M.I.T. Press, 1972.

FRANK LLOYD WRIGHT

WRIGHT, FRANK LLOYD. *An Autobiography.* New York: Longmans, Green, 1932; Duell, Sloan and Pearce, 1943.
HITCHCOCK, HENRY-RUSSELL. *In the Nature of Materials.* New York: Duell, Sloan and Pearce, 1942.
SCULLY, VINCENT. *Frank Lloyd Wright.* New York: George Braziller, 1960.
DREXLER, ARTHUR. *The Drawings of Frank Lloyd Wright.* New York: Museum of Modern Art, 1962.
EATON, LEONARD K. *Two Chicago Architects and Their Clients: Frank Lloyd Wright and Howard Van Doren Shaw.* Cambridge, Mass.: M.I.T. Press, 1969.

Index

PHOTOGRAPHIC CREDITS

The authors and publisher wish to thank the museums and private collectors for permitting the reproduction of paintings and sculptures in their collections. Photographs have been supplied by the owners or custodians of the works of art except for the following plates:

Aerial Photos of New England, Inc., Boston: 949; Andover Art Studio, Andover, Mass.: 1, 4, 15, 89, 90, 361; Wayne Andrews, Grosse Pointe, Mich.: 52, 55, 56, 65, 66, 281, 285; Bacci Attilis, Milan: 198; Oliver Baker (courtesy Geoffrey Clements, New York): 117, 130, 179, 235, 245, 327, 372, 402, 410, 423, 428, 444, 452, 463, 590, 592, 596, 641, 646, 651, 699, 804; Baltimore and Ohio Railroad Co., Baltimore: 277; Baumel, New York: 792, 869; Bettman Archives, New York: 22; E. Irving Blomstrann, New Britain, Conn.: 102, 293; Ferdinand Boesch, New York: 542, 712, 751, 780, 900, 932; Thor Bostrom, New York: 509; Miguel Rio Branco, New York: 785, 889; Rudolph Burckhardt, New York: 166, 360, 362, 398, 399, 407, 409, 442, 534, 543, 593, 602, 603, 606, 608, 616, 620, ·648, 653, 656, 658, 672, 698, 702, 705, 708, 711, 716,.717, 721, 749, 763, 768, 777, 781, 784, 795, 797, 802, 811–13, 817, 821, 822, 827, 828, 840, 844, 884, 922; Barney Burstein, Boston: 132; Cavendish Photographic Co., London: 610; Lawrence Cherney, Long Island City, N.Y.: 291; Chicago Architectural Photographing Co.: 21, 50; Chicago Tribune: 252; Geoffrey Clements, New York: 39, 101, 109, 115, 118, 120, 126, 141, 145, 148, 161, 163, 182, 191, 209, 215, 224, 241, 247, 312, 322, 334, 353, 356, 376, 411, 419, 445, 451, 455, 458, 479, 487, 502, 508, 510, 511, 521, 533, 545, 548, 611, 618, 623, 627, 636, 642, 645, 650, 652, 655, 679, 681, 684, 686, 688, 693, 697, 704, 707, 709, 713, 714, 722, 730, 736, 737, 740, 747, 753, 754, 756, 770, 771, 775, 789, 824, 865–68, 875, 904, 909, 910, 925; Colten (courtesy Peter A. Juley & Son, New York): 413; Edward Cornachio, Los Angeles: 940; Robert Damora, Bedford, N.Y.: 585; Dartmouth College, Hanover, N.H.: 44, 48, 53, 54, 57–60, 62–64, 253–57, 270, 282, 283, 556, 557, 565; William Dietz, New York: 580; Walter Dräyer, Zurich: 363; Dudley Studios Ltd., Oxford, England: 903; Edholm & Blomgren, Lincoln, Neb.: 266; The Empire State Building Co., New York: 269; Bill Engdahl, Hedrich-Blessing, Chicago: 24, 25; R. Everett, New York: 808; Thomas Feist, New York: 212, 217, 400; John A. Ferrari, New York: 381, 826; David Gahr, New York: 899; Will Gainfort: 598; General Motors Corp., Detroit: 274; Giacomelli, Venice: 154; Glasgow Art Gallery, Glasgow: 6; Gianfranco

Gorgoni: 852; Graphics/Anto, Chicago: 503; Pedro Guerrero, New York: 504; Charles Gwathmey, New York: 987; Howard Harrison, New York: 920; Harvard University News Office, Cambridge, Mass.: 947; Hedrich-Blessing, Chicago: 950; Bartlett Hendricks, Pittsfield, Mass.: 501; Yves Hervochon, Paris: 902; Steve Hill, San Francisco: 963; David Hirsch, Brooklyn, N.Y.: 948, 983; John Jacobus, Hanover, N.H.: 67–69, 71, 73, 74, 250, 258, 260, 262–65, 569–76, 956, 959; Philip Johnson & John Burgee, New York: 579; Peter A. Juley & Son, New York: 84, 171, 320, 332, 406, 440, 481, 488, 490; Frank Kelly, Manchester, N.H.: 213; Rollin La France, Philadelphia: 980; Nina Leen, New York: 469; Paulus Leeser, New York: 457; Dan Lenore, New York: 695; Kenneth Lester, Minneapolis: 692; Levitt and Sons, Lake Success, N.Y.: 985; Linich/Factory Foto, New York: 663; Herral Long, Toledo: 931; Laurin McCracken: 961; Fred W. McDarrah, New York: 816, 874; Robert R. McElroy, New York: 621, 643; Gene Meyer: 919; Marshall Meyers, Philadelphia: 970; Peter Moore, New York: 358, 794, 880, 881, 885, 887, 891, 896; Peter Morrin, Washington, D.C.: 957; John D. Murray, Andover, Mass.: 106; The Museum of Modern Art, New York: 248, 249, 284; Museum of the City of New York: 46; Hans Namuth, New York: 377, 820, 908, 928; O. E. Nelson, New York: 206, 317, 359, 378, 404, 405, 412, 429, 438, 443, 448, 468, 477, 485, 507, 524, 526, 532, 542, 667; New Haven Veterans Memorial Coliseum, New Haven, Conn.: 973; Irving J. Newman, Greenwich, Conn.: 424; New York Convention and Visitors Bureau, Inc.: 268; Phillips Studio, Philadelphia: 328; George Platt, New York: 365; George Pohl, Philadelphia: 969; Eric Pollitzer, New York: 37, 149, 155, 188, 192, 422, 461, 464, 465, 466, 538, 604, 611, 619, 629, 659, 660, 664–66, 669–71, 676, 690, 718, 732, 748, 760, 764, 772, 878, 895, 927; Port of New York Authority: 954; Nathan Rabin, New York: 315, 382, 675, 706, 776, 806, 888; Radio City Music Hall, New York: 275; Percy Rainford, New York: 82; David van Riper: 842; George Roos, New York: 773; Seymour Rosen, Los Angeles: 960; Walter Rosenblum, Long Island City, N.Y.: 540, 640; Walter J. Russell, New York: 135, 615, 752, 765, 778, 832, 850, 854, 859; John van Saun, New York: 830; John D. Schiff, New York: 121, 403, 426, 546, 617, 769, 809, 901; Peter Schmitt, London: 962; Walter Seng, North Versailles, Pa.: 918; I. Serisawa, Los Angeles: 29; Shunk-Kender, New York: 863, 871, 876, 883, 941; The Singer Company, New York: 47; Skidmore, Owings and Merrill, Chicago: 951; Ezra Stoller Associates, Mama-

roneck, N.Y.: 544, 563; Bill Strehorn, Dallas: 194; Eric Sutherland, Minneapolis: 522; William Suttle, New York: 938; Thomas Airviews, Bayside, N.Y.: 964; Charles Uht, New York: 94, 496; United Press International, New York: 952; Malcolm Varon, New York: 625, 762; William Watkins: 981; Etienne Bertrand Weill, Paris: 633; Joel Peter Witkin, New York: 694; Wurtz Bros., New York: 5; A. J. Wyatt, Philadelphia: 92, 240; Kurt Wyss, Basel: 968; Yale University Art Gallery, New Haven, Conn.: 587; Minoru Yamasaki and Associates, Troy, Mich.: 578